YALE UNIVERSITY PRESS
PELICAN HISTORY OF ART

Founding Editor: Nikolaus Pevsner

Ellis Waterhouse

PAINTING IN BRITAIN 1530 TO 1790

Professor Sir Ellis Waterhouse, who was born in 1905, after taking his degree
at Oxford, spent two years at Princeton University. From 1929 to 1933 he
was Assistant Keeper of the London National Gallery, and from 1933 to 1936
Librarian of the British School in Rome. As a result of his stay in that city he
published his book on *Roman Baroque Painting* in 1937. The year after he was
elected a Fellow of Magdalen College, Oxford. His standard book on *Reynolds*
came out in 1941. He was Director of the National Gallery of Scotland from
1949 until, in 1952, he took over the directorship of the Barber Institute of
Fine Arts at the University of Birmingham. He was Slade Professor of Fine
Art in the University of Oxford from 1953 to 1955. In 1955 he was made a
Fellow of the British Academy. On retiring from Birmingham in 1970, he
acted as Director of Studies at the Paul Mellon Centre for Studies in British
Art, London, visiting Kress Professor at the National Gallery, Washington,
and Curatorial Adviser to the National Gallery of Canada. Professor
Waterhouse died in 1985.

Yale University Press · New Haven and London

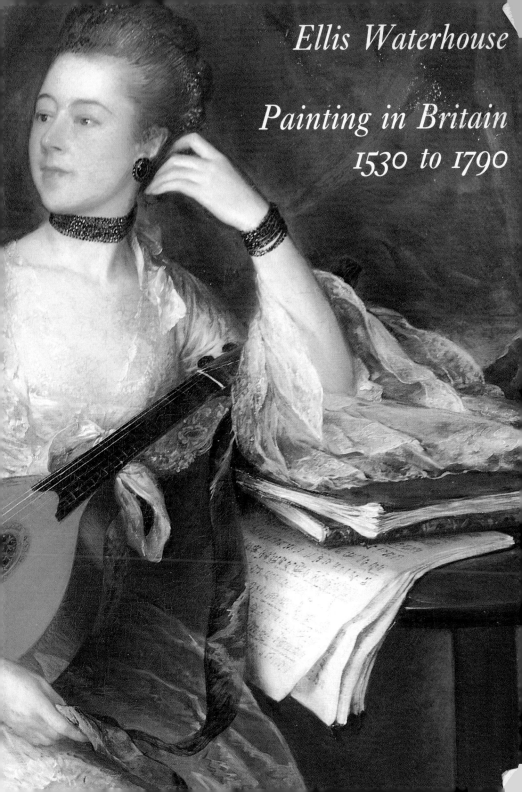

Ellis Waterhouse

Painting in Britain
1530 to 1790

First published 1953 by Penguin Books Ltd
Fifth edition with an introduction by Michael Kitson published by
Yale University Press 1994
20 19 18 17 16 15 14 13 12 11 10 9 8 7 6 5 4 3 2 1

Set in Monophoto Ehrhardt, and printed in Hong Kong through World Print Ltd

Designed by Gerald Cinamon

ISBN 0-300-05832-2 (cloth)
 0-300-05833-0 (p/b)

Library of Congress catalog card number 77-19107

CONTENTS

ACKNOWLEDGEMENTS

Anyone who has tried to see or to study British painting will know that my largest and deepest debt is to the great number of private owners who have allowed me to see their pictures, either by making their houses accessible to the public, by lending their pictures to public exhibitions, or by yielding benevolently to the importunity of a stranger. That part of our national heritage in painting which dates from before the nineteenth century is still very largely to be seen in its original and gracious natural setting, the private home, which ranges from the royal palaces to the country manor house. These houses and their contents are our national glory, and their steady disappearance before the sapping operations of the Inland Revenue is rapidly becoming our national shame. To all these owners who have allowed their pictures to be seen and reproduced here my greatest debt of gratitude is owed.

This wide dispersal of the material for the history of British painting – assisted by our national apathy – is the reason for its neglect by serious students and for the backward state of our knowledge of it. Its historian is not merely the latest of a long line, gleaning the chaff which may have escaped his forerunners who long ago established all the principal dates and the detailed lines of development of individual artists. There is still a great deal that we do not know, and hardly a week has passed since I began writing this book in which a new picture has not turned up or a signature and date been read which has modified previous conceptions. I am not apologizing for the tentative character of this book, but, as it is one of a series which includes much more richly cultivated ground, it is perhaps well that the ordinary reader should be made aware of the state of scholarship on the subject – and be encouraged to make further research and find the author wrong.

The bibliography and footnote references must provide the acknowledgements for the dead and for the living who have gone into print, but certain friends and helpers must not go unmentioned. It was C. H. Collins Baker who first guided my interest in British painting: and this book is the slow outcome of the interest and enthusiasm for which he, more than any other, is responsible. Of those of a later generation I am most indebted to John Woodward, who has not only drawn many pictures to my attention, but has read the proofs and drawn attention to my ambiguities and errors. Others who have been especially helpful are W. G. Constable, Oliver Millar, John Steegman, and Mary Woodall. For particular kindness in securing photographs and permissions for reproduction I am indebted to the National Trust, the National Gallery, the National Maritime Museum, the Governors of Christ's Hospital, the Manchester City Art Gallery, Messrs Christie's and Messrs Sotheby's; and to the Frick Collection in New York.

1953

NOTE ON THE FOURTH EDITION

A good deal of research – though not as much as one could have wished – has been published on British painting since this book first came out in 1953, and since it was last revised (with as few substantial changes as possible) in 1969. The most gains in our knowledge have been made in the period before 1625, and, for this new integrated edition, I have entirely rewritten the first three chapters. The rest of the text has undergone a thorough revision, incorporating new dates and new information and altogether recasting the bibliography. It has not seemed to me necessary to change many of the illustrations, but I have noted with interest how many pictures, made familiar for the first time in 1953, have now found their way into the Tate Gallery! I hope I have managed, by the alterations in the text – and especially by the alterations in the notes – to direct the attention of a later generation of readers to where they may find up-to-date additional information.

1977

INTRODUCTION TO THE FIFTH EDITION

For almost forty years following the outbreak of the second world war, Ellis Waterhouse (1905–85) was universally recognized as the leading authority on British painting of the period from the Reformation to the end of the eighteenth century. He was the author of two books on Reynolds, one on Gainsborough, a notable lecture series entitled *Three Decades of British Art 1740–1770* and, towards the end of his life, two useful if idiosyncratic dictionaries of sixteenth-, seventeenth- and eighteenth-century British painters. He also wrote numerous articles, reviews and contributions to exhibition catalogues devoted to British art. More important and better known than any of the foregoing, however, was the book here reprinted by Yale University Press, *Painting in Britain 1530–1790*, to which all Waterhouse's other writings on British art were in some sense either a prelude or a sequel.

Originally published in 1953 as one of the first four volumes in the Pelican History of Art series, then edited by Nikolaus Pevsner, *Painting in Britain 1530–1790* immediately superseded all previous studies of its subject and has regularly headed the reading lists of all students of British painting ever since. It owed – as it still owes – its success to its easy literary style, its lucid arrangement of the material, and the persuasiveness of both its chronology and aesthetic judgements. Here, the reader is painlessly made to feel, is what happened, and when it happened, in British painting during the period covered by the book; moreover, *these* (the artists discussed by Waterhouse) were the best and most important British painters – or rather, painters in Britain, for until the eighteenth century, of course, the majority of the most successful artists in this country were foreign born.

Anyone tempted to find such an account oversimple – and there would be some justice in that – should perhaps be reminded that Waterhouse was an extremely intelligent man. He had an unrivalled knowledge of pictures in museums and private collections both in Britain and abroad, and he made a point of building up large collections of books, sales catalogues and photographs both for his own use and at the institutions where he worked. His neat pencilled annotations on these materials are still a source of awe and amazement to his successors in the field. If the extent of his learning is not obvious from his writings it is because, like other British scholars of his and earlier generations, he subscribed to the gentlemanly convention that erudition should be lightly worn. (The day was admittedly past when a scholarly book could be written without footnotes, but Waterhouse always kept them to a minimum.) In addition, he was as familiar with Continental European, especially Italian baroque, painting as he was with painting in Britain. This gave a European perspective to his treatment of British artists, with the result that, although he thought more highly of them than did most of his predecessors, he never forgot the limited role allotted to them by their own society and the consequences this had for the quality of their art.

Painting in Britain 1530–1790 was extensively revised only once, in 1978, and then chiefly to take account of new information which had come to light for the period before 1625. No survey-book of its kind can be expected to last indefinitely, even with repeated revisions, and this one has already lasted longer than most. Even when it was first published the book contained some curious gaps. Waterhouse had no taste for drawings or prints, and his account of eighteenth-century landscape watercolours, for example, is seriously inadequate in consequence. He was also largely uninterested in philosophical ideas or in artistic theory, other than the compact, well-ordered, 'civilized' theory embodied in Sir Joshua Reynolds's *Discourses*. Waterhouse's mistrust of the untidy, the irrational and the extreme is evident in his antipathy

to such Romantic painters as Fuseli, Blake and Turner, and his unwillingness to deal with them was no doubt the reason why he ended his book at 1790, rather than continue it to 1830 like the companion volumes on British architecture and sculpture in the Pelican series.

Apart from the gaps mentioned above, it should also be remembered that there were distinguished scholars writing in the 1950s, '60s and '70s who made major contributions of their own to subjects occupying central positions in Waterhouse's volume. Among them were Roy Strong on Elizabethan and Jacobean painting, Oliver Millar on the seventeenth century, Ronald Paulson on Hogarth and John Hayes on Gainsborough, to name perhaps the most important. Yet all of these, while differing from Waterhouse in detail, used an approach that was essentially similar to his. Their findings were, indeed, to a considerable extent incorporated in his revisions of 1978 and their publications listed in his updated bibliography.

Why then cannot a further revision of the book be carried out, albeit by another hand, and the bibliography be updated once more, to take account of work produced since 1978? The reason is that during that time a revolution, no less, has occurred in the study of British art, rendering any such process unthinkable. It is true that the manifestations of this revolution have so far been confined to fewer than two dozen books, including books of essays, whereas the bulk of what has been published – chiefly monographs and exhibition catalogues – has continued to be conceived on traditional lines. Still, the new thinking in those books that exemplify it has been so fundamental in its implications that the only solution to the problem of updating Waterhouse is for a new book to be commissioned from another author.

Until such time as that appears and so long as *Painting in Britain 1530–1790* (in its 1978 edition) remains in print, it is worth trying to explain what has happened to the study of British art in the past fifteen years or so and then attempt to assess how far Waterhouse's book remains useful. This is the purpose of the present Introduction. We can ignore the traditional

material, though that is not necessarily to denigrate it. The revolution we have to consider is one of method of approach. In fact, there have been two almost simultaneous revolutions, one a good deal more radical than the other, and we shall need to examine each in turn. Central to both is the premise that, as John Barrell has expressed it, 'the story of art cannot be written as the story of art alone'.[1] In keeping with this, much of the new work in the field has been done by scholars from outside the discipline of art history, a majority of whom have been historians and critics of literature. A hallmark of the new approaches, especially evident in books of essays by several hands, is that they have often been consciously interdisciplinary in nature.

Neither revolution has, of course, been confined to the study of painting in Britain but the effect, arguably, has been more dramatic in that area than anywhere else. This is because of the contrast with what prevailed before. Until recently, that is, perhaps no other school of painting was studied so exclusively in terms of its own internal history. This is not to say that that history was thought to be free of external constraints; on the contrary. The conditions of patronage in particular were perceived crucially to determine the kind of subjects that artists could paint, in what style they could paint them (contrast, for example, the visually naive patronage of the Elizabethans with the much more sophisticated patronage of Charles I), and indeed to what extent artists could paint at all. As Waterhouse points out on the first page of *Painting in Britain*, the withdrawal of the support of the Church at the Reformation and the failure by the court and the aristocracy to develop a taste for pictures of classical mythologies dealt a severe blow to the prospects for art in sixteenth-century Britain, though the loss was partly made up for by the impetus given to portraiture by the growth of the Renaissance cult of individual personality. Later, in the second half of the eighteenth century, other external factors, such as the introduction of regular art exhibitions, the stimulus of Continentally-derived artistic theory and the increased wealth and numbers of the upper and upper-middle classes, created op-

portunities for British painters that had not existed before.

Within the framework of these constraints and opportunities, however, art was assumed to be largely self-generating. Artist begat artist in an unbroken sequence like the patriarchs in the Old Testament. What varied the pattern and gave it interest were the talents and energies of successive individuals. The function of the art historian, therefore, was threefold: to plot the transmission of influences, both stylistic and otherwise; to trace, which is an adaptation of the same thing, the stylistic development in the work of each painter; and to describe, assess and celebrate artistic quality. In addition, the art historian needed to possess some pieces of professional equipment: an extensive visual memory; a good enough eye to make convincing attributions and to tell the difference between originals and copies or fakes ('connoisseurship'); and an ability to use documents to establish facts.

Traditional art history of this kind, of which Waterhouse's *Painting in Britain 1530–1790* is a prime modern example, is not a dishonourable or trivial pursuit. It has a pedigree stretching back to Giorgio Vasari[2] and it fulfils a classic prescription for the study of art recently summed up by Richard Wollheim in the sentence, 'the task of criticism is the reconstruction of the creative process'.[3] In other words, if we want to know how art developed in a given period or region or in the work of an individual artist, this is one way of determining it. Of course, it is not the only way. A significant alternative, created in the early nineteenth century by German idealist philosophers, is in terms of cultural history. An offshoot of this, inaugurated at the end of the same century by Aby Warburg, is the study of the subject matter of art in relation to the cultural, in practice predominantly intellectual, context of its time. This is known for convenience as 'iconography' or 'iconology', and a preferred term for art is visual imagery, indicating a wider range of pictorial and sculptural artefacts, some of them not aesthetically refined, than the objects of fine art specialized in by the traditional art historian.

Iconography was introduced into British in-

tellectual life as a result of the transfer to London from Hamburg of the Warburg Institute in 1933 and into the United States at almost the same moment by the emigration to New York and then Princeton of the most intellectually brilliant exponent of the subject, Erwin Panofsky. By the 1950s in both countries, iconography had become fused with traditional art history, or at any rate they were not seen to be opposed any more, and in recent times almost all art historians have been willing as the occasion demanded to practise both. It must be said, however, that Waterhouse was not one of them. Admittedly, the period of British painting with which he was concerned involves the study of iconography less than does, say, the Italian Renaissance, but it is still by no means irrelevant. The fact that Waterhouse ignored it is one of the drawbacks of *Painting in Britain*.

The new art historians, or revolutionaries, have objected not only to traditional art history but also, though for somewhat different reasons and not to the same degree, to iconography. One reason for objecting to both these forms of approach is that they have been operated as a closed shop; the first, though not the second, has also been condemned as intellectually sluggish. To quote one of the fiercest critics (not a historian of British art):

Art history lags behind the study of the other arts. Whether this unfortunate state of affairs is to be attributed to the lethargy of the custodians of art, ... or to the peculiar history of the institutions devoted in this century to the study of art, a history which from the beginning has tended to isolate that study from the other humanities, or to some less elaborate reason, ... I cannot say ... What is certain is that while the last three or so decades have witnessed extraordinary and fertile change in the study of literature, of history, of anthropology, in the discipline of art history there has reigned a stagnant peace.[4]

To be fair, that was written in 1983, and whether the author, Norman Bryson, would describe the situation in quite such dismissive

terms today may be doubted. In so far as his criticism is more than just a complaint against specialization (a characteristic of which art history is not uniquely guilty) but is a plea for the discipline to be opened up to other, more philosophical forms of discourse it can only be welcomed. And that, to a degree at least, is exactly what has been happening.

It is now high time to consider the revolutions in the study of British art referred to earlier, beginning with the less radical of the two, which started first. I call it less radical because, unlike the other, it did not pose a direct challenge to traditional art history and indeed has always coexisted with it, if at times slightly uncomfortably. More than this, it has been positively close to the manner in which symbolic images are studied at the Warburg Institute. The basis of this revolution is the argument from English literature, and its exponents almost without exception have been literary historians by training. The starting point is the concept of the Sister Arts, three words which have served as the title or subtitle of more than one book in the field. This concept has been understood not so much in its classical sense, derived from Horace's phrase *ut pictura poesis* ('as is painting so is poetry'), to which the Renaissance and seventeenth and eighteenth centuries gave the extended meaning that painting and poetry had the same ends but expressed them by different means; it has been taken by recent scholars rather to mean that the two arts, provided they are part of a single culture, operate by similar means as well as, or more than, aiming at similar ends. This is not to say, of course, that they use the same media but that they exhibit similar structures. Thus a pictorial and a poetic composition may have the same balance of principal and subordinate elements, the same symmetry, the same rises and falls in tension, the same lights and shades. Further, a multiform painting or sequence of paintings may be constructed in a similar way to a novel. To take a third example, a painted portrait may be assumed to convey the same kind of information about a person as a written biography; both forms record similar details of physical appearance, role in life and

salient virtues, though not inward psychology.[5] In these circumstances, it is possible to 'explain' one art form in terms of the other: not 'account for its existence' – that is the province of traditional art history or literary criticism, whichever is relevant – but use each to find in the other a truer, deeper or more expressive meaning. It is not for nothing that the term 'reading' a picture, rather than 'looking at' it, has recently come into fashion.

The scholar sometimes credited with inaugurating this trend towards the integration of pictorial and literary analysis is Jean Hagstrum, whose book, *The Sister Arts: The Tradition of Literary Pictorialism and English Poetry from Dryden to Gray*, was published (in Chicago) as long ago as 1958. Unlike some later authors we shall be concerned with here, he explained his point of view with admirable clarity. He dismissed previous attempts to find parallels between individual paintings and poems on the basis of correspondences in feeling, in *Zeitgeist*, etc. as unscholarly and insisted that 'in order to be called pictorial a description or an image must be, in its essentials, capable of translation into painting or some other visual art'.[6] As this indicates, however, Hagstrum was concerned with only one category of literature, the pictorial. Moreover, while he used painting with unusual precision and sensitivity to illuminate the meaning of certain passages of poetry, he did not reverse the process by calling on literature to enrich the interpretation of paintings. His book, in short, remains essentially a work of literary history.

After an interval, there followed in the 1970s and early 1980s a group of books – concerned, like Hagstrum's, mainly with the eighteenth century – which more nearly struck a balance between the two arts.[7] I shall leave aside for a moment what seems to me the most remarkable example, Ronald Paulson's *Emblem and Expression* (which is in fact biased towards the visual arts), and consider first the very interesting short book on an earlier period by Lucy Gent, *Picture and Poetry 1560–1620: Relations between Literature and the Visual Arts in the English Renaissance* (Leamington Spa, 1981). Having discovered

that Elizabethan and Jacobean authors refer – and do so enthusiastically, at that – to works of visual art more often than is commonly supposed, Gent then notes with some dismay that the few examples of such works that can be identified today appear to modern eyes disappointingly poor in quality. What does she conclude from this? That the Elizabethans and Jacobeans were merely ignorant and without taste? No, her explanation is that these men and women as yet had no vocabulary with which to express refined ideas of form. They were still barely on the threshold of the new age in which notions of symmetry, proportion and perspective, devised in the art academies of the European Continent, would become available through publications in English. In the England of Shakespeare's time, the criteria for judging works of art were still essentially mediaeval.

Thus the native concept of painting is that it proceeds from a relatively unskilled outline drawing, which together with the underpainting provides the *adumbratio*, or shadow, to the skilled application of colours. The English tradition has no place, no words, for artistic drawing, for composition, perspective, design and chiaroscuro.[8]

There is a moment in the Introduction by Lucy Gent and her co-editor Nigel Llewellyn to the recent book of essays, *Renaissance Bodies: The Human Figure in English Culture, c.1540–1660* (London, 1990), when they seem about to compare the 'long-legged carapaced monsters of De Critz and Larkin' to a phrase such as King Lear's description of 'unaccommodated man' as 'no more but . . . a poor, bare, forked animal'. They don't, in fact, make this comparison but it is a tempting thought, especially perhaps in relation to the well-known portrait by Marcus Gheeraerdts of Thomas Lee (Tate Gallery), represented as an Irish foot-soldier standing barelegged in a bog. However, the point is not to suggest that the gentlemen represented in Elizabethan and Jacobean portraits, on the one hand, and Lear and Edgar on the blasted heath, on the other, are in similar situations, but that the kind of poetic language used by Shakespeare and his

contemporaries is analogous to the methods of the portrait painters. That language is direct, often physical, and always alert to things as they are. It is also innocent of the rules of classical poetic diction (the equivalent of the Renaissance conventions for representing the ideal human figure) yet capable of being splendidly ornate. So, in all these respects, are the painted portraits of the period. To be fair, the old idea that Elizabethan and Jacobean portraits are merely technically inept was long ago discredited by Roy Strong, but the invocation of contemporary uses of language to explain them is new and rewarding.

Not surprisingly in view of its date, *Renaissance Bodies* is a more 'modern' book than *Picture and Poetry 1560–1620*. As Gent and Llewellyn note in their Introduction, the essays in the book go beyond iconography and the decoding of metaphor to take in theories of representation, of the self and of the body, and other methodologies (including feminism) that have been developed in the past two decades. Yet for all that, and for all their great intrinsic interest and original quality of thought, I do not believe that any of these essays, not even that of Andrew and Catherine Belsey on the portraits of Elizabeth I, which is supposedly dependent on a 'frankly post-structuralist reading of its texts', would seem out of place in the *Journal of the Warburg and Courtauld Institutes*. This is not a criticism but a measure of the degree to which some aspects of the new art history can cohabit with some longer-established forms of the discipline.

It is perhaps unlikely that Ronald Paulson's *Emblem and Expression: Meaning in English Art of the Eighteenth Century* (London, 1975) would have been accepted by the editors of a Warburg series; they would have considered it too personal and too speculative. Yet it is not incompatible with traditional art history, while undoubtedly conceived as an alternative to it, and it contains several respectful references to E.K. Waterhouse (who repaid the compliment by including a patronizing and particularly stupid comment on the book in his updated bibliography to *Painting in Britain*). *Emblem and Expression* makes extensive use of the analogy

between visual and verbal structures to show how meaning is conveyed through images, but what makes the book remarkable is that it constitutes the first attempt to write a history of the visual arts in eighteenth-century Britain in terms of ideological attitudes, manifested in changing assumptions as to the kinds of things that art could do and what art was for. In brief, in the relatively homogeneous society prevailing in the first half of the period, art worked through symbols (including the symbols employed to create the structure of the landscape garden); in the second half, when society became more fragmented, art worked through expressive forms, whose shapes and relationships on the canvas are the source of meaning. (Paulson uses a type of analysis here which has been out of fashion pretty well since Roger Fry.) Not everyone will agree with the book in detail but it is an intensely serious enterprise and one which in some respects anticipates the pattern of the century as perceived by John Barrell in *The Political Theory of Painting from Reynolds to Hazlitt* and David Solkin in *Painting for Money*. In return, Paulson has adopted some of the interests in the relationship of art and politics shown by these authors in his own more recent writings, such as *Breaking and Remaking: Aesthetic Practice in England 1700–1820* (Rutgers University Press, New Brunswick and London, 1989) and his new three-volume biography of *Hogarth* (also Rutgers in collaboration with Cambridge, 1991–93), which puts the politics back into Hogarth, so to speak, having been taken out in the author's earlier *Hogarth: His Life, Art and Times* (New Haven and London, 1971).

Mention of politics brings us to the second and more radical of the two revolutions in method here under consideration. Unlike the first, which was ushered in gradually, this one broke out almost without warning. It is true that a few earlier authors, such as F.D. Klingender and Friedrich Antal, had already written about aspects of British eighteenth-century art from a Marxist point of view as far back as the 1940s.[9] But they made the mistake of arguing that the dominant attitudes of a society or ruling group were directly reflected in artists' styles: a 'progressive' stance gave rise to pictorial classicism,

a 'conservative' stance to pictorial romanticism; realism was indicative of democratic aspirations, the rococo of a decadent aristocracy; and so on. (It is a measure of how far art history was identified with stylistic analysis at the time that the impact of ideology on style was taken for granted.) Although correspondences of this type could sometimes be seen to hold good, it quickly became evident that too often they did not, and the method, despite the efforts of its practitioners to get round the inherent problems it presented, fell out of use. At this point – the early 1950s – the study of British art reverted to its former course, governed by that traditional version of art history – '*especially* traditional in the field of British art', Barrell called it in the essay already quoted[10] – that had shaped it for more than seventy years, virtually since Ruskin. In time, this approach was to be joined by the method using parallels with literature, as we have seen, but the old procedures based on charting stylistic developments, assessing the achievements of individual artists and generally adding to art-historical 'knowledge' continued more or less unchanged.

This was the background against which first, in 1980, John Barrell's *The Dark Side of the Landscape: the Rural Poor in English Painting, 1730–1840* and then, in 1982, David Solkin's *Richard Wilson: the Landscape of Reaction* burst upon the art world in Britain. Re-reading them more than a decade later it is not easy to understand what the fuss was about. Both books (especially Solkin's) were the products of careful historical research, their arguments were scrupulously, at times even tentatively, presented, and they were written in measured language. Yet a fuss there certainly was. The art-historical profession received a powerful shock which the majority of its members would now agree was salutary. The wider public, to judge from the newspapers, was outraged, particularly by Solkin's *Wilson*, which did double duty as the catalogue of a commemorative exhibition at the Tate Gallery.[11] The press commentary included personal attacks on the author which were nothing less than shameful.

The central idea of these books which caused such offence may be summed up as follows.

Two of the best-loved of British eighteenth-century painters, Thomas Gainsborough and Richard Wilson, renowned for the gracefulness and serenity of their art, were exposed as willing accomplices in a cruel confidence trick played by the ruling classes on the rural poor. That trick had two sides to it. One, described by Solkin as the 'myth of social harmony', had as its context the widespread acceptance in the early and mid-eighteenth century of the prescription for a peaceful and prosperous society originated by Virgil in the *Georgics*. The condition for such a society to come into being, Virgil argued, was the creation of an efficient agriculture, and this in turn depended on the landowning and the labouring classes working together in harmony for the benefit of both. The (many) workers depended on the (few) landowners for employment, while the latter depended on the former for a comfortable and leisured style of life, which enabled them to reflect calmly on how to order the nation's affairs. Such was the ideal, and it was keenly propagated by those members of eighteenth-century British upper-class society whose interests lay in the country – the 'country party', or anti-Walpole Whigs – some of whom were Wilson's patrons. 'This helps us to understand', says Solkin, 'why the representation of the poor in Wilson's landscapes ... places so strong an emphasis on their apparent contentment; inequalities of rank had to be shown as conducive to equality in overall well-being'.[12] Yet in reality, as he also notes, there were bitter divisions in both rural and urban society, and even if the poor got anything at all out of the supposed contract (which perhaps they did) they were still dreadfully exploited. They were also, of course, considered as subordinate beings, a fact illustrated in Wilson's paintings by his often placing them in shadow, while the rich enjoy their leisure in sunlight.

The other side of the trick became apparent a bit later in the century, by which time the Georgic notion of harmony had been largely abandoned, even in theory, to be replaced by a more commercial approach to the management of the countryside and a more moralistic attitude to the poor. The paintings chosen by John Barrell to illustrate this are the late fancy pictures of Thomas Gainsborough, those with titles such as *Cottage Children (The Woodgatherers)* and *The Woodcutter's Return*. Here is Barrell on these pictures:

> The sympathy that Crabbe and the later Gainsborough evoke for the poor is absolutely limited by such considerations as these (i.e. the acceptance of things as they are – 'whatever is, is right'). Both depict the poor as degraded, as indeed they had become by the process of transforming a paternalist into a capitalist economy; but the sympathy of both presents itself as a sort of moral compensation for the effects of that process. They become more expansively benevolent in proportion as they represent the poor as more repressed, and congratulate the very classes that were responsible for the repression of the poor for the humane concern they feel at the results of their own actions.[13]

This is a powerful indictment which I shall shortly seek to confront. For the moment what needs to be stressed is the method that both Solkin and Barrell employ. For them, art history is the process of tracing the interaction of visual imagery with ideology and political and social history. None of the elements in this equation is a fixed and transparent quantity, like a mathematical symbol. Each is open to interpretation and hence subject to debate, if only within fairly narrow limits. One possible topic of debate, therefore, is how far Richard Wilson's use of the ideal landscape formula in his pictures was a factor in his realization of the 'myth of social harmony' detected by Solkin. No doubt Wilson chose this formula initially for other reasons: because he had been to Italy, because it accorded with the taste of his patrons for the works of Claude and Gaspard Dughet, and because it offered him a vehicle for the exposition of ideas of republican virtue (another issue fascinatingly discussed by Solkin). But ideal landscape also offered Wilson a ready-made schema for depicting a seemingly idyllic, hierarchically ordered countryside, without the necessity of directly showing agriculture in progress, as the early Gainsborough did in *Mr and Mrs Andrews* and Stubbs in the *Haymakers* and

Reapers. By using such a schema Wilson was able to dispose figures representing different orders of society and different kinds of activity in their appropriate places. Members of the upper classes, if present, would be given the 'best' positions in the landscape, which meant at a focus for the viewer's eye. But these classes did not have to be present if the protagonists of the picture were of another sort, for example, figures of no determinate class or even peasants. The broader distinction seems to be between figures at rest, who serve as the thematic focus of the landscape and set its overall tone, and figures at work, who are glimpsed in the background or are tucked away at the side of the composition. The latter are often scarcely more than tokens, a sign that real life, as it were, goes on. In composing his pictures in this way, Wilson was drawing on the model set by the ideal landscapists of the seventeenth century, Claude, Poussin and Dughet.

As to Gainsborough, there is nothing in his letters or recorded sayings or actions to suggest that he shared the cold and calculating attitude towards the rural poor that John Barrell attributes to him in the passage quoted earlier. Not that there needs to be for Barrell to make his point; it is not on *that* sort of evidence that he relies. He is right, of course, in asserting that Gainsborough's fancy pictures could not have been painted, and still more could not have attracted the interest of patrons, if it were not for the fact that by the late eighteenth century the rural poor had newly become a major social problem. As a result of the economic changes Barrell describes, more of the poor were at large, living in hovels on heaths and in forests, instead of being corralled in settled communities as they had been earlier. There was no thought on the part of the ruling class of addressing the causes which had brought these distressing conditions about, nor would Gainsborough have used his work to make a plea for social reform. But although an awareness of the social situation is a prerequisite for understanding the artist's fancy pictures, it is not a sufficient explanation of what they are about.

We know from his friend, Uvedale Price, that Gainsborough was attracted to village scenes and groups of peasant children when he encountered them face to face, but this may have been no more than an emotional indulgence, of a piece with his often-expressed longing to escape from the fashionable worlds of Bath and London into the country in order to paint landscapes. It does not follow that he had any particular concern for the plight of the villagers and children he saw. What is more, to judge from a remark by Fuseli in 1785, he does not seem to have made the distinction, common in the period, between the deserving and the undeserving poor: in answer to an enquiry from the provincial William Beechey about the latest developments in art in London, Fuseli replied that 'Gainsborough was painting pigs and blackguards'.[14] Reynolds, in the fourteenth *Discourse*, which he delivered in 1788 shortly after his fellow artist's death, evidently regarded Gainsborough's woodmen as 'blackguards', and distinguished sharply between them and his representations of peasant children. It cannot be an accident that the protagonists of more than half Gainsborough's fancy pictures are children. They, in contrast to the woodmen, are seen as the embodiments of innocence, an innocence which is made to appear the more genuine by its subjects' very lack of material and spiritual advantages. It may be suggested that Gainsborough regarded both categories, woodmen and children, as denizens of a primitive world, which was at once appealing and dangerous. The existence of this world was real enough, as we have seen, but it was distanced, and hence rendered safe, by the romantic style in which Gainsborough painted it. For reasons which would take too long to explore here – but which would include the growing fragmentation of society in an age of heightened national self-consciousness, which in turn led to a new curiosity about what was going on in the country – there was an increased audience in late eighteenth-century Britain for paintings depicting everyday reality, so long as that reality was not represented too literally. The wealthy and sophisticated buyers of Gainsborough's fancy pictures would have been part of this

audience, and they would have been additionally attracted to his pictures by the fact that they are on a large scale, with the figures often life-sized. There is an element of seclusion, mysteriousness and even grandeur, as well as pathos, about Gainsborough's cottagers, woodcutters, and children posed alone, clutching sticks or tending pigs, which is hard to square with Barrell's idea that these paintings were intended to make the purchasers of them feel comfortably benevolent.[15]

I have dwelt at such length on John Barrell's *The Dark Side of the Landscape* and David Solkin's *Richard Wilson*, partly because these books were pioneering works of their kind at the time they were published, and partly because they bring out in a helpfully clear way the premises on which the new, radical approach to the study of British art is based. First, it is a fundamental article of faith that works of art derive a large part of their meaning from the context in which they were produced. This context is both ideological and social, 'ideology' being 'those modes of feeling, valuing, perceiving and believing which have some kind of relation to the maintenance and reproduction of social power',[16] while 'social' here refers to the way in which people live, own property, exchange goods, and publicly relate to each other. No artist can escape from the context of his period even if, like Blake, his instinct is to react violently against some of its constituents. At the same time, the artist is not a mere spokesman for his period or social group. Works of art are not (to change the metaphor) the mere unmediated reflection of anything. If they were, art history as a distinct – I do not say an independent – intellectual discipline would not exist and might as well submerge its identity in cultural studies. Art bears the impress of its period in ways that are peculiar to itself and it may at times play an active part in constructing the ideology of a whole society. The art of the Italian Renaissance is an obvious example of this. That painting could help give shape and purpose to a segment of eighteenth-century British society is a central theme of David Solkin's latest book, *Painting for Money*.[17]

In their writings of the early 1980s, both Barrell and Solkin drew heavily on the literature of post-second world war, left-wing, social history, the leading exponents of which were E.P. Thompson and Raymond Williams. On the other hand, they were – and are – suspicious of the history of ideas, for the very reason that the latter is a form of enquiry *not* rooted in history understood as the analysis of society, but one that concerns itself, rather, with an enclosed system of concepts derived from theology, philosophy and semantics. This is why I mentioned earlier that those scholars on the radical wing of the recent revolution in the study of British art, unlike their more moderate colleagues whose aim is to reform the discipline by drawing on analogies with literature, have been on the whole unsympathetic to Warburgian iconography. They (the radicals) are not much interested in deciphering the meaning of symbols and allegories by tracking down esoteric texts to which an artist may be supposed to have had access. They prefer literary sources which were well known and influential at the time they were printed, although these may have become obscure since and hence have to be recovered by the normal processes of historical research. (These remarks are not, of course, to be construed as an attack on the radicals' commitment to scholarship.) The significant relationship between a text and a work of art is perceived as being more the expression of a similar ideological point of view than the provision by the one of a semantic key to the other.

As pioneers of the more radical of the two revolutions, Barrell and Solkin were not left in isolation for long. They were soon joined by, in approximate chronological order, Stephen Deuchar, Michael Rosenthal, John Murdoch, Ann Bermingham, Stephen Daniels, Simon Pugh and Andrew Hemingway.[18] Several things are noticeable about this list. One is that all the authors, including, of course, Barrell and Solkin, write about landscape – or rather, figures (in Deuchar's case, also horses and dogs) in landscape, for all are deeply concerned with how human beings live in, use and mentally view the rural environment. However, in remarking this we should also note that there was a concen-

tration of studies of this type in the first half of the period in question, that is, between 1980 and 1986, or up to and including *Landscape and Ideology* by Ann Bermingham.[19] Since then the emphasis on landscape has diminished, to be replaced by a new interest in figure painting, the effects of which we shall shortly examine.

The second thing to be noticed is a corollary of the first. It is that all the authors mentioned except Solkin and Deuchar have gone beyond the dividing-line of 1790 chosen by Waterhouse as the ending of *Painting in Britain*. That they should have done so is understandable, since landscape painting in this country, whether considered as a stylistic development, an aesthetic category or a manifestation of sociological interests in the land and in travel, exhibits so marked a continuity from the mid-eighteenth to the mid-nineteenth century that it makes no sense to break off the story half way through. (The same is if anything even more true of history painting, and John Barrell, in *The Political Theory of Painting from Reynolds to Hazlitt*, treats this phenomenon as a unified episode in intellectual history, as we shall see.) By and large, it is only if the material under investigation is the work of a single artist that it is expedient to opt for one side of the divide or the other; examples of this are Solkin's *Wilson* and Michael Rosenthal's *Constable: The Painter and his Landscape* (1983). Admittedly, *Landscape Imagery and Urban Culture in Early Nineteenth-Century Britain* (1992), by Andrew Hemingway, is something of an exception, but, for one thing, it contains long introductory chapters on eighteenth-century artistic theory and, for another, it deals with a topic – the response to landscape painting by an urban audience – that does belong properly to the early nineteenth century. It may seem unfair to go beyond the chronological limits of *Painting in Britain* when putting up against it, for purposes of comparison, the literature that has been produced since, but, given the extent to which that literature has necessarily encroached on the period after 1790 it would be misleading to do otherwise.

The third characteristic common to these authors, in the early and mid-1980s especially,

is that they were all engaged in a programme of de-mystification. What this means, in short, is 'less gush'. It means fewer (or no) emotive phrases, fewer panegyrics, less talk of an artist being 'a born landscape painter' with an 'innate feeling for light and atmosphere', whose 'genius flowered' as he grew to maturity, etc. (These quotations are taken from a critical review by David Solkin of John Hayes's *The Landscape Paintings of Thomas Gainsborough*, 1982.[20]) This is not to say that all 'new' art historians are unresponsive to aesthetic quality, although some clearly have more of a feeling for it than others. It is rather that they regard quality as a source of private pleasure, having little or no place in the historical study of works of art (quite *how* small a place, or if it is to be no place at all, is a question that tends to be evaded). On one level, this position is entirely logical, for if it is held – as it is – that works of art derive their meaning to a large extent from the context in which they are produced, the artist's contribution to the end result is correspondingly diminished. On another level, however, the downgrading of quality undoubtedly operated for a time as a battle-cry. While the hysterical popular reaction to Solkin's *Richard Wilson* was ridiculous, the author, like John Barrell in *The Dark Side of the Landscape*, evidently saw himself as demonstrating a tough-mindedness which differentiated *his* kind of art history from that of the traditionalists who had held the field for so long. He ended the review from which I have just quoted – a review surveying a series of recent books on British art and published in 1985[21] – with the following sentences.

> At present there should be no pretense of compatibility, nor any illusion of a harmonious consensus. The divisions I have tried to describe are, in the final analysis, as much political as they are theoretical and methodological, and they cannot simply be wished away. Nor should they be. For it is precisely the prospect of conflict that holds out the promise of renewed intellectual vigor for a field which at long last appears to be coming of age.

That challenge having been issued, there was no need to repeat it. In consequence, although some scholars of British art have continued to adopt a combative stance up to the present day, it is generally true that, in the past six or seven years, a quieter atmosphere has prevailed. The leading historians of the new, radical persuasion have been able to get on with the job of developing their ideas without constantly feeling the need to attack the opposition. The main reason for this must be that that opposition has been substantially defeated. This does not mean that studies of British art relying on a traditional approach are no longer being published; they are, especially in the case of exhibition catalogues. But they are no longer in the ascendant, except perhaps in the field of landscape watercolours and in the study of Turner. It is a striking fact that no effective counterblast to the radical revolution in the interpretation of British art has yet been written. The one area in which 'new' art historians still have reason to feel embattled is that of feminism; but feminism, so far as the history of British art from the Reformation to the end of the eighteenth century is concerned, seems still to be regarded as of comparatively little relevance.

However, it is a major issue in Marcia Pointon's important new book, *Hanging the Head: Portraiture and Social Formation in Eighteenth-Century England* (1993). This book crackles with energy. It brings to light an immense variety of materials from disparate sources and puts them together in new combinations, to show how portraiture both reflected and articulated a wide range of social and ideological concerns. There must be a greater number of unfamiliar images reproduced in this book than in any other on British eighteenth-century art ever published. Both on account of its scope and its ideas, it bursts apart the stately procession of more or less idealized portraits of the British upper and upper-middle classes that fills most books on the subject. It reveals in fascinating detail how portraits were commissioned and produced and how they functioned both in the public and private sphere. In keeping with the author's feminist programme, the finest chapters are

those on portraits of women and, even more, children. The analysis of the various portraits of Lady Mary Wortley Montagu is one example, that of Zoffany's portrait of Queen Charlotte and her children another. In discussing these and other, comparable paintings, Pointon's palpable sympathy with the subject matter results in descriptions and arguments possessing sustained power and admirable clarity and depth. She is also particularly good on conversation pieces. Elsewhere, however, for example in the chapter on James Granger and his egregious collection of engraved portrait heads, she is capable of blowing up a subject out of all proportion to its importance, the reader is overwhelmed with detail, and the author's style becomes less assured. Still, uneven though it is in some respects, this is a dazzling and original book. Following its publication, the history of British eighteenth-century portrait painting will never look the same again.

The last two books to be considered here – John Barrell's *The Political Theory of Painting from Reynolds to Hazlitt* (1986) and David Solkin's *Painting for Money: The Visual Arts and the Public Sphere in Eighteenth-Century England* (1993) – in some ways go together. Both authors treat their subject matter as the reflection of a changing political discourse concerning the proper direction of society, both start with the model of public virtue proposed at the beginning of the century by the 3rd Earl of Shaftesbury, and both take for granted – that is, they hardly mention – an issue that had preoccupied them in the early 1980s. That issue was the price paid by the poor to enable the rich to theorize about political morality, enjoy leisure and cultivate the arts. As Solkin now puts it:

Under the spotless cover of an ostensibly autonomous subjectivity, Lord Shaftesbury's citizen-landowners were quite happy to depend on a ruthless legal and political system to ensure that they remained in private possession of their estates; and we should not need reminding that a hierarchy based on inequalities of class and gender was hardly a thing of beauty (or of public interest) from everyone's point of view.[22]

However, if one's subject is the interests and pursuits of those citizen-landowners, there is a limit to how long one can dwell on the cost to everyone else. What is more, it is a central theme of Solkin's recent book that it was not only citizen-landowners who were active in the arts but a new middle class, brought into existence by economic changes, for whom a new type of art was gradually forged. It is interesting to note that the historians whose work serves as the inspiration behind *The Political Theory of Painting* and *Painting for Money* are no longer the champions of the poor, E.P. Thompson and Raymond Williams, but the historians of bourgeois culture, political thought and the consumer society, Jürgen Habermas, J.G.A. Pocock, Neil McKendrick, John Brewer and J.H. Plumb (I use all these names in part symbolically, of course, not to suggest that they are the only historians to whom Barrell and Solkin refer).

Another factor which connects *The Political Theory of Painting* and *Painting for Money*, while at the same time signalling a difference between them, is that the second book is conceived in part as a rejoinder to the first. The first begins, as I have indicated, with an account of Shaftesbury, among others, as the spokesman of the theory of civic humanism, a term borrowed by Barrell from J.G.A. Pocock. To paraphrase, the fulfilment of a man's life was to be found in the practice of virtue in a republic of equal, active and independent citizens. The significant virtues were public, not private, and were defined as 'independent life', 'integrity in office' and above all 'a passion for the commonweal'. It followed that only a man of independent wealth and social standing could practise these virtues. The inspiration behind the theory was the citizen-republic of Periclean Athens. Its codes were formulated (this is Pocock's contribution to the history of the theory) in fifteenth-century Florence. And the implantation of the theory into early eighteenth-century England was made both attractive and possible by the revolutionary political settlement of 1688, which, though it did not establish a technical republic, gave to landowners a large measure of independence through the protection of the law and the ownership of property. The part played by the arts in all this was derived from the close connection, particularly strong in the mind of Shaftesbury, between morality and taste. Moreover, as another writer, George Turnbull, explained, the contemplation of the arts, by bringing the mind into contact with beauty and truth, teaches 'a generous love of the publick Good'.[23]

Now, the point was, the values associated with civic humanism were dangerously susceptible to corruption, either through the incidence of tyranny, which was not an immediate danger in early eighteenth-century Britain, or through the seductive power of commerce, which was a highly visible reality. Commerce relied on and promoted selfishness, which was the obverse of the disinterestedness civic humanism insisted upon. Commerce also induced the love of luxury, or the desire for material possessions. To note that is to see why history painting was the supreme, even the only, art form approved by civic humanism, because it was conducive to contemplation of the 'publick Good'; it was not a commodity to be traded or an object of luxury fashioned to satisfy private desires.

Barrell traces the ways in which the theory of civic humanism was, on the one hand, attacked as incompatible with the pragmatic interests of a commercial society and, on the other, underwent modification in response to the emergence of new social classes. By 1768, the date of the foundation of the Royal Academy, this theory had become considerably attenuated, or had become split between the ethical and economic spheres. Political economists were beginning to assert that the public welfare was best secured by everyone pursuing his (much less often her) own private interests, provided sufficient checks were put in place to prevent abuses. Nevertheless, when Reynolds came to deliver his fifteen *Discourses* he largely adhered to the traditional doctrines of civic humanism. This was partly because, ever since Shaftesbury, art had always been associated with ethics rather than economics; and partly because civic humanism upheld the concept of the academic hierarchy of genres, gave a role to the artist – or at any rate,

the history painter – in establishing a republic of taste, and justified the place of art in the organization of public life. As Barrell shows, there was never any doubt in Reynolds's mind of the connection between virtue and a 'true or just relish' of works of art. 'If all men of taste are also men of virtue, they are so, it seems, because they have cultivated a particular habit of mind: the habit of taking "comprehensive views", and of subordinating their personal interests and concerns to the interests of some wider "whole".'[24]

Of course, Reynolds could not follow the dictates of civic humanism in quite the same terms that Shaftesbury had defined for them over sixty years earlier. For one thing, as a busy portrait painter and the President of the Royal Academy, his mind was filled with practical considerations and questions of aesthetic criticism that did not concern his more purely contemplative predecessor.[25] For another, the changes that society had undergone meant that the centre of gravity of the republic of taste had shifted. The leaders of that republic were no longer the aristocracy, whose claim to be men of taste was assumed, not earned. It had

> involved no labour, no exertion, no diligent investigation of nature; but true taste, as well as executive excellence, is a product, and a product of labour, and the true republic of taste, like that of the fine arts, is a bourgeois republic, a civic association in which men emulate each other on the basis of what they do, not of what they are, or claim to be.[26]

Barrell's analysis of Reynolds's *Discourses* is extremely searching and subtle, as is his account of the writings of most (but not all) of the other theorists whom he discusses in the book: Barry, Blake, Fuseli, Haydon and Hazlitt. Even if there were space, it would be inappropriate to describe or criticize his reasoning in any detail in the present Introduction. But the theme of Barrell's book can be stated quite simply. It is to show how, beginning with Reynolds, a succession of British writers on art sought to make use of, adapt or repudiate their inheritance of the doctrine of civic humanism, all of them being convinced of the need to defend 'high art', or

'political art', from the corrosive influence of commerce. (In fact, Blake does not quite fit the first part of this pattern, and Barrell seems to include him – briefly – mainly because he wants to demonstrate that his ideas for art were political and not, as is usually supposed, romantic, personal and mystical.) What happened, as Barrell makes clear, is that the rising pressures of the 'discourse of private commerce' gradually forced the abandonment, at first piecemeal, then wholesale, of the tenets of civic humanism, and installed in their place a theory which defined the aims and satisfactions of art 'as being more or less exclusively private'.[27] This process was accomplished unconsciously by Haydon (unconsciously, because he acted as the champion of public art and was a propagandist for public patronage), and consciously by Hazlitt. A somewhat chilling though justified point is made by Barrell about the outcome of it all. Attempting to explain what it is that works in the higher style should aim to communicate, Haydon offered: 'a beautiful thought, a fine expression, or a grand form'.[28] However, unsupported by a political context – which rather similar remarks by Reynolds, of course, were not – such phrases remain dead on the page, essentially empty of meaning.

David Solkin's *Painting for Money: The Visual Arts and the Public Sphere in Eighteenth-Century England* also begins with Shaftesbury, as I have said. In fact, it begins more emphatically with him and, what is more, places the philosopher in a literally idyllic setting, i.e. depicted together with his younger brother, the Hon. Maurice Ashley Cooper, in a life-sized full-length portrait by John Closterman, in which the two men, dressed in what was then considered Grecian costume, are seen conversing in a wooded grove containing a classical temple. This immediately announces one difference between this book and John Barrell's: Solkin is far more concerned to find the expression of ideological and social doctrines in actual visual images, rather than in written theories. His full account of Shaftesbury's position on the civic humanist virtues of independence and disinterestedness and on the moral connection of beauty, truth and goodness makes almost as much use of the iconography of

Closterman's portrait as it does of Shaftesbury's own writings. His next move is to switch temporarily to the philosopher-Earl's opposite, Bernard Mandeville, the author of *The Fable of the Bees*, which came out in 1723 and 1729, some fifteen years after the first edition of Shaftesbury's *Characteristics*. Mandeville's defence of naked self-interest as the driving force in human affairs and his attack on the humbug associated with privilege was too destructive and too extreme to be acceptable to anyone in the 1720s, as Solkin recognizes, but one cannot help thinking that his placing a discussion of those attitudes here is designed to signal something about his own sympathies. At the least, he finds Mandeville's iconoclasm refreshing.

Solkin also makes a good deal more than Barrell of the diffusion of the ideas of civic humanism to a new class brought into being by the Glorious Revolution: a mixture of aristocrats, landed gentry, financiers, military officers and writers, who did not aspire to the lofty disinterestedness or life of stoic independence advocated by Shaftesbury but who, on the contrary, met in clubs, often engaged in commerce and/or politics, and belonged to the Whig party. Their most important and most typical centre was the Kit-Cat Club, to which many of them belonged. Their cultural mentors were Addison and Steele, the editors and in large part authors of *The Tatler* and *The Spectator*. Nevertheless, the concept that principally defined the culture of this group was one derived from Shaftesbury – the concept of politeness. 'All politeness', he affirmed 'is owing to liberty. We polish one another, and rub off our corners and rough sides by a sort of amicable collision'.[29] The conjunction of the two words, 'politeness' and 'polish', so similar in meaning as well as sound, is interesting, because it suggests that politeness is a quality that is acquired by experience, not derived through reading or contemplation. It also denotes exposure to other cultures and to the products of the arts and sciences; moreover, it has a moral dimension as well. In other words, politeness is more than simply good manners. At the same time, it is an eminently social quality

(and therefore perhaps not properly part of the civic notion of virtue that it was Shaftesbury's principal aim to promote). It is also compatible with at least some degree of engagement in commerce. It was this slightly watered-down version of the doctrine of civic humanism that was disseminated to the members of the Kit-Cat Club, among others, by Addison and Steele in their essays in *The Tatler* and *Spectator*. The famous series of portraits by Kneller of the members of the Kit-Cat Club was thus the first demonstration in art of the concept of politeness, and, in a fascinating chapter analysing the form and iconography of these portraits, David Solkin presents them as such.

Unsurprisingly, 'politeness' did not stop at a comparatively small group of publicly active, sophisticated Whig gentlemen. Addison, who described his method as an essayist as being 'to enliven morality with wit, and to temper wit with morality' and who was 'ambitious to have it said of me that I have brought philosophy out of closets and libraries, schools and colleges, to dwell in clubs and assemblies, at tea-tables and in coffee-houses', claimed a readership for his *Spectator* articles of 60,000 a day.[30] True, not all these people can have been converted to politeness overnight. Yet it was some twenty years before a style of painting emerged to give expression to the new, civilized social morality. As Solkin points out, the suspicion of luxury, and hence of the commercial activity that produced it, remained very strong and was harped on by defenders of Christian ethics and apologists for 'pure' civic humanism alike (even Addison and Steele, generally favourable to the new economic order, recognized that commerce, carried to excess, was liable to corrupt morals).

Moreover, painting, unlike essay-writing, was problematic in as much as it dealt in appearances. Whereas the essayist could give qualified approval (or not, as the case might be) in general terms to the accumulation of material possessions, the visual artist, in, say, a picture showing the interior of a man's house, could not avoid being specific. By a double stroke of insight, Solkin shows that it was the philosophical critic Francis Hutcheson (a follower of Shaftesbury)

who solved the ethical-cum-social dilemma posed by the pursuit of wealth, and Hogarth who took advantage of that solution by celebrating the same set of ideas in paint. In a series of essays and books published in the later 1720s, Hutcheson based the delight men take in acquiring wealth and fine possessions on the concern they naturally feel for the good of society. In high living, he proposed,

> There is such a Mixture of *moral Ideas*, of *Benevolence*, of *Abilitys* kindly employed; so many Dependents *supported*, so many Friends *entertain'd*, assisted, protected; such a *Capacity* imagin'd for *great* and *amiable Actions*, that we are never asham'd, but rather boast of such things.[31]

In such a way, Solkin points out, Hutcheson managed to reconcile the world of commerce with the ethical terminology of civic humanism. The same spirit, as he also points out, was introduced into painting by Hogarth in a series of his early conversation pieces dating from around 1730. In such a painting as *The Wollaston Family* [pl. 135], the figures – eight men and seven women – are disposed harmoniously in groups in an elegant but not ostentatiously opulent setting, probably the saloon in William Wollaston's town house in St James's Square. Each of the figures is paying polite attention to one or more of the others. They are there for no other reason than to give themselves and each other decorous pleasure. As a family, they embody one of the central institutions of bourgeois society, the counterpart in little of the larger political order and the chief agent of the accumulation and reproduction of capital, though none of that is directly referred to in Hogarth's picture. 'The humanity ascribed to the Wollastons centres around (sic) a notion of individual freedom, a freedom to be simply what they want to be'.[32]

Thus, crudely summarized, does David Solkin arrive at the central theme of his book: the establishment in Britain in the middle decades of the eighteenth century of a successful middle and upper middle-class, supported by a rational philosophy in agreement with the mechanisms of its economic power, and not only reflected in,

but also in part created by, its literature and visual arts. It will be noted that this is a more positive interpretation of the mentality of the period than Barrell's in *The Political Theory of Painting from Reynolds to Hazlitt*. Where Barrell saw chiefly an erosion of the high ideals of civic humanism until their temporary revival in artistic theory after 1768, Solkin sees a successful adaptation of those ideals to suit and to help bring into being a new society. It should also be obvious by now why Solkin's book is called *Painting for Money*. It has less to do with the stratagems used by artists to earn a living – there is more about *that* in Marcia Pointon's *Hanging the Head* – than with the fact that artists were working for a commercial, or moneyed, society. All the same, readers coming fresh to the book will get a more precise idea of its contents from its subtitle: *The Visual Arts and the Public Sphere in Eighteenth-Century England*.

It is the public sphere – literally – that provides the setting for the subject matter of the next two chapters, on Vauxhall Gardens and on 'Exhibitions of Sympathy'. By this time – the 1740s and 1750s – figure painting in Britain, in common with the other branches of art, had expanded considerably. There were more artists in business, and a more sophisticated artistic profession had grown up, centred on the second St Martin's Lane Academy (about which Solkin says rather little). The pleasure gardens at Vauxhall, re-opened to the public under new management – that of Jonathan Tyers – in 1732, were a venture designed to provide a new, more civilized public with a place of entertainment that was artistic, safe and 'polite', though it was never without the potential for minor scandal (which added to its attraction) and it was periodically threatened with a total collapse into licentiousness (which would have been regarded as going too far and would have resulted in closure). Fortunately, David Solkin is able to rely on the researches of others, notably Brian Allen, who have recovered the details of the very complicated array of ornamental buildings, sculptures, paintings and musical entertainments, all of which were constantly changed and added to over a period of thirty years and many

of which survive, if at all, only in the form of engravings. Solkin himself is therefore free to concentrate on Vauxhall Gardens as a 'political space', with all that that implies of the way in which the enterprise functioned for various levels of society.

'Exhibitions of Sympathy' begins with the story of the Foundling Hospital, which is simpler and better known than that of Vauxhall but which is still criss-crossed with the traces of ethical debate. Which should take priority? Humanity towards the innocents who had been abandoned? Or the defence of traditional morality by deliberately denying encouragement to women to have illegitimate babies? (Here, to an extreme degree, the parallel with issues under discussion in late twentieth-century Britain comes to mind. There are other places in the book where this happens too, if less dramatically. Someone, some day, will ponder the relevance of the fact that *Painting for Money* was written during the era of Thatcherism, though the book is clearly not a pro-Thatcher tract – it insists all along that there *is* such a thing as society. But it is not entirely an anti-Thatcher tract, either. One difference that will emerge from the comparison of the two eras is that the eighteenth century had a more profound, coherent and richer philosophy.) Other 'exhibitions of sympathy' discussed in this chapter occur in pictures of military conquest, where the victor is shown behaving magnanimously to the vanquished. There were written texts describing this exemplary theme in ancient Roman history, as well as visual prototypes in seventeenth-century Continental painting, to both of which British artists turned for inspiration. By this stage – the 1760s – 'politeness' had moved out of the context of relationships between individuals and had become a 'public' virtue in the most literal sense of the word.

The penultimate chapter, on Joseph Wright of Derby, is the most profound, the most subtle and the most difficult in the book, though it deals only with four pictures, all candlelight scenes: *Three Persons viewing the Gladiator* (1765), the *Lecture on the Orrery* (1766), the *Experiment with the Air Pump* (1768; pl. 222), and *An Academy by Lamplight* (1769). This chapter seems to gather up and re-examine all the themes discussed earlier in the book: the Shaftesburian equation of ethics with aesthetics and of 'excellent taste and clear judgement' with disinterested thought; the 'exhibition of sympathy' shown not in charitable or magnanimous action but in close attention to a phenomenon of art or science; the Hutchesonian idea of fellowship and private enjoyment based on a sufficiency of material goods; and so on. To all this is added a new discourse of the collective experience of aesthetic pleasure. Solkin insists that these paintings belong to the mainstream of British painting and not to its periphery. 'Though Wright's medium was a painted canvas, with the *Orrery* and the *Air Pump* he ... took it upon himself to construct an imagery designed to instruct his audience about the character of their own world'.[33] It is also made clear by implication that, for Solkin, this was the eighteenth century's 'best' world, and, if the book has a single hero, it is surely Joseph Wright.

In keeping with all this, the chapter on Wright is written with a warmth and sympathy that quite often appear elsewhere, if not quite to the same degree, but are decidedly absent from the last chapter ('From Criticism into Crisis'), which comes across with brutal force. Up to this point, the story of British eighteenth-century painting as told by Solkin has been a success story, based on a consensus of attitudes, albeit a changing and richly varied one. What shattered that consensus was the foundation of the Royal Academy, which is presented as a devious, self-serving and authoritarian institution subject to the will of the King. The quarrel it picked with the already established body, the Incorporated Society of Artists, of which Wright was a prominent member, is interpreted by Solkin in directly political terms, as a parallel with the imprisonment for seditious libel of John Wilkes in the summer of 1768, a few months before the Academy was founded. Indeed, it is hinted that the two events may have been connected. As with Wilkes, the conflict is presented as 'a clash between the forces guarding liberty (the Society of Artists) and those working in favour of

arbitrary power (the Royal Academy)'.[34] This is neat, but the contrast with the factors described as guiding the earlier development of British eighteenth-century painting is, I think, overdrawn.

Painting for Money is a work that scholars in other disciplines will instinctively find sympathetic and intelligible and while being thoroughly grounded in history and ideological theory, it draws its arguments ultimately from works of art themselves. It is thus properly speaking a work of art history, not an example of cultural studies, social history or the history of politics or economics. What the revolution will yield next, however, is hard to say.

The question that remains is, where does all this leave Waterhouse's *Painting in Britain 1530–1790*? As a book it could hardly be more different from *Painting for Money*, not least because Reynolds and the creation of the Royal Academy are, respectively, its hero and its climactic event, not its disastrous *dénouement*. In the first place, it has to be said that *Painting in Britain* contains too much gush, too much 'deep sincerity', too much 'lovely painting throughout' (this of a portrait by Gainsborough). In the second place, the book has lost its previous authority. It is a tenet of the revolution in art-historical method that 'there is no such thing as a body of knowledge'. Everything is interpretation. But so is *Painting in Britain*, and its author would not have claimed otherwise, though he would have said that it was fuller and better informed than earlier surveys of the subject. So from this point of view we are back to where we were: *Painting in Britain* differs from books of the new art history not absolutely, though it does

so in method, in approach, in scope, mood and style, and in practically any other way one can think of (except seriousness of scholarship).

There is one way in which this book surely remains useful, namely as a guide to the collections in museums and galleries. Museum art history is inevitably 'object-based', not 'context-based'. There can be as many display boards carrying explanatory texts as the museum director wishes, but if the pictures do not convey their meaning visually to the maximum extent of which they are capable, if that channel of communication is partially blocked by other sorts of message, the result is loss and confusion, as too many recent art exhibitions testify. Waterhouse's *Painting in Britain* belongs to an era in which there was no essential difference between museum art history and academic art history or, if there was, as in the case of Warburgian iconography, the two were not in conflict. It is one of the less happy consequences of the revolution in art history that the student is almost forced to choose between the two approaches. Whether they will ever be reconciled remains to be seen, though I am not unhopeful.

However, it is ultimately not on these utilitarian grounds that I would recommend a first reading or a re-reading of Waterhouse. It is rather on account of the breadth and liveliness of his curiosity. He was alert to nuances of visual expression and to idiosyncracies in the representation of character and social status that few of the new art historians can match. David Solkin and Michael Rosenthal can, but they have so far given their attention only to comparatively limited areas of the history of British art. Waterhouse was bold enough to consider it all.

NOTES

1. John Barrell (ed.), *Painting and the Politics of Culture* (Oxford, 1992), 3.

2. See especially the preface to part ii of the *Lives* (1550): 'When I first undertook to write these lives, I did not propose to make a mere list of the artists with an inventory, so to speak, of their works ... I have endeavoured not only to relate what artists have done but have tried to distinguish the good from the better and the best from the medium work, to note somewhat carefully the methods, manners, processes, behaviour and ideas of the painters and sculptors, enquiring into the causes and roots of things, and of the improvement and decline of the arts ... '

3. *Art and its Objects*, 2nd ed. (Cambridge, 1980), Essay iv.

4. Norman Bryson, *Vision and Painting: The Logic of the Gaze* (London, 1983), xi.

5. This topic is explored with sensitivity and thoroughness by Richard Wendorf in *The Elements of Life: Biography and Portrait-Painting in Stuart and Georgian England* (Oxford, 1990).

6. *The Sister Arts*, pp. xxi–xxii.

7. For example, Lawrence Lipking, *The Ordering of the Arts in Eighteenth-Century England* (Princeton, 1970) – an extremely useful analysis and survey on traditional lines; James S. Malek, *The Arts Compared: An Aspect of Eighteenth-Century British Aesthetics* (Detroit, 1974); Ronald Paulson, *Book and Painting: Shakespeare, Milton and the Bible. Literary Texts and the Emergence of English Painting* (Knoxville, 1982); and two books of essays, John Dixon Hunt (ed.), *Encounters: Essays on Literature and the Visual Arts* (London, 1971), and Richard Wendorf (ed.), *Articulate Images: The Sister Arts from Hogarth to Tennyson* (Minneapolis, 1983).

8. Gent, *Picture and Poetry*, 21.

9. F.D. Klingender, *Art and the Industrial Revolution* (London, 1947; revised and enlarged by Arthur Elton, 1968). (Elton's alterations, besides making the book more comprehensive and hence more useful, also drew out of it some of Klingender's Marxist sting.) Friedrich Antal (d.1954), *Hogarth and his Place in European Art* (London, 1962). Antal's other writings, not on British art, are more directly revealing of his approach; see especially *Classicism and Romanticism, with other Studies in Art History*, ed. Evelyn Antal (London, 1966; paperback, New York, 1973). The most ambitious attempt to write a total history of art from a Marxist point of view in this period was, of course, Arnold Hauser, *The Social History of Art* (New York and London, 1951).

10. Introduction to *Painting and the Politics of Culture* (as in note 1), 1.

11. Also shown in a reduced form at the National Museum of Wales, Cardiff, and the Yale Center for British Art, both in 1983.

12. *Richard Wilson* (London, 1982), 26f.

13. *The Dark Side of the Landscape*, 85.

14. Quoted by Waterhouse in this book, p. 262. The story concerning Gainsborough's taking a retired blacksmith into his house in 1787 to act as a model for his painting, *The Woodman* (now known only from an engraving), suggest that he could be impulsively generous at times, but only when it suited his own purposes.

15. Morland seems to me to address, more directly and variously than Gainsborough, the social issues and moral dilemmas of the period as they affected rural society, even if he did not bring his mind to bear on the matter consistently. One reason may be that his pictures have a stronger narrative component than Gainsborough's. John Barrell discusses these questions in detail in his chapter on Morland in *The Dark Side of the Landscape* – surely the best chapter in the book.

16. Terry Eagleton, *Literary Theory: an Introduction* (Minneapolis and London, 1983), 15.

17. *Painting for Money: the Visual Arts and the Public Sphere in Eighteenth-Century England* (New Haven and London, 1993), 1.

18. Stephen Deuchar, *Noble Exercise – The Sporting Ideal in Eighteenth-Century British Art* (exh. cat., New Haven, Yale Center for British Art, 1982; this was a trial run for the author's major book, *Sporting Art in Eighteenth-Century England: a Social and Political History*, New Haven and London, 1988); Michael Rosenthal, *Constable: The Painter and His Landscape* (New Haven and London, 1983); John Murdoch, *The Discovery of the Lake District* (exh. cat., London, Victoria & Albert Museum, 1984) and *The Lake District: A Sort of National Property* (London, 1986); Ann Bermingham, *Landscape and Ideology: The English Rustic Tradition, 1740–1860* (Berkeley–Los Angeles–London, 1986); Stephen Daniels and Denis Cosgrove (eds.), *The Iconography of Landscape* (Nottingham, 1988); Simon Pugh (ed.), *Reading Landscape: Country – City – Capital* (Manchester

and New York, 1990); Andrew Hemingway, *Landscape Imagery and Urban Culture in Early Nineteeth-Century Britain* (Cambridge, 1992). Ronald Paulson, *Literary Landscape: Turner and Constable* (New Haven and London, 1982), may also be mentioned here, although in method it is associable rather with the author's earlier *Emblem and Expression* than with the books listed above.

19. In fact, the growth of interest in landscape painting may be said to have begun in the 1970s, with the exhibition, *Landscape in Britain, c.1750–1850*, organized by Leslie Parris and Conal Shields at the Tate Gallery in 1973. This was followed by the great bicentenary exhibitions of Turner (1974–5) and Constable (1976), together with several other exhibitions of the work of both artists in different parts of the world at about the same time. However, all this was before the 'new' art history took over.

20. See 'The Battle of the Books; or, the Gentleman Provok'd – Different Views on the History of British Art, *The Art Bulletin*, LXVII, 1985, 507–15.

21. For the reference see the previous note. This long review article, which offers praise as well as blame (and includes an assessment of *The Dark*

Side of the Landscape), is itself an extremely important contribution to the literature here under consideration.

22. *Painting for Money*, 13.

23. Quoted by Barrell, *The Political Theory of Painting from Reynolds to Hazlitt*, 11.

24. *The Political Theory of Painting from Reynolds to Hazlitt*, 69.

25. Contemplative when he wrote the essays that went to form the *Characteristics*, that is. Shaftesbury (1671–1713) had been steeped in politics during his upbringing and for three years in his twenties had sat in the House of Commons.

26. *The Political Theory of Painting from Reynolds to Hazlitt*, 135.

27. *Ibid.*, 309.

28. *Ibid.*, 311.

29. Quoted by Solkin, *Painting for Money*, 25.

30. *The Spectator*, 12 March 1711.

31. Francis Hutcheson, *An Inquiry into the Original of our Ideas of Beauty and Virtue* (London, 1725); quoted by Solkin, *Painting for Money*, 83.

32. *Painting for Money*, 86.

33. *Ibid.*, 228.

34. *Ibid.*, 263.

PART ONE

PAINTING UNDER THE TUDORS

CHAPTER I

HENRY VIII AND THE GENERATION OF HOLBEIN

The year 1531, in which the Convocation of Canterbury recognized Henry VIII as Supreme Head of the Church in England, can conveniently be taken to mark the close of the medieval period of art in England. By 1535, at any rate, the old religious themes in painting were proscribed and the painter was no longer able to exercise his art in what had been the most fruitful field of subject matter for artists in Europe for a thousand years. A taste for pictures of classical mythologies had not as yet been imported from Italy, and a new and national tradition in painting had to grope its way to birth by exploring the only outlet which remained, the field of portraiture.

We can best estimate the nature of this deprivation from the latest and finest surviving monument of pre-Reformation religious art, the windows of King's College Chapel, Cambridge,[1] which were set up between 1515 and 1531. If Henry VIII had been endowed with the discernment necessary for an enlightened patron of the arts,[2] a wonderful opportunity was to hand for welding the painter's art to the service of a Protestant kingdom. For, by the end of 1532, Hans Holbein, who had paid an earlier visit of a year and a half to London, had come to settle in England for the remainder of his life, driven by economic necessity to seek fortune in what seemed a hopeful and prosperous kingdom in exchange for the meagre prospects for a great artist in a city, such as Basel, torn by the religious disturbances of the Reformation. Holbein, conscious of his prodigious abilities,

came to the Court of Henry VIII as a speculation, as Leonardo and Bramante, two generations before, had come to the Court of Ludovico Sforza at Milan. His powers were exploited to as little purpose as Leonardo's had been by his royal patron, but, by the time of his death in 1543, he had left few fields of art in England untouched. On painting, where there was little native tradition, his influence was less than it was on the arts of the printer or goldsmith, perhaps also less than his influence on architectural decoration. But 'modern' painting in any serious sense (as opposed to 'medieval' painting) may properly be said to begin in Britain with Holbein's second and final visit in 1532.

Portrait Painting in England before Holbein

The remains of portrait painting in the period before Holbein's arrival are more meagre than used to be supposed, since the 'Lady Margaret Beaufort' in the National Portrait Gallery (once supposedly of 1460/70) has been proved to have another head beneath its present surface.[3] There is documentary evidence that series of portraits of kings (or, at least, of 'images' of kings) were known in England as early as the fourteenth century, and a few of the early royal portraits still in the royal collection (the latest born of the sitters being Prince Arthur, who died in 1502) can now, on dendrochronological grounds,[4] be dated to the years around 1500. Such serial

portraits were produced up to the end of the sixteenth century – and probably well into the seventeenth – so that the status of various examples of the series must await detailed technical examination. The chief groups which survive in addition to those at Windsor (all different in serial composition and none complete) are in the possession of the Duke of Northumberland, the Marquess of Salisbury, and the Society of Antiquaries (once in the Paston family's possession) and a remarkable set which was at Southam Delabere until the sale by Sotheby's on 11 June 1947. A few of this last group and some others are in the National Portrait Gallery. An example with the head in relatively pure condition is the 'Henry VI' (National Portrait Gallery, 2450) [1].

by a visiting artist, pretty certainly Michael Sittow (National Portrait Gallery), who accompanied the agent of Maximilian, King of the Romans, on an embassy to offer the King one of Maximilian's daughters in marriage. Another nuptial embassy, in connexion with the marriage of Louis XII to Mary Tudor, brought the French Court painter, Jean Perréal, to England in 1514, but neither of these visits had any effect on the arts at the English Court. The best portrait of the young King Henry VIII, which can be securely dated to about 1520[5] (National Portrait Gallery, 4690) [2], is a somewhat nondescript work in the 'Franco-Flemish' tradition.

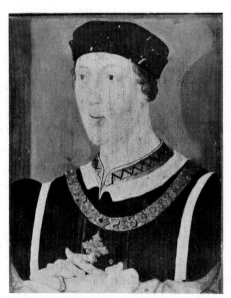

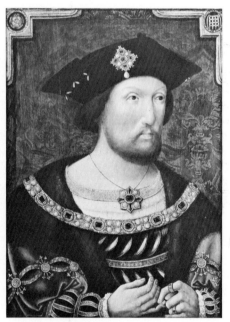

1. Unknown: Henry VI, early sixteenth century.
London, National Portrait Gallery

2. Unknown: Henry VIII, *c.* 1520.
London, National Portrait Gallery

Although certain portraits of Henry VII seem to have been painted from the life in England, and there was a standard pattern which Holbein was to use in his Whitehall fresco, much the best was that painted in 1505

The only painter's name which has been associated with portraits during these years is that of a Fleming, Joannes Corvus, whose two surviving works appear to be only very little more individualized than the images of dead

sovereigns, although he is generally presumed to have had access to his sitters – although this is by no means certain. It is generally accepted, and seems probable, that 'Joannes Corvus Flandrus' – as his name once appeared on the frames, both now destroyed, of 'Bishop Foxe' at Corpus Christi College, Oxford, and 'Princess Mary Tudor' at Sudeley Castle – is the latinized form of Jan Rav, who matriculated into the Painters' Guild at Bruges in 1512; of 'Jehan Raf, peintre de Flandres', who painted a map of England for François I in 1532, and a 'pourtraict de la ville de Londres' for the same King in 1534 (which perhaps implies his presence in England before that date); and of 'John Raven, born in Flanders' (but not described as a painter), who acquired naturalization in England on 13 May 1544. It has also been generally, but more rashly, accepted that the 'Foxe' may date before 1522 (which is a date which appears on a variant portrait of Foxe of a similar type at Sudeley Castle) and that 'Mary Tudor' (from her age of thirty-four, which was also recorded on the lost frame) dates c. 1530. But neither of these portraits has the air of having been taken from the life, and it is at least equally likely that they are copies by Corvus, perhaps from the 1540s, of earlier paintings, and that Corvus is an unimportant artist, the accidental preservation of whose name has lent him an artificial interest.

Painters other than Holbein in the Service of Henry VIII

The English work of Holbein is best considered in immediate precedence to that of his successors, so that it will be best to consider first the other names of painters – for they are still little more than names – which occur in the household expenses of Henry VIII. It can be stated without reservation that Henry VIII was not a considerable patron of the art of painting.[6] It was tapestries which were the chief artistic adornment of the walls of his palaces, and on which he spent relatively large sums. He could not, however, avoid employing painters, and those who served him can be divided into two classes – the Serjeant Painters, and those who otherwise formed part of his household. The Serjeant Painters[7] do not, at first, properly fall into the province of a history of painting. But, as names are few at this period, and as we know those of the Serjeant Painters, attempts have been made at various times to attribute existing works to them. They were extensively employed in the multifarious painting activities needed on special and festive occasions, and the preamble to the patent of Robert Streeter as Serjeant Painter in 1679 gives the fullest account of their charge: 'Serjeant Painter of all our works as well belonging to our royal palaces and houses as to our Great Wardrobe as also within our Office of Revels as also for our Stables, ships and vessels, barges, close barges, coaches, chariots, caroches, litters, waggons and close cars, tents and pavilions, Herald's Coats, trumpets, banners and for funerals to be solemnized.' The first of them was John Browne, who had been doing heraldic painting for the Crown since 1502, was appointed 'King's Painter' in 1511/12, and was raised to be Serjeant Painter in 1527. He died in December 1532 and was succeeded by Andrew Wright,[8] who had already received a reversionary grant of the office on 19 June 1532. Wright was followed by Anthony Toto (grant dated 26 January 1543/4), who died in 1554, who was the first of these who can, on present knowledge, also be considered to have been a painter of pictures.

The other painters who appear in the surviving volumes of the household books are Luke Hornebaud (Hornebolte, Horneband, etc.), Gerard Hornebaud, Vincent Vulpe, and Bartholomew Penni: there was also Nicholas da Modena, who was a versatile artist but perhaps did not practise painting in England; and a 'paintress', Levina Teerlinck, who was a miniaturist of distinction. Of these we can speak with conviction only of Gerard Hornebaud, who appears in the accounts from 1528 to 1531. He was an illuminator of religious

manuscripts and returned to his native Ghent when there was no longer a need for his services. He was dead by 1540.

Luke Hornebaud,[9] who came from the same large family of Ghent artists, where he was probably born about 1490/5, appears in the household accounts from 1526 until his death in 1544. He was made a denizen and appointed a painter to the King on 22 June 1534 and was paid 55s. 6d. a month, a higher salary than Holbein. He was certainly a portrait painter, both in miniature and on the scale of life, and Holbein perhaps was directed by him to miniature painting. Now that we know that the 'Edward IV'[10] at Windsor was painted about 1535/40, presumably for Henry VIII, it is reasonable to suppose it was by Hornebaud: and his name should also be considered for the 'Henry VIII' at Hampton Court, which has long but unconvincingly been ascribed to Joos van Cleve, and has been dated about 1536 on the supposition that the text from St Mark xvi.15 on the inscribed scroll held by the King alludes to Miles Coverdale's English version of the Bible. I would guess that the 1540 portrait of Lord Dacre visible in the background of Eworth's portrait of Lady Dacre at Ottawa [17] may also have been by Hornebaud and not, as Ganz supposes, by Holbein.

Vulpe, certainly an Italian, was employed mainly on the same sort of tasks as the Serjeant Painters; but we ought to be on surer ground with the other two Italians, Penni and 'Toto', who appear almost inseparably together in the accounts, since we have independent confirmation of their background from Vasari. Bartolommeo Penni, born in Florence in 1491 and brother of Gianfrancesco Penni and (apparently) Luca Penni, both better known High Renaissance artists, is first documented in the household accounts with Toto in 1530, became a denizen in 1541, and received his quarterly wages up to 1552/3, when he must have died. He was probably less important than 'Toto', whose real name was Antonio di Nunziato d'Antonio, and who was a pupil of Ridolfo Ghirlandajo. Toto signed a contract in Florence in 1519 with Torregiano, to remain with him for four and a half years to exercise his art in Italy, France, Flanders, England, or Germany 'or anywhere else in the world' for a certain salary. Torregiano was the Italian sculptor employed on the tomb of Henry VII, who in fact left England for good very soon after 1519. By then, however, Toto and Penni had probably come to England, and it is a fair hypothesis that they were employed by Wolsey, since it is immediately after the fall of Wolsey (October 1529) that both first appear in the royal service. Toto was made a denizen in 1538. His New Year gifts to the King, presumably of his own painting, include a picture of 'The Calumny of Apelles' at New Year 1538/9, and a 'Story of King Alexander' in 1540/1. In January 1543/4 he was appointed Serjeant Painter and held that position until his death in 1554. We have to imagine his style as a watered version of Florentine style of c. 1510/20, perhaps modified by a prolonged experience of Netherlandish Mannerist style, but the little that we know of him is valuable, since it gives a clue to the existence of some other kind of painting than portraiture at the Court of Henry VIII. One specimen survives of the kind of ambitious subject picture, in a mixed Flemish and Italianate style, which we may imagine to have been acceptable in London in the middle of the sixteenth century – the 'Judgement of Solomon' in the Hall of the Middle Temple.

Holbein (1497/8–1543) in England

The development of Holbein's style does not belong to the history of painting in England, but his later portraits are the most distinguished achievement of painting in Britain under Henry VIII. He was born in Augsburg in 1497/8 and trained there, and, by the time he settled in Basel in 1519, he had paid a short visit to north Italy (in particular to Lombardy) and, like Dürer before him, had fused something of the spirit of the Italian with that of the Northern Renaissance. He is the great artist of the Northern humanist movement, which had its centre in Basel round the personalities of

Erasmus (whose work he illustrated) and the printer, Froben, for whom he designed a very large number of woodcuts. Had it not been for the troubles caused by the Reformed religion in Basel, which drove him to seek employment in England, he might well have been predomin- antly a great religious painter. As things turned out, his mature painting was mainly in the field of portraiture, in which he remains unsurpassed for sureness and economy of statement, penetra- tion into character, and a combined richness and purity of style.

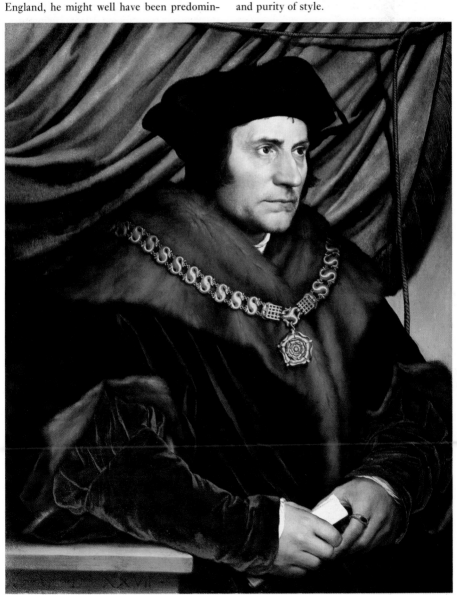

3. Hans Holbein: Sir Thomas More, 1527. *New York, Frick Collection*

In 1526, just before his first visit to England, he had painted the small 'Venus' and 'Lais' (both at Basel) which reveal a knowledge both of Leonardo and of Raphael. He thus arrived in London, in the autumn of 1526, the heir of all that was best and noblest in European art. He came with a letter from Erasmus to his friend Sir Thomas More, written from Basel. 'Here', says Erasmus, 'the arts are freezing, he is coming to England to scrape some angels together' (*ut corrodat aliquot Angelatos*) – which leaves one in no doubt that the journey was prompted by economic necessity rather than by any religious motive. The glamour, for Erasmus at any rate (who may well have advised Holbein to this move), of the early years of Henry VIII had not yet evaporated: the years when Erasmus's pupil, Lord Mount-joy, tutor to the young Prince Henry, had written to his old teacher (1509): 'Our King is not after gold, or gems, or precious metals, but virtue, glory, immortality.' That so much prom-ise could have come to so little fruit was more than the optimistic Erasmus could believe, but More, while saying to Erasmus in reply 'your painter is a wonderful man', adds 'I fear he won't find England as fruitful as he hoped'. Nor did he, but it would appear that the prospects seemed to him better than they were at Basel.

This first visit lasted only until the spring or early summer of 1528, and his patrons for portraiture were drawn only from the small group, of which More was the most conspic-uous, who were in touch with the international humanist movement: 'Archbishop Warham' 1527 (Louvre); 'Sir Thomas More' 1527 (Frick Collection, New York) [3]; 'John and Thomas Godsalve' 1528 (Dresden); and the astronomer 'Niklaus Kratzer' 1528 (Louvre). His major achievement on this visit was the lost group of 'The Family of Sir Thomas More', in a water technique, of which there only remain a diagrammatic drawing (Basel) and the later life-size copy in oil at Nostell Priory: but drawings from the life for seven of the heads are at Windsor.[11] This group of drawings ranks among the supreme masterpieces of portraiture

and surpasses in quality the more schematic and rapidly executed drawings of Holbein's later English years.

The handful of portraits from this first visit are more elaborate in their artistry and pattern than the later English group, and they have no successors in the work of Holbein's following in England. That of 'Sir Thomas More' may be taken as the standard for their style. Except for the work of Titian, nothing of the same senatorial dignity of presentation was being produced in European portraiture at this time, but the means – predominantly linear – are the exact opposite to Titian's. The figure bulks largely in a clearly defined space whose cubical volume is deliberately reduced by a curtain; features, hands, and the carriage of the body are all used to convey character with equal effect, and the whole work has a Shakespearean profundity and seems to convey the full image of a European personage. The very maturity of the style must have made such portraits seem strange in England to all but the international humanist circle, and, when Holbein came to London again, his style became more un-adorned for English sitters.

After four more uneasy years at Basel, Holbein was back in London by the end of 1532 and he remained there until his death between 7 October and 21 November 1543. The patrons of his earlier visit were dead or had fallen into disgrace, and it was the German merchants of the Hansa Steelyard in London who were his first new patrons. He painted for their Hall, about 1533/5, two large allegories in grisaille on a blue ground, executed in tempera on linen, of 'The Triumph of Wealth' and 'The Triumph of Poverty'. The two pictures left England in the seventeenth century, were last heard of in 1691, and are now known only from drawings (at Berlin) and engravings. Other than portraits these were the most important work of a permanent character which Holbein painted in England, but no echo can be traced of their influence on later British painting.

The chief portraits of the members of the Steelyard were painted in 1532 and 1533 and are now at Berlin, Windsor, New York,

Brunswick, and Vienna. The most elaborate is 'Georg Gisze' 1532 (Berlin), and in this and 'The Ambassadors' (National Gallery, London), which was his major work in 1533, it looks as though he were deliberately trying to show off his prodigious powers of imitation, perhaps to catch the unsubtle appreciation of the Court. The first Court official he is known to have painted was 'Robert Cheseman' 1533 (The Hague). About 1534 he came to the attention of, and painted (Frick Collection, New York), Thomas Cromwell, the great orchestrator of royal propaganda in the field of the arts. By 1536 he was on the official payroll of Henry VIII's Household.

The first of Henry's Queens that Holbein painted was 'Jane Seymour' (Vienna) [4], probably soon after her marriage in May 1536.

4. Hans Holbein:
Queen Jane Seymour, probably 1536.
Vienna, Kunsthistorisches Museum

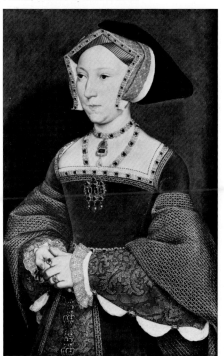

This may be taken as a standard for Holbein's second English style. The figure is no longer seen as displacing with its bulk a recognizable section of space: it approaches rather to a flat pattern, made alive by a bounding and vital outline. Reynolds, from an eighteenth-century viewpoint, speaks of 'a kind of defect' in the background of pictures, which 'have the appearance of being inlaid, like Holbein's portraits, which are often on a bright green or blue ground'.[12] This analysis is just, but, rather than criticize the effect, we should seek to inquire into the reasons for this change of style. It could be due to the specific taste of the English Court, to a changing trend in European painting, to the conditions under which the painter worked, or to a combination of all three of these causes.

There is no doubt that Henry VIII never appreciated Holbein's potential capacity as an artist. He esteemed him chiefly for being, in the words of the British Ambassador at Brussels in 1538, 'very excellent in making Physiognomies', and he sent him to foreign Courts in 1538 and 1539 on the (to him) immensely important task of taking the likenesses of possible wives for himself. In March 1538 Holbein was at Brussels to paint Christina of Denmark, 'Duchess of Milan' (National Gallery, London), and in 1539 he was at Düren to paint 'Anne of Cleves' (Louvre). In the case of the Duchess of Milan we know from the Ambassador's despatches that he had only one sitting of three hours – and yet the completed full-length picture is one of the most vital and lively ever painted. In this one sitting he may be presumed to have made only a drawing – such as those which form the wonderful series at Windsor[13] – and notes of colour; and the portrait was later elaborated in the studio without further access to the sitter. Similar conditions may well have prevailed with most of his aristocratic English sitters, and, in the Windsor drawings, which perhaps represent more or less what was left in Holbein's studio at the time of his death, we have the one living element which went to the building up of those elaborate pieces of jewellery and dress which some of his later portraits seem to be. This tendency to flat pattern, with elaborate

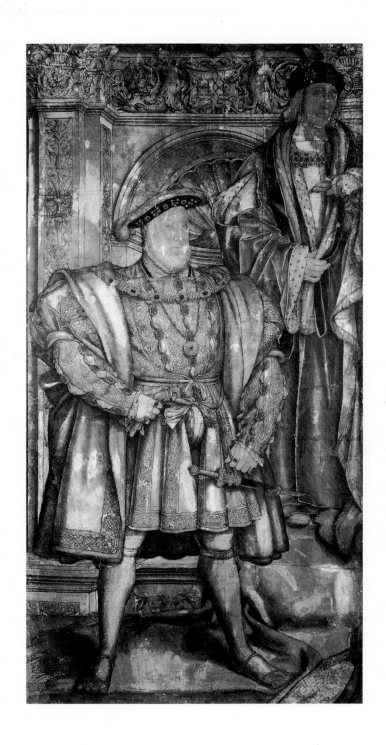

dresses and aloof, inscrutable features, persisted in England right up to the reign of James I, but it is uncertain whether it was imposed on the artist by the taste of his patrons or was a convention dictated by his limited access to his sitters. But it is significant that a parallel change of style is found in the work of Hans Eworth after he settled in England.

Holbein's first portrait of Henry VIII (formerly Althorp; now Thyssen Collection, Madrid) seems to date from 1537. It is in the style and

5 (*opposite*). Hans Holbein:
Henry VIII and Henry VII, 1537.
Fragment of a cartoon for a lost fresco at Whitehall.
London, National Portrait Gallery

6. Follower of Holbein: Henry VIII.
Liverpool, Walker Art Gallery

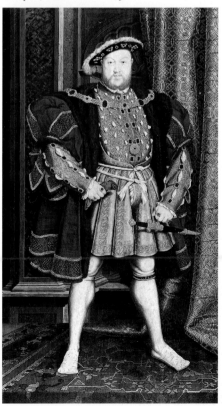

on the scale of Clouet's portraits and had as a companion the 'Jane Seymour' at The Hague, which is from the same sitting as the Vienna picture. This sitting of Henry VIII was used for the cartoon, of which the essential portion survives (National Portrait Gallery, London) [5], for the fresco commissioned in 1537 for the upper part of the wall of the Privy Chamber in the Palace of Whitehall. This was a commemorative group of the King and Queen, with Henry VII and Elizabeth of York, whose dynastic and imperial propaganda intentions have been unfolded by Roy Strong.[14] It was painted in a room to which only the great officers of state, the most favoured members of the Court, and foreign ambassadors could normally get access and it was intended to convey unequivocally to the beholder the prodigious power of the King as head of Church and State. Holbein's first portrait type was too tame for the royal ego and a further sitting was given, whose results (known to us only from early copies, such as illustration 6) will no doubt continue to provide the image by which Henry VIII is known to posterity until the Day of Judgement.

Apart from portraits of prospective wives no other major works for the King are recorded. But Holbein was engaged, at the time of his death, upon a large painting which must certainly have had royal approval – a picture commemorating the grant of a charter in 1541 by Henry VIII to the Barbers and Surgeons, who were recombined into a single society on this occasion. This is a curiously medieval work in spirit, with the King shown much larger than the assembled Barber-Surgeons, and the whole pattern of the picture must have been dictated by Holbein's patrons. Fire and repaint have rendered it rather inscrutable,[15] but it has an importance as the only major historical picture ever commissioned by one of the Livery Companies of the City of London. No doubt it was intended more as a visible historical document than as a work of art. With a King who had lately dealt so cavalierly with ecclesiastical charters, it was as well to have some more remembering evidence than the document itself.

In later reigns such a need was no longer apparent and the springs of art patronage in the City dried up. What Holbein's powers in this kind of composition might have been if untrammelled by medieval-minded patrons can be seen by the noble miniature in grisaille on vellum at Windsor of 'Solomon and the Queen of Sheba' – where Solomon is unquestionably modelled on Henry VIII – which could have been, as has been supposed, a study for a projected wall decoration.

All that remains otherwise of Holbein's work for the English Court is a small number of portraits of Henry's Queens, the enchanting 'Edward VI as a Baby' (National Gallery, Washington), and a very small number of portraits of people attached to the Court – and the marvellous series of portrait drawings at Windsor.[16] After some of these drawings tracings or copies seem to have been made, and from these later painters of more modest talent produced paintings such as the 'William Fitzwilliam, Earl of Southampton' (Fitzwilliam Museum, Cambridge) which bears the date 1542. But Holbein continued to paint the German merchants of the Steelyard, and his drawings for other purposes touched and influenced all the arts and crafts of the day – lettering, binding, architectural decoration, metalwork, and armour.

There remains the unresolved question of what studio, assistants, or pupils Holbein had in England. There are early variant 'copies', such as the Liverpool 'Henry VIII' [6], the different 'Henry VIII' at Belvoir, and the Woburn 'Jane Seymour' of very good quality, which cannot be accepted as from Holbein's own hand. These imply the existence of pupils or assistants trained to a high level of competent craftsmanship, and they cannot have dispersed at once, without a trace, on Holbein's death in 1543. Certain late portraits of 'Henry VIII' have been doubtfully supposed to be studio copies of designs for which a Holbein drawing has been postulated. These are of two patterns, one best represented by pictures at Windsor and in the Galleria Nazionale, Rome; the other by a picture at Castle Howard.

Holbein's immediate following

When we look for independent work (apart from copies) of this presumed group of direct assistants, the material is surprisingly scanty. The number of pictures which show anything like the accomplishment one would expect from a direct pupil is exceedingly small. An 'Unknown Lady' [7] at Milton Park is one of the

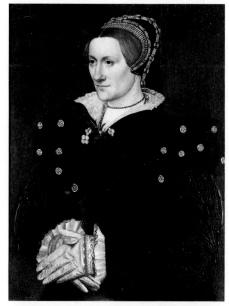

7. Follower of Holbein: Unknown Lady.
Private collection

best examples; a few pictures which pass under Holbein's name (such as the 'Edward VI' in New York) come under this heading; a few others can be named[17] and perhaps more will turn up.

In the National Collections in London can be seen a good example of each of the two types of Holbein follower: the 'Unknown Man' by John Bettes (Tate Gallery) is the unique signed work of a painter whose technique is in the Holbein tradition; while the 'William, Lord de la Warr' (National Gallery), of about 1549, is the work of a painter strongly influenced by

Holbein in pattern and style of presentation, but without a trace of his technical elegance.

Of John Bettes we know only that his signature in French (*faict par jehan Bettes Anglois*), cut from the original or from its frame, is now pasted on the back of the portrait in the Tate, which is dated 1545: and that he was paid for making certain miniature portraits in 1546/7 for Queen Catherine Parr.[18] The addition of *Anglois* to the signature presumably means that the picture was painted abroad. Only one or two pictures which might possibly be by the same hand are known.[19]

Finally there is the painter who appears in Princess Mary's Privy Purse expenses for 1544 as 'one John that drue her Grace in a table'. In the National Portrait Gallery (428) there is a portrait, dated 1544, of the Princess by a competent and quite individual hand, which can also be recognized in the full-length 'Lady Jane Grey' in the same collection (4451). He too may have been an assistant of Holbein's.

HOLBEIN'S SUCCESSORS AND HANS EWORTH

With the death of Holbein in 1543 and of Luke Hornebaud in 1544 the Household of Henry VIII was left without any considerable portrait painter. Until 1951 we were in the dark about what followed, but the researches of Erna Auerbach[1] have revealed that these painters were succeeded by Guillim Scrots (Scroets), who has hitherto lived only a shadowy existence in the history of art under the misnomer of 'Guillim Stretes'.

Guillim Scrots

Scrots, a Netherlander, was appointed *peintre en titre* to Mary of Hungary, Regent of the Netherlands, in 1537, and must have been trained in the style of the official portraiture of the Hapsburg Courts. Probably by 1545, and certainly by 1546, he had entered the service of Henry VIII as King's Painter with the annual salary of £62 10s., which was much higher than that any painter of the Household had received before. It is clear that the King was determined to spare no expense in getting the most up-to-date painter, with the best European Court pedigree, that money could buy. He did not choose carelessly, for, although Scrots was not a painter of high creative or imaginative gifts, he knew all the latest fashions, and a series of portraits appeared at the English Court during the next few years which could vie in modernity with those produced anywhere in northern Europe, even by painters of much greater natural distinction. Scrots disappears from the scene in the summer of 1553, and it is probable that he left the country – or perhaps died – about the time of the accession of Mary Tudor. About that time he was eclipsed in his own field by the new Hapsburg Court painter, Antonio Moro.

It would be reasonable to expect that one of the first things Henry VIII would require of Scrots would be portraits of Prince Edward and of Princess Elizabeth.[2] Now that we know, from the study of the tree-rings,[3] that the two portraits at Windsor of 'Edward VI as Prince of Wales' [8] and 'Princess Elizabeth' [9] are the

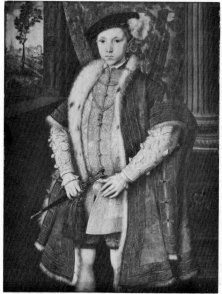

8. Guillim Scrots (?): Edward VI as Prince of Wales, 1546/7. *Royal Collection*
(by gracious permission of Her Majesty the Queen)

product of the same workshop and can be dated to 1546/7, we cannot doubt that they are by Scrots. They show in fact the elegance and distinction of which he was capable when his own execution was involved and he was not simply turning out studio replicas to order. The pose of Prince Edward is a filial echo, in reverse, of Holbein's image of his father in the Whitehall

fresco [5], but, by cutting the figure down to three-quarter length and by a series of subtle emendations, Scrots has contrived to give the portrait something of the decent timidity of youth. Another portrait of the boy Prince is the curious painting in the National Portrait Gallery (no. 1300) in which a panorama and a profile of 'Prince Edward' can only be seen by looking into a cylindrical mirror. This is still dated 1546 and Vertue (1.54) records that the frame originally bore the signature 'Guilhelmus pingebat'. Perhaps Scrots was showing off his cleverness to Henry VIII in the same way that Holbein had been doing when he painted the

standing portrait, which was later to become one of the types of picture most abundantly and most happily exploited by British painters, owed its origins to Germany. It first appears there early in the sixteenth century, and characteristic early examples are the portraits at Dresden of Duke Henry the Pious of Saxony and his wife, which are dated 1514. Its first appearance in Italy is Moretto's 'Unknown Man' of 1526 in the London National Gallery, but it did not become current in Italy until Titian, in 1532, in direct imitation of Seisenegger's 1532 'Charles V' at Vienna,[4] painted his own version of the Emperor, now at Madrid. In 1533 Holbein, in

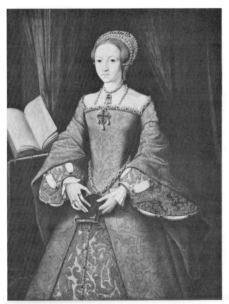

9. Guillim Scrots (?): Princess Elizabeth, 1546/7. *Royal Collection*
(by gracious permission of Her Majesty the Queen)

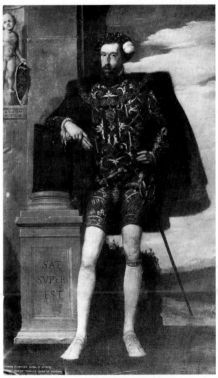

10. Guillim Scrots: Henry Howard, Earl of Surrey, 1546. *Parham Park, Sussex*

curious perspective distortions in 'The Ambassadors'.

But Scrots's speciality seems to have been the full-length standing portrait, which he probably introduced into England, and of which a considerable number – most of those surviving being probably workshop repetitions – were produced in the later 1540s. The full-length

'The Ambassadors', produced his first experiment in this vein, which was followed by his 'Duchess of Milan': and it was not until the

1540s that even with Titian (e.g. 'Cristoforo Madruzzo' 1542 in the São Paolo Museum) the standing full-length becomes anything but exceptional: and it is a curious fact that, by about the same date, it showed signs of having taken root in England, which was otherwise decidedly backward in the arts by comparison with the rest of Europe. The full-length 'Sir Thomas Gresham' 1544 (Mercers' Hall, London), which can hardly be attributed to Scrots, is the first of these and the closest in style to Holbein, even to the meticulously painted skull at the sitter's feet. But this may well have been painted abroad, as we know that Gresham was often in the Low Countries.

The first Scrots full-lengths are, oddly enough, 'opposition' pictures, being portraits of 'Henry Howard, Earl of Surrey' [10],[5] who was executed for treason in the winter of 1546/7. They are most probably posthumous and commemorative works. There are two plain full-lengths at Knole and Parham; a similar picture with fancy corners at Castle Howard; and another, figured under a very elaborate Mannerist fancy arch, at Arundel. It is clear that some, if not all, of these must be workshop repetitions. Oddly enough their closest parallel is with the work of Moroni, but Moroni's portraits of this character do not, at present showing, begin before 1554.

Scrots was continued as King's Painter, with the same high salary, under Edward VI. Dr Auerbach has shown convincingly that he must be held responsible for the standard type of full-length portrait of the young King which was especially used for the furtherance of political propaganda abroad. The most readily accessible of these is that at Hampton Court (which was acquired at the Hamilton Palace sale in 1882 as by Holbein), but the most revealing is that now in the Los Angeles County Museum in which the laudatory inscription is in English, Latin, and Greek, which suggests that it was made for export to any foreign country in which at least one of these languages would be understood. Unfortunately all those so far known seem to be studio products, and do not reflect much of the distinction of which Scrots was capable. But Dr

Auerbach has shown that the pattern seems connected with that of the Seisenegger of the 'Archduke Ferdinand' of 1548 at Vienna, and this deliberate blending of the Holbein formula with that of the Hapsburg Court may be taken to indicate a conscious attempt to keep pace with the current artistic trends on the Continent. This tendency is in marked contrast with what we shall find in the reign of Elizabeth.

There is one puzzling and rather splendid picture, the 'Young Man in Red' at Hampton Court [11], generally dated about 1550, which I am now inclined to think is a masterpiece from Scrots's own hand. This is not only unique in

11. Unknown: Young Man in Red, c. 1550. *Royal Collection (by gracious permission of Her Majesty the Queen)*

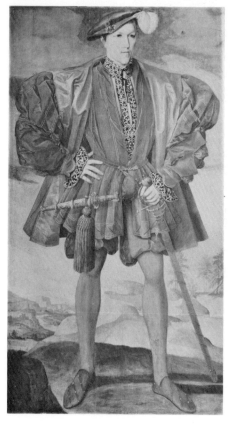

England, but it anticipates anything so far known in Europe as being a standing full-length silhouetted against a wide horizon, with a spreading landscape below. The sitter must certainly have been a person of great eminence, and the fact that the pose of the Whitehall 'Henry VIII' was permitted to be adapted for him must surely be significant.

Gerlach Flicke

Another foreign painter, a German from Osnabrück, Gerlach Flicke (whose name was corrupted into 'Garlicke' in the Lumley Inventory[6]), was working in England during the same years as Scrots. He can be traced here from 1547

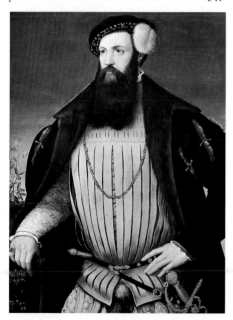

12. Gerlach Flicke: Unknown Nobleman, 1547.
Edinburgh, National Gallery of Scotland

until his death in London in 1558. In 1547 he signed and dated a distinguished portrait of an 'Unknown Nobleman' [12], bequeathed by the Marquess of Lothian to the Edinburgh Gallery, which is almost wholly in the Westphalian style:

but his signed 'Archbishop Cranmer', which is hardly later than 1546 (National Portrait Gallery), shows that Flicke had modified his style in the direction of the Holbeinesque. His only other certain work[7] is a miniature diptych of 1554 of himself and a fellow prisoner (for he was in gaol) named Strangeways. Long known only from a misleadingly bad reproduction, this reappeared in an anonymous sale at Sotheby's on 9 July 1975 (16) and proved to be a work of unexpected refinement and neatness – almost an intermediate stage between the miniatures of Holbein and those of Hilliard. We know that Flicke was a Roman Catholic, but the changes of official religion in the middle of the sixteenth century seem to have had little effect on the practice of such portrait painters as we know.

Foreign visitors under Queen Mary I (1553–8)

The only tangible figure whose career as an artist we can follow at all closely in the middle of the sixteenth century is Hans Eworth (see pp. 29–32), who was most probably, as Roy Strong suggests, official painter to Queen Mary I. Nicholas Lyzarde, a Frenchman, was appointed to succeed Toto as Serjeant Painter in 1554 and was confirmed in that office on 10 April 1556. He held it until his death in 1571, and presented a 'Story of Ahasuerus' as a New Year gift in 1558 (the drawing for which is possibly in the British Museum as Lambert van Noordt), but nothing else to the point is known about him or about his successor William Herne (Heron), who held the post from 1572 to 1580.

During the Marian restoration of the Catholic religion a certain amount of religious painting reappears in the churches, but only slight and battered remains have been recovered from later whitewash, and there was not time during these troubled five years for anything like a tradition to be formed or revived. But one painter of European note whose work left an impress on Eworth's style – and is therefore better considered before him – did pay a flying visit to England about the time of Mary's marriage to

King Philip of Spain in 1554. Antonio Moro (Anthonis Mor van Dashorst: c. 1517/20–1576/7) was the leader of the new style of portraiture which prevailed at the Hapsburg Courts, a style which was calculated to accord with the increasing formality of Court etiquette. Reacting against what may have seemed the embarrassing penetration of character in Titian's portraits of Spanish royalty, he drained out of them all the warmth and colour and perfected a reticent, rather marmoreal, type of 'historical' portrait – the northern counterpart to the style of Bronzino – which was perhaps more acceptable to Philip of Spain and Granvella than the style of Titian. Before his visit to England he had visited Rome, Madrid, and Lisbon, as well as the Spanish Court in the Netherlands, where he worked mainly. He is the last international painter of high repute to visit England in the sixteenth century – except for Zuccaro, whose visit was nearly as short as his own.

The only portraits that we can feel certain were executed in London by Moro in 1554 are the signed and dated portraits of 'Queen Mary' of which there are originals at Madrid, at Fenway Court, Boston, and in the Marquess of Northampton's collection [13]. But a number of English portraits exist, probably dating from Mary's reign, which show a very close imitation of his style, such as the 'Lord Maltravers' (d. 1556) at Parham Park, and the 'Edward, Lord Windsor'[8] belonging to the Earl of Plymouth. There is no need to postulate a later visit of Moro to England in 1568, for the 'Sir Henry Lee' of that year (National Portrait Gallery) and the later portraits of Gresham were most probably painted in the Netherlands. It is sufficient to note that examples of Moro's work, specimens of the most 'advanced' northern European style of portraiture, were available in England.

There was certainly nothing in the nature of a stampede of foreign painters of religious pictures to come to England at the time of the Marian revival of the old religion, but record exists of one painter from Antwerp who did come to London in hopes of such patronage about 1555 –

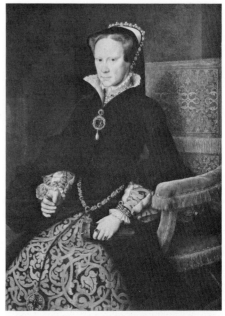

13. Antonio Moro: Queen Mary Tudor, 1554.
Marquess of Northampton, Castle Ashby, Northants

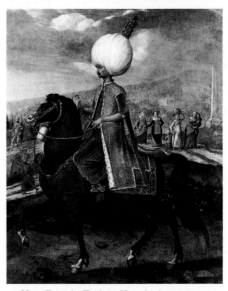

14. Hans Eworth: Turk on Horseback, 1549.
Earl of Yarborough, Brocklesby Park, Lincs

Cornelis van Cleve ('Sotto Cleve').[9] But he went mad about the time of Elizabeth's accession and nothing certainly done by him in England is known to survive.

Hans Eworth (Ewouts)

It is now accepted[10] that Hans Eworth is the name of the painter who uses the monogram HE, which is found on some thirty or so pictures – nearly all of them portraits – ranging in dates from 1549 to 1570. His name is spelt in the documents in a bewildering variety of ways – Haward, Eeuwouwts, Eywooddes, Everts, Evance, Huett, and perhaps Suete are by no means all. He was a native of Antwerp, matriculated in the Guild there in 1540, and can be traced in London from 1549 (possibly from 1545) until 1573. The first of his known pictures, a 'Turk on Horseback' 1549 (Earl of Yarborough) [14], and the last, an 'Allegory of the Wise and Foolish Virgins' 1570 (Copenhagen), are the only ones at present known which are not portraits, but there is record of a 'Mars and Venus' at Gunton Park in the eighteenth century, which bore his signature, and he was employed on mythological figures for the Office of the Revels in 1572/3.

Eworth was not of a stature to originate a style for himself; he is one of those secondary painters, so useful to the historian, who reflect with great versatility the changes in the taste of the patrons for whom they work. In his first portraits, of 1550, we can see the robust and bourgeois style he had learned at Antwerp, in which a landscape rich in incident or allegory gives information about his sitters. By 1554 he had achieved Court patronage and changed to a more sober and reticent style of presentation, and the rival influences of Holbein and Moro can be seen at work in him: in the reign of Elizabeth we find him tending sometimes towards the furniture-and-costume piece, in which pattern takes the place of style, and, in one instance,[11] venturing into the alembicated worl'' of allegory with which the Queen's poets surrounded her complex personality.

The two earliest dated portraits, both of 1550, are in many ways the most interesting of Eworth's works, since they introduce something new into the field of portraiture in England. They portray two filibustering toughs, uncle and nephew, who were planning a joint expedition to Morocco in 1550, when the younger, Sir John Luttrell, died of the sweat. The elder is 'Captain Thomas Wyndham' (Earl of Radnor), a bluff personage, caught in a moment of repose from the battlefield. A camp and soldiers are visible in the background: he is resting against a tree, with his powder-flask round his neck, two gun barrels behind his head, and his helmet ready to put on. It is almost an 'action' portrait, altogether alien from the aloof and timeless figures we have so far had to record. The companion portrait, 'Sir John Luttrell'[12] (Courtauld Institute, London) [15], is no less lively and even more curious. Sir John is naked and wading, waist high, in raging seas, with a ship broken by storm and lightning in the background, the survivors being overwhelmed in little boats. He

15. Hans Eworth: Sir John Luttrell, 1550.
London, Courtauld Institute

gazes up confidently to a vision in which a naked figure of Peace in the sky succours him. Technical examination suggests that the allegorical figures may be by another hand, but they seem to me to accord with the Antwerp tradition of Jan Massys or Frans Floris to which Eworth would have been accustomed, and in the painting of which he may have employed a different manner.

A few years afterwards, about 1553, Eworth first painted 'Mary Tudor' [16];[13] for the

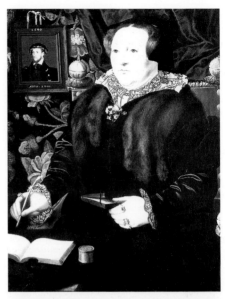

16 (*below*). Hans Eworth: Queen Mary Tudor, *c.* 1553. *Cambridge, Fitzwilliam Museum*

17 (*right*). Hans Eworth: Lady Dacre, 1559(?). *Ottawa, National Gallery of Canada*

18 (*below right*). Hans Eworth: Henry, Lord Darnley, and his Brother, 1563. *Royal Collection (by gracious permission of Her Majesty the Queen)*

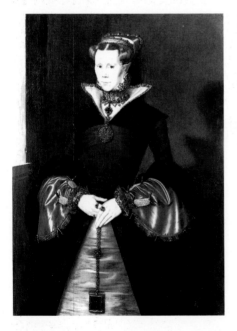

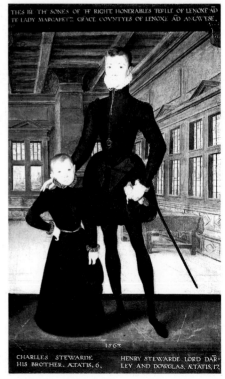

picture in the Fitzwilliam Museum, Cambridge, is surely Eworth's unsigned masterpiece rather than by another hand. In this he has gone back

to Holbein for inspiration, especially to the earlier Holbein where the figure is seen in a clearly defined space. The minute and beautiful painting of the jewels and the meticulous, yet soft, modelling of the face reveal an almost feminine talent working in Holbein's robust idiom. Probably[14] he became official painter to Queen Mary, and he painted her again in 1554, the year of Moro's visit. Echoes of both Holbein and Moro are plain in the 'Lady Dacre' [17], perhaps of 1559,[15] at Ottawa. A Holbeinesque(?) portrait of her husband hangs on a curtain behind, and the robust figure seems to be aiming at the solid and full presentation of Holbein's earlier style. Yet for all the wealth of accessories in the room the background gives the effect of a flat arabesque. By 1559, in the double portrait of the 'Duchess of Suffolk and Adrian Stoke' (Colonel Wynne-Finch), each of the two figures is conceived in the style of Moro, but with a richer feeling for arabesque and an

anticipation of the Elizabethan costume-piece, while the background is a plain, glossy, black, with the date and ages of the sitters inscribed across it in gold, as in Holbein's latest works. What seems to have been the earlier Tudor traditional Court style has been effectively superimposed upon the more robust and bourgeois style of Eworth's earlier period. But Eworth retains throughout a quite remarkable feeling for the interpretation of character.

In companion portraits of 1562, 'Thomas, Duke of Norfolk' (private collection) and the 'Duchess of Norfolk' (Audley End), Eworth has graduated towards the new 'costume-piece' style which was to be characteristic of Elizabethan art. The two pictures are conceived as forming a single unit, each set before one half of a continuous armorial tapestry. The likenesses are distinguished, but the figure is not otherwise of prevailing importance, and the charm of the pictures lies in the generally flat effect of all-

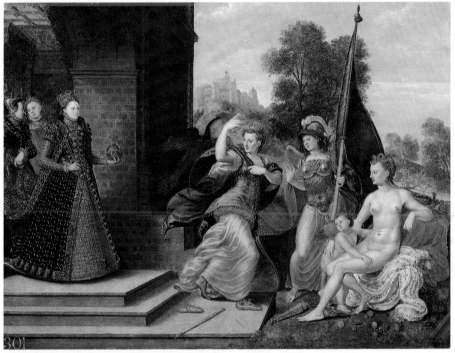

19. Hans Eworth: Queen Elizabeth confounding Juno, Minerva, and Venus, 1569.
Royal Collection (by gracious permission of Her Majesty the Queen)

over pattern. The backgrounds of Eworth's later works are more often plain, but a flat arabesque is usually the main element in their effect.

Two works, however, of particular interest fall outside this category. The 'Henry, Lord Darnley, and his Brother' of 1563 [18] at Windsor has full-length figures, but measures only 25 inches high, so that the spirit of the picture is more like that of a large miniature, or limning – and the miniature, as will appear, was to be at the head of painting fashions in the later years of Elizabeth's reign. Since the cleaning of the life-sized version of this picture at Holyroodhouse, which is dated 1562, but is unsigned, we can see that the Windsor picture is a copy of the latter, and the Holyrood picture, which is in 'water-werf' on fine linen (as Holbein's original of the More family group is reported to have been), is not altogether convincing as the work of Eworth. But it is by a hand no less distinguished, and suggests the surprises that may still be in store when Tudor portraiture is studied in depth.[16]

Eworth's final style is revealed in the 'Queen Elizabeth confounding Juno, Minerva, and Venus' of 1569[17] at Windsor Castle [19] and in an 'Allegory of the Wise and Foolish Virgins' of 1570 at Copenhagen. The former is an elegant piece of flattery to the Queen, no doubt laid down in a programme by a literary patron. It is a Judgement of Paris in modern dress, with Elizabeth as Paris, who surprises the goddesses by awarding the apple to herself. Variations of the same theme have been discovered in literature,[18] but so far they are later than 1569. The figure style of the goddesses is inferior in refinement to that of the portraits of the Queen and her two ladies-in-waiting – but it is not unlike that of the allegorical parts of the portrait of 'Sir John Luttrell' [15]. Mythological compositions of the same general sort are not uncommon, and, unless signed, are assigned to unknown Flemish Mannerists and presumed to have been painted in the Low Countries. It may well be that such pictures were in fact painted in England in the sixteenth century and are at present unrecognized. A certain example, already recorded in an inventory of 1601, is the 'Ulysses and Penelope' dated 1570 at Hardwick Hall.

PAINTING IN THE ELIZABETHAN AND JACOBEAN AGE

Painting in the Reign of Queen Elizabeth I

The career of Hans Eworth overlaps the first years of the reign of Queen Elizabeth I, a period of painting in Britain which has begun to be seriously studied only in recent years.[1] There is no lack of portraits, even of dated portraits, but the general level of work is of an even mediocrity, executed in the main, it would seem, by small factories of craftsmen rather than by painters with a personal style of their own. The records of Elizabeth's reign, more numerous than those of Henry VIII's, have been published much less fully: the painted portrait on the scale of life seems to have been less esteemed than it was earlier in the century, and there was no attempt to keep abreast of current trends in European style. Many of the new nobility of the age, which set high store by sculptured tombs (such families, for instance, as the Spencers and the Heneages, whose tombs are among the most memorable of the period), have left no painted portraits in this century, and it is not until about 1618 that a change comes over the portrait taste of this class of patron.

For it must be noted that, however momentous historically may have been the change from the dynasty of the Tudors to that of the Stuarts, with the union of the Crowns of England and Scotland, there is no change in pictorial style until the close of the reign of James I, when the precocious taste, first of Henry, Prince of Wales (d. 1612), and then of Prince Charles, began to make itself felt. As in architecture, we can fairly (if inelegantly) speak of a 'Jacobethan' style in portraiture, and the studios which were flourishing in the later years of Queen Elizabeth's reign continue unchanged under James I. It is thus convenient and appropriate to consider these groups of portraits, which centre round the Gheeraerts and de Critz studios, under the title of 'Jacobethan' portraiture.

Another point is fundamental to a consideration of Elizabethan painting – that, as at no time later, the art of miniature (called 'limning' at this time) far surpasses in quality and contemporary esteem all other forms of painting. Alone of painters in Elizabeth's time, Nicholas Hilliard and his pupil and rival, Isaac Oliver, are worthy to be named as contributors to the age of Shakespeare. It was these miniaturists whose practice and aesthetic were valid for this age, and the historian of painting in Britain must accord them a degree of attention which the art of miniature does not require in later centuries. It would seem that both Hilliard and Oliver did sometimes (but not often) also practise painting on the scale of life. But what is a superlative virtue in the private and intimate art of miniature hardly admits of being transplanted onto the scale of life.

Painters' names under Elizabeth I

As the result of a misunderstanding of venerable antiquity most Elizabethan portraits which today bear any label at all are ascribed to Federico Zuccaro (Zucchero). There is no justification for this, as will be seen when we come to consider Zuccaro among the occasional foreign visitors to England. But a good many names are known[2] from occasional documents and from two main contemporary sources – the Lumley Inventory of 1590, already mentioned, and Francis Meres's Wit's Commonwealth, part ii, 1598. Now that the disembodied names can be found accessibly published and documented, it will be sensible to consider only those who can be associated, with greater or less certainty, to surviving paintings. These are, roughly in the order in which they were active: Steven van der Meulen, George Gower, Hieronimus Custodis, and Sir William Segar.

Steven van der Meulen, who matriculated in the Antwerp Guild in 1552, was living in England in 1560, and was naturalized in 1562, may be accepted as 'the famous paynter Steven' of the Lumley Inventory, whose two portraits (1563) of 'John, Lord Lumley' and his wife survive, in rather battered state, in the Earl of Scarbrough's possession today. He was also most probably the 'Master Staffan' who went to Sweden in 1561 and painted King Eric XIV at the time of marriage negotiations between Queen Elizabeth and King Eric. A full-length now at Gripsholm has been plausibly identified as this picture, though it is a good deal more interesting than the two Lumley portraits. Some other possible attributions have been suggested.[3] He disappears in the later 1560s.

George Gower is a much more tangible figure and was a native Englishman, of gentle birth. From at least 1573 until his death in 1596 he seems to have been at the head of his profession as portrait painter. He was a grandson of Sir John Gower of Stettenham (Yorks.) and may have been the George Gower who became a Freeman of York 1555/6 with the profession of 'merchant'. Our certain knowledge of his personality and of his social and economic background derives from his 'Selfportrait' (Milton Park) [20] dated 1579. In the background is a pair of scales in one of which the painter's coat of arms is outweighed by a pair of dividers, the instrument of the painter's craft. The implication that even a gentleman might turn for his living to painting is further emphasized by some crabbed verses.[4] Two other portraits, 'Sir Thomas Kitson' and 'Lady Kitson' (Tate Gallery), both dated 1573, can be securely identified as by Gower from accounts, and a considerable group of portraits has been plausibly identified as his.[5] He must certainly have been responsible for some of the surviving portraits of Queen Elizabeth, for he was appointed Serjeant Painter for life in 1581, and a draft patent exists of 1583/4 which would have granted him the sole right to make portraits and prints of the Queen – with a similar right to be granted to Hilliard for miniatures. This patent is not known to have been executed and it was

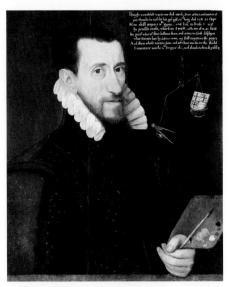

20. George Gower: Selfportrait, 1579. *Private collection*

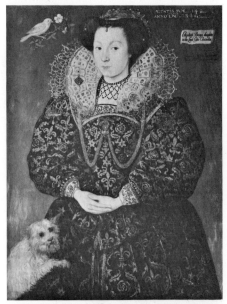

21. Hieronimus Custodis: Lady Elizabeth Bruges, 1589. *Woburn Abbey, Beds*

perhaps only a bright scheme by Gower and Hilliard to further their own interests, but it almost certainly means that Gower had already painted the Queen and that the portrait had been approved. A likely, but by no means certain, candidate is the Woburn version of the 'Armada' portrait type of about 1588.

A third painter, Hieronimus Custodis, who appears in Meres's list as 'Hieronimo', signed three portraits which bear the date of 1589 - a rather feeble 'Sir John Parker' at Hampton Court, 'Giles, Lord Chandos' at Woburn, and the charming 'Lady Elizabeth Bruges' [21] also at Woburn. We know that his widow remarried in London in 1593. Roy Strong[6] has identified a number of other portraits as coming from his workshop by the somewhat idiosyncratic form of the inscription which gives the age and date of the sitter - but very similar forms are also found on technically inferior portraits which date from after Custodis's known death. I am inclined to suspect that inscriptions were sometimes put on to the portraits of this period by an assistant who specialized in lettering and who may have worked at this speciality for more than one studio. If so, some caution is needed in making attributions on grounds of lettering style.

The fourth painter, also one mentioned in the Lumley inventory, who is now a recognizable personality is Sir William Segar, who started a career in the College of Heralds in 1585, became Garter King at Arms in 1603, was knighted in 1616, and died in 1633. He had probably abandoned painting by 1600, but the Dublin portrait of the 'Second Earl of Essex' of 1590 can confidently be identified with the picture listed in the Lumley inventory,[7] and around this a number of reasonably characteristic portraits have been grouped. No doubt in the course of research more light will be introduced into this still rather unclear period.

Portraits of Queen Elizabeth I

The subject of Queen Elizabeth's portraits is central to any understanding of English six-teenth-century portraiture. Very much the best, and almost the only ones which can be identified with absolute certainty as by a given painter, are the miniatures and drawings of Nicholas Hilliard (see p. 38). There is certainly no scarcity of those on the scale of life and they have been well catalogued,[8] but we are very little nearer knowing who painted most of them than we were a hundred years ago.

Historical evidence suggests that the Queen, for some years after her accession, was unwilling to sit to a painter, in spite of the constant demand which existed for her portrait. There exists a draft proclamation in William Cecil's handwriting to prohibit the making of unauthorized likenesses of the Queen until she should sit officially 'to some coning person mete therefor' - but Elizabeth is not known to have approved this proclamation. However, the earliest known portrait type, of which the best surviving version is the picture at Barrington Park, may well date from about this moment. The so-called 'Coronation' miniature at Welbeck is possibly by Hilliard but there is no evidence for its date; and the earliest certain dated Hilliard miniature of the Queen is that of 1572 in the National Portrait Gallery, which seems to be about the date when Hilliard was appointed goldsmith and limner to the Queen. It is also from the middle of the 1570s that the first of the more elaborate portraits of the Queen must date - the one holding a rose in the London National Portrait Gallery (190), and the closely related portrait with the Pelican jewel (Walker Art Gallery, Liverpool). These are the two portraits on the scale of life which have the best chance to be by Hilliard. The finest of all (perhaps c. 1575) is the 'Cobham' portrait [22] in the National Portrait Gallery (2082). The impulse behind this series seems to have been the various marriage projects, particularly those with France. The 'aesthetic' of these is that of the miniatures of Hilliard, and they show a certain preoccupation with facial likeness. The idea of a 'cult image' has not ousted the idea of portraiture. But, beginning with the type with the Queen holding a colander (symbol of virginity), of which the best version

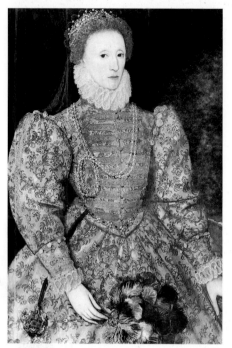

22. Unknown: Queen Elizabeth I
(the 'Cobham' portrait), mid 1570s.
London, National Portrait Gallery

crowns and powdered with diamonds, a vast ruff, a vaster farthingale, and a bushel of pearls', and of which Sir Henry Hake has written:[10] 'The origin and growth of the legend of Elizabeth is written in the succession of her portraits which become more and more fantastic and magnificent as her reign and legend advance.'

It is reasonable to date about 1588 the portraits with the defeat of the Spanish Armada in the background (Woburn Abbey and formerly at Shardeloes). George Gower might reasonably also be expected to have painted the principal new portraits of these years – but they are not obviously by the same hand or workshop. Another fairly secure date is that of the Ditchley portrait [23], bequeathed by Viscount Dillon to the National Portrait Gallery. This is traditionally a gift made to commemorate a visit of the Queen to Ditchley in 1592 and the hieratic quality of the image is extremely striking. It looms against a stormy sky like some protecting or avenging deity, and stands upon – or rises out of – a tapestry map of England, with the Queen's foot resting exactly upon the spot where Ditchley lies. Another image of a related sort is the full-length at Hardwick, in which the naturalistic animals on the embroidered dress are strangely at variance with the mask-like face.

Something of the aesthetic of these portraits will have become apparent from this historical account of them. The common principles by which the historian of painting is accustomed to judge western portraiture of the Renaissance do not apply. Likeness of feature and an interest in form and volume have gradually been abandoned in favour of an effect of splendid majesty obtained by decorative pattern, and the forms have been flattened accordingly. The Queen's astonishing wardrobe and the politic skill with which she used it alone make this anachronism in Elizabethan portraiture possible. James I inherited the wardrobe as well as the style, but the Elizabethan legend, which gave vitality to both, was incommunicable, and it is not surprising that it took some fifteen years for a new tradition to begin to develop.

is that in the Siena Gallery,[9] perhaps of about 1580, with its mysterious conceits in Italian and allegorical accessories, we find the Queen's portraits moving into the strange world of Emblem literature. The portrait with the ermine at Hatfield probably also belongs to the 1580s, and it is probably only after the defeat of the Spanish Armada in 1588 that the more legendary portraits of the Queen begin. By that time the Queen's features were certainly showing signs of age and she wore a wig of a colour unknown to nature. As her portraits from this time onward were distributed with politic discrimination and were intended as pledges of loyalty and symbols of state and power, some sort of cult image was required. It is from these years that date those pictures which Walpole sufficiently describes as showing 'a head of hair loaded with

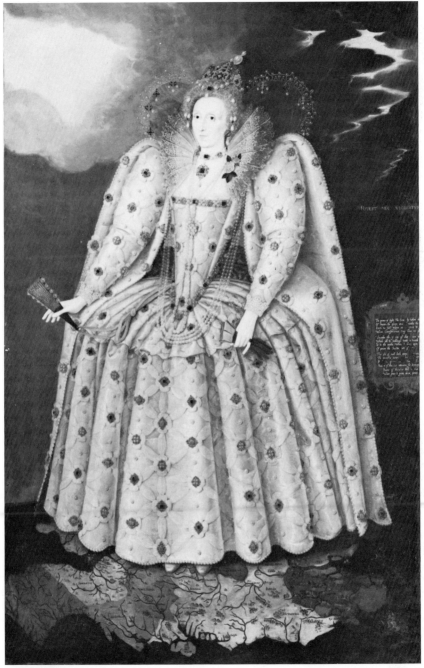

23. Unknown: Queen Elizabeth I (the 'Ditchley' portrait), *c.* 1592. *London, National Portrait Gallery* (now accepted as by Gheeraerts)

Nicholas Hilliard

The painters of most of Queen Elizabeth's portraits on the scale of life were not artists of great technical or intellectual gifts. These were reserved for the Queen's limner and goldsmith, Nicholas Hilliard,[11] a native of Exeter, born about 1547, since he was buried on 7 January 1618/19 at the age of seventy-two. What little has been surmised about his painting 'in greate' has been mentioned. Painters in miniature are normally a byway which the historian need hardly consider in a general account of a school of painting: but Hilliard is the central artistic figure of the Elizabethan age, the only English painter whose work reflects, in its delicate microcosm, the world of Shakespeare's earlier plays. It is an Italianate world, whose presuppositions about art, the theory of art, and the artist's title to distinction are derived from Lomazzo and Alberti and from Baldassare Castiglione's idea of a 'Gentleman'. Hilliard's art also has close formal connexions with the art of the French Court, which he visited in 1576/8. It is supreme in its orchestration of the non-representational and purely decorative elements in the Elizabethan style, as may be seen by comparing one of Hilliard's masterpieces, the 'George Clifford, Earl of Cumberland' (National Maritime Museum, Greenwich) [24], with its almost exact contemporary, the Ditchley 'Queen Elizabeth' [23]. Hilliard's work is most nearly paralleled by some of the finest of Persian miniatures; but he has another quality which is no less surprising than his virtuosity in arabesque – a prodigious gift of psychology. This he could not exercise in his miniatures of the Queen, but, in his *Arte of Limning*,[12] written about 1600, he gives some account of his aims and practice which explains what has been finely called[13] the 'tantalizing intimacy' of the best of his miniatures of private persons.

Hilliard describes[14] how the 'curious drawer' must watch and, as it were, catch 'these lovely graces, witty smilings, and these stolen glances which suddenly, like lightening, pass and another countenance taketh place'; he must note 'how the eye changeth and narroweth, holding

24. Nicholas Hilliard: George Clifford, Earl of Cumberland, *c.* 1590. Miniature. *Greenwich, National Maritime Museum*

the sight just between the lids as a centre, how the mouth a little extendeth both ends of the line upwards, the cheeks raise themselves to the eyewards, the nostrils play and are more open, the veins in the temple appear more and colour by degrees increaseth, the neck commonly erecteth itself, the eyebrows make the straighter arches, and the forehead casteth itself into a plain as it were for peace and love to walk upon'. Such are the refinements at which Hilliard's art was aiming, and which it achieved at its best. The painters on a larger scale, all inferior artisans, were aping an art whose springs they did not understand, and this perhaps explains the unsatisfactory character of most Elizabethan portraiture. With the death of Queen Elizabeth the understanding of these subtleties died too, and the more prosy reign of James I saw the rise to popularity of the miniature style of Hilliard's

pupil and rival, Isaac Oliver, whose aims were a realistic likeness attained by the use of shadow. Of the portrait painters in large only Gower may have had some inkling of an understanding of Hilliard's style: Gower's and Hilliard's names are joined in the draft patent of 1584, and the legend on Gower's 'Selfportrait' [20] suggests a preoccupation similar to Hilliard's about the social status of the artist. The more popular Flemings were craftsmen and did not aspire to be anything else.

Visiting Foreign Painters

None of the few foreign painters who worked in England for brief periods was important for the development of painting in Britain, but mention should be made of Lucas de Heere, Cornelis Ketel, and Federico Zuccaro. De Heere and Zuccaro are of interest chiefly owing to the reckless play which has been made with their names by those anxious to find an attribution for Elizabethan portraits.

Lucas de Heere (1534–84) was a distinguished painter from Ghent, mainly of subject pieces and historical decorations. He was a pupil of Frans Floris, and his historical style (which can be seen at Ghent) was probably much the same as that in which Hans Eworth also was trained. He also worked at Fontainebleau on designs for tapestries, and it is this connection with the French Mannerist school which makes his presence in England – as victim of the Duke of Alva's proscriptions – of possible significance. He was in England from 1567 to 1577, but no surviving portraits can be associated with his name.[15] He was, however, probably the teacher of the most prolific portrait painters of the next generation.

Cornelis Ketel (1548–1616) was a native of Gouda, who, like de Heere, had worked (in 1566) at Fontainebleau. He was in England from 1573 to 1581, when he finally settled in Amsterdam. He was both a portrait and a history painter, and, like Holbein before him, he found his first clients in the merchants of the Hansa Steelyard. A young English merchant,

whose name Van Mander gives as Pieter Hachten (possibly a Hatton and kinsman of the future Lord Chancellor), bought from Ketel an allegorical picture, with figures larger than the scale of life, of 'Force overcome by Wisdom and Prudence', of which he made a present to Sir Christopher Hatton. This introduced Ketel to Court circles and he is reported to have painted a portrait of Elizabeth in 1578 for the Earl of Hertford. Half a dozen signed portraits with dates from his English period have been traced,[16] and it will be seen from the 'Unknown Youth of Sixteen' of 1576 (Parham Park) [25] that there is little to distinguish his style at this

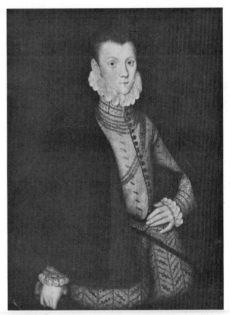

25. Cornelis Ketel: Unknown Youth of Sixteen, 1576. *Parham Park, Sussex*

date from the later work of Eworth. Unfortunately his most ambitious portrait of these years, the 'Sir Martin Frobisher' of 1577 (Bodleian Library, Oxford), is too ruined to provide a sure criterion of his style.

Federico Zuccaro (*c.* 1543–1609) was a name of much greater contemporary repute. On

Titian's death in 1576 (soon after Zuccaro's visit to England) Zuccaro was probably the most internationally famous of Italian painters, and, had he really stayed in England the four years which have been alleged from the time of de Piles up to the present century, it is possible that the current of British painting might have flowed more in consonance with the main stream of European style. But in fact he arrived in England in March 1574/5,[17] and was back in Italy by the autumn of the same year. All that he is recorded with any certainty to have painted in England are full-length portraits of Queen Elizabeth and the Earl of Leicester:[18] all that survives is the pair of drawings for these in the

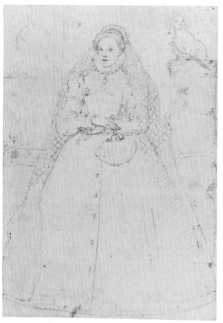

26. Federico Zuccaro: Queen Elizabeth I, 1575.
London, British Museum

British Museum (illustration 26 for 'Queen Elizabeth'). Zuccaro's name, taken in vain, is still to be found on the labels in many of the great houses of England.

The Development of Series of 'Historical Portraits'

We saw how portraiture seems to have begun with series of portraits of Kings, some of them perhaps imaginary. By the close of the century other series, of lesser personages, had begun to come into being, and it will be convenient to deal, once for all, at the birth of the type, with that recurrent phenomenon in British collections, the imaginary historical portrait, examples of which, mistaken by later ages for works contemporary with the sitter, have periodically been introduced to confound the history of art. First after Kings, perhaps, came series of portraits of religious reformers (all more or less contemporary), and an interesting correspondence has been published[19] giving an account of how one Christopher Hales, as early as 1550, was seeking to collect portraits of the Zürich reformers for the adornment of his library. But the crucial example of a set of largely imaginary portraits is that of the Constables of Queenborough Castle which Sir Edward Hoby had painted in 1593 for the hall of the castle of which he was then the Constable. These began with 'Edward III' (Queen's College, Oxford) and 'John of Gaunt' (now at Badminton) and continued up to Sir Edward himself. They all centred round a portrait of Queen Elizabeth, and the whole scheme was explained in some appropriate (but obscure) lines in Latin, followed by the date 1593.[20] The series was already dispersed by 1629, but most of them passed through the sale of Sir John Tufton in 1686, and sixteen were, in Vertue's time, at Penshurst, where two still remain. On the portrait of 'Thomas Fitzalan, Archbishop of Canterbury' (one of the two which survive) Vertue read correctly a monogram which appears to be a combination of the letters LCP, and he surmised, in the privacy of his notebook, that this was the signature of Lucas Cornelis de Kock, a painter otherwise unknown who is stated by Van Mander to have come to England in the early years of the sixteenth century. Hence examples of this series of portraits, now widely scattered,

have periodically been dated a century too early.

In this last decade of the sixteenth century, which saw the creation of the imaginary portraits of the Constables of Queenborough Castle, another kind of imaginary portrait also begins to come in – the college founder's portrait. At Oxford these were the creation of a Dutch painter, Sampson Strong, alias Starkey (c. 1550–1611), whose abundant activity can be traced there from 1589 until his death.[21] He is found also at Christ's Hospital, Abingdon, where there is a portrait almost certainly from his hand[22] of a benefactor who died in 1424, which is a work of pure invention. A parallel group of portraits exists at Peterhouse, Cambridge.

The Flemish Studios of the 'Jacobethan' Period

By the early 1550s the full-length portrait seems to have fallen out of favour, and it is likely that it was restored to favour by the two full-lengths of the Queen and Leicester painted by Zuccaro in 1575. Of the very few such portraits before that date – there are three at Petworth of 1571 and 1573 – both pattern and style are Holbeinesque. After 1575 a change takes place and full-length portraits become more frequent, at first of great persons, such as 'Sir Christopher Hatton' (Earl of Winchilsea) and the Earl of Leicester. The Ketel 'Frobisher' of 1577 is one of the first of the series, and, by about 1590, the full-length 'costume-piece', with a single figure, or, on occasion, family groups, had become the most typical and characteristic form of English portrait. From 1590 to about 1625 a great number of these 'costume-pieces' were executed. There are splendid series still at Woburn, Penshurst, and Welbeck, and some of the finest of dispersed groups were at Wroxton and Ditchley. Most of them today are covered with grime and give a false effect of what they were meant to look like. But when they can be seen cleaned – as in the wonderful group from Charlton (later at Redlynch), presented by Mrs

Greville Howard to Ranger's House, Blackheath – they glow with the enamelled brilliance of a formal parterre. There is nothing like them in contemporary European painting, and, although they should perhaps be classified with the decorative rather than with the plastic arts, their qualities deserve respect. It is customary, but incorrect, to associate most of these with the name of Marcus Gheeraerts. They seem in fact to be the product of several closely associated workshops of painters of Flemish origin who were interconnected by marriage. The two main dynasties are the families of de Critz[23] and Gheeraerts,[24] and connected with these are Robert Peake and the miniature painter, Isaac Oliver.

A goldsmith of Antwerp named Troilus de Critz settled with his family in England, where he became a denizen in 1552. Of his children, John (born probably before 1552: died 1642) became a pupil of Lucas de Heere in 1571 and was an independent painter and travelled in France as a protégé of Walsingham in 1582: by 1598 he was one of the best known painters in England, and he stepped into the office of Serjeant Painter (at first jointly with Leonard Fryer, who had succeeded Gower in 1596) almost immediately after the accession of James I in 1603. He still held that office at the time of his death in 1642, but in 1607 Robert Peake was associated with him in the office of Serjeant Painter. The eldest of this John de Critz's sisters, Susanna, married in 1571 the elder Marcus Gheeraerts, a historical and decorative painter and engraver from Bruges, who was a refugee in England from 1568 to 1577; a younger sister, Magdalena de Critz, married in 1590 Susanna's stepson Marcus Gheeraerts the younger (1561/2–1635/6). Sara, one of the daughters of Susanna de Critz and the elder Marcus Gheeraerts, became in 1602 the second wife of Isaac Oliver. It may well be not far from the truth that the four painters, John de Critz, the younger Gheeraerts, Peake, and Oliver, were the leading figures in a small factory or factories which produced the costume-pieces of the age. Some clarification

has been attempted in sorting them out by studying the forms of inscription to be found on many of the portraits,[25] but I am inclined to believe that the same letterer worked for more than one studio.

The crucial document for John de Critz is a bill of 1607 for various portraits painted for the Earl of Salisbury. They included a portrait of James I and several of the Earl himself: one of the latter was for Sir Henry Wotton, Ambassador at Venice. In a letter[26] of 22 June 1609 to Lord Cranborne, Wotton explains how he has had a mosaic made from the portrait in Venice, and this mosaic, which is still at Hatfield, serves to identify the de Critz type of portrait of the Earl of Salisbury. It is probable also that most of the earlier portraits of James I and Anne of Denmark issued from the de Critz workshop, and in 1606 there is a payment for such pictures which were sent to the Archduke of Austria. An accessible example, one of very many, is the 'James I' dated 1610 at Greenwich [27] and there are also full-length versions.

It is probable that the elder Marcus Gheeraerts (c. 1520–c. 1590) was never a portrait painter, and that the small panel (18 by 15 ins.) of 'Queen Elizabeth' [28] signed 'M.G.F.' (private collection), in a dainty and almost

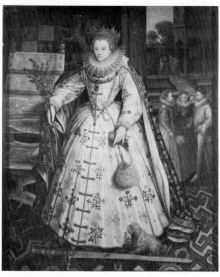

28. Marcus Gheeraerts: Queen Elizabeth I, c. 1590(?). *Private collection*

miniature-like technique, is an early work of the younger Marcus. Vertue[27] records a letter at Penshurst in which the name of 'Gerrats' was associated with a portrait group which can be identified as the 'Barbara, Lady Sidney, and her Six Children' [29], which is correctly (but by a later hand) dated 1596. In 1611 Gheeraerts is styled 'his Majestie's paynter' and there are payments in 1611, 1613, and 1618 for various portraits of the royal family. A handful of signed works is now known,[28] and lettering has led to a number of attributions. The variations in style suggest a workshop with a variety of hands.

Unlike the others of this group Robert Peake was, so far as is known, an Englishman, and he was not involved in the family interconnections of the de Critzes and Gheeraerts. But his training must have been along the same lines, and it would be a reasonable guess that they

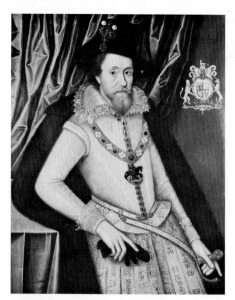

27. John de Critz (?): James I, 1610. *Greenwich, National Maritime Museum*

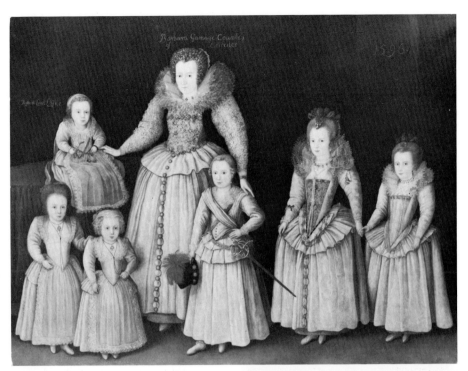

29. Marcus Gheeraerts: Barbara, Lady Sidney,
and her Six Children, 1596.
Viscount De L'Isle, Penshurst Place, Kent

30 (*right*). Robert Peake: Prince Charles (detail),
1613. *Cambridge University Library*

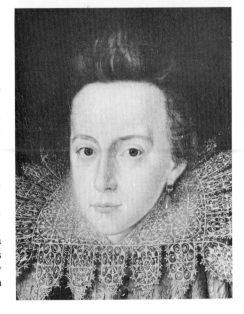

were all pupils together of Lucas de Heere. He
first appears[29] in the office of the revels in 1576:
by 1598 he was in good employment as a
portrait painter: and in 1607 he was joined with
John de Critz in the office of Serjeant Painter.
Probably this was because of his role as 'painter
to Prince Henry' – as he is described in 1610.
The known payments also suggest this. He
received payment in 1613 for the full-length
'Prince Charles' [30] which is still in Cambridge
University Library. A signed 'Man' of 1593
(Yale Center for British Art, New Haven) gives a
clue to his earlier style, and a number of pictures
have been associated with this by an idiosyncrasy
of lettering in the inscriptions. He died in
October 1619.

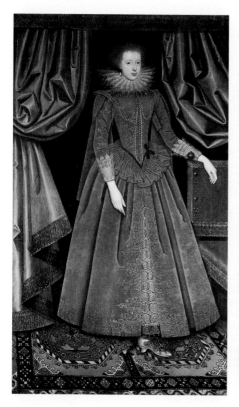

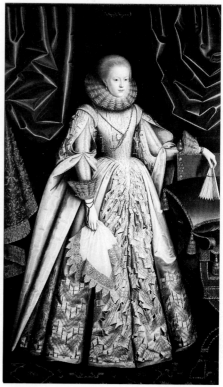

31. Unknown: Countess of Suffolk.
The Suffolk Collection, Ranger's House,
G.L.C., Blackheath

32. Unknown: Countess of Stamford.
The Suffolk Collection, Ranger's House,
G.L.C., Blackheath

Another artist, William Larkin, documented as active from about 1609 to 1619,[30] has become a favourite name for attributions in recent years, because of the to me untenable attribution to him of almost all of the splendid series of full-lengths [31, 32] from the Suffolk Collection given to the Ranger's House, Blackheath, by Mrs Greville Howard. These seem to me to be by at least three different hands, and I do not think that any of them can be equated with the painter of the two certain Larkin portraits on copper at Charlecote. For perhaps two of them I am still inclined to think that an attribution to Isaac Oliver is not impossible.

Isaac Oliver came as a child from Rouen to England in 1568 and died in London in 1617. He is well known as a miniaturist, and learned his dexterity of hand from Hilliard, but his style belongs to the post-Elizabethan spirit. He was possibly in Holland in 1588 and certainly in Venice in 1596, and his means of obtaining likeness in his miniatures are the European ones of light and shade and modelling in the round, which Hilliard evaded. Although Hilliard retained his position under James I, Oliver was made limner to Queen Anne of Denmark in 1604, and had a monopoly of her and of Prince Henry's portraits in miniature. It is Oliver who gives us the most living portraits of the reign of James I, prefiguring the style of the next generation. The literary evidence suggests that he probably also painted on the scale of life; and a portrait such as the 'Frances, Countess of Essex' (private collection) [33] shows on the scale of life all those qualities which delight us in his miniatures. A comparison of his full-length miniature of the 'Third Earl of Dorset', signed and dated 1616 (Victoria and Albert Museum) [34], with the life-size portrait of 1613 of the same sitter at Ranger's House, Blackheath [35], shows what an Oliver on the scale of life might well look like. Oliver also made religious and historical drawings in a Mannerist style, and copies after Italian compositions.

Two pictures exist which are rather more than mere group portraits, and which can be associated with this style – the 'Visit of Queen Elizabeth to Blackfriars' at Sherborne Castle,[31]

33. Style of Isaac Oliver: Frances, Countess of Essex. *Private collection*

34. Isaac Oliver: Third Earl of Dorset, 1616. Miniature.
London, Victoria and Albert Museum

35. Style of Isaac Oliver: Third Earl of Dorset, 1613.
The Suffolk Collection, Ranger's House, Blackheath

and the two versions (National Portrait Gallery and Greenwich) of 'The Conference of English and Spanish Plenipotentiaries' 1604.[32]

Beginnings of Landscape and Genre: Wall Paintings

Topographical landscape in drawings and watercolour is to be found in the sixteenth century, but only one oil picture is so far known (at any rate of moderate distinction) which shows an English scene and combines landscape and genre – the 'Wedding at Horsleydown in Bermondsey'[33] at Hatfield, signed by Joris Hoefnagel. Hoefnagel (born Antwerp, 1542: died Vienna, 1600) was a miniaturist and topographical draughtsman as well as a painter, and there is room, in his much-travelled career, for a visit to England about 1569. The picture is unique in showing a bourgeois scene in a recognizable English setting, and the style is a competent derivation from the Brill–Brueghel manner. But the picture seems to have remained without successors in England.

Secular wall paintings from the sixteenth century do exist,[34] but they are mainly decorative and the work of local house-painters. An exception is the series from Hill Hall, Essex,[35] now in the Victoria and Albert Museum, which are pedestrian imitations after tapestries from Raphael school designs. It is sufficient to have mentioned the existence of this class of work.

Painting in Scotland

There were portrait painters in Scotland before the union of the two crowns in 1603 under James I (and VI): but they were fewer than in England, and very much less of their work survives. To set against the long series of portraits of Elizabeth I, there is not one of the authentic portraits of Mary, Queen of Scots, which was painted during her stay in Scotland. Whether the battered painting at Hardwick of 'James V and Mary of Guise' (1540) was contemporary has not yet been explored by dendrochronology: but Mary of Guise brought with her from France Pierre Quesnel, who became the father, while resident in Scotland, of two distinguished portrait painters who later worked in France. The first 'paynter to the King' was Arnold Bronckhorst, who was appointed to that office on 9 September 1580;[36] a bill survives for a full-length and a half-length portrait of the young James VI and a portrait of Buchanan. In June 1581 there is also a payment in the Treasurer's accounts to Adriaen 'Vanson' for portraits of the King and of John Knox sent to Beza in 1580 and engraved in his *Icones*.[37] He was still alive and 'painter to his Majesty' in 1600. He married Susanna de Colone, who was certainly a widow by 1610: and one Adam de Colone, who may have been her son, is recorded as working in Edinburgh and London between 1622 and 1628 (see p. 68).

A specifically Scottish type of picture, with-

36. Unknown: The Bonnie Earl of Moray, 1591.
Earl of Moray, Darnaway Castle, Morayshire

out parallel in England, is what one may call the 'vendetta portrait', designed to keep alive the memory of an atrocious deed. The earlier of the two known is the 'Darnley memorial picture' (showing the young James VI at his father's tomb) at Holyrood, of which there is a second version at Goodwood.[38] This appears to have been painted in London in 1567 by a Brussels artist, Levinus Vogelarius, but it was assuredly a Scottish commission. The other is the most gruesome pictorial document of the age, the life-size portrait of the corpse of 'The Bonnie Earl of Moray' (Earl of Moray, Darnaway Castle) [36] as it lay in state in 1591 with all the ghastly wounds of Huntly's vengeance meticulously depicted. The formal qualities of this picture are superior in energy and realism to the contemporary English costume-piece, and it remains also an effective reminder of how little we know of the painting of this period. Something about the facture suggests the work of a professional herald painter.

PART TWO

PAINTING UNDER THE STUARTS, UP TO THE REVOLUTION OF 1688

CHAPTER 4

THE PRECURSORS OF VAN DYCK

The beginnings of a change of style in portraiture – away from the Elizabethan 'costume-piece' and in the direction of contemporary practice in the Courts of Northern Europe – are hardly to be discerned until the year 1617, some fourteen years after the accession of James I. The hundred years which follow can properly be considered as a single unit by the historian of art, and can conveniently be described as 'the age of the Stuarts', although the period ends rather with the death of Sir Godfrey Kneller in 1723 than with the passing of the Stuart dynasty in 1714 with the death of Queen Anne. The painting of this age falls naturally into four subdivisions: the precursors of Van Dyck, the age of Van Dyck and Dobson, the age of Lely, and the age of Kneller. It will make for clarity if they are treated separately.

The Precursors of Van Dyck

Three painters from the Low Countries, all trained abroad, make their appearance in Court circles in England nearly simultaneously, in 1617 and 1618: Paul van Somer, Abraham van Blijenberch, and Daniel Mytens. The year 1618 also marks the beginnings, in so far as present knowledge goes, of the finest British-born portrait painter of the generation before Van Dyck – Cornelius Johnson. The boundaries between the work of Mytens and the work of

Johnson are still imperfectly defined, and the style of all these painters seems to depend on the contemporary school of portraiture at The Hague, which centres round the personality of Mierevelt (1567–1641).

Paul van Somer (Paulus van Someren)

Van Somer is perhaps a little more archaic in style than the other painters named when we first meet his certain work in 1617. But, by 1620, he is abreast of Mytens and Johnson. So little is known of him that extreme caution must replace the rather reckless use which has been made of his name in the past. He was born in Antwerp about 1577/8: in 1604 Van Mander mentions him as working at Amsterdam with his elder brother, Bernard, with a reputation both as a portrait and as a history painter: in 1612 and 1614 he was living at Leyden: he is recorded in passing at The Hague in 1615 and at Brussels in 1616, and he had settled in London by December 1616.[1] He was buried at St Martin in the Fields on 5 January 1621/2. His working life in England amounts, therefore, to little more than five years, but he seems to have been employed by the Crown almost at once. The huge full-length representing 'Queen Anne of Denmark' [37], with a horse, a Negro groom, five Italian greyhounds, and a view of one of the royal palaces (believed to be Oatlands), is fully

37. Paul van Somer: Queen Anne of Denmark, 1617.
Royal Collection (by gracious permission of Her Majesty the Queen)

signed and dated 1617. Although the painting of the face is only a little freer than the painting of the Gheeraerts and de Critz group of portraits, the general air and grandiose arrangement of the picture suggest something of a more European world, and the ribbon which floats in the sky bears the Italian legend *La mia grandezza dal eccelso* (perhaps an assertion of ˙Divine Right). Paul van Somer could conceivably have studied in Italy – as his brother is known to have done – but no close parallel to this fashion of portrait has yet been noticed. In the Royal Collection is also a battered 'Third Earl of Pembroke' signed and dated 1617.

A respectable tradition gives to Van Somer four head-size portraits of 'Elizabeth Countess of Exeter' and her three daughters, once in the possession of the Marquess of Ailesbury, which bear either the date 1618 or a picture of the famous comet of that year; and two half-lengths, signed and dated 1619, also formerly in the same collection – the 'Second Earl of Devonshire with his Son' and the 'Countess of Devonshire with her Daughter', which are entirely harmonious in style with the 'Anne of Denmark'. They are very close to the work of Mytens, but stand a little more limply and with less physical assurance. In the same years he is recorded in documents as working for the Earl of Rutland and the Earl of Dorset, and, for the years 1619 to 1621, there are records of official payments for portraits of the King, the Queen, Prince Charles, and for a copy of a portrait of Prince Henry (d. 1612).[2] A single signed and dated portrait reveals to us his later style, 'Thomas, Lord Windsor' 1620 (Earl of Plymouth), a finely drawn and painted head, a little more tender in its interpretation of character than Mytens, and a little broader in handling than the contemporary early work of Johnson. A very handsome full-length 'Countess of Oxford' of *c.* 1621 (Marquess of Ailesbury; in deposit at Deene Park) is also inscribed as by Van Somer. Cleaning and opportunities for throwing a strong light on to dark pictures will probably round off our knowledge of Van Somer.

The same is hardly to be anticipated for Abraham van Blijenberch, of whom our knowledge is extremely scanty. From documents we know that he was taking pupils at Antwerp in 1621/2, and we can feel reasonably confident that he paid a short visit to England, probably about 1618. This is to be deduced from the facts that he painted a portrait of Charles, Prince of Wales,[3] and that his portrait of 'Robert Ker, Earl of Ancrum' (Marquess of Lothian) is dated 1618. His other known portrait of an English sitter, the signed half-length of 'William, third Earl of Pembroke' (Earl of Powis), shows him to have been the hardly distinguishable peer of Mytens or Van Somer of about 1618.

Daniel Mytens

The career of Mytens was prolonged in England until after the final arrival of Van Dyck and brings us into contact with the chief patrons of the arts in the golden age of collecting: Thomas Howard, Earl of Arundel, King Charles I, and, in a lesser measure, George Villiers, Duke of Buckingham. At this time in England (and perhaps at no other) collecting and the patronage of the living painter went hand in hand. The artistic programme of Charles I, which he may be said to have taken over from the Earl of Arundel, was to align and marry the tradition of art in Britain to the European tradition. In this he succeeded and British painting has never been the same again. But the first inspirer of this aim was Lord Arundel and he was more or less directly responsible for introducing into England the three artists who most contributed to this end: Mytens, Inigo Jones (in architecture), and Van Dyck. Mytens is by far the least of these, but he is not an inconsiderable figure.

Daniel Mytens[4] was born at Delft; in 1610 he matriculated in the Guild at The Hague, which leads to the plausible suppositions that he was a pupil of Mierevelt and was born about 1590; he was still at The Hague in 1612, when he

made his first marriage; he is next documented in August 1618, when he writes to Sir Dudley Carleton from London in excellent English and is described in a letter from Carleton to Arundel as 'your Lordship's painter'; in 1618 he had not yet succeeded in doing a portrait of Prince Charles, but he seems to have been introduced to James I about 1619, and official payments for portraits ordered by the Crown begin in May 1620 (a payment for the portrait of the 'Earl of Nottingham' now at Greenwich); on Van Somer's death he succeeded as Court portrait painter, and payments for portraits of James I and Prince Charles begin in 1623 (presumably, therefore, painted in 1622). He was more particularly favoured by the Prince (perhaps through Arundel's influence), but was granted a pension of £50 a year for life by James I on 19 July 1624 'on condition that he do not depart from the realm without a warrant from the King or the Council', which clearly reflects the royal misgivings over Van Dyck's departure after his abortive visit in 1620/1. On 22 August 1624 Mytens was made a denizen 'by direction of the Prince', and the same month he was granted the lease of a house in St Martin's Lane, also by the Prince's directions: this lease was enrolled on 30 December 1624 through Sir Henry Hobart, Prince Charles's Chancellor (d. 1625), who had sat to Mytens for his portrait on 22 December 1624.[5] King James died in March 1625 and on 30 May 1625 Charles I appointed Mytens 'One of our picture drawers of our Chamber in ordinarie': on 8 August 1626 there appears among the Acts of the Privy Council a 'passe for Daniell Mitten, his Majesty's picture drawer, to goe over into the Low Countries and to remaine there for the space of six months'. This must surely have been an inspired journey so that Mytens could re-familiarize himself with the latest fashions in Flemish portraiture, and the work he did on his return shows that he had studied to good advantage. Thereafter payments for royal portraits are continuous until after the arrival of Van Dyck in England in the spring of 1632. Such payments in fact continue until May 1634, but no certain royal portrait by Mytens is known

after 1633. At what date Mytens finally returned to Holland is obscure, but the pass for him to go to the Low Countries 'with his truncks' is dated 12 September 1630, and that for his wife, with three children and two maids and 'to take with them their truncks of apparel &c', is dated 11 May 1631. In 1637 he was living at The Hague acting as one of Lord Arundel's many agents for his collections, and he seems to have died there before 1647. Only four paintings are at present known which date after his departure from England.

There is a bust of the 'Third Earl of Southampton' at Althorp which appears to bear Mytens' genuine signature and the date 1610,[6] and is entirely consonant with the style of Mierevelt. The next pictures which can be ascribed to him with reasonable certainty are

38. Daniel Mytens: Thomas, Earl of Arundel, *c.* 1618. *Arundel Castle, Sussex, on loan from the National Portrait Gallery, London*

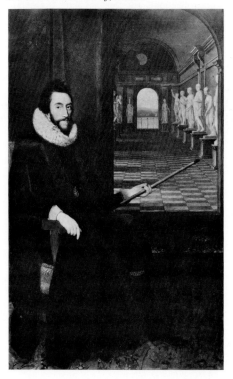

the pair of life-size full-lengths at Arundel Castle of 'Thomas, Earl of Arundel' [38] and his 'Countess', which can, with every probability, be identified with those mentioned as already painted in the letter of 1618. There is still a certain stiffness about the figure of Lord Arundel, but the hands have a quality of flesh and blood which had been lacking in earlier portraiture in England, and there is a certain breadth and 'impressionism' about the painting of the ruff which distinguishes this picture from the meticuluous portraits of bits of lace and linen which had prevailed hitherto. The setting of the portrait also has a precise localization which marks it off from the earlier groups of portraits, for it is in the Sculpture Gallery of Arundel House and shows the first large-scale invasion of the Mediterranean world into England, that collection of Roman sculpture which led Horace Walpole to call Arundel 'the father of *virtù* in England. In the Greenwich portrait of the 'Lord High Admiral the Earl of Nottingham' (paid for in 1620: repetitions at Nostell Priory and in the Nottingham Gallery), the typical Mytens formula is established. The bulk and weight of the man are presented as never before in English portraiture, but character is achieved at the expense of elegance. This last defect (if such it be) is more apparent in the earliest of the portraits of 'Charles, Prince of Wales', that dated 1623 at Hampton Court, in which one feels at once that the sitter is faithfully but not flatteringly represented.

It was in 1623 that Prince Charles and Buckingham made their impulsive visit to Spain to woo the Infanta, which was attended with artistic consequences almost as important as its political consequences were trivial. In Spain Charles came under the influence of Venetian painting of the High Renaissance and, in the Spanish royal portraits from the hand of Titian, Rubens, or the young Velazquez, he saw for the first time what eloquence of authoritative persuasion could reside in a royal image. If Charles's impassioned collecting of 'Old Masters' and the purchase of the great Mantua collection can be directly traced to this experience of the Spanish journey, so too can his search for a painter who

would understand and fulfil his royal needs. Such a painter he finally found in Van Dyck, but he attempted at first to convert Mytens to his purposes. Soon after his accession he made him his painter and sent him to the Low Countries to study the latest fashions in Court portraiture. And the results were rewarding. There is an elegance, where possible also an air of romance, about Mytens' full-length portraits painted in the years immediately after his return from the Low Countries. It has often been said that, in these, he anticipates Van Dyck, but it is more likely that he visited Antwerp and drew his new inspiration from the same springs at which Van Dyck was feeding his more precocious and courtier-like talent. Mytens' most notable works of these years are the 'Duke of Buckingham' 1626 at Euston Hall (repetitions at Milton Park and elsewhere), the 'George, Lord Baltimore' 1627 (private collection) [39], and the wonderful portrait of the 'First Duke of Hamilton' 1629 (Scottish National Portrait Gallery) [40], which is the great masterpiece of pre-Vandyckian portraiture in England.

It does not – as has generally been supposed – seem to have been altogether from Rubens that Mytens derived this new inspiration. In 1625 Rubens had painted that equestrian portrait of Buckingham in the full Baroque style which perished by fire in 1949 with the Earl of Jersey's pictures: the 1626 Mytens of the same sitter has no tincture of this style, but rather a certain Spanish gravity. The 'Lord Baltimore' of 1627 has this in an even more marked degree and is only comparable (allowing for a difference in degree of genius) with the contemporary work of Velazquez. Velazquez is known to have painted a sketch of Charles in Madrid in 1623, which is now lost, and it may well be an echo of this work which accounts for the gravity of 'Lord Baltimore'. There is a payment in 1625 to Mytens for a copy of 'Titian's great Venus', and the profound influence of Charles I's collection of Venetian pictures on those painters who could gain access to it begins to operate from this moment. The 'Duke of Hamilton' of 1629, with its wonderful harmony of silver

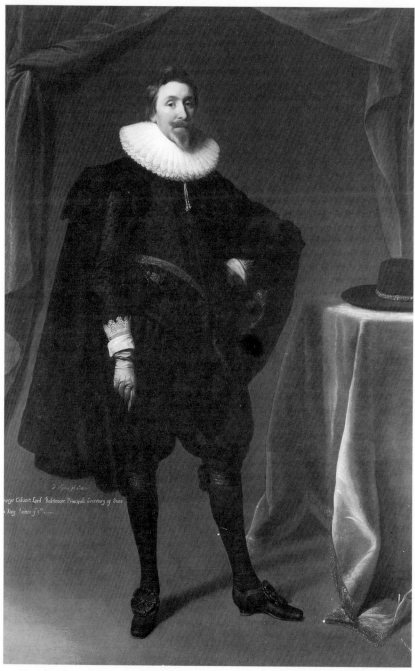

39. Daniel Mytens: George, Lord Baltimore, 1627.
Private collection

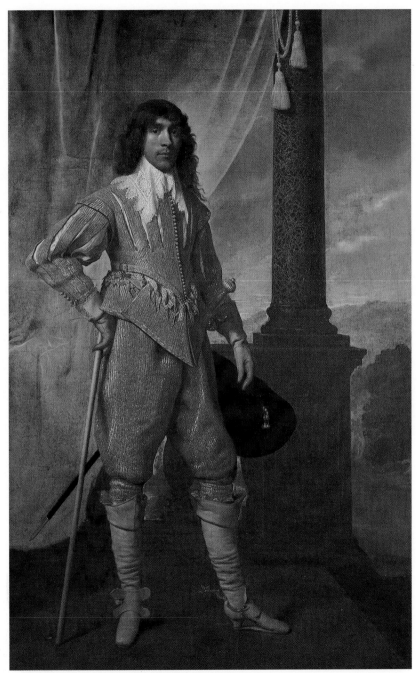

40. Daniel Mytens: First Duke of Hamilton, 1629.
Scottish National Portrait Gallery, Edinburgh

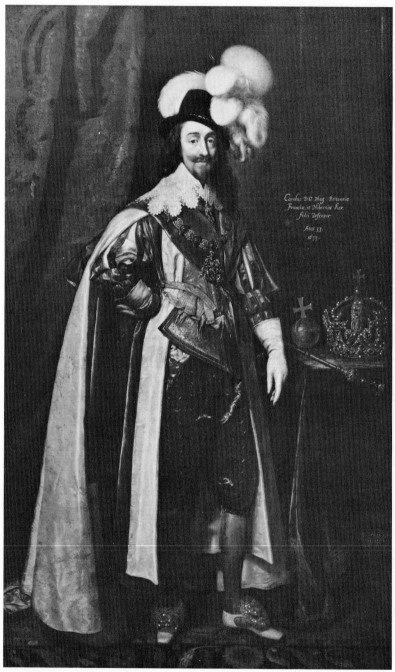

Carolus D G Mag Britannie
Francie, et Hibernie Rex
fidei Defensor

Ætat 33.
1633.

41. Daniel Mytens: Charles I, 1633.
Private collection

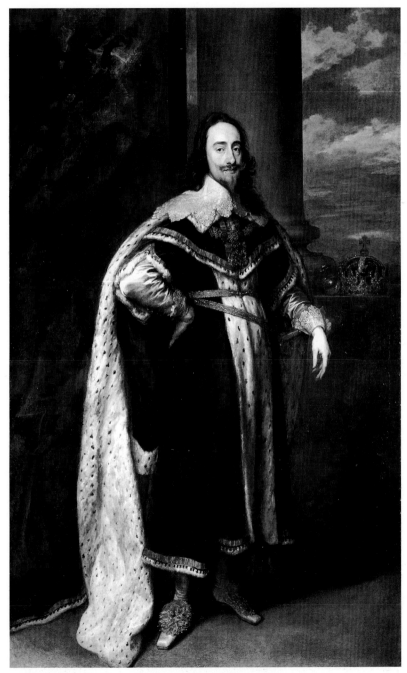

42. Sir Anthony Van Dyck: Charles I in Robes of States, 1636.
Royal Collection (by gracious permission of Her Majesty the Queen)

against a clear, silvery, blue curtain, shows a feeling for colour which was entirely Mytens' own, as well as his power of romantic interpretation with a favourable sitter.

But his time from 1629 onwards was mainly taken up with royal portraits, and the sitters were not favourable to Mytens' genius. What Charles I and Henrietta Maria really looked like it is no longer possible to say, since Van Dyck has transmitted to posterity his 'official' image. But we know that neither was tall or graceful, and it is clear that Mytens' powers of imagination were insufficient to the task of ennobling propaganda. There are three principal types of Mytens' portraits of the King – the type in red (of which there is a signed and dated original of 1629 in New York and a rather hard studio copy of 1631 at Greenwich): the type in grey (of which there is a studio version dated 1631 in the National Portrait Gallery): and the type in Garter Robes (of which there is an original dated 1633 at Milton Park [41] and others at Balcarres and the St Louis Museum). It will be sufficient to compare this last with the 1636 Van Dyck of 'Charles I in Robes of State' [42] to appreciate where the King found Mytens lacking. There are payments also for several Mytens portraits of 'Henrietta Maria with the dwarf Jeffrey Hudson' (a subject which inspired Van Dyck to one of his most triumphant impositions) but no certain example is known.[7]

This factory production of royal portraits is a phenomenon which persists from now onwards, and the difficulty of estimating a painter from such works – even when they are of high quality – has been proved in the case of Mytens. There is a payment in 1630 to Mytens for 'his Majesty's picture at large with a prospect, and the Crown and the Sceptre, in a scarlet embroidered suit', and such a picture (the only one known with a prospect) exists at Chatsworth. It is an exact version otherwise of the signed Mytens type in New York, but the penetrating eye of Sir Oliver Millar[8] noticed that it is signed by Cornelius Johnson and dated 1631. Johnson therefore must have been devilling for Mytens at this date with hardly distinguishable

fidelity, and there are portraits, such as the double bust figures of the King and Queen at Welbeck,[9] before which it is impossible to feel certain which of the two was the painter.

There remain a number of full-length portraits, some of them of real distinction, which cannot be allotted to any of the painters so far named, although they mostly masquerade under the name of one or other of them. Cleaning and research into early accounts may well bring back a number of forgotten painters of this kind to our knowledge, and one such has, in fact, been rediscovered – John Eycke, whose signature, with the date 1630, appears on a full-length of the 'First Lord Fitzwilliam'[10] at Milton Park, where there is also a companion portrait of Lady Fitzwilliam. He may well be the same as 'Mr. Yeekes the picture drawer', who received £4 for a posthumous portrait of Lady Crane in Sir Henry Hobart's accounts for 1 May 1624 (Norfolk Record Society).

Cornelius Johnson (Jonson)

It is in single heads, however, rather than in full-lengths that the beginnings of what may perhaps be called a native British tradition can first be discerned. The first unquestionable master of these is Cornelius Johnson, a British-born subject (since he was baptized in the Dutch Church at Austin Friars on 14 October 1593), although his father had come to London as a refugee from Antwerp and his more distant forebears hailed from Cologne. He has received much praise as an all-British product and as the first to seize (as only an Englishman could) upon that shy and retiring streak in the English temper, whose presence in a portrait is a sure sign of native English art. It would probably be more true to say that he was a painter beautifully sensitive to individual character and wholly without any private national temper, for the portraits he painted in Holland after his retirement from the Civil War in 1643 are as Dutch as his English portraits are English.

We have no clue to his training, which is as likely to have been Dutch as English. It was

certainly not unusual for a young Englishman to be apprenticed in Holland to learn painting in the early years of the seventeenth century.[11] His first signed work, a portrait of an 'Old Lady' dated 1617,[12] looks like a Dutch work and a Dutch sitter. His undoubtedly English work begins in 1619, and we can trace his career year by year, in a succession of signed and dated works,[13] until 1643, when his wife's fears at the outbreak of the Civil War led him to retire to Holland. His pass for leaving the country is dated 10 October 1643 and he settled first at Middelburg. Later he is found working at Amsterdam and at Utrecht, and he died at Utrecht 5 August 1661.[14]

His portraits of 1619/20 mark a new departure in style in England, and it will be well to analyse a typical (if unusually attractive) example, the 'Susanna Temple'[15] [43] dated 1620. It has the air of an Isaac Oliver miniature in large and it may well be that Johnson had learned of a miniaturist (although his own miniatures, which are in oil on copper, hardly begin before 1625). The feigned oval surround, which Johnson sometimes paints as if it were a marble frame in these early works, emphasizes

the oval form, as in a miniature, and the paint has a high enamel and the colours often a bright glossiness which may well derive from the same source. All the resources of the artist are put into the head, and, unlike our view of Mytens, it is by his heads that we remember Johnson. He certainly began by specializing in heads and had already achieved mastery in that form by 1619. The earliest three-quarter-length with hands that has been identified is the earliest of his portraits of Lord Keeper Coventry[16] (a constant patron), dated 1623. In this the hands and pose are still relatively clumsy but, in the 1627 three-quarter-length of the same sitter in Lord Brabourne's collection, he can be seen to have learned from Mytens and even to be copying the Mytens form of hand. By 1631 (as has been noted in the Chatsworth Charles I) he is actually doing an almost indistinguishable copy of a Mytens. He seems to have been rewarded by being sworn 'His Majesty's servant in ye quality of picture maker' on 5 December 1632 (after Van Dyck's arrival, and perhaps to supply the defection of Mytens, who was unwilling to play second fiddle to Van Dyck). Even as early as

43. Cornelius Johnson: Susanna Temple, 1620. *Formerly with Messrs Vicars*

44. Cornelius Johnson: Lady of the Kingsmill Family, 1632. *Parham Park, Sussex*

1632 something of Van Dyck's air has begun to creep into his sitters, as may be seen from the charming 'Lady of the Kingsmill Family' 1632 [44], formerly at Longford Castle and now at Parham. But Johnson, in such pictures, takes from Van Dyck only as much as he can assimilate, and Van Dyck's rhetoric is muted down into a formula adapted to the domestic rather than the public portrait. In these years Johnson's heads have often a lovely silvery tone. In his rare (or rarely identified) full-lengths, which, by what is perhaps more than an accident, are scarcely ever signed, he imitates the patterns and trappings of Van Dyck's portraits more closely and with less of his own particular charm. Fairly certain examples are the portraits (dated 1638 but not signed) of Thomas Earl of Elgin and his Countess at Ranger's House, Blackheath. It seems possible from these that a number of pictures which now pass under the name of Van Dyck or his studio may be from Johnson's hand.

So sensitive was Johnson to the changes of taste and fashion that his latest English works, such as the 'Sir Robert Dormer' 1642 [45] (now

45. Cornelius Johnson: Sir Robert Dormer, 1642. *Private collection*

in Mr C. Cottrell-Dormer's collection), betray a close kinship in style to Dobson. In all these changes of style, except perhaps in that revealed in his first works, Johnson follows rather than initiates a trend in taste, but he retains his liking for the feigned stone oval to the last and he keeps that freshness of approach to his sitter's personality which is his greatest virtue.

English Contemporaries of Johnson

Johnson's technical excellence and high qualities as a draughtsman of a head mark him off from the general level of contemporary work, but vast numbers of portraits exist which belong generically to the same style of portraiture. A very few such pictures bear signatures and it is possible from some of these for the first time to get a glimpse of the activity of painters working outside London. A single portrait of an 'Unknown Man' 1636 in a Welsh collection[17] is signed by an equally unknown Edward Bellin: the full-length of Lord Keeper Williams in the muniment room of Westminster Abbey is dated 1624 and signed 'J.C.', and this painter might be the same as the 'J. Carleton 1635' whose name is traditionally attached[18] to three heads of members of the Danby family formerly at Swinton Park, which suggests a provincial Cornelius Johnson. In the possession of Mrs Vaughan Morgan in London (1938) was a portrait of a lady signed 'T. Jones fecit' and dated 1628. Two portraits have been published[19] which bear the letters IO in monogram and are dated 1637 and 1641: these may well be by the same hand, and the signature not an attempt at clumsily forging the signature of Isaac Oliver (d. 1617), but the suggested identification with John Osborne, the English craftsman in whalebone and horn who settled in Amsterdam, is sufficiently improbable.

As further evidence for what little is known of the lesser painters of this period a few disembodied names may be listed: amongst the Naworth Castle accounts[20] portraits are mentioned by one Heskett in 1621 and by Charles Barker in 1629 and 1633 – these latter were

certainly painted on the spot; Evelyn's *Diary* under 1626 records that his picture was 'drawn in oil' at his father's house at Lewes 'by Chanterell, no ill painter'; and a list of such names could presumably be very considerably extended.

More interesting than any of these are two contemporaries of Johnson who are each mainly familiar to us by a more ambitious work: John Souch and David des Granges. John Souch was a Chester painter. In 1616/17 he is recorded in the Roll of Freemen of the City of Chester as prentice to Randle Holme, the herald painter

who was Deputy of the Office of Arms, and he himself received a prentice at Chester in 1636.[21] A signed portrait by him of a Cheshire sitter is now in the Tate Gallery, but his chief surviving work is the remarkable group of 'Sir Thomas Aston at the Deathbed of his First Wife' 1635 (Manchester) [46].[22] This is obviously, in many ways, the work of a herald painter. The figures are treated more or less as symbols and are not arranged in a grouping at all closely imitated from nature: the first Lady Aston appears, in an altogether medieval way, both as a living portrait and as dead in the same picture. But the

46. John Souch: Sir Thomas Aston at the Deathbed of his First Wife, 1635.
Manchester City Art Gallery

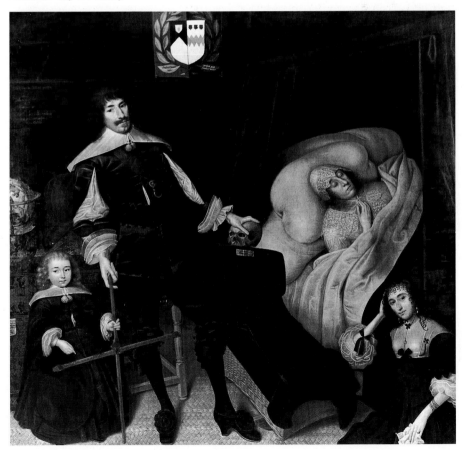

heads are clearly studied from the model and are treated in the same spirit as Johnson treats his heads.

David des Granges is relatively well known as a miniature painter of secondary importance. His family came from Guernsey, but he himself was born in London either in 1611 or 1613[23] and survived until the 1670s. A portrait on the scale of life, in style like an inferior Johnson from the 1630s, is at Wemyss Castle, and another life-size (49 by 40 in.) portrait of a 'Lady and Child', dated 1661, was in the sale at Mottisfont Abbey in 1933. But his one memorable picture can be precisely dated to 1637 or 1639,[24] the group of the 'Family of Sir Richard Saltonstall' [47] and his second wife taken at the time of the birth of one of his last two children. This was formerly at Wroxton Abbey, where it traditionally bore an attribution to des Granges, and was acquired in 1933 by Sir Kenneth Clark.

It is gay in colour – salmon and silver are the prevailing notes – and tender and domestic in interpretation, the only thing of its kind at present known to rival Johnson in those endearing qualities of interpretation for which he is most justly admired. It is now in the Tate Gallery.

The closest in style of all these minor painters to Johnson, though far beneath him in gifts, was Gilbert Jackson, whose active career can be traced from 1622 to 1640.[25] About twenty signed and dated portraits by him have been found and others can often be recognized by his liking for dresses of strong grass green (often with garish vermilion bows) and a way of painting lace which makes it look as though soaked in water. He is less addicted than Johnson to the painted oval and altogether inferior in drawing. Although based on London it seems possible, from the distribution of certain groups of

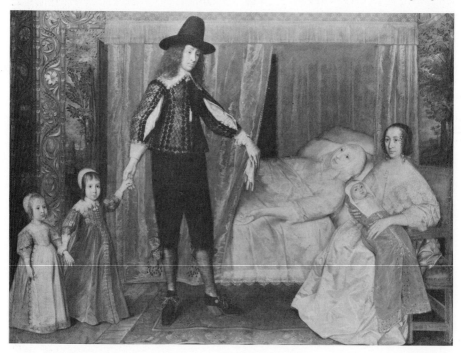

47. David des Granges:
The Family of Sir Richard Saltonstall, 1637 or 1639.
London, Tate Gallery

portraits by him, that he travelled the country and settled in various districts for months at a time – Wales in 1631/2 and Oxford in 1634/5.

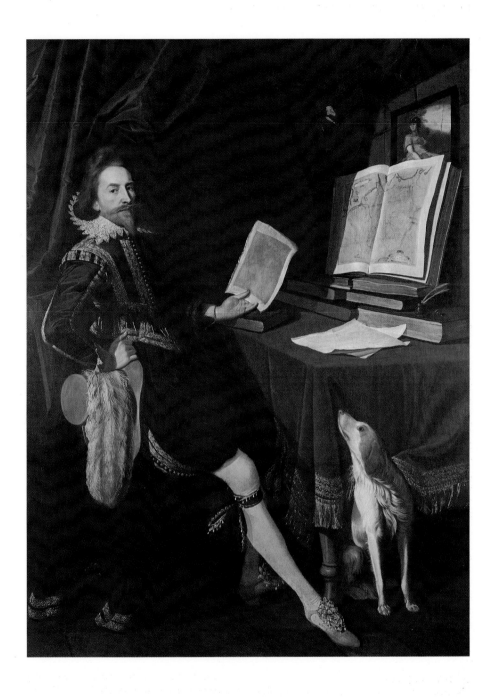

48. Sir Nathaniel Bacon: Selfportrait. *Earl of Verulam, Gorhambury, Herts*

His most important portrait is the 'Lord Keeper Williams' 1625 at St John's College, Cambridge. Very close also to Johnson in many ways is George Jamesone, who must be considered under painting in Scotland.

Sir Nathaniel Bacon

The only truly native English painter of real distinction of the generation before Van Dyck was an amateur, Sir Nathaniel Bacon. He was born in August 1585 and was buried at Culford on 1 July 1627. He painted only for his own family and his works had no influence on his contemporaries, and four of the half-dozen paintings which survive are portraits of himself. By far the most remarkable is the full-length at Gorhambury [48], which shows the gifted amateur in his study (rather than his studio) and reveals an interest in painting accessories and still life that is repeated in 'The Cookmaid' in the same collection. He also painted, in a miniature on copper, the first British landscape (Ashmolean, Oxford), which is a curiosity rather than a work of art, and records survive of classical subjects. The portrait at Gorhambury (c. 1620) reveals some study abroad, and the silver-grey and lemon colouring of parts of it indicate Utrecht as the source, and probably Terbrugghen as the painter who inspired it.

Foreign Painters contemporary with Johnson

Foreign visitors among the portrait painters are less numerous than might have been expected. An attractive painter, otherwise unknown, signed a picture of 'Lord William Russell and his Dwarf' 1627 at Woburn Abbey as 'Johannes Priwizer de Hungaria'; in 1628 Gerrit Honthorst was in England for some months, apparently on trial as official Court portrait painter, for he was made a denizen on 28 November 1628 and granted a pension for life as 'the King's servant', but he returned to Holland in December 1628 after painting a few portraits such as the 'Duke of Buckingham and Family' (Buckingham

Palace) and the large composition for Hampton Court. Hendrik Pot painted Charles I (Louvre) in London in 1631, and a number of well-known painters were in London for short periods: Sandrart (1627), Hannemann (1626–c. 1637), Ter Borch (1635), Lievens, etc.; but nothing is known of their work in England. Sir Balthasar Gerbier[26] (1592–1667) may have painted a few portraits, but was chiefly occupied with other business; Nicholas Lanier (1588–1666), whose interesting 'Selfportrait' is in the Examination Schools at Oxford, was mainly a Court musician and agent for picture collecting; George Geldorp, who came to England about the time of Charles I's accession, is documented as the painter of two admirably prosaic full-lengths of the second Earl of Salisbury and his Countess at Hatfield,[27] but he seems soon to have developed into an artistic impresario, dealer, and pimp, and, although he survived the Restoration and was mixed up with art and artists all his life, there is little evidence that he did much painting himself – he died in 1665. There is finally Cornelius de Neve (who has been wrongly confused with other Neves or de Neves working in the 1640s or 1650s), by whom there is a portrait signed and dated 1626 (National Portrait Gallery, no. 1346) and a double full-length of Lord Buckhurst and his brother of 1637 at Knole: the former of these may well have been painted in Holland and is typical of the Hague school.

Painting other than Portraiture

In the Low Countries the first quarter of the seventeenth century saw the birth of an immensely rich and various school of landscape painting, but there was nothing comparable in England. The very word 'landscape' was a Dutch importation into England in this century for something which had to be imported from abroad. A few views of British scenes exist, however, pretty certainly by Flemish workmen, in the tradition of topographical draughtsmanship. Among the most notable are a pair of views of the river at Richmond in the Fitzwilliam

Museum, Cambridge, which were ascribed in the eighteenth century to the Antwerp painter, David Vinckeboons, but which bear no resemblance to his signed works. These perhaps date from the 1620s, and there are similar views of Pontefract Castle in the Royal Collection and in Wakefield Art Gallery. Clearly dated 1630 is the handsome view of 'Old London Bridge' at Kenwood signed by Claude de Jongh (d. 1663), and another such view is said to be dated 1650.[28] The Antwerp painter Alexander Keirincx (1600–52: in England called 'Carings') was in the employ of Charles I and is documented in England in 1640/1: he practised the style of landscape created by Van Coninxloo, which very rarely bore much relation to natural scenes; and another Antwerp painter, Adriaen van Stalbemt (1580–1662), was in England in 1633 and signed (together with J. van Belcam) a 'View of Greenwich Park' (Windsor) with small figures of Charles I and his Court. 'The River Thames from above Greenwich' [49] is also the

ative panels, as in the heads of the Prophets and Sibyls at Chastleton House, which perhaps date about the middle of the reign of James I. Sir Nathaniel Bacon, no doubt imitating his foreign models, is said to have painted pictures of Ceres and Hercules and the Hydra, but the only northern artist who can seriously be mentioned in this connexion is Francis Cleyn.

Cleyn was born at Rostock in 1582 and spent some years studying in Rome and Venice, where he absorbed impartially most of the prevailing styles. He then became Court painter to Christian IV of Denmark and a number of historical paintings from his hand survive in the various Danish royal palaces.[29] He settled in England in 1625 and became chief designer for the Mortlake tapestry works, which supplied the equivalent of historical paintings for the royal palaces. His most remarkable designs, which were executed in tapestry, are the 'Hero and Leander' series of which the finest examples survive in the Swedish State collections, but he

49. Unknown: The River Thames from above Greenwich, c. 1635. *London Museum*

subject of the solitary landscape worthy of the name which can be allotted to these years. It is now in the London Museum and can be dated about 1635. It is painted in the broad panoramic style of Hollar's etchings, and, if we knew that Hollar ever practised in oil, an attribution to him would hardly be wide of the mark.

Figure subjects are even rarer. There is occasional evidence that country workmen still used some of the old Catholic repertory (except for the persons of the Gospel story) in decor-

seems also to have turned his hand to paintings and some of the unattached full-length portraits may prove to be from his hand. On the strength of his work in Denmark one may accept Dr Margaret Whinney's attribution to him of the three canvases from the 'Story of Perseus' let into the ceiling of the Double Cube Room at Wilton.[30] This seems to have been set in place after 1654. Cleyn was buried in the church of St Paul's, Covent Garden, on 23 March 1657/8.

Italy, however, was the great seat of historical painting and Charles I succeeded (after a failure with Guercino) in persuading one Italian painter of distinction to settle in England: Orazio Gentileschi. Gentileschi came to London in 1626 and died there in 1639. Two of his easel pictures survive at Hampton Court, and the ceiling of the hall at Marlborough House is pretty certainly that which he painted for the Queen's House at Greenwich. Yet another of the pictures of his London period may be the handsome 'Rest on the Flight' in the Birmingham Gallery.

Painting in Scotland

A considerable number of portraits survive in Scottish collections, dating from about 1620 onwards, which were assuredly painted in the Northern Kingdom. The chief name which can confidently be associated with many of them before the middle of the century is that of George Jamesone.[31] Jamesone is an almost exact Scottish counterpart to Cornelius Johnson, although he was neither so sensitive a draughtsman nor so perceptive an observer of character. He is also particularly difficult to judge today, since the medium with which he painted was usually so frail that most of his surviving portraits are mere travesties of what they once were. One of the very few which can still give some impression of his style is the 'Marquess of Montrose' 1629 [50] at Kinnaird Castle, and Jamesone's surviving works are all of more or less the same character – except for a late and battered 'Selfportrait' (Countess of Seafield) which shows the painter in his studio with pictures ranged upon the walls, which include a sea piece and a large mythology. Apart from this we have no evidence that he painted such things.

Jamesone was born about 1590 and came from Aberdeen: on 27 May 1612 he was apprenticed to one John Anderson at Edinburgh, who is otherwise unknown. About 1619/20 he was working on his own in Aberdeen in a style akin to that of Johnson. He came to Edinburgh in

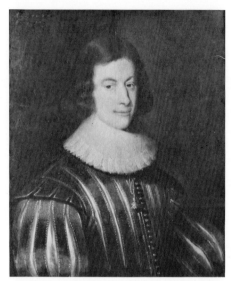

50. George Jamesone: The Marquess of Montrose, 1629. *Private collection*

1633, on the occasion of the visit of Charles I, and settled there. From 1634 he worked mainly at Edinburgh, or travelled round Scotland, and he died at Edinburgh late in 1644.

Jamesone is only certainly known from busts or half-length portraits and there is no convincing evidence that any of the whole-lengths which are ascribed to him are from his hand. The 'Erskine' portrait in the Edinburgh Gallery is too damaged for judgement, and the 'Lord Spynie' at Balcarres is by a different and perhaps superior hand. Nearly all Scottish portraits of this period tend to be ascribed to him, but it is better to withhold judgement in the present state of knowledge, and some of the most distinguished portraits which bear his name (such as the 'Earl of Melrose' – later first Earl of Haddington – of 1624 at Tyninghame) seem to be by a more competent painter trained in the Miereveld tradition. Dr Duncan Thomson has identified him as Adam de Colone (for whose parents see p. 48), who was working in both London and Edinburgh between 1622 and 1628. The 1628 'Third Earl of Winton and Two Sons' (Earl of Kintore) is documented in a

diary as by 'Adáme', and in 1623 he produced a new full-length pattern for 'James I and VI', which shows him as a Scottish variant of Mytens. Specimens of this design are to be seen at Hatfield and at Newbattle Abbey in Midlothian.[32]

On the evidence of a portrait in the Edinburgh Gallery which is alleged, on very slender evidence, to be a 'Selfportrait' by a painter named Scougal, a fourth Scottish painter of this name has found his way into the literature. This is a picture in the Mytens tradition of the 1630s or early 1640s, but there is no documentary evidence for a painter of the name of Scougal until the second half of the seventeenth century – nor has any other picture of this period been met with in Scotland which seems to be by the same hand.

THE AGE OF VAN DYCK AND DOBSON

The dominant figure in Northern Baroque art is Rubens, and England was not exempt from his pervasive influence. He had painted the Earl of Arundel first in 1620 and the Duke of Buckingham (in Paris) in 1625, and he was already something of a legend in English Court circles by the time of Charles I's accession. Toby Matthew, writing from Brussels to Sir Dudley Carleton as early as 1620, says, 'his demands are like ye Lawes of Medes and Persians', and it seems possible that he was already marked out as the painter of the ceiling of the Banqueting Hall at Whitehall (the building of which was finished in March 1622) as early as 1621. He finally visited England, on a diplomatic mission, from 5 June 1629 to 6 March 1630. During these months he was as much fêted as an artist as he was as a diplomat and Charles I knighted him on 21 February 1630. During this stay he painted the picture of 'St George' (Buckingham Palace) in which Charles I appears as St George and Henrietta Maria as the Princess and the background is a view of London. He also presumably made final arrangements on this occasion for the ceiling of the Banqueting Hall, of which the separate elements were painted on canvas at Brussels and were completed by 1634. They finally reached London in December 1635 and were installed in the ceiling in March 1636.

The ceiling of the Banqueting Hall is the one full Baroque painted decoration in England, and, although it has remained *in situ* up to the present century, it has never received the attention that it deserves.[1] Recent opportunity for close examination shows that a considerable number of the major figures are executed by Rubens himself, and the whole invention gives proof of prodigious vitality and decorative power. But it was set in place at a time when the shadow of the coming Civil War was already beginning to obliterate all thoughts of grandiose projects, and it has remained the least fruitful

and the least studied of the surviving great works inspired by the patronage of Charles I.

Sir Anthony Van Dyck

It is with Van Dyck that the name and fame of Charles I and the glamour of the Royalist cause are indelibly bound up. We are perhaps no longer able to judge dispassionately today how much the common verdict of men, and even 'the judgement of history', on Charles I and his times owe to the poet and magician whose name was Van Dyck. The extraordinary treatment which he received from the King makes it clear that his value as a propagandist in the cause of absolutism was fully appreciated, and he was treated, as no painter had been before, by the high aristocracy of England as an equal.[2] A weighty element in the secret of the style of his English portraits – a style which has no real parallel in British painting until the time of Lawrence – is that he painted his sitters, in all the fabulous glamour of Cavalier costume, as an equal.

The details of Van Dyck's development as an artist are no part of the history of British painting. He reached England fully formed. But his influence has been so immense that, as was the case with Holbein, we must not omit him (as has been usual), but treat him as an integral part of the tradition of British painting and seek to analyse his character as an artist. Much detailed study has been made of his earlier work, but a proper study of the portraits he painted in England is still a desideratum[3] and no attempt can be made here to fill the gap.

Van Dyck was born at Antwerp on 22 March 1599 to a prosperous middle-class family. He was an infant prodigy and was apprenticed to Van Balen when he was eleven; before he was nineteen, in 1618, he was entered in the Antwerp

Guild as a Master. By that date he had absorbed, with mystifying precocity, everything which the flourishing contemporary Antwerp school could teach and he was in a fair way to rivalling Rubens himself, on whose style his own was formed. His heart was perhaps always in Antwerp, but one city could not sustain two such fertile geniuses at the same time, and we no doubt owe it to this fact that he was latterly willing to settle in London.

On the instigation of the Earl of Arundel, Van Dyck paid a visit of a few months to London at the end of 1620, and he definitely entered the service of James I. In February 1621 he left London, with leave of absence from the King for eight months, to go and perfect himself in Italy – and he then defaulted from the royal service. It remains obscure what works of painting he executed on this first visit to London:[4] for his subsequent history they were certainly unimportant. What is certain is that he spent at least the eight months of his leave working in Antwerp and we find him for certain in Italy by the latter part of 1622. In Italy he remained until 1627, travelling much, but lingering longest at Genoa and Rome. He was back in Antwerp by the end of 1627 in full command of all the knowledge and experience, both social and pictorial, which went to the formation of his English style when he finally settled in London about the beginning of April 1632.

Italy, and above all the study of the works of Titian, had given Van Dyck's style an additional tincture of southern mellowness and refinement which he could not have got from Rubens. The contrast in temperament between Rubens and Van Dyck was a contrast between Rubens' robustness, his sense of abounding life and energy, and Van Dyck's sensibility and awareness of the whole repertory of formal reticence in aristocratic life. This knowledge Van Dyck used in his Genoese portraits, but he found little scope for its exercise when he painted the Antwerp artists and *bourgeoisie* on his return from Italy. Only when he came to England did it emerge again as an essential element in his portrait style, and it is founded to a large extent

on the pattern and practice of Titian, the detailed study of whose works is so clearly proved by Van Dyck's Italian sketch-book at Chatsworth. The sombreness of Italian costume and the rarity of Titian full-lengths make Titian a model more often for the spirit than for the detail of Van Dyck's English portraits, but where a specially heroic invention was required, as in the 'Strafford with the Dog' or 'Strafford and his Secretary' (both at Milton Park), Van Dyck took the whole pattern from Titian (the Prado 'Charles V' and the group absurdly called in England in the seventeenth century 'Duke Cosimo and Machiavelli').[5]

On Van Dyck's arrival in London his defection to James I was at once forgiven and he was treated by Charles with extraordinary favour. A house was provided for him in Blackfriars (i.e. outside the liberties of the City of London and thus outside the jurisdiction of the Painter-Stainers Company). Before July 1632 he was appointed 'principalle Paynter in ordinary to their Majesties' with a pension of £200 a year; he was knighted on 5 July 1632; he was given by the King a gold chain and medal on 20 April 1633; and the King and Queen frequently made personal visits to his studio. He became a denizen in 1638, and the King attempted to secure his permanent residence in England by finally arranging, in 1639/40, his marriage to an English lady of noble origin. No artist had received such favours before.

Van Dyck died in London on 9 December 1641. Even during his official residence in England he had spent some time abroad. He was away a whole year in Antwerp from early in 1634, and he made visits of some months to Antwerp and to Paris in 1640 and 1641. His whole active career in England lasted for less than eight years and his activity during that time must have been almost incessant, even though his patrons were limited to the royal family and to the immediate circle of the Court. In his English portraits he created – or brought to light by sensitive observation – a new world which has imposed its authority on the imagination of Europe. How much, we must ask, of this world had an objective existence? For it is often

held against Van Dyck that he falsified the truth of appearances and hopelessly corrupted an honest British tradition in portraiture which was beginning to be formed.

Van Dyck's Portraits of the Royal Family

Such an inquiry may best begin by considering the portraits of Charles I and Henrietta Maria, for evidence on whose features (at any rate on the King's) we have ample comparative material by other artists. It was for the painting of royal portraits that Van Dyck was encouraged to come to England, they were his principal task during his first few years in London, and it was because of their success that the King made much of him. A number of Privy Seal Warrants[6] survive for payments to Van Dyck for specific work, and there is a bill from Van Dyck, which

must date from 1638, for work done and not then paid for. From these it appears that, in the first four months of his residence in London (by 8 August 1632), Van Dyck had completed: portraits of the King and Queen separately; the group (now at Buckingham Palace, but falsified by later enlargements) of the King, Queen, Prince Charles, and Princess Mary; four portraits (presumably repetitions from stock) of the Archduchess and members of the House of Orange; a companion Emperor to the series of Titian emperors from Mantua; and repaired one of the Titians. Another nine portraits of King and Queen were completed before May 1633 and these may well not include the equestrian portrait with M. de Saint-Antoine (at Buckingham Palace) which is dated 1633. These nine portraits came to £444 and by February 1636/7 there is a payment of £1200 for additional pictures, one of which was no

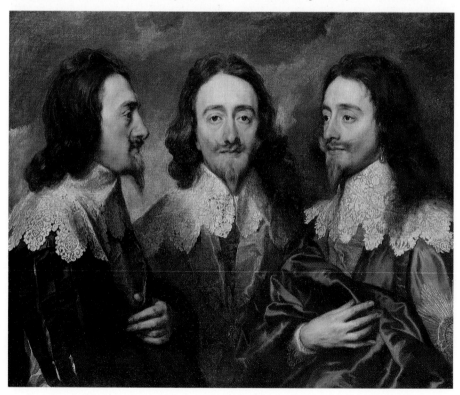

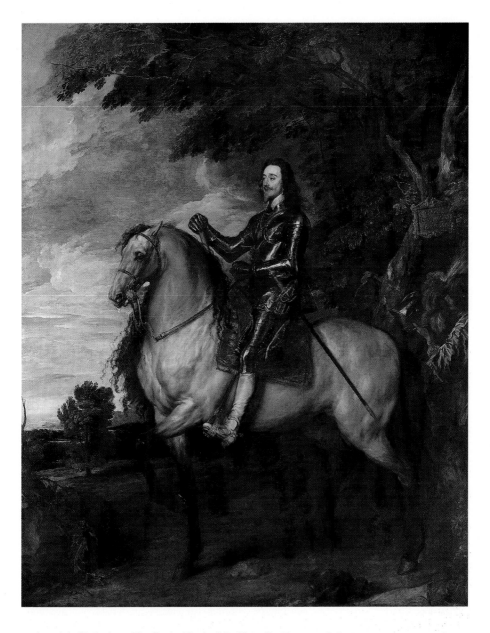

51 (*opposite*). Sir Anthony Van Dyck: Charles I in Three Positions, *c.* 1636.
Royal Collection (by gracious permission of Her Majesty the Queen)

52 (*above*). Sir Anthony Van Dyck: Charles I on Horseback.
London, National Gallery

doubt the King in Garter robes at Windsor, dated 1636, and another the group of the three elder children (Windsor). Finally, we have the bill of 1638 which itemizes twenty-two portraits, including the splendid 'Charles I with Groom and Horse' (Louvre) and the group of the five children at Windsor. With such a series of Van Dycks judiciously distributed to friendly royalty abroad and to loyal supporters at home, it is not surprising that the King never, of his own free choice, sat seriously to another painter after Van Dyck's death.

As far as truth of feature goes Van Dyck's portraits of the King are in sufficiently faithful agreement with those of him by Mytens and Johnson. In the most exacting of all, the view of the King's head in three positions [51], painted about 1636, to be sent to Bernini in Rome to enable the sculptor to make a bust of the King, Van Dyck comes off triumphantly. It is in the full-length portraits and in the use of Baroque accessories that Van Dyck's gifts of elegant interpretation (and thus, by implication, of 'falsification') appear. Neither the King nor the Queen was tall and perhaps neither was altogether graceful, and Van Dyck certainly slides over these difficulties. We may allow the last word on this point to be with Sophia of Bavaria (later the Electress of Hanover), who saw the Queen when she came to Holland in 1641 and wrote: 'Van Dyck's handsome portraits had given me so fine an idea of the beauty of all English ladies, that I was surprised to find that the Queen, who looked so fine in painting, was a small woman raised up on her chair, with long skinny arms and teeth like defence works projecting from her mouth. . . .'

Van Dyck also added new overtones of authority to the most grandiose of his portraits of the King, of which perhaps the noblest is the 'Charles I on Horseback' in the National Gallery [52]. This is perhaps inspired by the equestrian 'Charles V' by Titian and the implications of the equestrian portrait (a novelty in English royal iconography) were all with the commanders of victorious armies. The King was no doubt as much responsible for this absolutist element as was Van Dyck, but it is in

such pictures that we find, for the last time for a century, painting done in England fully in line with the most advanced contemporary European tradition.

Van Dyck's Portraits of the Court

It was not, however, his royal portraits but his portraits of the British aristocracy which left such a profound bias on the direction of British taste. The revolution which Van Dyck effected can best be appreciated by the form in which the theory of portraiture was canonized in the early eighteenth century by Jonathan Richardson: 'a good portrait, from whence we conceive a better opinion of the beauty, good sense, breeding and other good qualities of the person than from seeing themselves, and yet without being able to say in what particular it is unlike; for nature must be ever in view'. We can perhaps go a little further than Jonathan Richardson in analysing in what particulars Van Dyck's portraits are unlike.

It is not for nothing that Waller speaks of Van Dyck's studio as a 'shop of beauty'. The beauty specialist is concerned with studying the temperament of the individual and advising how that can best be exploited along the lines of prevailing taste. Van Dyck had precisely this sensibility, which he directed not only towards individuals but towards nations and classes of society. It is usually possible at a glance to guess whether a portrait by Van Dyck represents a Genoese nobleman, a burgher of Antwerp, or a member of one of the princely houses of northern Europe. Given the national temper and the national costume, he devised a series of patterns appropriate to these various classes. The individual appears only in the features of the face, which Van Dyck studied and drew with meticulous fidelity. A certain absence of strong character was presumably not uncommon at the Court, but Van Dyck was equal to interpreting a strong character in a woman, such as the 'Frances, Marchioness of Hertford' at Syon House [53], or a thoroughly unpleasant one, such as the 'Lady Castlehaven' at Wilton

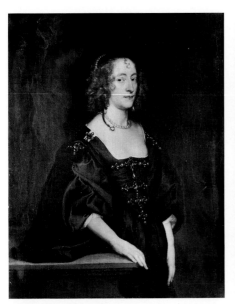

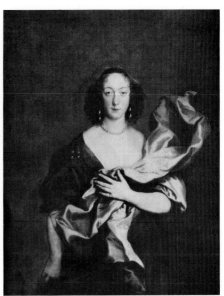

53. Sir Anthony Van Dyck:
Frances, Marchioness of Hertford.
Duke of Northumberland,
Syon House (Copyright Country Life)

54. Sir Anthony Van Dyck:
Lady Castlehaven.
Earl of Pembroke and Montgomery,
Wilton, Wilts

[54]. For each shade of character he adopted an appropriate technique and no great painter has shown a greater variety of handling in his heads. He rearranged the standard trappings of the Baroque portrait, the damask curtain, the pillar, or the truncated column, with corresponding sensibility, and, on the rare occasions when he painted a poet rather than an aristocrat – as in the 'Killigrew and (?)Lord Crofts' at Windsor [55] – he prescribed for himself a different kind of pattern. It is needless to add that these personal subtleties escaped his countless imitators. But his poses, his hands, and his dresses became the fashion-plates of the contemporary artist, and an important source for their wide circulation was the series of etchings by Hollar published in 1640 as 'Ornatus muliebris anglicanus', a number of which echo (with a great loss in elegance) some of the poses of Van Dyck's portraits.

Van Dyck's Work apart from Portraiture

On the information of Sir Kenelm Digby, Bellori (1672, pp. 261-2) gives a list of religious and mythological paintings executed by Van Dyck for British patrons during his English period. Of these little or nothing survives, but a 'Cupid and Psyche' (which is not mentioned by Bellori) remains at Windsor. As with most great artists whose living is perforce gained mainly from portraiture, the desire was ever recurring to display his powers on some ambitious scheme of public decoration. About 1638 Van Dyck had sufficiently interested the King in a project of decorating the walls of the Banqueting House with scenes illustrating the history of the Order of the Garter for him to be required to make some sketches. A brilliant sketch in grisaille, for one wall, in the collection of the Duke of Rutland, is all that survives of this project.[7] It

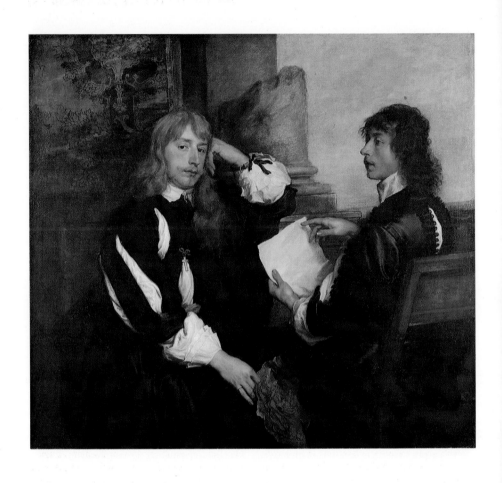

55. Sir Anthony Van Dyck: Thomas Killigrew and (?)Lord Crofts, 1638.
Royal Collection (by gracious permission of Her Majesty the Queen)

shows the King in the centre and a procession of all the Knights of the Garter, and is conceived in emulation of Veronese. But the King could not afford to finance the scheme and this disappointment may have played a part in causing Van Dyck to seek, as he certainly was seeking during the last years of his life, suitable employment away from the English Court. In spite of his great collections and his undoubted love of art, Charles I was unable to employ his one great painter to the full capacity of his powers.

Van Dyck's Studio and his immediate Following

The question of Van Dyck's studio remains profoundly obscure. Apart from a statement, which probably refers to Edward Bower, that he was at one time 'servant to' Van Dyck, there is no evidence (contrary to what is often said – of Dobson for instance) that any British painter of consequence learned directly from Van Dyck. The names of his assistants that we know, J. de Reyn and David Beck, are Flemings, and he probably preferred to have Flemish workmen, trained in the same studio tradition as he had been himself, to help him in the subordinate work on his portraits and to execute replicas. That a considerable number of replicas of different sizes could be ordered at one time we know from a letter of Strafford's,[8] but the great number of inferior repetitions which appear today to be more or less contemporary, were probably painted after Van Dyck's death by professional copyists such as Belcam, Van Leemput, and Simon Stone. Of these, Van Leemput (d. 1675 and known as Remée) certainly painted original portraits as well as copies. On the other hand, an enormous number of portraits exist which date from about 1638 to 1650 and which are closely modelled on Van Dyck, so closely that the individuality of the painter is obscured. It has occasionally been suggested in recent years that these may be by Weesop, a painter who came to England about the time of Van Dyck's death and left in 1649, but there is not a shred of evidence for this, and

Weesop's signed 'Execution of Charles I' (Earl of Rosebery, on loan to the Scottish National Portrait Gallery) disproves it. We can only recognize at present that the imitators of Van Dyck form a numerous and nameless tribe, whose works spread the more obvious elements of Van Dyck's style far beyond the limited aristocratic circles for which he had worked himself. A great many such works are 'traditionally' called Van Dyck today in the houses where they hang.

Van Dyck's few portrait groups, of which the most notable is the huge 'Pembroke Family' at Wilton, had no immediate following. For an artist so accomplished in the single figure and in occasionally inspired double portraits[9] they are all curiously awkward and clumsily designed.

Painters of the 1640s uninfluenced by Van Dyck

The influence of Van Dyck did not succeed in pervading the work of all his contemporaries, even of all those who were employed about the Court. The elder John de Critz, who was appointed Serjeant Painter about the time of the accession of James I, has already been noticed in the last chapter. He continued to hold that office until his death in 1642, but was only employed by the Crown on decorative work and restoration. Two at least of his sons, John the younger (born before 1599) and Emmanuel (born between 1599 and 1609), were early associated with him in the office of Serjeant Painter, to which the younger John succeeded by warrant dated 18 March 1641/2. This John fell fighting at Oxford soon after his appointment and we know nothing of his work, but a group of portraits survives in the Ashmolean Museum at Oxford which there is good reason to suppose is by a member of the de Critz family and slightly less good reason to suppose is by Emmanuel.[10] All are portraits of persons related to the de Critz family and one is a portrait inscribed by an eighteenth-century hand as 'Oliver de Critz', 'a famous Painter' (but nothing else is known of his painting); the others are all of the Tradescant family and that

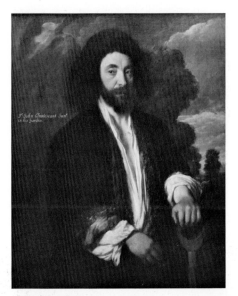

of 'Hester Tradescant and her Stepson' is dated 1645. With them can be associated the portrait of 'John Tradescant Jr' in the National Portrait Gallery, but no other absolutely convincing attribution to the same hand has been found. In style this group of pictures looks forward perhaps to Gerard Soest, but its antecedents are mysterious. Two of the pictures are, in a minor way, masterpieces, fine in quality and original in interpretation – 'John Tradescant with a Spade' [56] and 'John Tradescant and John Friend, brewer of Lambeth' [57]. There is a seriousness, a meditative sadness,

56. Emmanuel(?) de Critz:
John Tradescant with a Spade.
Oxford, Ashmolean Museum

57 (*below*). Emmanuel(?) de Critz: John Tradescant and John Friend, brewer of Lambeth.
Oxford, Ashmolean Museum

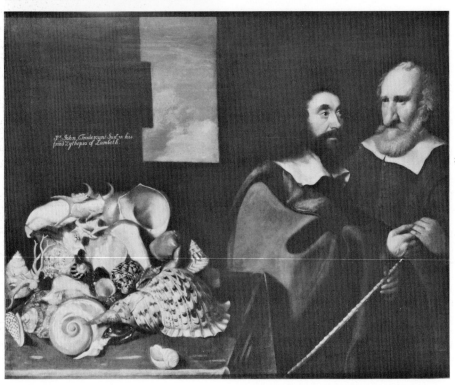

about both these pictures, akin to what we shall find in Dobson but without Dobson's romantic Cavalier overtones. No doubt this is a reflection that the times were out of joint, but the painter has risen to the occasion and shown himself a master of the poetic possibilities of portraiture. Tradescant's Cabinet of Rarities was well known and the still-life of shells in his portrait with John Friend is an allusion to this, but the shells have been endowed with more than the value of a mere decorative accessory and their collector's love for them has been conveyed by the painter in his making them appear as a third personality in the portrait group. Emmanuel de Critz lived on until 1665, but all that we know of his later practice is that he copied a Lely for Pepys in 1660 – a sad decline.

Connected by marriage with the Tradescant and de Critz families (his mother had remarried John de Critz the younger), and in style with the group of portraits called Emmanuel de Critz, was Cornelis de Neve (or Le Neve), perhaps related to the painter who has already been mentioned among the contemporaries of Johnson. A portrait in the Ashmolean Museum at Oxford, which came with the Tradescant portraits, is inscribed 'Mr Le Neve / a famous Painter' and is probably a selfportrait of about 1650: in the same collection is a portrait of Nicholas Fiske, which is conceivably by the same hand and is dated 1651 and signed 'CDN'. Le Neve is mentioned in Sir Edward Dering's accounts for 1648 and 1649,[11] and Evelyn mentions him casually in 1649: the last that is recorded of him is that he painted a portrait of Elias Ashmole in 1664, which is now at Merevale Hall.

Traces survive of two other painters, not altogether dissimilar to one another in style and both equally distant from Van Dyck, who were active in the 1640s and most probably executed their few works at present identified when travelling the country. Of each a single group of works from one year only is known for certain. T. Leigh is found in North Wales in 1643. He signed, in a flowing hand,[12] five portraits of members of the Davies family of Gwysaney and Llanerch, and all are dated 1643.

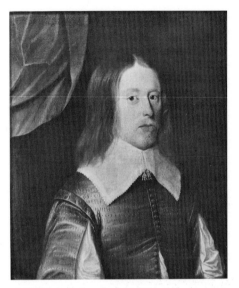

58. T. Leigh: Robert Davies, 1643. *Cardiff, National Museum of Wales*

Two are now in the Cardiff Gallery, of which the female portrait is a ruin, but the 'Robert Davies' [58] and the three still at Gwysaney (Capt. Davies-Cooke) show a competent painter trained in a tradition akin to Cornelius Johnson. It is possible, but needs further exploration, that he may be the Thomas Leigh who signed, in 1656, a receipt for a posthumous portrait of Robert Ashley in the Middle Temple.

The second painter, akin to Leigh but a little more awkward in style, seems to have borne the initials 'IW'. In the possession of the Pochin family at Barkby Hall in Leicestershire are four portraits[13] signed 'I.W.F.' and dated 1648. Nothing further by the same hand has been traced.

A versatile artist, perhaps more of the journeyman class, Richard Greenbury, also deserves to be mentioned. His career overlaps Van Dyck's stay in London at both ends, and we find him as copyist, restorer, glass painter, and as executing painted altar-hangings.[14] He was apparently a Roman Catholic but was already employed by the Crown in 1622/3 for a portrait of James I (perhaps a copy): the last

date we have for him is 1651. He followed Sampson Strong at Oxford and painted a portrait of the Founder for Magdalen in 1638, and did other work about the college, but he also copied old masters for the King and the competent copy of Dürer's portrait of his father at Syon House is a surviving specimen of his work. There is record of a lost work, a large canvas showing the cruelties of the Dutch at the Amboyna massacres in 1623, which he painted for the East India Company for purposes of propaganda, and which was so fearsome that it had to be destroyed. He appears to have been able to turn his hand to any class of painting or restoration and his career throws light on the lost corners of art history in England at this time.

William Dobson

Aubrey, who knew him, quite rightly called Dobson 'the most excellent painter that England hath yet bred'. He is, in fact, the most distinguished purely British painter before Hogarth. He was born in London in 1610/11, the son of a Master of the Alienation Office: his father was of a respectable St Albans family who had wasted his estate by luxurious living. Dobson is said to have inherited this tendency to extravagance, but he was forced to learn the business of painting in order to earn his living. Richard Symonds, who no doubt learned it from Cleyn himself, wrote in his notebook in 1653 that 'Mr Clein was Dobson's master and taught him his art'. From Cleyn he inherited much of the tradition of the Italian High Renaissance and a leaning towards the Venetians, and through Cleyn he could presumably gain access to study, and perhaps copy, some of the Venetian paintings in the royal collection. Without such training we should have to postulate that he had been to Italy, for Dobson's style is nearly independent of Van Dyck and could not have been learned from Van Dyck. It is probable that he copied Van Dyck too, and a copy has been reported of Van Dyck's 'Earl of Arundel and Grandson' with Dobson's signature (formerly in Major Baker-Carr's posses-

sion). Until this reappears it is better to suspend judgement, for there is no other evidence of any nearer connexion between Dobson and Van Dyck. We know nothing whatever of Dobson until 1642 (at the earliest), when the Court had moved to Oxford. Van Dyck had died in 1641 and John de Critz, the new Serjeant Painter, was killed in the fighting at Oxford. Dobson seems to have filled in a makeshift way something of the gap caused by both deaths, but there is no evidence that he was ever appointed 'Principal Painter to the King' and only the unsupported note of an eighteenth-century antiquary (Oldys) that he was Groom of the Privy Chamber and Serjeant Painter. He seems to have been active partly at Oxford and partly in London during the period 1642 to 1646 and he was buried at St Martin's in the Fields in London on 28 October 1646. He painted the official portraits of the King's children and members of the royal entourage at Oxford during these years, but the King does not seem to have sat for the completion of his own portrait.

The work of these last four years is thus all that we know of Dobson and between fifty and sixty paintings are at present traced.[15] Of these, only two are full-lengths, four are double portraits or groups, a few are single heads, and by far the greater number are half-length portraits with hands. A particularly mature and splendid example of this last class is the 'Endymion Porter' in the Tate Gallery [59], which is valuable for the analysis of his style as it can be compared with a portrait of the same sitter by Van Dyck (in a double portrait) in the Prado.

The spirit of Dobson in this portrait[16] is altogether more robust and less consciously elegant than the spirit of Van Dyck. The hands are larger and more solid, the te paint rough and impasted and not smooth, the figure bulks larger because nearer to the plane of the picture's surface. Van Dyck uses his Baroque accessories, the pillar and the curtain, for purely decorative ends: Dobson employs a more learned and specific repertory of such accessories. A colossal bust of Apollo in the back-

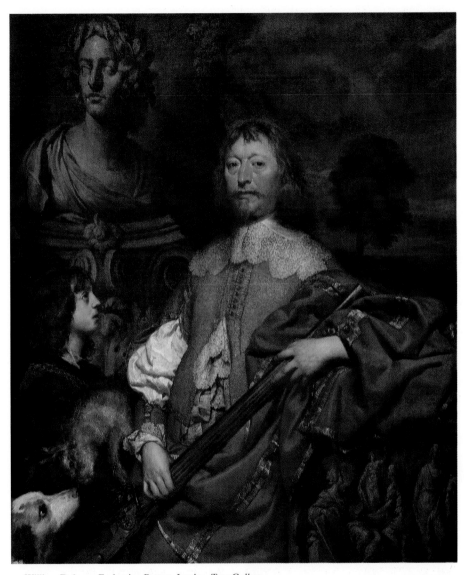

59. William Dobson: Endymion Porter. *London, Tate Gallery*

ground, and a relief, perhaps representing the Arts, in the lower foreground, are clearly intended to have some sort of relevance to the person represented. And such accessories are almost habitual with Dobson. 'Sir Charles Lucas' (at Corsham and Audley End), 'Sir William Fermor' (private collection), the 'Marquess of Montrose' (Duke of Montrose), the picture called 'Sir George Carteret' (Greenwich), and the 'Sir William Compton' and 'Earl

of Northampton' (both at Castle Ashby), all have enigmatic classical reliefs or similar accessories in the background. This practice is altogether unknown to Van Dyck and rare in Europe in the seventeenth century, although it had become more or less standard by the time of the manuals for painters which were popular at the end of the century (e.g. Gerard de Lairesse). Its origin, however, and the source from which Dobson, probably through Cleyn, derived it, was Italian sixteenth-century manuals, particularly Lomazzo, who had been translated into English in the sixteenth century. In his *Trattato dell'arte della pittura, etc.*, Book VI, chapter 50, Lomazzo says, 'First you must consider the quality of the person who is the subject of the portrait, and, according to that quality, give the portrait its appropriate symbol'. Dobson's style is thus learned as well as aristocratic and relies much more than Van Dyck's on the intellect of the spectator.

In what is perhaps Dobson's masterpiece among single portraits the accessories are less enigmatic – the 'Charles II as Prince of Wales' in the National Portrait Gallery of Scotland [60]. The boy soldier is seen with his page, with

60. William Dobson: Charles II as Prince of Wales. *Edinburgh, Scottish National Portrait Gallery*

a battle raging in the background, and a jumble of military trophies on the ground from which emerges a hideous mask of Envy and Civil War. The figure is deliberately cut off at the knees (as Van Dyck would never do) to give weight and moment to it, and the difference between Dobson and Van Dyck can nowhere be better observed.

This learned, latinizing, and allegorical aspect of Dobson's art is most fully (and least happily) exemplified in the only[17] subject picture by him at present known, an 'Allegory of the Religious Wars in France' (C. Cottrell-Dormer).[18] The invention here is presumed to have been largely Sir Charles Cotterell's, but we know that Cotterell and Dobson were close friends, and the picture is evidence of the cultured and allusive world with which Dobson associated. As a picture it is far from satisfactory and it reinforces the suspicion that Dobson, although a master of the half-length portrait, was ill at ease in full-lengths. The only two of these known, 'Sir William Compton' (Castle Ashby) and the 'Earl of Peterborough'[19] (Drayton House, signed and dated 1644), are much more dependent on Van Dyck models for pattern than one would have expected, and they show considerable uneasiness in the treatment of the lower half of the human figure.

Dobson's greatest originality, however, is shown in his few group arrangements of half-length figures. Two of these are among the finest and most interesting British paintings of the first half of the century, and neither has any close parallel among works of this age. The group of 'Prince Rupert, Colonel William Murray, and Colonel John Russell' [61] can almost be described as a 'historical conversation piece' on the scale of life. It depicts an incident during the Civil War when Colonel Russell was persuaded not to abandon the Royalist cause and the three men are about to drink to this decision, Colonel Murray dipping a Royalist cockade into the glass. There is about all Dobson's portraits – nearly all of which portray men prominent in the royal cause – a look of romantic heroism, as of the fated defenders of some precious heritage, but this group surprises the

61. William Dobson: Prince Rupert, Colonel William Murray, and Colonel John Russell.
Private Collection

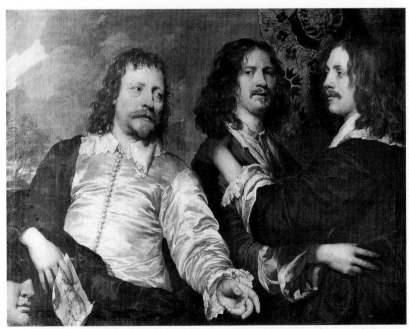

62. William Dobson: Dobson, Sir Charles Cotterell, and Nicholas Lanier.
Duke of Northumberland, Alnwick Castle, Northumberland

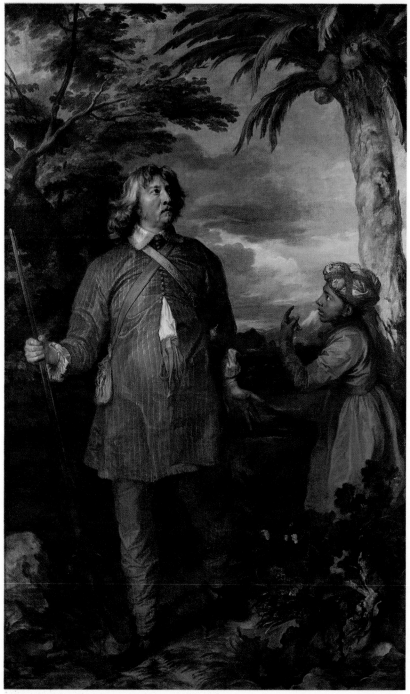

63. Sir Anthony Van Dyck: First Earl of Denbigh. *London, National Gallery*

kind of decision which gave rise to such a look, and this psychological element in his portraiture, which is far removed from the aristocratic aloofness of the Van Dyck tradition, is what marks Dobson off from all his contemporaries.

The other group is more enigmatic and shows 'Dobson, Sir Charles Cotterell, and Nicholas Lanier' (Duke of Northumberland) [62]. The painter is the central figure and he seems to be being rescued by Cotterell from some temptation put forward by Lanier. It is at least possible that this group also signifies a conflict of loyalties of the same sort as the other, but one more personal to Dobson himself.

Pictures akin to Dobson

The splendid portrait of the 'First Earl of Denbigh' [63] given to the National Gallery in London by Count Seilern in 1945 is recorded in a Hamilton inventory of the 1640s as a Van Dyck, and it shows that there were moments, for an unusual sitter, when Van Dyck could employ a formula with which Dobson would have sympathized. But the number of Vandyckian portraits of the 1640s is very much greater than the number of Dobsonesque ones which cannot be attributed to Dobson himself – and we know nothing of any pupils. A fine portrait of a kindred character to the 'Lord Denbigh', also with a suggestion of the Orient about it (there are pyramids and a crocodile), is the half-length of 'Sir William Paston' at Felbrigg (National Trust).

Henry Stone

Confusion prevails over the paintings which can be ascribed to the only known English contemporary of Dobson whose name might be put forward as the possible painter of Dobsonesque pictures – Henry Stone. The main facts of his life are known.[20] He was baptized in London on 15 July 1616 and died there on 24 August 1653. On his tomb, which was set up by his brother, John, it is categorically stated

that he 'passed the greatest part of 37 years in Holland, France, and Italy'. We know that he returned to England from Italy in 1643 and that he was apprenticed as a young man to his uncle, the Dutch painter Thomas de Keyser, at Amsterdam. This would give him perhaps ten years abroad before 1643, so that we can reasonably assume that he was out of the country for a considerable period also between 1643 and his death in 1653.

The literary tradition fails altogether to conform to this. According to this,[21] 'one Stone' worked for Van Dyck; he was a pupil of Michael Cross, who was sent by Charles I to Spain to copy the Titians in the Escorial, and he perhaps accompanied Cross to Spain; in 1652 'Mr Stone who copies' showed Richard Symonds the pictures in Suffolk House; he 'was an extraordinary copier in the reigns of Charles I and II'; he was generally known as 'Old Stone'. Since the days of Vertue this Old Stone who specialized in copies has been equated with Henry, son of Nicholas Stone the sculptor, but

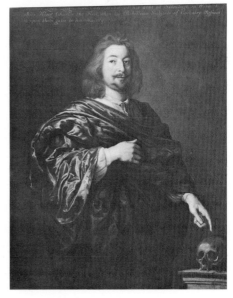

64. Henry Stone: Thomas, Lord Leigh, 1649. *Lord Leigh, Stoneleigh Abbey, Worcs*

only the blind desire of the blind to follow the blind can justify the equation.

We now know, however, from an account at Woburn dated 1661,[22] that the Stone who copied Van Dycks was a certain Simon Stone who worked on until after the Restoration, so that the way is clear for considering independently the work of Henry Stone, who may have painted some of the puzzling Dobsonesque portraits.

There is, in fact, a portrait of this character at Stoneleigh Abbey (a repetition is at Lamport), which is decidedly Dobsonesque and rather foreign in style and bears an old inscription (it is hardly a signature), 'H. Stone F. 1649'. From this portrait of 'Thomas, Lord Leigh' [64] it should be possible to recover some knowledge of the true Henry Stone.

Edward Bower

Dobson and Stone were more or less independent of Van Dyck, and the former at least was the leading painter on the Royalist side. When we come to those who worked for sitters on the side of Parliament it is curious that we should find a much stronger dependence on Van Dyck models. Bower, in fact, in a contemporary letter of Lord Fairfax,[23] is stated to have been servant to Van Dyck. This must have been before 1638, which is the first date known for him. He came very probably from the south-west, perhaps Devonshire, and he picked up in Van Dyck's studio (where he can in no sense be considered to have been a 'pupil') enough of the machinery of picture-making to enable him to produce provincial imitations. He probably painted Lord Fairfax at Bath in 1646 and he was certainly in London at the time of the King's trial in January 1648/9, when he made drawings of the King from life, as he sat at his trial. From these he produced at least three slightly different paintings which were popular with the copyists for a number of years. They are more historically poignant than competent as works of art, but Bower seems to have enjoyed a certain prestige in the City of London from then until his death in January 1666/7.

Robert Walker

There would, on grounds of style, be more reason to surmise that Walker, the much inferior counterpart to the Royalist Dobson on the Parliamentary side, may have actually been a pupil of Van Dyck. The date of his birth is

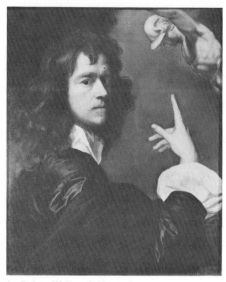

65. Robert Walker: Selfportrait.
Oxford, Ashmolean Museum

unknown and the only material on which to base a supposition of his age and early training is his 'Selfportrait' [65] in the Ashmolean Museum at Oxford. This very interesting picture is signed and gives evidence of a degree of sardonic wit in Walker which one would not have guessed from his other known works, for it is a deliberate parody of Van Dyck's 'Selfportrait' [66] in the collection of the Duke of Westminster. Van Dyck displays himself with a good deal of arrogance, as the object of royal patronage. He stresses the gold chain which the King had given him in April 1633 and he points to the sunflower, a symbol of royal patronage, which is turned towards him. Walker converts the image into a straitened and upright design (he is always prone to exaggerated verticals) and

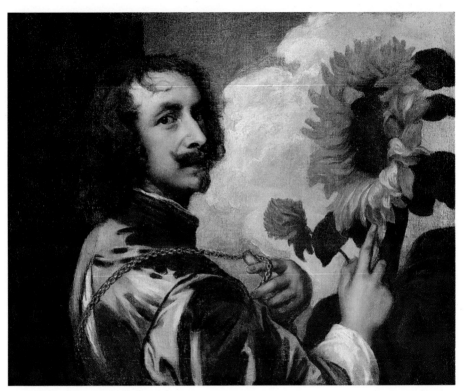

66. Sir Anthony Van Dyck: Selfportrait.
Duke of Westminster

he points, not to a sunflower, but to a statuette of Mercury, the patron of vagabonds and thieves. If the Van Dyck was perhaps painted about 1633/4, and the Walker was only a year or two later and shows a man of some twenty-five to thirty, we can suppose Walker born between 1605 and 1610. He seems at any rate to have been in independent practice by 1637, if his signature and the date have been correctly read on a picture of 'Cardplayers' in the von Rechberg collection at Donzdorf.[24] The latest certain date that we have for him is 1656: he was possibly still alive in 1658, and he is generally supposed to have died a little before the Restoration.

The rather Italianate kind of joke shown in the Oxford 'Selfportrait', the subject of the picture of 1637, and the fact that Richard Symonds in 1652 quotes Walker's opinion about the effect of rolling them on pictures painted on the canvas favoured in Italy, make plausible C. H. Collins Baker's suggestion that he studied in Italy. We certainly know that he did copies of Titians in the royal collection and his connexion with Titian's patterns is sometimes even closer than Van Dyck's. He is next heard of in 1648, when John Evelyn sat to him for the very curious portrait now on loan from the Evelyn family at Christ Church, Oxford. This is perhaps the least English-looking portrait painted in Britain during the seventeenth century and must have been directly intended by the sitter to give him the air of an Italian virtuoso. For it is a sort of parody of a typical Italian picture of the

67. Robert Walker: Colonel John Hutchinson
and his Son.
Private collection

68. Robert Walker: Mrs Hutchinson
and her daughter.
Private collection

'Penitent Magdalen'! We may surmise that
Evelyn would have chosen a painter lately in
Italy for the execution of this curious whim. By
1649, however, we find Walker painting Crom-
well[25] and the *peintre-en-titre* of the new régime.
We can gather by implication from the arrange-
ments for Cromwell's funeral that he had no
'official painter'.

Walker was kept busy during the first years of
the Protectorate painting portraits of Cromwell
(National Portrait Gallery, Leeds, Althorp,
etc.); and a certain number of portraits of other
prominent personalities of the time are so en-
tirely consonant in style with these that we need
not hesitate to ascribe them to Walker. One of
the best is the 'Colonel John Hutchinson and
his Son' at Milton Park [67], which is of ex-
ceptional interest for being accompanied by a
companion portrait of 'Mrs Hutchinson and her
Daughter' [68] which can safely be treated as a
norm for Walker's female portraits. Just as the
Cromwell portraits all derive from Van Dyck
patterns, the 'Colonel Hutchinson' is deliber-

ately imitated from Titian's 'Allocution of the
Marquis of Vasto' now in the Prado, and it is a
significant reflection that the official Common-
wealth portraits should all echo the designs of
absolutist Court painters. On the other hand, no
full-length and no equestrian paintings of
Commonwealth personalities are known.[26]

Two signed and dated portraits of 1656 sur-
vive – an 'Unknown Youth' belonging to the
Shirley family in Ireland and the 'Second Duke
of Somerset' at Syon House. Both betray a
flagging hand and a continued dependence
upon the models of Van Dyck. The truth is that,
even during the Commonwealth period, the
rising star of Lely had eclipsed in popular
patronage the artist favoured by the Protector.
Walker is also known to have painted 'Philoso-
phers', which we may imagine to have been in
the vein of Ribera.

Isaac Fuller

Although he lived on long after the Restoration, Isaac Fuller is best considered with Dobson and Walker. He may well have been older than either, but there seems no sound evidence for placing his birth, as is often done, in 1606. He studied in France under François Perrier, presumably before Perrier's second visit to Italy (1635/45), and he was working at Oxford in 1644, at the same time as Dobson. After some years at Oxford he became established in London, and closed a steadily more besotted existence on 17 July 1672. His work of 1644 and that of 1670 show common qualities, a sort of fierceness of approach and *bravura* of execution, which, combined with his known fondness for the bottle, has led the Bodleian 'Selfportrait' [69] to be absurdly labelled as 'painted when drunk'! It was clearly painted when in full control of a lively hand and an original mind, and makes us regret tht so little of his work is known to survive today.[27]

69. Isaac Fuller: Selfportrait.
Oxford, Bodleian Library

A portrait at the Tate wrongly inscribed 'John Cleveland' [70] bears on the back a label saying that it was painted at Oxford in 1644, and there is eighteenth-century tradition to support the attribution. It is something new in British painting, and shows a new tendency from which Lely was to learn. The quiet pose and gestures of Van Dyck or Dobson have given way to something more vivid and expostulant, and it may be instructively compared with a picture such as the Bourdon 'Selfportrait' in the Louvre. The face is executed with a certain careless dash and shows an unquiet spirit, and the same characteristics appear in the 'Edward Pierce' at Sudeley Castle, painted some years after the Restoration. The only other certain works of importance which survive are three variations of a selfportrait. The earliest is perhaps that in the Bodleian, signed and dated 1670, in which the plain dark cap he was originally wearing has been altered – entirely in the interest of the design – into a singular dark crimson headpiece. In the variant in the National Portrait Gallery a bust is placed instead of the drawing and the picture is converted more into a 'virtuoso

70. Isaac Fuller: Unknown Man, 1644.
London, Tate Gallery

portrait'; in that at the Queen's College, Oxford, Fuller's son has been added behind. These are a striking anomaly for their time, with the scale deliberately a little larger than the life. They are a faint echo of Rembrandt's later self-portraits, and as nearly out of touch as those are with the prevailing taste.

Fuller's work other than portraiture is largely lost. He did some religious painting at Oxford[28] and decorated a large room at the Mitre Tavern in Fleet Street with a series of life-size figures of classical divinities in which Vertue thought the Bacchic figures the best. From his description[29] we can still picture with some vividness the 'fiery colours' and the prominent marking of the muscles. One is reminded, for the muscles, of Perrier's engravings after the Antique. Some large historical paintings of the adventures of Charles II after the Battle of Worcester, which once adorned the Irish Houses of Parliament, and are now in the National Portrait Gallery, London.

The names of a few painters are known whose style may be distantly associated with Fuller. William Sheppard is known by several versions of a single portrait of Thomas Killigrew, painted at Venice in 1650, of which the original is perhaps at Dyrham. From Venice Sheppard seems to have gone to Rome, but was back in England before the Restoration. A portrait of the 'Third Earl of Downe', datable to 1658, was last in a sale at Sotheby's on 17 February 1937 (77) and was signed 'Betts f.'. This had a ruggedness reminiscent of Fuller, which was not repeated in a portrait of 'Lady Humble'[30] signed 'John Betts 1660' (formerly in the John Lane collection), which is dominated by the style of Lely. In the Examination Schools at Oxford is a portrait signed 'Ro. Fisher Pinxit' and dated 1655, whose bold and rough facture suggests a direct connexion with Fuller: and the same remarkable collection includes a portrait of 'Christopher Simpson' engraved as by J. Carwarden in 1659. Carwarden is mentioned in 1636 and a signed portrait by him, dated 1658, was in a sale on 5 May 1927, lot 86. He may have been the composer John Carwarden. In the Autobiography of the Rev. Henry Newcon

(Chetham Society, XXVI, 97) there is reference to a painter named Cunney working at Manchester in 1658, and another provincial portraitist who has left more extensive traces is Edward Mascall. He was the son of an embroiderer at York, where he was born about 1627, and where he was admitted a Freeman in 1660. His works, ranging in date from 1650 to 1667, were found mainly in the north of England (two were at Hornby Castle,[31] one at Wykeham Abbey, and one at Lowther Castle), but two, one of 'Mary Edgcumbe' 1658, were among the pictures destroyed by bombing at Mount Edgcumbe. His work has an austere Puritan cast which is not without distinction.

Painting other than Portraiture

Little survives of landscape which can be associated with the years from 1630 to 1660. Certain watercolours, apparently of English scenery, are ascribed to Van Dyck and have a surprising freshness of approach, and there is a solitary oil painting at Chatsworth (with little figures partly cribbed from Rubens) which shows something of the same spirit. This is traditionally ascribed to Inigo Jones (1573–1652) and, if it be his, it is unique. It agrees well enough, however, with the style of Frans Wouters (1612–59),[32] a pupil of Rubens who came to London in 1637 and was made 'Painter to the Prince of Wales'. Wouters was back in Antwerp by 1641, but he painted one or two landscapes in England (in the style of Rubens and not from nature) and an admirable example from the collection of Charles I remains in the Royal Collection.

A negligible future was before another kind of painting which had a certain vogue in England at this time – the architectural interior. The younger Hendrik van Steenwyck was already settled in London in 1617 and he appears to have remained in England until his death about 1649. Only one English continuator of the same tradition is known, a certain Thomas Johnson,[33] whose working life is known to extend from 1651 to 1685. His single surviving original work

is more poignant as a historical document than important as a work of art – a view of the interior of Canterbury Cathedral in 1657 with figures of Puritans destroying the stalls and the stained glass. It reveals unexpected possibilities, and Johnson is reported in 1685 as showing to the Royal Society a number of views that he had taken in the neighbourhood of Canterbury.

Painting in Scotland

There is no lack of names of painters in Scotland at this time, nor lack of portraits, but there is a lack of identification of the painters of portraits between the death of Jamesone in 1644 and the emergence of the first certain member of the Scougal family. The most prominent of the painters who took prentices at Edinburgh during this period are John Sawers (Sewers) who took eight prentices between 1595 and 1649 and whose son-in-law, Joseph Stacie, took a prentice in 1656: one Telfer (Tailfier) also was taking prentices between 1647 and 1663.

THE AGE OF LELY

Sir Peter Lely

From about the year 1650 Lely had the largest practice of any portrait painter in the kingdom, but his name is as indissolubly connected with the years after the Restoration in 1660 as that of Van Dyck is with the reign of Charles I. He was the first painter after Van Dyck to attain to anything like the same position of public eminence, and Charles II appointed him his Principal Painter and, on 30 October 1661, granted him a pension of £200 a year 'as formerly to Van Dyck'. His style, infinitely less subtle and less personal than Van Dyck's, left a deeper impress on British painting, and we can trace back to Lely, and perhaps no further, the main themes of later British portrait painters and the establishment of a sound, well-grounded, unimaginative tradition of studio practice which has dogged official portraiture in Britain to our own times. He is the first painter in England by whom an enormous mass of work survives. For it would not be difficult to make a catalogue of four or five hundred pictures more or less painted by Lely himself, and the number of studio replicas and copies runs into thousands.

Lely's style is matter for the historian rather than for the student of the genius of the creative artist. In mere executive ability he was perhaps equal to Van Dyck. His drawing could be impeccable, he was capable of lovely colour, and he has hardly been surpassed in his painting of the texture of silks and satins. In the power of rendering the sleepy voluptuousness which was fashionable at the Court of Charles II (and elsewhere in Europe at the time) he was unrivalled. But he altogether lacks that flame of personal genius, that power of creating as well as recording an image, which warms the imagination when we contemplate a masterpiece by Van Dyck or Dobson. His style is international rather than English, and one or two portraits by Jan Mytens in Holland or Bourdon in France are scarcely to be distinguished from Lelys. Although he never left England after he had made his name, and although his portraits were hardly to be seen abroad, Sandrart, who had never seen a Lely painting, records his great reputation and reveals the secret of his success in a little poem[1] which begins:

Was reimet sich auf wahre Kunst?
Herr Lilli saget: Königsgunst.

(What rhymes with true art? Mr Lely says: 'The favour of Kings'.)

Lely's family name was Van der Faes and he was born on 14 October 1618 at Soest. Though his family was Dutch he happened to be born at Soest in Westphalia rather than at Soest in Holland.[2] He was trained at Haarlem under Pieter de Grebber and became a Master in the Haarlem Guild in 1637. Nothing is known of his work before he came to London and the date of his arrival is uncertain. There seem to have been rival traditions in the eighteenth century that he came over (a) for the marriage of William of Orange and Princess Mary, which took place in 1641, (b) in 1643. I think 1643 the more probable date,[3] and it is likely that Geldorp, who had been concerned in Van Dyck's coming over in 1632, was concerned in Lely's also.

At any rate Vertue was told by the veteran painter Isaac Sailmaker (1633–1721) that Lely 'wrought for Geldorp in his house' on his first coming over and that the young Sailmaker was employed there also. This might well be about 1643/5. Vertue also reports that Lely first painted landscapes and history pieces on coming to England, and only later turned to portraiture, and, in another passage, Vertue refers to early Lely portraits which were in the style of Dobson or Fuller. A possible candidate for an example of Lely's first phase is the 'Blind

Harper' at Althorp [71], which is strongly reminiscent of what we know of Fuller.

As a painter of portraits Lely first comes into prominence in 1647 and no certain portrait by him of an earlier date is known. During some months in 1647 when the King was at Hampton Court he was visited by his children, who were in the custody of the Earl of Northumberland, and Lely painted for the Earl the curious and rather moving group of Charles I and the Duke of York [72] now at Syon House. This picture is without parallel in Lely's *œuvre* and shows something of the same psychological interest as was noticed in Dobson's groups.

71. Sir Peter Lely(?): Blind Harper.
*Earl Spencer, Althorp, Northants
(Copyright Country Life)*

72 (*below*). Sir Peter Lely: Charles I and the Duke of York, 1647.
Duke of Northumberland, Syon House

At this time (1646/7), when the three younger of the royal children were in the care of the Earl of Northumberland, he also commissioned from Lely a portrait group of them, now at Petworth [73], which, although more tender in interpretation than is usual with Lely, shows for the first time some of the new elements he was to introduce into fashionable portraiture. In addition to landscape' which was to become a dominant theme in British painting until the end of the eighteenth century. It is significant that this particular Van Dyck is more charged with voluptuous overtones than any other of his English works. The patronage of the Earl of Northumberland may well have given Lely his first opportunity to study Van Dyck, and it is

73. Sir Peter Lely: The Younger Children of Charles I, 1646/7. *National Trust, Petworth, Sussex*

Van Dyck's column and curtain Lely has introduced a very elaborate Baroque fountain and cherub and he has set the figures well inside a gently wooded parkscape. The only Van Dyck portrait which anticipates these motives is the picture called the 'Countess of Carlisle' at Windsor, which may well have been taken by Lely as the starting-point for this 'portrait in a worth recording that the two finest Van Dyck copies which traditionally bear Lely's name – the 'Algernon, Earl of Northumberland' (Syon House) and the 'Anne, Countess of Bedford' (Count Bentinck, Middachten) – are both after originals which at that time belonged to Northumberland (originals now at Alnwick and Petworth).

At about the same time we also find Lely associated with so strong a Royalist as the poet Lovelace, who might almost be described as serving Lely as a press agent. On the group at Syon House Lovelace wrote his poem 'See what a clouded Majesty . . .' and it is curious to find what element in the portrait he selects for admiration, for it is a quality which Lely speedily eliminated from his portrait style. 'The amazed world', says Lovelace, 'shall henceforth find / None but my Lilly ever drew a Minde.' On 18 October 1647 both Lovelace and Lely were together made free of the Painter Stainers' Company and Lely made a drawing of 'Lucasta' – a *décolletée* lady at full length, with a scoop – for the 1649 edition of Lovelace's poems. A painting in a similar style which must be of this date is the 'Henry Sidney' (later Earl of Romney) at Penshurst [74], where there is a group of Lely portraits of about 1650. The boy (b. 1641) is seen walking in a landscape with a dog, in a costume which might be described as 'pastorally classical'. He is extremely conscious of the spectator and the tranquillity of Van Dyck has given place to movement, Van Dyck's gracious ease is replaced by something of affectation, and there are unequivocal overtones of the voluptuous. It should be added that it is also splendidly painted and has a captivating resonance of soft colour, and it is worthy of remark that this confection was produced in the first years of the Commonwealth. It is the direct ancestor of certain portraits of children by Reynolds.

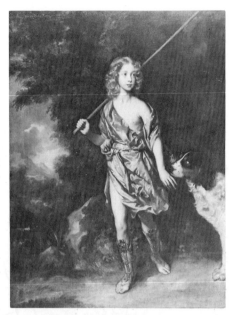

74. Sir Peter Lely: Henry Sidney, later Earl of Romney, *c.* 1650. *Viscount De L'Isle, Penshurst Place, Kent*

Another poem by Lovelace, *Peinture. A Panegyrick to the best Picture of Friendship, Mr Pet. Lilly,* which must have been written during the early 1650s, makes it clear (amid a great deal of obscure jargon) that Lely was painting a number of mythological subjects at this time, and it is probably correct to date in the middle 1650s such pictures as the 'Europa' at Chatsworth and the 'Sleeping Nymphs' at Dulwich, the latter of which seems almost a foretaste of Etty. A much copied picture, 'The Duet' [75] (which often goes under the bizarre title of 'Anne Hyde and her Music Master'), now in Lord Dulverton's collection, is actually signed and dated 1654. It is Metsu done over in terms

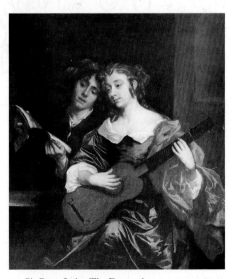

75. Sir Peter Lely: The Duet, 1654. *Lord Dulverton, Batsford Park, Glos*

of Van Dyck.[4] Up to the time of the Restoration, when he had no time for anything but portraits, Lely probably produced a steady stream of such subject pictures, which seem to have found a ready market in the austere days of the Commonwealth and Protectorate.

In 1651 Lely even made a bid with Parliament for employment as a historical painter. The proposal, in which Lely was associated with those dubious characters, Gerbier and Geldorp, was to decorate Whitehall with oil pictures of all the memorable achievements since the Parliament's first sitting. The scheme came to nothing, but is an indication of Lely's adaptability to the immediate political scene, a quality less admired at the moment than it has been in the past. At any rate he made a good deal of money during the Commonwealth and began that collection of pictures and drawings, one of the finest non-princely collections in Europe, whose sale after his death was the first of the spectacular picture auctions of the modern world. By the time of his death he was in possession of no less than twenty-five first-rate pictures by Van Dyck and his collection of old master paintings and drawings made unnecessary for him a visit to Italy and must have turned his studio into an academy for young painters, whose fruits can hardly be estimated.

Where the materials from which to select are so ample it will be best to consider only a relatively small number of his portraits, and such only as can be rather closely dated. At the beginning of the 1650s Lely received £5 for a head-size and £10 for a half-length, and the payment, on 21 April 1651, for the half-length of 'Lady Dering' (now at Parham Park) [76] occurs among Sir Edward Dering's accounts.[5] A companion picture of her sister, 'Lady Finch' (from Burley-on-the-Hill), belonged to Judge Beckett, and the two provide a norm by which to date portraits in this style. The pose is tranquil and derived from Van Dyck: so too is the texture, tone, and painting of the draperies; but the ladies are more embowered in a rocky forest, a little more modishly pastoral than is normal to Van Dyck – and, in one, the ubiquitous Cupid fountain appears. A splendid example of the

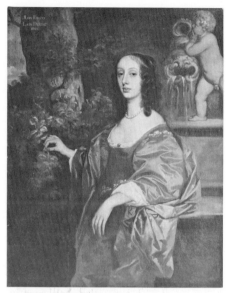

76. Sir Peter Lely: Lady Dering, 1651. *Parham Park, Sussex*

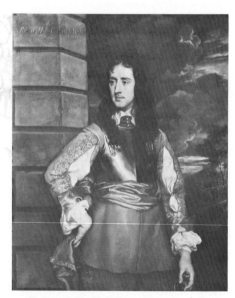

77. Sir Peter Lely: Sir William Compton, *c.* 1651. *Ham House, Surrey*

male portraits of about the same date[6] is the 'Sir William Compton' [77] at Ham House, long called a Dobson in spite of Lely's signature. In this, as in other portraits at Ham of the same period, Lely is certainly dependent on Dobson's temper for his own interpretation. Where he had no models, however, as in his rare child portraits, he could contrive a pretty fancy without imitating – as in the 'Third Duke of Somerset and Lady Elizabeth Seymour' as babies, c. 1652/3 (formerly at Savernake). By 1653 he was painting portraits of Cromwell for the various foreign ambassadors, an example of which is now at Birmingham: and he shows that he could adapt himself to the requirements of dowdiness in the 'Ladies Anne and Arabella Wentworth' of about 1653/4 (Beckett, plate 32). The extreme limit of his austere Commonwealth style appears in 'The Perryer Family', signed and dated 1655, at Chequers Court – five gloomy people who appear to be waiting for the end of the world in the presence of an over-life-size bust. Busts of this character[7] are a common feature in Lelys up to the time of the Restoration, when they vanish altogether. A glimpse into Lely's relations with his sitters is to be found in Dorothy Osborne's correspondence[8] in October 1653, where she writes of a portrait of herself that 'Mr Lilly will have it that hee never took more pains to make a good one in his life' but 'that was it I think that spoiled it; he was condemned for making the first hee drew for mee a little worse than I, and in making this better hee has made it as unlike as tother'. It is almost as if we had surprised the exact moment at which Lely decided to abandon a scrupulous truth to feature (at least in female portraits) to flattery. He never looked back.

Although Lely perhaps worked only in his London studio after the Restoration, he did not disdain in the 1650s to visit 'gentlemen's houses'[9] in the role of a travelling painter. It

78. Sir Peter Lely: The Family of the Second Earl of Carnarvon, 1658/9. *Private collection*

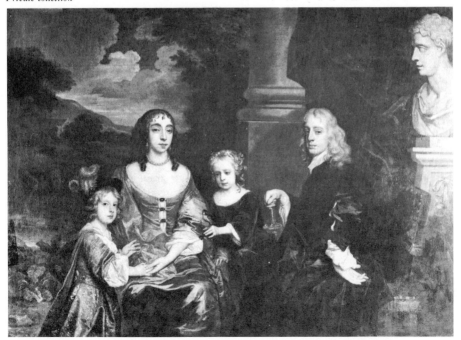

may have been when in Suffolk about 1655 that he met Hugh May (son of Sir Humphrey May) who appears in the disguise of Lely's 'servant' on a pass for travel to Holland which was granted to both of them on 29 May 1656. May's later activity as an architect is still little studied, but he and Lely between them seem to have cornered a good deal of the royal patronage to artists at a later date and it is at least possible that both made contact with the exiled Court on this journey to Holland in 1656. Lely's immediate recognition as the official painter after the Restoration and certain obscure financial transactions with the Crown at a later date suggest that, on this visit to Holland in 1656, Lely may have embarked on a policy of 'reinsurance'. He was back in London by 1658, if Vertue read that date correctly on a portrait of the dwarf painter, Richard Gibson (also with a colossal bust), which seems to have been the original of the picture now in the National Portrait Gallery; and at least three large portrait groups can be dated with some certainty to the very end of the Protectorate. The largest and most accessible, the 'Hales Family' at the Guildhall, presents certain difficulties of dating, but 'The Family of the Second Earl of Carnarvon' (Sir John Coote, Bart) [78] can be closely dated to 1658/9 and 'The Family of Sir John Cotton, Bart' (Manchester) is inscribed with the date 1660. The Carnarvon group is signed and includes one of the gigantic busts, and is a repertory of Lely's style just before the Restoration. These groups are more judiciously disposed than any comparable works by Van Dyck, and are the forerunners of a kind of picture which was to remain fixed in the British tradition. Parallel with these are two 'fancy conversation pieces' with figures on a smaller scale, of which the most famous is the group wrongly called 'The Artist and his Family' (Courtauld Institute, London). These are probably unidentified subject pieces and should be classed rather with the Chatsworth 'Europa' than with the portrait groups.

With the Restoration Lely became Principal Painter and his output became incessant. He veered over at once to a new style which ac-corded with the taste of the Court and which he had no occasion to alter for the rest of his life.

By 1660 Lely's prices had advanced to £15 for a head and £25 for a half-length: in 1671 he put them up to £20 a head, £30 a half-length, and £60 for a whole-length. The latter seems to have remained constant, but in 1678 he was charging £40 for half-length portraits. To cope with the vast influx of work he needed an extensive studio organization, for his time for sittings was soon booked up days in advance and sittings began at least as early as 7 a.m. Perhaps his most valuable assistant was John Baptist Gaspars (d. 1692), a native of Antwerp who came to England in the 1640s and painted 'postures' successively for Lely, Riley, and Kneller, as well as executing a number of copies: the backgrounds, ornaments, and draperies were often painted by Lankrink (1628–92), another Antwerp artist, who was also in independent practice as a landscape painter: Joseph Buckshorn (Bokshorn) often painted his draperies: and many other lesser names are known. At the end of his life he perhaps had some assistance in accessories from the young Largillierre. We can best picture the method of the studio and understand the various degrees of 'originals' which issued from it by comparing it with that of Rigaud, from whose Livre de raison we have the fullest available documentation of a busy studio practice of this kind. Studio method was now, perhaps for the first time in England, in line with continental practice.

The fertility of Lely in finding new variations of pose for ladies of assured or easy virtue, and for men whose appearance after 1664 was rendered increasingly monotonous by the perruque, is remarkable. But these poses, or 'postures', all have in common a Baroque element which is lacking in the postures of Van Dyck and Dobson, and whose beginnings have been noticed in Fuller. They tend to be restless, the figures are often in movement, and the hands are eloquent, either in repose or in gestures which, to modern eyes, are often far from elegant. The ladies draw closer to them a scarf which is falling from their shoulders, they make

play with a glass bottle or a globe or a pearl necklace, they cool their hands at a Baroque fountain, they draw up their sleeves preparatory to dipping their hands in water, or they seem to point to mysterious assignations in the distant groves. The men are more static, but they too cannot keep their hands still. By at least 1670 Lely had formalized these poses into numbered series and his executors' accounts have all the postures numbered. An entry such as '58 Lord Arran (ye Ladie 57)' reads like a dressmaker's catalogue. But, in spite of this realistic attitude towards his job, Lely never became slack (as Kneller did) in his own practice. He was for ever refining the subtlety and dexterity of his technique, and those of his latest portraits which he troubled to paint with his own hand carry all the resources of his considerable powers to their highest pitch.

Two famous and accessible series of portraits sufficiently indicate his style in the 1660s – the 'Windsor Beauties' (at Hampton Court) and the 'Flagmen' at Greenwich. Between them they show the extreme limits of his powers in voluptuousness and austerity. The spirit of the Windsor Beauties is best indicated by de Grammont:[10] 'The Duchess of York wished to have a gallery of the fairest persons at Court: Lely painted them for her. In this commission he expended all his art; and there is no doubt that he could scarcely have had more beautiful sitters.' An example with a very characteristic 'posture' is the 'Elizabeth, Countess of Northumberland' [79]. Pepys first saw the series in place in 1668 and calls them 'good, but not like'. They are perhaps the most characteristic of Lely's work, but are far surpassed, to modern taste, by the series of Admirals at Greenwich which were being painted in 1666/7. Of these the 'Sir Jeremy Smith' [80] shows Lely at the summit of his powers of drawing, painting, and interpretation. In such works Lely's splendid prose borders upon the poetry of the great masters.

At rare moments, with a favourable sitter (preferably, perhaps, not an Englishman), Lely could attain even to something of this poetry.

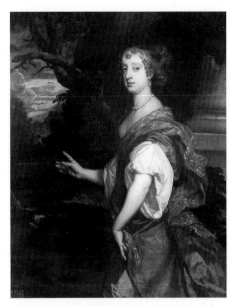

79. Sir Peter Lely: Elizabeth, Countess of Northumberland. *Royal Collection (by gracious permission of Her Majesty the Queen)*

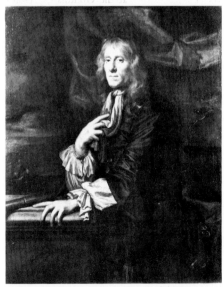

80. Sir Peter Lely: Admiral Sir Jeremy Smith, 1666/7. *Greenwich, National Maritime Museum*

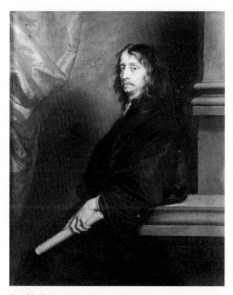

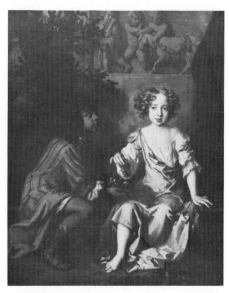

81. Sir Peter Lely: Francis Mercury van Helmont, *c.* 1671. *London, Tate Gallery*

82. Sir Peter Lely: Lady Barbara Fitzroy (b. 1672). *York, City Art Gallery*

The 'Van Helmont' in the Tate Gallery [81], which can be securely dated to about 1671, has about it the repose of the philosopher and makes us assume that the postures of Lely's English sitters were required by their own rather than the painter's taste. A little later, in a more modish but still charming vein, is the picture which probably represents 'Lady Barbara Fitzroy' [82] (b. 1672), once at Ditchley and later acquired by the York Art Gallery. This has the dazzling prettiness and colour of Lely's latest style.

Lely has been dwelt on at this length because he is, for the historian of painting, by far the most important figure working in England in the seventeenth century. He established the types of portrait which prevailed until the romantic period, and his business-like pliability to the taste of his sitters established a tradition which was first to be attacked by Hogarth. He was knighted on 11 January 1679/80 and he was buried in St Paul's, Covent Garden, on 7 December 1680. His place as Principal Painter in Ordinary was not filled until March 1684/5,

when Antonio Verrio was appointed 'in place of Sir Peter Lely deceased'.

Lely's vogue was not seriously rivalled by any of his contemporaries, although the clique which surrounded Queen Catherine of Braganza sought, about 1664, to spread the report that Huysmans 'exceeded' Lely. The general view of contemporaries can be taken from Pepys, who visited Wright's studio after Lely's in 1662 and remarks, 'Lord! the difference'; and in 1667 Pepys notes that Lely's 'pictures are without doubt much beyond Mr Hales's, I think I may say I am convinced: but a mighty proud man he is, and full of state'. Among his contemporaries there are four who deserve particular attention, Hayls, Soest, Wright, and Huysmans.

John Hayls (Hales)

Probably the oldest of these, and certainly the most elusive and the least important, is Hayls. He only comes alive to us in the pages of Pepys's *Diary*, and the portrait of 'Pepys' in the Na-

tional Portrait Gallery is certainly a version of one he was painting in 1666. This is perfectly consonant in style with the portraits of two of the younger children of Montague Bertie, second Earl of Lindsey (Charles and Bridget), which were formerly at Uffington and retained an attribution to 'Hales'. They must date about 1653 and there is some likelihood, from a note in one of Richard Symonds's notebooks, that Hayls was in Rome in 1651. Other early attributions to Hayls remain puzzling.[11]

Gerard Soest (Zoust)

Soest is a more tangible figure and a better painter than Hayls, and his style is sufficiently mannered to make him one of the most easily recognizable of portrait painters. He was probably older than Lely, since Flesshier, who knew him well, thought him near eighty at his death on 11 February 1680/1. He is supposed to have come from Lely's own birthplace, Soest in Westphalia, which would be a curious coincidence. Campo Weyerman (a dubious authority) mentions a Joachim van Soest, by whom he certainly means this artist, who came to London in 1664, and there is reasonable circumstantial evidence, from the 'Earl and Countess of Bridgewater' at Welbeck, that he was here before 1650. A signed group in the National Portrait Gallery, inscribed (certainly incorrectly) 'Sir Thomas and Lady Fairfax' [83], is a marriage portrait of the middle of the 1650s and has a grace and tenderness about it which is distinct from Lely. It has also a deliberate

83. Gerard Soest: William, Third Lord Fairfax, and his Wife(?), mid 1650s.
London, National Portrait Gallery

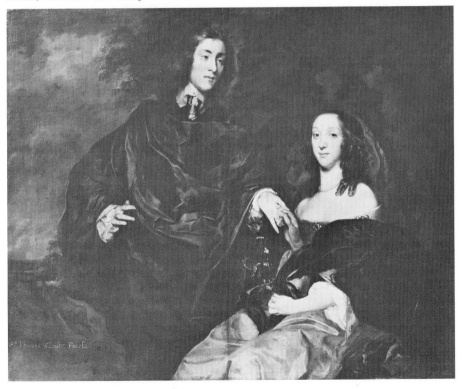

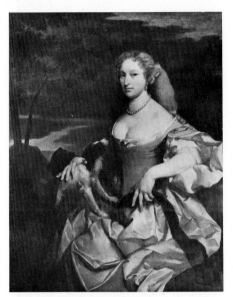

84. Gerard Soest: Unknown Lady.
Formerly Twisden Collection, Bradbourne

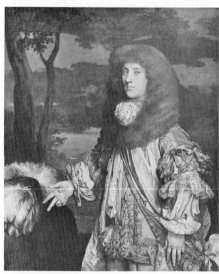

85. Gerard Soest:
John, Second Marquess of Tweeddale.
Art Gallery and Museum, Glasgow

sense of pattern and composition, independent of its portrait content and based on large, sweeping curves, which was always to be characteristic of Soest. By the Restoration his manner had become fixed, and a portrait of an 'Unknown Lady' [84] formerly in the Twisden collection at Bradbourne is an epitome of his 'er manner. The dress is a deep and striking rry red: the drapery forms a series of flowing curves, independent of nature and forming folds as if made of thin plates of zinc. The whole figure is slightly pneumatic, with large and pulpy hands, which never quite clutch the object to which they are attached. These elements remain constant with Soest and give a certain mannered fascination to his work, though the legend was insistent in Vertue's day that Soest did not succeed with portraits of ladies. But he is hardly ever uninteresting and a portrait such as 'Major Richard Salwey' (Salwey collection, Overton House), signed and dated 1663,[12] comes near to rivalling Lely's 'Flagmen' of nearly the same date. Soest, however, never approached Lely's vogue, and, in 1667, when Lely charged £15 for a head, Soest's charge was only £3. Yet this was his best period, in which he must have painted the 'John, Second Marquess of Tweeddale' (formerly Yester House) [85], as can be deduced from the 'Persian Vest'[13] the sitter is wearing. This also is signed and a dazzling display of gay colour, notably salmon and silver. The same short-lived costume effectively dates what is undoubtedly Soest's masterpiece, the signed group of 'Cecil, Second Lord Baltimore, with a Child and a Negro Page' [86] now in the Enoch Pratt Library, Baltimore. In this the basic pattern is deliberately modelled on the much earlier formula of Mytens,[14] whose portrait of the first Lord Baltimore [39] it was doubtless designed to match. But this imposed austerity is compensated for by a luxury of incidental detail, which makes it one of the most fascinating portraits painted in England in the seventeenth century. There is a flavour of the eccentric and of the true artist about Soest, which makes us regret that he was born to such prosaic times. In later life he seems to have explored other modes

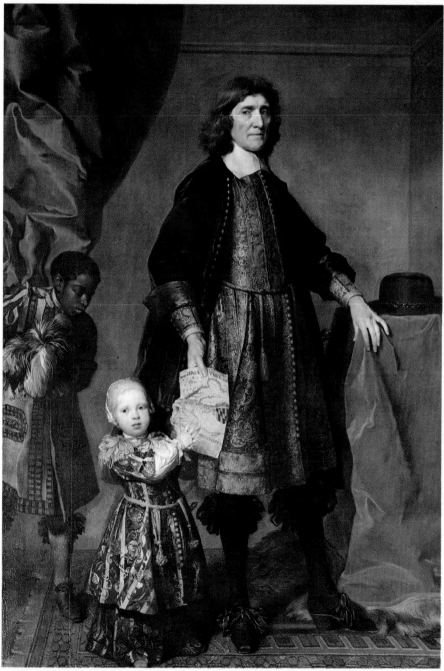

86. Gerard Soest: Cecil, Second Lord Baltimore, with a Child and a Negro Page.
Baltimore, Enoch Pratt Library

than portraiture, and there is a justifiable temptation to ascribe to him other works which are not strictly portraits. A remarkable and pretty certain example is now in the Boston Museum.

Jacob Huysmans (Houseman)

Huysmans is a much lass tangible figure and no great number of pictures can be identified with absolute certainty as his work. He is almost certainly the Jacob Huysmans, a native of Antwerp, who was apprenticed to Frans Wouters at Antwerp in 1649/50. He was perhaps a Roman Catholic and it may well be that much of his work in England consisted of religious and historical works, for Vertue reports that 'the most famous piece of his performance' was over the altar of Queen Catherine's Chapel in St James's. It is certainly with Queen Catherine of Braganza that he is chiefly identified today, and Vertue also reports that he called himself Her Majesty's painter. The Queen's supporters seem to have cried him up for a time as the rival of Lely, about 1664, perhaps soon after his coming to England. In that year (26 August) Pepys saw in his studio the 'Duchess of Richmond in Man's Attire' (Windsor) and the two most ambitious portraits which remain to us today of Queen Catherine of Braganza – the 'Queen as St Catherine' at St James's Palace, and 'Queen Catherine as a Shepherdess' at Windsor [87]. This elaborate confection is the fullest epitome of Huysmans' style, which is more nearly allied to what one may call the Continental Catholic Baroque than Lely's Protestant idiom. It is full of allegorical reference. The Paschal Lamb was the Queen's emblem and the Cupid is probably an allusion to the child of whom she was, in 1664, hopefully expecting to become the mother. In the background other Cupids disport themselves, and one, who is flying, recurs in other Huysmans (the Coke family group [88] and Mrs Granville's 'Anne Granville'.)[15] The ducks and large weeds in the foreground anticipate Wissing, and the colour also, with its metallic lustre and the

87. Jacob Huysmans: Queen Catherine of Braganza as a Shepherdess,
c. 1664. *Royal Collection*
(by gracious permission of Her Majesty the Queen)

sharp, tortured folds, is wholly unlike Lely. With a view to annoying the Queen, the Duchess of Cleveland had Lely paint her in a very similar pose, in a picture now known only from Sherwin's engraving; but the opposite of this, Huysmans deliberately imitating Lely, has yet to be proved and it is better to reject from Huysmans' work the various versions of the

'Father John Hudleston',[17] signed and dated 1685, at Hutton John, a portrait of 'Izaak Walton Junior'[18] of 1691, and a 'Bathsheba' of 1696. He died in London in 1696 and had never been a serious rival to Lely.

Huysmans' was the best, but not the only example of the French style. Its extreme example was only a visitor to London, Henri

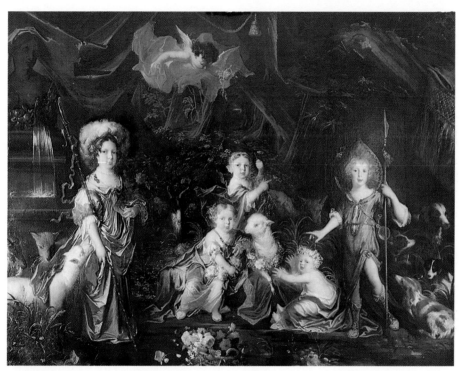

88. Jacob Huysmans: Four Children of John Coke of Melbourne.
Marquess of Lothian, Melbourne Hall, Derbyshire

Duke and Duchess of York which now tend to be ascribed to him.

Huysmans' most important picture is the group of 'Four Children of John Coke of Melbourne' (Marquess of Lothian) [88], in which flowers, sheep, waterfalls, and a Cupid riot unrestrained.[16] No more Baroque group was painted in England. But his signed 'Izaak Walton' at the National Portrait Gallery shows that he was equally capable of severe restraint in the Dutch manner. Later dated works are

Gascars. Just as Huysmans was pushed by the Catholic clique around the Queen, Gascars was pushed by the Catholic supporters of Charles II's sister, the Duchess of Orleans. It is even not unlikely that he was a French agent.[19] He came to London about 1672 and was extremely favoured by the Duchess of Portsmouth: he left soon after Princess Mary had married the Prince of Orange, and Louis XIV, in consequence, ceased his payments to the King (1677). He is next found, in 1678, painting

the Commissioners for the Peace Treaty at Nijmegen, which certainly looks suspicious. He is abundantly represented at Goodwood, but his most outrageous attempt to introduce the French mode is the 'James, Duke of York, as Lord High Admiral' at Greenwich [89],

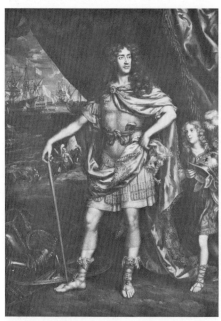

89. Henri Gascars:
James, Duke of York, as Lord High Admiral.
Greenwich, National Maritime Museum

which appears as Gascars in James II's catalogue. His ladies and children wear torrents of lace and simper in the most Frenchified manner, and it is not surprising that his engraved group of the daughters of the Earl of Warwick was sold from Burley-on-the-Hill on 20 June 1947 (73) as by Mignard.

Michael Wright

Far and away the most interesting and serious of Lely's contemporaries and possible rivals was Michael Wright. Not only was he the only

one of them who was British born, he also showed the greatest promise, had the best opportunities, and seems to have had a considerable practice. At least sixty of his works are now known which can be closely dated, and a good many more are convincing attributions, for his style is easily recognized. At his best he is a portrait painter of high distinction, and, unlike his contemporary painters in England, he had come into direct contact with the best painting that Europe was producing in his own time. Yet his promise never fully materialized, and a number of important problems about him remain unsettled. Even his name and his origins are obscure.

The tradition since Vertue's day has been that he was a Scotsman. Vertue had the information from Alexander Nesbit, himself a Scotsman, who was born at Leith in 1682. But an unnamed, no doubt non-juring, source independent of Nesbit and curiously circumstantial, told Thomas Hearne[20] in 1715 that Wright was born in Shoe Lane in the Parish of St Andrew's, Holborn; that he was converted to the Roman Catholic faith by a Scottish priest and taken to Scotland, and thence to Rome. He cannot be traced in the registers of St Andrew's, Holborn, but he is presumably 'Mighelle s[on of] James Wryghtt' baptized on 25 May 1617 in St Bride's, Fleet Street, and his appearance as a youth in Edinburgh is certain, for he was apprenticed to George Jamesone on 6 April 1636 as 'Michaell (Wright), son to James W., tailor, citizen of London'.[21] What he did when his apprentice days were up (about 1642) is not known, but his presence in Italy in 1647 is to be inferred from an etching of a 'Madonna, after Carracci' which is signed 'Michael Ritus'. We know from Orlandi that he was enrolled a member of the Academy of St Luke at Rome in 1648,[22] and he appears in the list of members given by Missirini, as 'Michele Rita, inglese' (*not* 'scozzese'). He was the only British painter so enrolled in the seventeenth century, and the fact that he was a Roman Catholic can be taken as certain. In the Academy at Rome he came into direct contact with the most distinguished artists of the Mediterranean world at this time,

not only the native artists, Algardi, Bernini, and Salvator Rosa, but the very cream of European painting (outside the Dutch). Among the foreigners listed in the Academy of St Luke in 1651[23] appear 'Claudio Melan, Gioachino Sandrart, Nicolo Pussino, Diego de Silva Velazquez, Michaele Rita, pittore inglese'. To have seen Poussin and Velazquez plain is more than was given to any other British painter, but Wright seems only to have made himself master of the superficial qualities of the Roman Baroque.

The trouble seems to have been that, in Rome, Wright became an impassioned antiquary as well as a painter, and perhaps his scholarly and social interests always made painting with him something of a pot-boiling side line. Hearne's informant reported that Wright 'was very well versed in the Latin Tongue, and was a great master of the Italian and French', and also that he 'made himself known to the most celebrated Antiquaries [in Rome], who had a respect for him, and were very ready and willing to communicate their Knowledge to him'. We know from Vertue that many of his gems and coins were later bought by Sir Hans Sloane, and from Evelyn (6 May 1664) that he had a collection of rare shells. It is also corroborated by Torriano[24] that he made a considerable name for himself in Italy, but the only possible evidence for pictures done in these years is the record of a copy of Van Dyck's 'Charles I in Three Positions' [51] (then in Bernini's possession), which appeared in an eighteenth-century sale, and a signed 'Cleopatra' formerly at Welbeck, probably the copy of a Guido. Again according to Hearne's informant, Wright then went into Flanders and became Antiquary to the Archduke Leopold William,[25] and it was perhaps as the result of the Archduke's resignation of his position as Governor of the Netherlands in 1656 that Wright decided to return to England. His first dated work[26] is the small panel (wholly uncharacteristic of the painter in size and material) of 'Elizabeth (Cromwell), Mrs Claypole' [90], signed and dated 1658, in the National Portrait Gallery. The sitter died in 1658 and I have no doubt that the picture is posthumous, but it is not, as

might be supposed, satirical.[27] The fact that it is on a small panel makes it at least possible that it was painted in Flanders.

'Mrs Claypole' is perhaps the most Italianate portrait painted in England in the seventeenth century. It is a mass of Italian emblems and seems to indicate the most deliberate and unblushing toadying to Cromwell, who was Mrs Claypole's father. The relief in the lower left

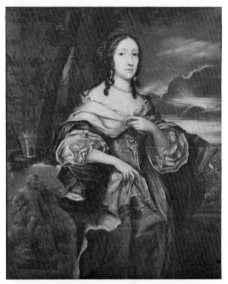

90. Michael Wright:
Elizabeth (Cromwell), Mrs Claypole, 1658.
London, National Portrait Gallery

corner shows Minerva issuing from the brain of Jove and has the legend 'Ab Jove incrementum', which presumably refers to Mrs Claypole's relationship with Cromwell. The tower and laurel are symbols of Chastity, of which the tower represents its incorruptibility, while we know from Ripa that a branch of laurel accompanies the figure of Matrimonial Chastity. It is signed 'I. MRitus', and, for the next twenty years, Wright fitfully puts 'J', 'Jo.', 'Jos' (for Johannes) before the Michael of his signature. No explanation of this is forthcoming unless it signifies his repudiation of the Roman faith. During his London career he was patron-

ized to some extent by Catholic families (there were several examples of his work at Arundel and Wardour Castles), but by no means exclusively so. On the other hand, his selection for the post of Steward of the Household to the Roman Catholic Earl of Castlemaine on his embassy to the Pope in 1685 suggests that he had never abandoned his faith. Already in 1659 he was called 'the famous painter' by Evelyn in his *Diary*, but he never contrived to modify his style according to the prevailing Court taste and, in consequence, he always played second fiddle to Lely. He was, in fact, at the height of his powers in 1659 when he signed and dated the 'Colonel the Hon. John Russell' at Ham House, a picture which shows a revival of the style and spirit of Dobson.

Throughout the 1660s Wright produced a series of portraits in this Dobsonesque vein. His men look as if they were fighting for a cause, and his women look as if they were of gentle birth. Occasionally, as in the 'Sir Robert Rookwood' of 1660 (formerly at Hengrave Hall), he even adopts Dobson's trick of a classical

91. Michael Wright: Lord Henry Howard, later 6th Duke of Norfolk.
Private collection

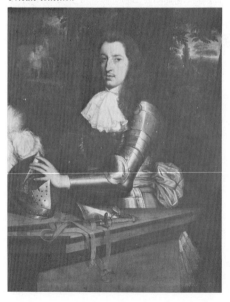

figure in the background. A characteristic (but unsigned) example is the picture from Wardour Castle representing 'Lord Henry Holland, later 6th Duke of Norfolk' [91].[28] The pattern is original and the whole conception of the portrait has a quality of nobility to which Lely never attained. Perhaps with proper patronage Wright might have expanded his powers to their true stature. Instead he was compelled to imitate the Lelyesque, if he was to secure Court patronage. His 'Duchess of Cleveland'[29] (Earl of Lisburne), signed and dated 1670, shows how he tried to add something of his Roman learning to an imitation of Lely's voluptuousness, but it does not bring out those qualities in the sitter which were her chief capital. He did, however, do some work for the Court. In 1667 he painted the child 'Duke of Cambridge' (Buckingham Palace and Belvoir) and he also painted a ceiling (Nottingham) for Whitehall. It may have been these commissions which led him to place 'Pictor Regius' (or some such formula) after some of his signatures after 1668. No official appointment to justify this signature has as yet been traced.

It is conceivable (but unproved) that Wright visited Scotland between 1662 and 1665. The few dated works of these years are of Scottish sitters – the 'Countess of Cassillis' 1662 at Yester (an unsigned companion of her husband is at Culzean) and 'Sir William Bruce' 1665 in the Scottish National Portrait Gallery.

At any rate, Wright was back in London and busy from 1667 to 1669 (at least a dozen pictures from these years are known), and, in 1670, he was considered the next best painter after Lely. On 19 April 1670 the Court of Aldermen of the City of London[30] decided to have the portraits taken of the Lord Keeper and the various Justices of the Common Pleas and King's Bench and Barons of the Exchequer, who had assisted in the difficult adjudications occasioned by the Great Fire of London. After (it is reported but not documented) a failure to agree with Lely, who insisted that the sittings should be at his studio, on 27 September 1670 a committee was appointed to decide on a painter. The names of Wright, Huysmans, and Hayls

were recommended to the committee, but Wright was decided upon and payments to him begin on 28 February 1671. Between 1671 and 1675 Wright painted twenty-two full-length portraits at £36 each, which remained (in, for the most part, sadly restored condition) in the Guildhall until the last war. Now there are only two survivors in a fit state to be hung in the library. These were perhaps Wright's most considerable works and the series by which he was famous to his contemporaries. While he was painting them he also did important work for one of the Aldermen who was responsible for his appointment, Sir Robert Vyner. He painted for Vyner in 1672 the full-length 'Prince Rupert' which, after curious vicissitudes, has found its inappropriate home in the hall of Magdalen College at Oxford: and in 1673 he painted 'Sir Robert Vyner and his Family' (NPG, London) [92], the most ambitious of his

later works, which shows a tendency in the accessories towards the French taste.

Continental models, French or Dutch, seem in fact to have been the sources from which Wright sought inspiration in his later years. About 1676 we first find him putting his sitters into pseudo-Roman attire, as Maes was doing and other Dutch painters, and some of his backgrounds have a distinctly French air. The most original picture of these years is the 'John Lacy in Three Roles' at Hampton Court, one of the earliest actor pictures and the ancestor of one of the great genres of British eighteenth-century painting. This appears to be dated 1675 beneath its present grime, and it is tempting to associate with it, as C. H. Collins Baker has done, the so-called 'Highland Chieftain' [93] in the Scottish National Portrait Gallery, of which there are at least two other versions. But there is a companion picture of 'An Irish Chieftain', of

92. Michael Wright: Sir Robert Vyner and his Family, 1673.
National Portrait Gallery, London

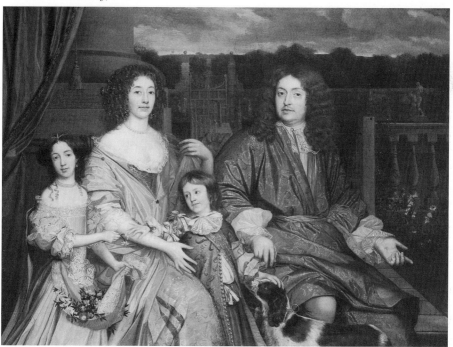

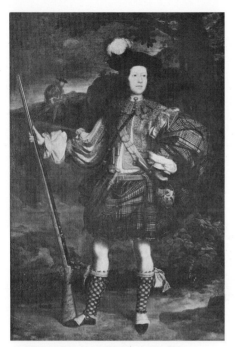

93. Michael Wright: A Highland Chieftain.
Edinburgh, Scottish National Portrait Gallery

which there are versions in the Tate and at Dunrobin Castle. At the end of the 1670s Wright seems to have visited Ireland, and a picture dated 1679 was at Malahide Castle. He was back in England by 1683.

From 1685 to 1687 Wright was back in Rome as Steward of the Household to Lord Castlemaine's singularly fruitless embassy to the Pope, and he occupied his time in writing an account of it in Italian, of which a very entertaining translation in English was 'printed for the author' in 1688. He seems to have done no painting in Rome and such portraits as are known of the members of the embassy while in Rome are the work of Tilson or others. This diplomatic absence proved fatal to Wright's portrait practice, for it was precisely during these years while he was away that Kneller consolidated his position as Lely's successor.

No work certainly dated after his return has been traced,[31] and a note in Vertue (v, 14) shows Wright selling his books in 1694. Hearne's informant gives a picture of Wright forced to sell all his collections to pay his debts and then falling into a decline, and Vertue gives good authority for the statement that he died in 1700 and was buried at St Paul's, Covent Garden (no longer, it is to be presumed, a Catholic). The only possible entry in the Registers is 'John Right' who was buried on 23 February 1699/1700.

In his best work Wright is much more sensitive to the nuances which make up a character than is Lely: and the ladies in his portraits do not all look like one another. It may well have been these virtues which weighed against his popularity, for the ladies represented by all the really successful portrait painters up to and including Hudson, although the fashionable appearance differs from one generation to the next, all seem to have enjoyed looking as much alike as possible. Wright's Catholic background may also have limited the number of his clients.

By what may be no more than an accident it was another Roman Catholic painter who approached most nearly to Wright in the scrupulous honesty of his presentation of character – Pieter Borsselaer. He was a Dutchman and is documented as painting chimneypieces at Middelburg in 1684 and 1687, but he was working in England in the 1660s and 1670s.[32] Little of his work is known, but what survives shows a distinguished and severe sense of character, particularly with elderly sitters. His portrait of 'Sir William Dugdale' (Merevale Hall) is signed and dated 1665 and is accompanied by a portrait of 'Lady Dugdale'. There is a kinship with Soest in the form of the hands and a certain melancholy seems to pervade all his portraits. In December 1673 'Petrus Busler, Lymner' of St Peter-le-Poor, Broad Street, was indicted for recusancy and the same charge appears in 1678 and 1679 for a Petrus Busler of St Gregory's, though he is styled 'generosus' and not 'lymner' under these dates. It is probable that he returned soon afterwards to Holland.

Lely's immediate Pupils: Greenhill, Wissing, etc.

We only hear of Lely recommending to the King the work of painters (such as Verrio and Roestraeten) who were not portraitists and thus were not likely to rival his own monopoly. Most of his own pupils were kept tied closely to the studio and were engaged in executing copies directly after the Master, or the accessories in his own pictures. A few of these emerged as portraitists on their own after Lely's death, but only one pupil of Lely's earlier time achieved independence – John Greenhill – and he predeceased his master.

Greenhill is an interesting figure as one of the few British-born painters of this age who showed real promise, but his career was cut short by dissipation. He came from a family of substantial yeomen of Steeple Ashton, Wilts., and was probably born at Salisbury (where his father became Diocesan Registrar). The date of his birth is usually given as 1644/5 on the slender ground that his younger brother, Henry, is known to have been born in 1646: but he may well have been born about 1640, or even earlier. He went to London as a young man to become Lely's pupil and his apprentice years were at any rate over by 1665 when he signed and dated a 'Portrait of a Mother and Child'.[33] Style and hairdressing in this picture of 1665 exactly agree with the 'First Mrs Cartwright' at Dulwich [94], signed 'J.G.', which we would be unable to date on other grounds. In the Cartwright bequest to Dulwich there are four portraits authenticated as by Greenhill from Cartwright's list of 1687: a head of the Duke of York, Cartwright's first wife's picture 'like a shepherdess', a portrait of Greenhill himself, and a 'Man with a Bald Head'. This last (no. 374) is signed 'J.G.' and could well be an actor's portrait in a character part, and it is significant that it is wholly unlike Lely. The other two pictures at Dulwich now called Greenhill are presumably not by him, as they are not so called in the 1687 list. But the four certain examples may be taken as a standard for Greenhill's early style of c.1664/5, and are nearer to Soest than to Lely. In 1667

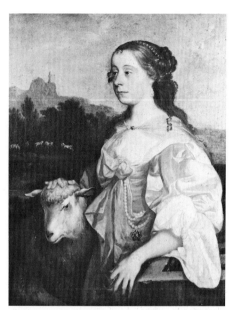

94. John Greenhill: The First Mrs Cartwright, *c.* 1665. *Dulwich College*

Greenhill did his one known etching, a portrait of his brother Henry: and it is not until about 1673, when we next meet him for certain, that his imitation of Lely is very close. The 'Seth Ward, Bishop of Salisbury' (Salisbury Guildhall) was commissioned from Greenhill in October 1673; and a portrait of 'Sir John Oxenden, Second Bart' (collection the late Richard Jeffree) is dated 1673 and signed. The 'posture' in the latter is one Lely was using about 1670/1 and the picture is hardly to be distinguished from a Lely studio work. Later still, Greenhill escaped from this servitude to Lely and was branching out with a style of bust portrait which anticipates Riley when death overtook him, on 19 May 1676.

Only three portraits are known of this last phase of Greenhill, which is much the most interesting – the 'Captain John Clements' at Greenwich (which has always been ascribed to Greenhill); another portrait of a 'Naval Officer' at Greenwich [95], with *JG* in a monogram,

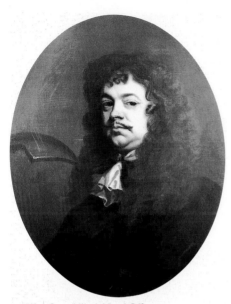

95. John Greenhill: A Naval Officer.
Greenwich, National Maritime Museum

which was sold at Lord Kinnaird's sale on 21 June 1946 (71) as 'Admiral Grenfelt' by Sandrart; and a portrait of 'Thomas Weedon', with a similar monogram, in the Earl of Ellesmere sale, 18 October 1946 (93). The last suggests a possible date, as it may be a marriage portrait of 1675,[34] so that this group would represent Greenhill's final style. There is something sturdy and solid about these pictures which foreshadows the style of the generation which succeeded Lely, of which Greenhill would seem to be the pioneer. The Cartwright portraits showed that Greenhill was already associating with players at the outset of his career, and it was this association which was his undoing. The society he kept in his latter days is sufficiently indicated from the fact that Mrs Behn (for whom he nourished a passion) and Lord Rochester wrote poems on his death.

The most important of Lely's later pupils, who emerged into independence on his death in 1680, was Willem Wissing. Like Greenhill he too died in his thirties, just as he was developing a style of his own: but it was a style neither

sturdy nor restrained. The essential facts about Wissing's life can be extracted from the fulsome Latin of the monument put up to his memory by John, Earl of Exeter, in St Martin's, Stamford.[35] He was born at Amsterdam in 1655, was a pupil of Lely, and had spent some time in France. His early training took place at The Hague, whence he came to England in the latter part of 1676; he presumably entered Lely's studio at once. In the accounts of Lely's executors he appears as one of the assistants, and it may well not have been until after Lely's death that he went to France, where he picked up a passion for metallic flowers, huge weeds, and a generally frenchified line in accessories. Dated works in England begin to be numerous in 1684 and he certainly painted 'Charles II' (St James's Palace). On the accession of James II he found particular favour with the new King and was sent to Holland in the summer of 1685 to paint the Prince of Orange (signed versions at Penshurst and St James's Palace, etc.). On his return he painted the whole royal family, and mezzotints after a series of 'originals painted by Mr Wissing' are advertised in the *London Gazette* for 19/23 August 1686. But his chief patrons during his last years (1685–7) were a group of allied families in Lincolnshire and the surrounding counties. His first patron in the group was Sir John Brownlow, whose wife he painted at full length in 1685: this is still at Belton together with the portrait of the infant 'Elizabeth Brownlow' [96] surrounded by a veritable shrubbery of exotic weeds. The same tendency appears in other children's portraits of this date and in a number of full-lengths (Grimsthorpe Castle and elsewhere). Finally Wissing was taken up by the Earl of Exeter, and he died at Burghley while painting what is certainly his masterpiece, the young 'Lord Burghley' with dog and gun [97], which is still at Burghley House. Wissing has been damned by recent writers as the apex of vulgarity in seventeenth-century portraiture, but this last picture of his shows him working in the tradition which runs from Van Dyck to Reynolds, and he might well have developed into a painter of distinction. All his known work was crowded into four years

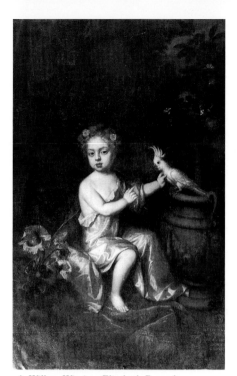

96. Willem Wissing: Elizabeth Brownlow.
The National Trust, Belton House

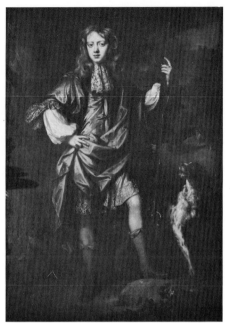

97. Willem Wissing: Lord Burghley, *c.* 1686.
Burghley House Collection

and he was at least as popular as Kneller during these years. His death left the way open for Kneller's all too undisputed supremacy.

Of the other personalities involved in Lely's studio after his death we know little. The man who finished most of the pictures seems to have been Sonnius, of whom little more is known than that Roger North called him 'old and touchy' in 1687. One of Lely's chief hands, however, must have been Thomas Hawker, who, apparently in hopes of succeeding to Lely's practice, took over Lely's house and studio from 1683 to 1685, but had finally to be ejected for insolvency. There is a full-length in robes of the 'First Duke of Grafton' (Euston Hall), of about 1680/1, which is engraved as by T. Hawker, and the signature 'Tho Hawker Pinxit' appears on a charming oval bust of the boy 'Third Earl of Rochester' once at Hinchingbrooke, of about the same date. Both these owe everything to Lely and have nothing individual about them. The only other known work is a group of 'Five

Children of Theophilus Leigh', about 1696, at Stoneleigh Abbey, whose signature once read 'THawker fecit'. This shows an adaptation of the Lely manner to the Kneller style and has a certain rustic charm. The same Hawker, presumably, was living in Covent Garden and patronized by the Leighs' kinsman, the future Duke of Chandos, in 1700 and 1701. There is no evidence to equate him with the 'Edward Hawker, painter' who is recorded by Vertue as alive in 1721 aged about eighty. But a Thomas Hawker was buried at Covent Garden on 5 November 1699.

The most devoted follower and copyist (she was hardly the pupil) of Lely was Mary Beale. Born Mary Cradock, she was baptized at Barrow, in Suffolk, where her father was the incumbent, on 26 March 1632/3. In 1651/2 when she married Charles Beale she was already practising painting.[36] Very little, however, is known about her work until about 1671. From that year to 1681 we have transcripts of several

of her husband's diaries, which cover six years and give a record of her work. About 140 portraits are recorded for these six years, a number being copies after Lely, and a goodly proportion of the sitters being clerical. Enough of her work has been identified to show that, with the exception of an occasional portrait of a sympathetic sitter, she was a drab and unoriginal follower of Lely's manner – at any rate after 1670. She particularly affected heads in feigned stone ovals adorned with fruit in stone. She was buried at St James's, Piccadilly, on 8 October 1699.[37]

Among Lely's professional copyists should be mentioned Theodore Russel (Rousel), baptized in London on 9 October 1614 and at first a pupil of his uncle, Cornelius Johnson, and later of Van Dyck. He specialized in neat, small-scale copies of Van Dyck and, later, of Lely, and survived until 1688/9. A female amateur who painted her own portrait in the style of Lely and also did small-scale pictures, both portraits and mythologies, was Miss Anne Killigrew,[38] who died in 1685 aged twenty-four.

Minor London Painters

Bare mention must suffice for a few painters known only from occasional works. One Robert Mallory, a City painter (documented c. 1653–88), was perhaps the vendor rather than the painter of the 'Walter Pell' which hangs under his name in the Hall of the Merchant Taylors Company. William Trabute of St Anne's, Blackfriars, by whom there is a signed portrait of 1670 in the Oldswinstead Hospital, Stourbridge, was indicted for recusancy in 1673, and a portrait, said to be signed and dated 1677, is reproduced in *The Ancestor*, XII, 17. Thomas Sadler, whose parents married in 1645, is best known for his signed portrait of 'John Bunyan' of 1684, and another portrait, of 'Mary Bryan', signed and dated the same year, belonged to Sir Bryan Godfrey-Faussett; Walpole, on good authority, says he was a friend and pupil of Lely and took to miniature painting in his later years. Matthew Snelling (working 1647 to 1672) was

also mainly a miniature painter, but a very feeble portrait of 'Dr Baldwin Hamey' belonging to the Royal College of Physicians (to which it was presented by his nephew in 1700) has always been ascribed to Snelling, although his initial is now given as 'J'.

Painters in the Provinces

By the latter part of the seventeenth century it was becoming increasingly frequent to find a portrait painter established in the larger provincial towns. A few examples may be given for widely separated areas. In York, which developed a considerable artistic life of its own at the turn of the century, a portrait painter named Comer was settled for a number of years. Charles Beale mentions him on a visit to London in 1677 and there are bills for his work at Welbeck dating from 1683 and 1685. At Welbeck a group of full-length portraits in the style of a scholar of Lely can be associated with the bills. Moving across the country to Cheshire, a portrait painter, Thomas Gomersall (Gumerson), said to be of Chester, was married at Wrexham in 1670,[39] and was living at Wrexham in 1671 and at Shrewsbury in 1675/6: in 1682 and 1683 there are payments to him for portraits in the Chirk Castle accounts. A Jeremias Vandereyden, a pupil of Hannemann at The Hague in 1658, received payments (Belvoir MSS.) in 1675 and 1676 for work for Lord Roos, and was buried at Stapleford, Leicestershire, 17 September 1695, under the name of 'Jeremiah Vanroyden'. Among the Salisbury Corporation accounts[40] there are payments in 1672 and 1683 to Christopher Gardiner of Bristol, painter, and some of his uninspiring works survive. At Oxford, thanks to Mrs Lane Poole's researches,[41] rather more is known. The tradition of Sampson Strong was carried on by John Taylor, who became Mayor in 1695. He was perhaps living in London in the Parish of St Botolph, Bishopsgate, where he married in 1655, but his Oxford residence and activities begin about that year, and he continued at Oxford for forty years, doing portraits for the

city, the university, the colleges, and Christ's Hospital, Abingdon, a good many of which survive. Mention should also be made of James Gandy (1619–89), who is said to have settled in Ireland about 1661 and had a good practice there; I have never seen a documented example of his work.

Occasional Foreign Visitors

A few foreign painters of a more ample reputation worked for periods of varying length in England. There is little to justify the interesting legend of Rembrandt's brief residence at York in later life, but one of Rembrandt's pupils, Samuel van Hoogstraeten (1627–78), worked in London from 1662, until the Great Fire of 1666 led him to return to Dordrecht. The only portrait so far known from these years is that of 'Thomas Godfrey' (Sir Bryan Godfrey-Faussett), signed and dated 1663, but he made a name for himself by ingenious perspective inventions. Pepys admired one of these (19 January 1663) in Mr Povy's closet, and that is probably the 'Perspective of a Corridor' dated 1662 at Dyrham Park (Glos.), where there is also another very large 'Perspective of a Court Yard'.

Benedetto Gennari (1633–1715), a nephew of Guercino, was taken into the employment of Charles II and much employed on religious painting for the Crown, for which the Queen's Catholic Chapel made considerable demands. He reached England in September 1674[42] and remained until the Revolution of 1688. A good many of his mythological paintings, authenticated by the James II catalogue, are still among the storerooms at Hampton Court. In 1687 he was painting various pictures for the Chapel at Whitehall and in 1682 he did the 'Holy Family' for the private chapel in St James's Palace (City Art Gallery, Birmingham): all of which were paid for out of the Secret Service money of James II. He also painted a number of portraits of leading figures about the Court, most of which remain to be traced. But his Italian style left no traces in England.

Nicolas de Largillierre (1656–1746), although he belongs to a later European generation, should be mentioned here, since he was one of the latest recruits to Lely's studio. After entering the Antwerp Guild as Master in 1672, he came to London in 1674, an accomplished fruit and flower painter. It was in Lely's workshop that his talents as a portraitist first developed, and he probably remained attached to it until Lely's death in 1680, although he painted a few portraits on his own in England, which are only known from engravings. A signed 'Still-life' of 1676 was in Lord Darnley's sale on 1 May 1925 (40): and 'Two Bunches of Grapes', signed and dated 1677, in the Lugt Foundation in Paris, show great delicacy and accomplishment. These mark the beginnings of still-life painting in England, a genre which never found much favour. Largillierre left London for Paris in 1682, impelled by the Test Act, but he returned for a short visit in 1685/6 to paint the new King and Queen. Mezzotints after these are advertised in the *London Gazette*, 9/13 December 1686. He carried something of the spirit of Lely to France, but left no mark of his own on British painting.

The still-life tradition, in a rather original vein, was also successfully practised by Pieter Roestraeten, a native of Haarlem and son-in-law of Frans Hals. Born about 1631, he was apparently in London by 1666, and at first painted scenes of peasant genre. There are half a dozen of such pictures, signed and dated between 1672 and 1676, at Ugbrooke, showing a surgeon, a cobbler, a woman plucking a turkey, and other domestic scenes. But Roestraeten's main forte was a new kind of still-life, in which wrought plate, silver, or ivory tankards, and the like, form the main ingredients. These are not uncommon in moderate size, and an enormous example, dated 1678, was at Chatsworth. He was buried at St Paul's, Covent Garden, on 10 July 1700.

Another Dutchman, the Leyden painter Edward Collier, did variations on this kind of still-life with letters, gazettes, globes, and so on. He appears to have been in London for a short time about 1695/8, and the last known date for

him is at Leyden in 1706. It should be remarked that Dutch painters seem to have done still-life arrangements of this kind in Holland with English letters and newspapers – presumably for the English market. Lord Lothian seems to have been a particular patron of this kind of painting, for there remain at Newbattle Abbey examples of Roestraeten and Collier and the solitary signed 'Flower Piece' of B. Ferrers (d. 1732) dated 1695.

History Painting[43]

Vertue records the names of a number of history painters of whose works no trace remains today; but decorative history on walls and ceilings, which was to expand to real importance in the hands of Verrio and Laguerre, finds its beginnings in the personality of Robert Streeter, who left no branch of painting untried and would have been a universal genius had he been en-

dowed with the requisite talent. Pepys speaks of his 'perspectives', and these may have been pictures in the vein of Hoogstraeten, but his main reputation was for landscape and history. The traditional date of his birth is 1624 and he died early in 1679. He was certainly trained abroad, already had a high reputation in England by 1658, and was appointed Serjeant Painter by Charles II at the Restoration in 1660 – presumably as the most handy, British-born, painter-of-all-work available. The Earl of Bedford bought a landscape from Streeter for his bedroom (presumably for a chimneypiece) in 1660 for £4 10s. (Woburn MSS.) and the one landscape by him known, the 'View of Boscobel House' (Hampton Court) [98], which appears as by Streeter in the James II catalogue, may well have been painted not long after the Restoration. It is not pure topography and shows some of the resources of art, and must count as the first respectable ancestor of the 'country house portrait' which was to become a popular genre

98. Robert Streeter: View of Boscobel House.
Royal Collection (by gracious permission of Her Majesty the Queen)

in the eighteenth century. Two rather non-descript 'Prophets' exist at St Michael's, Cornhill,[44] but the most important of Streeter's surviving works is the ceiling of the Sheldonian Theatre at Oxford, painted in 1668/9. A variety of allegorical figures appropriate to the building are arrayed in the heavens, from which they spread their benign influence. Mosaic Law, the Gospel, History, Divine Poesy, Mathematics, Astronomy and Geography, Architecture, Rhetoric, Law, Justice, Physic, Logic, Printing, and Truth are the principal figures, and the whole is disposed with at least the science of the painters of the Italian or French Baroque. The execution may be unselect and the whole ceiling a very minor example of a form common enough in the rest of Europe, but it is not in the least amateurish in compositional resource. But though the fashion may have been set by Streeter, it was more profitably and amply exploited by foreign visitors whose reputation it is difficult for us to understand today.

Landscape

There was no shortage of landscape painting in England at this time, but nearly all of it was of poor quality and most of it was unrelated to the English scene.[45] Lankrink, who painted backgrounds for Lely, continued painting landscapes in the style of Gaspard Poussin or Francisque.[46] He was buried at Covent Garden on 11 July 1692. Jan Loten (d. 1681) painted scenes in the Dutch taste; Robert Aggas (d. 1679) had a considerable reputation, and one of his works remains in the Painter-Stainers' Hall: other names have been preserved by the piety of Colonel Grant, and one may add, for landscape painters in the provinces, the record of one Thomas Francis, who was painting 'landscapes for chimney pieces' at Chirk Castle in 1672.

Apart from Streeter, however, the only two names of note are Hendrick Dankerts and Jan Siberechts. Dankerts (whose elder brother John was a history and portrait painter and also worked in England) became Master in The Hague Guild in 1651 and accompanied his brother to Italy in 1653. He married his first wife in the Catholic Chapel Royal in London on 24 October 1664 and was thenceforth a good deal employed by the Crown. The royal collection still contains a number of his landscapes. He specialized however, in views of famous places which he turned out to pattern. In 1669 he did for Pepys views of Windsor, Whitehall, Greenwich, and Rome, and the Earl of Bedford bought from him in 1675/6 'a landscape of Plymouth and the citadel there and parts adjacent' for £10. No doubt he had made drawings on the spot, which he kept as his stock-in-trade for turning out to order views of famous places. He left England about the time of the Test Act in 1678 and died in Amsterdam apparently early in 1680.

Jan Siberechts is at times a good deal more interesting.[47] He was baptized at Antwerp on 29 January 1627 and was a fully formed landscape painter when he came to England some time between 1672 and 1674, perhaps on the invitation of the Duke of Buckingham. He too was a Catholic and one of his daughters was employed in making lace for the Queen's pious purposes. He remained in England until his death, which traditionally took place in 1703. Although the bulk of his paintings executed in England are simply landscapes in the Flemish style with Flemish peasants, occasionally a hint of the English scene creeps in. There is, however, a group of paintings which show him as the first professional exponent of the 'country house portrait'. As early as 1675 and 1676 he painted views of 'Longleat' which still belong to the Marquess of Bath, he painted Chevely in 1681 (now at Belvoir Castle), and in 1694 he was summoned to Chatsworth to paint the old house before it was demolished. This picture only survives in what is probably a later copy by Richard Wilson, but a drawing at Amsterdam inscribed 'By Chatsworth in Derbyshire 1694' is the first fresh and sincere view of one of the wilder pieces of British scenery done by a competent artist and without any attempt to Italianize the scene. In 1695 he painted for Sir Thomas Willoughby a more or less topographi-

cal view of 'Wollaton Hall and Park' (Lord Middleton), and a number of other pictures, one of which (undated), a 'View of Nottingham and the Trent' [99], has claims to be nearly the beginning of British landscape painting. He

Sporting Painting:
Francis Barlow (d. 1704), etc.

It is refreshing and unexpected to come upon so simple and honest a painter as Francis Barlow

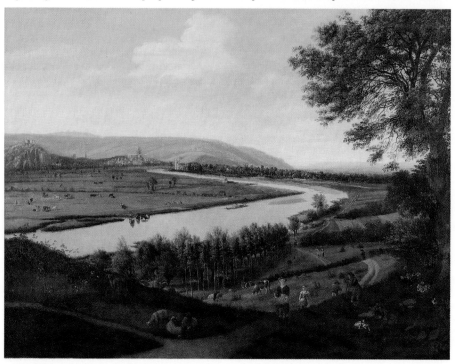

99. Jan Siberechts: View of Nottingham and the Trent. *Lord Middleton, Birdsall House, Yorks*

must have travelled extensively in these years, for there is a 'View of Nannau Hall and Park' in Cardiganshire dated 1696; another view of a country house, dated 1697, was in the Wanstead sale in 1822; and in 1698 he signed his last known work, a panoramic prospect of 'Henley on Thames'.[48] This aspect of Siberechts has been neglected in favour of his better-known and more conventional pictures, but he has better claims than anyone to the title of the 'father of British landscape'.

in a period such as this. There is about him that tinge of amateurishness which clings to so much of the best British painting, married to faithful observation of nature and to honesty. In one of Thomas Rawlinson's notes he is felicitiously called 'a happy painter of birds and beasts', but he is a little more than that, though birds and beasts were his main subject. He was probably (as he calls himself) a Londoner, but an early tradition (found in Peck's *Desiderata Curiosa,* 1732) calls him 'Barlow of Lincolnshire'. The date of his birth is uncertain, but he was probably born in the 1620s and he first emerges as an etcher in some illustrations to Benlowe's *Theophila,* 1652. The text on the portrait title-

page of that book (which was perhaps also engraved by Barlow) curiously enough uses in his praise the same expression of approval as Lovelace had used of Lely in 1647: 'Where others' art surpast you find / They drew the body, he the mind.' As early as 1653 Richard Symonds records that he received £8 for a picture of fish, and Evelyn in 1656 (*Diary*, 1908

Pyrford, one of which is dated 1667, there is a veritable anthology of wildfowl and waterfowl, as well as a frieze of closely characterized hounds. There is a lively picture at Parham of a hound holding on to the leg of a flying game-bird, and among a group of Barlows formerly at Shardeloes (one of which seems to have on it the date 1696) there are carp and a huge pike, as

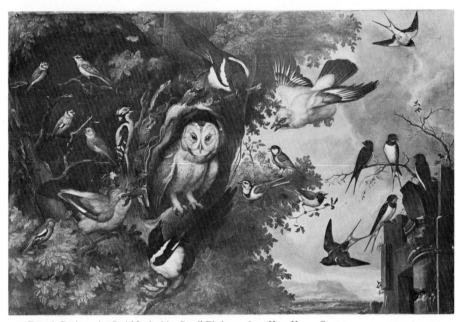

100. Francis Barlow: An Owl Mocked by Small Birds, *c*. 1673. *Ham House, Surrey*

ed., p. 188) calls him 'the famous painter of fowls, beasts and birds'. A typical example is 'An Owl Mocked by Small Birds' [100], one of a pair of overdoors at Ham House, of which the companion (which is much damaged) is signed and dated 1673. No doubt it lacks the elegance of Baroque pattern with which Hondecoeter orchestrated his arrangements of fowls, but it is not without a feeling for design and it reveals that loving observation of animal structure and character which was to achieve its greatest exponent in Stubbs. Barlow must have watched with close attention all manner of creatures. In the half-dozen, mainly vast, canvases in Lord Onslow's collection[49] which Evelyn saw at

well as a charming full-length portrait of a boy. Perhaps Barlow did not do very many paintings (not many are known), for he could never resist crowding them with animal life. His drawings, mainly for engraving, and his own etched illustrations are numerous and cover many fields of sport untouched by his known paintings. He is the real father of British sporting painting and one of its more distinguished exponents. Recent research has shown that a Dutchman, Leonard Knyff, was the painter of what was, till lately, considered to be Barlow's masterpiece, 'Arthur, Third Viscount Irwin' (Temple Newsam House, Leeds) [101]. This too is crowded in the same way with animal life.

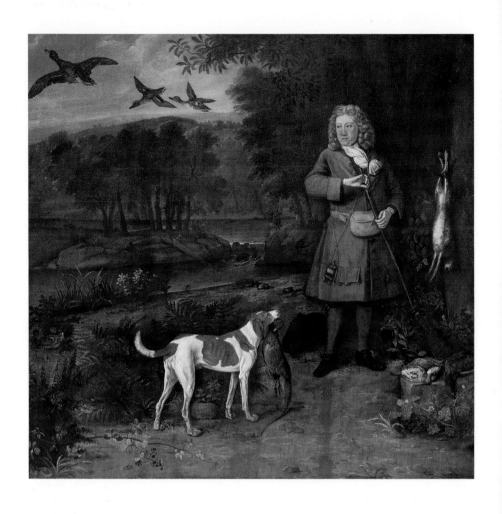

101. Leonard Knyff: Arthur, Third Viscount Irwin, 1700. *Temple Newsam House, Leeds*

Knyff died in 1721, seventeen years later than Barlow.

A contrast to Barlow is provided by the Rotterdam painter, Abraham Hondius, who had travelled in Italy before he settled in London about 1666. He died in London about January 1695, and painted all manner of subjects, but specialized in animal scenes, usually of some savagery. His technical equipment was far superior to Barlow's and he had a considerable sense of Baroque design, but there is a lack of humanity and of loving observation about all his animal paintings, which, by comparison, throws Barlow's virtues into relief.

Finally, one should mention the first appearance during this period of a minor form of portrait painting which was long to remain next in popularity with British patrons after the portraits of their immediate family – the painting of their prize-winning animals. An obscure portrait painter named Otto Hoynck, from The Hague, where he became a Master in the Confrérie in 1661, came to England, where he became 'painter to the Duke of Albemarle'.[50] He is last recorded in an Amsterdam document (perhaps his will) of 1686, but the point of interest about him is that he signed a picture of a greyhound (Christie's, 16 March 1956 (121)) which was the winner of Lord Shaftesbury's collar in 1671 and of the Duke of Albermarle's collar in 1672. The picture is dated 1675/6 and is the earliest example of its class at present known.

Miniature Painters

Although the absolute pre-eminence which miniature painting achieved in the time of Hilliard was not maintained throughout the seventeenth century, the miniaturists of Lely's day were sufficiently important to require attention here. From the close of the century they can be omitted from a general history of painting in Britain.

Peter Oliver, the eldest son of Isaac Oliver, was born about 1594, and was buried in St Anne's, Blackfriars, on 22 December 1647.

Although a competent painter of portrait miniatures, he was of nothing like the importance of his father, and he specialized in miniature copies after Italian paintings. More remarkable was his near contemporary, John Hoskins, whose first signed works date from the 1620s. Hoskins emerges from the style of Isaac Oliver and had evolved, by the time of his death on 22 February 1664, a new style parallel with Lely's style in portraiture. He has not yet been altogether disentangled from his son, another John Hoskins, but, as no dated works by either are known from after 1664, it is almost certain that the elder Hoskins was the only one of the two to count. The elder Hoskins was limner to Charles I, who granted him in 1640 an annuity of £200 a year for life – but he must already have been, by that date, employed by the Crown for a number of years. His real importance lies in the fact that he was the uncle and teacher of Samuel Cooper, who stands, with Hilliard, as one of the two greatest British painters in miniature. Cooper, like Hoskins before him, executed a number of miniatures which were reductions in little after portraits by Van Dyck or others, but the great bulk of his work was clearly from direct sittings. After the end of the century the work of the professional miniature painters became more and more a matter of reproducing large paintings by others in little.

Samuel Cooper[51] is a somewhat mysterious figure. He was born in 1609 and died in London on 5 May 1672. After Van Dyck he was certainly the most widely cultivated artist of his age in Britain, and he had the biggest international reputation in his own day of any British painter. His prices were at least on a level with Lely's and we know that Pepys, in 1668, paid Cooper £30 for a miniature of his wife, without the frame. Cooper is generally supposed to have worked with Hoskins at least until 1634 and he is known to have travelled extensively on the Continent. These travels must be fitted in before 1642, when the dated series of his works begins. In the 1640s he painted Royalists and Parliamentarians alike and his portraits of Cromwell and his near associates are much the most distinguished likenesses of the chief

figures of the Commonwealth. This did not prevent his being appointed limner to Charles II; and he painted most of the chief persons of the Restoration Court. Many of his miniatures are thus of the same sitters as Lely and we may compare the interpretation of the two artists. There can be no doubt that Cooper is always the better artist when any qualities of refinement are called for. His talent has a feminine delicacy about it, it is a wood-wind instrument by comparison with Lely's brass.

The next generation is best represented by Thomas Flatman (1635–88), a gentleman by birth and education, and Lawrence Cross (or Crosse), who died in 1724, aged something over seventy.[52]

Painting in Scotland

An otherwise unknown painter who signs himself L. Schünemann appears to have been working in Scotland in the later 1660s. A portrait of 'Lady Margaret Hamilton', signed and dated 1666, was in the Hamilton Palace sale in 1919,[53] and the Scottish National Portrait Gallery has a signed 'Duke of Rothes', probably painted soon after he became Lord Chancellor in 1667. The several painters of the name of Scougall, however, seem to have been the leading portrait painters in Scotland at the time, although there is some confusion about them. A more or less putative John Scougall, whose supposed 'Self-portrait' is in the Edinburgh Gallery, has already been mentioned among the contemporaries of Mytens. But it may well be that this portrait is rather later than it looks and is by the first of the Scougalls for whom there exists anything like a historical documentation – David Scougall. He appears under date 17 May 1672 in Sir John Foulis of Ravelston's Account Book, and two gentle and rather timid little companion portraits of the 'First Marquess of Lothian' and the 'Marchioness of Lothian', now in the Scottish National Portrait Gallery, are dated 1654 and that of the lady is inscribed (rather than signed) 'Dd Scougall'. These do not agree at all in style with the accredited works of John Scougall.

John Scougall, who was known in later life – to distinguish him from his son, George – as 'Old Scougall', is a fairly clear figure and was the leading portrait painter resident in Edinburgh

102. John Scougall: Sir John Clerk, First Baronet, 1675. *Sir John Clerk, Bt, Penicuik House, Midlothian*

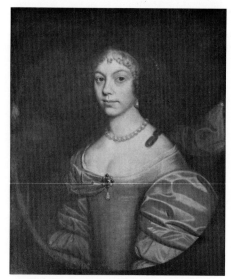

103. John Scougall: Lady Clerk, 1675. *Sir John Clerk, Bt, Penicuik House, Midlothian*

during the last quarter of the century. He died at Prestonpans in 1730 at the age of eighty-five and he probably gave up painting about 1715. The first certain reference to him[54] is in the accounts at Penicuik House for November 1675: 'To John Scougall for 2 pictures £36' (i.e. £36 Scots = £3 sterling). These pictures can fairly confidently be identified with the portraits of (presumably) 'Sir John Clerk, First Baronet' [102] and 'Lady Clerk' [103] still at Penicuik. They are his best and most sensitive portraits at present known and I am inclined to see in them something of the influence of Michael Wright, who was perhaps in Scotland in the 1660s. Among the Wemyss Castle accounts are three for portraits signed by John Scougall in 1692, 1694, and 1697, and his name occurs several times in Lady Grisell Baillie's Household Book[55] from 1696 to 1705. Among the pictures at Mellerstain which descend from Lady Grisell are several inscribed in a hand of the 1720s 'Scugal P.' or 'Old Scugal P.' – 'Mrs Kirktown' 1694, 'Rachel Baillie' 1696, 'Grisel and Rachel Baillie' as children 1698, and 'Patrick, Lord Polwarth' 1700. These are much harder and more perfunctory than the Penicuik pictures and we must assume that Scougall's quality steadily deteriorated as his age advanced. He worked for the Glasgow Town Council in 1708/12 and 1715, painting portraits of Kings and Queens which are mainly feeble copies after stock designs by Kneller. From 1715 to 1724 there are various payments to his son George Scougall, whose style is almost beneath consideration. Portraits in the style of John Scougall are fairly numerous in Scottish collections, but some of them are probably by David Paton.

David Paton is best known as a miniaturist. Copies of plumbago miniatures after Samuel Cooper of Charles II, dated 1668 and 1669, are at Ham House and Drumlanrig, and the Duke of Hamilton possesses three frames, each containing five plumbago miniatures, which are signed on the mounts 'David Paton fecit 1693. Edinburgh'. But he also painted in oils, as early engravings testify. The original of the engraved 'Thomas Dalyell' (d. 1685) appears to be the picture at The Binns, and the original of the engraved 'Sir John Nisbet' (d. 1687) is at Winton Castle. This latter is very close to Scougall in style. The last date at present known for Paton is a receipt among the Wemyss Castle accounts, dated 26 March 1697, and signed 'David Paton, Leith'.

A journeyman painter, for whom mention is almost more than sufficient, Jacob de Wett, contracted in 1684 to paint one hundred and ten (largely legendary) Kings for Holyroodhouse, where they remain. And he did similar work at Glamis Castle in 1688/9.

THE AGE OF KNELLER AND ENGLISH BAROQUE

CHAPTER 7

THE DECORATIVE PAINTERS FROM VERRIO TO THORNHILL

All the great movements in European painting during the seventeenth century passed Britain by. The expansion of the Baroque style took place largely in Catholic countries, but Rubens had left a noble example of it in the ceiling of the Banqueting Hall at Whitehall. The coming of the Commonwealth left it without a successor. The realistic movement associated with the name of Caravaggio had sent one of its best painters, Orazio Gentileschi, to the Court of Charles I – in vain. The classic art of Poussin was unknown in Britain and those great controversies between the adherents of Poussin and those of Rubens which enlivened Paris at the close of the century had no echo in London. But the Court and the nobility who looked to France for the guidance of taste were aware that it had become fashionable for the staircases and ceilings of houses to be covered with vast mythological or allegorical paintings, and, by the time Baroque painting had lost its initial fire and faded into decorative platitude, it was introduced, in this watered form, into the British Isles. A beginning, by a native painter, has already been mentioned – Streeter's ceiling in the Sheldonian Theatre at Oxford. Its better-known foreign practitioners were not more distinguished artists than Streeter. Of a number of names two still linger in the public consciousness, immortalized by Pope's sufficient account of the kind of wall or ceiling that they decorated – 'where sprawl the Saints of Verrio and Laguerre'.

Antonio Verrio

Verrio perhaps counts as the most heavily remunerated painter in Britain up to the time of Sir John Millais. It suggests some reflections on the British character that he is also one of the worst. In a grandiloquent inscription on one of his (now destroyed) paintings at Windsor Castle he calls himself a Neapolitan and 'of no humble stock'. By a considerable stretch 'Neapolitanus' could imply that he was born at Lecce, in the heel of Italy, and it has been cheerfully accepted that he was born there about 1639 since the statement was first made by de Dominici, one of the least reliable even of Neapolitan writers. There is certainly a tradition today at Lecce of one or more painters named Verrio who sought their fortune outside the Salentino – and came to a bad end – but I am not convinced that the two paintings at Lecce now called Verrio are early works of the painter who came to England. De Dominici mentions a ceiling in the Pharmacy of the Jesuit College at Naples which was signed and dated 1661 by Verrio, but this has vanished. In the later 1660s Verrio was working at Toulouse,[1] and two altar-pieces by him survive in the Toulouse Museum; in 1671 he was *agréé* at the Paris Academy, and it is probable that he came to England the same year at the instigation of the Duke of Montagu. His first work was for Lord Arlington, but this too has vanished. On 5 May 1675 Verrio became a denizen and his first royal employment is said to date from 1676,

although the published warrants do not begin until 31 October 1678. From then until the Revolution of 1688 Verrio was in continuous employment by the Crown and received something like five and a half thousand pounds for work done at Windsor Castle, as well as several 'bounties' from the Secret Service money and payments from the same source (after 1685) for his subsidiary role as gardener at St James's Palace. Details of his work for Windsor and (after 1686) for Whitehall can be extracted from the Calendars of State Papers (Domestic) and Calendars of Treasury Books. The most illuminating is a warrant dated 16 November 1678 that there be no molestation to 'several foreigners, being painters and other artists employed in paintings and adorning Windsor Castle', for being Popish recusants. These are named as 'Antony Verrio and Frances d'Angely his wife, and John Baptiste and Francis their sons: Michael Tourarde, Jacob Coquet, – Lanscroon, Bertrand du Mailhey, painters employed by Verrio: René du Four his apprentice . . . etc.'; later is added, 'Antonio Montingo, a painter of flowers employed by Signor Verrio at Windsor Castle'. Evelyn saw the work being done on 23 July 1679 and speaks of 'that excellent painter, Verrio, whose work in fresco at the King's Palace at Windsor will celebrate his name as long as those walls last'. From 1680 he was being paid at the rate of £200 a year, and, by Royal Letters Patent dated 30 June 1684, Verrio was appointed 'our chief and first painter', and with all rights and privileges belonging to that post 'as amply as Sir Peter Lely, late deceased, or any other held the same'. Only the most meagre fragments remain of the work at Windsor and none of the work at Whitehall, which occupied most of Verrio's time until he was turned out of his house and employment at St James's after the Revolution and Riley and Kneller were jointly sworn and admitted as chief painter in December 1688.

Verrio at first refused to work for William III and his name disappears from the Treasury Books from 1688 to 1699. His chief employment during these years was at Chatsworth[2] – where he painted the Great Staircase in 1690,

the State Dining-room 1691/2, the altar-piece for the Chapel 1693, and the ceiling of the present Library in 1697/8 – and at Burghley. He had done work for Lord Exeter in 1687 and was certainly a member of the Earl of Exeter's household at Burghley House in 1694 when he was probably engaged on the vast wall spaces which he covered there from 1694 to 1697. In 1699 a new period of royal patronage begins and he was employed at Hampton Court and Windsor from 12 June 1699 until early in 1705. Soon afterwards his eyes failed and he was pensioned by Queen Anne. He died at Hampton Court 15 June 1707.

His work can be sufficiently seen on the Great Staircase at Hampton Court, which includes most of the gods and goddesses of Olympus; on the ceiling of the State Bedchamber there, with paintings emblematical of sleep; and in 'Mars reposing on the Lap of Venus' [104] on the ceiling of the King's dressing-room. All these were completed shortly before 1702 and make us wonder why on earth Verrio was so greatly admired. In quality, liveliness, and imagination he was surpassed by Laguerre.

Louis Laguerre

Verrio was a pretentious, vulgar, and extravagant personality, but Laguerre was the reverse. He was also the better painter. Born in Versailles in 1663, he worked for a short time with Lebrun and came to England at the age of twenty in 1683/4 with Ricard, an architectural painter whom he assisted for some years. Together they worked for Verrio at Christ's Hospital in 1684, and in 1689 they were both at Chatsworth, where between 1689 and 1694 they painted the Chapel, the ceilings of a number of the State Rooms, and the Painted Hall. Between 1691 and 1695 Laguerre was working at Sudbury Hall.[3] Although Verrio monopolized most of the royal commissions (Laguerre only did some grisailles at Hampton Court for William III), there was ample scope for Laguerre in country houses. He painted much at Burghley and the learned programmes which he affected – due

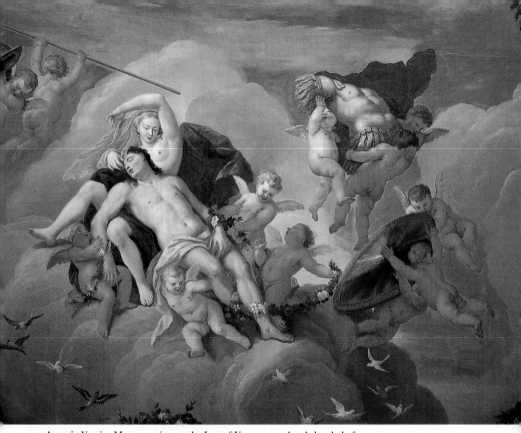

104. Antonio Verrio: Mars reposing on the Lap of Venus, completed shortly before 1702. *Hampton Court, ceiling of the King's Dressing Room (Crown Copyright)*

probably to his early training under the Jesuits – can be gauged from the text for the decoration of the Ballroom at Burghley which is preserved in Peck's *Desiderata curiosa*. Among much other work he is recorded at Devonshire House in 1704; painting Marlborough's battles at Marlborough House in 1713/14; and in 1719/20 doing his masterpiece, the Saloon at Blenheim. From about 1711 he came up against his more pushing rival, Thornhill, who had learned, so Vertue reports, much of his art from Laguerre: and the better commissions tended to go to Thornhill. From about 1714 he did a good deal of work at Canons, and he died in London 20 April 1721. During his last years he gave himself more to portraiture and history painting than before, but little work of this kind is known to survive.

A number of lesser figures of the historic style need only be mentioned. Gerard Lanscroon (d. 1737), in 1678 an assistant of Verrio, painted at Powis Castle and Burley-on-the-Hill; Pierre Berchet (1659-1720) came to England in 1681 with the architectural painter Rambour, and also worked first for Verrio and later on his own (nave ceiling of Trinity College Chapel, Oxford); another such was Nicholas Heude who alone carried this style into Scotland. He was a French Protestant from Le Mans, who had been *agréé* at the Paris Academy in 1672 and came to England in 1685 as an assistant to Verrio. The Duke of Queensberry is said to have brought him to Scotland, but his only surviving works are two signed ceilings including an *Aurora* – at Caroline Park near Edinburgh. He died in indigence at Edinburgh in 1703.

The other decorative and historical painters who were active in Britain before the predominance of Thornhill can be divided into two groups, the invasion from France, patronized by Ralph Montagu (later first Duke of Montagu), who had been special Ambassador in Paris from the 1660s onwards; and the invasion from Italy, centring round the personality of Pellegrini, who was brought over to England by another Montagu, Charles, Earl (and later first Duke) of Manchester, when he was Ambassador at Venice.

The Duke of Montagu's Artists

Ralph Montagu was building the first Montagu House in Bloomsbury in 1675, 'in the French taste', with Hooke as architect. This was decorated with mythological paintings by Verrio, but the house was destroyed by fire in January 1685/6. Lord Montagu (as he had then become) at once set about building a new house, and, as a zealous supporter of French art, he selected a French architect, Puget, in 1687, and introduced a number of French decorative painters. The chief of these were: Charles de la Fosse (1636–1716), who was at work here only *c.* 1688/90 and returned to France on Lebrun's death in 1690; Jacques Rousseau (1631–93), a pupil of Swanevelt who had also studied in Italy, and specialized in landscapes with architecture and figures in a manner derived from Poussin; and Baptiste Monnoyer (1634–99), one of the most distinguished painters of flowers, who had worked for Lebrun at Versailles. Both the last two painters did canvases [105] for the decoration of Montagu House until its completion about 1692, and many of these remained in the collection of the Duke of Buccleuch until they were sold 1 November 1946. A number of Monnoyers from Montagu House still survive at Boughton. Five architectural landscapes by Rousseau remain as *superportes* at Hampton Court, but he is not known to have done other work. Flower-pieces by Monnoyer are not uncommon in the older British collections, al-

105. Jacques Rousseau: Decorative landscape from Montagu House. *Formerly Duke of Buccleuch*

though his name is used generically for pictures which are not from his hand. He is commonly known as 'Baptiste'.

Another French painter of a younger generation, James Parmentier (1658–1730), was also employed as assistant in the work for Montagu House. He had visited England first in 1676 but later went to France and Italy and settled here only in 1680. In 1688 he did work for Montingo (Verrio's flower painter) and for Berchet and Henry Cooke (d. 1700), both minor history

painters. In 1689 he worked for Closterman and began to assist Rousseau at Montagu House, where he continued until 1692. In 1694 he worked for William III in Holland at Het Loo, but he was back and settled in Yorkshire by about 1700/1, where he did work at Hull, York, and elsewhere – history paintings, altar-pieces, or portraits. He is mentioned occasionally by Thoresby's Yorkshire correspondents (Thoresby Society, XXI, 192) and settled in London on the death of Laguerre in 1721, but did not meet with much success. He died in London 2 December 1730. By accident we can reconstruct his career from Vertue's notes, so that he can be taken as typical of a class of painter of whose movements in general we know little. His altar-piece at Hull is deplorable.

In the 1690s Montagu was also doing much decorative work at Boughton, and for this he employed another French history painter, Louis Cheron (1660–1725), who came to England about 1695 after study in Rome, where he had made many drawings after Raphael. Cheron's watered Marattesque style can be seen on several ceilings at Boughton and he was working also at Chatsworth 1699/1700, but his importance rests on the fact that he was much concerned in the instruction at the two drawing academies started in London in 1711 and 1720, in which his teaching along Roman lines had a considerable influence on the younger generation of painters, Vanderbank, Highmore, etc., who had never visited Italy. He died in London 26 May 1725.

The Italian Invasion

It is a comfort to turn from these depressing minor Frenchmen to the Venetian painters who came over a generation later, Pellegrini and the two Ricci. They were not great painters, but they were masters of an easy, fluent, decorative style which it is still a pleasure to look at, and they brought with them something which was badly needed in England at the time, the breath of one of the most civilized (perhaps even over-civilized) cities in Europe. The history of the best in British painting in the eighteenth century is largely the history of the assimilation by British painters, for the first time, of the best that Italy had to offer, and the first appearance of Italian painters in England at the beginning of the century is an important symptom.

Although not the oldest of them, Gianantonio Pellegrini (1675–1741) was the first to arrive. He had been a pupil of Sebastiano Ricci at Venice, and married one of the sisters of Rosalba Carriera. In 1708 the Earl (later Duke) of Manchester, then British Ambassador at Venice, returned to England, where Vanbrugh was engaged in adapting his house at Kimbolton. With him he brought Pellegrini, whose versatility and lightness was well adapted to go with that passion for the heroic and gigantic which was an element in Vanbrugh's style. Pellegrini did not paint much at Kimbolton,[4] but what he did was charming – some wall-paintings of a Roman Triumph, a staircase fresco with a Moorish trumpeter and some musicians on a balcony [106], a niche with a chained monkey and a parrot on a perch, and a few ceilings with Cupids, in addition to a large canvas of the Duke's children. He also painted the Duke of Manchester's London house (now destroyed) and Vanbrugh found much work for him at Castle Howard, where he finished in 1712 the cupola of the Great Hall, which was destroyed by fire in the 1940s. There is also a fascinating canvas of girls round a table at Castle Howard, and the method of wall decoration by canvases let into the wainscoting was what he practised at Sir Andrew Fountaine's at Narford, where the most varied selection of his work remains today. 'Thetis Bringing the Infant Achilles to Chiron', 'The Rape of Europa', 'Nessus and Dejanira', 'Hylas', 'Minerva and Arachne', 'The Death of Lucretia', and 'Medor and Angelica' are among the subjects painted at Narford, and the lightness and facility of the style remind us for the first time of the Mediterranean world. Pellegrini was involved in the foundation of the Academy in London in 1711, but he left for Düsseldorf in 1713, and was back only for a

106. Gianantonio Pellegrini: Musicians on a Balcony, after 1708. *Kimbolton Castle, staircase*

short visit *c.* 1718/19, after which he went to Paris. An Italian pupil of his, Vincenzo Damini, did some feeble painting in Lincoln Cathedral in 1728, but returned to Italy in 1730.

The two Ricci, Sebastiano (1659–1734) the uncle, and Marco (1676–1729) the nephew, are more important for the history of painting in Venice than they are in England. The elder tempered the style of Veronese with a Rococo idiom and was the forerunner of Tiepolo, and the younger was the pioneer of the fantastic landscape which came to full perfection in Guardi. Marco Ricci came to England first with Pellegrini, in 1708, but he soon returned to

Venice and brought back with him (*c.* 1712) his uncle, who had been Pellegrini's master. In England the two Ricci sometimes collaborated, Sebastiano painting the figures and Marco the landscapes, and also worked independently. The fresco of the 'Resurrection'[5] in the semi-dome of the apse in Chelsea Hospital Chapel is Sebastiano's surviving masterpiece. It has a Rococo verve and a feeling for decoration and movement which were altogether new. Two large mythologies by him, 'Diana and her Nymphs' and 'The Triumph of Venus', still hang on the stairs of Burlington House. A wave of nationalist feeling, fanned by Thornhill, pre-

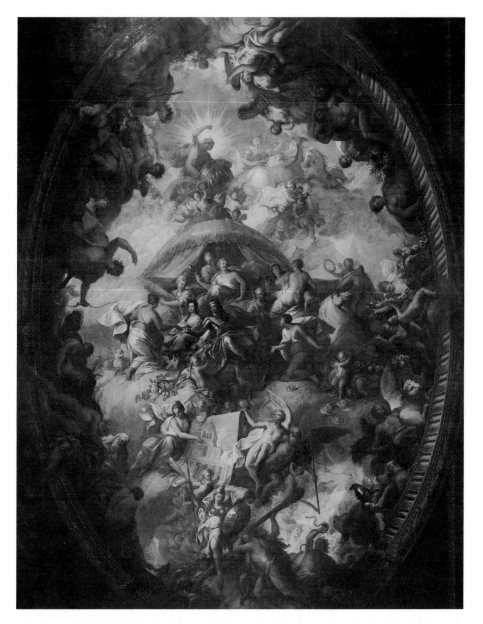

vented Ricci getting the commissions for Hampton Court and for St Paul's, and the two Ricci left England about 1716 (when they are recorded at Paris) soon after Thornhill had started work

107. Sir James Thornhill:
Ceiling of the Painted Hall, begun 1708.
Greenwich, Royal Naval College

on St Paul's. Easel pictures painted by one or the other, or by the two in collaboration, are at Chatsworth and Welbeck, but the great series of works by both in the royal collection comes from Consul Smith and was painted after the two had finally returned to Venice in 1720.

About the time the Ricci left England, in 1716, another Venetian painter, Antonio Bellucci (1654–1727),[6] came to London from Düsseldorf. He belonged to an older tradition than Sebastiano Ricci, deriving his style rather from Padovanino and Luca Giordano and having no tinge of the Rococo about him. He remained only until 1722. The best of his works to be seen in England today is a vast canvas of 'The Family of Darius before Alexander' in the Ashmolean Museum at Oxford. A rather feeble 'Adoration of the Shepherds' and a 'Deposition' from his hand also remain at the sides of the altar in the church at Whitchurch, Edgware, commissions from the Duke of Chandos.

Sir James Thornhill

Baroque decorative painting in Britain culminated, however, in the personality of Thornhill, an Englishman, born of good Dorset stock in 1675/6. His early training is obscure, but certainly included a good deal of practical knowledge of architecture. Vertue makes clear that he thinks Thornhill derived most of his pictorial style from Laguerre, and this may well be true. He seems to have succeeded Verrio and Laguerre at Chatsworth, where he was working about 1707. He came into prominence as a historical painter under Queen Anne just at the time Verrio died, and his first major commission about which we have knowledge was the decoration of the Painted Hall at Greenwich [107], where his work was started in 1708 and dragged on rather fitfully until 1727. It is his best and most visible work and has an energy and gusto which reveals the lesson of Ricci as well as the schooling of Laguerre. A number of lively drawings for the scheme are in the British Museum, but their vivacity is hardly carried through into the finished work. The scheme at

Greenwich is of particular interest since some of the main themes to be depicted were from recent or contemporary history, such as 'The Landing of William III' and 'The Landing of George I'. Thornhill was thus faced with the problem of how much truth to appearances was consistent with the grand manner, and the issue was complicated for him by the fact that he had a natural bent towards closely observed genre.[7] On a drawing in the British Museum for the latter subject is a revealing list of 'Objections that will arise from the plain representation of the King's landing as it was in fact and in the modern way and dress'. These objections were: that it was night, that no ships were visible, but only small boats, which would make a poor show in the composition; that the nobles who were actually present were, many of them, in disgrace at the time of painting, and that it would be difficult 'to have their faces and dresses as they really were'; and that the King's own dress on the occasion was not graceful 'nor enough worthy of him to be transmitted to posterity'. Finally there was a vast crowd 'which to represent would be ugly, and not to represent would be false'. Thornhill chose not to be 'ugly' and to represent the King's dress 'as it should have been rather than as it was'. The problems which beset the painter of scenes from contemporary history have never been more clearly analysed, and this clear thinking sufficiently reveals Thornhill's native instinct towards realism, which marks him out from his foreign predecessors.

The final result certainly shows that Thornhill had at least as considerable knowledge of the Italian repertory of decorative expedients as his foreign rivals. His abilities were various and extensive, and paintings by him of every class, from landscape to religious history, are listed in his sale after death, but very few examples of the minor categories have so far been identified. Three portraits, dated 1710, are in the Master's Lodge at Trinity, Cambridge, and others, a little later, are at All Souls', Oxford. But he is hardly known today outside his grandiose decorations, although his sketch-book, made on a journey in 1711 to Holland and Belgium,

shows at least as great an interest in architecture as in painting, and his name was put forward in 1719 for the post of Surveyor to the Board of Works. He was also loud in pushing himself forward and imposed his predominance, partly by underground political channels and the support of the Earls of Sunderland and Halifax, during the early years of the Hanoverian dynasty. He was working at All Souls', Oxford, in 1713/14; in 1715 he painted the ceiling of the Prince's Apartments in Hampton Court, and when, in the same year, the question came up of who should get the commission for painting the cupola of St Paul's, he was given the job against Laguerre and Ricci. Ricci, disappointed of Hampton Court and St Paul's, left the country, and there seems to have been a current of nationalist feeling which Thornhill fanned and profited by. In this, as in other things, Hogarth followed in his father-in-law's footsteps.

Thornhill began the eight huge grisaille 'Stories from the Life of St Paul' in the cupola on 1 May 1716 and they were completed in September 1719. But he was doing many other works at the same time, in addition to carrying on at Greenwich. In 1716 he was still at work on the ceiling of the Great Hall at Blenheim, which commemorated the Duke's victory at Blenheim. In 1717 he visited Paris. In 1718 he signed the 'Stories from the Aeneid' at Charborough Park. His period of greatest prosperity runs from 1716 to 1723. He succeeded Kneller in 1716 as head of the Academy which had been founded in 1711, but it is doubtful if this first Academy lasted for more than a further year or two. In June 1718 he was sworn 'History Painter to His Majesty', and on 8 March 1720 he succeeded Thomas Highmore as Serjeant Painter, was Master of the Painter Stainers' Company, and was knighted on 2 May. In 1722 he was elected M.P. for Melcombe Regis, but his desire to be everything overreached itself and Lord Sunderland's death the same year affected his progress. The rising arbiter of taste was Lord Burlington and his protégé was William Kent, and Kent's appointment in 1723 to decorate Kensington Palace was the turning-point in Thornhill's

painting career. It was a turning-point in the history of taste in England also.

William Kent (1685–1748), whose name is justly honoured in the history of architecture and subsidiary arts, need not be taken seriously as a painter, though he had studied painting under Luti in Rome 1714/15, where he had first met Lord Burlington. The alliance of Kent and Burlington begins in London in 1719, with Kent finishing the painting which Ricci had left uncompleted at Burlington House, but Lord Burlington gradually saw that his friend's talents lay outside the field of history painting and in the direction of the picturesque enlivenment of architecture. What was happening in England was what had happened earlier in France, where the heroic style of Le Brun, to which we may parallel that of Thornhill, gave way to the Rococo modes in which the painter played a minor and more subordinate part to the architect and decorator.

The South Sea Bubble of 1720 also no doubt played its part in chastening the style of building and decoration. Soon after the work at Greenwich was completed in 1727 Thornhill was engaged in a lawsuit with Mr Styles of Moor Park over payment for the work he had done there. In 1729 Vertue notes that he had 'no great employment in hand' and he devoted his later years to making copies of the Raphael cartoons at Hampton Court, which were still in his possession at his death on 4 May 1734. In the obituary notice in the *Gentleman's Magazine* he was described as 'the greatest History Painter this Kingdom ever produced', which was probably true enough, since competition was slight. His name and fame left as a legacy that bias towards the Grand Style, from which Hogarth never escaped, with which Reynolds was tinctured, and which was only finally exorcized by the suicide of Haydon. Thornhill remains the least studied in detail of the eminent names in British painting.

Jacopo Amigoni (1682?-1752)

The final collapse of the patronage for large-scale historical decoration is shown in the case of the last of the distinguished Italian visiting painters, Jacopo Amigoni, who worked in England from 1729 to 1739. He painted several London houses, now demolished, but his best

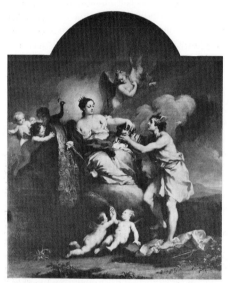

108. Jacopo Amigoni:
Mercury Presenting the Head of Argus to Juno,
1730s. *Moor Park, Herts*

surviving work is the series from the 'Story of Jupiter and Io' at Moor Park,[8] where he succeeded to Thornhill after the latter's quarrel with Mr Styles. These are very accomplished examples of Venetian Rococo - the best is 'Mercury Presenting the Head of Argus to Juno' [108] - but they show a new departure in decoration which had been anticipated by Pellegrini at Narford on a smaller scale. They are large canvases let into the wall instead of frescoes, but taking up the space that wall-painting would have done. The principle, but not the scale of canvas, was to become the norm. Gradually the role of the painter became more and more subordinate and painting was used only for chimney-pieces and superportes - exactly as had happened in France. But the great bulk of these decorative pictures were the work of journeymen hacks and cannot find a place in a general history of British painting.

Amigoni did a fairly good business in large canvases of mythological subjects, but he was finally forced, like all the native British painters, to eke out his livelihood with portraits. These he diversified by the introduction of Cupids, whenever possible, but examples survive of a more prosaic vein.[9] His most remarkable English portrait is the full-length of 'Lady Sundon' at Melbury, which has a distinctly foreign air. He married an Italian, Antonia Marchesini, at the Catholic Chapel Royal on 17 May 1738, and departed the next year for Paris and Venice, ending up in the more congenial atmosphere of Madrid, where he was Court Painter.[10]

PORTRAITURE IN THE AGE OF KNELLER

AND HIS IMMEDIATE SUCCESSORS

John Riley

When Lely died at the close of 1680 no immediate appointment was made to the post of 'chief painter'. It may well not then have been obvious who would succeed to the fashionable portrait practice of Lely from the three or four possible candidates. The young foreigner Kneller was beginning to come into favour, but his star was still only in the ascendant; Michael Wright had serious claims but could hardly be called fashionable; John Riley had perhaps established a fair name for himself among the middle classes; and another young foreigner, Wissing, was beginning to become known. We have seen that it was not until 1685 that the appointment was made, and it then went to Verrio, perhaps from motives of economy (since Verrio was already in receipt of £200 a year from the Crown), but the uncertainty as to who was the right portrait painter for the job persisted and was solved by a compromise after the Revolution of 1688, when Verrio was turned out and, in December 1688, John Riley and Godfrey Kneller were jointly 'sworn and admitted chief painter'. In the meantime Wissing had died, and Wright, by his absence at Rome, had lost any fashionable support.

John Riley had for a time been a pupil of Soest, and he was born in 1646. One of his scholars told Vertue that Riley was a man 'of established reputation' in 1680, but he seems to have been little noticed by the great world before Lely's death and we are still without any certain clue to his early style. From 1680 until his death in London 30 March 1691 a fair number of portraits survives which can be documented by engravings, diaries, early inventories, or nearly contemporary inscriptions that they are by Ryley, Royley, or Royle, as his name was

indifferently spelt. He did his best with the great world which he was called upon to paint, taking over from Lely some of his poses and even his posture-painter, Gaspars, who was later taken over by Kneller: but there is evidence of his diffident and uncourtierlike temperament, and the native Riley is only plainly apparent in the one or two pictures he painted of persons in the humbler walks of life. Curiously enough, the two chief of these are fully signed and are

109. John Riley: The Scullion.
Oxford, Christ Church

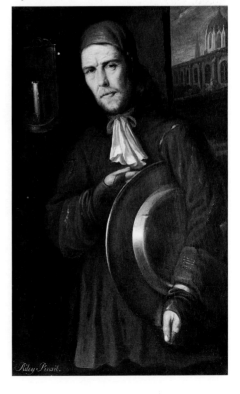

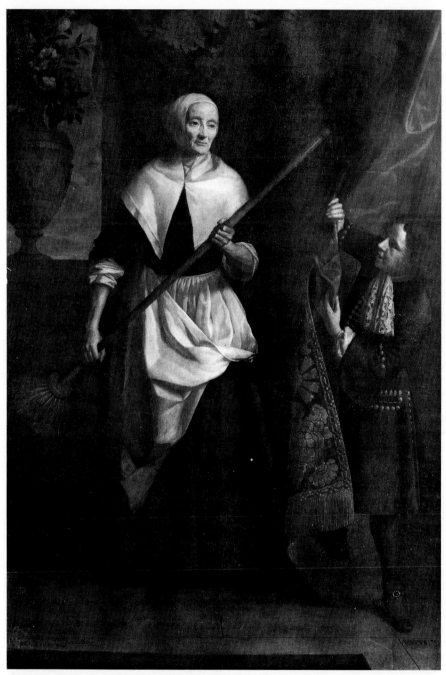

110. John Riley: Bridget Homes, 1686. *Royal Collection (by gracious permission of Her Majesty the Queen)*

amongst the most sympathetic portraits of this depressing period – the 'Scullion' (Christ Church, Oxford) [109] and the portrait at Windsor of 'Bridget Holmes' [110] (dated 1686), the venerable housemaid to James II, in her ninety-sixth year. There is a faint friendly air of parody about this latter work which could never have been anticipated from Riley's official manner. The curtain and Baroque pot suggest the grand manner and the old woman is wielding her mop as if it had been a general's baton, and is directing it against a mischievous page boy. It is obvious that Riley was most at home below stairs, and the portrait at Kensington Palace of 'Mrs Elliot', the King's nurse, for which we have the evidence of the Queen Anne Inventory[1] that the head only is by Riley and the rest by Closterman (i.e. c. 1689/91), confirms this.

This collaboration with Closterman probably began when Riley was appointed chief painter. The two artists formed a partnership and shared expenses. They also shared equally the profits of whole-lengths (at £40 each) and half-lengths (at £20 each): but for heads only (at £10 each) Closterman received only 30s. and Riley pocketed the rest.[2] It is indicative that Closterman did very badly from the arrangement. Typical examples of this dual control are the three half-lengths of the 'Misses Bishopp' at Parham of about 1690, in which the qualities which make Riley a portraitist of some distinction have almost evaporated.

This distinction is one of temper rather than of painting. His best male portraits have a haunting, shadowed melancholy, from which the vulgarity of Lely's style has been drained away: and his few women's portraits have a shy and gentle aspect. The Woburn 'Mr and Mrs John Howland', probably painted at the time of their marriage in 1681, illustrate both these characteristics. At Althorp is a 'Lady Spencer of Offley and her Son John', which can be dated by the sitter's diary to October/November 1683, in which this air of shyness is almost embarrassing. In men's portraits he was more successful, and the 'Elias Ashmole' 1683 (Ashmolean Museum, Oxford), 'Sir Charles Cotterell' 1687 (Cottrell-Dormer Collection), or the 'Duke of

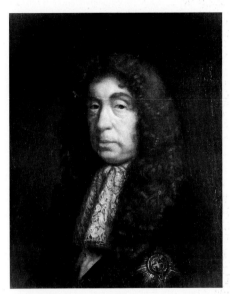

111. John Riley: Duke of Lauderdale.
Duke of Northumberland, Syon House
(Copyright Country Life)

Lauderdale' [111] at Syon House, are fine examples of his power of probing character of a grave and melancholy cast. But it should be added that this melancholy may be as much mannerism as penetration, for it is found also coupled with a discordant gaiety of draperies in the full-length portraits (c. 1686/7) of two of the Brownlow Baronets and their wives at Belton. In his royal portraits Riley was at his least characteristic: certified examples are at Oxford (Ashmolean and Bodleian Library – some of the latter very bad) and at Althorp.

One of Riley's fellow pupils under Soest is identifiable in William Reader, son of a clergyman at Maidstone, who lived for a time in a nobleman's house in the west of England and fell upon evil days, ending them in the Charterhouse (Vertue, IV, 83). The nobleman seems to have been the Earl of Aylesford, and a number of Reader's portraits appeared in the Aylesford sale 23 July 1937. Portraits signed by him are known dated 1672 and 1680. They are extremely rustic and primitive, but the hands and drapery folds clearly betray Soest's training.

Riley's historical importance lies partly in the fact that he was the teacher of some of the most important portraitists of the next generation – Murray, Gouge, and Richardson. Through the last, who represents the main stream of Riley's tradition, the line runs through Hudson to Reynolds.

Sir Godfrey Kneller

Riley's partner in the office of 'Principal Painter' after the Revolution was Godfrey Kneller, who assumed the whole office on Riley's death in 1691, was knighted on 3 March 1691/2 and was created a baronet 24 May 1715. This honour was conferred by George I, the least art-loving and the least British of our sovereigns, and it raised the official painter to a position of social eminence unequalled until it was surpassed by Queen Victoria when she conferred a peerage on Lord Leighton. There can be no doubt that Kneller was the dominant artistic figure of his age in England. His mature portrait style reflects with relentless objectivity the fashionable world under the reign of three sovereigns with no leanings towards the arts. The downright shoddiness of much of his enormous output is a mirror of the cynicism of his age, but he had a wonderfully sharp eye for character, could draw and paint a face with admirable economy, and maintains, even in his inferior work, a certain virility and down-to-earth quality which is refreshing after the languishments of the age of Lely. He was one of the first to concentrate on the portrait as a document concerned with the likeness of a historical personality rather than as a work of art. The art historian may shake his head over him, but the historian must rate the vast series of portraits that Kneller left behind him as a most precious aid to his studies. A hundred years later a rather similar artistic personality appeared in Raeburn.

Godfrey Kneller was born in Lübeck, either in 1646 or 1649.[3] He studied under Bol in Amsterdam, perhaps from about 1662 onwards, and is alleged to have come into contact with Rembrandt in his latter days. From Holland he went to Italy from 1572 to 1575, when he was back in Lübeck. In Rome he encountered Maratta[4] and Baciccia, the leading native portrait painters of their time; in Naples he is alleged to have worked with some success, and in Venice too, where Bombelli was the leading portraitist. No trace of his work has been found in Italy, and there is little to show from these Italian contacts in his first works after he settled in England in 1676. A 'Philosopher' of 1668 (Lübeck), painted before his Italian journey, is like the work of a pupil of Bol such as Cornelis Bisschopp, and the so-called 'Admiral Tromp' of 1675 (Antony House), which is the first known picture of his post-Italian phase, is entirely in the spirit of Bol, which remains the dominant influence in the portrait of his first English patron, 'Mr Banks' 1676 (London, Tate Gallery). But a change comes over his style about the time that he was introduced to Court. He first painted Monmouth's Secretary, 'Mr Vernon', in 1677 (National Portrait Gallery) in a soft smudgy style recalling Voet rather than anything English or Dutch, and this led to his painting Monmouth himself. If the 'Duke of Monmouth' [112] at full length at Goodwood,[5] of about 1677, is by Kneller, as is traditionally supposed, it is his first masterpiece and explains his introduction to the King and his sudden rise to popularity. But there is a curious gap in our knowledge of Kneller from 1678 to 1682. Not more than a few portraits are known.[6] In 1685 Kneller emerges with something approaching his mature style – which is markedly different from his works of 1677 – and hardly a year passes from then until his death from which at least half a dozen signed and dated works cannot be named. He visited France in 1684/5 to paint Louis XIV for Charles II, which may account for the assured quality of his style in 1685 in contrast to his rather timid beginnings.

By 1685 Evelyn, in his *Diary*, was calling Kneller 'the famous painter'. Wissing's death and Wright's absence in Rome in 1685 may have had something to do with it, but Kneller him-

self, with his keen eye to the main chance, was no doubt the chief reason. His style in 1685 – unlike that of 1677 – is based on Lely. He uses, with very slight modification, many of Lely's poses, and he adopts the same unquiet gestures: but he stiffens up the backbone of the figures in his portraits. The 'Sir Charles Cotterell' [113] of c. 1685(?) and 'Edmund Waller' of 1684, both at Rousham,[7] have this new, more rigid pose, and a picture such as the 'Duchess of Portsmouth' [114] of 1684, at Goodwood, although it represents one of the most languorous personalities of the age, has a military rigidity of bearing if compared with Lely's various full-lengths of the 'Duchess of Cleveland'. At times during these early years Kneller even shows something of the same sensitive penetration of character and melancholy as Riley – as in such an unusual and noble work as the 'Philip, Earl of Leicester'

[115] of 1685 at Penshurst: a sad and disappointed old man, his disquiet shown by a use of diagonals that was altogether outside Lely's canon. Kneller is an artist who can be usefully judged only by his exceptional and outstanding works, which are sufficiently numerous to make it plain that they are not happy accidents but really represent what he would have been capable of had the times been favourable to the sensitive use of his talents. One may cite as examples of these before the end of the century (all certified by signatures and dates): the 'Chinese Convert' 1687 (Royal Collection), which he himself considered his masterpiece; 'Mrs Dunch' 1689, at Parham Park, an uncompromising study of an elderly lady; 'Anthony Leigh as "The Spanish Friar"' 1689 (National Portrait Gallery), one of the first actor's portraits in a character part; the 'Duchess

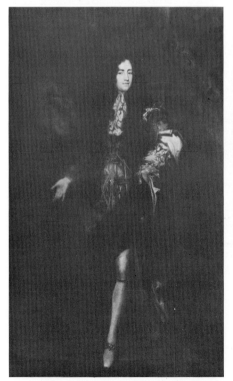

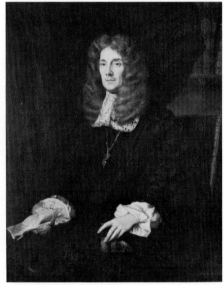

112 (left). Sir Godfrey Kneller(?):
Duke of Monmouth, c. 1677.
Duke of Richmond and Gordon, Goodwood, Sussex

113 (above). Sir Godfrey Kneller:
Sir Charles Cotterell, c. 1685(?).
C. Cottrell-Dormer, Rousham, Oxon.

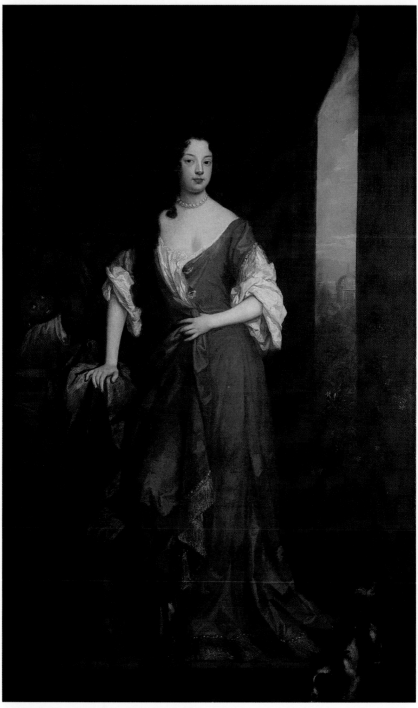

114. Sir Godfrey Kneller: Duchess of Portsmouth, 1684.
Duke of Richmond and Gordon, Goodwood, Sussex

of Marlborough and Lady Fitzhardinge' [116] 1691, at Blenheim, a most admirable study of two great ladies playing cards; 'Dr Burnet' 1693, at The Charterhouse, friendly and grave and sober, and wholly lacking in irrelevant frills, comparable to the undated 'Mrs Richard Jennings' and 'M. de St Evremond' at Althorp; and the 'Matthew Prior' 1700 in the Combination Room at Trinity College, Cambridge. This is a gallery of something close to masterpieces judged by any standards of portraiture, and of much richer variety than could be produced from any fifteen years of Lely's activity.

Like Lely, Kneller is probably best known by certain series of portraits. Kneller's Hampton Court Beauties, dating from 1690/1, are at full length and cannot compare in voluptuousness with Lely's Windsor Beauties: his series of Admirals at Greenwich, dating from the first decade of the eighteenth century (with some companion portraits by Dahl) do not reach the same high level as Lely's Flagmen, although a picture such as the 'Sir Charles Wager' of 1710 has an energy and directness of a kind Lely never achieved: but Kneller's Kit Cat series, which has now happily found a home in the National Portrait Gallery, not only surpasses any group of portraits by Lely in historical interest, but includes some masterpieces of direct painting and incisive portraiture, which are the legitimate ancestors of Hogarth and Gainsborough and much of the best British portraiture in the eighteenth century.

The best of Kneller's later work, after 1700, is concentrated in the Kit Cat series. These forty-two portraits, all but one of the size of about 36 by 28 in. (which has become known from them as the Kit Cat size and has the advantage of showing both head and one hand), were painted between 1702 and 1717, and represent the members of the Kit Cat Club, which has been described as the Whig Party in its social aspect. In most of these Kneller took more trouble with hands and drapery than usual, and some of the heads – such as the 'Sir Samuel Garth' [117] – are among the most brilliant he ever painted. For variety of character, though mostly seen within the equalizing

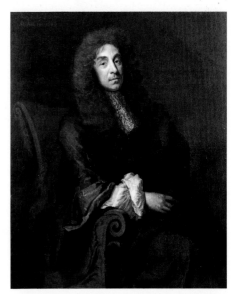

115. Sir Godfrey Kneller: Philip, Earl of Leicester, 1685. *Viscount De L'Isle, Penshurst Place, Kent*

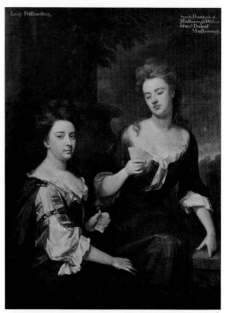

116. Sir Godfrey Kneller: Duchess of Marlborough and Lady Fitzhardinge, 1691. *Duke of Marlborough, Blenheim Palace, Oxon*

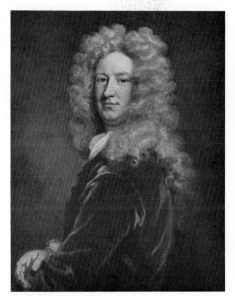

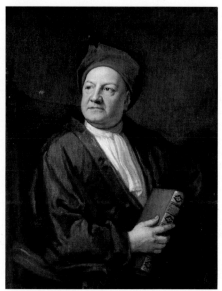

117. Sir Godfrey Kneller:
Sir Samuel Garth (Kit Cat series).
London, National Portrait Gallery

118. Sir Godfrey Kneller:
Jacob Tonson (Kit Cat series), 1717.
London, National Portrait Gallery

frame of the periwig, they are quite splendid and reveal in Kneller a knowledge of the human mind which one would not have guessed from the many tales of his prodigious vanity. The fatuous libertine 'Lord Mohun', the pensive, almost feminine, melancholy (which led to his suicide) of the 'Earl of Scarbrough', the superciliousness of the young 'Duke of Grafton', 'Sir John Vanbrugh's' consciousness of success, are all admirably portrayed; and in the portrait of old 'Jacob Tonson' [118], who commissioned the whole series, Kneller took the trouble to add some subtlety of design and produce something which was a work of art as well as a portrait.

The last date on any of the Kit Cat series is 1717 and Lord Nottingham, writing in that year to his daughter,[8] says: 'Sir G. Kneller shall draw me as you propose unless upon viewing some of his later pictures we find what I have been told that his eyes fail him as well they may at his age'. But his eyes lasted well enough until his death on 19 October 1723, and his last

portrait of 'Alexander Pope' (Viscount Harcourt), painted in 1722, shows little diminution of his powers.

In 1711 Kneller became first Governor of the first Academy of Painting to be set up in London, and he showed keen interest in the Academy until he was replaced as Governor in 1716 by Thornhill. In this way he helped to impose a sound studio tradition on the next generation of painters, and he set the tone which was to prevail in British portraiture for at least a generation after his death.

It may well be also that Kneller's own studio practice, which was comparable to Rigaud's in France, had a demoralizing influence on contemporary portraitists. His studio was a model factory. Kneller himself would draw the face from his sitter and transfer it to the canvas, while the rest, as often as not, was finished off by a multitude of assistants. There was a specialist for perukes, for draperies, for lace, for architectural backgrounds, for the landscape,

and so on. The names of a number of Kneller's assistants are known, but few attained to independent distinction.[9]

Lesser Portrait Painters

Of the considerable number of names[10] of portraitists which are known for this period, a few were of sufficient repute or promise to deserve more than a passing reference. They may be taken alphabetically.

John[11] Closterman was a personality and certainly played a fairly prominent social role. He has already been mentioned in connexion with Riley. Born at Osnabrück about 1660, he was a pupil of François de Troy at Paris in 1679 and came to London in the early 1680s. For the last years of Riley's life (up to 1691) he painted draperies, hands, and accessories for Riley and a considerable number of Rileyesque portraits survive which can be generically called Riley-Closterman. One of the best, in which Closterman's participation is documented by an early inventory, is the 'Mrs Elliot' in the Royal Collection. He also completed the works left unfinished in Riley's studio. During the 1690s he was taken up by the Duke of Somerset and the group of 'Seven Children of the Duke of Somerset' at Syon House was one of his most important commissions. He went to Spain in 1696, just after he had completed the huge group at Blenheim of the 'Duke and Duchess of Marlborough and their Children', and he had probably already, before his departure, formed a connexion with the Earl of Shaftesbury, that enlightened but eccentric patron of the arts who was looking for a pliable painter who would execute his own philosophic ideas. It is not certain whether his full-length portrait of the 'Earl of Shaftesbury' (used as an engraving to the 1723 edition of Shaftesbury's *Characteristics*) was painted before or after his travels. In Madrid, as is certified by a letter of 12 November 1698, he painted his masterpiece, the full-length of the 'Hon. Alexander Stanhope' at Chevening [119]. There is evidence in this that

119. John Closterman: Hon. Alexander Stanhope, 1698. *Chevening Park, Kent*

he had at least troubled to look at Velazquez's portraits. In 1699 he was at Rome, where he painted Maratta from the life, and he was back in England by the end of 1702. He seems to have painted less in his later years and taken more to picture-dealing. He was buried in London on 24 May 1711. His later style derives wholly from Kneller and is well exemplified by the engraved 'Duke of Argyll' in the Marquess of Lothian's collection at Melbourne Hall.

By contrast Thomas Hill was a painter of some refinement. His dates are generally given as 1661 to 1734, but the date of his death (at Mitcham) may perhaps have rather been 1724. A dozen or so engravings are known after his portraits, and the few that survive[12] – several of them of his friend 'Humphrey Wanley' – are all original and refreshing in a stereotyped age. Vertue (who knew him) records that he learned

drawing from Faithorne and painting, presumably about 1678/9, from Theodore Freres, so that his work does not automatically belong to the Lely, the Riley, or the Kneller style. He also seems to have been something more like an English gentleman than most contemporary portrait painters, except Tilson, whose friend he was. Hill's engraved 'Sir Henry Goodricke' of about 1695, which was in the Castle Howard sale, 18 February 1944 (49), as a Lely, is nearer to Michael Wright in colour and temper than anything else. On two separate occasions, the first perhaps soon after 1700, the second in 1720, he stayed at Melbury and painted a number of pictures for the Strangways family, including a huge group of 'Mr and Mrs. Thomas Strangways and their eight Children'. The signed 'Susanna Strangways' [120] at Melbury

120. Thomas Hill: Susanna Strangways, c. 1705.
Private collection

of *c.* 1705 has a gentleness and refinement hardly to be found in any other portrait painter of the time.

Another gentleman painter was Hugh Howard, born in Dublin on 7 February 1675. He had to earn his living and he accompanied the

Earl of Pembroke in 1696 on his travels through Holland and Italy. In Rome he decided to professionalize what had before been an amateur talent and he became a favourite pupil of Maratta. He also, like Wright in Rome before him, became an art expert and in 1700 he 'brought home what the Italians call *la virtù*, and we a taste and insight in building, statuary, music, medals, and ancient history'.[13] At first this stood him in little stead and he had to practise portrait painting, first at Dublin, and later in London – a documented example, very like Closterman in style, is the 'Sir Justinian Isham' of 1710 at Lamport. But he married money in 1714 and his antiquarian knowledge recommended him to the Duke of Devonshire, who secured him the post (9 November 1714) of Keeper and Register of the Papers and Records of State, whereupon he abandoned 'the mechanical, though genteel' art of painting. On 18 June 1726 he succeeded Dartiquenave as Paymaster of the Royal Palaces, and he died, a very rich man, on 17 March 1737/8 – one of the first of the enriched 'experts'.

Edmund Lilley, who was buried at Richmond (Surrey) 25 May 1716, enjoyed considerable patronage in the reign of Queen Anne.[14] There is a huge engraved 'Queen Anne' signed and dated 1703 at Blenheim, and another of 1705 was in Lord Clarendon's collection. A signed portrait of some distinction is 'Edward Tyson' at the Royal College of Physicians. The last recorded date at present on any of his pictures is 1707.

Henry Tilson was one of the most promising of the lesser portrait painters. Born in London in 1659, he was son of Henry Tilson of Rochdale, Lancs., and grandson of a Bishop of Elphin. He was at first a pupil of Lely and may then perhaps have veered into the orbit of Kneller. In 1685 he accompanied Dahl (who will be considered later) to Paris (1686) and to Italy. They spent most of their time in Rome, where Tilson is said to have made a name for himself by doing crayon copies of the Old Masters. A crayon portrait of 'Francesco Giuseppe Borri', done in Rome in 1687, is in the Hansteen collection in Oslo,[15] and a small

oil portrait of 'Hon. Thomas Arundell', done in Rome in 1687 and formerly at Wardour Castle (private collection). These are both in the Roman rather than the British tradition. In 1689 he had returned to London with Dahl and was developing a style very similar to Dahl's, when he cut short his life by suicide about 25 November 1695. A signed portrait of 'Master William Blathwayt' 1691 at Dyrham, and a signed 'Mrs Howell' 1693 at Courteenhall,[16] and some portraits of his own family known only by old photographs, are all that remain of his later work at present identified. But they are enough to show that he promised better than most of his contemporaries.

John Vandervaart, born at Haarlem, probably in 1653, came to England in 1674 as a painter of still-life and small landscapes with figures. From about 1685 to 1687 he painted draperies for Wissing and then set himself up as an independent portrait painter, in which he had only moderate success. Typical late works are the 'Mr and Mrs Robert Bristow' of 1713 at Squerryes Court. About 1713 he largely abandoned original work for restoring and expertise and there is an account of his later activities in Vertue, III, 32. He was buried at St Paul's, Covent Garden, 30 March 1727.

The Verelst Family

So much confusion attends the scattered published references to the several painters of the name of Verelst, that it is better to treat them all together, although the last continued his activities into the middle of the eighteenth century. Sifting a good deal of conflicting evidence,[17] I would sort them out as follows. Two sons of a painter at The Hague (who never came to England), Peter Verelst, finally settled in England. The elder son was Harman Verelst, who became a member of The Hague Guild in 1663, worked later at Amsterdam and Paris, and went to Vienna in 1680, where he became Painter to the Emperor. When the Turks besieged Vienna in 1683, Harman came to

England, and his earliest portraits in England, all dating from 1683, are found in East Anglia. In the later 1690s he probably worked a good deal in Yorkshire, and he died in London in 1702. He was a competent portrait painter in the Closterman style. His younger brother Simon, baptized at The Hague 21 September 1644, seems to have come to London as a flower painter in 1669 and is mentioned as newly arrived in Pepys' *Diary* 11 April 1669. Although he seems to have painted a certain number of portraits in the 1680s - a fairly certain example is the extremely odd 'Marquess of Lothian' in the Scottish National Portrait Gallery - he was already showing signs of insanity by 1691 and spent his latter years painting enormous roses and other aberrations proper to a flower painter. He died in 1710. Harman's son Cornelius (1667-1728/9) seems to have been a flower painter and nothing of his work is known. Harman's daughter Maria (1680-1744), known as 'Mrs Verelst', specialized in small oil miniatures, of which examples are to be seen at Welbeck and Penshurst, and also painted rather pedestrian portraits on the scale of life, of which several examples are at Mellerstain, dated 1725. The next generation is represented by what are probably two sons of Cornelius Verelst: John, who is probably 'Mr Verelst, a noted Face Painter', whose death is recorded in the *Gentleman's Magazine* under 7 March 1734, and by whom I have seen signed and dated works ranging from 1706 to 1734; and William, whose painting career begins just after John's death, in 1735, and who seems to have died c. 1755/6. William's work will have to be considered in passing under the painters of conversation pieces, but John has a smooth, unflattering style, making his figures look a little as if made of rubber, which makes him easy to recognize.

The Swedish Portrait Painters - Dahl and Hysing

Kneller's nearest contender in public patronage was the Swedish painter, Michael Dahl. Born in Stockholm on 29 November, probably in

1659, he learned the essentials of the international Baroque portrait style under Ehrenstrahl. He left Sweden for further study abroad in July 1682 and came first to London, where he seems at once to have entered into Kneller's orbit, and may even have assisted him. In 1685 Dahl and Henry Tilson, who has already been mentioned, travelled through Paris to Italy, where they remained for three years, visiting Venice and Naples, but mainly settled in Rome, where Dahl painted 'Queen Christina of Sweden' 1687 (Grimsthorpe Castle). They left Rome in November 1688 and came via Frankfurt back to London (March 1688/9), where Dahl finally decided to settle. He formed close friendships with the Swedish diplomatic personnel in London and seems to have been successful from the start in securing sufficient patronage. About 1696 he succeeded Closterman in the good graces of the Duke of Somerset and did a good deal of work at Petworth from that date until 1720. His Petworth Beauties of the later 1690s compare very favourably with Kneller's Hampton Court Beauties and may well have been planned in conscious rivalry. There is a softer, gentler, more feminine character about them than about Kneller's, and Dahl's colour at this date has a corresponding softness and tenderness. About the same date he was first patronized by Prince George of Denmark and Princess Anne, and, after the accession of Queen Anne in 1702, he painted a number of the presentation royal portraits. His Admirals at Greenwich, painted c. 1702/8 in a series to which Kneller also contributed, are the best index of his powers and of the difference in his outlook from Kneller's. 'Sir Cloudesley Shovell' [121] and 'Sir James Wishart' are perhaps the best examples, and there is a genial and friendly quality about the interpretation which is distinct from Kneller's straining after more heroic or more forceful characterization. There is never any of Kneller's bravado and vulgarity about Dahl, nor was there in his private character, but it becomes increasingly difficult after about 1715 to distinguish between an ordinary Kneller and an ordinary Dahl. After Queen Anne's death in 1714 Dahl's patronage from

121. Michael Dahl: Admiral Sir Cloudesley Shovell, c. 1702/8. Greenwich, National Maritime Museum

the Court ceased, but this did not bring any corresponding loss of patrons among the nobility and gentry, the Law, and the Church. For the ten years after Kneller's death he was probably the most busily employed portraitist, but old age made him give up painting about 1740 and he died 20 October 1743, having outlived the fashion of the style to which he had kept. A 'Holy Family' at Stockholm, although certainly made up of portraits, is the only example, and a pretty one, of his style outside straight portraiture which is known to survive.

Except for changes in the fashion of dress and the fact that plain backgrounds or interiors take the place of the Lelyesque rocks and trees, Dahl's pattern and style carry on the tradition of the late seventeenth century right up to the time when the young Reynolds began to learn the craft of painting. His gentle style suited old-fashioned and conservative persons, and his one pupil of any importance, Hans Hysing, carried the style on for another decade. Hysing (Huyssing) also was born in Stockholm, where he was apprenticed to a goldsmith for three years

from 1691, but he later took to painting and came to England in 1700, where he lived with Dahl until about 1725, although he was practising on his own long before that date. In the Earl of Ducie sale 17 June 1949 were eight whole-length portraits, all by the same hand, one of which was signed and dated by Hysing 1721. The postures are perhaps a little more awkward than Dahl's and Hysing never attains the faint quality of personal charm beneath the conventional presentation which is to be found in Dahl's best work, but otherwise he is a faithful disciple. He died in London in 1753.

The Generation after Kneller

This period is the most drab in the history of British painting. The one lively personality that it includes is Thornhill, who was predominantly a decorative painter and the successor to Verrio and Laguerre, as well as being the father-in-law of Hogarth. In portraiture the leaders were Richardson and Jervas, but neither of them deserves to give his name to the age in the same way that Lely or Kneller have done. Horace Walpole, speaking from a consciousness of the defect of the later (and, to our minds, greater) age which succeeded it, makes a penetrating statement to account sympathetically for the barren prosiness of Richardson's style. 'The good sense of the nation' he says 'is characterized in his portraits. You see, he lived in an age when neither enthusiasm nor servility were predominant.' This hits unkindly the defects of the qualities of the great age of British painting, but it finely describes the background of those painters who belonged to a younger generation than Kneller and were active at the time of his death in 1723. Vertue (III, 12) gives a convenient list of 'Living painters of Note in London' in 1723. A few of the older, such as Dahl, Vandervaart, and Parmentier, have already been mentioned in the previous chapter. It is the older members of the group, who flourished before the explosion of Hogarth in about 1730, who must be dealt with now.

Riley's Pupils: Richardson, Murray, etc.

It is a curious fact that Riley, perhaps the least prominent of the successful painters of the generation after Lely, but the only one of them who was born an Englishman, should have been the lineal father of the strongest tradition in eighteenth-century British painting. He was the teacher of Richardson, who, in turn, was the teacher of Hudson and Knapton, and Hudson was the first master of Reynolds. From Kneller only Jervas came forth, though the younger painters of this period learned much of their craft from the academy which both Kneller and Richardson were instrumental in founding in 1711, and from its successors.

Jonathan Richardson (1665–1745) was the oldest of this new generation. He came to independent practice rather late, having first been apprenticed to a scrivener, and he worked with Riley as his pupil for the last four years of Riley's life, about 1688 to 1691. It was in Riley's studio, by his own account, that he first happened upon the works of Milton, and the most interesting thing about Richardson is, in some ways, that he had a bent for learning and for the theory of the arts, and his published writings (dating from 1715 onwards) had a much more vivifying influence than his painting. These writings fired the young Reynolds to be something more than an 'ordinary' painter. From them we get the clue to understanding what Richardson was driving at, and to what Vertue means when he says Richardson 'studies a great manner' and describes his style as 'more sedate' than that of his contemporaries.

Richardson must have been in considerable practice before 1700, but the only portrait I can point to as in all probability his and from this time is the 'Lady Catherine Herbert and her brother Robert' at Wilton of c. 1698/1700. In this the prevailing style is that of Riley, but Kneller also counts for something. In later works – except for a few selfportraits, in which he shows a greater liveliness – the likeness to Kneller evaporates, and a more solemn and mask-like piece of prose results. Signed examples are uncommon, attributions frequently

wild, and not many of the engraved portraits can at present be identified. But Walpole's judgement that 'he drew nothing well beyond the head' is unjustified. He was certainly at his best in men's portraits, and certain examples which are accessible are: 'Edward Colston', 1702 (City of Bristol); 'Lord Chancellor Cowper' c. 1710(?) at Firle Place [122]; the 'First

1736 (Warwick); 'George Vertue' [123] 1738 (National Portrait Gallery). This last is as good a piece of solid and incisive prose as one could wish for, with a plain, British directness such as Kneller lacks: and 'Sir Hans Sloane', Richardson's noblest experiment in the grand manner, is a handsome and entirely individual work. We are on less certain grounds in esti-

122 (*left*). Jonathan Richardson: Lord Chancellor Cowper, *c.* 1710(?). *Viscount Gage, Firle Place, Sussex*

123 (*above*). Jonathan Richardson: George Vertue, 1738. *London, National Portrait Gallery*

Marquess of Rockingham' 1711 (St John's College, Cambridge); 'Robert, Earl of Oxford' 1712 (Christ Church, Oxford); 'Matthew Prior' 1718 (Welbeck); 'Lord Carmichael' 1726 (Scottish National Portrait Gallery); 'Sir Hans Sloane' 1730 (Bodleian); 'Richard Hale' (d. 1728), of whose portrait there is a replica by Richardson himself of 1733 in the Royal College of Physicians, London; 'Frederick, Prince of Wales'

mating Richardson's female portraits. There is a signed and dated full-length of the 'Duchess of Roxburghe' 1716 at Floors Castle, and there are busts of 1720 and 1722 at Mellerstain which have a weight and manner quite unlike the work of Jervas. Finest of all is the full-length 'Lady Mary Wortley Montagu' at Sandon.

Richardson's prices in 1718/19 were 10 guineas for a head and 20 for a half-length

(double Dahl's prices), and he had raised his scale by 1730 to 20, 40, and 70 guineas. In December 1740 he publicly announced that he had given over business, but he continued his literary studies, latterly in collaboration with his son Jonathan Richardson the younger (1694–1771), who also did a little painting, but who specialized in the new study of 'connoisseurship'. In addition to his literary bent, Richardson possessed the classic collection of Old Master drawings, worthy to rival, in its separate way, with Lely's collection of paintings and drawings of the century before.

The career of Riley's other pupil of some consequence, Thomas Murray, who was reputedly of Scots extraction, is almost the exact opposite to Richardson's, whose elder he was by two years. He was born in 1663 and apparently had some training under the last of the de Critzes before entering Riley's studio. He is found in 1695 and 1697 doing posthumous likenesses of benefactors for Oxford colleges (Queen's College and St John's), and, in 1697, also doing replicas of Kneller's royal portraits for the Merchant Taylors' Hall. Unlike Richardson the best of his known work seems to have been done before 1700, and in style very close to Riley's. A signed 'Mrs Vernon' of 1692 was in the Ratcliffe sale 28 July 1938 (20) and is one of his few identified women's portraits, for, like his master and like Richardson, he does not seem to have excelled with ladies. One of his most attractive works is the young 'Sir Edward Smyth', signed and dated 1699 (formerly Sir Algernon Tudor-Craig), and the likeness to Closterman may perhaps be accounted for by what Vertue tells us of his using other hands to paint his draperies, landscapes, etc. After 1700 he pursued a prosperous business among the clergy and the professions and in academic circles, maintaining an even level of dullness in most of his portraits but with rare and happy exceptions. Several examples are at Queen's College, Oxford, and there is a 'Sir Isaac Newton' of 1718 at Trinity, Cambridge, which is a little above his average. By astute parsimony he had accumulated a fortune reputed at

£40,000 at the time of his death on 1 June 1735, so that his practice must have been large although his portraits are rather infrequently to be found today, at any rate with his name attached to them.

Lesser members of Riley's school, whom it will be sufficient to mention, were: Anthony Russell (c. 1663–1743), one of Vertue's most assiduous informants, but none of whose works have been traced – unless a monogrammed Bishop Burnet of 1691 in the Scottish National Portrait Gallery be his; and Edward Gouge, who died of hard drinking 28 August 1735. Portraits by Gouge of 'Sir Roger and Lady Hudson' were in Miss Oswald Smith's sale 13 February 1948 (2) and were of sufficient individuality to make attributions to him of other nameless portraits possible. He also painted a 'Polyphemus' and some copies after Guido and Cignani for Lord Egmont.[18]

Charles Jervas

The name of Jervas (pronounced, and often spelled, Jarvis) would have been more wholly forgotten than it is, if this astute painter, who married money, had not cultivated by his hospitality the society of men of letters. But as it crops up frequently in the correspondence (and even in the poetry) of Swift and Pope, and as the *Tatler* (4 April 1709) refers to 'the last great Painter Italy has sent us, Mr Jervase', and as Jervas painted many of the portraits of his literary friends, he is still fitfully remembered. He was born in Ireland, traditionally about 1675. For a year (probably 1694/5) he studied in London with Kneller and made copies of the Raphael cartoons at Hampton Court, which he sold to Dr George Clarke of All Souls, who financed his travel to Italy. Although recorded in Dublin in 1698, he was in Paris in 1699, where he drew a head of 'Prior' in crayons, which is now at Welbeck, and he had finally settled in Rome (presumably after travelling in North Italy) by the beginning of 1703.[19] He was back in London by the beginning of 1709 and

seems to have become famous overnight. Except for a few visits to Dublin and a collecting visit to Italy in 1738/9, he remained in London until his death on 2 November 1739.

While we know Richardson best from his men's portraits, we know Jervas best from those of ladies. His patrons were at once in the highest ranks of society as well as in the literary world, and we know that, as early as November 1711, he was painting the Duke of Marlborough's daughters and Lord and Lady Strafford.[20] His women all look astonishingly alike and resemble a robin or one of the birds of the finch tribe. They languish rather more than Kneller's female sitters and often affect one hand up to their heads, and certain favourite poses (a 'shepherdess', etc.) are repeated. At his best Jervas has a pleasant soft and flowing quality to his silks and satins, which is rare in this age, and which he no doubt learned from the Van Dycks and Titians that he assiduously copied. He was appointed Principal Painter to the King 25 October 1723, in succession to Kneller, an impulsive act of George I, partly from pique

124. Charles Jervas: Jonathan Swift.
London, National Portrait Gallery

at Dahl's refusal to paint a royal baby.[21] George II continued him in this office, but although his royal portraits did not please, he was much patronized at the end of his life by Sir Robert Walpole. A good and sufficient example of his work is the 'Jonathan Swift' [124] at the National Portrait Gallery.

Just as Richardson was a dull painter for all his learning, Jervas was a dull painter for all his serious study of the Old Masters. In his sale (11 ff. March 1739/40) were life-size copies by himself after many of the most famous English Van Dycks, as well as of many of the most famous Italian pictures. Yet the light of the Italian genius, which was to transform the style of the generation of Reynolds and Wilson, seems to have shone in vain on Kneller and Jervas, perhaps because they approached the great works of the past with imperfect humility.

Painting in Scotland

Kneller's equivalent in Scotland was undoubtedly John Baptist Medina, who was knighted by the Lord High Commissioner in Scotland in 1706. He was of a Spanish family, born in Brussels about 1659 and trained there under Du Chatel, and he came to London in 1686 as a painter of history, landscape, and portraits, but only his portraits are known. He seems to have specialized in Scottish sitters and a portrait of 'George, Earl of Melville', signed on the back and giving Drury Lane as his address, is in the Scottish National Portrait Gallery. It differs in style from Kneller only in its less firm drawing and in the preference, which Medina always showed, for arrangements in dark rose and blue. About 1688/9 Medina settled in Edinburgh and did a thriving business in portraits for the rest of his life. His charges were £5 a head and £10 a half-length, and his works can be seen in abundance in most older Scottish collections. An accessible group of about thirty oval portraits, including a 'Selfportrait' 1708 [125], which is perhaps Medina's masterpiece, is in the Surgeons' Hall at Edinburgh. These are Medina's more modest equivalents to

125. Sir John Medina: Selfportrait, 1708.
Edinburgh, Surgeons' Hall

126. William Aikman: Selfportrait.
Edinburgh, Scottish National Portrait Gallery

Kneller's Kit Cat series. He died 5 October 1710 and his practice was carried on by his son, who was using his father's postures and costumes far into the eighteenth century. Medina was also the teacher of William Aikman, the most distinguished Scottish portraitist of the next generation.

If Medina corresponds to Kneller, Aikman may fairly be held to be the equivalent in Scotland of both Richardson for his men's portraits and Jervas for his women's portraits. Son of the laird of Cairney, where he was born 24 October 1682, he must have had some powerful bent towards painting, for he sold the family estate to travel abroad and improve his art. Examples can be seen at Penicuik House of his portraits of about 1707, when he had studied under Medina only, and of soon after his return to Edinburgh in 1712, after several years in Rome and a visit to Constantinople. There is a gain in assurance but no evidence, in the later work, of anything which only Italy could give him. As with most of the painters of this period, his 'Selfportraits' are the best, of which there is a good example at

Edinburgh [126]. He painted assiduously in Scotland from 1712 until about the date of Kneller's death in 1723, when he migrated to London in search of wider fields. In London he moved in the same literary circles as Jervas, and had a fair practice among the Scots in London, but ill-health soon set in and he died 7 June 1731. With Richardson he counts as the best portraitist of the generation which followed Kneller's death, but his masks are Scottish masks and Richardson's are English, and that is the only difference between them; but Richardson had greater variety.

The first painter of Scottish origin to have begun to break away from this deadening tradition in the direction of Hogarth is Jeremiah Davison (*c.* 1705?-45). He seems to have got his training in London and was given facilities for copying from the royal collection. His main practice was in London, but he made a profitable visit to Scotland under the patronage of the Duke of Atholl. His work is still too little explored to define the limits of his gifts, which were considerable.

MARINE PAINTING: LANDSCAPE: OTHER GENRES

Naval Painting - the Van de Veldes

The first introduction into England of the great Dutch school of painting which had grown up throughout the seventeenth century occurred in a severely practical way. Willem van de Velde the Elder, who was born at Leyden in 1611, had been employed since the time of the first Anglo-Dutch war in 1652 as the official Dutch war artist for the various seafights which took place between the Dutch and English navies. He accompanied the Dutch navy into battle and made countless drawings on the spot, and he elaborated a new technique for more permanent painted records, which would not lose the spontaneity of the drawings. This was to draw in black paint (in emulation of Indian ink) on a prepared vellum-coloured ground, and these large grisailles are the main feature of his art. He also painted shipping pieces in oil (of which there are examples at Greenwich), but he was essentially an official war artist and historical precision of delineation is the prime element in his paintings. For this reason, one must suppose, his powers were desired in the service of the British navy, and in 1673, in the middle of the third Anglo-Dutch war, upon what inducement we do not know, he simply changed sides and settled in England with his son, Willem van de Velde the Younger.[1] In 1674 father and son were given official appointments under the English Crown to take and make 'draughts of seafights', and they were provided with a studio in The Queen's House at Greenwich. The elder Van de Velde never stepped out of this role as the recording artist for the navy until his death in London in 1693, but the son added many of the more peaceful graces of art to his official gifts and became the ancestor of a school of sea-painting in England.

Willem van de Velde the Younger, who was born at Leyden in 1633, no doubt learned the rudiments of art and the drawing of ships from his father, but he was also a pupil of Simon de Vlieger, an artist for whom the moods of the sea were as interesting as the details of the ships upon it, and who had more of a landsman's sense of the picturesque than old Van de Velde. The younger Willem continued his pictures of naval battles and portraits of single vessels, but he also painted sea pieces, usually on a smaller scale, for the mere pleasure of the marine subject. He remains the uncontested master of tranquil marine painting, with a lovely sense of pearly tone, and the tradition which he established in England was continued unaltered in essentials, in the work of Monamy, Scott, Brooking, and many lesser names, until Turner, at the end of the eighteenth century, troubled the waters by the intrusion of romantic heroics. He died at Greenwich 6 April 1707 and can be admirably seen at the National Maritime Museum, but the formation of his style belongs to the history of Dutch rather than of English painting.

The English Imitators of Van de Velde

Direct pupils of Van de Velde are not known in England, but his first important imitator, Peter Monamy, born in Jersey probably about 1690 (the usual date of *c.* 1670 seems much too early), is called, in the Latin inscription on the engraving made from his portrait in 1731, 'Painter of Ships and Marine Prospects, second only to Van de Velde'. He too can be well studied at the National Maritime Museum and he had caught the tone of his exemplar's style very well. But his knowledge of the sea was much less than his knowledge of ships and there is a faint air of calico about much of his water. His seafights, also, were, in the main, reconstructed arrangements of earlier battles, done to order, and even his later scenes of contemporary naval

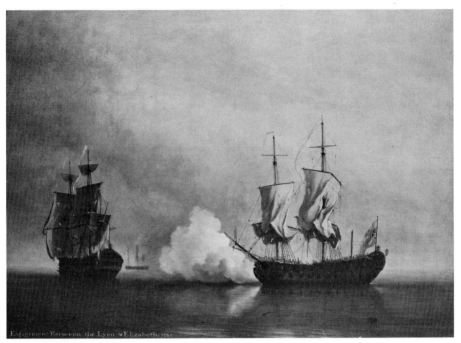

127. Samuel Scott: The Engagement between 'The Lion' and 'The Elizabeth', 1745.
Formerly at Hinchingbrooke

actions (from about 1739 onwards) were probably not done from study at the time. His smaller pictures were made for dealers and, at the time of his death, 1 February 1748/9, he does not seem to have been in a good way of business. A lesser echo of Monamy is Robert Woodcock (c. 1691–1728), a musician of ability who took to painting copies of Van de Velde in 1723, but died of the gout in 1728.

The painter, however, who earned, and not inappropriately, the title of 'the English Vandevelde' was Samuel Scott (1702?–72),[2] who will be discussed at greater length as a painter of London views. Although he is recorded as only having once been to sea, his first phase as a painter is wholly in the Van de Velde tradition, studies of men-o'-war and sailing vessels in a calm, rather loosely strung together into a pattern which shows that he had not at first mastered Van de Velde's sense of design. His earliest known picture,[3] which is of this kind, is

dated 1726, and another, dated 1732, is at Parham Park. In 1732, he also collaborated with George Lambert in painting views of the East Indies Settlements (in what was until recently the India Office), and joined Hogarth and others on a jovial trip, to whose illustration he contributed a marine view. But his best work of this class was commissioned by the Earl of Sandwich and Lord Anson to record the naval actions of 1745. In 'The Engagement between "The Lion" and "The Elizabeth", 1745' (formerly at Hinchingbrooke [127] – the Marquess of Bute has a closely similar picture painted for Lord Anson), which Horace Walpole called 'the best picture Scott ever painted',[4] and 'The Engagement between the Blast Sloop and two Spanish Privateers, 1745' (Wilton House – signed and dated 1747), Scott shows a mastery of tone and a rather dramatic sense of pattern, which differentiates him from Van de Velde and reveals him as a master in his own

right. 'Admiral Anson's Action off Cape Finis-terre' *c*. 1749 (Tate Gallery; from Hinching-brooke) is the most splendid of these scenes of naval engagements. After Canaletto's arrival in London in 1746 Scott seems to have turned, almost for good, to views of London or reaches of the river, which were presumably more popular and more lucrative.

The last of the marine painters of this genera-tion, and the one with most active experience of the sea, was Charles Brooking (1723–59), by whom there are several signed examples at Greenwich. His career was cut short by death, soon after the Treasurer of the Foundling Hospital had discovered his work in a dealer's shop and promised him some patronage. There is a poetry of tone and a sense of fresh breeze about his few surviving works, which show that he had the promise of becoming the best sea-painter of the century. The success which might have been his went to a more pedestrian Gascon, Dominic Serres (1722–93), who be-came a foundation R.A. and received most of the commissions for sea pieces.

The Landscape Tradition from Wyck to Lambert

The Dutch father of the first English landscape tradition may probably be found in Jan Wyck. His father, Thomas Wyck (*c*. 1616–77), was a specialist in pictures of alchymists, oriental har-bours, and such exotics, who had visited England in the 1660s and painted some London views, but his main work was done in Holland, where Jan was born, presumably at Haarlem, 29 October 1652, according to the inscription on Faber's mezzotint of his portrait by Kneller. Jan spent most of his working life in England and was famous for his battle pieces (especially for pictures of the 'Battle of the Boyne') and for subjects with broad panoramas, in which horsemen and (sometimes) portraits were com-bined. He seems also occasionally to have painted sporting groups, and it was during the later 1690s that he was the teacher of John Wootton, the first artist who was to popularize the sporting picture in Britain with something

like the same level of distinction and success as the portrait painter. Jan Wyck died at Mortlake 26 October 1700.[5]

A painter who worked at times in collabora-tion with both Wyck and Van de Velde was Gerard Edema (1652–*c*. 1700), a versatile painter of picturesque landscapes. He had been a pupil of Van Everdingen, the first artist to introduce Scandinavian scenery into Dutch painting, and he himself travelled as far afield as Norway, Newfoundland, and Surinam, but he was based on London from about 1670 and he died at Richmond in Surrey. His work is lively and decorative, with a tendency towards the bizarre and the 'picturesque', of which he was one of the earliest exponents in England. It can be seen on a vast scale at Chatsworth and in a number of little pictures at Althorp. Lesser Dutchmen who settled in London in the 1670s were Adam Colonia (1634–85), who painted the figures, and Adriaen van Diest (1655/6–1704), who painted the landscapes, in works of col-laboration. Van Diest is also known as a minor portraitist and genre painter, but had a name chiefly for the decorative landscapes which were part of the house furnishing of the time.

Apart from these more or less imaginative artists, a certain amount of landscape painting was being done at the close of the seventeenth century by the professional topographers. Leonard Knyff (1650–1721) was a masterly topographical draughtsman of bird's-eye views of gentlemen's parks, and John Stevens, who died 6 October 1722, worked at times in the same vein in painting. In addition to small dec-orative landscapes done for dealers, he painted a series of vast views of Hampton Court, Herefordshire, which were in the sale at the house in 1925. One of these is now in the possession of Viscount Hereford.[6]

The elder Jan Griffier (*c*. 1645–1718), a Dutchman who came to London about the time of the Great Fire (1666), but spent the years of the turn of the century in Holland and Ger-many, painted a number of topographical land-scapes in a style based on Siberechts, but his chief work was in imitation of earlier painters, and his importance lies in the fact that he was

the father of two painters who were among the first decent topographical artists, with a bent for real landscape, that worked in England. The two younger Griffiers have not been fully disentangled. Their names were Robert, allegedly born in England 7 October 1688, who died about 1750, and Jan II, who was working in England in the 1730s and 1740s. A 'Regatta on the Thames' [128] in the collection of the Duke of

has thrown into the shade his considerable contribution to the landscape tradition. It has been suggested that he was the John Wootton who was baptized at Snitterfield (Warwick) 16 September 1683, but he was probably born rather earlier, if we may believe the evidence of a drawing of 1694, in which he contributed figures to a landscape by Siberechts. In the later 1690s he was a pupil of Jan Wyck, with

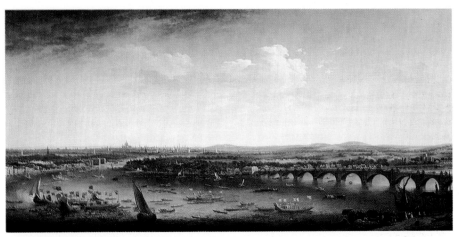

128. Robert Griffier: Regatta on the Thames, 1748.
Duke of Buccleuch and Queensberry

Buccleuch is clearly signed R. Griffier and dated 1748, and suggests that the artist had not neglected to look at Canaletto (who visited London in 1746), and prospects of Windsor and London signed Jn. Griffier are at Milton Park, while views of Billingbear and Audley End, dated 1738 and 174(2?), also signed by Jan Griffier, are at Audley End. All these are enlivened by little figures, but the basic style is topographical and not that of Gaspard Poussin or stage designing, which was the alternative landscape tradition which obtained in England in the first half of the eighteenth century. Lesser exponents of the same style can be unearthed from the pages of Colonel Grant.

The rival landscape style, a more artificial one, can be best seen in the work of John Wootton, whose repute as a sporting painter

whom he collaborated in one or two battle pieces, and at a much later date, presumably the early 1720s, the third Duke of Beaufort (to whose great-aunt he had been page)[7] paid for him to travel to Rome. It was presumably in Rome that he fell under the spell of Gaspard Poussin and Claude, the two classic masters whose work was to become so highly appreciated by British collectors in the middle of the century, and, on his return in the 1720s, Wootton introduced Gaspardesque landscapes into the British tradition. There are good examples of such pure landscapes at Temple Newsam, but he not infrequently introduced a classic backdrop into his sporting pictures, which form the major part of his work.

Wootton will be treated more at length under Sporting Painters, but his landscape experi-

ments are important because he became the teacher of George Lambert, and because the Gaspardesque style which he introduced was at the bottom of one aspect of Gainsborough's poetic landscape style. Direct imitations of Gaspard did not lose their popularity until the birth of the great naturalist school of British landscape painting at the close of the century, and the predominance of the Gaspardesque idea was one of the most powerful obsessions with which the naturalist school had to contend.

George Lambert, who was born in Kent in 1700 and died in 1765, has been rightly claimed by Collins Baker as the painter best qualified to be called 'the father of English oil landscape'. As early as 1722 Vertue notes him as a young painter of promise who was imitating the style of Gaspard Poussin and Wootton. He was still producing very handsome 'variations on a theme of Gaspard' in the later 1740s, but it is not for such works that he most deserves to be

esteemed. In 1727 his portrait by Vanderbank was done in mezzotint by Faber (no doubt partly as an advertisement) with the inscription 'Chorographiae Pictor', which is presumably meant to mean that he took portraits of actual places and landscapes, and in 1732 he collaborated with Scott in the pictures of the East Indies Settlements (India Office Library).

It is about the middle of the 1730s, however, that we first begin to learn his true form in a set of pictures of 'Westcombe House, Blackheath' [129], which are now at Wilton. Tradition relates (and there is no reason to doubt it) that the figures in these are by Hogarth, and the shipping, in one of them, by Scott. We thus find Lambert ranged from the start with the progressive painters, and the pictures are the first portraits of a country house which are not of purely topographical interest but show an eye for picturesque arrangements and involve an awareness of the idea of landscape gardening –

129. George Lambert: Westcombe House, Blackheath, mid 1730s.
Earl of Pembroke and Montgomery, Wilton House, Wilts

of which William Kent was the first great master – which had such a hold over British taste in the eighteenth century. In a sense, the greatest English landscapes of the century are not the works of Lambert or Wilson or Gainsborough, but the gardens of Rousham (as they once were) and of Stourhead (as they still are today). British landscape painting before the romantic period is founded on the same artificial principles as British landscape gardening, and it is significant that Lambert, about the time he painted the views of Westcombe House, became the chief scenery painter at Covent Garden, and the kind of picturesque artifice which was appropriate for the stage is also at the bottom of Lambert's views of gentlemen's seats. Three views of 'Chiswick Villa' (Duke of Devonshire) are dated 1742, with figures – as always with Lambert – by another hand. In these the stage convention and artificial nature are married to perfection, and the same spirit, with a vaster stage and a greater command of atmosphere, is found in the two 'Views of Copped Hall'[8] of 1756, which reveal in their skies a kinship with Richard Wilson. Lambert also painted the simple English rural scene, but in studied arrangements, which suggest a little the backdrop for the stage. These were perhaps a little more 'stock designs' than has been supposed, for the most famous of them, the big landscape dated 1757 at the old Foundling Hospital – which he presumably presented to that institution as one of his best works – is a repetition of a small picture of 1753.[9] But Lambert was the first native painter to apply the rules of art to the English rural scene, and, in this sense, Wilson followed him.

Canaletto and Samuel Scott

In the early 1740s the War of the Austrian Succession considerably interrupted the steady stream of British Milords and gentlemen who travelled round Europe and spent a good deal of money on the arts. British painters at home began to launch out in the 1740s into other forms of art than portraiture, hoping to catch some of the money which had been going to foreign painters, and, as the obverse to this situation, first Antonio Joli (c. 1700-1777) in 1744, who was a specialist in topographical painting and scenery, and then Antonio Canaletto (1697-1768), who had relied very largely on the British visitor to buy his steady output of views of Venice, in 1746 decided to visit England themselves. It was clearly a case of the Mountain coming to Mahomet, and it is sufficient to remark that there is hardly a single Canaletto painting of any importance in any of the public collections of Italy.

An introduction was effected at once to the Duke of Richmond, and Canaletto began his English period with the two lovely 'Views of London from Richmond House' [130] 1746, which are now at Goodwood. He never painted better pictures in his life. The enchantment of Venetian sunshine was still upon him, the weather when he was painting them must have been fine, and the two most sparkling views of London that have ever been achieved were produced, sprinkled with little figures as alive and full of London character as his Venetian figures had been alive with the *genius loci*. He later painted many admirable London prospects, but he never recaptured the same sparkle. His contemporaries related that he painted best what was before his eyes, and the grey British skies and masses of trees, with both of which he was unfamiliar, must have filled his horizon. He found good patrons later in Sir Hugh Smithson (later Duke of Northumberland), in the Duke of Beaufort, and the Earl of Warwick, for whom he painted their country seats. But he was never at home with the English scene, as he was, before and after, with Venice. His English views have been fully catalogued by Mrs Finberg, and all show a high level of even accomplishment.[10] There are many drawings as well as paintings among them, and Canaletto's method was to build up a repertory of drawings, from which he would later elaborate his picture in the studio. Sometimes he seems even to have painted views from other people's drawings (presum-

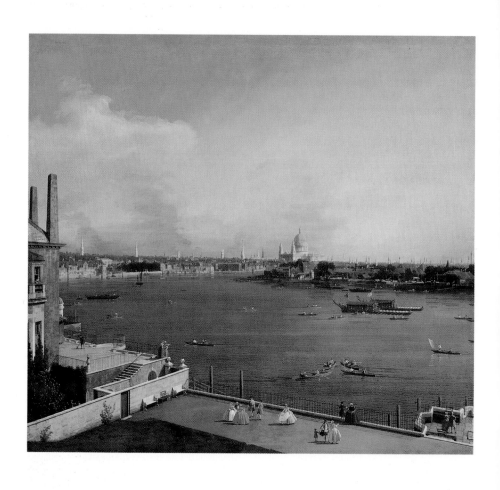

130. Antonio Canaletto: View of London from Richmond House, 1746.
Duke of Richmond and Gordon, Goodwood, Sussex

ably Samuel Scott's), showing work under construction as it was before his own arrival in London. Except for a period of eight months in 1750/1, when he was back in Venice, Canaletto remained in England until 1755. When he left, the vogue had been established for London views, especially reaches of the Thames, diversified with characteristic figures. The heir to this new fashion was Samuel Scott.

Scott's beginnings have already been described in the account of the English followers of Van de Velde, and there is no evidence to hand that he was known as anything but a marine painter at the time of Canaletto's arrival in London in 1746. He does, however, appear to have done some topographical studies of London in pen and wash which can be dated, on archaeological grounds, as far back as 1738. It appears to have been Canaletto who created the demand for this kind of picture, and Scott veered over to the new fashion and was in good practice by 1748.

Scott learned a good deal from Canaletto, but he was not a base imitator. His true quality, more even than with most British painters, has been obscured by the mass of feeble copies and imitations which pass under his name. He

diversified his views with little figures, sometimes gay and amusing ones, but he did not seek to give them Canaletto's almost factitious sparkle. Like Canaletto he kept a repertory of drawings, from which he produced painted versions and repetitions, either with alterations only in the figures – as in two versions of identical size of 'The Building of Westminster Bridge' of which that in the Bank of England (formerly Lord Hatherton's) was being painted 1748/9, while that from Herriard Park is signed and dated 1750; or with enlargements and additions, as in the Bank of England 'Old London Bridge' 1748/9, whose composition was varied and extended in 1749 to fit as an overdoor in Longford Castle. He is at his best when he can combine, as Canaletto could not, the view of the London waterfront with the marine style of Van de Velde, as in Lord Hambleden's huge 'Tower of London' 1753 [131]. In all these the watery quality of the English atmosphere is rendered with a feeling very different from Canaletto's Venetian brilliance. Scott, in fact, for all his amateurishness (when compared with Canaletto), has converted a foreign fashion into a native product. At times he even achieves an unexpected grandeur and

131. Samuel Scott: The Tower of London, 1753.
Viscount Hambleden, Hambleden, Bucks

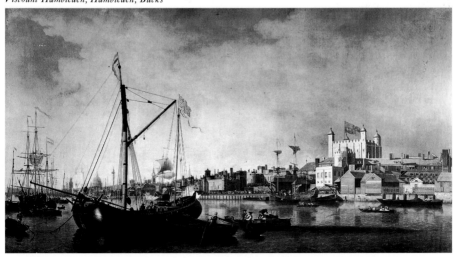

132. Samuel Scott: An Arch of Westminster Bridge.
London, Tate Gallery

solemnity of design, as in the Tate's 'An Arch of Westminster Bridge' [132]. In the 1750s Scott settled at Twickenham, where he painted various prospects, and he made a first visit to Bath in search of health in 1760. He finally left the London area in 1765 and, after a short stay at Ludlow, where he painted some inland views, settled at Bath until his death on 12 October 1772.[11] It is unlikely that he painted much in his later years and certainly no change came over his style after the 1750s beyond variations on earlier patterns.

Amongst imitators it will be sufficient to have mentioned Francis Harding (died before 1767) who is mentioned by Vertue already in 1745 as an able imitator of Pannini and Canaletto, and W. James (exhibiting 1761–71), the sedulous ape of Scott.

Landscape in Scotland

The classical landscape tradition penetrated also to Scotland. A family, or firm, of decorative painters named Norie, whose dynasty died out only in 1845, practised the Gaspardesque mode from the middle of the eighteenth century.[12] The founder of the family was James Norie the elder, born at Knockando (Morayshire) in 1684, who died a Town Councillor of Edinburgh 11 June 1757. His son, the younger James (1711–36), and a younger son, Robert (who lived to 1766), were joined with him in business, and a number of decorative landscapes, presumably by this family, remain in some of the older houses in Edinburgh. Documented examples are four upright pictures, signed 'R. Norie 1741', in the Duke of Hamilton's apartments at

Holyrood. These show a blend of Gaspard Poussii l Pannini in style, although one may be intended to represent the 'Falls of the Clyde'. As teachers of Alexander Runciman and Jacob More, in the former of whom native Scottish landscape begins, the Nories can be considered the modest founders of a tradition.

Popular Genre and Scenes from Common Life

It was a Dutchman too who first introduced paintings of what one may call popular genre into England, a field which was to be richly elaborated by Hogarth. Egbert van Heemskerk has been little noticed,[13] and he did not work for the patrons of high art. Born at Haarlem 1634/5, he can be traced in Holland until the end of the 1660s. He was trained in the tradition of painting boors and scenes from the tavern, of which

Brouwer (whose works he copied) was the greatest exponent. Coming to England, probably in the 1670s, he developed as his speciality the illustration of scenes from the life of the people, in which he displays a keener eye for character and the savour of the scene than he does skill in execution. His works are realistic and rude rather than caricatures, and some of them were doubtless indecent. But Vertue tells us that, about the time that Hogarth was beginning to form his genre style, Heemskerk's works were 'in vogue among waggish Collectors & the Lower Rank of Virtuosi'. They are, in fact, symptoms of the times. Among his more important pieces are several pictures of 'Quaker Meetings' (Hampton Court; Powys Museum, Welshpool, etc.), and a very lively 'Election in the Guildhall, Oxford' [133], signed and dated 1687, which is now in the Oxford Town Hall. This last is not an unworthy precursor of

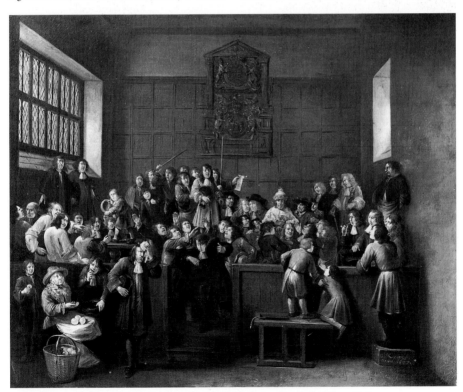

133. Egbert van Heemskerk: Election in the Guildhall, Oxford, 1687. *Oxford Town Hall*

Hogarth's scenes from common life, but it is ingenuously and shrewdly observed and not loaded with Hogarth's satirical counterpoint. Heemskerk died in London in 1704.

This tradition was carried on, at the same level of low life, by Joseph van Aken, who came to England in the second decade of the eighteenth century and died in 1749. Although best known as the most employed drapery painter of the 1730s and 1740s, he painted a number of genre scenes from common life, ranging in date from about 1720 to 1740.[14] These are works produced in the studio, in which the same figure, or group of figures, reappears in different arrangements, and they are of more sociological than artistic interest. Peter Angillis (1683/5–1734), who worked in England from 1712 to 1728, specialized in genre in which piles of vegetables play a large role, but his scenes do not often have a specifically British background, although he is known to have painted Covent Garden. He also painted, in a collaborative scheme with Vanderbank and others, some small scale histories of the life of Charles I (formerly Duke of Leeds).

Covent Garden is also the subject of several pictures by a painter of Spanish origin who married in London in 1729, Balthazar Nebot.[15] His 'View of Covent Garden' 1735 (Woburn Abbey) to some extent combines in anticipation the style of Scott's London views with figures which owe something to Hogarth, but are wholly lacking in satirical overtones. Nebot's best work deals with the London scene, but, in later life (1754 and 1762), he is also found painting views of Fountains Abbey.

Painting of Birds, Still-Life, etc.

Francis Barlow had no successors in his faithful interpretation of native bird and animal life, but a bird and beast painter named Cradock, whom Vertue and Walpole call Luke, but the burial registers Marmaduke, was buried at St Mary's Whitechapel, 24 March 1717. He had some reputation, and a picture of 'Poultry and Ducks' by him is at Knowsley. A more tangible foreigner of the same class is the Hungarian, Jakob Bogdany, who specialized in exotic fowls and did a good deal of work for William III, both in England and Holland. He was also a favourite of Queen Anne, and there is a large collection of his work at Kew Palace; he died at Finchley in 1724. A Fleming from Antwerp, Pieter Casteels (1684–1749), seems later to have had the largest business in bird painting from the time of his coming to England in 1708 until he retired from painting to make designs for calico in 1735. He popularized the style of Hondecoeter, but without anything of the same kind of Baroque swagger in his patterns. His pleasantly composed arrangements of hens, doves, and ducks, sometimes with a peacock to give them an air, are still to be met with fairly frequently, but they are an offspring of Dutch art without anything to suggest that they were painted in England.

HOGARTH AND THE PRECURSORS
OF THE CLASSICAL AGE

INTRODUCTORY

The shadow of Kneller hung over painting in Britain during the long years of Whig Government with a persistency which rivalled that of the political predominance of Sir Robert Walpole. It was not that there was no opposition to it, but that that opposition, whose focal point was Hogarth, failed to attain the authority to impose itself. The successful portrait painters, and their wealthy patrons, seem to have subscribed to Walpole's motto: *Tranquilla non movere*. It seems, therefore, at a first reading, as if the young Reynolds, when he settled in London in 1752 after returning from Italy, took the town by storm with an entirely novel style, and soon imposed his own predominance on the tomb of Kneller's reputation. Reynolds's biographers have encouraged this view and Northcote tells the amusing story[1] of John Ellis, the last survivor of Kneller's pupils, coming to see Reynolds's portrait of 'Marchi', and saying 'Ah! Reynolds, this will never answer! Why, you don't paint in the least degree in the manner of Kneller'; and finally, unable to give any good reasons for his objection, crying out in a great rage 'Shakespeare in poetry, and Kneller in painting, damme!' and immediately running from the room. But a closer examination of the tangled skein of painting from about 1729 to 1749 shows that Reynolds was not so remarkable an innovator as he has seemed. Rather, he was fortunate in coming to maturity in the opposition school, when the

major battles had already been won, and when society was ripe for a change. A genial address and great pliability of disposition, gifts which had been denied to Hogarth, helped him to win and to hold his new predominance. It is the story of what happened to painting in the reign of George II which made this possible, that must be related here.

We can follow in much closer detail than heretofore what was happening in the art world of London from the Notebooks of George Vertue, which begin just about the time of the death of Kneller and end just before Reynolds is ready to step onto the scene. Amid the welter of minute facts, Vertue occasionally pauses to reflect, and he notes in 1732 that 'Art flourishes more in London now than probably it has done 50 or 60 years before'. In 1737, after speaking with approval of the style of Teniers, Watteau, 'and some of those Flemish Masters of the Scholars of Rubens', he adds, 'and indeed some painters lately here, have studied that pencilling, touching manner, with great Success and freedom of composition which is likely to carry a merit with it of a lasting duration'. In December 1738 he remarks that 'whatever advances the Art of painting has made in England since I have taken notice of it – is neither getting nor looseing. That is, instead of Sir Godfrey Kneller, who then stood paramount, now we have several painters who draw and colour masterly.'

Such observations made at the time are very precious, but Vertue was an accumulator of the raw facts of history, and in no sense a historian. He never puts down observations, probably he never reflected, upon the larger issues which lay behind the changes which were taking place. One of the most considerable of these was that the British genius, after one of its phases of inspissated insularity, was going through one of its periodical spells of catching up with the European tradition – absorbing, while affecting to despise, it. When Fielding,[2] in his introduction to *Tom Jones* (1749), describes his general bill of fare as human nature which he will at times 'hash and ragoo . . . with all the high French and Italian seasoning of affectation', he might be describing, with a dash of mockery which was already becoming old-fashioned, the spirit in which Reynolds set out for Italy in the very year the words were written. Hogarth's attitude is exactly like Fielding's: he devoured, with Gargantuan voracity, anything which France and Italy had to offer (usually through the medium of prints) but insisted that the foreign executant should be despised and only the British painter patronized. At the height of Van Loo's popularity in London, in 1741, Hogarth, doubtless in exasperation, signed his 'Portrait of a Man' at Dulwich 'W. Hogarth Anglus pinxt'.

It was no new thing for a British painter to journey to Italy. The change which occurs in the middle of the eighteenth century is a change in what the painters did when they got there. Howard had been a pupil of Maratta in the 1690s and had acquired a knowledge of *virtù*, but his portraits show no sign of Italian influence. Jervas showed equally little evidence of profiting by his Italian studies; Kent in 1714 was a pupil of Benedetto Luti, whose portraits are an inferior parallel to Kneller's; and the favourite teacher for foreigners in Rome in the 1730s was Francesco Imperiali. Young painters would eke out their money by copying Old Masters, usually perhaps of the Bolognese school, for visiting Milords, and they would absorb some knowledge of Greco-Roman sculpture, but perhaps their chief aim would be to form a profitable association with some wealthy British visitor, who would patronize them on their return. Certainly there was no systematic study of the Great Masters, and in particular of Raphael and Michelangelo, who now become the chief objects of study. A new direction to the studies, both of patron and painter, was given by the publication by the two Richardsons, in 1722, of *An Account of some of the Statues, Bas-reliefs, Drawings and Pictures in Italy*, a very creditable volume which listed judiciously what was most to be admired and the grounds for such admiration. It certainly played a great part in the growth of connoisseurship among British collectors, and it was probably as often to be seen in the hands of the young British painter in Rome. Most of the leading portraitists of the younger generation studied in Italy and their return is duly chronicled by Vertue. Pond came back to England in 1727, Knapton in 1732, Slaughter (from Paris and Flanders) about 1733, Giles Hussey in 1737, Hoare in 1738, Ramsay in 1738, Edward Penny in 1743. For the older generation the Italian journey was to some extent made up for by the various academies which were active in London from the first foundation of that of which Kneller became Governor in 1711, where Italian painters (such as Pellegrini) and those who had studied in Italy (such as Cheron) participated. The history of the several academies is not altogether clear. Thornhill succeeded Kneller in 1716 as the Governor of the 1711 Academy, but it is doubtful if it still survived in 1720, when Vanderbank and Cheron were instrumental in founding another. This too did not last for many years, and Thornhill, in the winter of 1724/5, opened an academy in his own house. Hogarth inherited the apparatus of this at Thornhill's death in 1734 and it was reorganized on 'democratic' lines and survived until the foundation of the Royal Academy in 1768, which took over its paraphernalia. The artist in London was thus much better placed than he had ever been in the preceding century. There was, however, nowhere for him to exhibit his pictures except his own studio. The first attempt to remedy this position was made, on

the initiative of Hogarth, at the newly established Foundling Hospital, to which a number of painters, during the 1740s, presented works of portraiture, history, and landscape, which were available to the inspection of inquiring visitors. The sense of a body corporate of artists thus took gradual shape during the reign of George II, blossomed in 1760 into the Society of Artists, and was finally canonized in 1768 by the establishment of the Royal Academy.

The marriage of the British tradition with the Italian Grand Style was not, however, fully solemnized until the time of Reynolds. It was prepared for by a series of flirtations with the French style,[3] which was much better calculated to undermine the formality of the Augustan age. Peace with France established at once much closer communication between the two countries and the coming and going of painters and engravers from France was much greater than is usually realized. In 1720 Raoux paid a visit to London of some months, and the dying Watteau was also in London during 1719 and 1720; from May to November 1724 Antoine Pesne paid a visit from Berlin, and Mercier probably settled in London about 1725. Numerous engravers had been settled here for some years: in 1722 Vertue lists Dorigny, Baron, Dubosc, Dupuis, and Le Blond, and the traffic in prints from France was considerable. Most important of all was Gravelot, who worked in England from 1732 to 1746 and profoundly influenced both painters and engravers in the direction of elegance. Probably Hogarth himself, and certainly Highmore, show the influence of Gravelot, and Hayman and the young Gainsborough (in his figures) are saturated with Gravelot's art.

Although at the level of the Court there was a marked divergence between British and French taste, the middle classes of the two countries approximated more and more in their likes and dislikes, and the enthusiasm which greeted Samuel Richardson's *Pamela* (1740) in France initiated the period when the products of British culture, now well established at home, began to make themselves known abroad. Diderot was familiar with the work of Hogarth and Hogarth probably played a considerable part in the formation of *la peinture morale* in France, for which Diderot proclaimed such passionate affection. The 'small conversation' or 'conversation piece' was probably introduced via France by Mercier and the French pastoral was imitated in England by Nollekens. Even the recovery of some popularity for the history subject, for which there was almost no demand in 1736,[4] may in part be claimed to be due to the French engravers and the fashion for illustrated editions of standard authors which spread to England from France. One of the first of such books was Tonson's *Racine* (1723), with plates by Louis Cheron. By the beginning of the 1740s the idea of pictures illustrating literary subjects had spread to English painters, and Vanderbank's small paintings of the 'Story of Don Quixote' bear dates from 1731 to 1736. Harmer's edition of Shakespeare with Hayman's illustrations was published in 1744 and contemporary paintings by Hayman of Shakespearean subjects exist. Highmore's pictures which were made for the illustration of Richardson's *Pamela* were engraved in 1745 and Hayman was painting at about this time the decorations for Vauxhall Gardens, in some of which the invention of Gravelot is documented. Hogarth's 'novels in paint' may be mentioned here in this context, but belong to a class by themselves. Thus the reign of George II will be seen to be the formative period for British history painting which makes such a vast outcrop in the later part of the eighteenth century.

French influence also counts for much in the introduction of a painterly texture, what Vertue calls 'the pencilling, touching, manner' which is so conspicuous in Hogarth and gives life to the portraits of his slightly older contemporaries, Vanderbank, Highmore, and Dandridge, although Kneller himself was not immune from this virtue. The most conspicuous difference between the two schools of portraiture in this transitional period is between those who descend from Kneller and the contemporary French tradition, who apply their paint in such a way that it is a pleasure to look at, and those, such as Hudson, Pond, Knapton, and lesser

figures, who descend from the tradition of Riley and Richardson and despise the surface graces. It is an irony that the young Reynolds should have been apprenticed to Hudson, and the difference between them which led to a friendly separation may have been in part due to Reynolds realizing that he was learning in the wrong school.

In addition to these influences from abroad certain changes were coming over society during these years and the class of patrons for portraiture was expanded to include the increasingly prosperous and educated middle classes. For the newly rich there were, and always have been, painters who would cater for their affectations, but there was a demand also during these years for a genuine and informal style which would reflect, not the severe and masklike image of the Augustan period, but the human and informal graces of men and women whose hearts were touched by the 'sensibility' reflected in Richardson's *Pamela*, and whose practical good nature found its outlet in works of philanthropy such as the establishment of the Foundling Hospital. Hogarth's 'Captain Coram' [137], painted for the Hospital, is the most splendid monument of this style and it is reflected in nearly all his portraits, as well as in those of Highmore after the early 1730s. Highmore's 'Mr Oldham and his Friends' (Tate Gallery) [145], of the 1740s, shows the length to which this new informality could reach. It is reflected also in Court circles, as the result of that curious animosity which persisted throughout the Hanoverian dynasty between the Kings and their eldest sons. Frederick, Prince of Wales (1707–51), whose virtues were more apparent in his appreciation of the arts than in other walks of life, signalized his opposition to his father by patronizing experiments in portraiture as far removed as possible from official formality. Mercier became his official painter soon after his arrival in England (from Hanover) in 1728, and painted, in 1733, the very singular 'conversation' of the Prince and his sisters (who were then hardly on speaking terms) making music in the gardens at Kew (National Portrait Gallery): and the large Du Pan group of 1746 at

Windsor of the Princess of Wales and her children [152] is the first deliberately domestic royal portrait painted in England. During the reign of George II the domestic virtues gradually triumphed in some of the upper and in the middle classes until they were canonized by the example of the Court under George III. The nature of the accompanying change in portraiture can be most clearly seen when we reflect that a Lely or a Kneller Duchess is usually represented as plucking a blossom of syringa or slapping her knee with a rope of pearls, while Reynolds frequently represents sitters of the same quality engaged in embroidery or the making of lace.

A brief chronological survey of the main changes in fashion, as they are reflected in Vertue's notes, combined with what seem today the most important painting achievements of the time, will properly precede an account of Hogarth and his contemporaries. Just before Kneller's death, in 1723, and at the outset of his notes on living artists, Vertue gives a list of the painters then in the public eye. Nearly all the portraitists have already been mentioned in the earlier chapters and the only new names are: Thomas Gibson (c. 1680–1751), a follower of Kneller, of whom nothing further need be said; John Vanderbank, and Enoch Seeman; in the same year he notes the first appearance of the young Highmore. John Smibert, who was soon to leave for the New World, is added in 1724. In 1728 Gay's *Beggar's Opera* was produced with great success, not least because it contained much covert satire on the Walpole administration: and it is significant that Hogarth first appears as a painter in 1728 in a picture taken directly from the stage performance of that work. About the same date the 'Conversation Piece', with small-scale figures, in an intimate setting, perhaps introduced by Mercier 1725/6, first becomes popular. Dandridge, Hogarth, Charles Phillips, and Gawen Hamilton are the names which are first associated with this new genre, and with the allied small-scale whole-length single figure. The scale made this a cheap form of portraiture and it is significant that those who were successful in this form

turned away from it as soon as they could to the more remunerative field of life-size portraits. In 1730 Vertue mentions Vanderbank's drawings for 'Don Quixote' and his paintings on this theme date 1731-6. Jeremiah Davison puts in an appearance in 1731, Marcellus Laroon in 1732, and the same year Vertue notes that art flourishes more in London than it had for fifty years. It was in 1732 also that Hogarth's first series of moral stories in paint, 'The Harlot's Progress', appeared in engraving: the first pictures designed for mass reproduction and to appeal to all classes. Hudson, who was later to be the most prosperous of the snob portraitists, is first mentioned in 1733. In 1735 Hogarth's copyright act, immediately followed by his engravings of 'The Rake's Progress', marks a step forward in the artist's status, and the first of an invasion of foreign portraitists, drawn to England by the prosperous condition of the arts, appears in the person of the Cavaliere Rusca. His visit was short, but he returned in 1738, and, in the meantime, Soldi had arrived about 1736, Van Loo in 1737 – with prodigious success – so that Allan Ramsay, who had returned from Italy in 1738, described his London success in a letter of 1740 as 'I have put all your Vanloes and Soldis and Ruscas to flight and now play the first fiddle myself'. In 1737 Vertue first notes the prosperity of Joseph van Aken, who painted the draperies (and most, except the face) for a considerable number of portrait painters. This had reached such a pitch by 1743

that Van Aken seems to have worked at least for Highmore, Hudson, Knapton, Pond, Ramsay, Dandridge, Wills, and Winstanley, and, as Vertue says, 'puts them so much on a level that it is very difficult to know one hand from another'. On his death in 1749 he seems to some extent to have been succeeded by a younger brother, and the Van Aken problem makes certain questions of connoisseurship in this period extremely tricky. The incorporation of the Foundling Hospital in 1739, followed by Hogarth's presentation to the Hospital in 1740, marks the beginning of a period in which the principal painters of the newer school, led by Hogarth, sought scope for historical and religious subjects, and Highmore, Hayman, Wills, Casali (who arrived in England in 1741) presented religious works to the Hospital, while others, including Richard Wilson and the young Gainsborough, presented landscapes. In the 1740s a national school of painting had at last reached maturity, and the new tendencies were well on the way to winning the field. In 1740 Jonathan Richardson retired from the practice of painting and devoted himself to literary studies, an example which was to be followed in later years by several of those who had helped to make possible the final victory of Reynolds – Ramsay, Highmore, and Hudson. The central figure of the period is undoubtedly Hogarth, who must be treated first. The lesser figures, both older and younger, can be grouped around his achievement.[5]

HOGARTH (1697-1764)

Hogarth was far and away the most significant artist of those who were the first to owe their technical training to the academies which had been founded in London in the second decade of the eighteenth century. But he was neither a typical nor a model product of those academies, since he relied all his life on a prodigious visual memory rather than on drawing from the thing or person before him, and his first training had been under Ellis Gamble, a professional engraver of arms on silver plate. Alone of the painters of consequence of his generation (or the next) - if we except Hayman - he had been brought up in the world of engravers, and this was to affect his art in more ways than one. The overloading of ornament which was in fashion for engraved plate at this time encouraged Hogarth's naturally flamboyant fancy, and gave him a facility in its expression which could hardly have been acquired by a more academic training in drawing. It also, however, encouraged spirited improvisation rather than studied composition, and led to his overcharging some of his compositions with more figures and matter than they could reasonably bear. The London engravers, many of whom were of French origin, were in closer touch with the Continent than the painters, and it was through the brisk trade in engravings that the ideas and compositions of the great classics of painting became current outside their own country, while the same trade served for the circulation of prints of scenes from common life and of illustrations to works of history and romance. The young Hogarth seems to have devoured everything of this kind that he could get a sight of, storing in his visual memory everything from the formulas of Raphael and the vivid idiom of Callot to the lowest, but sometimes effective, awkwardness of cheap Dutch broadsides. It is this apparent faculty of having swallowed whole a popular illustrated encyclopaedia which makes

Hogarth appear today, when scholars have painfully detected his 'borrowings', a prodigy of learning. But it is likely that his use of this vast visual repertory may rather have been to some extent subconscious. None the less, it is the stuff from which many of his pictures are formally derived.

Hogarth was a man of pugnacious and self-assertive temperament, one of the first English painters of note who could be called a 'character'. He ceaselessly publicized his activities, had no scruples about being consistent, and was something of an opportunist. His propaganda in his own favour has been sufficiently successful for him to be glibly called, in one British history of painting after another, 'the father of British painting'. It will be apparent that this is nonsense, and the false claims of the Hogarth legend have done a good deal to obscure the real claims of Hogarth the painter. In order to follow the course of his career with sympathy, it is necessary to understand the general lines of his ambition, which remained constant throughout his life. He tells us himself that it was the works of Thornhill at St Paul's and Greenwich which fired him to be a painter. Not so much, perhaps, the glamour of the works themselves as the fame and distinction which surrounded the artist who had done them - a knighthood, the position of King's Painter, and the reputation of having earned a name in history painting, the highest flight in the current hierarchy of art in European esteem. His ambition was quite simply to succeed Thornhill and become heir to all his successes, and he died a disappointed and rather embittered man because he had failed. He pursued his ends with something of the engaging naïveté of a (quite imaginary) African native who would eat a white missionary on the assumption that he would thus become possessed of the white man's knowledge and powers, and it never occurred to

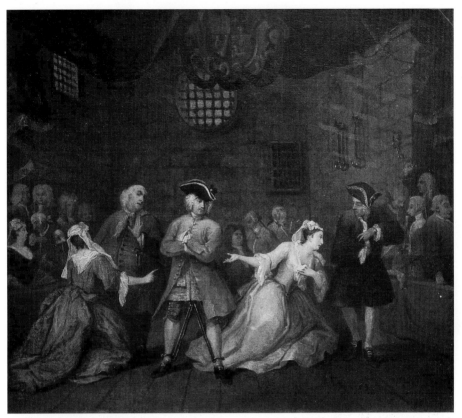

134. William Hogarth: The Beggar's Opera, 1728/9.
Birmingham City Art Gallery

him that Thornhill's position was largely due to the aptness of the times in which he lived to support a history painter of his class, and that the times had changed. He began by marrying Thornhill's daughter (1729), and he carried on very vocally a strong nationalist line (which had played some part in Thornhill's success) and attacks on the 'Old Masters', while, all the time, pillaging the old and modern masters of half Europe for his own compositions. All these elements in his character[1] are apparent in his work.

He must also have been endowed from heaven with a gift for handling the medium of oil paint. There were two schools of painting among the portraitists of the time, the one descending from Kneller, which included the more progressive younger artists, Vanderbank, Dandridge, Highmore, Gawen Hamilton, and Hogarth, in which the actual texture of the paint surface counted for something; and the other descending from Riley, and including Richardson and, later, Hudson and Ramsay, in which a smooth texture, without 'pencilling', was favoured. But the Kneller-Vanderbank tradition was quite insufficient to account for the lovely and dainty use of paint which is found in Hogarth right at the beginning of his career. It is something nearer to Watteau or to Jean-François de Troy than to anything in England,

and it remains a mystery how Hogarth can have come by it. His very first paintings, a series of repetitions of a scene taken from *The Beggar's Opera*, which was then playing to crowded houses, were done in 1728/9 and are something completely new in British painting. They would not look out of place among a collection of works by Lancret and Pater, and it is impossible to avoid the conviction that Hogarth had seen something more intimately French than the work of Mercier. With a mind of such quick visual response a single picture might have been enough.

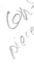

'The Beggar's Opera' (Hever Castle) [134], which shows the scene as it was presented on the stage, was so successful that Hogarth was commissioned to make three or four repetitions of it, which show slight variations. He had to invent nothing, so that the scene is not overloaded, and his visual method enabled him to present the incident with the vivacity of a moment in a real drama. It made his name as a painter of lifelike portraits on a small scale, and he soon had to turn this reputation to account, since his runaway marriage to Jane Thornhill in 1729 forced him to earn a living seriously by portraiture, and the small-scale group or conversation piece, introduced by Mercier about 1725/6, was in its early popularity.

A good many single figures of 'conversation' size and small conversations date from 1729 to 1733 and one or two are as late as 1738, but the mode was not sufficiently remunerating for the labour involved and Hogarth abandoned it as soon as he had struck another and more profitable vein. Only one or two of the more ambitious examples need be considered, and it is worthy of remark that those which take place indoors are always more successful than those which have a landscape background. Hogarth's sympathy was always with man and cities rather than with 'nature', with which he probably had little patience, and his conversations are always better the nearer they approach to a scene on the stage. With characteristic ambition he tried, very early in the series, to paint a conversation

of more participants than those of any of his rivals, and Vertue notes that 'The Wollaston Family' [135] 1730 created a considerable stir. No less than seventeen persons are arranged in the room, in two groups, which are somewhat naïvely bound together by a gentleman whose gesture has no psychological relevance but to introduce one group to the other. There is evidence of alternative arrangements of some of the figures showing through the more transparently painted afterthoughts and it is characteristic of Hogarth that, even in so ambitious and difficult a composition, he did not work it all out in a drawing first, but improvised as he went along. In 'The Assembly at Wanstead House' (Philadelphia), painted 1729 to 1731, there are no less than twenty-four figures, but the composition is a good deal less ingenious, and the figures at the back are crowded in, in something approaching desperation. It was the vivacity of the stage which inspired Hogarth and, when once he could combine the stage and a conversation piece, as in the 'Children playing *The Indian Emperor* before an Audience' 1731/2 (private collection) [136], he produced his masterpiece in this vein. The scene on the stage is itself a sort of heroic version of that which he had depicted in 'The Beggar's Opera' [134], and the sideways view of stage and spectators gave him an opportunity for a second group of equal vivacity with the first. Hogarth hardly ever later displayed the rich resource of his powers of picture-making to better advantage, and the picture must count as the first real masterpiece of small-scale figures in British painting. It is also as good as anything of the kind painted in France, and there is a tenderness in the observation of the children which had to wait for Gainsborough to rival it.

About 1731 Hogarth painted half a dozen pictures which were engraved in 1732 with the general title of 'A Harlot's Progress'. The originals perished in the fire at Fonthill in 1755, but their importance as the first of a new class of picture, with which Hogarth's name is perhaps today most generally associated, requires that the genesis of this new mode should be

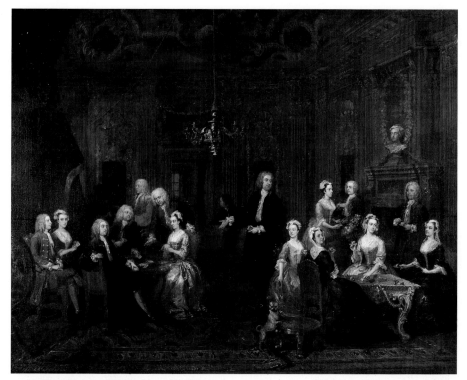

135. William Hogarth: The Wollaston Family, 1730.
H. C. Wollaston's Trustees

considered. Vertue, writing at the time (in 1732), not only reveals their immediate success, when he calls the series 'The most remarkable Subject of painting that captivated the Minds of most People, persons of all ranks and conditions, from the greatest Quality to the meanest', but indicates their accidental genesis. He says that Hogarth began with a single picture, without any intention of painting a series. He was then advised to make a companion to it, and then 'other thoughts increased and multiplied by his fruitful invention', so that he painted six in all. This smacks of the truth and is so true to our other knowledge of Hogarth's character that it is difficult to disbelieve. The type of picture grew out of what he was doing at

the time, small-scale stage groups and conversations. The difference in 'A Harlot's Progress' is that Hogarth invented the drama himself as well as painted the scene, and it is characteristic of his mind that he should have invented the drama as he went along and not worked it out carefully in advance. In his later years, when he wrote his autobiographical notes, and in the light of his later works of the same kind, Hogarth describes in relation to this series what were no doubt his final intentions in later pictures of this class. 'I therefore turned my thoughts', he says, 'to a still more novel mode, *viz.* painting modern moral subjects, a field not broken up in any country or in any age . . . I wished to compose pictures on canvas, similar

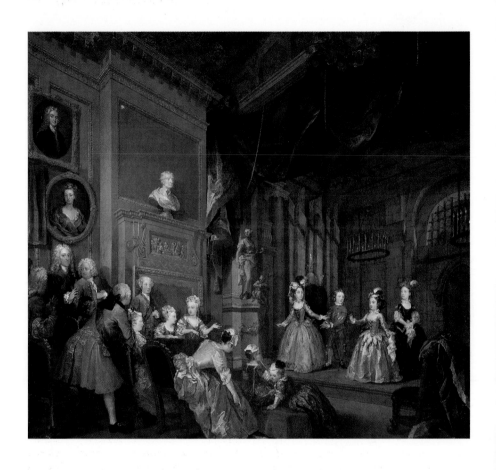

136. William Hogarth: Children playing *The Indian Emperor* before an Audience, 1731/2.
Private collection

to representations on the stage; and farther hope that they will be tried by the same test and criticized by the same criterion . . . In these compositions, those subjects which will both entertain and improve the mind, bid fair to be of the greatest utility, and must therefore be entitled to rank in the highest class.' The reasoning in the last sentence is characteristically Hogarthian and false. But Hogarth at least makes clear that these pictures must be judged as the work of a dramatic writer and a moralist, as well as the work of a painter. No doubt the triple intention overloads his canvases and obscures at times (too often) their purely artistic virtues, but the historian of art should take what he is given and seek to give an account of it, and not complain that it is not something else. By engraving this series Hogarth's art penetrated into every class of society and the engravings were immediately pirated. This provoked Hogarth to action, and his next preoccupation was to get an act passed which would ensure the copyright in the engraving of his works to the artist who had created them. This act was passed shortly before Hogarth issued his second series of moral fables, the eight pictures of 'A Rake's Progress', which were engraved in 1735 and have now found a home in the Soane Museum (London).

We have no means of telling what the painterly quality of the 'Harlot's Progress' series was like. That of the 'Rake's Progress' is extremely uneven. At times it reaches the highest degree of exquisite paint and at others it is merely perfunctory. The reason is presumably the simple one that, since the engravings were to be the lucrative element, and Hogarth neither hoped to sell (nor succeeded in selling) the original paintings at even a decent price, the paintings themselves could be skimped. This is no doubt reprehensible, but Hogarth's importance is twofold: his importance in the technical tradition of painting, and his importance in the popularization (or vulgarization) of the works of the contemporary artist. At any rate, the two Progresses deflected him for a time from his remoter goal of becoming the great history painter of the time, but the

engravings of 'A Rake's Progress' brought him in enough money to enable him to work more along lines in which he was interested himself than on the lines on which he could get commissions. He had also drunk deep of the sweets of being a castigating moralist, and his mind was by nature directed towards philanthropy. It is characteristic of the man that he contrived to turn his energies in a direction which would combine the interests of a philanthropist, a moralist, and a painter.

Thornhill's death in 1734 re-awoke Hogarth's ambition to shine as a history painter, although he had so far had no experience in that branch of art beyond having possibly painted one or two figures for his father-in-law. Commissions for historical work were not forthcoming, so Hogarth devoted much of 1735 and 1736 to painting huge compositions of 'The Pool of Bethesda' and 'The Good Samaritan' for the staircase of St Bartholomew's Hospital, of which he had recently become a Governor.

The Old Masters had been generously (and judiciously) pillaged for these vast works, but Vertue reports that they were by everyone judged to be more than could have been expected from Hogarth. Their chief shortcoming is perhaps their lack of monumentality. They have the air of compositions planned on the scale of conversation pieces and then enlarged. They did not provoke any commissions and Hogarth had to suppress again, for a time, his desire to shine as a history painter, and turn once more to popular genre for engraving – such as the 'Four Times of Day' (two at Grimsthorpe Castle, and two in the National Trust collection at Upton House). At the same time, having inherited the apparatus of the academy which Thornhill had held at his own house, Hogarth promoted a new academy, which, under more democratic management, survived until the formation of the Royal Academy and its Schools in 1768.

Hogarth now turned for a further livelihood to doing portraits on the scale of life, a task to which all British painters had to turn their hand if they were to prosper. After a few experiments with his family and friends he characteristically

again appeared before the public with an ambitious portrait, which, with interested generosity, he presented to the Foundling Hospital. This was the seated full-length of 'Captain Coram' [137], that noble and benevolent man who had secured a charter for the Foundling Hospital in 1739. Coram was a friend of Hogarth's and Hogarth became one of the first Governors of the Hospital, to whom he presented the portrait in 1740. At the same time, under Hogarth's inspiration, the Foundling Hospital built up, during the first ten years of its existence, a connexion with the best artists of the day, who presented to it examples of their work, which were exhibited in rooms to which the upper-class public had certain access. In this way Hogarth contrived to set in motion the machinery which was to lead to the formation of the Royal Academy. The portrait of 'Captain Coram' is one of the great landmarks in British portraiture. It was at once the most original portrait to have been painted for at least half a century in Britain, and one of the first to be more or less on public exhibition.

Even its subject-matter was to a large extent new.[2] It is not an aristocratic portrait painted for a palace, nor even a full-length to fit in with the family series in the house of a country gentleman. It is, as it were, a 'state portrait' of a middle-class philanthropist, painted to form (as it remains) the principal ornament of a benevolent institution. It was painted with affection to keep Captain Coram's name in remembrance, and the aspect of his character which is stressed is not his birth, nor the social status to which he has climbed, but his good nature. The man himself smiles out at us from the canvas. He is no longer a type with individual features, but an individual in his own right, whose character is reflected in those features.

'Captain Coram' is not, of course, the first portrait in which these elements appear. Hogarth himself had shown the way to middle-class portraiture of this kind before, and all the more progressive artists of his generation, most of all Highmore, had been escaping gradually, from about 1730, from the tyranny of the social mask. But 'Captain Coram' is the first portrait of this class which partakes also of the nature of a 'state portrait'. Dr Antal has convincingly shown that Hogarth deliberately modelled himself on Rigaud's portrait of 'Samuel Bernard' (with which he would have been familiar from Drevet's engraving), and toned down that full Baroque presentation of a prosperous financier into something which had lost all the overtones of arrogance, while it retained to the full the feeling of dignity. Considerable resources of art were, in fact, needed to give dignity to the squat figure of the old naval captain without straying from the truth of appearances, and it is a gauge of Hogarth's powers as a creative and intellectual artist that he has married his new subject-matter to the European tradition. Old-fashioned painters and old-fashioned sitters might go on for many years in the old tradition, but the vanguard of British painters, who were to make British portraiture the most impressive in Europe in the next generation, took their lead from 'Captain Coram', and Hogarth himself never had occasion later to turn his forthright vision to such monumental purposes.

The five years from 1740 to 1745 are those during which Hogarth was most active as a portrait painter on the scale of life. Among the most typical and accessible examples are the 'Unknown Man' of 1741 at Dulwich, signed 'W. Hogarth *Anglus*', no doubt as a dig against the great temporary popularity of Van Loo in London; the 'Mrs Salter' of 1741 or 1744 in the National Gallery; and the 'Graham Children' of 1742, in the Tate Gallery. 'Mrs Salter', on its more modest scale, is worthy to rival 'Captain Coram'. This unclouded directness of apprehension of character is more remarkable in a woman's portrait than in a man's, and the sparkle of life in the face and in the mere paint as well suggest that Hogarth had refreshed his experience of France. This makes the reading of the date as 1744 the more likely; for Hogarth visited France in 1743, where he must have seen in the Salon the work of the only other great European middle-class painter of the time – Chardin. That love of the texture of paint, which is part of Chardin's means of

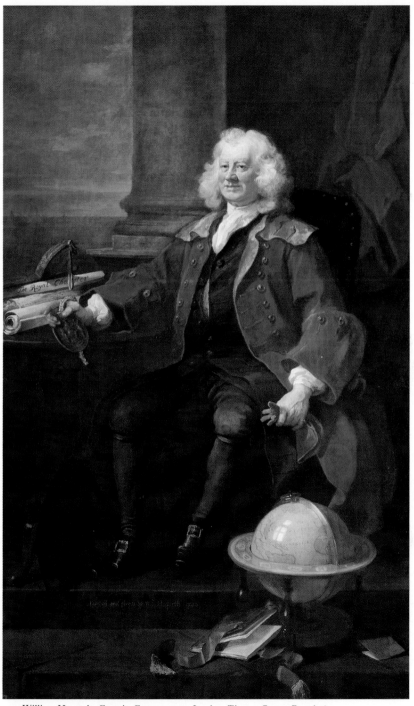

137. William Hogarth: Captain Coram, 1740. *London, Thomas Coram Foundation*

transforming common things into symbols of an ideal world, is nowhere more apparent in Hogarth's work than in 'Mrs Salter' and in the greatest of his series of modern moral subjects, the six pictures of 'Marriage à la Mode' in the National Gallery, at which he was working from 1743 to 1745.

the best of the series, to a lucid economy of order and design, no less rich in satirical counterpoint. George Barnfield has given place to Molière. 'Scene II: Early in the Morning' [138] is not only a miracle of psychology, and a brilliant exercise in the comedy of manners, it is also one of the most captivatingly lovely

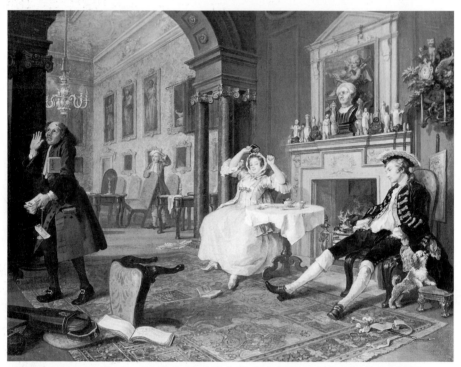

138. William Hogarth: Marriage à la Mode, II: Early in the Morning, 1743/5. *London, National Gallery*

The 'Marriage à la Mode' series is incomparably superior to 'A Rake's Progress', and not merely because it was designed to appeal to, and to castigate, a higher level of society. The engravings probably had the same appeal to all classes of persons, but Hogarth, to judge from the loving beauty of their execution, seems to have hoped that the original paintings might in this case appeal to a collector of a superior class. And well they might. The top-heavy piling up of pictorial wisecracks, which makes the earlier series so tiring to read, has here given place, in

paintings of the English school. In Fielding's already quoted words from the 1749 introduction to *Tom Jones*, here is human nature which Hogarth has contrived to 'hash and ragoo with all the high French and Italian seasoning of affectation'.

In June of 1745 Hogarth, who had spared nothing of self-advertisement, held a sale of the various painted originals for his popular engravings. The result was a failure, and it became clear that contemporary paintings of modern moral subjects could not compete in

value with quite secondary Old Masters. At the same time the building of the Foundling Hospital was completed and Hogarth turned again to his original ambition of history painting and to organizing the more progressive artists into

Profiting by the excitements of the Forty-five he also painted 'The March of the Guards towards Scotland', in which the vein of the modern moral subject was blended with political satire in a way which broke new ground in the

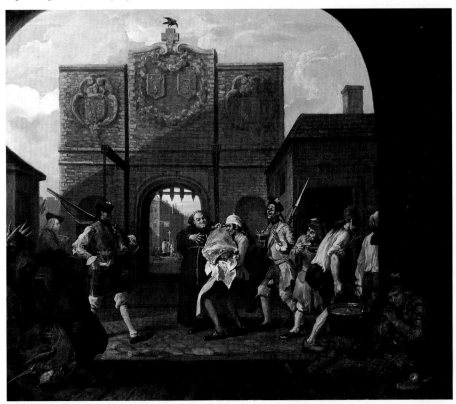

139. William Hogarth: O the Roast Beef of Old England!, 1748–9. *London, National Gallery*

helping to decorate the Foundling Hospital. Four large religious histories were presented to the Hospital during the next few years by their painters, Hogarth, Hayman, Highmore, and the Rev. J. Wills. Hogarth's own contribution was 'Moses brought before Pharoah's daughter' (1746), and this was followed by his one more-or-less public commission for a history picture, 'Paul before Felix' 1748 at Lincoln's Inn, in which the Raphael cartoons are the obvious inspiration. These do not enhance his reputation.

field of the subject-matter of painting. The possession of this also fell to the Foundling Hospital as the result of an ingenious but rather unsuccessful attempt to get a good price for the picture by raffling it. A second experiment in the same genre, the fruits of an unsuccessful attempt to visit Paris in 1748, was 'O the Roast Beef of Old England!' or 'Calais Gate' (National Gallery) [139], in which the pictorial and satirical qualities are admirably fused. This also made a highly successful print but did not find an immediate purchaser. After this, however,

Hogarth retired more or less from painting until he had completed his polemico-theoretical work, *The Analysis of Beauty*, which was published in 1753. It has a greater importance in the history of European art theory than in the history of British painting. It reinforces, however, the impression of Hogarth's wide and intelligent knowledge of the work of foreign artists.

When Hogarth re-emerged as an active painter, about 1754, the star of the young Reynolds was already in the ascendant, and the 'new style', to which Hogarth himself had contributed so much, had won the day. But Hogarth himself was not in the line for fashionable commissions and he was not in busy practice during the last ten years of his life. Nor was he one of those to whom old age brings a lucid wisdom, with a corresponding enhancement of the creative powers. The four pictures of his last series, 'An Election' (Soane Museum,

London), painted about 1754, show a return to the overloaded narrative style of 'A Rake's Progress'; and the vast 'Triptych' which he painted in 1756 for St Mary Redcliffe, Bristol, shows no advance in monumentality over the religious compositions painted for St Bartholomew's Hospital. Even 'The Lady's Last Stake' of 1758/9 (Albright Art Gallery, Buffalo), though not unworthy to compete with the 'Marriage à la Mode' series, shows no progress beyond them and must have seemed, at the time it was painted, to be an attractive survivor of the style of the 1740s. His one novel experiment, the 'Sigismunda' of 1759 (Tate Gallery) [140], was greeted with laughter and abuse. It was a serious attempt to show that an English painter could produce as good a work in the Bolognese manner as many of the old masters of that school for whose pictures British collectors were then paying enormous sums. In that aim,

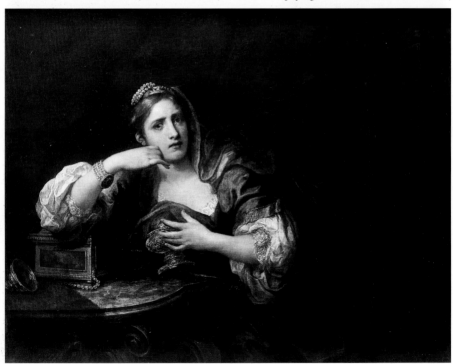

140. William Hogarth: Sigismunda, 1759. *London, Tate Gallery*
141 (*opposite*). William Hogarth: Hogarth's Servants. *London, Tate Gallery*

it must seem to unprejudiced eyes today, it has succeeded; it is at least as distinguished a work of art as the Furini of the same subject, whose spectacular auction price had led Hogarth to the experiment. Had Hogarth sought to sell it as an Old Master, instead of as a creation of his own fancy, it might well have been a success.

It is in certain sketches or studies, not made for the public eye, that Hogarth in his last years still reveals to us today that he had lost nothing of his freshness of vision – 'The Shrimp Girl' and the wonderful 'Hogarth's Servants', both in the Tate Gallery [141]. In the six heads in this latter picture, painted with tenderness and sympathy, without a thought of public praise or blame for the finished work, with no desire to point a moral, we can see Hogarth's natural gifts at their most unclouded. He seems to set before us a group of characters for a story as innocently charming as *The Vicar of Wakefield*.

In this, and in a few portraits such as 'Captain Coram' [137], we can see how much of the Goldsmith in Hogarth was lost in his public parade of the Fielding element in his character. Private pictures of this kind are not those which make Hogarth important in the history of British painting, but they must none the less be numbered among the small company of great masterpieces of the British School.

Hogarth's place in the broader panorama of European art is probably greater than that of any other British painter, and it is hardly related to his importance within the British school. His modern moral subjects lie behind the growth in France of *la peinture morale* of which Greuze was the most fashionable exponent. Their ramifications extend towards David and Goya. But in British painting, which is our concern, Hogarth's art has always been respected, but has never been dynamic.

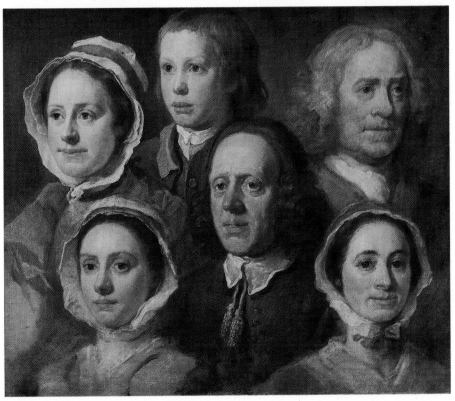

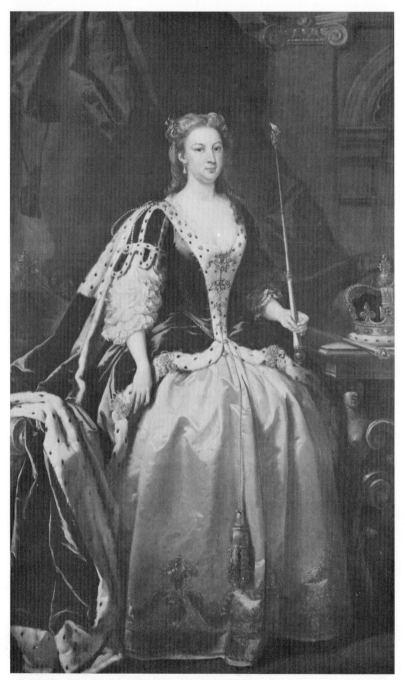

142. John Vanderbank: Queen Caroline, 1736. *Duke of Richmond and Gordon, Goodwood, Sussex*

CHAPTER 12

HOGARTH'S CONTEMPORARIES

Although the historian must inevitably focus his main light upon the lively personality of Hogarth, there was a group of slightly older painters, who had a more considerable fashionable practice as portraitists and who were tending, more or less independently, in the same forward direction. They would doubtless have been highly displeased at being categorized as 'Hogarth's contemporaries', and a critic of that age would have been no less surprised at the description. George Vertue, speaking in 1731 (III, 54) of the leading artists, after calling Dahl, Richardson, and Jervas 'the three foremost Old Masters', goes on to the next class of those that studied in the academy under Kneller, and he names Hogarth last in a group which includes Vanderbank, Highmore, and Dandridge, all of whom were in good practice before Hogarth started oil painting. All three belong to the group which was interested in the texture of the paint surface, and all three are candidates for the authorship of pictures which have strayed incorrectly into the lists of Hogarth's works.

John Vanderbank

Elder son of the well-to-do Huguenot tapestry weaver John Vanderbank, the younger John was born in London on 9 September 1694 and died there, from the aftermath of debauchery, on 23 December 1739.[1] Vertue, who knew him well, thought that he had the greatest promise (though it was not fulfilled) of any painter of his time. A member from 1711 of Kneller's academy, he took the initiative, with Louis Cheron, another Frenchman, in founding a second academy in 1720, and his certainly signed works begin, on present knowledge, the same year.[2] From 1723 one can point to signed and dated works for every year of his life. In

pattern they are not often strikingly original, but they are hardly ever banal, and Vertue (III, 57) makes clear that it was Vanderbank who started, in 1732, the fashion of using a Rubens costume for portraits of ladies.[3] The faces are admirably drawn with the brush in the free, painterly style which is characteristic of Hogarth also, and which Vertue calls 'a greatness of pencilling'. His masterpiece is perhaps the 'Queen Caroline' [142] of 1736 at Goodwood, which conveys something of the indomitable personality of the then dying Queen, and is the first vivid portrait of British royalty since the Revolution of 1688. Outside of portraiture Vanderbank is at present known chiefly by twenty small scenes illustrating *Don Quixote*,[4] which range in date from 1731 to 1736. These too are first cousins to Hogarth in their fresh, if slovenly, use of paint, and are amongst the earliest examples of painting with a literary source in England, a genre which was to have a considerable expansion during the eighteenth century. His lively drawings suggest a greater involvement in history painting, and one or two examples have recently turned up.

Joseph Highmore

Highmore was, in temperament, the exact opposite to Vanderbank. He was a man of 'habitual temperance' and lived to the ripe age of eighty-eight, having been born in London 13 June 1692, and dying in retirement at Canterbury 3 March 1780, on the eve of the romantic period. He had by then long given up the practice of painting, a characteristic of those of the earlier generation who survived into the new world of Reynolds and Gainsborough. He was a man of letters and had first been trained to the Law, but he spent his leisure hours at Kneller's academy 'where he drew ten years'.

His clerkship expired in 1714 and he began painting as a profession in the following year. A portrait of 1721[5] and an accomplished etching of a man in profile, dated 1723, are all that is at present identified of his work before 1728, but from 1728 onwards his career can be followed, year by year, in a series of signed and dated portraits until his retirement from practice and to Canterbury in 1762.[6]

The development of Highmore's art runs closely parallel to that of Hogarth in its formal elements, and even to some extent in its social implications. But it is entirely without a bias towards the satirical, the comic, or the moralizing. The writer of Highmore's obituary tells us that 'he had a tender, susceptible heart, always open to the distress of his fellow creatures and always ready to relieve them', and, if we may liken Hogarth to his friend Fielding, we can best understand Highmore by considering him the parallel in painting to his friend, Samuel Richardson, whose portrait he painted

143. Joseph Highmore: Samuel Richardson, 1750.
London, National Portrait Gallery

and whose work he illustrated. As in Hogarth we begin to find a friendly warmth creeping into his portraits from the beginning of the 1730s, a directness in the interpretation of character. Its progress may be measured, to take examples from accessible collections, by comparing the 'John Whitehall' of 1731 at Birmingham, with the 'Mrs Perry' of 1739 at Penshurst. The small full-length of 1750 of 'Samuel Richardson' (National Portrait Gallery) [143] has a genial quality which amounts almost to an introduction, and it is this geniality, which has as its complement a certain tender and almost feminine quality, which marks the difference between Highmore and Hogarth.

In the twelve paintings illustrating Richardson's *Pamela*, which are now divided between the Tate Gallery, the Fitzwilliam Museum at Cambridge, and Melbourne, and were engraved in 1745, Highmore can be seen working in a vein superficially comparable with Hogarth's in his 'Marriage à la Mode' series. But the difference of spirit and intention is considerable, much greater than the difference in quality. Highmore is illustrating, and not *telling* the story. The French daintiness of handling is common to both series, but the corresponding daintiness in feeling is Highmore's alone, although it is to be reckoned with in painters such as Hayman in their work of the middle of the 1740s. A comparison of Highmore's 'Pamela telling a Nursery Tale' (Cambridge) [144] with the 'Children building Houses with Cards', engraved in 1743 as by Hayman after Gravelot's invention, shows the same spirit at work and suggests the source of the influence – Gravelot. The importance of Gravelot, who was a draughtsman and engraver rather than painter,[7] can hardly be overestimated in this connexion. He was the prime sponsor of the rococo and French manner, which did much to break down Augustan formality, and reached its purest English flowering in the early work of Gainsborough. Of the older generation it was Highmore who felt this influence most and corrupted it least. In Hogarth's hands it became something like a French dish attempted by an English cook.

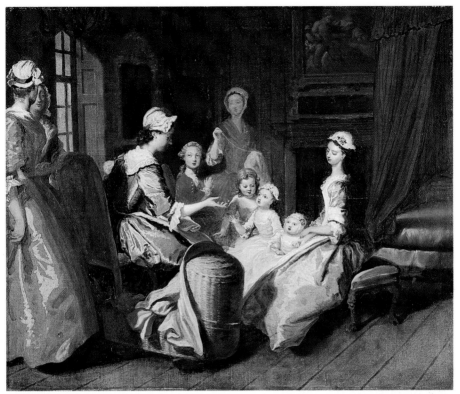

144. Joseph Highmore: Pamela telling a Nursery Tale.
Cambridge, Fitzwilliam Museum

In 1746 Highmore was one of those who presented a religious history picture (under Hogarth's stimulus) to the Foundling Hospital, and his 'Hagar and Ishmael', which harks back somewhat to the style of Lely, is the most agreeable of the series, and Highmore is recorded as having painted four or five other history pieces of the same character.

We probably do not as yet know the full gamut of Highmore's art. The writer of his obituary says that he painted more 'family pieces . . . than anyone of his time', but hardly any have been identified, and his single conversation piece on the scale of life at present known was only re-identified by Dr Antal[8] after it had been acquired by the Tate Gallery on its own merits as by an unknown hand. This 'Mr Oldham and his Friends' [145], probably painted in the 1740s, considerably enlarges our knowledge of Highmore's possibilities. In style it is perhaps nearer to Mercier (who will soon be discussed) than to Hogarth, but it has an English quality and informality which Mercier lacks, and it picks up a thread in the British tradition which had been lost since the time of Dobson's more heroic 'Conversations'. Here the figures seem to have stepped from the pages of Sterne rather than of Richardson. Character is conveyed as truthfully as by Hogarth, but with less rude directness, and Highmore's softer modelling allows for the play of shades and gradations, of suggestions rather than statements, which Hogarth's brusque method rejects.

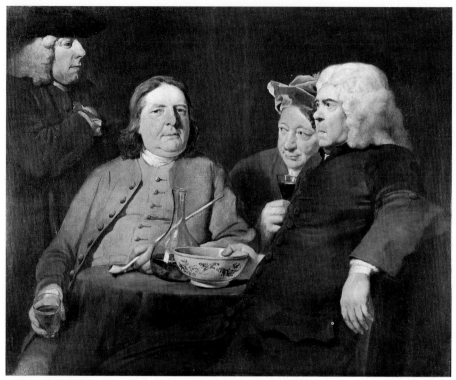

145. Joseph Highmore: Mr Oldham and his Friends, 1740s(?).
London, Tate Gallery

Bartholomew Dandridge

Dandridge[9] was baptized 17 December 1691 and was working as late as 1755. In his normal portraits on the scale of life he differs little in style from Vanderbank, except that he has rather less bravura of touch, but his groups and single figures on a smaller scale are more interesting, and Dandridge must count for something in the development of the conversation piece. As with Hogarth and Highmore the series of his recognizable works begins with 1728. What is especially interesting in Vertue's account of Dandridge is the fact that he seems to have made something of an art of organizing the grouping of his conversations, making little models of the figures to enable him to study the play of light and shade. This is something quite different from Hogarth's more slap-dash method of improvisation and the difference can be clearly seen by comparing 'The Price Family' [146] of about 1728[10] (Metropolitan Museum, New York), which is pretty certainly by Dandridge, with Hogarth's Wollaston group of 1730. Dandridge has grasped the principles of Rococo style, which Hogarth never did.

The same decorative preoccupations can be seen in two later groups, 'The three Noel Girls' (Manchester) of about 1740, and 'Mr and Mrs Clayton and their Daughter' at Squerryes Court, of about 1754. It is apparent, too, and there seems to be something French about it,

in the small-scale equestrian portrait of 'Frederick, Prince of Wales' 1732 in the National Portrait Gallery, and in one or two other pictures of the same category.

(1688–1751?), a native of Edinburgh who had studied in Rome and was beginning to make a name for himself in London before he accompanied Bishop Berkeley to Bermuda in 1728,

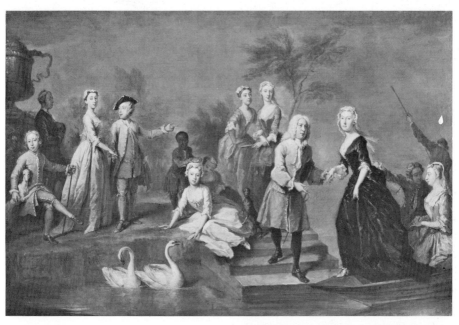

146. Bartholomew Dandridge: The Price Family,
c. 1728. New York, Metropolitan Museum of Art

147 (right). John Smibert:
Sir Francis Grant, c. 1725/6.
Edinburgh, Scottish National Portrait Gallery

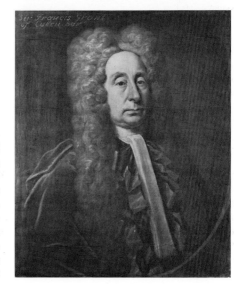

Minor Painters

Of the lesser fry, other than painters of conversation pieces, many names are known and many more portraits survive on which the signature of some otherwise unrecorded painter can give a moment's interest to the curious student. We know enough of the eighteenth century – as we hardly do as yet of the seventeenth – to feel sure that they need no mention in a general history. A few artists, however, deserve mention, though not always for the same reasons. The least of these is John Smibert

whence he migrated the following year to Boston and became the founder of the independent portrait tradition of New England. The best of his pre-American works is the 'Sir Francis Grant' (Lord Cullen) [147] of about 1725/6 in the Scottish National Portrait Gallery.

The two less expensive portrait painters at this time who had a good practice in copying as well as in original portraits were Enoch Seeman and Isaac Whood, both of whom carried on the style of Richardson without yielding to the blandishments of the new style. They perhaps specialized in the more old-fashioned clients, and Whood (1688–1752) had considerable connexions in antiquarian circles and was kept in employment for many years (largely on making copies) by the Duke of Bedford. Enoch Seeman (1690?–1745) was a native of Danzig who came young to London and was in good employment by 1717. He was accurately categorized by the Duchess of Marlborough in a letter of 1734:[11] 'Seeman copies very well, and sometimes draws the faces like', but uncommissioned works, such as the 'Selfportrait' at Thirlestane Castle, show that he was not as uniformly pedestrian as he seems. His last major commission, 'Lady Cust and her nine Children' at Belton, of 1743/4 is specifically known to have been given to Seeman because Hogarth persisted in asking too high a price.[12] Enoch's brother Isaac Seeman, who survived until 1751, was also a portrait painter, but does not seem to have had a considerable practice.

Two much abler and more attractive painters, both probably of the generation born before 1700, are best mentioned here, as the work of both is sometimes confused with that of Hogarth. Of G. Beare no documentary reference has been found, but it is probable that he was working in the West Country. His signature is known on some twenty portraits ranging in date from 1744 to 1749, two of which (both of 1747) – 'Thomas Chubb' and 'Francis Price' – are in the National Portrait Gallery. They show a friendly directness not unworthy of Hogarth, and Beare's 'Jane Coles' at Ven House, a child with a doll and a cat and a basket of fruit, is so Hogarthian in the texture of the

paint as well that it has twice been exhibited as by Hogarth although plainly signed and dated 1749 by Beare. The other painter is George Knapton (1698–1778), who will be mentioned also among the painters in crayons. After seven years with Richardson and three on his own in London, he spent a further seven years in Italy from 1725 to 1732. Nothing is known of his work and little of his activities before 1736 when he became a foundation member of the newly formed Society of Dilettanti, with the official title of Painter to the Society. Between 1741 and 1749 he painted a remarkable series of portraits[13] of members of the society in a variety of fancy dress (except for the Duke of Bedford), which shows that he was in touch with the principal patrons of portraiture in the

148. George Knapton: The Hon. John Spencer and his Son out Shooting, 1745.
Earl Spencer, Althorp, Northants

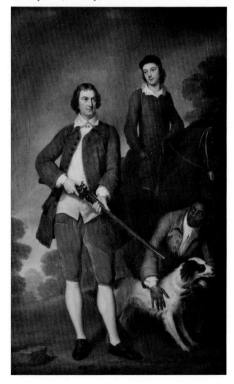

country. From at least 1737 he had a large practice in doing crayon portraits, but his work in oil is rather infrequent, though hardly ever without some originality or distinction. One of the prettiest is the engraved, but undated, 'Lucy Ebberton' at Dulwich, and typical examples of his best work are the 'Earl of Burlington' 1743 (Chatsworth), 'The Hon. John Spencer and his Son out Shooting' 1745 (Althorp) [148], and the huge group of 1751 at Marlborough House of the 'Princess of Wales and her Eight Children'. In 1763 Knapton resigned his place in the Dilettanti Society and appears to have given up painting. As far as our knowledge goes he did little after the early 1750s. His latest dated work at present known is the 'Wathen Family' in the Birmingham Gallery of 1755.

CONVERSATION PIECES AND FANCY PICTURES:

MERCIER AND HAYMAN

Towards the close of the 1720s there came into fashion what was for England a new kind of picture, which is to-day called the 'Conversation Piece'. The essence of such pictures is that they represent a number of persons, a family or a group of friends, with a certain degree of informality and at ease among themselves, not stiffly posed for the benefit of the painter. They may be represented in their homes or in their gardens and the figures should be small in scale, generally some twelve to fifteen inches high. The eighteenth century applied the term 'a conversation' to all informal groups, whether small in scale or on the size of life, and whether the figures were portraits or productions of the painter's fancy, but today the term is restricted in general use to small-scale portrait groups.

This type of picture was not uncommon in Holland in the seventeenth century and in France in the first quarter of the eighteenth, but it acquired a special character of its own only after its introduction into England, not for reasons connected with art but because of the structure of English society. It is not an aristocratic form of portraiture, and it is no accident that it begins to appear at precisely the time when the formality of British portrait style begins to yield under the softening influence of more natural manners. When the middle classes, often with large families, began to wish to have their portraits painted, a kind of picture was inevitably evolved which was adapted to relatively small houses. For figures on this modest scale a correspondingly modest price per head could legitimately be demanded, so that economic and social considerations combined to promote the vogue of the conversation piece. On the other hand the more ambitious painters, whose early reputation had been made in this kind of small-scale group, Hogarth, Mercier,

Dandridge, and Charles Philips, all found later that this genre was insufficiently remunerative and sought to graduate into portraiture on the scale of life. A few others, such as Arthur Devis, settled comfortably into a routine of steady employment in portraiture on this scale for middle-class patrons, either in groups or in single figures of corresponding size.

Among the earliest of British conversation pieces must be counted 'An English Family at Tea' (National Gallery 4500, on loan to the Victoria and Albert Museum), which is generally dated, on grounds of costume, to about 1720. This is only a step removed in style from the genre pictures of Joseph van Aken, and it would not be at all surprising if the picture turned out to be by Van Aken himself. But something more modish – and the conversation piece, though rarely aristocratic, is almost invariably modish – first appears in a picture by Philip Mercier, which is dated 1725.

Philip Mercier (1689?-1760)

Philip Mercier[1] was the son of a French Huguenot tapestry worker who had migrated to Berlin, where Philip is said to have been born in 1689. He studied in the Berlin Academy under Pesne, who gave a French bias to his art. Vertue, whose account of Mercier's earlier years is all we have to go on, writes in a language which is susceptible of several interpretations. At some time he studied in Italy and in France and he was making etchings after Watteau in 1723/4. Whether he made these in London or Paris is far from clear, but there is no serious evidence to justify the constantly repeated statement that he was Watteau's host in London in 1720. His first dated painting is a conversation piece,

signed and dated 1725, formerly in the collection of Lord Rothermere, which does not look as if it had been painted in England.[2] As it descended in the family of Baron Schutz, a prominent Hanoverian figure at Court from the time of the accession of George II, and as much points to its having been painted at Hanover, we may provisionally place Mercier's effective beginnings in England between 1725 and 1726 when he painted 'Viscount Tyrconnel and his Family' [149] in another conversation piece at Belton House.[3] This amusing picture

is the first modish conversation piece at present traced in England. But it is exceptional in that it is almost wholly French in style, is aristocratic in intention, and includes a figure of the painter himself, who is shown drawing the others in their recreations. Mercier, however, did not need to continue to practise in this vein since, in 1728, the young Frederick, Prince of Wales, reached England from Hanover and took his old Hanoverian friend into favour. Mercier was appointed Painter to the Prince of Wales 6 February 1728/9, Page of the Bedchamber on

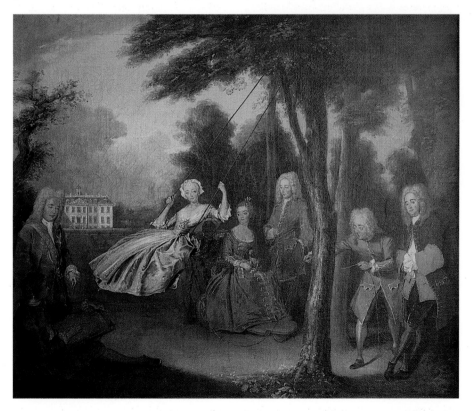

149. Philip Mercier:
Viscount Tyrconnel and his Family, 1725/6.
National Trust, Belton House

6 March, and Library Keeper 26 January 1729. In 1728 he painted full-lengths of the three Princesses, which were given by the Queen to Lord Grantham, and he was kept busy during the next few years with portraits of the 'Prince of Wales' (of which the best is in the

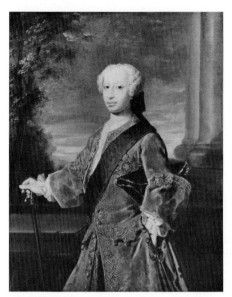

150. Philip Mercier: Frederick, Prince of Wales.
London, National Portrait Gallery

National Portrait Gallery [150]), with occasional conversation pieces of the royal family such as the (perhaps maliciously intended)[4] 'Frederick, Prince of Wales and his Sisters at Concert' 1733 (National Portrait Gallery), and possibly with catering for some of the Prince's less edifying pranks. It may have been in the latter role that he finally quarrelled with his royal master about 1736/7, and was deprived of his Court appointments. But he had also established a considerable Huguenot connexion, notably with Sir Thomas Samwell of Upton,[5] and he settled down for a time as a portrait painter in Covent Garden, and to the creation of a new kind of genre, which one may call 'fancy pictures'.

Vertue, in 1737, gives, in his confusing English which shows a brave attempt to find words for something new, an account of these fancy pictures – 'pieces of some figures of conversation as big as the life: conceited plaisant Fancies and habits: mixed modes really well done – and much approved of'. Nine of these, ranging in theme from 'A Venetian Girl at a Window' to

'A Recruiting Officer', were engraved by the younger Faber in 1739. Hogarth's pioneer work no doubt counts for something in these, and they were probably designed to make money by the engraving rather than as paintings, but the subjects are intended only to please and have no moral or satirical connotation, and they are quite literally works of fancy.

By 1740 (when he signed and dated the huge conversation piece at Thorpe Hall) Mercier had retired to Yorkshire, where he had a good practice for some years in portraits on the scale of life, often full-lengths. Good examples, of 1741 and 1742, are in the York Gallery, at Temple Newsam and at Burton Agnes. He also travelled further afield. He may have been in Scotland in 1745: in 1747 Vertue mentions a brief visit to London to sell pictures of 'The Five Senses' as well as a short visit to Ireland: in 1750 his presence in Edinburgh is attested by a receipt at Wemyss Castle.

In 1751 Mercier returned to London, and his latest dated portrait that I have seen (of 1752) shows that he was master of the new style. But the competition of the rising generation was too much for him, and he all but settled in Portugal in 1752. His later years in London were largely occupied in producing fancy pieces for the engravers, of which Houston scraped a good number 1756/8. Few of the originals are in accessible collections, and some are very feeble, but the 'Girl with Kitten' at Edinburgh (engraved 1756) suffices to show how strong a French tincture his art retained to the last.

Mercier was hardly a genius, but his pictures have passed under the names of Hogarth and Watteau, and he was a restless and mobile personality of a decided artistic character. That character was markedly French and his most original productions were widely diffused in popular engravings. He deserves the attention he has received as a constant French influence in the formation of the British style. He and Gravelot both count for something in Hayman. The style of his fancy pictures was taken up by Henry Morland: and it was later carried on by Gainsborough, under whose name at least one of Mercier's pictures has constantly passed.

Old Nollekens and Young Laroon

Two minor figures deserve passing mention, who worked in something of the same tradition as Mercier. Joseph Francis Nollekens (1702–48), the father of the well-known sculptor, was a native of Antwerp, who is stated to have been a pupil of both Watteau and Pannini. He came to London in 1733, where he worked at first for Tillemans, but later built up for himself a fairly good independent practice in small fancy pictures and galant genre in decidedly distant imitation of Watteau and Pater. His best patron was Earl Tilney, and the list of his works in the sale of Lord Tilney's heirs at Wanstead House in 1822[6] provides the best catalogue of the kind of fancy subject, with figures on a small scale, which was popular in the 1730s and 1740s. A genuine conversation piece (said to be from Wanstead) formerly at Northwick Park, if correctly ascribed to Nollekens, suggests that he was capable of better things than the usual run of his imitations of Pater.

The younger Marcellus Laroon (1679–1772), whose father has been noticed as a follower of Kneller, amid the diversions of a busy and hectic life, which included the stage, the army, and a good deal of general roistering, produced a number of paintings (and more drawings) of the same character, mainly during the 1730s and 1740s. One or two portraits by him are known, but most of his paintings are works of fancy, sometimes pastoral, sometimes of low life, and sometimes inspired by the stage. His 'conversation pieces', of which the Duke of Buccleuch's 'Musical Party' [151] is one of the best examples, appear also to be works of imagination. But all his pictures are original in

151. Marcellus Laroon: A Musical Party.
Duke of Buccleuch and Queensberry

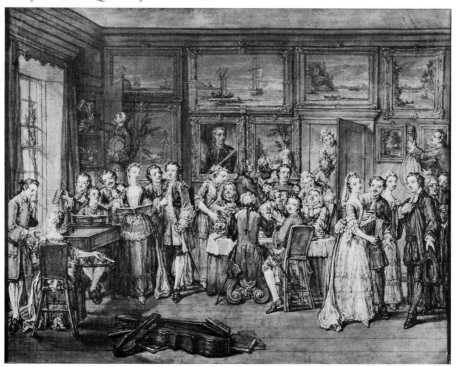

technique and lively in drawing. Many have the appearance of stained drawings, and all have a suggestion of tapestry rather than of oil paint about them. They are also curiously un-English and may owe something to his stay in Venice.[7]

A third foreign practitioner of the conversation piece was the Swiss Barthélemy Du Pan (1712–63), who was in England from 1743 and

Arthur Devis and his Forerunners

The conversation piece, and the single portrait on the same small scale, found their first contented specialist in that comfortable painter, Arthur Devis. But Devis was in no sense a pioneer. His limited vogue, 'limited' in the sense that his patrons were mainly drawn from the rising middle classes, was led up to by cer-

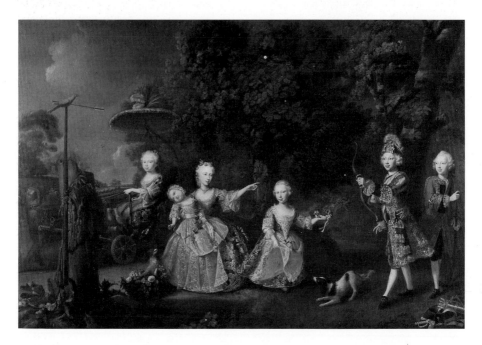

152. Barthélemy Du Pan: The Children of Frederick, Prince of Wales, 1746. *Windsor Castle*
(by gracious permission of Her Majesty the Queen)

returned to Switzerland about 1751 (after a visit to Dublin). When Mercier had fallen into disfavour with Frederick, Prince of Wales, Du Pan, in 1746, painted the large group of 'The Children of the Prince of Wales' [152] at Windsor, which carried on the same tradition as Mercier, and set a new fashion in the treatment of portraits of royal children, which was to lead on to Zoffany and Copley.

tain minor predecessors, in addition to Hogarth and Dandridge. In the early 1730s, when the conversation piece first became fashionable and before it had acquired its middle-class flavour, it was Charles Philips (1708–47) who was popular in the highest circles rather than his abler contemporaries. His vogue with the aristocracy lasted during the years 1732 to 1734, in which he painted groups of doll-like families, usually in an elaborately wainscoted interior, for the Earls of Albemarle, Fitzwilliam, Northampton, and Portland, and doubtless for many more. By 1736 the aristocracy no longer favoured this kind of group and Philips had

graduated to portraiture on the scale of life, in which he was merely an inferior Mercier. During this same period also, Gawen Hamilton[8] (1698-1737) was considered by Vertue to be, in some ways, superior to Hogarth, and his portrait group of 'An Artists' Club in London

but not spacious. Other painters, too, occasionally strayed into the conversation genre, such as Peter Tillemans (d. 1734), the sporting and topographical artist, who was Devis's first teacher and painted the children of his best patron, Dr Cox Macro; and Willem Verelst,

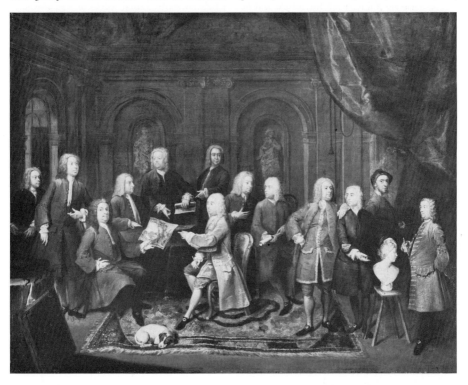

153. Gawen Hamilton:
An Artists' Club in London, 1735.
London, National Portrait Gallery

1735' (National Portrait Gallery) [153][9] shows more vividly than any other picture the worldly condition of the more successful and conservative artists of the time. Both Philips and Hamilton painted, alongside their groups, single figures at full length on the same scale, a diminutive kind of portrait which gained increasing popularity with the growing number of persons who lived in rooms which were neat

whose 'Family of Mr Harry Gough' 1741 (Elvetham Hall) makes one hope that other conversations from his hand will be discovered. But Arthur Devis was the first painter who found in portraiture on this scale a means of making a constant livelihood throughout pretty well the whole of his career.

Arthur Devis (1711–87)[10] was born at Preston and was the son of a man who became a Town Councillor there. He thus sprang from the kind of level of society which was to find most satisfaction in his work. He appears today as a rather refreshing figure in a sequence of painting which is dominated at one end by Augustan

formality and at the other by the high rhetoric of Reynolds. He is a 'discovery' of the twentieth century (even of the 1930s) and his fascination for the social historian has led him to be a good deal overrated in recent writing on English painting. He was a very minor figure in his own day and had no influence on the future, but he was prominent among the successful group of painters who were not 'out of the top drawer', as may be inferred from his becoming President of the Free Society of Artists in 1768, just as all the more forward painters were going over to the newly mooted Royal Academy. A letter of 1764/5 from Lord John Cavendish to his sister (Welbeck MSS.) shows vividly what aristocratic patrons thought of his powers. The fourth Duke of Devonshire had offered his picture to his old tutor and had left the choice of a painter to him, and the tutor 'desired it may be painted by one Mr Devis of Queen Street, because he makes all his pictures of a size, which suits his rooms better than those of other painters: I am much afraid it will be frightful, for I understand, his pictures are all of a sort: they are whole lengths of about two feet long; and the person is all ways represented in a genteel attitude, either leaning against a pillar, or standing by a flowerpot, or leading an Italian greyhound in a string, or in some other such ingenious posture.' The Duke was prepared to submit, but would not pass any criticism on the picture in order not to be held responsible for any absurdity which might result. And a contemporary pamphlet on the Exhibition of 1762 (*An Historical and Critical Review*) remarks of one of Devis's portraits (No. 65) 'Dog like a pig. Leather breeches the principal object.' After this warning contemporary note, we can allow ourselves with a clear conscience to yield to the undoubted charm with which the kindly passage of two centuries has invested Devis's works. The world they picture is so secure.

Devis is reported to have first studied under Peter Tillemans (d. 1734), who was a master of panoramic landscape, as can be seen in his numerous views of Newmarket Heath. It may well be that he began with the intention of becoming a landscape painter, as his younger brother, Anthony Devis (1729–1816), an altogether minor person, remained for the whole of his long life. His first known work is an imitation of Pannini, dated 1736; but by 1742, when he was already settled in London, he was an accomplished painter of conversations and small portraits. Dated works of this character range from 1742 to 1764. By that date he was eclipsed in his speciality by Zoffany, and so spent his later years experimenting with painting on glass and acting as a restorer. During the twenty years of his heyday his style scarcely alters, and very nearly the whole man can be read in a single example of each of his two characteristic types of picture. 'The James Family' 1751 (Tate Gallery) is an excellent specimen of his conversations. The setting is a spreading parkland, with the suggestion of a distant village, and one has the impression, common to all his outdoor scenes, that it is always afternoon. This spreading park, in which the tradition of Tillemans still lingers, is inhabited by its proprietor and his family. A certain sense of ownership of all that the eye surveys, of his park, his wife, and his children, is one of the elements which no doubt helped to make Devis's works popular with the gentlemen who paid for them. In accordance with this intention the various individuals and objects (chairs, vases, and distant pavilions) are itemized, as if in an inventory, and given an allotted portion of space to themselves. The figures do not in fact 'converse', but present themselves, however formally linked by hand or gesture, in turn, in a sort of timid isolation, which has an air of charming *naïveté*. And a feeling for colour, at once tender and gay, takes away what might otherwise seem an excessive display of interest in 'property'. This effect is too constant in Devis for it to have been unconscious, and we must count him as a master of middle-class social overtones. Just as the English middle classes had no parallel in Europe at this time, Devis too had no parallel among contemporary European painters, and his wood notes are among the most purely native in English painting.

In his single figures he is rather less at ease. He is too fond of the ingenious and genteel

postures which roused the misgivings of the Duke of Devonshire. A particularly engaging example, full of character in spite of its genteel absurdity, is the 'Unknown Young Man' [154]

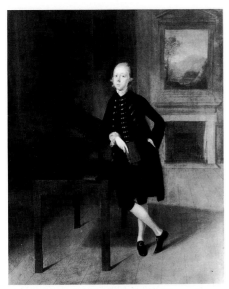

154. Arthur Devis: Unknown Young Man, 1761. *Manchester City Art Gallery*

of 1761 at Manchester. He stands by a reading-desk and seems to have been surprised while practising to an invisible audience his powers as an orator. It is pictures like this which give Devis something of the charm of a minor novel-ist, and, however slender his claims to distinc-tion may be rated by the historian of art, he will always rank high in the affections of the historian of manners. It should be added that his name is often, at present, used in vain for a mass of less competent work by contemporaries who are still unidentified. None of them comes near to the quiet peace of Devis's settings or to his nice appreciation of social values.

Francis Hayman

Hayman is historically the most important of this group of painters: he is also the most versa-

tile. It has been pointed out by T. S. R. Boase[11] that he was 'the meeting-place of two schools, the continental and the English', but he was the meeting-place also of much more than that. His career touches at some point all the various traditions which went to make up the medley of English painting and draughtsmanship in the middle of the eighteenth century, and he had a large finger in every artistic pie of the time.

Born in Devonshire *c.* 1708, he survived until 1776. He was first employed as scene painter at Drury Lane and became a master in the field of popular subjects which he was one of the first to use for easel pictures. When he first swims into our ken as an artist, in 1741, it is as a ceiling painter in 'histories' and this no doubt accounts for Edwards's statement, which would other-wise seem surprising, that he 'was unquestion-ably the best historical painter in the kingdom, before the arrival of Cipriani'.[12] By 1744 he was busy in several roles. He collaborated with Gravelot in the designs and engraving for Hanmer's *Shakespeare*, which appeared that year: he had started work for Jonathan Tyers on large paintings for the pavilions and boxes at Vauxhall Gardens:[13] and he was one of the most active promoters, again with Gravelot (and with James Wills), of the academy in St Martin's Lane. He was as much a part of the engraving world as Hogarth was, and his familiarity with 'histories' can be gauged from the fact that he was employed for the engravings to Congreve, Milton, Pope, Don Quixote, and for Dodsley's portraits, and he was still doing new engravings for Shakespeare as late as the 1770s – and this leaves out of account a considerable number of occasional frontispieces.[14] He was one of those who presented, in 1746, a history picture 'The Finding of Moses' to the Foundling Hospital. He was active in the negotiations which led to the formation of the Society of Artists in 1760 and he was President of the Society from 1766 until 1768 when he seceded to the new Royal Academy, of which he became a founder mem-ber and, in 1771, Librarian. His closest links are with the two leading figures of the older generation, the very British Hogarth and the very French Gravelot, and with one of the most

original native geniuses of the younger generation, Gainsborough, who pretty certainly worked with him and Gravelot in the later 1740s. He is, as it were, the funnel through which the traditions of stage decoration, of Hogarth, and of Gravelot pass and mingle, to emerge refined in the early style of Gainsborough. During the later 1740s, while Hogarth was in semi-retirement, Hayman bore his mantle, and his output during his most active decade (1745–55) includes religious histories, painted illustrations to Shakespeare, scenes from the stage, fancy pictures, some of the earliest unaffected scenes from the common life of the people, sporting pictures, conversation pieces, as well as portraits on the scale of the conversation piece and on the scale of life. No other painter of his day could show such variety.

There is a reverse side to this rather glowing picture; the important figures in the history of art need not all be great painters, and Hayman is one of those who were not great. Horace Walpole, who was too much alive to his defects, says unkindly that he was 'a strong mannerist, and easily distinguishable by the large noses and shambling legs of his figures', and we may guess that Walpole was thinking of a picture such as the 'Self Portrait with Grosvenor Bedford' (National Portrait Gallery) [155], in which these defects are more than usually to be discerned.

This picture, which cannot be later than 1745, may serve as a standard for Hayman's style, although his more pleasing conversations normally take place in the open air. It is at the opposite pole from the conversations of Devis. The figures are much larger in scale and they are linked together in what may legitimately be called 'conversation'. In none of Hayman's groups are there any overtones of pride of

155. Francis Hayman: Self Portrait with Grosvenor Bedford. *London, National Portrait Gallery*

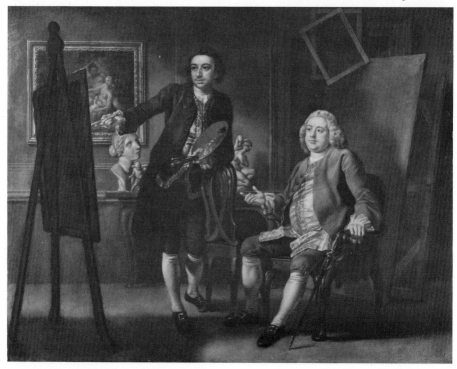

possession in family or land. The features of Hayman himself also deserve attention, for we can understand what Walpole means by calling Hayman a 'strong mannerist', when we rediscover this rather plebeian, or equine, face leering at us as the Princess in the 'Finding of Moses' or frowning at us as Hamlet in the pictures from Vauxhall Gardens. Even in a fancy picture such as Mrs Christie-Miller's 'Girl at a Spinning Wheel', or in scenes of low comedy such as the 'Lecherous Friar' (Musée Magnin, Dijon – as Hogarth), it is the same smug face, and Hayman is one of the most easily recognized of painters.

But Hayman's importance is independent of these defects, and so is the charm of a number of his works. It is no mean achievement to have painted one of the earliest scenes from Shakespeare,[15] 'The Wrestling Scene from *As You Like It*' [156], which presumably dates from

suppose that the four Shakespearian scenes which Hayman painted for the Prince of Wales's pavilion at Vauxhall, probably in 1744/45, were of the same character.

Hayman's work at Vauxhall,[16] for which he painted a variety of large pictures from about 1744 to 1760, must have been more constantly before the public eye than any other painting of the time in London. It blended the tradition of stage scenery with the 'historical' style, and ranged in theme from the pure pastoral to subjects from the story of the Seven Years' War, with contemporary portraits. The most interesting pictures were canvases, measuring about five by eight feet, which adorned the alcoves which studded the various walks. A few were of scenes from Shakespeare or from contemporary novels, but most were simple pictures of rustic games or folklore scenes. Two of these, 'Sliding on the Ice' and 'The Dance of the Milkmaids on

156. Francis Hayman: The Wrestling Scene from *As You Like It*, *c*. 1744. *London, Tate Gallery*

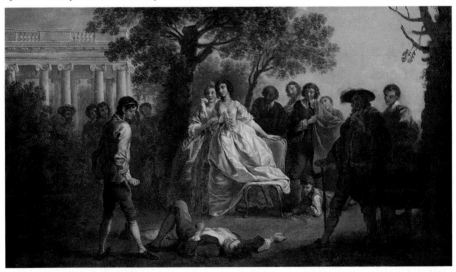

about 1744, when Hanmer's *Shakespeare* was published; though a free variation, it is based on the engraving. It is a genuine illustration, and not imitated from the stage scene, although the style of stage scenery is clearly involved, especially in the light key of colour. We may

Mayday' [157], were acquired by the Victoria and Albert Museum in 1948. They are something new in theme for British painting, just as the commission for them was something new in British patronage, and they mark the beginning of a tradition which reached its height in

Wilkie and continued vigorously through the nineteenth century. They are a sort of London equivalent, on a popular and rustic level, of what Boucher was doing in France. The difference is that they are studied from common life, and the ornamental element 'with the high French seasoning' is super-added upon something which is quite down to earth. Exactly the same character belongs to Gainsborough's Ipswich pastorals of the middle 1750s. But it is Hayman who must count as the creator of this specifically British form of a continental genre.

The style of Hayman's landscape backgrounds is sometimes so curiously similar to early Gainsborough that we may be permitted to wonder whether Gainsborough did not in fact sometimes paint them for him in the later 1740s. We know that his backgrounds were often by other hands,[17] and there can be no doubt in my mind, in spite of much argument against the thesis by Mr Whitley, that Hayman in his early Vauxhall period was the formative influence on the young Gainsborough.

After 1755 Hayman would seem to have done rather little painting, and that mainly of large historical or religious subjects. Perhaps mercifully for his reputation, none of these are accessible today.

Bare mention should also be made of the Rev. James Wills, an agreeable minor painter in Hayman's orbit in the 1740s. He has been mentioned as active, with Hayman and Gravelot, in running the St Martin's Lane Academy in 1745, and his 'Little Children brought to Christ' 1746 was the fourth of the large religious works presented to the Foundling Hospital by their painters – the other artists being Hogarth, Highmore, and Hayman. It is perhaps more religious in feeling than the others and it is very close, in places, to Hayman's figure style. A conversation piece of the 'Andrews Family' 1749 (Fitzwilliam Museum, Cambridge) [158] is also close to Hayman, but more loosely constructed and less 'conversational'. But Wills did not prosper as a painter and he joined the Church, dying Vicar of Canons in 1777.

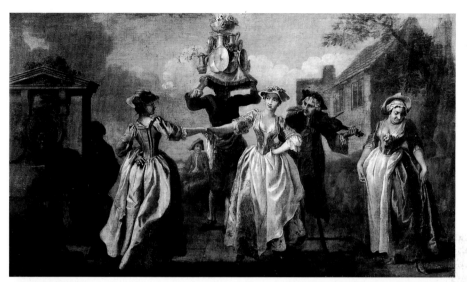

157. Francis Hayman: The Dance of the Milkmaids on Mayday. *London, Victoria and Albert Museum*

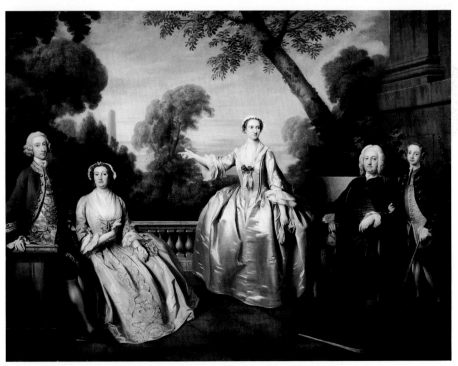

158. James Wills: The Andrews Family, 1749. *Cambridge, Fitzwilliam Museum*

FASHIONABLE PORTRAITURE TO HUDSON AND RAMSAY

In December 1737 there arrived in London the Frenchman Jean-Baptiste Van Loo (1684–1745), who had already had a certain vogue in Turin and in Paris. He arrived at a very opportune moment, when Richardson and Dahl were in their decline and before the emergence of a new generation of fashionable face painters. After a few months, says Vertue, 'a most surprising number of people of the first Quality' sat to him, and he became the rage. It is not easy for us today to see why, for he had none of the graces of the art of France. One of the first portraits which made his name was that of 'General Dormer', signed and dated 1738, which is still at Rousham. In it we see the style of Richardson seasoned with a little of the high French affectation. The pose is a little less placid and easy, hands and arms make a little for elegance: draperies and the tablecloth curl into a little more Frenchified folds – and that is about the whole difference. But Van Loo is important, because it is this tinge of modishness which he introduced into the Richardson formula which marks the change between Richardson and his son-in-law, Thomas Hudson. Van Loo remained in London in good practice until the autumn of 1742. His success perhaps also contributed to the rise to temporary prosperity of another foreigner, the Italian Andrea Soldi (c. 1703–71), who had been in England since about 1735. His portraits of around 1740 have the same cosmopolitan air as Van Loo's, which seems to be what English sitters liked, but they become increasingly English with advancing years. He is at his best in a few large groups such as the 'Thomas Duncombe and Family' 1741 (Earl of Feversham), or the musical group of 'The Family of Sir Thomas Head' 1750 (on loan to Aston Hall, Birmingham). We can judge of the predominance of Van Loo and Soldi at this time from the young Ramsay's letter of 1740, in which he says: 'I have put all your Vanloes and Soldis . . . to flight'. He mentions no English rivals.

The English fashionable painters during this trough period were, in fact, unusually poor. But mention should be made of Arthur Pond (c. 1705–58), a pupil of Vanderbank who had returned from Italy in 1727, and had made a certaine name for himself as a crayon portraitist and a much greater name as a virtuoso. In oil portraits he is usually uncommonly feeble and his highest level is his 'Richard Snow' 1738 (Fitzwilliam Museum, Cambridge). But he has been credited in recent years with the charming group of 'A Lady winding Wool and a Gentleman drawing'[1] (National Trust, Upton House), which would make him a lesser figure of some interest. On purely stylistic grounds, however, it seems likely that this is by Pieter van Bleeck (1697–1764), a painter of portraits and theatrical groups, usually of quite modest ability, who painted at least one certain work of real distinction, the 'Mrs Cibber as Cordelia' c. 1755.[2]

Thomas Hudson

To these lesser fry succeeded Thomas Hudson (1701–79), the son-in-law of Richardson and the heir of what one may call the Riley tradition. We can watch his gradual emergence in the pages of Vertue's notebooks. Vertue first mentions him in 1733; by 1738 he is still not listed as among the 'principal painters'; but he is in full swing by 1741; and by 1744 he was thought to have the fullest run of employment in town. The large number of his surviving works, and the fact that the young Reynolds was his pupil from the end of 1740 to 1743, have led to his being one of the few names of painters familiar to those who believe that British painting begins with Hogarth and Reynolds, and he has a little niche in all the standard books. It

is doubtful if he deserves this eminence, and he is altogether inferior to such a painter as Highmore. Hudson may fairly be described as the last of the conscienceless artists, of whom Lely was the first in England, who turned portraits out to standard patterns and executed comparatively little of the work themselves. The drapery painter counts for a great deal in Hudson, first Joseph van Aken (who died in 1749) and then Van Aken's younger brother. Hudson and Ramsay are linked in this respect, and they were Joseph van Aken's executors: but whereas Ramsay must rank as one of the major formative influences on British painting of the age of Reynolds, Hudson, for all that he was Reynolds's teacher, counts for very little.

Some of the portraits of civic worthies in Barnstaple Town Hall may represent Hudson about 1740; and a very large group, 'The Family of Walter Radcliffe of Warleigh' (on loan to the National Trust at Dyrham), which can be dated 1741/2,[3] during the years when Reynolds was his pupil, is ingeniously composed and goes some way to explaining why he was chosen to be Reynolds's teacher. But his immense vogue, on present experience, seems to have been about 1746 to 1755, when the young Reynolds began to make his name. Certainly one of his best pictures, and one on which he probably took more trouble than usual – since it was more or less for public exhibition – is the full-length 'Theodore Jacobsen' 1746, which he presented to the Foundling Hospital. It is sound and solid and conservative, but the learned accessories are out of Hudson's usual canon, and a more typical example of his style is the 'Admiral Byng' 1749 at Greenwich [159]. This is straightforward and solid, with no graces and no nonsense and no poetry about it. The drapery was no doubt put in by the drapery painter and the shipping in the background by a marine specialist. For young men there were more elegant poses, sometimes the holding of a mask: for ladies there were several standard poses in studio costume, complete with pearls. There is an even hardness and roundness of modelling to the faces, and a corresponding hard metallic glitter to the satins. The impassive masks of Richard-

159. Thomas Hudson: Admiral Byng, 1749.
Greenwich, National Maritime Museum

160. Thomas Hudson: Sir John and Lady Pole, 1755.
Sir John Carew Pole, Bt, Antony House, Cornwall

son are only slightly modified and the draperies have a tinge of the Rococo which was due to Van Loo, and the personality of the painter hardly appears. This is all the more conscience-less since we know, from a very few experiments, that Hudson was not altogether incapable of something better. The engraved 'Charles Erskine' of 1747 (Edinburgh Gallery) is a surprising essay in the vein of Rembrandt, and Hudson could attempt with some felicity a rather playful group such as 'Sir John and Lady Pole' 1755 (Antony House) [160]. Towards the end of the 1750s he went into prosperous retirement before the rising star of Reynolds, but occasionally painted a portrait, if specially commissioned, such as the full length of Sir William Browne 1767 at the Royal College of Physicians. In this the texture of the paint in a few places shows that he had deigned to look at Reynolds, and the lighting is suggestive of the new style, but those are the only concessions to modernity.

Allan Ramsay

Hudson's style is nearly invariable and his portraits never show any traces either of a sensitive approach to his sitter's character or of a refined perception. Ramsay's lowest standard is almost indistinguishable from Hudson's normal, but this is comparatively rare: at his highest he is often a worthy rival to Reynolds, and he continued refining his art up to the time, in the middle 1760s, when he more or less abandoned painting. Although a dozen years younger than Hudson, his known career begins well before we know Hudson's. Few certain Hudsons are known before 1742, but one can name thirty to forty Ramsay portraits before that date. He may thus be considered as belonging to Hudson's generation. At the same time, although his working career was over before the foundation of the Royal Academy, his finest and most familiar portraits stand comparison with the works of the first generation of Academicians. He is the only portrait painter (and he painted nothing but portraits) who belongs equally to both worlds, and he and Hogarth, in their very

different ways, are the two pioneers who broke the ground for the age of Reynolds. The difference between these two can be easily assessed by pondering Northcote's remark on a Ramsay portrait of 'Queen Charlotte' of the early 1760s: 'It was weak in execution and ordinary in features but the farthest possible removed from anything like vulgarity. A professor might despise it, but in the mental part I have never seen anything of Van Dyke's equal to it.'[4] It is what Northcote calls 'the mental part' which is the keynote to the new style, and it was something which had been largely lost to British painting since Van Dyck. He means by it not only everything which goes into making a portrait into a picture, but also the whole process of interpreting character in terms of form, colour, and tone. Ramsay was sometimes lazy about the mental part, but the stuff of it was in him. One should add that, although Ramsay was particularly qualified by sympathy and experience to interpret the Scottish physiognomy, his importance lies in his contribution to the development of the English School and not in the small part he played in the development of painting in Scotland.

Born in Edinburgh in 1713, the son of the writer of *The Gentle Shepherd*, Ramsay somehow picked up the rudiments of drawing in Scotland before passing a few months in Hysing's studio in London in 1734. His father's friends, the Clerks of Penicuik (Sir John had studied drawing under Mieris, and his son, the architect Sir James, had been a pupil of Imperiali), probably account for his early training much more than anything he learned under Hysing, and, when he went to Italy in 1736, he could draw a head in the manner of Richardson. From 1736 to 1738 he worked in Rome with Francesco Imperiali and in Naples with the aged Solimena (1657-1747), and it is what he got from these two masters, a novel air of life and breeding and a feeling for the composition of a portrait, which led to his immediate success on his return to Britain.

Francesco Fernandi, called Imperiali, was until recently one of the most elusive Roman painters of his time. His patronage by Cardinal

Imperiali enabled him to live a sort of black-market career outside the fold of the Roman Academy of St Luke, and the official biographers of Roman painting have therefore all been silent upon him.[5] His art is of Marattesque derivation and he specialized in teaching foreigners, and it is probably significant that his one known Italian pupil was Pompeo Batoni (1708-87), who was to specialize in portraits of British gentry and nobility travelling abroad.[6] There is a certain complementary quality in the art of Batoni and Ramsay: the air of cosmopolitan breeding which the young traveller learned to like from Batoni in Rome, could be best obtained from Ramsay when he had returned to London. From Solimena Ramsay learned what Lord Chesterfield called 'the graces'. There is a drawing of a girl's figure at Edinburgh on which Ramsay has written: 'From a picture of Solimena in his own house 1737', which is perhaps taken from the 'Jacob and Rachel' now at Venice. Ramsay has shown no interest in the flaming Baroque element in Solimena's style, but has copied a figure, gracious and feminine, in line with his own special talent – and he has laid special emphasis on the movement of the hands. In the great collection of Ramsay drawings at Edinburgh, which comes from the painter's studio, there are more than a hundred studies of hands – hands which indicate grace and character. This new approach to portraiture Ramsay may well have owed in considerable part to Solimena, whose few recognized portraits are the most lively that were being produced in Italy at the time. A single dated portrait of this period survives, the 'Samuel Torriano' 1738 at Mellerstain [161], in which the hand and the drapery and the head all play an equal part in building up the character. Were it not signed, it might well have baffled attribution, but the kind of trouble which Ramsay has taken to make the portrait into a picture gives a foretaste of his later method.

By 1739 Ramsay had settled in London. Although he made fairly frequent visits to Edinburgh up to about 1755, he always remained based on London, where even a Scotsman would pay more for his own portrait than he

161. Allan Ramsay: Samuel Torriano, 1738.
Earl of Haddington, Mellerstain, Berwickshire

would in Edinburgh. By 1740 he was writing complacently to a friend: 'I have put all your Vanloes and Soldis and Ruscas to flight and now play the first fiddle myself'. Hudson in fact was his only serious competitor in the 1740s, and, in 1746, Ramsay matched Hudson's gift of his portrait of 'Theodore Jacobsen' to the Foundling Hospital with his own gift of the full length of 'Dr Mead' [162], a far more accomplished work, in the European 'grand style'. Here, for the first time in the century, we come upon a portrait which shows that the painter had profited to the full by a training in Italy. It lacks the intensely English temper of Hogarth's 'Captain Coram' [137], but it has altogether escaped from the English awkwardness of Hudson, and the 'grand style', about which Reynolds has so much to say in his *Discourses*, has been introduced into British portraiture. Even the secret, which has generally been considered one of Reynolds's own specific contributions, that this style can be achieved by the adaptation of classical models to modern portraits, was anticipated by Ramsay. In his 'Norman, Twenty-second Chief of Macleod'

1748 (Dunvegan Castle) [163] Ramsay has adapted the 'Apollo Belvedere' to a portrait walking by the seashore, as Reynolds was to do in his 'Commodore Keppel' 1753/4 (Greenwich)[164], which made his reputation. Ramsay has been even bolder than Reynolds was to be, for he has put his Apollo into tartan trews! With such evidence it is impossible to escape from the conclusion that the marriage of the Italian grand style to British portraiture was primarily the achievement of Ramsay.

These high lights in Ramsay's work of the 1740s, though they must be picked out by the historian, are not altogether characteristic of his output. His work in this decade is more curiously uneven than that of any of his contemporaries, and this has delayed the recognition of his importance. It was no doubt due to the extraordinary pressure of demands upon his brush. An able Scottish painter working in London, skilfully advertised by his father in Edinburgh, brought about at once a demonstration of the loyal solidarity of his fellow countrymen. In his first year in London he had painted the dukes of Argyll and Buccleuch and the duchess of Montrose, and the number of his portraits of Scottish sitters in the 1740s is very large. To get through the work he had recourse at once to the drapery painter and he shared Van Aken with Hudson and many lesser men. The results were sometimes extremely perfunctory, but there is evidence from his drawings that Ramsay used the drapery painter with a greater sense of responsibility than his contemporaries.

Ramsay differs from all the other major British portraitists of the century in his use of drawings. Reynolds's drawings (other than quick sketches from the compositions of others) are rare and slight and hardly ever related to his portraits: Gainsborough's drawings are independent works of art and also hardly ever made with a specific portrait in view. Ramsay's are mainly studies of pose and costume, when they are not studies of hands: the face is usually left blank, but he took the greatest trouble with graceful arrangements of dresses and hands, as well as with arrangements of the figure. A number of these have on them what seem to be

instructions to the drapery painter, and, as far as can be judged by comparison with Van Aken's own drawings (many of which found their way into Ramsay's studio and were once catalogued at Edinburgh as Ramsay's own), whereas other painters sent their portraits to Van Aken to be dressed up in one of his own genteel arrangements, Ramsay sent his with specific instructions and an accompanying drawing. In this way, even while having recourse to the drapery painter, Ramsay built up a new repertory of natural and graceful arrangements to supersede the stock models of the earlier generation.

Ramsay might well have been content to rest on his laurels in the 1750s if it had not been for the competition caused by the emergence of Reynolds about 1754. Alone of the portraitists of the earlier generation Ramsay rose to the occasion and his 'Hew Dalrymple, Lord Drummore' 1754 (SNPG) [165], with its new lighting and 'modern' sense of the weight and presence of the sitter, shows him competing with Reynolds[166] with some effect. It was probably a feeling that he must refresh his knowledge of Italy, whence Reynolds had lately returned, rather than the reason usually given of the difficulties over his second marriage, which led to his second visit to Italy from 1755 to 1757. But this time he sought a different source of inspiration. He drew at the French Academy and he made studies, not from those examples of the grand style which had so much influenced Reynolds, but from such models of gracefulness as Domenichino's frescoes in S. Luigi dei Francesi. It may well be that his admitted masterpiece, the 'Portrait of his Wife' (Edinburgh) [167], dates from these years, before which one must echo Northcote's already quoted remark (on another picture) that it is 'the furthest possible removed from anything like vulgarity'.

It may be that Ramsay had felt that it was precisely this quality, which, with a delicacy akin to his own, we may call 'an absence of vulgarity', that was lacking in Reynolds's early style, and that therefore it was one on which he should concentrate himself. It certainly prevails in his later works, which may be said to begin with this portrait of his wife. The figure

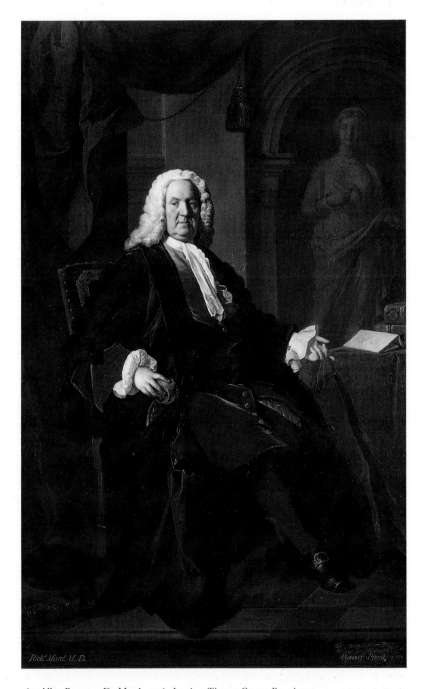

162. Allan Ramsay: Dr Mead, 1746. *London, Thomas Coram Foundation*

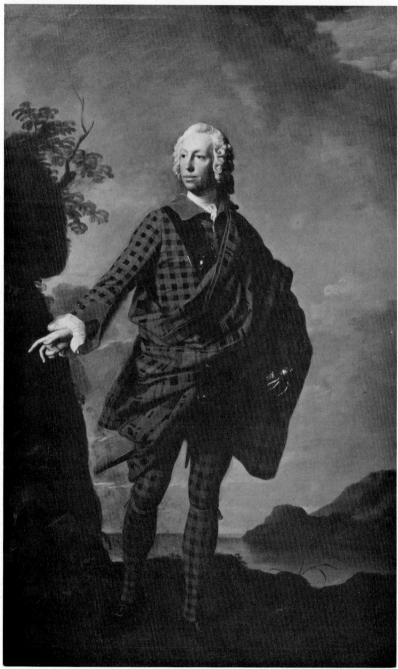

163. Allan Ramsay: Norman, Twenty-second Chief of Macleod, 1748.
The late Mrs Macleod of Macleod, Dunvegan Castle, Skye

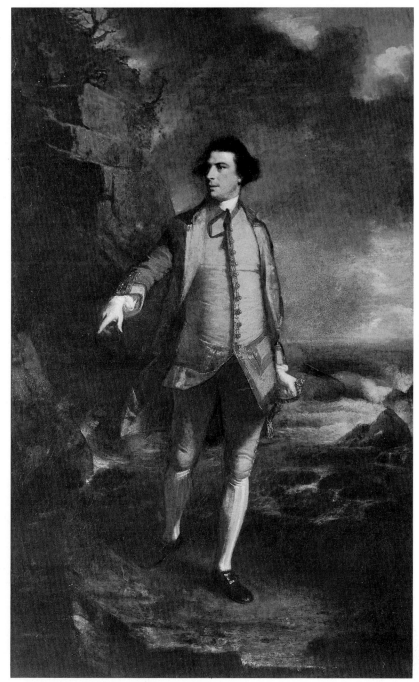

164. Sir Joshua Reynolds: Commodore Keppel, 1753/4.
Greenwich, National Maritime Museum

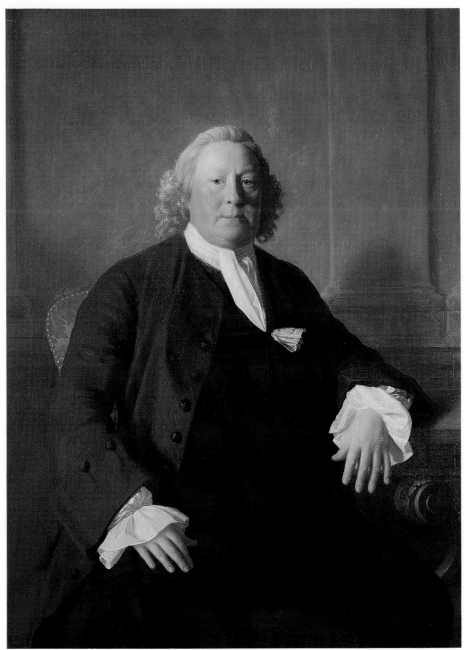

165. Allan Ramsay: Hew Dalrymple, Lord Drummore, 1754.
Scottish National Portrait Gallery, Edinburgh

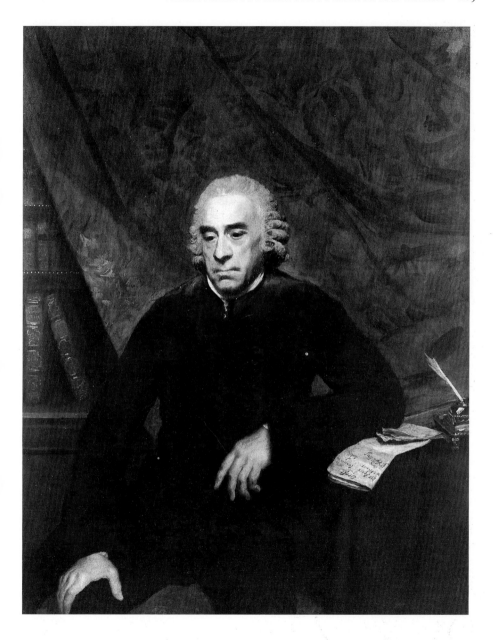

166. Sir Joshua Reynolds: Joshua Sharpe, 1786.
Viscount Cowdray, Cowdray, Sussex

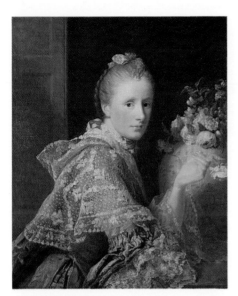

167. Allan Ramsay: Portrait of his Wife.
Edinburgh, National Gallery of Scotland

is set a little distance in from the picture frame, a muted light, with silvery or greenish shadows, prevails in the flesh tones, and more attention than ever is given to the hands. Horace Walpole, with keen penetration, sums up the contrast which was felt between Ramsay and Reynolds in 1759, when he says: 'Mr Reynolds and Mr Ramsay can scarcely be rivals; their manners are so different. The former is bold and has a kind of tempestuous colouring, yet with dignity and grace; the latter is all delicacy. Mr Reynolds seldom succeeds in women, Mr Ramsay is formed to paint them.' Reynolds soon took steps to learn from Ramsay in this respect, but the judgement was true at the time it was made.

Immediately on his return to London in 1757 Ramsay became involved in a new source of patronage which was profoundly to affect his later output. Another Scottish patron, Lord Bute, engaged his services to paint full-lengths of himself and the young Prince of Wales (both at Mount Stuart), which are the introduction to the great series of full-lengths of his second style. At Mount Stuart too are 'Augusta, Prin-

cess of Wales' *c.* 1758, 'Lord Mount Stuart as a Harrow Archer' 1759, and the most original achievement of his later time, 'Lady Mary Coke' 1762. This muted harmony of silvery white satin and soft dark green exhales a gentle poetry and tender reticence which convinces the imagination however little it may accord with what we know of the tempestuous character of the sitter. It is one side of Van Dyck recreated in eighteenth-century terms, and, in what Northcote would call 'the mental part' of it, it surpasses Van Dyck.

Ramsay's portrait of the Prince of Wales found favour, and when the Prince succeeded in 1760 as George III Ramsay was commissioned to paint the official portraits in spite of the fact that John Shackleton (a decidedly minor person who died in 1767) was King's Painter. He also painted several versions of Queen Charlotte and the demand for repetitions of these pictures was so extensive that he gave up outside commissions except for particular friends.[7] Although he was at the height of his powers and some few of his private commissions of these last years – the 'Sixth Earl of Coventry' 1764 (Earl of Coventry) and 'Lady Holland' 1766 (Melbury) – are among his finest portraits, he seems to have been content to turn his studio into a factory for the repetition (by assistants) of royal portraits. Much of his later life (he did not die until 1784) was devoted to literary pursuits, and no certain painting is known from his hand after 1769. He refused a knighthood and had no connexion with the Royal Academy, though he retained the friendship of the President. No satisfactory explanation has ever been given of this change of heart, but an accident to his arm, at some unspecified date, may have had something to do with it. At his best he certainly ranks among the major figures in British portraiture.

William Hoare

William Hoare[8] of Bath (*c.* 1707–1792) may reasonably be linked with Ramsay's name since he too was a pupil of Imperiali and is said to

have become a friend of the young Batoni in Rome. Hoare went to Italy with Giuseppe Grisoni (1699–1769) in 1728, and stayed there some nine years. Grisoni was an Italian portraitist of some merit – as his 'Colley Cibber' at the Garrick Club shows – and was Hoare's first master, so that it is curious that Hoare should never have shown himself to be anything but a prosy and competent follower in the line of Richardson. He had settled in Bath by 1739 and was the leading portraitist there in oils and crayons until the arrival of Gainsborough in 1759, who took away a good deal of his custom. He was a favourite in the families of Pitt, Grenville, and Pelham and a considerable portion of his recognized work consists of repetitions of portraits of that political clique. In 1769 he became an Academician, but ceased exhibiting after 1779. It is possible, since the bulk of his work in oils remains unrecognized, that the present estimate of his quality is too low, and there is an original sense of colour, sound drawing, and a considerable feeling for personality in his 'Mrs Richard Jesser' (of the end of the 1740s) in the Bristol Gallery. At any rate it compares very favourably with Hudson's work of the same period. His group of 'Three Sons of the Ninth Earl of Lincoln' (Duke of Newcastle) of the middle 1760s has the mechanics of Hudson but a fresh perception of life and youth in the heads, which almost amounts to charm. But he never, as Ramsay did, accepted or understood the new style.

Thomas Frye

Thomas Frye[9] (1710–62), an Irishman who came to London in the middle 1730s, also deserves mention. Some of his earlier portraits have been mistaken for Hogarth's, and his later work is more advanced than Hudson and has been confused with Ramsay. But his practice of painting was discontinuous, as he founded and managed the Bow porcelain factory from 1744 to 1759, and spent much of 1760 producing rather singular portrait mezzotints

in imitation of Piazzetta drawings. He also painted miniatures in addition to full-lengths, both life-size and on conversation scale. He is never uninteresting.

Portrait Painters in the Provinces

A number of painters who worked in provincial centres in what is loosely called 'the Hudson style' deserve a passing notice. Knowledge of them is probably at present very incomplete, but several were in quite good practice in East Anglia and in the Lancashire-Cheshire areas. Norwich in particular seems to have been a profitable area for portrait painters. A certain D. Heins, of German origin, was working there from about 1725 until his death in 1756, and his son, John Theodore Heins (1732–71), continued his Norwich practice, but migrated to London in 1767. Both Heinses painted sound, solid, portraits on the scale of life as well as occasional conversation groups. Thomas Bardwell[10] (1704–67) too, a native of Suffolk, who achieved some reputation in London in the 1740s and 1750s, was settled in Norwich until his death and had an extensive Norfolk clientèle. In the Lancashire-Cheshire area one can point to James Cranke (1707–80), a 'self-taught' artist, who formed his style by copying Hudson; James Fellowes, whose activity can be traced from 1711 to 1751; and Henry Pickering, who returned from Italy about 1745 and was active in and around Liverpool until 1760. Pickering's full-length of Sir Rowland Wynn 1752 at Nostell Priory is not inferior to the best of Hudson's efforts. In Somerset too we can trace a fairly abundant activity for one painter, Richard Phelps, who can be traced from 1729 until 1785. He too painted entirely in Hudson's manner and can be studied at Dunster Castle and Crowcombe Court. It is probable that further exploration would bring to light many other names, but these are sufficient to give an indication of the sort of work which was being carried on in the provincial centres during this period.

PART FIVE

THE CLASSICAL AGE

CHAPTER 15

INTRODUCTORY

Just as the reign of George II was the formative period of British painting, the first thirty years of the reign of George III can be called the 'classical' age. The same loose, but convenient terminology entitles us to call the period which begins in the 1790s and coincides with the French Revolution and the early poetry of Wordsworth the 'romantic period'. Lawrence, Fuseli, Blake, Alexander and J. R. Cozens, Girtin and Turner are the prime elements of this later period, and their names will start another volume. But a number of survivors of the earlier style lived on until as late as the 1820s and can properly be treated here, while the chief interest of other figures who died in the 1790s lies in their role as forerunners of romanticism. The classical age did not end and the romantic begin at any moment of time to which the historian can point his finger, yet the year 1789 stands out as the watershed between these two periods. Gainsborough had died in 1788 and Reynolds went blind in 1789, and in the latter year the young Lawrence, who had first exhibited in 1787, showed his 'Queen Charlotte', which is now in the National Gallery. We can certainly say that the strength of the classical age was over. Yet of two almost exact contemporaries, Rowlandson and Blake, the former must be treated in this volume, while the latter must await the next.

The beginning of the classical age can be defined more closely. The year 1760 was marked not only by the accession to the throne of a young king who was sympathetic to the arts – and no one with a vestige of artistic feeling had sat on the throne since the revolution of 1688 – but by the first public exhibition of the Society of Artists of Great Britain. From that year onwards at least one, and latterly more, public exhibitions of pictures were held, so that young painters could see and study the work of their elders and good or bad work could become a subject for public discourse. It is true that printed criticism of the exhibitions was slow in developing and the field was mainly occupied by the scurrilous works of 'Peter Pindar' and 'Anthony Pasquin', but the *Morning Post*, under Bate-Dudley's editorship, in the 1780s began to take a serious interest in painting, and other papers have short and sporadic notices of the exhibitions. George Vertue's notes on contemporary painters, which are the gossip of the studio, give way to literary sources of a different kind, and it is rather from the gossip of the collecting classes, such as Horace Walpole's letters, that we have to estimate the contemporary view of art and artists in the reign of George III. This is not a gain in factual wealth, but it is evidence of the higher esteem in which art was held. The man who had done, and who continued to do, most to raise the status of the artist in this way was Sir Joshua Reynolds.

Year by year, from 1760 to 1789, Reynolds exhibited what he felt were his most important portraits and historical compositions. And year by year, from 1769 until his eyesight failed, he

read at the annual prize-giving of the Royal Academy Schools a *Discourse* which reinforced and supplemented the lesson of his paintings. The theoretical background against which the painting of the classical age must be considered is to be found in Reynolds's *Discourses*.[1] No one, not even the President himself, altogether lived up to this high standard, and one of the main interests for the historian is to watch the gradual breakdown of these principles, but their dominance is not in doubt. It was against them that the more reflective of the romantic painters consciously reacted, and this reaction can be seen in its most violent and instructive form in Blake's petulant and angry comments in the margin of his copy of the *Discourses*.

Reynolds, who was conscious that a native school was only beginning in his own time, was all for high art. He had a keenly developed economic sense and he probably felt as strongly as Hogarth the fact that British connoisseurs, apart from portraits, would spend their money only on foreign paintings. The classic story to illustrate this point of view in the 1760s is that related by Northcote of one of the many collectors who went to see with such enthusiasm West's 'Pylades and Orestes'. When asked by his son why he had not purchased a picture he spoke of with such praise, he replied: 'You surely would not have me hang up a modern English picture in my house, unless it were a portrait?' It was this attitude Reynolds sought to undermine, not, as Hogarth had tried, by satire and invective, but by an elaborate process of intellectual sapping. By first marrying the portrait to the tradition of history painting he hoped gradually to educate public taste into considering history pictures a natural thing for a British artist to paint and for a British collector to buy. It cannot be claimed that he was successful, although a considerable number of the great quantity of history paintings produced during these thirty years did in fact find private purchasers.

The opportunity of exhibiting their pictures in public after 1760 was not an unmixed blessing for British painters. We know from one or two engravings what these public exhibitions were like, and they are horrifying by modern standards. The walls would be plastered with pictures arranged like the components of a jigsaw puzzle, with the frames touching one another. There would be as many as six rows of small pictures, and those full-lengths which were given the best position 'on the line', would have the toes of the figure about on a level with the eye of a tall spectator. Nothing but trumpet tones would be heard in a display of this kind, and this sufficiently accounts for the fact that Ramsay, whose style in the 1760s was of a deliberately shadowed and feminine kind, never exhibited in public, and that Gainsborough, after a final quarrel in 1784 over the hanging of his pictures, abandoned the Academy and held exhibitions in his own painting room. It was in this way that the 'exhibition picture' was born, an unnatural genre which has been the curse of painting ever since the foundation of academies. In Reynolds's own work of the 1760s there is a clear distinction between his portraits for public exhibition, such as the 'Duchess of Hamilton' at Port Sunlight, and those for private commissions, such as 'Countess Spencer and Daughter' at Althorp [173]. After the opening of the first Academy in 1769 Reynolds hardly painted a picture which was not planned to be capable of being shown in public, and this accounts for the preference many people feel today for the more informal portraits of his earlier years.

The Society of Artists quickly got out of hand. At first anyone who sent in a picture was entitled to have it shown, and the first exhibitions, for all that they included some very distinguished pictures, were flooded with a torrent of trivialities which would hardly find admission today to a parish bazaar. It was too late to formulate a rational principle of admission and exclusion, and the justification for the foundation of the Royal Academy in 1768, to which most of the best artists from the Society of Arts seceded in 1769 – which those who did not, or were not invited to, considered a betrayal – was that it was necessary to begin all over again and to be able to exclude the absurd. The first Academy exhibition was very high-

minded indeed and contained only 136 items, but the number had increased to 245 the second year, and by 1788 it had increased to 656. A great deal of a very low standard was admitted to these early exhibitions, but they did succeed in keeping out such items as 'A basket of flowers – in paper' and miscellaneous objects in wax and needlework. It was no doubt this feeling of the need for keeping a high standard of formality which excluded Stubbs and Gilpin, as mere 'sporting painters', from the first Academy, but this rigidity was soon relaxed and the Academy then, as ever since, has tried to provide accommodation for the greatest possible number of exhibitors who reach a certain level of competence, so that they could profit by the unquestioned prestige of its exhibitions.

The emergence of various classes of picture during these years will be noticed in subsequent chapters, which deal with the work of the various artists, but it may be useful to summarize here the main landmarks in chronological order. To the first public exhibition, in 1760, Reynolds had sent his 'Duchess of Hamilton as Venus' (Port Sunlight), a picture shamelessly designed to be hung high and to delude the eye into being a history picture: it won enthusiastic praise. In 1761 Hogarth sent his 'Sigismunda' (Tate) [140], which was openly called a history piece in emulation of the Seicento: it was greeted with howls of execration. Zoffany's first theatrical conversation appeared in 1762, and Gainsborough's first landscape in 1763. In 1764 the young Benjamin West exhibited his first classical history picture and aroused great interest (but no commissions), while Edward Penny's 'Death of Wolfe' [221], perhaps because it was so unheroic in character, passed unnoticed. In 1765 came Wright of Derby's first 'candle-light picture', and, about 1766, the conversation piece, hitherto reserved for the middle classes, was reintroduced into the fashionable world by some royal commissions to Zoffany. The earliest of these were not exhibited, but the fashionable conversation piece probably owes its twenty years' vogue to the new passion of the royal family for domesticity. In 1767 a young Scot-

tish painter, John Runciman, just before his early death, painted in Rome a picture of 'King Lear in the Storm' (Edinburgh) which is the first herald of literary romantic painting. In 1768, just when the quarrels and negotiations which led to the foundation of the Royal Academy were seething, Sawrey Gilpin, a sporting painter who had hitherto been content with horses, began his series of 'Gulliver and the Houyhnhnms' to show that sporting painters could tack on to the history wagon too. The year 1769 was sufficiently marked by the first Academy, in which those painters who were permitted to exhibit were on their most solemn behaviour, and it is interesting that one of the few pictures praised by the contemporary Press was Gainsborough's 'Lady Molyneux', which was one of the few which had made no concessions to the prevailing solemnity. This high tone was somewhat relaxed in 1770. In 1771 West's 'Death of Wolfe' [215], in contemporary costume (but with no attempt at historical truth), showed that there was a keen public interest in heroic pictures of modern events and that it was no longer obligatory to dress all heroic figures in antique costume. In 1773 Reynolds showed his first fancy picture in a lighter vein, the 'Strawberry Girl', and for the years 1773 to 1775 the Academy suffered its first temporary defection of a major kind through Gainsborough not troubling to exhibit. Both Reynolds and Gainsborough, at London and Bath, had a scarcity of sitters at about this time and Gainsborough came up to London in 1774, a date which marks the decline of Bath as a second seat of artistic patronage, for Wright, who tried to settle there in 1775, could not make a living. The same years mark the arrival of an interest in 'medieval' histories: Alexander Runciman had completed his Ossian ceiling at Penicuik House in 1773, and West exhibited at the Academy in the same year his 'Death of Bayard', in which Salvator Rosa is a predominant influence. At the Society of Arts at the same time Mortimer was showing 'Banditti' and pictures of wandering soldiery which also owed their inspiration to Salvator. In 1775 came the first direct attack on Reynolds and on

his method of cribbing from the Old Masters to enhance the distinction of his portraits. This was Nathaniel Hone's picture of 'The Conjurer', which was excluded from the Academy on the grounds of impropriety, as the female assistant was supposed to resemble Angelica Kauffmann. In 1776 Romney set up in Cotes's house in Cavendish Square and became a third among the fashionable portraitists in London. At the same time the interest in the South Seas was at its height, Reynolds exhibited his portrait of 'Omai' and Hodges his views taken on the expedition to the South Seas. Tilly Kettle too, in the preceding years, had been sending back portraits of native princes from India and the field of subject-matter at the Academy was taking on imperial proportions.

The critical period for the ideas of high and classical endeavour, with which the Academy had started, occurred about ten years after its foundation. From 1777 to 1783 Barry was at work on his paintings for the Royal Society of Arts, which are the one major project, that came to fruition, which was the logical outcome of Reynolds's theories. They were coldly received, and pictures of a quite opposite character were making the Academy interesting. A tepid breeze from France was felt in the rather *risqué* pictures of ladies in bed which Peters was painting just before he turned to the Church in 1778, and Copley's 'Brook Watson and the Shark' [218] of 1778 was the direct antithesis to everything that Reynolds had preached. In 1779/80 Copley painted his 'Death of Chatham', a naturalistic rendering of a contemporary event which anticipated the work of Jacques-Louis David.

In the 1780s the constricting influence of the Italian Seicento, and even of Raphael and Michelangelo, was on the wane. Reynolds himself, after a visit to Flanders, absorbed a good deal of the influence of Rubens; Gainsborough's fancy pieces, of which the first was exhibited in 1780, aroused an interest in scenes from common life which was quickly followed by the younger generation. Opie, who first exhibited in 1782, showed 'The School' in 1784, and the domestic pictures of Wheatley and Morland began to make their appearance. The fashionable conversation piece came to an end with Copley's 'Sitwell Family' of 1787, and the young Lawrence started to exhibit the same year.

The later 1780s and 1790s were the heyday of the history picture, but it was a history picture of a very different kind from anything Reynolds had recommended. The introduction of 'period' costume on to the stage (and of a 'period' unknown to history) had corrupted the purity of the classical tradition, and although some painters clung to the old formulas, most of the contributors to Boydell's Shakespeare Gallery (begun in 1786), Macklin's Poet's Gallery, Macklin's Bible, Bowyer's Historic Gallery, and other such ventures, adopted a convention from what one can only call 'public theatricals'. It was no more than a step to the purely romantic convention of Fuseli, who had begun to exhibit in England in 1775. For the history picture Fuseli stands as Lawrence stands to portraiture, and with the full emergence of these two lively and impressive figures the classical age of British painting is over.

SIR JOSHUA REYNOLDS (1723-92)

The name of Reynolds has recurred fitfully in earlier chapters. He can be said to have given it to an age as no one since Kneller had done. He was the intimate friend of Burke, Dr Johnson, Garrick, and Goldsmith, and he was no stranger to Horace Walpole. Just as we cannot picture the age of Charles I without doing so through the eyes of Van Dyck, we cannot picture the splendid years of the third quarter of the eighteenth century, when Britain was so rich in statesmen, soldiers, sailors, founders of empire, lawyers, and men and women of literature, the arts, and the stage, except through the eyes of Reynolds. There is more affinity in nervous temperament between Van Dyck and Gainsborough – and in the tender loveliness of their mere painting – but in everything else Reynolds must be accounted the eighteenth-century equivalent of Van Dyck. Like Van Dyck he came to maturity at an opportune moment in the development of art, as heir to the struggles of an earlier generation. Rubens, with great intellectual effort and against a weight of conservative opinion, had created the 'modern' European style of the seventeenth century, and Van Dyck fell heir to it: Hogarth and, in a much lesser degree, Ramsay had created the 'modern' British style of the eighteenth century, and Reynolds was born at the right moment to fall heir to it. He was also endowed by nature with a rational intellect of a high order, and he had a power of phlegm which was denied to Van Dyck.

Anyone who seeks to estimate the qualities of Reynolds must take into account his virtues both as a painter and as a historian. It is easier to criticize him as a painter. He was curiously insensitive to draughtsmanship, if by 'draughtsmanship' we mean only a feeling for the beauty of line, a quality which Gainsborough possessed in a high degree. But, if we enlarge the concept of draughtsmanship into what the Italian theor-

ists call *disegno*, we discern that Reynolds has a compensating feeling for mass and the solidity of bodies, in which Gainsborough is often strangely lacking. The outlines of Reynolds's masses may often strike us unfavourably, but their placing and value in a picture are rarely at fault. And in what Northcote, writing of Ramsay, has called 'the mental part' of a portrait, Reynolds is supreme, and this touches on his value as a historian. He had the unusual advantage, to a portrait painter, of being deaf during the years of his maturity. I cannot doubt that this sharpened and accelerated his power of reading character, and, as a painter of men and women who have played a part in history, there is hardly a single European painter who can touch him for variety. Gainsborough's well-known comment on Reynolds: 'Damn him, how various he is!' was a criticism wrung from the heart, and points surely to that aspect of his whole output which no longer abides our judgement.

It is worth while therefore to define the range of this variety, and to try and indicate the principles which controlled it, and which give a unity to Reynolds's work as a whole. A consideration of Reynolds in relation to Kneller and Van Dyck will help to make clear his range. Kneller had been a master of the 'historical portrait' in the sense that he had a fine eye for the lineaments of the face (in men) and for the outward and visible marks of character: but he fitted his admirably observed faces into a set of stock patterns, which did nothing to bring out and a good deal to conceal the character of the sitter. His men are all dissimulators with different faces, and most of his women are puppets. Van Dyck on the other hand, as we have seen, was extremely sensitive to the shades of personal character and even modified his brushwork in accordance with his view of his sitter. But his sitters almost all belonged, in England, to the

small circle of the Court and are invested with the same kind of elegance. If, however, we turn to Van Dyck's portraits of his brother artists, we shall see a range and variety much more akin to Reynolds. Reynolds had absorbed both traditions, and it is not for nothing that his earliest experiment in a complicated portrait group, 'The Eliot Family' 1746 (Port Eliot), is modelled on the Wilton Van Dyck, which he can then only have known from an engraving. The vitality of Kneller's heads, and a pattern and posture which would bring out the character in the style of Van Dyck, were two of the main elements in Reynolds's portrait style. But, in his best work, there is more than this.

The strata of society from which Reynolds drew his sitters were much more varied than had been the case with Van Dyck, and Reynolds, in his best portraits, shows as much concern with the character of the type to which his sitter belongs, as with the individual character of his sitter. In the earlier manuals, such as Lomazzo or de Lairesse, it was considered enough to show, by some appropriately chosen symbol (as a globe for a navigator), what sort of profession your sitter had. Reynolds does not scorn such symbols, but he is concerned to reinforce their message by the pose and pattern of his figure. One of the most splendid examples is the 'Lord Heathfield' (National Gallery) [168], as solid as the Rock of Gibraltar of which he was Governor, holding, by a chain round his wrist, the key of the fortress with a gesture which makes plain the security of his defence of the Rock. These are new resources in British portraiture, although they are not altogether new in European painting. Rembrandt had more poetically employed symbols in a double context, and Titian had invested his men, beyond their personal likeness, with what Reynolds himself called a certain 'senatorial dignity'. It was this enhancement of personality which Reynolds sought to emulate, and he did it by the assiduous study of the Old Masters and of classical statuary, whose formulas and poses, more familiar then than they are now to the subconscious of cultivated Europeans, could be translated from 'history' into portraiture with the value of symbols. This

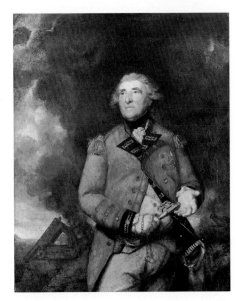

168. Sir Joshua Reynolds: Lord Heathfield, 1788. *London, National Gallery*

translation, which has already been noted in Hogarth's 'Captain Coram' and Ramsay's 'Macleod of Macleod', is of the essence of Reynolds's style. It was described by Horace Walpole as 'wit', and it contributed more than anything else to raising the status of portraiture and of the painter in England, where the native practitioner had been despised for half a century as beneath comparison with what the travelling gentleman met with on his Grand Tour. This raising of the status of the British artist was the political objective of Reynolds's life and the mainspring of his conduct as first President of the Royal Academy. It was an objective in which he was wholly successful and his achievement in this field may be thought to have contributed more than anything to making possible the flowering of a British school of painting of which we can be legitimately proud.

There is a trait of character, revealed in a story from Reynolds's early youth, which marks him out from the generations before him and suggests the forerunner of the romantic period. Before serving his apprenticeship to Hudson in

London, there was a discussion at home of an alternative career for him, and he broke out with the statement that 'he would rather be an apothecary than an *ordinary* painter'. Hogarth, one may surmise, would have sympathized with this, but the ambition of all earlier British eighteenth-century portraitists, even I suspect of Ramsay, was to be a successful ordinary painter. It was this spirit, in which he set out, which makes Reynolds's journey to Italy so memorable and so different from all earlier painters' years of Italian study. From the beginning of the century and the time of Jervas onwards the British portrait painter had been going to Italy and returning, at best, with nothing more than a reputation for connoisseurship. Reynolds, and Richard Wilson at the same time, went to Italy with a different kind of inquiring ambition. The light of the art of the Mediterranean world and its rich visual tradition broke over them, and they returned incomparably enriched. Something of the same kind had happened in the field of architecture thirty years earlier to Lord Burlington. We may fairly say that the plant of British painting, which had long been slowly maturing, suddenly ripened

into flower about 1750 under the warmth of the Italian sun.

It may be that Reynolds swallowed this intoxicating nectar a little too rapidly. The sublimity of the figure style of the Italian High Renaissance, that quality about Michelangelo's statement of the human form which Reynolds, in his last *Discourse*, refers to so movingly as 'the language of the gods', was reached after many generations of endeavour. Yet it is this strong wine in which, in his writings, he recommends that the student with high aspirations should immerse himself. From his Italian notebooks, however, we can gather that Reynolds himself got more immediate profit from the more ornamental style of the Venetians, which, in his teachings, he affects to discourage as of inferior value. In his portraits he only rarely allows his devotion to 'the language of the gods' to get out of hand, and he can even adapt figures from the Sistine ceiling (as in the 'Duchess of Marlborough and Child' at Blenheim) with impeccable taste, but it is another story in the rather few historical subjects of his later years. Even in what is in many ways the finest of them, the 'Death of Dido' (Royal Academy 1781) [169] at

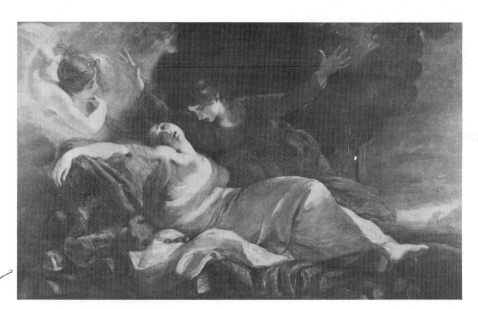

169. Sir Joshua Reynolds: Death of Dido, 1781.
Royal Collection (by gracious permission of Her Majesty the Queen)

Buckingham Palace, we can discern the justness of Mrs Thrale's uncharitable lines,[1]

A rage for sublimity ill-understood
To seek still for the great by forsaking the good.

But there is no painter of such uneven gifts for whom familiarity breeds such respect as Reynolds. His vast output, as fully documented as that of any known painter, is widely scattered and there is no collection where he can be seen fully in the round. To give a fair account of his work there are hardly less than a hundred paintings which one would like to take into consideration, either for their success, their originality, or their influence. The fourteen *Discourses* which he delivered, as President, at the annual prize-givings at the Royal Academy Schools, remain the most practical, the most sensible, and the best written discussions on the theory and practice of painting in the English language. They do not form a connected treatise and they deal often with problems of an occasional kind, but they lay down very clearly the terms in which the British school can be understood, as well as the attitude against which some of the romantic painters were to react at the end of the century.

A word should also be said about Reynolds's personal character, which has a bearing on his art and on his influence. It was so strongly in contrast to the character of Gainsborough that an understanding of the virtues of these two great rival portrait painters is made easier by a knowledge of their character. Reynolds was cool, businesslike, and eminently objective: to those who admired enthusiasm and a quick response to the impulses of the heart, his temper seemed too frigid. He was a man of letters and he chose his friends from the world of letters and never admitted a fellow painter to his intimacy, although his acts of kindness to young painters were numerous. His life passed without indiscretions, and one would be tempted, from some of his recorded observations, to think of him as cynical, if he were not so obviously in earnest about the noble qualities of art, and if a whole range of his portraits did not show such an unclouded response to beauty and strength and innocence of character.

Reynolds was apprenticed to Hudson for four years in October 1740, at the age of seventeen. He quickly acquired the routine knowledge of the work of an 'ordinary' portrait painter's studio, which was all that Hudson could give him, and this apprenticeship was terminated amicably after two and a half years. From the middle of 1743 until May 1749, when he set out for Italy, he practised on his own, mainly in his native Devonshire, but also for a year or two (1744/6), in London. Some fifty[2] or so works of these years are known, some little better than pot-boilers, done hurriedly to earn a little money; some of his father and sisters, with a tender candour of approach which shows that he had looked at Hogarth rather than at his master, Hudson; some with passages of rich, creamy pigment which show already an interest in the texture of paint (which he is alleged to have derived from seeing the works of the elusive William Gandy at Exeter); others which show an eye to what Ramsay was doing in the 1740s. An accessible and perhaps characteristic example, signed and dated 1747, is the 'Lieutenant Roberts' [170] at Greenwich. In style it is nearer to Ramsay than to any other painter, with a little more alertness than was common with Ramsay, and with an interest in bold light and shade, to give mood to the subject, which already shows one of the problems he was to give most detailed study to on his Italian travels.

He sailed for Italy with his friend Commodore (later Admiral and Viscount) Keppel; landed in January 1750, and remained in Rome until May 1752, when he came home overland with short stays at Florence, Parma, Bologna, Venice, and Paris. Early in 1753 he settled in London. It was in Rome that his art and mind were formed, not, as with Ramsay, by the teaching of contemporary Italian painters and by study at the French Academy, but by daily communion with the great masters, with Raphael, Michelangelo, and the Antique. Here, in contrast to the narrow world of London, he bathed himself in the majesty of a long tradition of art.

170. Sir Joshua Reynolds: Lieutenant Roberts, 1747. *Greenwich, National Maritime Museum*

He approached this great tradition with humility and sought first for intellectual regeneration, and not, as his predecessors had done, merely for the tricks of the trade. He did not, of course, neglect the latter and made numerous studies of pose and arrangements of figures and patterns of light and shade, but all these were hints, memoranda, towards the understanding of the Grand Style. An over-simplified statement would be that Reynolds returned from Italy saturated with the idea of the Grand Style and determined, since the practical bent of his mind made him aware that there was no living to be made by a painter in London except through portraiture, to elevate the British portrait tradition by marrying it, as far as possible, to the Grand Style. In later life, in the 1780s, he came to see that the Grand Style should be used in portraiture only with considerable discretion and on a character which could bear it. But that was after it had won perhaps too overwhelming a victory in England, and the second phase of Reynolds's career, which may be said to cul-

minate in the foundation of the Royal Academy in 1768, is centred on the naturalization into England of the Grand Style. By an understandable reaction almost the only original work Reynolds did during his Italian years was a series of caricature groups of British visitors to Rome. These throw considerable light on Reynolds's power of perceiving character, but he prudently decided to abandon this genre as one ill-calculated to advance the success of a professional portrait painter.[3]

Success followed immediately upon Reynolds settling in London, and by 1755[4] he had as many as a hundred sitters and was employing considerable studio help. In 1759 the number had risen to 150 and he had to raise his prices to reduce the volume of business. Many of the works of this period are naturally rather dull single heads, but it would be accurate to say that the wealth and variety of Reynolds's portraits in the 1750s revolutionized the taste of Britain and the older generation of artists were driven into retirement from fashionable practice and, if they could afford it, retired altogether.

The picture with which Reynolds secured his reputation was the 'Commodore Keppel' [164] of 1753/4 at Greenwich, and it is instructive to compare it with Ramsay's 'Macleod of Macleod' [163].

The pose and the general pattern are nearly identical – the 'Apollo Belvedere' in reverse. There is a rock at the left, with a few scraggy trees, and the sea to right. But the difference is prodigious in the communication of life and energy. One is tempted to suppose that Reynolds knew exactly what he was doing: that he deliberately took a classical theme which had been arranged by Ramsay for chamber music and showed what he could make of it by scoring it for a full orchestra. Ramsay's figure is sharply and daintily silhouetted against a calm sky: it barely stands upon the shore and the right arm is thrust forward in a gesture rather of welcome than command. The landscape is little more than a photographer's backdrop for an elegant puppet and there is no motive to unite figure and background. The motive in Reynolds's 'Keppel'

is that the Commodore had lately been ship-wrecked and he is shown as a man of action, striding along the shore and braving the tempest. Walpole might have been thinking of these pictures when, in 1759, contrasting Reynolds and Ramsay, he says of the former that he is 'bold' and 'has a kind of tempestuous colouring' which Ramsay lacks. The difference in power and character made by Reynolds's alteration of the movement of the right arm, and the immense gain in the appearance of life by limiting the amount of the silhouette which is sharply outlined against the background are additional elements in Reynolds's new receipt for portraiture. In nothing is the new style so distinct from the old as in this marriage of the figure to an appropriate background by a use of light and shade which Reynolds had learned from his study of the Old Masters. In later years the setting of many of his full-length figures against parkland, evocative of the surroundings of the great country houses in which his sitters lived, is an extension of this method and the adaptation of a formula of Van Dyck to a modern theme. It is not surprising that this new style took the world by storm, or that Ramsay should soon have gone on a second journey to Italy to seek inspiration again at so invigorating a source. It is significant that Reynolds never felt the need of returning to Italy himself.

By no means all Reynolds's portraits make so complete a break with the old style. Heroic overtones were not always possible and the great bulk of his commissions was more for domestic portraits than for full-lengths. A much more typical example is the 'Mrs Francis Beckford' [171] of 1756 at the Tate Gallery, a single three-quarter-length figure, in a far from easy or natural pose, and with as much emphasis on the dress as in any of Hudson's portraits. What is it which gives life to this and marks it of the new age? It is not, in the main, a question of lighting, although the shadows flicker in a more subtle fashion over Reynolds's surfaces, and more of the outline is lost in shadow. It is much more in the tender and sympathetic approach to a character, which cannot, in this instance, have been very strongly formed. There is an absence

171. Sir Joshua Reynolds: Mrs Francis Beckford, 1756. *London, Tate Gallery*

of Hudson's fixed expression, his stare, as it were, at the camera; a certain gracious shyness, a momentary quality, as of being caught unobserved. There is also an enchanting colour, the silvery blues which predominate in early Reynolds. It is a return of the Graces.

It is curious that Horace Walpole, as late as 1759, should have thought that Reynolds rarely succeeded with women, while Ramsay was formed to paint them. It is true, however, that Reynolds was keenly aware of what Ramsay, his only formidable rival in London at the time, was doing, and he may well have consciously set out, as he had done in his 'Keppel', to excel him in his own field. When Ramsay had painted Lord Bute in 1758, Reynolds is reputed to have said,[5] of a portrait he painted a little later, that he 'wished to show legs with Ramsay's "Lord Bute"'. I imagine that this picture was the 'James, Seventh Earl of Lauderdale' (formerly Thirlestane Castle) [172] of 1759, one of the most lively of his full-lengths of peers in robes, in which he has used the base of a twisted column beloved of Van Dyck, and invented a pose to justify the crossed legs, which was absent

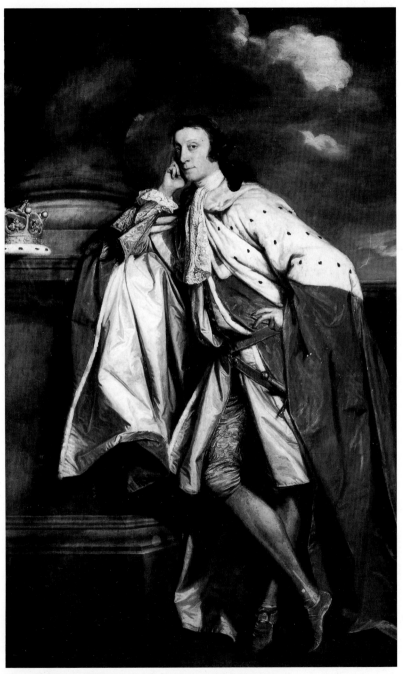

172. Sir Joshua Reynolds: James, Seventh Earl of Lauderdale, 1759.
Formerly Countess of Lauderdale, Thirlestane Castle, Berwickshire

in Ramsay's figure. In selecting another Scottish peer for this display of wit, there would be a conscious irony which was not alien to Reynolds's character. When the time came, in 1760, for the first public exhibition of artists' works at the Society of Arts Ramsay abstained from exhibiting and Reynolds emerged as the acknowledged leader of the English school. An article in the *Imperial Magazine*[6] at the time says that his 'merit is much beyond anything that can be said

in his commendation'. He perhaps inspired the article himself.

The ten years from 1759 to the first Academy Exhibition of 1769 are the culmination of Reynolds's earlier style. It is less classical than his style of the 1770s and less dramatic than his final phase. To many it seems the period when he was at the height of his gifts. A picture such as 'Georgiana, Countess Spencer, and her Daughter' [173] of 1760/1 (Althorp) must count as one

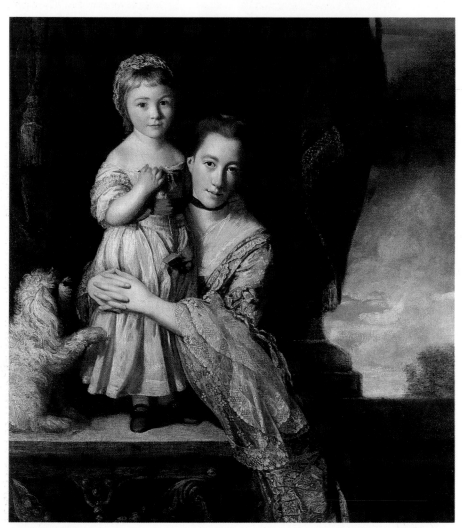

173. Sir Joshua Reynolds: Georgiana, Countess Spencer, and her Daughter, 1760/1.
Earl Spencer, Althorp, Northants

of the great masterpieces of English portraiture. It is not a masterpiece of formal design and it achieves its ends more by tenderness and human value than by the resources of art, although the colour and the texture of the paint are alike lovely. As Northcote said of Ramsay, it is the furthest possible removed from vulgarity, and that is a virtue more positive in portrait painting than one might at first suppose. It is in fact a *Madonna* design and the extremely tactful use of a formal pattern of this kind with the value of a symbol is a part of its haunting power. Something of the same quality lingers round the 'Nelly O'Brien' of about 1762 in the Wallace Collection.

But Reynolds was hankering after a more powerful instrument of rhetoric than the style displayed in pictures of such quiet perfection. It may well be that he saw something of his own predicament in the picture he exhibited in 1762 of 'Garrick between Tragedy and Comedy' (Private Collection) [174]. It was a modern variation on the old theme of 'Hercules between Virtue and Vice', and Reynolds has also given it a pictorial nuance by painting Comedy in the manner of Correggio and Tragedy in the manner of Guido Reni. It was also a symbol of a struggle he was going through himself between the more or less intimate portrait, of which he was a master, and the heroic portrait, with which he was beginning to experiment as early as 1760, in the 'Duchess of Hamilton and Argyll' at Port Sunlight. By 1765, in 'Lady Sarah Bunbury sacrificing to the Graces' (Chicago) [175], Reynolds's second and classical manner is seen at the full, and it is hard today not to feel some suggestion of the 'sense of sublimity ill-understood'. Lady Sarah is, as it were, an illustration to much that he has to say in the *Discourses* about the Grand Style, antique drapery, and so on.

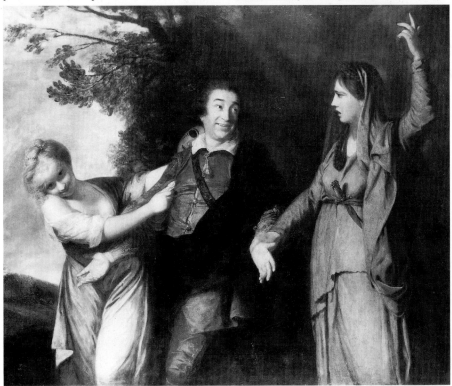

174. Sir Joshua Reynolds: Garrick between Tragedy and Comedy, 1762.
Private Collection

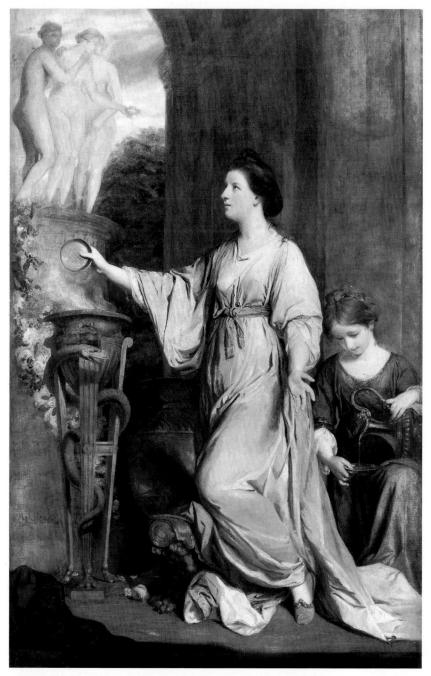

175. Sir Joshua Reynolds: Lady Sarah Bunbury sacrificing to the Graces, 1765.
Chicago, Art Institute

She is conceived in the manner of Guido Reni, whose popularity was then at its height, and it was perhaps in an attempt to emulate the Old Masters that Reynolds conceived this somewhat unfortunate portrait style. It was a deliberate innovation of his own, for it does not correspond to any contemporary European fashion nor to a perceptible reaction towards classicism apparent in British society.

It was under the influence of this high-minded and doctrinaire style that Reynolds set about his duties as first President of the Royal Academy, and his contributions to the first exhibition are all in this vein – the Duchess of Manchester as 'Diana' removing a bow from her infant son as 'Cupid' (taken from Albano); Lady Blake as Juno receiving the cestus from Venus (from a Roman statue); two ladies moralizing at a tomb inscribed 'Et ego in Arcadia' (a fancy from Guercino); and an exercise in the manner of Correggio with the title of 'Hope nursing Love'. It is impossible to avoid the impression that the President was seeking to impart a lesson in style.

From the time of the exhibition of 1769 nearly all Sir Joshua's most important works appeared at the Academy. One can name hardly a dozen really major works from 1769 to 1790 which were not so exhibited, and Reynolds's importance as the arbiter of contemporary taste and as setting the example by his exhibits of one year for what the ambitious youth of the next would paint, becomes paramount. He was never so unremittingly classical again as in 1769, but the predominance of his high classical manner persists until the completion of his designs for the window of New College Chapel at Oxford in 1781. In each exhibition he sought to include a subject picture and, parallel with his sublime or heroic subjects, such as 'Ugolino' (Royal Academy 1773: at Knole), we begin to find in 1773 single figures or fancy pieces of a more temperate cast, such as the 'Strawberry Girl' (Wallace Collection). Reynolds does not seem himself to have set great store by these, as a number did not find their way into the exhibitions, but they gradually came, especially through engravings, to have a powerful influence on popular taste. These were often ex-

cursions into the style of the Old Masters. The 'Shepherd Boy' c. 1772 (Earl of Halifax) was an experiment in the vein of Murillo, and the 'Children with Cabbage Net' (Royal Academy 1775: Buscot) [176] is an essay in Rembrandt-

176. Sir Joshua Reynolds:
Children with Cabbage Net, 1775.
Lord Faringdon, Buscot Park, Berks

esque lighting and simple genre. The former anticipates Gainsborough's fancy pieces, and the latter is a precursor of the early (and best) style of Opie. Then the fancy piece and the child's portrait become blent as in the 'Master Crewe as "Henry VIII"' (Royal Academy 1776: Lord O'Neil), which is a fancy picture in parody of Holbein engagingly combined with a portrait. In this, and in the 'Lady Caroline Scott as "Winter"' (Royal Academy 1777: Duke of Buccleuch) [177], he showed that, even in the middle of his most didactically classical phase, when the subject could not justify such treatment he had lost nothing of the freshness and perception of his understanding. There is a blend in such pictures of detached sympathy and authentic visual or pictorial values uncomplicated by those sentimental overtones which

177. Sir Joshua Reynolds: Lady Caroline Scott
as 'Winter', 1777.
Duke of Buccleuch and Queensberry, Bowhill, Selkirk

make similar works by Sir John Millais so
nauseous to those who respect the work of the
creative artist. It is this fact that, in so much of
his best work, pictorial and human values re-
inforce one another, which makes Reynolds
such a difficult painter for the purist critic to
appreciate.

The most ambitious of all Reynolds's portrait
commissions, the great group of 'The Family of
the Duke of Marlborough' (Blenheim) [178],
appeared at the Academy of 1778. It remains
still the most monumental achievement of
British portraiture, worthy of Blenheim, which
was to house it. There is nothing on this scale
which can count seriously between Van Dyck's
group at Wilton and this, unless it be the Hud-
son group at Blenheim of the second Duke and
his family, which is stiffly composed, though not
without some ingenuity. As a composition the
Van Dyck is a failure, while the Reynolds errs
perhaps a little in being in accordance with all

the rules. But it is not what other such groups
had been in England, conversation pieces en-
larged to the scale of life; it is a history picture.
It is the one occasion when Reynolds was able to
demonstrate to the full the possibilities of apply-
ing the historical grand style to portraiture. It is
thus the very centrepiece of his public style.
From this time onwards Reynolds was to ex-
periment with great success in a more informal
mode.

One of the most brilliant of such experiments
was the 'Lady Worsley' (Royal Academy 1780:
Harewood House) [179]. Towards the end of
the 1770s his devotion to a more or less classical
style of drapery abated and he came to realize
that he could infuse more life, with no loss of
monumentality, into his full-length portraits,
by the scrupulous observance of contemporary
costume. It may be that it was Gainsborough's
arrival in London in 1774 which partly led to
this change. In the 'Countess of Bute' 1777/9
(Mount Stuart), an old lady slowly walking
across a park with a folded blue parasol, and in
the 'Lady Worsley' in a red riding-habit and a
black feathered hat, he suddenly makes his god-
desses come down to earth. In such pictures he
inaugurates his third and final style, which re-
verts once more to the human values of his
earlier manner, but retains overtones of the
classical style which it supersedes.

Reynolds's interest in the informal was sup-
ported and enriched by a journey that he made
to Flanders and Holland in the summer of 1781.
On this occasion he particularly studied Rubens
and was impressed by the combination of
dramatic and informal elements in some of his
portraits, and also by the rich texture of his pic-
ture surface. The result was apparent at once in
his own work and at its height in the Academy
of 1786, at which he showed 'The Duchess of
Devonshire and her Daughter' now at Chats-
worth [180] and Viscount Cowdray's 'Joshua
Sharpe' [166]. It is instructive to compare the
picture of the Duchess with the Althorp group
of her mother with herself as a child painted a
quarter of a century before. Both are, in a sense,
intimate pictures of a mother and child. But the

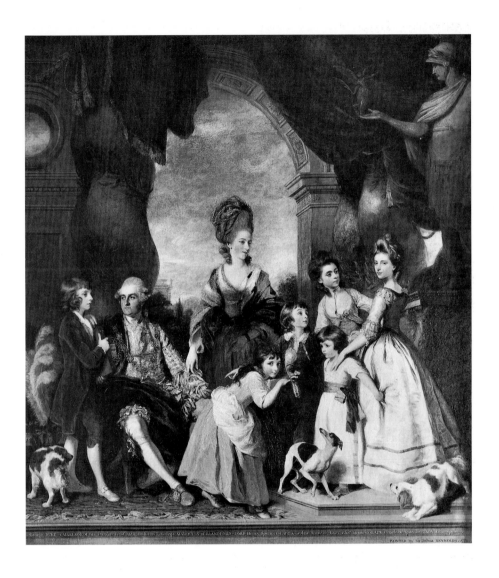

178. Sir Joshua Reynolds: The Family of the Duke of Marlborough, 1778
Duke of Marlborough, Blenheim Palace, Oxon

179. Sir Joshua Reynolds: Lady Worsley, 1780.
Earl of Harewood, Harewood House, Yorks

scrupulous in its observance of the balance between the two interests in a portrait.

The 'Joshua Sharpe' and the 'Lord Heathfield' (Royal Academy 1788) [168] may be taken as among the finest examples of his latest style in men's portraits, one a study of a man of thought, the other of a man of action. Both are pictures of types as well as of individuals, and much richer compositional resources have gone to their making than in his earlier portraits. The head of the grave lawyer is placed low on the canvas, the mass of the body slumped and concentrated, while the arrangements of the soldier's body are reversed. In both the figure is off centre, and there is a dramatic intention in this displacement and in the lighting. Not all Reynolds's later work is contrived with such thought, and he used the classical mode, which perhaps came most easily to him, on appropriate occasions even in his latest works. But until his eyesight began to fail in 1789 and he was forced to give up painting, he was constantly developing new resources in his art. We know so much more of the routine production of his studio than we do in the case of earlier painters, that it is not altogether easy to judge him fairly, but, judged by the standard of the very considerable number of his finer works, we can say without hesitation that he was the chief intellectual force in the first great age of British painting.

serenity of the earlier picture, which owes allegiance to the Italian masters of the High Renaissance, has given way to a lively and dramatic style akin to Rubens's baroque. The timeless has given place to the momentary, and there is something more modish about the later work which announces the age when fashions in dress and gesture made up a large part of the character of men and women. It is from Reynolds's works of the middle 1780s that Hoppner and Lawrence derived their style. Reynolds himself kept a fine balance between his baroque curtains of sealing-wax red, the shimmering muslins and the glossy blacks of men's or women's dresses, and his closely characterized faces, but the next generation was not always so

Reynolds's Pupils

Few of Reynolds's direct pupils deserve attention, for he does not seem to have had the qualities of a teacher and there was a tendency for his pupils to degenerate into 'assistants'. The best known was Northcote, who finds his place under the history painters, but one or two, who were portraitists, deserve a passing mention. The best was Thomas Beach (1738-1806), a man from the West Country, who was a pupil of Reynolds about 1760/2 and finally settled in Bath, from at least 1769 until a few years before his death. In the middle 1770s Beach would spend a few months in London, but his chief practice was in Bath itself, or in the West

180. Sir Joshua Reynolds: The Duchess of Devonshire and her Daughter, 1786.
Trustees of the Chatsworth Settlement

Country, in which he would make a summer tour, visiting a succession of country houses at which he was commissioned to paint portraits. His work can be followed from about 1768, when it owed a good deal to Reynolds's formulas, up to about 1800. It is never without a certain individual character and includes a number of group portraits (which are never 'conversation pieces'). These have a certain agreeable *gaucherie* in their composition, but his single busts or half-lengths are at least as good as Beechey's, whose work they anticipate, and have no disagreeable modishness.

The chronological list of Reynolds's pupil-assistants is, after Beach: Hugh Barron (1764-6), who later painted a few attractive 'Conversation Pieces'; John Berridge (1766-8); Northcote (1771-6); and the only other one who merits separate notice, William Doughty, who died in 1782 on his way to India. He was a native of York and studied with Reynolds *c.* 1775-8, but is best known as a mezzotint engraver. He did not often reach the level of the portrait of his chief patron, 'William Mason', now in the York Gallery, which is perhaps the closest to Reynolds in style of any work by his pupils.

RICHARD WILSON (1713-82)

Wilson fills much the same place in the development of a tradition of landscape painting in Britain that Reynolds does in the development of portraiture. Both appear on the scene at the same kind of moment, when the ground had already been broken for the establishment of a new style; both were sons of the clergy and had some pretensions to scholarship; both were in Italy in the early 1750s and became saturated with the Mediterranean tradition. But there the likeness ends and, in their outward circumstances, there was great disparity. Reynolds imposed his style upon contemporary public taste, but Wilson – although his qualities were always esteemed in the professional circle of artists and he became a foundation Royal Academician – had to wait until a generation after his death for serious appreciation. Reynolds had accommodating manners, a cool temper, and an eye for fame: Wilson had a sharp and explosive tongue and was no respecter of formality, and he loved his art more than his reputation. Wilson has less variety and range than Reynolds, nor did he steadily develop from strength to strength over a period of forty years: once formed his style changed little, and his best work was produced in a period of little more than twenty years. But it might be held that Wilson shows a greater intensity and power of creative imagination in establishing the classical British landscape than Reynolds required to establish the classical British portrait. His precursors had advanced less far along the road.

It is still matter for surprise that Wilson's landscapes met with such little success amongst an aristocracy which was modelling the landscape of its parks on the Italian scene, and hailed Claude as the master of the picturesque and Gaspard and Salvator Rosa as masters of the sublime. Wootton and Lambert had already introduced the conventions of Claude and Gaspard to some extent into British landscape painting. But a landscape to them was either a mere piece of decorative furniture or a record of an actual scene. It was Wilson who first charged the 'landscape' in Britain with the values of an independent work of art, sometimes – and in these he was less successful – by attempting the Grand Style and combining 'history' with landscape, and sometimes, which was his great achievement, by infusing into his scene a feeling, either solemn or lyrical, for the divine element in nature which can best be apprehended by likening it to the feeling which is the constant theme of Wordsworth. One cannot sum this up more clearly than by quoting Ruskin's words that with 'Richard Wilson the history of sincere landscape art founded on a meditative love of nature begins in England'.

We know something of Wilson's own views on landscape from a story related by Beechey,[1] who once asked Wilson whom he considered the best landscape painter, and received the reply: 'Claude for air and Gaspard for composition and sentiment. . . . But there are two painters whose merit the world does not yet know, who will not fail hereafter to be highly valued, Cuyp and Mompers.'[2] Even without this, we should have no difficulty in claiming Claude, Gaspard, and Cuyp as the three principal ancestors of Wilson's style. Indeed, in speaking of Claude and Gaspard, Wilson was doing no more than echo the prevailing views on those masters. The building up of a formal composition with a dark foreground, tree or rock masses at either side, and the eye carried in the centre to a far mountain distance, the gradations finely articulated by a sarcophagus, a temple, and other nostalgic memorials of an ancient or Arcadian civilization, and peopled with appropriate figures, are the elements of Claude's formula. Gaspard, more than any other painter, had loved the sites at Tivoli, Frascati, Albano, and Nemi, which form much of the material of Wilson's repertory.

From Cuyp, who was to come into his own at the end of the century - with Wilson himself - he learned the devoted study of clouds and the play of light in northern climates, which is absent in Claude's airy vault of Mediterranean sky, and a feeling for transient gleams of splendid light which can sometimes start tears in the beholders' eyes. In his finest designs, when produced at moments of unclouded sensibility, these qualities are to be found. That he repeated these designs, sometimes with subtle variations, sometimes mechanically, sometimes with downright carelessness as mere pot-boiling (in his latter days he called such compositions 'good breeders'), is a matter for regret at times, but does not affect the value of the original inspiration. All Wilson's own work, even when slovenly in execution - and his own shortfalling has enabled much rubbish to pass today falsely under his name - retains something of this core of seriousness which lingers from its original inspiration and has a solid formal framework. We can perhaps appreciate this most easily by comparing it with the work of a popular rival, who had been friendly with Wilson in Italy, Francesco Zuccarelli.

Zuccarelli (1702-88) was a painter of Tuscan origin who had found success at Venice in the production of fancy landscapes in rather watered imitation of Marco Ricci. He was in London from 1752 to 1762 and again from 1765,[3] when he became a foundation member of the Royal Academy, but he was back in Venice by 1772. In London he met with great success and Windsor Castle is still full of his facile works. Some contemporary critics held it against George III that, just as he patronized Ramsay and neglected Reynolds, he patronized Zuccarelli and neglected Wilson - and the charge seems true enough. Wilson's first biographer relates a story that, soon after Wilson's return from Italy (probably about 1758), a group of artists who considered themselves the arbiters of taste came to a resolution 'that the manner of Mr Wilson was not suited to the English taste, and that, if he hoped for patronage, he must change it for the lighter style of Zuccarelli'.[4] Wilson's style seemed solemn and severe (which

indeed are his virtues) and his contemptuous refusal to change to the *lighter* style lost him much success. Zuccarelli's style is indeed 'light'. Although a few of his pictures include compositions from classical story treated in the spirit of a snuff-box, the bulk of them are loosely composed picturesque views of a predominantly Italian cast, peopled with shepherds or *contadine*. This passion for the frivolous was by no means confined only to George III and an echo of the same sort of complaint can be heard in Reynolds's *Fourteenth Discourse*, when he objects, of Wilson, that he has been 'guilty . . . of introducing gods and goddesses, ideal beings, into scenes which were by no means prepared to receive such personages. His landscapes were in reality too near common nature to admit supernatural objects.' It looks as though Sir Joshua were not willing that *two* people should introduce the Grand Style into England, and, when he goes on to say that to do what Wilson was trying to do 'requires a mind thrown back two thousand years, and, as it were, naturalized in antiquity, like that of Niccolo Poussin', he seems also to be passing unfavourable judgement on his own works. Today Wilson's landscapes do not seem to be too near to common nature, and Wilson never laid claim to emulating the heroic landscapes of Nicolas Poussin. Rather he was creating a new genre out of Claude and Gaspard, which one might have thought specifically appropriate to the taste of Northern gentlemen who were steeped in classical culture. His figure-scale is larger than Claude's and his Italian landscapes with classical figures are meant rather as nostalgic evocations of the ideal landscape of the Mediterranean world visibly inhabited by the proper persons, either mythological or historical - Diana and her nymphs at Nemi, and Cicero and his friends at Arpinum. His views of Nemi in fact are as convincing with classical beings in the foreground as they are when peopled only by the monks from the convent at Genzano, or mere nameless figures from the contemporary scene.

Wilson was a Welshman, born at Penegoes in Montgomeryshire. He was apprenticed to a portrait painter in London and became himself a

portraitist at least as advanced as, and of equal distinction with, anyone working in London in the middle of the 1740s. His 'Admiral Thomas Smith' [181] at Greenwich (engraved 1746: a rather less free full-length variant of 1744 is at Hagley) is very little below Hogarth in its genial interpretation of character and in the attractive quality of its paint surface. But he was not suited

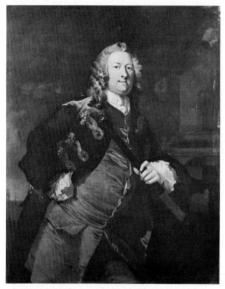

181. Richard Wilson: Admiral Thomas Smith.
Greenwich, National Maritime Museum

by temperament to be a fashionable portraitist, and that he had leanings towards landscape painting at this time is clear from the fact that the pictures he chose to contribute to the collection at the Foundling Hospital in 1746 were two small circular prospects of London hospitals which are executed in a style very close to that of George Lambert. He had certainly painted a view of Dover before 1747[5] and it is possible that he had begun also to specialize in 'views of gentlemen's seats' before he left for Venice late in 1750. In the general history of British painting, however, his work is of little moment before his Italian journey and his decision, made after 1750, to become a painter of landscape.

Wilson remained in Venice (where he painted a few portraits, such as those at Cardiff and in the Tate Gallery) from about November 1750 until at least the latter part of 1751. Then, still torn between landscape and portrait, according to William Lock who was his fellow traveller, he passed through Rimini and Florence and reached Rome by January 1752.[6] It was Rome – and perhaps, in some slight degree, the encouragement of Vernet – which settled his uncertainty, and from 1753 he can be considered only as a painter of landscapes.

Wilson remained based on Rome from 1752 until 1756 or 1757. He ranged as far up the Tiber Valley as Terni and Narni and he went south, probably with Lord Dartmouth, to the classical sites round Naples, but it was the Roman Campagna which won his heart, as it had won Gaspard Poussin's a century earlier. The landscape of the Campagna did for Wilson what Michelangelo's and Raphael's works did for Reynolds during the same years. It saturated him with an ideal beauty from which his imagination was never to escape. From Claude he no doubt learned the bare grammar of classical landscape, but he studied the scene on the spot, with its accidents of cloud and shadow, as Claude himself had done in his drawings. Wilson's own drawings on the ground are little more than memoranda, sometimes only of rocks or tombs or antique fragments. They have nothing of Claude's splendours about them and may rather be compared with the drawings such Dutchmen as Berghem must have brought back with them, which were to serve them for painting Italian scenes for the rest of their lives. But Wilson also had some practice in making drawings of studio compositions of the Roman scene, such as the series he made for Lord Dartmouth in 1754.[7] He probably also made a set of such compositional models or patterns for himself, and at least half of his output after his return to England was of Italian scenes. Except for a few favourite compositions such as the 'Bridge at Rimini', these fall mainly into two groups, scenes from the country immediately round Rome, Tivoli, Albano, Castelgandolfo, and Nemi, and scenes from the classic landscape of

the Phlegraean fields, Cape Misenum, the Lucrine Lake, the Lago di Agnano, and the Bay of Baiae.

A few large paintings can be identified with certainty, from their bearing dates, as having been painted during Wilson's years in Rome. Two companion pictures, one dated 1753, were in Lord Dartmouth's collection,[8] and one, dated

are conversing near a tombstone, on which is written 'Ego fui in Arcadia'. Zuccarelli was to be commissioned in 1760 by a Scottish patron, to do a picture with a similar tomb, which was to symbolize that his Grand Tour days were over, but Wilson invests his picture with a melancholy poetry unknown to Zuccarelli, and the nostalgia, which is a prominent element in his style, is here

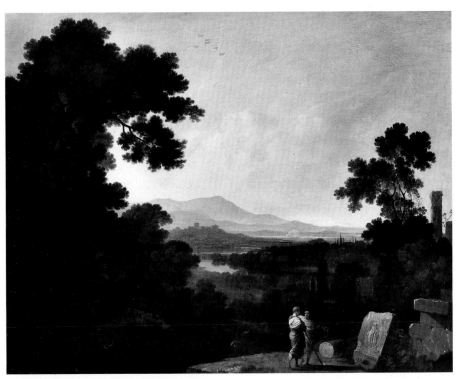

182. Richard Wilson: Ego fui in Arcadia, 1755.
Viscount Enfield, Abbots Worthy, Hants

1755, is at Abbots Worthy [182]. In these the tone is muted, almost subdued, and has none of that clear, hard brilliance of high Italian summer which we find in some of his later repetitions. The figures are meditative and pastoral, never classical, and in the picture we reproduce Wilson re-uses an old motif which makes it almost an account of his own feelings for his Italian years. Two classically dressed shepherds

unusually explicit. It may be that Wilson also did a few oil studies more or less on the spot while in Italy. Such a picture as the 'Lago di Agnano' [183] at Oxford, with its unforced range of tone and its lack of the dramatic contrasts which are natural in the studio, can hardly have been produced in any other way. It is nearer to Corot's early Roman studies than to any other paintings, and it suggests what possi-

bilities were latent in Wilson's art if the time had been ripe for their development. One or two of the late battered sketches in the national collections, which were among Wilson's possessions at his death, reveal that he went on painting such things for his own pleasure into later life.

The Italian landscapes can be divided into two classes, the dramatic 'histories' in the Grand Style, and the more tranquil compositions, whether peopled by divinities or peasants. The dramatic histories, at which Sir Joshua tilts in his *Discourses*, are very few in number (not more than half a dozen) but are important as they are

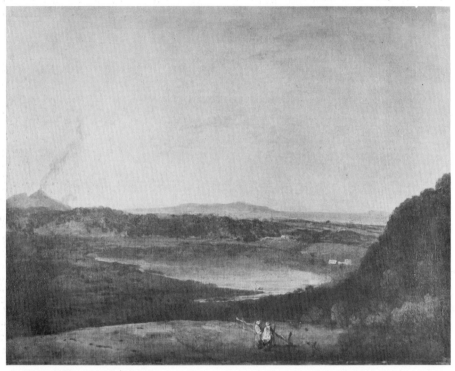

183. Richard Wilson: Lago di Agnano.
Oxford, Ashmolean Museum

Wilson was settled in London by 1758 and we are on less secure ground for his chronology in his later years. But his work falls readily into three categories: the later Italian views, the interpretations of the British landscape scene, and commissioned views of country houses. These can most easily be considered in turn, premising that he seems to have done little work beyond copying his own old compositions after about 1774, and he retired to Wales, a broken man, about a year before his death in 1782.

presumably the pictures with which Wilson hoped to obtain the highest class of patronage. Probably all were painted before the foundation of the Academy in 1768 and they were finely engraved between 1761 and 1768. The earliest (? *c.* 1760/1) seems to have been the 'Niobe' [184] of which the finest (though perhaps not the earliest) recension was the picture in the Tate Gallery destroyed during the war. It is hardly distinguishable in spirit from Gaspard Poussin and it is difficult not to consider Rey-

nolds's strictures as provoked by jealousy. That they were felt as justified by others, however, seems indicated from the fact that Wilson himself later tried to introduce more Salvatorial figures into such a scene (as in 'The Unransomed' at Port Sunlight) and that the classical figures in his later 'histories', such as 'Apollo and the Seasons', are hardly to be distinguished from pastoral personages.

a little in the number or disposition of the figures, or in the contour of the distant hills. This does not indicate, as similar duplicates perhaps do in El Greco, a constant search for perfection of composition, but simply that, like all true artists who are forced by circumstances to repeat themselves, he could not bear to be always merely copying. In some arrangements there are adaptations which almost amount to a

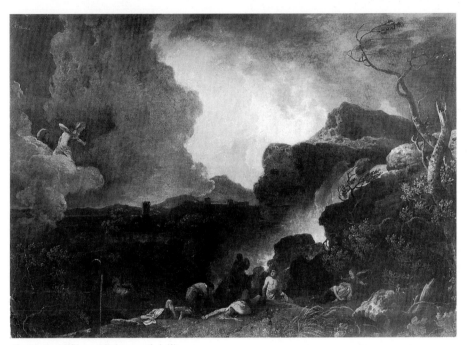

184. Richard Wilson: Niobe, c. 1760/1(?).
London, Tate Gallery (destroyed)

The remaining Italian views make up about half of Wilson's output after he had returned to London. They are sunnier and more glowing – as if enriched by memory – than the scenes painted in Italy, and later versions are richer and more buttery in pigment than the earlier. But, aside from mere pot-boiling copies, they are wonderfully true in tone and have very little air of having been confected in the studio. Of certain popular designs, such as 'The White Monk', there are at least a dozen originals, each varying

new picture, and the way, for instance, in which Wilson has converted the small upright design engraved as 'Hadrian's Villa' (of which one of the best versions is in the National Gallery) into a new oblong picture in the example at Manchester [185] shows the bent of his art.

It is, however, in his interpretations of the British scene that Wilson made his most original contributions to landscape painting. His range of country is not very wide: Kew and Syon House, the Thames and Windsor Park, certain

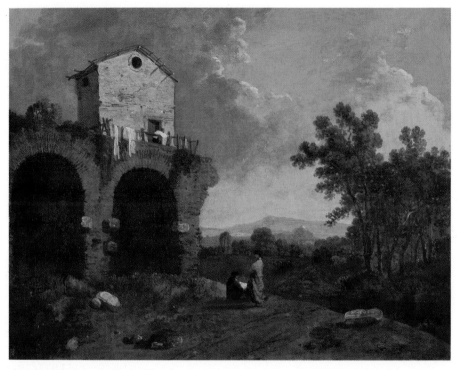

185. Richard Wilson: Hadrian's Villa.
Manchester City Art Gallery

districts in the South-West, and, above all, the streams and mountains of his native Wales. His Welsh views are the cream of his work and he saw the country with a mind rich in memories of the Roman Campagna. His eye sought those aspects of the country which fell into the classic mould, and he composed landscape true to the tones of Wales but invested with the authority of the classical tradition. Sometimes we may wonder whether the river is the Arno or the Dee and, in a picture like 'A Road by a River' [186] at Gosford House, the air of Italy is so strong and the effect of the design (which unexpectedly echoes Canaletto) so powerful, that we have to look hard to distinguish the British figures and hollyhocks and the British trees. Such pictures are not imitations of Claude or the Old Masters, but the application of one of the great traditions of landscape painting, in a quite personal way,

to the native scene. In what is perhaps the finest of all his designs, the 'Snowdon' (of which there are admirable examples both at Liverpool [187] and Nottingham), he produced the most classical of all British landscapes under the stress of the same deep feeling for mountain scenery as inspired so much of the finer portion of Wordsworth's poetry. Its deep sincerity shines out most fully if it is compared with Turner's brilliant imitations of this kind of Wilson, which always keep something of a borrowed sentiment about them.

In another field Wilson continued the line which had been marked out by George Lambert and brought the 'country house portrait' to its finest perfection. It may be that the singular view of 'Old Chatsworth House' (Duke of Devonshire), as it was at the close of the seventeenth century and based on a drawing by

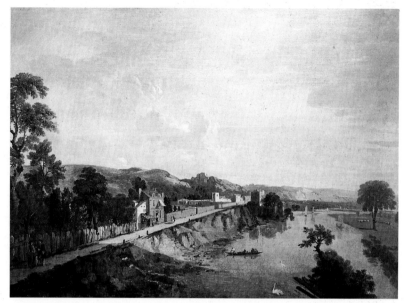

186. Richard Wilson: A Road by a River. *Earl of Wemyss and March, Gosford House, East Lothian*

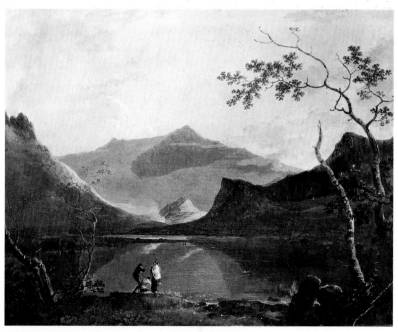

187. Richard Wilson: Snowdon. *Liverpool, Walker Art Gallery*

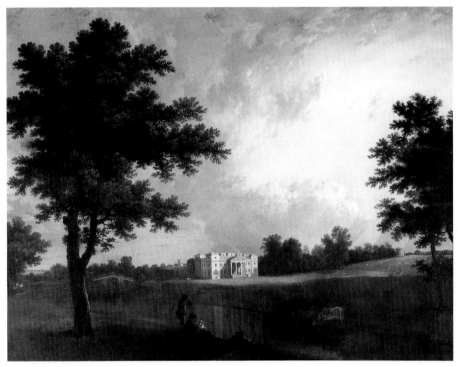

188. Richard Wilson: View of Croome Court,
1758/9. *Birmingham, City Art Gallery
(lent by the Earl of Coventry)*

Siberechts, was painted before his Italian jour-
ney. The 'View of Croome Court' (lent by the
Earl of Coventry to the Birmingham Gallery)
[188] was painted for fifty guineas in 1758/9 to
hang in the house depicted, as a companion, by
a certain irony, to a 'Rape of Europa' by Zuc-
carelli. The Italianate mansion is shown in a
classical design which combines faithfulness to
the character of English park scenery with a
certain poetic licence in the topographical treat-
ment. Other views of this kind followed. The
'Moor Park' 1765 series (Marquess of Zetland)
is only a fine continuation of the tradition of
Lambert; but the five 'Views of Wilton', of un-
certain date but probably fairly early, are of the
highest originality. Picturesque views are taken
of the house and park from all points: one is
painted in emulation of a 'blue' Claude, another

of a 'pink' Claude; the compositions of Dutch
painters such as de Koninck are used as models,
and bold experiments in light, such as the 'South
View of Wilton from Temple Copse' [189],
combine a close study of local atmospheric
effects with the attempt at rivalling Ruisdael in
a *coup de soleil*. The whole series is a succession
of poems in the picturesque style unrivalled in
the painting or poetry of the age, and has never
been surpassed. In his romantic prospect of
'Houghton House' (Royal Academy 1771:
Woburn), Wilson is obviously emulating Ruis-
dael's views of the 'Castle of Bentheim'; and in
'Muswell Hill with Minchenden House' (Royal
Academy 1775: Stoneleigh Abbey) Philips de
Koninck is again the model. Occasionally
Turner, in his 'Somer Hill' (Edinburgh), or
Constable continued this tradition of portraits

of country houses, but Wilson explored the whole range of this specially British field and established the models which his successors

England he soon specialized in the painting of landscapes faithfully representing a particular spot or picturesque view, usually within the

189. Richard Wilson: South View
of Wilton from Temple Copse.
Earl of Pembroke and Montgomery, Wilton, Wilts

have been more or less bound to follow. Since W. G. Constable's exhaustive book on Wilson was published, it has been possible to appreciate Wilson as one of the major masters in the history of the British school.[9]

Rivals and Followers of Wilson

Worldly success, which passed Wilson by, was for a time liberally accorded to his younger contemporary George Barret (1732?-84), an Irishman whose landscapes were uncharitably (but not altogether unperceptively) described by Wilson as 'spinach and eggs'. Barret formed his landscape style in Ireland, in the park at Powerscourt and amid the mildly Salvatorial scenery of the Dargle, and settled in London in 1762. In

private demesne of a noble patron. He was a foundation member of the Royal Academy; and at the first Academy exhibition, whereas Wilson's pictures, as works of imagination, are simply entitled 'a landskip', Barret's scenes are particularized to the nearest milestone. Barret had a sound sense of what was picturesque in a commonplace way, he was troubled neither with the knowledge nor the love of classic landscape, and he provided what his noble patrons wanted. The dukes of Portland and Buccleuch were his most notable patrons, and his best work remains in their collections today. In later life he tried to imitate something of Wilson's classical manner, but his design lacks Wilson's authority, his tone Wilson's sureness, and his trees Wilson's sense of organic growth. His work is chiefly interesting today as serving, by

comparison with its prose, to set off the poetic quality of Wilson's vision.

Next in age after Barret was William Marlow (1740-1813), who had been a pupil of Samuel Scott from 1754 to 1759, but is also listed by Wright among Wilson's pupils. His use of paint, in his best works, comes very close to Wilson, and the pattern of his career also resembles that of Wilson, except that, at the end of his life, Marlow never lacked money. From 1762 to 1765 Marlow travelled England and Wales as a wandering landscape painter, but the patronage of the Duchess of Northumberland enabled him to travel in France and Italy from 1765 to 1768. From the studies made on these journeys he produced French and Italian views for the rest of his life, repeating, like Wilson, favourite patterns. His prevailing tone is silvery and he experimented also in coast scenes in the style of Vernet, in admirable views (more literal than Wilson's) of country houses, such as the four of 1772 at Castle Howard, and even in such freaks of fancy as what Canaletto had called *capricci*. The Tate Gallery has a picture of St Paul's in

190. William Marlow:
A Capriccio, St Paul's and a Venetian Canal.
London, Tate Gallery

which a Venetian canal has taken the place of Ludgate Hill [190], and in which the styles of Scott and Wilson meet. The topographer and the painter of picturesque landscape meet on the same canvas, as if to explain the fusion of the two styles which was taking place in the middle of the eighteenth century. By 1785 Marlow had retired professionally and only continued to paint a few landscapes for his own amusement.

Of the painters whose style was wholly formed by Wilson, only Thomas Jones (1742-1803) and William Hodges (1744-97) deserve attention, for Joseph Farington (1747-1821), although later a personality of high importance in the art world, was of little account as a painter. Thomas Jones, like Wilson a Welshman of good family, was at first educated for the Church: but he became a pupil of Wilson in 1762, first exhibited independently in 1765, and spent the years 1776 to 1782/3 in Italy, mainly at Rome and Naples. He painted some ambitious 'histories' in the style Wilson was practising in the 1760s (the most famous is at Leningrad), and, while in Italy, painted a few Italian views saturated with memories of Wilson, but lacking his sureness of tone and betraying rather a botanist's interest in foreground plants. The studies he made in Italy, especially in Naples, directly from nature, rival those of Valenciennes in anticipating the work of the young Corot.[10]

William Hodges (1744-97) was probably the most accomplished painter of fake Wilsons. He studied with Wilson *c*. 1763/5, and his style in 1772[11] was so close to his master's that rather more than the evidence of the eye is needed to distinguish between the two. But he did not meet with much success in London and, in 1772, joined Captain Cook's second voyage to the South Pacific as official landscape painter. He was employed on this journey from 1772 to 1775, and he later visited India from 1780 to 1784.[12] Something 'strange' in nature or architecture was needed to bring out Hodges's best qualities and he succeeded to a considerable extent 'in combining the documentary with the picturesque without sacrificing the requirements of either'.[13] A number of his views in the South Pacific were done for the Admiralty (he

191. William Hodges: Tahiti.
Greenwich, National Maritime Museum

repeated them also for commercial purposes) and are now at Greenwich and the 'Tahiti' [191] is a characteristic example. Wilson's rules of picture making and technique are both apparent, but Hodges skilfully adapted them to exotic material, to which he gave an air of documentary fidelity. He became a Royal Academician in 1787 and travelled in Europe, but his original contribution to landscape is limited to his handling of his Pacific and Indian sketches with few exceptions. He abandoned painting for banking in 1795 but died two years later.

THOMAS GAINSBOROUGH

Gainsborough is the most difficult to assess fairly of all the major painters who make up the first great age of the native British school. His genius was lyrical: it developed altogether independently of the Mediterranean tradition, which cast a dominating shadow over the work of his chief contemporaries; his mind was wholly without the strong intellectual bias of Reynolds's, and sought its recreation with music and musicians and not in literature and the society of *hommes de lettres*. Yet he seemed, even to Reynolds, an artist of sufficient stature to become, after his death, the central theme of one of the *Discourses* (the Fourteenth) which he delivered at the Royal Academy prize-giving – an honour he accorded to no one else. For Reynolds his rival, because he never attempted 'history', was a 'genius in a lower rank of art'; yet he observes that 'if ever this nation should produce genius sufficient to acquire to us the honourable distinction of an English School, the name of Gainsborough will be transmitted to posterity, in the history of the art, among the very first of that rising name'. What he is captivated with in Gainsborough's art is 'the powerful impression of nature, which he exhibited in his portraits and in his landscapes, and the interesting simplicity and elegance of his little ordinary beggar children'. Reynolds's detailed comments are still the most judicious account of Gainsborough's virtues, in spite of, and because of, the fact that they were to some extent wrung from his reluctant admiration by a style and an approach to painting which were the reverse of his own. To Reynolds Gainsborough seemed something of what we should today call an 'impressionist', allowing too much to be filled in by the spectator: yet he praises 'his manner of forming all the parts of a picture together', and the great protagonist of the study of the Antique and of the Italian masters praises Gainsborough because 'he very judiciously ap-plied himself to the Flemish school' and because 'his grace was not academical or antique, but selected by himself from the great school of nature'.

Nor can we do better than begin an attempt at appraising Gainsborough's work by asserting with Reynolds that he possessed the 'quality of lightness of manner and effect . . . to an unexampled degree of excellence' and that 'whether he most excelled in portraits, landscapes, or fancy pictures, it is difficult to determine'. The great mass of his surviving work is in portraiture, yet he several times complains in letters that he painted portraits only for a living and that his heart was in landscape – and today he is mainly thought of as the only serious rival to Reynolds in portraits. An intelligent contemporary, who had been admirably painted by both Reynolds and Gainsborough, writes in 1787 to her husband that she cannot bear anyone having a Sir Joshua of him but herself, but that she thinks 'a daub by Gainsborough' would do well enough for his college.[1] By a 'daub' she meant only a sketchy, 'impressionist' likeness, and not what we would mean today. She realized that the full man would emerge only from the more intellectual and psychological approach of Reynolds, and it is true that Gainsborough is at his best with sitters who have almost no positive character and can be treated as arabesques with that lightness of manner and effect which made Lady Spencer call them 'daubs', and which causes them to become today, if they have been badly cleaned, little but expensive smudges. His landscapes present the same relation to reality and are animated by the same pervasive rhythm. For them we have Gainsborough's own words in a letter to Lord Hardwicke[2] that 'if his Lordship wishes to have anything tolerable of the name of Gainsborough, the subject altogether, as well as figures &c., must be of his own brain'. Curiously enough, it is in his 'fancy pictures' that he came

closest to the direct imitation of nature, for he selected his 'little ordinary beggar children' (as Reynolds incorrectly called them, for they were far from 'ordinary') from a model or models which came close to his own ideal of the beauty of innocence in children. In all three genres his prevailing interest as a painter was the same – in the beauty of fleeting effects of shadow and texture. This led him not only to do much of his painting by candlelight, but also to dislike increasingly for his finished pictures the glare of public exhibitions, so that he finally withdrew altogether from showing his pictures at the Royal Academy. Gainsborough is thus a painter apart from the main stream of British painting during the first hundred years of the Academy's life – perhaps up to the time of Rossetti – in that he never submitted to the tyranny of the 'exhibition picture'. In the same way he never submitted (or did submit so rarely as makes no matter) to the co-operation of the drapery painter. In all his works he was something of a lyrical individualist and it is this quality which makes him so hard to judge fairly in an age of reason.

Reynolds and Wilson made their great contributions to the British school on the side of 'sense'; Gainsborough's was all on the side of 'sensibility'. Gainsborough's first direct heir in British painting was Constable. On looking at Gainsborough's landscapes, says Constable, 'we find tears in our eyes, and know not what brings them', so that it will be seen that a history of British painting which closes with the dawn of the romantic age must treat Gainsborough as something of an isolated phenomenon. It would be convenient if, following the remarks of Reynolds and of most contemporary commentators, we could see in Gainsborough an artist who really sought his inspiration direct from nature, and specifically from the English scene. But, unfortunately, the better we know Gainsborough, the further this view seems to be from the truth. We have his own word for it that he held no very high opinion of the beauties of English landscape in the raw, and that his pictures had to be the creations of his own brain; and we even know that, over a number of years,

he painted landscapes from little models made up of moss and pebbles, which he had arranged in his studio. Yet, if we compare them with the landscapes of painters from any other country, there remains something incomparably English about them, a perception of light and a feeling of English woodland growth. There can be no doubt that he loved to draw the rural scene direct, but the result was always transmuted into lyrical terms.

In the Victoria and Albert Museum is a drawing wrongly ascribed to Fuseli of Gainsborough sketching in the country, which is not without satirical overtones. It shows a gay, almost raffish, person reclining at ease, rather than settled with the high-minded earnestness of purpose of a pure artist communing with nature. He is drawing the landscape but his eye is at least as busily directed at a promising female form which diversifies the scene. I cannot help feeling that we shall come much nearer to understanding Gainsborough's work if we approach it after this first revealing glimpse of the man, than if, as was proper for Reynolds, we come to him with a letter of introduction from Dr Johnson. Gainsborough's art is gay, nervous, and full of 'enthusiasm': he was endowed with a heaven-sent sensibility to linear rhythms, and he loved the use of line in drawing and that effect in painting which he called 'the touch of the pencil'. Where Reynolds's figures are all fee-fi-fo-fum, standing solidly planted in English parks, Gainsborough's are sometimes almost wraiths, exhalations of the autumn foliage. Reynolds concentrates on mass and solid textures: Gainsborough loves everything which is flickering and evanescent, the play of shadow on a silk dress in movement, and his most astounding prodigies of painting can only be enjoyed today when, as in the 'Queen Charlotte' at Windsor, the old concealing, discoloured varnish has been removed and the texture of the painting below has remained unharmed.

In character he was blithe, optimistic, *enjoué*: everything that Reynolds was not. His letters are delightfully incautious and one of his daughters admitted to Farington that he would sometimes give way to conviviality to such an extent

that he was unable to paint for a day or two. He was very good company and had no fine manners, and Mr Whitley, whose biography, in the matter of documentation, is one of the best things ever written on an English painter, seems to me to have falsified Gainsborough's character (and our understanding of his art) by trying to make him out to be much more of a model of the domestic virtues than he was. But, with all his 'Bohemian' leanings, he too, like Reynolds, must have been a prodigious worker. We have at present record of more than seven hundred portraits[3] (about 125 of them full-lengths), pretty well all painted, as all Reynolds's were not, with his own hand; perhaps two or three hundred landscapes of various sizes, a few fancy pieces, and an enormous quantity of landscape drawings.

Thomas Gainsborough was the son of a once prosperous cloth-merchant of Sudbury, Suffolk. He was the youngest of five sons (and there were also four daughters) and was born in 1727. He showed a decided leaning towards painting at an early age (conflicting evidence says towards landscape or portraiture) and was sent to London, with a view to becoming an artist, about 1740. The evidence about his training is obscure and conflicting, but a hypothetical account of his life between 1740 and about 1753, when he was settled in Ipswich, might be something like the following: these years were spent mainly in London, with periodic visits to Suffolk; the last few years mainly in Sudbury. He had no academic training, but two influences predominated: the influence of Gravelot, with whom he worked in London as an assistant in his engravings (before 1745), and the influence of Dutch seventeenth-century painters (notably Ruisdael and Wynants), whom he copied whenever he could and whose works he restored for dealers in London. This combined French and Dutch influence orientated him away from the prevailing Mediterranean tradition, but the French and the Dutch styles pulled in opposing directions. Gravelot's influence made for daintiness in the figure and for an emphasis on the city-dweller's conception of the pastoral idea in the tradition of Boucher and the lesser Frenchmen

of the time: the Dutchmen brought him back to nature, but with the presupposition that nature needed 'composing'. To these influences must be added the fact that Gainsborough himself was clearly most sensitive to the specific beauties of the Suffolk scene, to the play of light on the trees, to the movements of clouds, and to the details of leafy growth. At the very end of this period, perhaps on a short visit to London in the early 1750s, Gainsborough seems to have come into direct contact with Hayman and to have been influenced by his figure style.

The certainly datable pictorial and other evidence for these years is rather meagre, but it is enough for our purpose. In 1745, no doubt on a visit to Suffolk, he painted a portrait of a dog named Bumper (more or less a bull-terrier, but described on the back of the canvas as 'a most remarkable sagacious Cur') which now belongs to Sir Edmund Bacon. In this Gainsborough's neat and natural touch and sense of the tone of tree and cloud in Suffolk landscape is already perfectly developed. In July 1746 he married in London (at Dr Keith's Chapel, which secured only legality and not parental consent) a girl named Margaret Burr, who added to personal charm (which declined as she grew older) the substantial advantage of having an annual allowance of £200, which was paid to her as being a natural daughter of a Duke of Beaufort. In 1748, certainly in London, he painted the view of 'The Charterhouse' [192], which he presented that year to the Foundling Hospital, as one of the series of views of London hospitals contributed by Richard Wilson, Wale, and Haytley. Among its companions, which have all a topographical intention, it was a revolutionary work. Its companions all show the general plan and aspect of the building, but this is purely a picturesque landscape, with the emphasis on the play of light and shade, with the clouds as important as the buildings, and with the main emphasis on two children playing on the flagstones in a patch of sunlight. It is the loveliest and the most natural English landscape that had been painted up to date, the work of a youth of twenty-one. If the taste of the time had encouraged Gainsborough to continue on these lines, which were

192. Thomas Gainsborough: The Charterhouse, 1748.
London, Thomas Coram Foundation

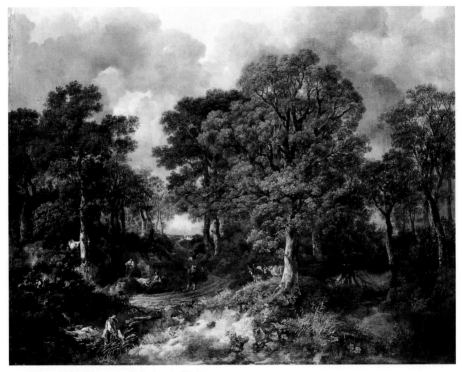

193. Thomas Gainsborough: Gainsborough's Forest, 1748. *London, National Gallery*

clearly natural to his genius, we may fairly suppose that he would have anticipated Constable. But it was not to be.

At the close of 1748, at Sudbury, where he had gone to help wind up his father's estate, he seems to have finished (perhaps, in its present form, to have painted entirely) the picture known as 'Gainsborough's Forest' [193] in the National Gallery. We have his own authority for its date, and it is an epitome of his early, artificial, landscape style, what he calls, in a letter written at the end of his life,[4] his 'imitations of little Dutch landscapes'. All the component details are Suffolk, and the light and tone are the very breath of a native English landscape, yet the composition is intensely artificial, a blend of Ruisdael and Wynants, with the eye carried far into the distance, down a break in the trees, by a winding sandy lane, with a horseman or a

pedestrian to articulate each bend, to a distant church spire on the horizon. The foreground weeds, the donkeys, the flying duck, all the r sources of composition he had learned from the then still unfashionable Dutch naturalist painters, are combined in this almost classic work, and it is not surprising that, when Boydell bought it in 1788, at the end of Gainsborough's life, and had it engraved, it should have been regarded as something of a phenomenon – for its Dutch prototypes were then beginning to come again into fashion. Gainsborough never again in his Suffolk period, which lasted until 1759, put all his learning into one composition, for there is matter in this for half a dozen of his normal little Suffolk landscapes. But it serves perhaps better than any other picture to epitomize his first landscape style, and it shows very clearly the subordinate part which the direct representa-

tion of nature played even in his earliest landscapes.

Not long after this, probably not later than 1749, Gainsborough painted one of the first, and certainly the loveliest, of his portrait groups, 'Mr and Mrs Andrews' [194]. In this, for the with the artificial backdrop. The 'Heneage Lloyd and his Sister' at Cambridge can be only very little later than 'Mr and Mrs Andrews', and yet much of the freshness and lack of sophistication of the earlier picture has evaporated. Even in the matter of the lighting there is no

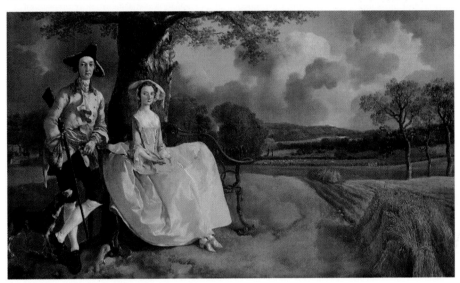

194. Thomas Gainsborough: Mr and Mrs Andrews,
c. 1749. London, National Gallery

first time, the old tradition of the 'conversation piece' becomes transmuted in the hands of an artist for whom the portrait and the landscape are both of equal interest. There is a dewy freshness about this picture, a friendly naturalness of vision of an artist as yet untainted by any preoccupation with fashionable taste, which makes it one of the eccentric masterpieces of English painting. In a sense it is at once the promise and fulfilment of all that Gainsborough might have been. For another fifteen years he tried fitfully, in a series of experiments in compromise, to paint the English country gentleman at ease in the native English landscape, but it found no favour with his clients and he had at last to fall back on the kind of landscape setting as artificial as the Victorian photographer's backdrop.

It may well be that we must credit (or blame) Gainsborough himself for first experimenting common bond between the figures and the landscape, and the suggestion that the whim was Gainsborough's own and not his patron's becomes probable when we find him exploiting the two modes in portraits of the same family. The 'Unknown Lady and Gentleman' at Dulwich, resting by a stile in a lovely and natural Suffolk landscape, are companions to the 'Unknown Girl' in the Paul Mellon collection,[5] who sits against the pompous backdrop of an Italianate villa. By the middle 1750s he had probably given up altogether portraiture on this neat and exquisite scale and turned to the more lucrative practice of portraits on the scale of life.

It is generally believed that Gainsborough settled at Ipswich about 1752, and the date is probably correct to within a year: but it may well be that he was not so much a stranger to London at this time as is usually inferred. The

next certainly dated landscapes are the two of 1755 at Woburn,[6] which enable us to place in the early 1750s the group of landscapes with Suffolk scenes with a prevailing hot red-brown tone in the foreground, pinky-grey skies, and an abundance of swinging curves, which are the nearest an English painter ever got to the rococo style. The Woburn pictures, which were painted as overmantels, and are thus to be considered as 'furniture pieces' rather than as serious landscapes, show an altogether different intention from the earlier 'little Dutch landscapes'. It is probable that the inspiration behind their new style is French, and that one of the main channels of that style was Gainsborough's remembrance of his time working for Gravelot. One of them is a rustic idyll: a milkmaid is resting her pails under a tree and is coyly half-refusing to give a bowl of milk to a boy who has been chopping wood [195]. The figures are a lovely echo in paint of Gravelot's engravings, and the cow is richly and thickly executed in a manner (unparalleled elsewhere in Gainsborough) which almost suggests that he had seen a Fragonard.

In the other Woburn picture there is a group of figures loading a haycart in the background as naturally observed and as musical in rhythm as a passage from Watteau, heralding the spirit of his best landscapes of the Bath period.

But commissions for such works were rare and his living was mainly made from portraiture on the scale of life during his Ipswich years. We can discern how relatively ill at ease he still was in this genre by comparing the commissioned portraits with a number of portraits of himself and of his own family which he painted for pleasure during these years. Secure dates are very scarce. The formal and gauche 'Admiral Vernon' (National Portrait Gallery) can be dated about 1754: in 1756 he dated a portrait of one of the officers of the First Dragoon Guards,[7] who seem to have been stationed near Ipswich, for there is a companion portrait of a fellow officer, 'The Hon. Charles Hamilton' (Tyninghame). This is beautifully drawn in the face, but the costume is still relatively hard and awkward. Gainsborough has set his head and shoulders in a feigned oval, which is based in

195. Thomas Gainsborough:
Milkmaid and Woodcutter (detail), 1755.
Woburn Abbey, Beds

196. Thomas Gainsborough:
William Wollaston, *c.* 1759.
Ipswich, Christchurch Mansion

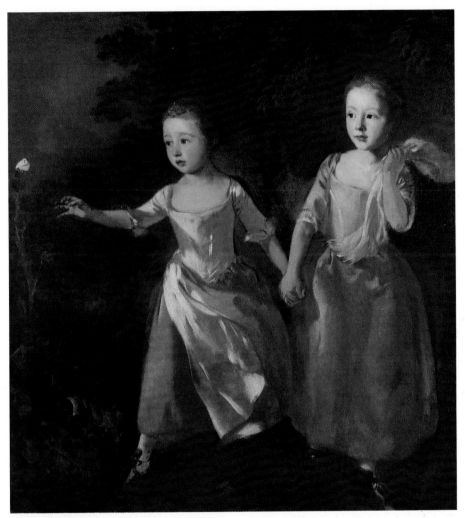

197. Thomas Gainsborough: Gainsborough's Daughters chasing a Butterfly, c. 1755/6.
London, National Gallery

design on the heavy fruited stone ovals of Mary
Beale, but he has treated it with such fluency of
paint and lightness of feeling that it gives the
effect of a rococo setting. Here again we can dis-
cern the spirit of Gravelot and are reminded of
the report that Gainsborough helped in engrav-
ing the decorations for the series of Houbraken's
Heads. As an example of the latest and maturest
phase of Gainsborough's Ipswich portraiture

we can take the 'William Wollaston' (Christ-
church Mansion, Ipswich) [196], who can prob-
ably be dated about 1759 since the sitter was
M.P. for Ipswich. His fondness for music ob-
viously made him a sympathetic sitter and the
result, though it shows, almost for the first time,
Gainsborough's mature style as a fashionable
portrait artist, has an informality that few Mem-
bers of Parliament would have appreciated.

But his potential capacity as a portraitist only comes out in these years when there is no question of pleasing a patron. The lovely unfinished bust of himself belonging to the Marchioness of Cholmondeley is dated by good tradition about 1754, and the likeness in handling to the Woburn milkmaid gives a date of about 1755/6 for the picture of 'Gainsborough's Daughters chasing a Butterfly' (National Gallery) [197]. This is one of the most enchanting, most original, most native, and most natural things in English painting. It is unfinished, as all Gainsborough's private masterpieces tended to be – like the picture of the same two girls with a cat, of about two years later, also in the National Gallery; and perhaps we must put it into the same class as Hogarth's 'Servants', of pictures outside the direct line of their artist's development, which show what they might have been had they not been for ever involved in the economic system of their times. It is only in lyrical outbursts like these that we see Gainsborough's full gifts, which makes him so difficult to judge against Reynolds, whose full powers were displayed in the business of exploiting a splendid sitter.

Gainsborough disposed of his house and furniture at Ipswich in October 1759 and moved to Bath, where he was established until he finally settled in London in the summer of 1774. Even during these years he paid periodical visits to London, but his main clientele was drawn from the fashionable visitors to Bath. It is clear that he was an instant success – he had, on his going, no one better than William Hoare to compete with, and the number of his portraits which date from about 1760 to 1764 is perhaps greater than the number for any other period. It includes also more thoroughly dull portraits than any other period, and it is perhaps worth noting that Reynolds in London was also busiest during just these years and also produced more pedestrian work than at any other time.

In the large world of fashion Gainsborough was very little known when he settled in Bath. By 1768, when the Royal Academy was formed in London, he was without hesitation asked to become a foundation member and he was the only portraitist so honoured who was not established in the metropolis. His first nine years at Bath were thus the period during which he gained this eminent position and the really formative years for his mature style.

He set about to remodel himself on the example of Van Dyck, whose work he had had little chance to see before he moved to Bath. For he realized that the English aristocratic idea of elegance was modelled on notions imbibed from portraits by Van Dyck. That he visited Wilton we know, and he made a small copy from memory (aided by the engraving) from Van Dyck's great family piece. Others of his large direct copies, such as the 'Lords John and Bernard Stuart' (St Louis, Mo.), are imitations of rarely exampled sympathy. The newly formed Society of Artists in London opened its first exhibition in London in 1760, but Gainsborough, who perhaps had nothing ready as yet of sufficiently ambitious scope, sent no picture to it until the exhibition of 1761. We can follow his exhibits yearly from then on until the first show of the Royal Academy in 1769, when he transferred his allegiance to the new institution. The

198. Thomas Gainsborough: Sir William St Quintin, 1760. *Sir Thomas Legard, Bt, Scampston Hall, Yorks*

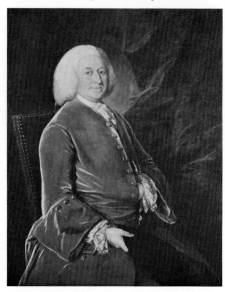

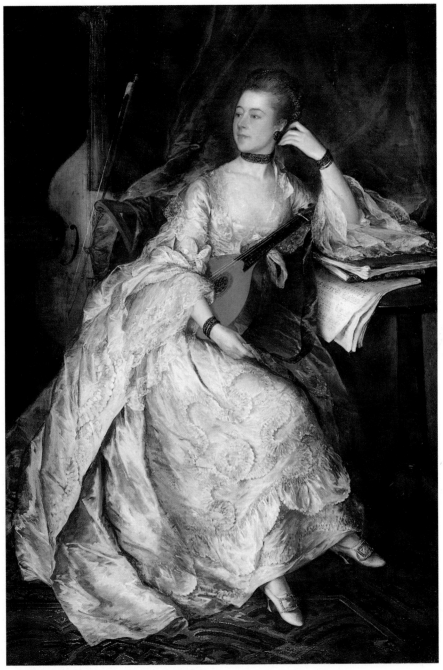

199. Thomas Gainsborough: Mrs Philip Thicknesse, 1760. *Cincinnati Art Museun.*

portraits that he sent were almost all his finest full-lengths and most can be identified today, and when we survey this series we cannot be surprised that through them and timely appearances in London, perhaps at least once a year, his reputation had spread by 1768 so that he was as well known there as in Bath.

Yet he did not adapt his natural leaning towards a certain easy informality into the more solemn style, which the patrons of the age demanded, altogether easily. His first Bath portraits of men are the direct continuation of the late Ipswich style of the 'William Wollaston'. The 'Earl Nugent' (Corporation of Bristol) can be dated securely to 1760 and it is so nearly identical with the 'Sir William St Quintin' [198] at Scampston Hall that the latter also must date from 1760. In this Gainsborough had the advantage of a sitter with whom he was on terms of considerable friendship and his sympathetic power of presenting character is at its best. The picture is in the tradition of Hogarth rather than of Reynolds, and the lesson of Van Dyck appears only in the curtain in the background. The overwhelming impact of Van Dyck appears, however, in the first of his ambitious female full-lengths, which we know to have been begun the same year (its execution dragged on for some years), the 'Miss Ford' (soon to become 'Mrs Thicknesse') now at Cincinnati [199]. This was seen at Gainsborough's house by Mrs Delany, on 23 October 1760, and her comment on it in her letter to Mrs D'Ewes reveals the kind of feeling which Gainsborough had to contend with in his patrons: 'a most extraordinary figure,' – she calls it – 'handsome and bold; but I should be very sorry to have anyone I loved set forth in such a manner.' It was from people whom his patrons loved that Gainsborough hoped to earn his living by painting. He had to tame his perceptiveness and not make his ladies look 'bold'. In the same way his gentlemen's portraits at first must have looked to his sitters altogether too easy and rural, too informal. The 'William Poyntz', with his dog and gun at Althorp, resting against a tree trunk, was sent to the Society of Artists in 1762, and in 1763 he sent 'Mr Medlycott' (Watlington Collection,

Bermuda), who is sitting at ease on a rustic stile. We are perhaps right in seeing in these a gallant attempt at popularizing a more or less informal type of full-length, in which Gainsborough would not have to contend with Reynolds on his own field. But commissions of this sort did not follow and Gainsborough settled down to a more solemn manner.

How well he succeeded can be seen from the 'Mrs William Henry Portman' (Viscount Portman) [200], which can be dated about 1767/8 from its close similarity of style with the securely datable 'Duchess of Montagu' at Bowhill. If we compare it with Reynolds's 'Lady Sarah Bunbury' [175], its contemporary within a year or two, we can discern very clearly the difference between these two pre-eminent masters of their time – although one should add in fairness that the Reynolds is not one of his happiest creations. In Gainsborough's picture the uniform beauty of the painting in face, hands and arms, dress, and even in the fragment of a Gainsborough landscape in the room behind, is what most strikes one. It is lovely painting throughout, in harmony with the tender interpretation of the character of the lady, who was a widow of sixty. It is essentially modest in spirit and makes no claims which it cannot substantiate. The Reynolds is essentially immodest: it goes all out for an impression of grandeur and skimps the details. At this moment of his career Gainsborough reached the finest balance of observed truth and imagination.

This golden period lasted for a few years only, from just before the founding of the Royal Academy in 1768 until a little after Gainsborough migrated from Bath to London. His most remarkable exhibit at the first Academy exhibition in 1769 was the 'Isabella, Lady Molyneux', later Countess of Sefton (Liverpool). It partakes of the same character as the 'Mrs Portman', and the figure, for all its lightness of painting in reflected silk, is solidly planted in the

200. Thomas Gainsborough:
Mrs William Henry Portman, c. 1767/8.
Viscount Portman

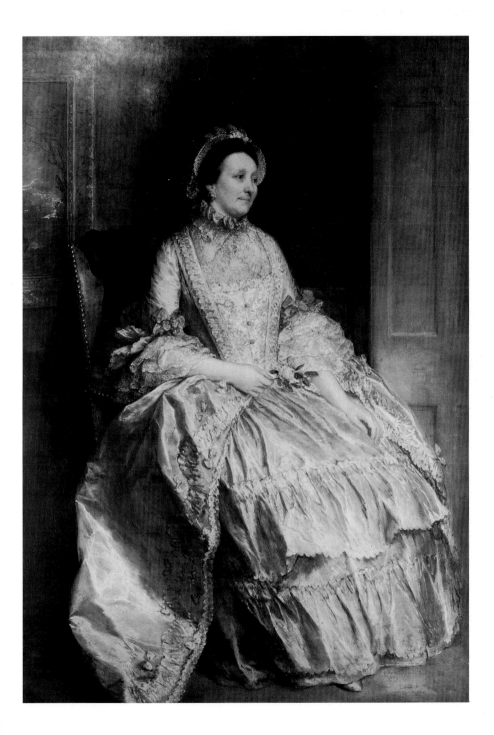

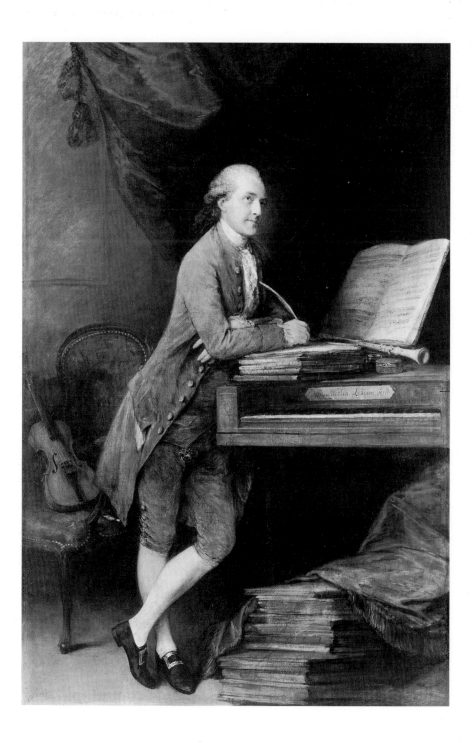

space and stands firmly upon her feet. When Gainsborough settled in London in 1774 he was at the height of his powers and he seems to have experienced no difficulty in finding a sufficient stream of sitters to keep him busy and bring in a substantial income. In fact he did not even exhibit at the Academy for the years 1773 to 1775. By 1780 he had gained the patronage of the Court (who were temperamentally averse to Reynolds) and he sent to the Academy in 1781 the full-lengths, now at Windsor, of 'George III' and 'Queen Charlotte', of which the latter is one of his most splendid pieces of painting. It is also among the latest of his really solid portraits.

For the portraits of Gainsborough's later London years, although they include what are some of his most famous and most expensive masterpieces, are strange, airy stuff. After a quarrel with the Academy in 1784 he never exhibited there again but held private exhibitions in his own house, where he could control the hanging and the lighting so that he had no need to give his pictures that weight and body which a portrait that must stand up to the rigours of an Academy exhibition requires. His genius became more and more feminine and fanciful, and the really memorable portraits of men of his London years are surprisingly few. The solid British male, in whose portraiture Reynolds excelled, was outside Gainsborough's sympathy. His best male portraits of these years are of a few dandies in the Prince of Wales's world; of foreign musicians, such as his friend Abel and his son-in-law, Fischer; and of young men in the flower of their almost feminine youth, such as the two 'Swinburne' portraits at Detroit, of 1785; or the 'Samuel Whitbread' of 1788 at Southill. The portrait of 'Johann Christian Fischer' [201], the hautboy-player (Royal Academy 1780), at Buckingham Palace is perhaps the finest of these as a work of art. Yet its virtues, the very emphasis on the sitter's sensibility, would put it beyond the pale as a portrait of an English gentleman of middle age (for Fischer was forty-seven when it was painted). The truth is that Gainsborough, in his latest years, was only supremely fitted to paint the portraits of lovely creatures who were all heart and sensibility. The finest of them are 'Mrs John Douglas' 1784 at Waddesdon [202]; 'The Morning Walk' 1785 (National Gallery, London) [203] – an incomparable picture of young love; 'Mrs Sheridan' 1785/6 at Washington; and 'Lady Bate-Dudley' 1787 (Lord Burton). These are celestial beings, devoid of the grosser qualities of human personality, almost the loveliest garden-statues come to life. They belong to a world as artificial and as tenderly melancholy as the creations of Watteau, but they are life-size. They hardly belong to the history of portraiture so much as to the world of the 'fancy pictures' which Gainsborough was painting in his last few years.

These fancy pictures (the name was given to them by Reynolds) may be said to have developed naturally out of the landscapes that Gainsborough was painting, at first more for his own pleasure than for profit, from the time he settled in Bath. Very few such landscapes seem to have found buyers before he moved to London, and there is no firmly established chronological series (as there is with his portraits) by which we can trace his development as a landscape painter. We may presume that a picture such as 'Carthorses drinking at a Ford' (Tate 310) dates from about 1762, since the trees and foliage recall the background to 'Mr Poyntz': and a 'Milkmaid and Farmer's Boy' at Scampston has an old date of 1766 on its label and was probably exhibited at the Society of Artists that year. Both of these pictures are concerned with the same pictorial matter as the Woburn landscapes of 1755. It is a countryside in which the details are drawn from nature, inhabited by ideal small figures of persons of the peasant class whose life is unclouded by the existence of the world of towns or fashions – a sort of faubourg of Arcadia. As Gainsborough's imagination matured, he got nearer to Arcadia itself. The landscape broadens, the horizons become vaster, beyond ranges of pearly hills, and the peasant inhabitants become more closely sum-

201. Thomas Gainsborough:
Johann Christian Fischer, 1780.
Royal Collection
(by gracious permission of Her Majesty the Queen)

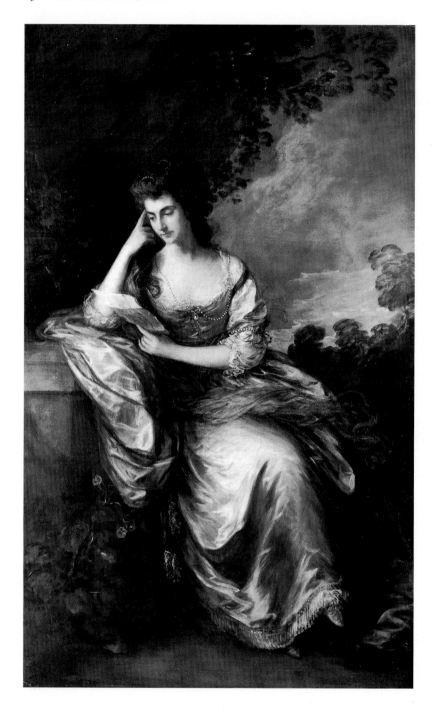

202 (*opposite*). Thomas Gainsborough: Mrs John Douglas, 1784. *National Trust, Waddesdon Manor, Bucks*

203. Thomas Gainsborough: The Morning Walk, 1785. *London, National Gallery*

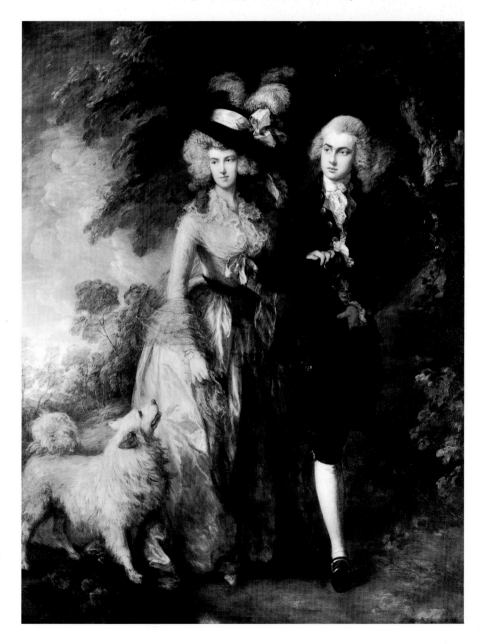

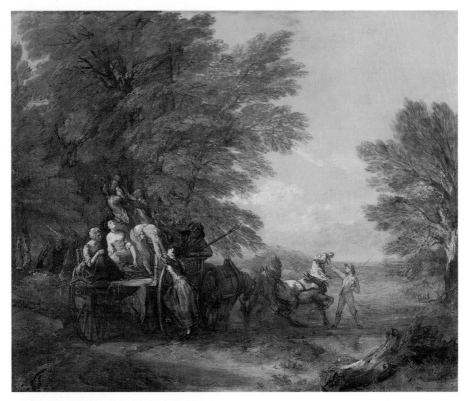

204. Thomas Gainsborough: The Harvest Wagon, *c.* 1767(?).
Birmingham University, Barber Institute of Fine Arts

marized and more ideally lovely. But they re-
main figures seen at a distance and do not take
on the stature of life-size creatures. The great
masterpieces of Gainsborough's early mature
landscape style, from the last years of his Bath
period, are 'The Harvest Wagon' (Barber In-
stitute, Birmingham University) [204], which
was perhaps exhibited in 1767, and 'Going to
Market: Early Morning' (Holloway College,
Egham), which was seen by Mrs Lybbe Powys
at Stourhead in 1776.

'The Harvest Wagon' can claim to be one of
the supreme masterpieces of British painting.
It has a musical rhythm, kept exquisitely under
control, both in the line and in the play of light
and shade, and the single figures, both of people

and horses, combine a genial naturalness with
a perfection of grace which makes the most
studied arrangement seem natural. The girls,
probably taken from the painter's own daugh-
ters, are lovely creatures, fit inhabitants of a
pastoral Arcadia. They are almost portraits, yet
the distance from which they are seen gives
them a certain generalized air which suggests
that we are not peering too closely at an ideal
world. Later, in his fancy pictures, Gains-
borough was to try and take its actual por-
traiture. In terms of style the picture is almost
Watteau recreated in an English landscape with
ideal rustic humanity substituted for the fine
ladies and fine gentlemen. If we compare it with
the picture of 'The Mall, St James's Park' (Frick

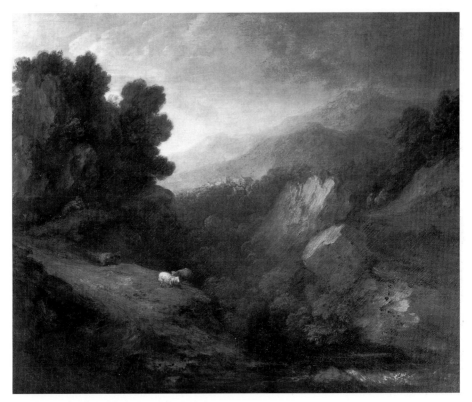

205. Thomas Gainsborough: Romantic Mountain Landscape, 1783.
Edinburgh, National Gallery of Scotland

Gallery, New York), which Gainsborough painted about 1783 as what one might call a 'society' equivalent, as a deliberate English Watteau, we can see how much was lost in the later transcription. Unpleasant as it still is for some of us to introduce the shade of Marx into the history of art, it may contribute to the understanding of Gainsborough to make plain that, unlike Reynolds, whose finest achievements owe a good deal to his sense of social values, Gainsborough's supreme quality lay in his awareness that the beauty of the English scene lay in the lyrical exploitation of the world which lay outside the canons of social distinctions.

After settling in London Gainsborough certainly found himself more remote from the kind of nature which he took pleasure in studying directly. He seems to have fallen back on the great number of landscape studies which he had made and, with these and the little compositional models he made of pebbles, weeds, etc., to have become more and more artificial in the construction of his landscapes. From the earlier London years, up to about 1780, he was perhaps preoccupied especially with the theme of 'The Cottage Door' (a townsman's nostalgic view of the country), of which the finest horizontal design is at Cincinnati and the finest upright design (possibly Royal Academy 1780) in the Huntington Foundation in California. There is a more artificial quality about these than in 'The Harvest Wagon'. Trees 'crowd into a shade'

more knowingly; and, in the Huntington picture, the young mother has such an air of Mrs Sheridan in disguise that one can understand the absurd title long given to an unfinished study in the national collection as 'Mrs Graham as a Housemaid'. The difference between Gainsborough and his slightly earlier French parallels is that, whereas the French pictures were quite clearly, say, 'Mlle Clairon en bergère', in Gainsborough's there remains a certain ambiguity, and the protagonist seems rather to be a peasant woman who recalls Mrs Sheridan. There is even early evidence that Arcadia was giving way to Bohemia (the native country of Gainsborough's musician friend, C. F. Abel), and Bohemia has more of a smack of the stage about it than Arcadia. In Mrs Piozzi's old age, in 1807,[8] she writes about a landscape in her possession: 'The subject cattle driven down to drink, & the first cow expresses something of surprize as if an otter lurked under the bank. It is a *naked* looking landscape – done to divert Abel the Musician by representing *his* Country Bohemia in no favourable light. . . .' One should beware of trusting too much to Mrs Piozzi's fancies, but her description puts us on the look-out for the curious overtones which lie in Gainsborough's London landscapes.

In 1781 Gainsborough experimented with sea pieces (one is in the Duke of Westminster's collection) and he followed them in 1783 with 'The Mouth of the Thames' at Melbourne, a picture which strangely anticipates Wilson Steer. But these pictures were not in the main current of Gainsborough's style and the next change of a decisive character occurred in 1783, the year of a visit to the Lake District. This may well have been a deliberate visit to the most Gaspardesque scenery in England, since Gainsborough had already exhibited in the Academy of 1783 (just before his visit to the Lakes) a 'Romantic Mountain Landscape' (Edinburgh) [205], wholly typical of the new style which his lakeland visit encouraged. It was clearly an attempt at playing to the taste of the collecting classes, who were still hypnotized by the wild sublimities of the landscape style of Salvator Rosa and Gaspard Poussin. The smiling glades and happy pastoral figures have gone: shepherds live a more uneasy life at the mercy of a more inhospitable nature, but the 'scenery' (for such it is) is the creation of Gainsborough's own fancy on the model of the sublimities of Salvator and Gaspard.

But Gainsborough's latest kind of picture, by which he set most store (for he charged the highest prices for it), was the 'fancy picture', to whose invention he seems to have been inspired by seeing a version of one of Murillo's paintings of the 'Child St John' in the later 1770s.[9] At the same time he discovered several models (notably children) who seemed to combine remarkable and unsophisticated beauty with the simplicity of common life. It was as if one of the figures in his Bath period landscapes had become real and could be treated on the scale of portraiture. His first experiment in this vein (which perished in a fire in 1810) was shown at the Academy of 1781. It was in the new spirit of the times, for a writer in the *Gentleman's Magazine* for 1780 (p. 76) writes, '. . . and you will find artists who know nothing of Greek or Latin, and can hardly talk English, paint a beggar-boy or gypsey-girl with all the propriety of Poussin or Rubens'. The 'aristocratic' critic did not like the new experiment, but the Academies of the 1780s were soon abounding in pictures of this genre, and Gainsborough's second attempt, 'A Girl with Pigs' (Royal Academy) [206] at Castle Howard, earned unstinted praise from Reynolds, who bought the picture himself. It was almost the first new kind of picture which had appeared at an exhibition since the Academy had started which Reynolds himself had not initiated, and we can estimate something of the stir it created from the fact that the provincial Beechey, meeting the London Fuseli at Houghton in August 1785, and asking what were the latest developments in art in London, was told that 'Gainsborough was painting pigs and blackguards.'[10] His popular fancy pictures were also used by Gainsborough to provide a new incentive to the sale of his landscapes, for the group of 'The Girl with Pigs' reappears, seen again at

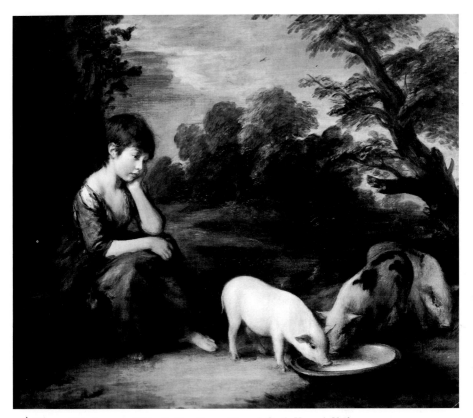

206. Thomas Gainsborough: Girl with Pigs. *George Howard, Castle Howard, Yorks*

the distance from which these ideal creatures had emerged for a moment into the foreground, in a landscape of 1786 which belongs to Mrs Scudamore. In his last years Gainsborough seems to have found a market for the kind of picture which he most liked to paint. Portrait and landscape and the pastoral idea were merging into a new synthesis which anticipates the *Lyrical Ballads*, and Gainsborough's latest fancy picture, 'The Woodman' (now preserved only in engraving), in which he had developed from unaffected childhood to a more mature theme from 'common life', is an almost perfect counterpart to Wordsworth's *Michael*. In this highly creative and original phase Gainsborough was struck down by illness and died in 1788.

Gainsborough Dupont (circa 1754-97)

Gainsborough was too individual a stylist to have founded a school even to the limited extent to which Reynolds did: but his nephew, Gainsborough Dupont, who perhaps played a larger part in his studio than has been generally admitted, carried on the tradition without his uncle's genius. He engraved his uncle's 'fancy pieces', and the small-scale 'engraver's copies' which exist of some of them (and usually pass as original Gainsboroughs) are probably by him. He completed the series of portraits of members of Whitbread's brewery (now at Southill) which Gainsborough had begun, and one would be hard put to it, without his signature, to say that

some of them are not by Gainsborough. He did not exhibit independently at the Royal Academy until 1790, and a tinge of the age of Lawrence begins to creep into his theatrical portraits about 1794.[11]

Traces of Gainsborough's style are also sometimes visible in Thomas Hickey (1741–1824), an Irish portraitist, who worked at Bath and London in 1771–8, but the bulk of whose rather inferior work was done in India after 1784.

OTHER FOUNDATION MEMBERS OF THE ROYAL ACADEMY

We are still to some extent in the dark over the intrigues which went on to decide which painters should, and which should not, become foundation members of the Royal Academy.[1] The exceptions were Ramsay, who had more or less given up private practice and, as King's painter, may have thought himself outside and above the Academy; Romney (who, almost alone, never showed at the Academy), whose reputation hardly begins before 1769; and the specialists in certain picture genres which ranked low in the hierarchy of the day, such as sporting painters. We can consider those who made the grade as Academicians in three groups: the portraitists, the decorators, and the history painters.

The Portraitists:
Cotes, Hone, Dance, and Mason Chamberlin

Francis Cotes[2] (1726–70) was the most important fashionable painter of portraits in the 1760s apart from Gainsborough and Reynolds. In the last six years of his life his business was perhaps as great as theirs and only his early death has caused his name to sink into relative oblivion. The place that he would have taken, in the eyes both of fashion and of the historian, was taken by Romney, and Romney did in fact in 1776 take over the lease of his handsome studio and residence in Cavendish Square.

Few painters are more easy to recognize than Cotes. He went all out for health and youth and fine clothes, a strong likeness and no nonsense. His complexions are usually of milk and roses, his men bear no burden of intellect and his ladies are neither bold nor pensive; his draperies (which were often executed by Peter Toms) look as if they had come out of a bandbox and are subjected to no delicate nuances of light and shade. He has a personal, sometimes almost

gaudy, palette which owes a good deal to his early training as a painter in crayons.

He studied crayons under Knapton during the years the latter was painting his portraits for the Dilettanti Society, and he achieved considerable mastery at drawing the face in that medium pretty young. There is a pastel of 1748 at Melbury which is decidedly accomplished. His earliest oil that I have seen dates from 1753 and is only a much more timid transcription into oil of his crayon manner. Up to about 1753 he leans neither very strongly to the old conservative style of portraiture nor to the new, but he made up his mind in the middle 1750s, threw over the patterns of Knapton, and, presumably under the influence of Reynolds's success, came out as a leading exponent in the new lively style. The pastel of 'Sir Richard Hoare' [207] at Stourhead, of 1757, shows him completely at ease in

207. Francis Cotes: Sir Richard Hoare, 1757. Pastel. *National Trust, Stourhead, Wilts*

the new manner. It is even a little more vivacious than most Reynoldses of this date and considerably in advance of Gainsborough's contemporary commissioned portraits. One may have to give Cotes some of the credit for being a leader in the new style, but his spirit in general was not that of the innovator.

Up to the end of the 1750s pastels predominate very strongly in his work and he never altogether gave up their practice, but, when he settled in Cavendish Square in 1763, his main output was in oils, and his prices, twenty, forty, and eighty guineas, were between those of Reynolds and Gainsborough. He was in full fashionable practice by 1764 and, in 1767, he did full-lengths of the Queen, of a pair of the Princesses, and, among others, of the Duchess of Hamilton and Argyll (Inveraray). This last, in which the sunflower is wilting before the bright radiance of the sitter's beauty, is Cotes's solitary flight into fancy. A wholly typical work is the 'Unknown Lady' [208] of 1768 (once called 'Kitty Fisher') in the Tate Gallery. The carefully instantaneous pose – as in the work of fashionable

photographers of a later age – the suspicion of a large baroque pot, the luxuriance of accessory foliage and draperies, and the sharp accent of vivacity explain Cotes's popularity – and also why we need linger very little over his work. He is not known to have attempted anything beyond straightforward portraits.

Nathaniel Hone (1718–84)

Hone, an Irishman, was the oldest of the generation who survived in good practice as a portrait painter into the 1780s. He seems to have started as a miniature painter, especially on enamel, and the high polish of that medium never altogether deserted him, though he gave it up in the 1760s. He must have learned his art under a painter of the generation of Dahl or Richardson, for a portrait of 1741, in the days when he is said to have practised as an itinerant painter, looks like a Richardson with a polished surface.[3] But it already has Hone's main characteristics, a certain look of smugness and a bright gleam in the

208. Francis Cotes: Unknown Lady, 1768.
London, Tate Gallery

209. Nathaniel Hone: Kitty Fisher, 1765.
London, National Portrait Gallery

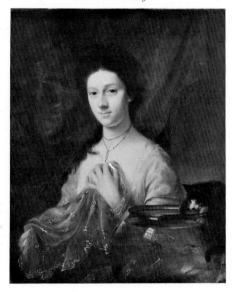

eye. In York in 1742 he married a lady with an allowance as the natural daughter of a Duke (as Gainsborough did later). This enabled him to settle in London, study in Italy from 1750 to 1752, and gradually give up miniature painting for the more lucrative trade of oils on the scale of life. Very few of these have been traced from before 1763, and by that date his style was settled and remains unchanged up to his death. The 'Kitty Fisher' [209] of 1765 in the National Portrait Gallery is a typical specimen, more attractive than the average. It has his invariable bright gleam in the eye and a self-conscious look of posing for the painter. Hone was a vain man and his numerous 'Selfportraits' (National Portrait Gallery; Royal Academy Diploma Gallery; Dublin; Manchester, etc.) show his limited range at its fullest. He painted a few fancy subjects, with his children as models, of which 'The Piping Boy' (Royal Academy 1769) in the Dublin Gallery is a pretty example and an early attempt at the genre. But although he showed several such at the Academy, they were all in his possession in 1775, when he held a private exhibition as the result of a disagreement with that body over a picture called 'The Conjurer'.[4] This was a very interesting skit on the President's practice of cribbing from the Old Masters and shows considerable powers of satirical invention. It is also interesting as marking the moment of a change of taste, for it is one of the first criticisms of the habit of exploiting the traditional arrangements of the classical masters, and foreshadows the new ideology of the romantic age, and the revaluation of 'originality'. But Hone himself had little new in his genius.

Nathaniel Dance (1735–1811)

One of the youngest of the foundation Academicians, Dance[5] never became more than a man of promise, for he retired from practice in 1776, on inheriting a fortune. In 1783 he married a wealthy widow and he resigned altogether from the Academy in 1790, when he became a Member of Parliament. His career was crowned in 1800 when he was created a baronet as Sir

Nathaniel Dance-Holland. Even so, he cuts a moderately substantial figure as an artist.

He was a pupil of Hayman (1753–4) – just when Hayman was at his best in small-scale 'conversations' that recall Gainsborough – and Dance is said to have encountered Gainsborough during these years. But his style was mainly formed in Rome, where he spent the twelve years 1754 to 1765, in company with his brother George, the architect, and where he latterly nursed a hopeless infatuation for Angelica Kauffmann. The chief influence on him in Rome was Batoni, who gave a certain 'tone' to the informal conversation style he had acquired from Hayman, and his most pleasing pictures are certain groups of young travelling Englishmen, which can quite simply be defined as Hayman made elegant in the spirit of Batoni. Perhaps the best is 'Hugh, Duke of Northumberland, and his Tutor Mr Lippyatt' (Syon House) [210], signed and dated 1763 and ex-

210. Nathaniel Dance: Hugh, Duke of Northumberland, and his Tutor Mr Lippyatt, 1763. *Duke of Northumberland, Syon House, Middlesex (Copyright Country Life)*

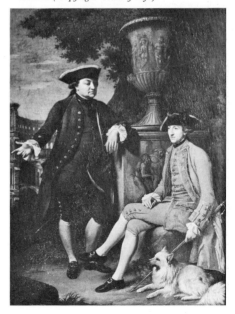

hibited at the Free Society of Artists in 1764. It is obviously the work of a 'gentleman' (which some of Hayman's groups were not) and it includes the Colosseum and a handsome classical vase for full measure. With the connexions he had made in Rome, Dance had no difficulty in establishing himself as a successful portrait painter on his return to London – at prices the half of Reynolds's. His style is difficult to define, yet easy to recognize. Uncharitable contemporaries called his 'George III' 'a bit of wood', and there is an unfashionable, but not altogether disagreeable, stiffness about his life-size figures. The 'Pratt Children' 1767 (Bayham Abbey) [211] shows him at his best, and with a dark

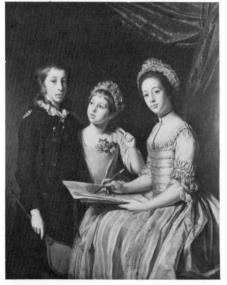

211. Nathaniel Dance: The Pratt Children, 1767.
Marquess Camden, Bayham Abbey, Sussex

background. When he introduced landscape he could never keep figure and landscape in tone. He had worked hard in Rome at becoming a history painter, but the only surviving example is the 'Timon of Athens' (Society of Artists 1767) at Hampton Court. During his short public career he tried his hand also at more heroic themes. The 'Garrick as Richard III' (Royal Academy 1771), now belonging to the

Corporation of Stratford-on-Avon, is the best, and owes something to the model. When he worked entirely out of his head, as in the 'Death of Mark Antony' (Royal Academy 1776) at Knole, he is a less interesting exponent of the manner of Gavin Hamilton.

Mason Chamberlin (d. 1787), who perhaps drew his normal patronage from the merchant classes, is the most puzzling of all these portrait painters. Enough of his work survives to make it clear that he has no normal style, but echoes something of his more distinguished contemporaries without ever descending to imitation. His two works publicly accessible in London – 'A Naval Officer and his Son' (Royal Academy 1776) at Greenwich, and 'Dr Hunter', c. 1781, in the offices of the Royal Academy – and a handful of others all rouse interest as out of the ordinary, but Chamberlin awaits further study. Of other portraitists who were foundation Academicians, West and Penny are both more profitably considered as painters of history.

The Decorators:
Cipriani and Angelica Kauffmann

The pretty stipple engravings of Bartolozzi and others after their designs have made the names of Cipriani and Angelica Kauffmann well known beyond their deserts. Both of them assiduously exhibited pictures of historical subjects at the Academy, and one must bear in mind Edwards's remark about Hayman, that 'he was unquestionably the best historical painter in the kingdom, before the arrival of Cipriani'. Yet I cannot claim ever to have seen a single one of Cipriani's easel pictures.

Giovanni Battista Cipriani (1727–85), a Florentine, came to England in 1755, and Angelica Kauffmann (1741–1807), a Tyrolese with an Italian training and a gay and charming personality, arrived in 1766. Both were steeped in the tricks of classical composition and were rich in those accomplishments which our native artists lacked. They could arrange any subject you liked to name, but neither had any feeling whatever for the human drama which renders in-

teresting the narratives of Homer, Shakespeare, or Klopstock. Every subject, no matter what its size, was reduced to the spirit of a decorative vignette, and they cannot be numbered among the painters of history.

Angelica[6] only remained in England until 1781, when she married an Italian painter, Antonio Zucchi, who had been one of the chief decorative artists employed by the brothers Adam. They settled in Rome, and Angelica later became one of the Goethe circle, and succeeded to some extent to the practice of Batoni as the painter of portraits of travelling Englishmen. The best of her English portraits is one of Reynolds (National Trust, Saltram), and she painted a number of small-scale 'conversations', but she was at her best in single decorative figures such as the four ovals at Burlington House, of 'Paint-ing', 'Design', 'Genius', anu 'Composition' [212], which were originally executed for the ceiling of the Lecture Room at Somerset House. The figure of 'Composition', with her dividers and a chess board, symbolizes neatly enough her contribution to the arts in England. If literature had been her *métier*, these attributes would fittingly have been replaced by scissors and paste.

212. Angelica Kauffmann: Composition, 1779. *London, Royal Academy of Arts*

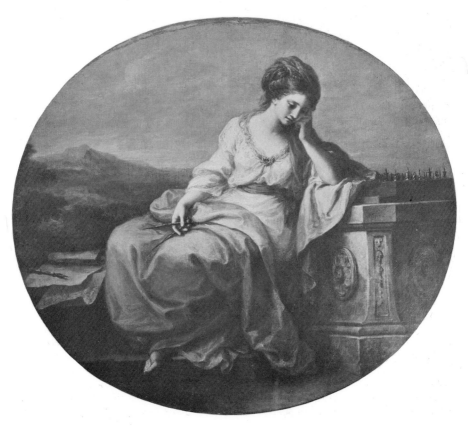

Portraitists who were not Academicians:
Pine and Kettle

Two portrait painters, each with rather pronounced mannerisms, who did not make the grade as Academicians, although the quality of their best work deserved that honour, may be best mentioned here. Robert Edge Pine (*c.* 1730–88)[7] won premiums at the Society of Arts for history painting in 1760 and 1763, but his main work was in portraiture and he was one of the first to paint actor portraits in character parts. His masterpiece is an extremely sinister full-length of 'George II' (1759: at Audley End), for which he had no sitting. He was also a friend of Garrick, of whom he painted numerous portraits. His style is nearer to Hone than to other contemporaries and he can often be recognized by a fondness for a three-quarter view of the head in which the far top-corner of the cranium seems to have been sliced off. He worked at Bath about 1772 to 1779, and his most ambitious group, the 'Family of the First Lord Bradford' (Weston Park), dates from these years. In 1784 he emigrated to Philadelphia, taking with him a number of subject pictures from Shakespeare, and he died in 1788 after four years' considerable practice as a portraitist in the United States.

Tilly Kettle (1735–86)[8] was a rather better painter than Pine. He studied in the St Martin's Lane Academy and improved himself by copying Reynolds's portrait of 'Marchi' with variations. Certainly his first work, in the early 1760s, is wholly dependent on Reynolds, and of rather good qualities. In the middle 1760s he was touring the Midlands and then settled in London, where he leaned somewhat to the style of Cotes. His masterpiece is 'An Admiral in his Cabin issuing Orders' 1768 (formerly Highnam Court). This excellent and original composition should have won him a place in the Academy, but he was disappointed, and this may have led him to go to India in 1769, the first painter of any consequence to make that journey. In India he prospered exceedingly from 1769 to 1776, doing numerous portraits of the native princes and nabobs. But success did not attend his return to London, although such portraits as 'Admiral Kempenfeldt' 1783 at Greenwich are fully up to the level of Dance and Hone. After a short visit to Dublin he died in the Syrian Desert on his way back to India to recoup his fortunes. Kettle's portraits can be readily recognized by his tendency to render the human skull as of the shape of a football, but he has a pleasant and decorative key of colour and ranks fairly high among the lesser portraitists of the time.

THE PAINTERS OF HISTORY

The subject of 'history' painting in Britain has been sadly bedevilled. The idea and the practice were by no means the same, but the idea took an intolerable time to die. It was inherited from the French Academy in the later seventeenth century, was accepted as an article of faith by cultivated Europe in the first half of the eighteenth century, and was blandly enunciated by Reynolds in his *Fourth Discourse* as an unquestioned truth. Barry put it in the following form: 'History painting and sculpture should be the main views of any people desirous of gaining honours by the arts. These are the tests by which the national character will be tried in after-ages, and by which it has been, and is now, tried by the natives of other countries.' Barry believed this perverse nonsense, and so did Haydon after him, and the result was disaster for both. They tried to live by a theory and did not reckon with the state of patronage in the country where they worked. It was a general belief among the writers on art that, once art was linked to royal patronage – as it had been by the foundation of the Royal Academy – a time of prosperity would dawn for artists as it had in the time of Louis XIV. But they do these things much better in France – and much sooner. The first faint imitation of Colbert to have been produced in Britain was the Arts Council, and the difference between George III and Louis XIV was crisply but unkindly told by 'Peter Pindar', who wrote of George III:

> Of modern works he makes a jest –
> Except the works of Mr West.

The 'sublime' style which Reynolds inculcated, the kind of subject he favoured and its dependence on classical models, has already been seen in his 'Death of Dido' (Royal Academy 1781) [169]. It may be that the President had more than an inkling of the direction from which the attack would come, for he sent to the Academy of 1774 'The Triumph of Truth, with the Portrait of a Gentleman' – which was in fact the portrait of 'Dr Beattie', now at Marischal College, Aberdeen – in which the public readily recognized, in the dim faces of Truth's opponents, the features of Voltaire, Hume, and Gibbon. These authors had been undermining the heroic conception of history, and the interesting trend in history painting during the first twenty years of the Academy's life is the gradual debunking of the Augustan tradition, in which everyone had to be dressed in classical draperies. The change was not all in one direction. One line, the most daring, introduced the representation of contemporary events, and culminates in the heroic *reportage* of Copley; another substituted for the classical trappings an equally artificial mode, based on popular misconceptions of 'contemporary' costume, and led to the Wardour Street medievalism of Northcote or Opie and of many of the lesser contributors to Boydell's Shakespeare Gallery; while yet a third treated subjects in themselves so gentle, or historical events in so mild a manner, that the 'grand style' was not involved at all – as was the case with Edward Penny. A romantic history style, more dependent on literature than on the tradition of classical painting, also arose in such painters as the Runcimans and Wright of Derby, which culminated, in the next generation, in the stormy inventions of Fuseli.

The latter years of the eighteenth century were certainly the golden age – if there ever was one – of the history picture in Britain. Benjamin West, by monopolizing royal patronage in this field, was paid over £34,000 by the Crown for his history pictures alone between 1769 and 1801: and Alderman Boydell, who almost alone seems to have learned Hogarth's lesson that history pictures could be made to pay by selling engravings after them, commissioned his Shake-

speare Gallery in the years following 1786. More than one hundred and fifty pictures, both large and small, made up the final Shakespeare Gallery, commissioned from more than thirty artists, and Boydell's health as 'the commercial Maecenas of England' was drunk at the Academy banquet in 1789, on Burke's suggestion, by the President, the Prince of Wales and the assembled guests. Boydell's venture was followed by Macklin's 'Poets' Gallery', from 1788 onwards, but these groups of commissioned pictures were made to pay by the sale of engravings and of entrance money to the exhibitions, and they did not provoke any serious patronage of the history picture among British private collectors. When the Napoleonic wars put on the market Old Masters of a quality hitherto unobtainable by British collectors the patronage of our native produce very nearly evaporated altogether.

Of those artists who aspired to the grand style of history painting in the pure form in which Reynolds enunciated it, with heroic subjects and life-size figures, either nude or in classical draperies, only two painters need be considered – Gavin Hamilton and James Barry, the former

a Scottish gentleman, the other an Irishman of very elevated enthusiasm. Gavin Hamilton (1723–98) must count as a considerable rarity in British painting, for his pictures were better known in Europe than at home, and even had a certain influence on French neo-classicism. He went young to Italy and was a pupil of Agostino Masucci in the 1740s: in London about 1752 he painted a few portraits – notably of the Gunning sisters – but he had an irresistible bent towards history and in 1756 settled in Rome for the rest of his life. In Rome he was a leading member of the classical school of which Mengs was the most reputed painter and Winckelmann the prophet, and he started his large-scale illustrations to the story of the *Iliad* in the 1760s. Being a man of some means he had these engraved by Cunego (from about 1764 onwards) and his reputation expanded throughout Europe. The Director of the French Academy at Rome mentions his work in 1763, and Grimm, writing to the Empress Catherine in 1779, mentions his painting with considerable approval. Only in Britain was he almost unknown, although he contrived to sell a number of his large works to British collectors by insisting on a commission

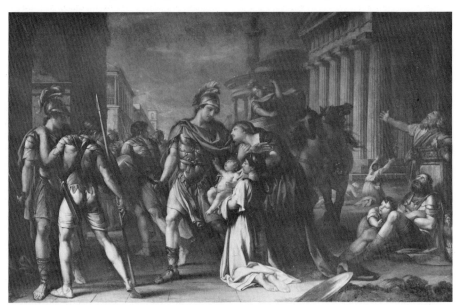

213. Gavin Hamilton: Hector's Farewell to Andromache. *Duke of Hamilton, on loan to Glasgow University*

as part payment for the works by Old Masters or classical statues in which he trafficked.[1] His pictures are rarely to be met with today, but the 'Hector's Farewell to Andromache' [213] (Duke of Hamilton, on loan to Glasgow University – where 'Dawkins and Wood discovering Palmyra' (1758) is also on loan) is almost a Jacques-Louis David *avant la lettre*. He has only lately attracted study[2] and he boldly persisted in the old classical tradition after the innovations of West and Copley in the modern heroic manner had won the day, so that a writer in 1793[3] says of his works that they preserve 'a propriety with regard to *costume* which distinguishes them from most modern compositions, and a dignity of manner that is seldom attained by those who make living characters the principal object of their studies'. Perhaps no statement shows so clearly the revolution in history painting which had occurred between 1769 and 1793.

James Barry (1741–1806) was an altogether different character. His historical importance extends beyond the scope of this volume, for Barry and Fuseli between them made up a considerable part of the background which helps to account for Blake – and Fuseli can only be dealt with by the historian of the romantic period. Barry was an Irishman of humble origin, who had more than a spark, perhaps the real fire, of genius in his make-up. But he had a wild and arrogant enthusiasm, the tongue of an asp, and a voluble inconsiderateness for others which led to his undoing. As a self-trained stripling he brought a whole group of historical compositions to Dublin in 1763, impressed Edmund Burke with his genius, and was brought by Burke to London in 1764, where he was introduced to Reynolds and 'Athenian' Stuart, from both of whom he met with encouragement and kindness. No painter of his generation took the President's encouragement towards the 'grand style' so close to the letter and with so small a grain of the salt of common sense. Again financed by Burke, Barry went to Italy in 1766 and remained until 1771, saturating himself only too faithfully in the ancients and in Michelangelo. His genius, which was authentic, was recognized at once on his return, for he became

an A.R.A. in 1772 and an R.A. in 1773. But he only became the more intransigent in his high classical principles and exhibited in 1776 a 'Death of Wolfe' (New Brunswick) which, no doubt as an attack on West's famous picture of 1771, appears to have been first painted in the classical nude and then draped with modern uniforms, as if to show the incompatibility of the heroic style with modern costume.[4] Whatever disagreements may have in fact arisen over this, he never exhibited at the Academy again. But the years 1777 to 1783 were wholly taken up with his major work and most serious claim to fame – the series of large canvases (two of them forty-two feet long) which he painted for the Great Room of the Society of Arts. The theme of the whole decoration is *The Progress of Human Culture*, and these paintings must still be accounted the most considerable achievement in the true 'grand style' by any British painter of the century. They do not, as Barry believed, compare favourably with the work of Raphael, but they are works of genius and have a general grandeur of conception, in spite of peccancy in the taste of numerous details. Close in date to these, perhaps about 1784, must be Barry's portrait of 'Hugh, Duke of Northumberland' (Syon House) [214], which has the gravity of their spirit and is more accessible to illustration. It has a kind of solemnity which was denied to Reynolds, and the resources of art which Barry here employs would perhaps have been more fitting for St George about to affront the dragon – and Barry did in fact paint a similar picture of the 'Prince of Wales as St George' now in the Municipal Gallery at Cork – than for a portrait of a peer in Garter Robes. But never was there a more vivid example of Reynolds's recommendation to elevate the style of portraiture by borrowing from the grand style. Barry's taste for sublimity was far better understood than Reynolds's, but lack of the right patronage turned him sour. Becoming Professor of Painting at the Academy about the time his work for the Society of Arts was completed, he used his lectures increasingly as a vehicle for the abuse of his colleagues, and was finally turned out of the Academy in 1799. To

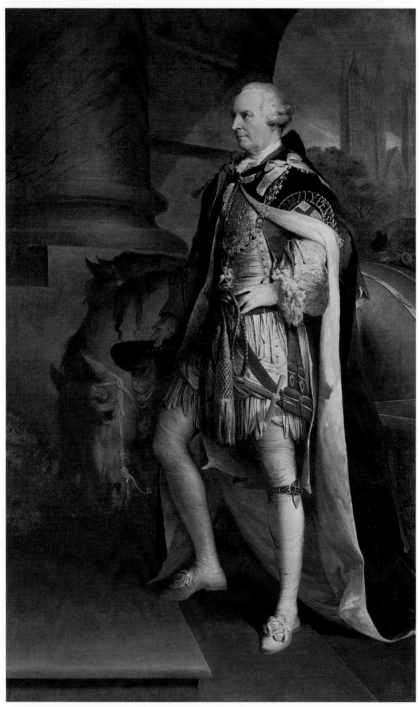

214. James Barry: Hugh, Duke of Northumberland, *c.* 1784.
Duke of Northumberland, Syon House, Middlesex (Copyright Country Life)

some extent his spirit was deranged, but it was a spirit of a noble fire.

Fire was what was lacking in Benjamin West, whose prodigious success provides the contrast to Barry's misery. Their pretensions had something in common, for Raphael's name was mentioned freely by West's admirers also and West gave his own son the Christian name of Raphael. Benjamin West (1738–1820) came of Pennsylvania Quaker stock, and it is significant that he and Copley (a New Englander) were the pioneers in modernizing British history painting. Forerunners of some of the characters in Henry James's novels, they came to Europe full of eagerness and appreciation but with minds free from the incubus of inherited tradition in the matter of high art. It may have seemed almost as strange to them as it does to us today to represent scenes from contemporary history in classical costume, and their minds were better attuned than were those of professional British

artists to understand what was of interest to the common man. The native painters who worked for the upper classes had been saturated, from the beginning of their working life, with the prejudices of the 'connoisseurs'. West to some extent, and Copley more fully, realized the value for the artist of the new feeling of national pride in the achievements of one's own nation which had grown up with the generality of the public, and which had been fed hitherto, in the matter of art, only by the engravings in such volumes as Rapin's or Hume's histories. The stage too had begun to affect 'contemporary' costume when possible, and West and Copley, by the shortness of their roots in the European tradition, rather than by any profound originality in their own natures, were able to become the first articulate painters of a new range of subject-matter of general interest. It is the story of Hogarth over again with a different public, for the engraving of West's 'Death of Wolfe' [215]

215. Benjamin West: Death of Wolfe, 1770.
Ottawa, The National Gallery of Canada

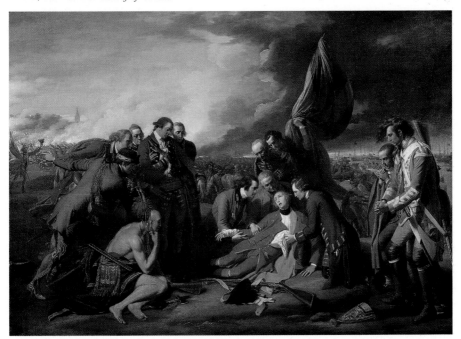

is said to have earned as much as £15,000. West also was lucky in that the very mediocrity of his mind found a kindred spirit in the mind of George III.

A dispassionate study of West, whose importance at the time can be gauged from the fact that he succeeded Reynolds as President of the Royal Academy, is a desideratum. Writers who have been concerned with him incidentally have hitherto been forced to rely, however cautiously, on Galt's biography, published in part after West's death, but with his approval, which partakes of a somewhat legendary character. It is written in a spirit which we are more accustomed to find applied to South Italian saints than to a Quaker Academician who lived into the last century, and it is probable that most of its famous anecdotes have been improved in the telling. The evidence of his pictures themselves, in so far as they can be identified today, is all that we can go upon securely at present.

Having learned 'the mechanical part' of painting in America, the young West spent the years 1760-3 in Italy, where he visited Rome, Florence, Bologna, and Venice. In Rome he was certainly in close contact with the circle of Mengs and Gavin Hamilton, and his notion of the subject-matter of history painting was certainly coloured by theirs. But he had had no experience of the academic practice of drawing from the Antique, and it may well have been this fact, rather than any more positive predilection, which turned West's ideas to the kind of history picture which Haydon later called scornfully 'Poussin size'. In the meantime he improved his social contacts and became reasonably proficient as a portrait painter in a style nearer to Mengs than to Reynolds.

It was as a portrait painter that West set himself up in London, where he decided to settle soon after his arrival in 1763, but he sent two subject pieces to the exhibition of the Society of Arts in 1764. His success, both in Rome and in London, can be partly accounted for by his being an American, and thus a 'phenomenon' in which society could allow itself to be interested. Cardinal Albani (who was blind) had naïvely supposed that he was a Red Indian, and it was

an age when Wonders from the Western World were all the rage. At any rate his history pictures met with some response from the bench of bishops, a body of men who have patronized the arts with effect on no other occasion, and one cannot help wondering whether the reason for this was not some obscure feeling of transferred missionary endeavour. It was Archbishop Drummond who introduced West to the King in 1768, with a picture of 'Agrippina landing at Brindisi', which had been commissioned by himself. The result was that the King suggested to West the subject of 'The Final Departure of Regulus from Rome' [216] as a commission for the royal collection. The 'Regulus' appeared at the first exhibition of the Academy in 1769 (of which West became a foundation member) and West's long association with the Crown began.

The 'Agrippina' and the 'Regulus' are remarkable works for their time. Their style is that of Gavin Hamilton, reduced to the more manageable size of Poussin. There is, above all, much of Raphael in them, but nothing of that extraordinary combination of harmony and purely formal qualities which gives Raphael's designs the air of being by an intellectually superior being. Their limitations made them the very pictures for George III and they were quickly popularized in engravings. A few British painters, such as Alexander Runciman, imitated West's choice of subjects, but this was reserved rather for the French, whose minor academic painters followed West's choice of subjects with a fidelity which cannot be accidental.[5] But West himself soon graduated from classical subjects in the neo-classical manner to the baroque rendering of contemporary history, and showed at the Academy of 1771 his 'Death of Wolfe',[6] which is generally accepted, with reasonable accuracy, as marking the turning-point from the old style of history painting to the new.

The story, as related by West's hagiographer, is that Reynolds, hearing that West was painting a heroic history of the death of Wolfe in contemporary costume and not in classical draperies, came to persuade him against any such impropriety; that West used the various arguments that one would imagine today and asked

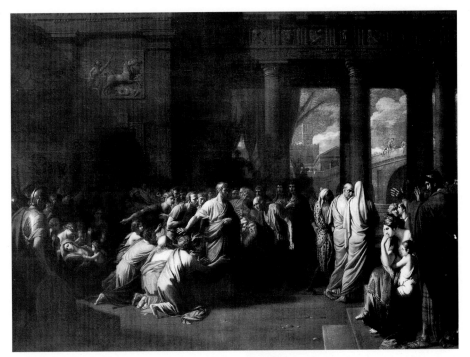

216. Benjamin West: The Final Departure of Regulus from Rome, 1769.
Royal Collection (by gracious permission of Her Majesty the Queen)

Reynolds to suspend judgement until the work was finished; and that, on his final visit, Reynolds generously said: 'Mr West has conquered. . . . I foresee that this picture will not only become one of the most popular, but occasion a revolution in the art.' It is perhaps more parable than truth, but West's picture did in fact become extremely popular and helped to stimulate a movement away from classical subjects to the heroic rendering of national or contemporary history.

The picture itself has no claims to accuracy of historical presentation. Except for Wolfe himself, hardly any of the figures in the picture were present at his death, and the Red Indian is a purely symbolic figure. Without accepting all the sources put forward by Mr Charles Mitchell[7] as contributing to West's design, we can agree that it is composed on a standard baroque formula and that the main group is based on the

traditional pattern of a 'Mourning over the dead Christ'. What has not always been observed, in the heat of controversy, is that, within its limits, it is rather a good picture. West himself does not seem at the time to have thought he was doing anything revolutionary in the sense that it was 'modern', for he proposed to the King, for a series of companion pictures of 'historic deaths', those of 'Epaminondas' and 'Bayard', both of which were exhibited at the Academy of 1773. The former was treated in the classical manner, but the latter, as befitted a 'medieval' subject and in consonance with the new practices of the contemporary stage, is modelled on Salvator Rosa and in tune with the bandit pictures which were being popularized at exactly this time by John Hamilton Mortimer. It was this last style which West exploited most freely in his later works, and by which he belongs also to the romantic period.

Even by these pictures West's historical vein was not wholly exhausted, for a picture like 'The Apotheosis of Prince Alfred and Prince Octavius' (*c*. 1784: Royal Collection) [217] is altogether and literally in the style of Mengs.

217. Benjamin West: The Apotheosis of Prince Alfred and Prince Octavius, *c*. 1784.
Her Majesty the Queen
(reproduced by gracious permission)

Unfortunately, like Gavin Hamilton, West had almost no feeling for colour or for the texture of paint. His contemporary fame and his legend have militated against a judicious appreciation of his work, which has an importance in the general history of European art, but left very little impression on the national school.

It was left to a second American painter, John Singleton Copley (1738–1815), to exploit to the full the popular subject from contemporary history, for which West had led the way. Unlike West, Copley was a Bostonian, and he had none of the curiosity value of West. What is more, he had waited fourteen years longer than West to come to Europe and had already formed a highly personal and distinguished style of his own in portraiture before he set out. Copley's New England style is unfortunately no part of the history of British painting: 'unfortunately' because, at its best, it is rivalled only by Hogarth for directness and sincerity of approach. Copley had had to work it out for himself to suit a clientele who accepted the general rule that Truth was to be preferred to Beauty, and who were prepared to give the painter long sittings. Neither of these conditions obtained in Europe and Copley felt that he must learn a new language during the period in 1774/5 that he spent in Italy and dashing through half Europe on his way from Italy to London. He learned it so effectively that no traces of his New England style survived, and he settled in London to paint portraits and groups in a style between Reynolds and West in 1775. As an American portraitist Copley rates very high indeed; as a European portraitist he can only be considered as an accomplished secondary painter except for his rare incursions into the rococo conversation piece, such as 'The Three Princesses' (Royal Academy 1785) at Buckingham Palace, and 'The Sitwell Family' 1787 at Renishaw Hall. These are, in their way, masterpieces and owe a good deal of their charm to being so agreeably un-English, since the children conduct themselves in a manner which, though not uncommon with children, is more lively than most British parents liked to have perpetuated in a picture.[8]

The prime virtue of these pictures rests in their composition, and 'composition' was what Copley found he had a genius for when he came to Europe. He had been so isolated from academic practice in Boston that he had no idea how a painter set about a group portrait, and it is astonishing to find the best painter in New England writing to his half-brother as follows on his first arrival in London at the age of thirty-six: 'The means by which composition is obtained is easier than I thought it had been. The sketches are made from life, not only from figures singly, but often by groups. This, you

remember, we often talked of, and by this a great difficulty is removed that lay on my mind.' A new world of art had opened for him and he had discovered his personal gift. In Rome he painted an 'Ascension' (Boston) which is perhaps superior to any of West's compositions in his own style, and by 1778 he felt himself sufficiently established in London to send a composition to the Academy.

The picture of 'Brook Watson and the Shark' (examples are in Washington [218], London, and Boston), sent to the Academy in 1778, broke all the accepted rules of history painting. Much more than West's 'Death of Wolfe' does it deserve to be considered the pioneer work of a new age, for its like was not produced until the great days of the French romantics in the 1820s. The subject was contemporary and not classical: the

hero was no national figure but rather the kind of person made familiar today by some of the Sunday newspapers: and the action has no grave historical import or moral lesson for mankind, but was frankly exciting and romantic. It is extremely unlikely that Copley had any idea how revolutionary his work was, and the reason why he turned from such pictures to more notable scenes from contemporary history was doubtless the fact that the engravings from them would sell to a much wider public. But the best of the later works all partake of the same characteristics: they are dramatic, they have a contemporary subject, they are presented with a sufficient degree of accurate local colour to count as heroic *reportage*, and they gave Copley a chance to exploit his newly found passion for composition. The later ones were so vast that

218. J. S. Copley: Brook Watson and the Shark. *Washington, D.C., National Gallery*

219. J. S. Copley: The Death of Major Pierson,
1783. *London, Tate Gallery*

they had to be shown in special buildings by themselves, where they provided, to the exasperation of the Academicians, a new and popular rival to the exhibitions at the Royal Academy.

Copley's pictures of this class, which rank as the one series of great modern history paintings done in England in the eighteenth century, are as follows: the 'Death of Chatham', painted 1779/80 (Tate Gallery); the 'Death of Major Pierson' 1783 (Tate Gallery) [219]; 'The Repulse of the Floating Batteries at Gibraltar', finished 1791 (Guildhall, London: finished study in Tate Gallery); 'Admiral Duncan's Victory at Camperdown', finished 1799 (Camperdown House, Dundee). The unwieldy size of the last two has caused the first to be inaccessible and the last to be immovable, but the whole series of pictures was an artistic achievement of a new kind. The finest is the 'Death of Major Pierson', in which Copley was not faced with the difficulty of including a vast number of individual portraits. In the frightened mother and children at the right he has been able to include figures not essential to the story and so to concentrate less on documentary history and more on exciting and romantic elements in the scene. This splendid picture would hold its own and find its natural affinities in a room with *Les Pestiférés de Jaffa* and the great French romantic histories of the next century. One has only to compare Copley's works with the feeble historical subjects of George Carter, with whom Copley had travelled from London to Italy, to see how much that was new the American artist introduced into British painting. But for all the popular enthusiasm these pictures aroused, their lesson was lost on British artists and they founded no school of history painting.

The next type of history painter can be broadly classified as 'the Boydell group', from the stagy kind of history picture which made up Boydell's Shakespeare Gallery. The two most

important members of this group are Opie and Northcote, who both started their London careers about the same time, and both became A.R.A. in 1786 and R.A. in 1787. Opie was much the younger, but much the more considerable talent, though he lacked the kind of training and knowledge of the Antique which Northcote had. They both came from humble West Country stock and became friends.

John Opie (1761–1807) had the makings of a serious painter in him, and the fact that so many of his portraits are thoroughly dull, if not frankly bad, was due to the fact that he had no elegance in his make-up but was commissioned to do portraits of fashionable persons. His father was a Cornish carpenter, and the young Opie, who showed a precocious passion for drawing, was taken up, when he was fourteen, by John Wol-

cot, best known by his satirical verse under the name of 'Peter Pindar', who was then practising medicine in Cornwall. Wolcot had been a pupil of Richard Wilson and he constituted himself the young Opie's teacher and impresario. What training he gave him he kept remarkably dark, since his aim was to bring him upon the London stage as 'the Cornish Wonder', an untrained and self-taught prodigy, once he had rubbed off some of the young man's superficial asperities. Wolcot's scheme was largely successful and his advice both original and sound. He saw that the young man had a natural gift for local tone and for the strong rendering of rough natural types in a correspondingly strong chiaroscuro, and he fed him on Rembrandt and the Tenebrists, no doubt through the medium of prints. This was done with something of the secrecy which now

220. John Opie: The School, 1784.
Loyd Collection, Lockinge, Berks

attends the training of a racehorse, and Wolcot established himself with Opie in London in 1781 and pretended that the young prodigy had never seen an Old Master or had any serious training.[9] At the Academy of 1782, and in the selection of pictures taken to show the King, only such morsels of common nature were selected as 'A Jew' or 'A Cornish Beggar', and Opie was successfully sprung on the world as a sort of modern Ribera. For a year or more society flocked to him and demanded that he paint their portraits, and his old men and old women (such as 'Mrs Delany' 1782 in the National Portrait Gallery) were both novel and good. At this date Opie had a sense of paint texture and a broad touch which were refreshing, and his vaguely Rembrandtesque effects of lighting seemed original and pleased. Anything that was natural he could paint with sympathy, old people and children as well, for the four pictures of the four children of the Duke of Argyll of about 1784 at Inveraray are among his best portraits. At the Academy of 1784 he showed his first considerable subject piece, 'The School' (Loyd Collection, Locking) [220], which has a naturalness and rather pleasing awkwardness of composition which enabled Opie to excel in this kind of subject. It was a new voice in English painting, and the *Morning Post* presciently observed that: 'could people in vulgar life afford to pay for pictures, Opie would be their man'. This picture marks a return to Dutch and Flemish seventeenth-century painting as a source of inspiration, which was to reach its peak in Wilkie and to persist throughout the nineteenth century. As a history painter Opie was fully launched by 1786, when he began the first of seven pictures for Boydell's Shakespeare Gallery: in that year he also painted for Boydell 'The Assassination of James I of Scotland', and in 1787 'The Death of Rizzio', which Boydell gave to the Guildhall Gallery. These were destroyed by bombing in 1941, but they, the Shakespeare subjects, and a number of others painted for Bowyer's 'Historic Gallery' in the 1790s made Opie famous. Today we have to judge them mainly from engravings, and find them turgid, with spurious 'period' costumes

and stock stage expressions. But their influence was much greater than the much better history pictures of Copley and the tradition which culminated in Delaroche stems from these pictures of the 1780s and 1790s.

Opie's genius was of the kind which burns brightly at the outset and steadily grows dimmer with increasing contact with sophistication. The more positive the subject before him, the better he painted, and vague fancy pieces of his later years do little to enhance his reputation. His later subject-pieces belong thoroughly to the romantic period and are sometimes a novelette in themselves. Of these 'The Angry Father' (or 'The Discovery of Clandestine Correspondence': Royal Academy 1802) at Aston Hall, Birmingham, is a very complete example.

James Northcote (1746–1831) is at once the complement and antithesis to Opie. Their professional success was similar and their output of the same general character – great numbers of portraits, a number of histories in the Boydell vein, rather vapid fancy pieces: to which Northcote added some rather absurd series of moral stories in an unsuccessful attempt to emulate Hogarth. Intellectually and critically Northcote had the gifts to make an artist of a high order, and his training should have given him enormous advantages over Opie. From 1771 to 1775 he lived as a pupil and assistant in Sir Joshua Reynolds's house; from 1777 to 1780 he studied in Rome; and he settled in London about the same time as Opie in 1781. But, in spite of a strong sense of character, Northcote had no feeling for paint or for tone. Out of the combined virtues of Opie and Northcote one could have produced a painter of real eminence, but neither alone could achieve very high rank. Northcote embarked on scenes with a literary subject in 1784, and, in the next years, was one of the first to contribute to the Shakespeare Gallery. The only difference between his Shakespeare pictures and Opie's is that figures from the Antique and the Italian classics find their way more often into Northcote's compositions. Even in such a purely popular moral fable as 'The Wanton Servant in her Bedchamber', Northcote cannot resist modelling his frail

female on the sleeping Ariadne. Opie had had too slight an acquaintance with the tradition of the classics, while Northcote's years with Reynolds and in Rome had numbed his powers of natural invention. Yet the later works of the two painters can sometimes quite readily be confused.

In strong contrast to this school is the work of Edward Penny, the earliest born and the least dramatic of narrative painters of the classic age. Penny (1714–91) would be important if his work had had any effect, for he was the first to paint the 'Death of Wolfe' (in 1764) [221]. But he

the Ashmolean Museum at Oxford and at Petworth, and, although 'in modern dress', they have a gently elegiac quality, which is characteristic of Penny's Muse. He had been a pupil of Marco Benefial in Rome, one of the forerunners of neo-classicism, and returned to England in 1743, where he at first practised in his native Cheshire and Lancashire as a portraitist in a style close to the contemporary work of Richard Wilson. From 1762 he exhibited at the Society of Artists and he became a foundation member of the Royal Academy and its first Professor of Painting, which shows the esteem in

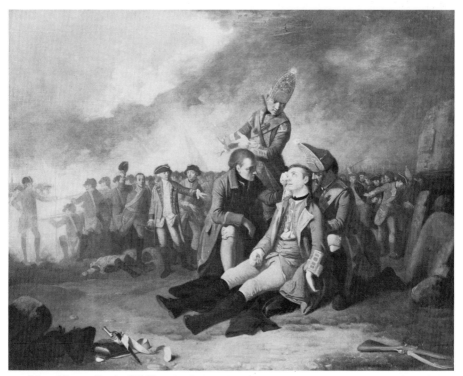

221. Edward Penny: Death of Wolfe, 1764. *Oxford, Ashmolean Museum*

painted the subject, not as a dramatic modern history, but as a moral exemplar of a military virtue, and he painted as its companion 'Lord Granby relieving a Distressed Soldier and his Family'. Examples of both these designs are in

which he was held. He retired from that office in 1783 and made way for Barry.

Penny's narrative pictures (for such they are, rather than 'histories') are the continuation of Hayman's style. He had a nice sense of tone,

gentle and silvery, which is apparent from 'The Generous Behaviour of the Chevalier Bayard'[10] of 1768 to the 'Lavinia and Acasto'[11] of 1781, but his defect was summed up by the contemporary critic who called the latter picture 'very tame indeed'. The picture was an illustration to Thomson's *Seasons*, one of the most popular sources for lesser painters of a literary cast, and the feeling for nature in Thomson, which finds its echo in Stubbs, crept into narrative painting in the work of Penny, who may yet turn out to deserve more of our notice.

WRIGHT OF DERBY

AND THE PAINTERS OF ROMANTIC LITERATURE

The French pundits were very strict in their definition of a 'history picture', and the category of 'history painter' was the highest and most envied class in which to be received into the French Academy. In the year 1769, just about the time of the first exhibition of the Royal Academy in London, Greuze, in spite of having painted a 'Severus reproaching Caracalla', was only admitted as a 'painter of genre', a class to whom the highest academic honours were not open. Yet Greuze had developed a kind of picture which had won the enthusiastic praise of Diderot and reflected the tastes of that highly intelligent body of men who were to affect most profoundly the direction of thought in Europe and America – the Encyclopaedists. In England, also in the 1760s, Wright of Derby reflects the same tendency, but since he found no literary champion, although a much more sincere artist than Greuze, we can best judge the place and importance of his early style in terms of what Diderot says of Greuze. This style answers to what Diderot calls *le genre sérieux*, and its distinction from the current history style, which Diderot expressed in terms of the drama, was the difference between a *coup de théâtre* and a *tableau*, and the latter was defined as 'an arrangement of the characters so natural and so true that if faithfully rendered by a painter it would give me pleasure'. Had he known them, Diderot would probably have acclaimed Wright's first important pictures as models of this class. They have another character too, that of experiments in the scientific study of light, which reflects Wright's contact with the group of men – Erasmus Darwin, the Lunar Society, and the first founders of industry in the Midlands – who came nearest in England, in the direction of their thought, to the Encyclopaedists.

Joseph Wright (1734-97), generally known as 'Wright of Derby', is interesting for other reasons too. He was the first painter of real distinction to be settled for his whole life in the provinces (apart from Bath) and he was also 'the first professional painter to express the spirit of the industrial revolution'.[1] Trained as a portrait painter under Hudson (1751-3), he returned again to Hudson's studio in 1756/7, to complete his technical knowledge after his first experience of practice in his native Derby. He was thus in London during the triumph of the 'new style' in portraiture but he remained faithful to the Hudson patterns until a year or two after 1760. Though based on Derby, we know that, apparently in the year 1760 alone, he was painting portraits at Newark, Lincoln, Boston, Retford, and Doncaster. But he soon established a permanent practice in Derby, where he remained, except for a substantial stay at Liverpool in 1769, until he went to Italy in the autumn of 1773, soon after his marriage.

His first style dates from these pre-Italian years, which can broadly be called his 'candlelight period'. In Derby, surrounded by a society devoted to scientific experiment, from which emerged two of his principal later patrons, Wedgwood, one of the pioneers of pottery, and Arkwright, a pioneer of the cotton industry, it was natural that Wright should show in his art a bent towards science. The play of light, artificial at first, became his absorbing interest, and he was the first artist, above the level of the exponents of popular art, to give expression to the passionate interest of the Midlands in science. He must have seen some works by Honthorst or Schalken, and from these he evolved his own, wholly original, candlelight pictures. There are many single studies of figures in such lighting, but three finished masterpieces: 'Three Persons

viewing "The Gladiator" by Candelight' (Society of Artists 1765) (Private Collection); 'The Orrery' (Society of Artists 1766) (Derby Gallery); and 'An Experiment on a Bird in the Air Pump' (Society of Artists 1768) (Tate Gallery) [222]. This last is the masterpiece of the genre, and perhaps the most remarkable picture painted in what Diderot called *le genre sérieux*. The passionate interest in science of the Midlands is married to a complicated and successful design in which the whole group is both 'natural and true', and there is a great variety of tender human feeling. At the same time it was in no sense a 'history picture' and fell outside of any of the categories of contemporary appreciation. It is one of the wholly original masterpieces of British art, but it is amusing to observe that

222. Joseph Wright of Derby:
An Experiment on a Bird in the Air Pump, 1768.
London, Tate Gallery

Wright was so wrapped up in observing nature under these artificial conditions of light that some of his portraits of this period, such as 'Mrs Carver and her Daughter' (Derby Art Gallery), though feigned to be in the open air, show the drapery glossy and lit as by candlelight. With scenes of 'A Blacksmith's Shop' (Mr and Mrs Paul Mellon) and 'The Forge' (Earl Mountbatten) he had nearly exhausted the possibilities of popular subjects in this style, and in 1772 he exhibited his first romantic history, 'Miravan opening the Tombs of his Ancestors' (Derby Gallery) [223].[2] The literary source of this has not been traced (although the story occurs, with other names, in Herodotus), but the picture is of an entirely new kind, with affinities to the novels of Mrs Radcliffe, and it includes a piece of furniture which suggests a Wedgwood nightmare. It is rare in England to find a painter so closely in line with contemporary trends in literature and fashionable artifacts.

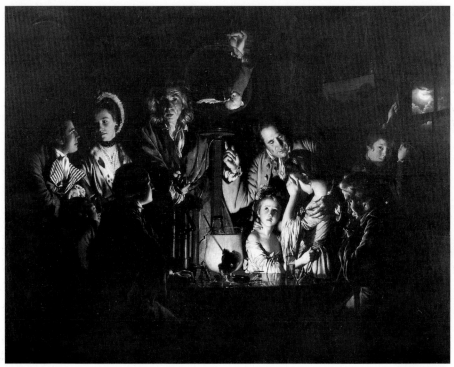

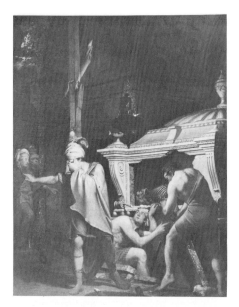

From the same year dates Wright's first exhibited landscape, but it was not until his Italian journey (1773/5) that he began to appreciate how his interest in sources of light could be combined with landscape painting. The more monumental Italian art left little impression on him, but he was lucky to see Vesuvius in eruption and the annual fireworks at the Castel S. Angelo, and he exhibited landscapes of both of these phenomena on his return in 1776. He also appreciated in Italy the style and popularity of Vernet and saw the possibility of competing with his pictures of moonlight.

223. Joseph Wright of Derby:
Miravan opening the Tombs of his Ancestors, 1772.
Derby Art Gallery

224 (*below*). Joseph Wright of Derby:
Moonlight Scene, 1780s.
Ex Palmer-Morewood Collection

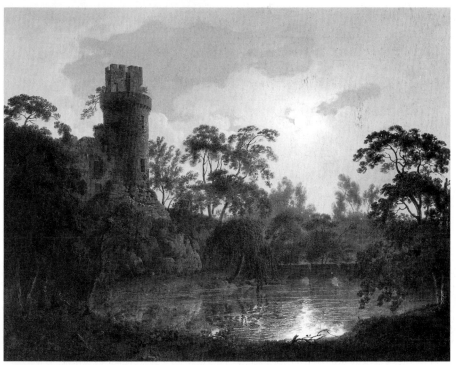

'Vesuvius' especially became one of Wright's favourite themes in later years and more than a dozen variants of the subject are known. But his most original contributions to English landscape painting were views of his native Derbyshire, especially the country round Matlock, seen under unusual conditions of sunlight or in moonlight arrangements. A typical example, signed and dated from an unreadable year in the 1780s, is the 'Moonlight Scene' [224] (ex Palmer-Morewood Collection). The architectonics of the scene are only a little different from those in the more topographical views of Thomas Smith (d. 1767 and known as 'Smith of Derby') from which his own first taste for landscape may have derived. The moonlight gives a 'romantic air' to such pictures, but their aim was much more the faithful rendering of effects of moonlight than this air of romance. In fact, just as his earlier candlelight study had shown its

effects in his daylight portraits, his study of the even, glassy smoothness of moonlight is carried over into his daylight landscapes, giving them the disquieting effect of smooth linoleum.

Wright's study of the Antique in Rome had a curious and not altogether happy effect on his later portrait style. His draperies often cling to the form in a sheathlike fashion, which anticipates the extravagances of Fuseli, and his hands make more eloquent play than is normal among the more impassive peoples of the North. His best portraits date from about 1781, and one of the most illuminating is the 'Sir Brooke Boothby' (Tate Gallery) [225] of that year – a gentleman pensively reclining in a woodland glade and meditating on the volume which he clutches so carelessly and which is lettered 'Rousseau'. It well illustrates all the peculiarities of Wright's later style and points to one of their sources in the intellectual world of the Encyclopaedists.

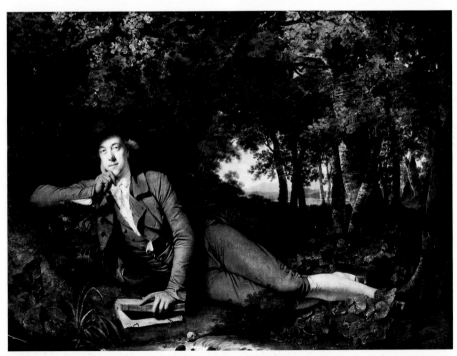

225. Joseph Wright of Derby: Sir Brooke Boothby, 1781. *London, Tate Gallery*

226 (*opposite*). Joseph Wright of Derby: The Dead Soldier, 1789. *Brooklyn Museum (lent by James Ricau)*

Soon afterwards he painted his masterpiece of group portraiture, 'The Coke Family' (Derby Art Gallery).

In subject pictures Wright found that he had exhausted the vein of candlelight pieces by the time of his return from Italy in 1775. Hoping to become established as a fashionable portrait painter he moved to Bath (which Gainsborough had left in 1774) as soon as he was back, but clients did not come and he returned for good to Derby in 1777, where he found a steady stream of portrait clients and enough leisure to paint landscapes and the subject pieces in which he was most interested. But literature, rather than history, was the source of his themes. To the Academy of 1778 he sent a study of 'Edwin' (no vulgar boy) from Beattie's *Minstrel*, of which at least three originals are known; and to that of 1781 a study of Sterne's 'Maria' (Derby Gallery), which, in style and arrangement, recalls the figures on Wedgwood's pottery; while for Wedgwood himself he painted in 1784 'The Maid of Corinth', a theme lately popularized by Hayley in a poem, and which had already been treated by Alexander Runciman and David Allan. For the first time contemporary poetry and painting went hand in hand, and Wright's masterpiece in this genre was 'The Dead Soldier' (on loan to Brooklyn) [226], a subject from Langhorne's poems, which was popularized by an engraving and, according to contemporary letters, brought tears to the eyes of beholders. The age of romantic sensibility has arrived and Wright's picture, shown at the Academy of 1789, is one of the finest of its early examples. About the same time he did two pictures for Boydell's Shakespeare Gallery, which had much more of the air of an illustration to the text than the stagy pictures of Opie and Northcote.

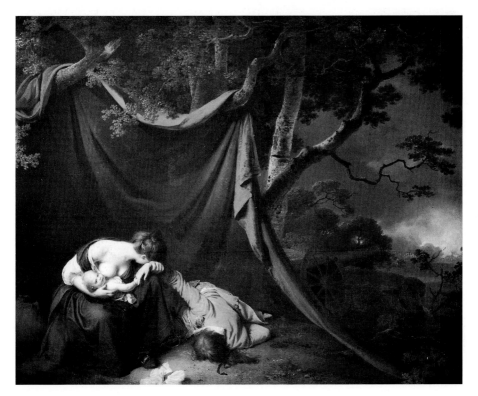

More nearly related to the work of Greuze and to *le genre sérieux* as it was practised in France is the rare work of Henry Walton (1746–1813), a gentleman painter who was a portraitist of only moderate ability, but who between 1776 and 1780 painted a few genre pictures of surprising perfection. He had been a pupil of Zoffany and first appears as a portraitist in 1771. There can be little doubt that he must later have visited France and seen the kind of subject Greuze (and others) were painting, and felt the perfection of Chardin's tone. Half a dozen pictures, beginning with the 'Girl plucking a Turkey' 1776 (National Gallery), are all that we have from him of this kind, but 'The Cherry Barrow' (Royal Academy 1779) [227] is as near perfection in the genre as has been achieved in English painting, and the feeling

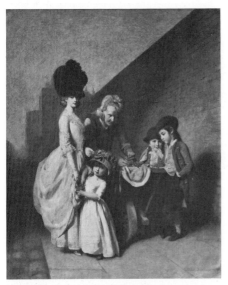

227. Henry Walton: The Cherry Barrow, 1779.
Reresby Sitwell, Renishaw Hall, Derbyshire

for tone is worthy of Chardin. Why Walton gave up this kind of painting is obscure, for there was certainly in England at this time a small group of patrons with a taste for this kind of picture. Mrs William Lock, writing to Fanny Burney about engravings after Greuze in 1789, says 'I wish we had more painters of *Domestic Subjects*'.[3]

Equally important with Wright as a pioneer of romantic literary subjects was John Hamilton Mortimer[4] (1740–79), who has long been known for the engravings which exist after his studies of Shakespearean heads and single figures. One of his works is known to have impressed and influenced Blake, and the kind of subject in which he latterly delighted paved the way for Fuseli. A pupil of Hudson at the same time as Wright (probably 1756/7), he later worked for a short time with Pine, but was practising on his own as a portrait painter in the early 1760s. In 1763 and 1764 he won premiums for straight history pictures from the Society for the Encouragement of the Arts, but he made his living in the later 1760s mainly by conversation pieces and small single figures in the style of Zoffany and in occasional theatre pieces (also in the style of Zoffany), such as the 'Scene from *King John*' 1768 at the Garrick Club. Only in 1770 did he first find his natural bent, which Edwards describes as 'representations of Banditti, or those transactions recorded in history, wherein the exertions of soldiers are principally employed, as also incantations, the frolics of monsters, and all those kind of scenes, that personify "Horrible Imaginings" '. Edwards's words are supported by the titles of Mortimer's pictures exhibited at the Society of Arts, and, in 1778 and 1779, at the Royal Academy – and some of these have now reappeared.[5] They read like an anticipation of much of the subject-matter of Fuseli; and Mortimer too, in 1778, was one of the first to take a subject from Spenser, who became a favourite source for romantic history pictures. These themes read oddly as the work of a painter who was severely criticized by his biographers as preferring to excel at cricket rather than take his art seriously! But he was redeemed from the downward path by a virtuous marriage, about 1775, and exhibited the same year four companion pictures of 'The Progress of Virtue' [No. 111, 228], which are now in the Tate Gallery. In the most lively of these his experience of vice stood him in good stead: the youthful hero is seen abandon-

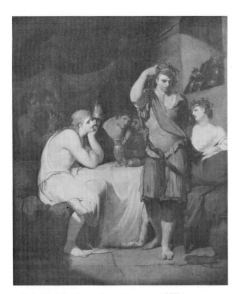

228. J. H. Mortimer: The Progress of Virtue, No. III, 1775. *London, Tate Gallery*

ing, at a rather late stage in the repast, a military dinner at which females are present, and removing a wreath of vine-leaves from his hair. No other British painting corresponds so precisely to the dubious sincerity of Greuze in his paintings of moral subjects. Wright and Walton represent in England the painting of 'moral subjects' (in Diderot's sense) of a neutral or domestic cast, while Mortimer represents the seamier side. His Banditti pictures owe something to Salvator Rosa, and it is characteristic of his temperament that he was latterly painting scenes from *Don Quixote*. As a portraitist, though he disliked the genre, he also deserves consideration, for his group of the 'Drake Family'[6] (Royal Academy 1778) formerly at Shardeloes is the best conversation piece of its period in the Zoffany tradition, and distinctly superior to Zoffany's own work of this date. Enough of his pictures are now known to enable a just estimate of Mortimer to be arrived at; and there can be little doubt of his historical importance, and the space devoted to him in Cunningham's biographies shows that the memory of him lingered.

Another notable exponent of what we have, perhaps rather unfairly, called 'the seamier side' of genre painting was Matthew William Peters (1742–1814). He has a link with Mortimer, since one of the most reputed of his half-length arrangements of young ladies 'in an undress' was a portrait of Mortimer's sister as 'Hebe', which was engraved in 1779. He has also a much stronger link with France than other British painters of genre, since he was in Paris in 1775 (when he was copying Rubens), and again in 1783/4, when he associated closely with Vestier and the young Boilly. Those who admired him (and they were less numerous than his detractors) called him 'the English Titian', not solely because he had spent the years 1773/4 in Venice, but because he had a lush juiciness of colour during his best years, and a rich creamy impasto, which remind one, at a long remove, of Venice. His high key and his feeling for texture of paint are certainly his most unusual and agreeable characteristics, but it must be admitted that his colour reminds us more often of the 'jammy' effects of Baroccio than of the sonorous harmonies of Titian. Peters too had been a pupil of Hudson in the later 1750s, perhaps at the same time as Wright and Mortimer. But we know nothing of his Hudsonesque phase and he quickly adapted himself to modern continental modes by study in Italy from 1762 to 1766. His first mature phase, from 1766 to 1772, is of little importance. Much of his work at this time was portraiture in crayons (though little has been identified) and he had developed in the later 1760s a tendency to imitate the cheesy impasto of Reynolds. In 1769 he became a Freemason and established a connexion with a body of patrons who stood him in good stead in his art, and later in the Church. But his really formative years were spent abroad from 1772 to 1776, at Venice, Parma, Paris, Rome, and probably elsewhere. It was during these years that he acquired a liking for a high key of colour, for the swimmy facial expressions of Correggio, for harmonies of pink and cream and smoke, and for genre subjects of a mildly *risqué* kind. On his return to London he exhibited at the Academy a series of lightly draped busts of smiling and in-

viting ladies, which caused a mild scandal and became instantly popular in engravings. These are the English equivalent of yet another aspect of Greuze's work, and they are, to modern taste, more agreeable than that phase of Greuze, since they are completely devoid of moral overtones and the yearning glances are given no cover by being made to appear to be motivated by a dead sparrow or an attitude of prayer. This phase only lasted until about 1778 (when Peters became an R.A.), but it is for the pictures of this period that he is famous. They were followed by genre scenes in the same key and with the same qualities of paint, such as his Diploma picture, 'Children with Fruit and Flowers' (deposited with the Academy in 1777) [229], and a few portraits, especially of women, which have an evanescent and very feminine charm – in single figures only, for his efforts at group portraits are all of them failures.

In 1779, perhaps for prudential rather than from higher motives, Peters was at Oxford, studying to be ordained. In 1781 he was ordained Deacon, in 1782 Priest, and he celebrated this change of life by exhibiting at the Academy of 1782 'An Angel carrying the Spirit of a Child to Paradise', which was followed by other works in the same vein. They became extremely popular in engraving, but they belong to the curiosities of the history of taste rather than to the history of art. Peters's last serious works as a painter (except for a few portraits, such as the lively 'Bishop Hinchliffe', engraved 1788, at Trinity College, Cambridge) were some history pictures for Boydell's Shakespeare Gallery and for Macklin's Poets' Gallery in the later 1780s.

229. M. W. Peters: Children with Fruit and Flowers. *London, Royal Academy of Arts*

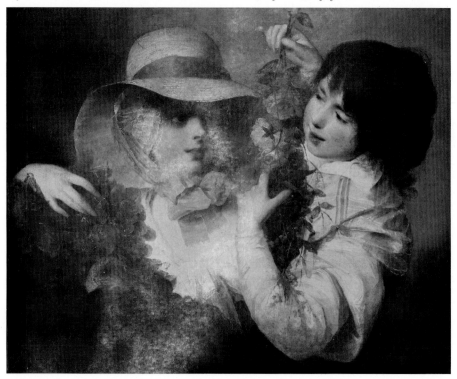

These did not altogether meet with ecclesiastical approval, for, although his scenes from *Henry VIII* are as dull and stagy as the worst of Northcote, his illustrations from *The Merry Wives of Windsor* and *Much Ado about Nothing* show something of the same spirit, under a cloak of Shakespearean respectability, as his studies of feminine genre of the 1770s. They are among the most light-hearted works of the Shakespeare Gallery, but Peters retired from professional painting and membership of the Academy in 1788 and settled down to the comfortable enjoyment of a plurality of livings. He was quite a good clergyman, but, before he took orders, he showed promise of being a painter of some individual talent.

These English pioneers of domestic genre and of the romantic literary subject can all be seen in some sense as a British counterpart to a popular continental mode, whose most famous exponent was Greuze, and some of them, such as Wright and Mortimer, can also be treated as among the forerunners of Fuseli. Their Scottish counterparts were of a more serious tone and their connexion with Fuseli was closer. Two brothers, sons of an Edinburgh builder, were the leaders: Alexander Runciman (1736–85),[7] who was historically the more important, and his younger brother, John Runciman (1744–68), who had given promise, at the time of his early death, of becoming one of the most original and sensitive British painters of the century.

Alexander Runciman was apprenticed in 1750 to the decorative painting firm of 'Robert Norrie and Coy.', who were continuing to adorn the houses of Edinburgh in a tradition derived from a blend of Gaspard Poussin and Pannini. Unexpectedly he developed a passion for landscape for its own sake and it is said that, at the time of his starting independent practice in 1762, landscape was the object of his ambition. Certainly he was the first to paint watercolours, lightly tinted, of the Scottish scene in a more advanced romantic style than the pretty topographical views of Paul Sandby. The date of the half-dozen or so such watercolours in the Print Room of the Scottish National Gallery is un-

certain, but they probably date from after his return from Italy, since they betray a knowledge of the landscape drawings of Claude as well as of those of Rembrandt. Alexander was presumably the teacher of his brother John, and Farington relates[8] in 1797 that he was shown certain 'specimens in imitation of Rubens' by Stothard, who told him that 'much of the process he learnt from one of the Runcimans, whose father, a painter at Edinburgh, was taught it by a Fleming'. As Stothard can hardly have learned it from John, it must have been from Alexander, but it is John whose few pictures show a profoundly sympathetic use of something like a Rubens technique. They cannot be seen in public outside the Edinburgh Gallery, and the four best probably date from the end of his life, between 1767, when he followed Alexander to Rome, and 1768, when he possibly committed suicide in Naples after destroying much of his work in a fit of self-depreciation. Three of these are small scenes of religious genre, but the fourth is a larger picture, signed and dated 1767, of 'King Lear in the Storm' [230]. This is an altogether surprising masterpiece, mature in both technique and invention, remarkable as a subject at so early a date, and altogether unvitiated by any suggestion of an influence from the stage. The theatre was still forbidden in Edinburgh, and this fact no doubt helped to keep John Runciman's style unsophisticated, but it does not account for a purely romantic painting which was about half a century in advance of its time. The Runcimans were probably the first British painters for whom the study of poetry was a direct source of inspiration, and their passion for Shakespeare is further documented by the 'Selfportrait' of Alexander with his friend John Brown, painted in 1784, where the two are discussing the interpretation of a passage in 'The Tempest' (Scottish National Portrait Gallery).[9] It is not unnatural that a mind attuned in this way would feel moved, among the splendours of Roman Antiquity, to turn to a subject from the greatest of British poets, but John Runciman seems to have been the first to do so. Fuseli, who reached

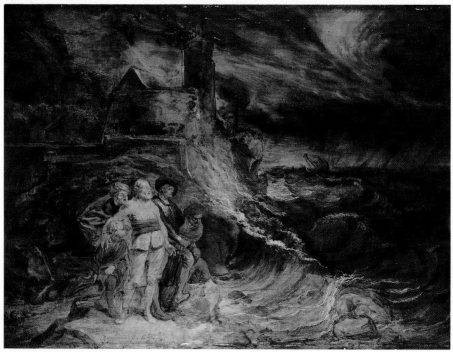

230. John Runciman: King Lear in the Storm, 1767.
Edinburgh, National Gallery of Scotland

Rome in 1770, after John's death, became friendly with Alexander Runciman and seems to have started in Rome his own series of paintings from Shakespearean themes, which first appeared at the Academy of 1774.

Of Alexander's own work in Rome, apart from some drawings and watercolours, we know only that he developed an interest in history, and 'The Origin of Painting' (the same subject that Wright later painted for Wedgwood), which is still at Penicuik House, may date from this period. He left Rome in 1771, and, after a brief stay in London, was appointed Director of the Edinburgh Academy in 1772. This body, which had hitherto had no loftier ambition than to serve the needs of providing patterns for Scottish industry, was allowed by Runciman to fall more in line with the Academies of London and the rest of Europe. History painting was now esteemed in Scotland in the first place of honour. Alexander Runciman himself painted a series of scenes (finished by 1773) from the story of Ossian in the great hall of Penicuik House, which were unfortunately destroyed by fire in 1899, but their intensely romantic and 'illustrative' character can be estimated from a number of studies which survive in the Print Room at Edinburgh. Perhaps they are too 'poetical', but they are in marked contrast to the stagy rhetoric of the Boydell group of painters, and their affinities are all with Fuseli, whom Runciman does not seem to have met again after his return to Scotland. In less ambitious works, such as the 'Landscape with a Hermit' at Edinburgh – one of the few British landscapes in a spirit akin to Richard Wilson – or 'David returning vic-

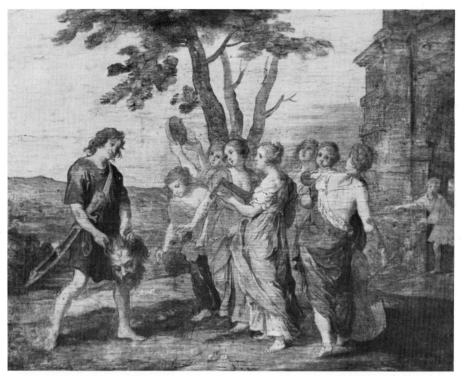

231. Alexander Runciman, after Rubens: David returning victorious after slaying Goliath.
Sir John Clerk, Bt, Penicuik House, Midlothian

torious after slaying Goliath' [231] after Rubens at Penicuik House, Alexander Runciman is seen operating within his range and shows a fresh imagination and a sense of design which promised well for the future of Scottish painting. That this promise was not fulfilled must be laid at the door of Scottish patronage.

As Master of the Edinburgh Academy Runciman was succeeded by David Allan (1744-96), son of the shore-master at Alloa and a pupil of the Foulis Academy at Glasgow, who also had studied in Italy from 1764 until about 1775 or 1776. Allan had studied under Gavin Hamilton and had won a medal at the Academy of St Luke in Rome in 1773 with his *Origin of Painting* (Edinburgh), and he too had returned (at first to London) with aspirations to be a history painter. But he had abandoned this Utopian

desire by the time he finally settled in Edinburgh in 1780, where he found there was little desire for anything but portraits on the scale of life, conversation pieces, and occasional scenes of genre. Fortunately he had experimented with these lesser modes on a visit to Naples, where he had a letter to Sir William Hamilton. From 1775 date various versions of a conversation piece of 'Sir William and Lady Hamilton' (Earl Cathcart, etc.), and the first example of a genre scene from common life by a Scottish painter, the rather trivial 'The Uncultivated Genius' in the Edinburgh Gallery. But this picture is interesting as the ancestor of one of the most characteristic types of Scottish genre, of which Wilkie was the best exponent. While at Naples peasant types from Procida attracted Allan and he painted a few studies in oil of such figures and

many small watercolours, at Naples, Rome, and on his return through France, of characteristic local types of the sort which Wheatley had made popular with his *Cries of London*. Some of these, and typical scenes of common life in Rome and Naples, Allan exploited in a mixture of etching and aquatint, and he found a ready market for similar works of Scottish inspiration. These led on by natural stages to his illustrations to Allan Ramsay's pastoral, *The Gentle Shepherd*, by which Allan is best known today, and such works earned him the absurd title of the 'Scottish Hogarth'. His work is, in fact, pure rustic genre, without any overtones of satire or social, political, or moral preoccupations. But it is the ancestor of much of Wilkie, Carse, Lizars,

Geikie, and one of the most natural and un-affected types of Scottish genre, which never altogether found its counterpart in England. As a portrait painter Allan is less important. He is well represented in every aspect of portraiture at Hopetoun House, but his most pleasing works are naïve conversation pieces, in which he followed the tradition of Zoffany without ever becoming falsely modish. One of the most lively is 'The Family of Sir James Hunter Blair, Bart' [232] 1785, at Blairquhan, which is almost an anthology of the various *motifs* which can be used for large groups of children of this kind, and also shows the attenuated form in which aspirations to historical composition had to find their outlet.

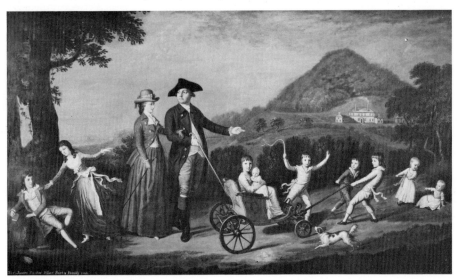

232. David Allan:
The Family of Sir James Hunter Blair, Bart, 1785.
Sir John Hunter Blair, Bt, Blairquhan, Ayrshire

SPORTING PAINTERS FROM WOOTTON TO STUBBS

After the portraits of himself, his wife, and his children the English patron of the eighteenth century liked best to have a portrait of his horse, and copies or engravings of portraits of famous horses or sporting scenes were in at least as great demand as portraits of the royal family or of popular heroes. But patrons were often less fastidious over the artistic quality of horse pictures than of human portraits, and the general run of sporting painting, although of absorbing interest to the social historian and to the student of the turf, is on a level with the work of those lesser portraitists whose achievements are passed over in silence in this book. To discuss the Sartorius tribe and such painters is no business of the historian of art, no matter how bitter the accusations of neglect are wont to be from those specialist writers who sometimes confuse the history of art with praising famous horses. The founder of sporting genre in England, Francis Barlow, was a distinguished painter in his own right; the Kneller of the field, John Wootton, made a valuable contribution to the British landscape tradition; George Stubbs was one of our great masters; and, after the period with which this book deals, Ben Marshall, who first emerges as a sporting painter in 1792, deserves a respectable niche in the history of British painting. The other figures who deserve mention are few.

The racecourse at Newmarket seems to have been the centre from which sporting pictures originated. The three founders of the school, Wootton, Tillemans, and Seymour, all worked there, and some of the most attractive early sporting pictures are panoramic views of Newmarket Heath with a string of horses. Such paintings are rather numerous, and, without the signatures, it is not always easy to tell a Wootton from a Tillemans. They show the first marriage of the topographical tradition of landscape with a sporting element.

John Wootton (d. 1756) was born early enough to have been a pupil of Wyck in the 1690s and to have assisted Siberechts in 1694. Wyck was a battle painter and Siberechts a specialist in a landscape style which was just beginning to break away from the topographical tradition. To this background Wootton himself added only a specialization in the painting of the horse, and, in the first reference to him among the Welbeck accounts, in 1714, he is described as 'ye horse painter'. He is very liberally represented at Welbeck and his horse portraits vary little in style from 1714 until the end of his career. The normal run is of pictures about 40 by 50 in., with the horse in profile, held by a groom, with a suspicion of a classic portico indicating a gentleman's stables at one side. Sometimes there are two grooms, sometimes a dog is added, sometimes a classical pot, but the formula is constant. Sometimes too the picture is life-size. From this basic type Wootton's other kinds of picture evolve – the sporting conversation piece, hunt groups, and so on. He was nearly as prolific as Kneller and prospered proportionately. Hounds also did not come amiss to his brush and, in his earlier years, he was not above doing a portrait of a lap dog. Sometimes he collaborated with Dahl (as in the 'Henry Hoare' 1726 at Stourhead) in doing the horse for a full-scale equestrian portrait. He was an adequate, but hardly a scrupulous, painter of the personality of individual horses and his best pictures are those in which his genuine bent for landscape could be given play. Two great series of sporting scenes, planned to be built into a hall as decoration, are at Longleat and Althorp, and the latter can be dated from a passage in Lord Egmont's diary around 1734. In such a scene as 'Leaving the Kennel' [233] at Althorp, Wootton appears as a good deal more than a sporting painter. He shows resource as a designer, a lively fund of human and animal

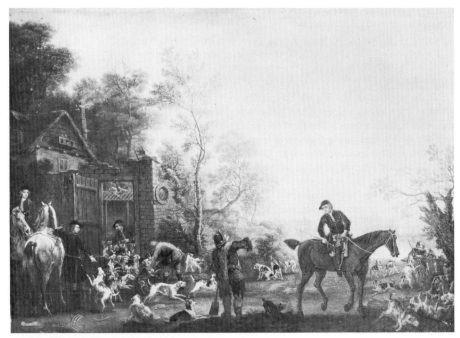

233. John Wootton: Leaving the Kennel, *c.* 1734.
Earl Spencer, Althorp, Northants

observation, as well as a sympathy with his subject. If he had been given much chance to exploit this sort of vein he might even have become a sort of sporting Hogarth. Wootton is in fact at his best when he is doing something different from the pure horse portrait, and late works such as 'George II at Dettingen' 1754 (Hopetoun House) have an extremely lively battle scene in the background, which shows that he must have learned much from Wyck and refined that knowledge with something of the spirit of Vandermeulen. A great many nondescript pictures pass undeservedly under Wootton's name, but his original work has always a considerable level of competence. His importance in the history of British landscape painting has already been discussed.

Peter Tillemans, who died in 1734, was an Antwerp painter who must have been somewhat younger than Wootton. Brought over to England in 1708, he was employed at first in hack copying of Old Masters and then graduated into being an antiquarian draughtsman. In 1719 he did about 500 drawings for Bridges's *Northamptonshire*. From this to doing views of gentlemen's seats was a natural step, and from topographical panoramas to enlivening them with strings of horses was another. In his later years he did many such views of Newmarket and he also painted horse-portraits in Wootton's manner, but usually with more daintiness about his treatment of the sitter on horseback, a quality which can best be expressed by noting that he was the first teacher of Arthur Devis. To sporting genre he contributed nothing new.

The third of the 'Old Masters' of sporting painting was James Seymour (1702–52), a gentleman with some personal experience of the turf and a gift for drawing. He must count to some extent as an imitator of Wootton, but his drawings of horses suggest a quality of interest in the personality of the animal which

Wootton did not have. He too settled at New-market and his interest, unlike Wootton's, was solely in horses and horse-painting. He is thus of more interest to the historian of the turf, and it may well be that his horses give a much more accurate account of the originals than Wootton's do. But as pictures his works seem merely rather amateurish and amusing imitations of Wootton. Certain examples are not common, but there is an important group in Lord Hylton's collection at Ammerdown[1] which probably covers the full range of his achievement.

Between this first generation and the generation of Stubbs and Sawrey Gilpin there is no connecting link. Horse paintings continued to be produced but no progress was made in the genre, which, though lucrative, was considered very low in the artistic scale. With Stubbs it rises to a level with the most distinguished achievements of British painting, although the struggle which both Stubbs and Gilpin made to have their art recognized as on a level of seriousness with the portrait painter's and history painter's was not crowned with success.

To classify George Stubbs (1724–1806) as a 'sporting painter', as was done in his own lifetime, has been habitual since, and is repeated for convenience in this book, is assuredly wrong. He has no links with the sporting painters of the generation of Wootton, he never painted at Newmarket, and horse pictures form only a part of his work, which embraces, in its affectionate study, man, the whole animal kingdom, and nature. His earliest passion was for anatomy, and he seems at first to have practised portraiture as a means of livelihood while pursuing his anatomical studies. Wigan (1744), Leeds, York (about 1746 to 1752), Hull, and Liverpool were the scenes of his early practice before he made a visit to Italy, in 1754, 'to convince himself that Nature is superior to all art'.[2] We know nothing of his paintings during these years, but he gave private lectures on human anatomy to the pupils in York Hospital in 1746, and he drew and etched the human embryo for a book on midwifery by Dr Burton of York, which was published in 1751. Instead of academies and the Antique he approached the study of painting through anatomy and this training isolated him from all his contemporaries in England. Another eccentric trait for an eighteenth-century character was that man was much less the centre of the universe for him than a mere element in the animal kingdom, and he was absorbingly interested in wild animals of all kinds and especially in the horse. Trees and plants also received the same loving attention. One can imagine the kind of superior criticism from some Italian-travelled face painter which must have exasperated this unspoiled student of the natural sciences into visiting Italy to see for himself that there was no need for him ever to have gone there! On this journey too he is said to have visited Morocco and to have seen a lion attack a frightened horse, an incident which laid the foundation for his interest in dramatic animal-history pictures. That he found horses to be preferable to human beings seems probable, and I cannot but suppose that he found encouragement for this view in some of the pictures of Albert Cuyp, which are the only artistic antecedent to which one can point. The dwarfing of his human figures by comparison with his horses, the emphasis on the noble characteristics of the beast, and the setting of it against an expanse of sunny sky and landscape (often of a kind unsuited to the training of race-horses) all point to Cuyp as a formative influence. But Stubbs is not recorded ever to have mentioned the name of Cuyp. Soon after his return from abroad he went to Lincolnshire, where his earliest known portraits are to be found at Scawby, and during 1758 and 1759 he was engaged in making the drawings for a great work on *The Anatomy of the Horse*, in a remote Lincolnshire farmhouse, where he lived in studious discomfort with the animals he was dissecting. These drawings were finally published in 1766, and it was this astonishing and monumental work, rather than any connexion with the turf, which – ironically enough – established Stubbs's reputation as a 'horse painter', and gradually forced him to take, in the hierarchy of fashionable art, a place below those who painted human beings with a complete disregard for their anatomy.

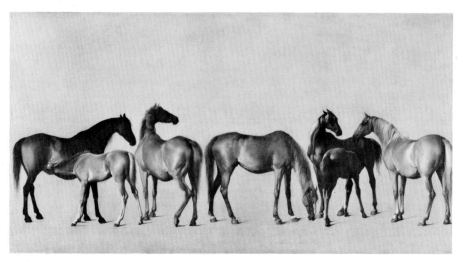

234. George Stubbs: Brood Mares and Foals.
Earl Fitzwilliam, Milton Park

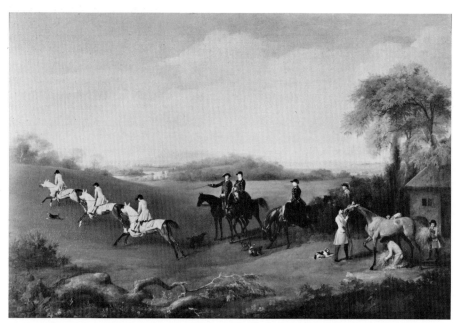

235. George Stubbs: The Second Duke and Duchess of Richmond watching Horses exercising, *c.* 1760/1.
Duke of Richmond and Gordon, Goodwood, Sussex (Copyright Country Life)

In his work and drawings for *The Anatomy of the Horse* Stubbs places himself among the great natural scientists England has produced, for it is not altogether beside the mark to liken his work on the horse to what Vesalius had done for human anatomy. At the end of his life, from about 1802 onwards, Stubbs was engaged on *A comparative anatomical exposition of the structure of the human body with that of a Tiger and Common Fowls*, which was never completed, from which it is plain that the leading interests of his life remained unaltered. But the eye of the anatomist and the eye of the artist are not altogether at one, and it is sometimes a fair criticism of Stubbs's pictures that the artist yields to the anatomist. His animal figures will be beautifully and accurately drawn, his trees and foreground weeds will command admiration from the botanist, and there will be a charming landscape. Yet everything is not pulled together so as to produce the effect of a single act of vision. From uncompleted pictures such as the frieze of 'Brood Mares and Foals' [234] (Earl Fitzwilliam) we can see Stubbs's method. He concentrated first on the single figures of horses and arranged them in a lovely and flowing arabesque – and then the landscape would have been laboriously inserted, piece by piece, between the legs. For what he could see with a single look Stubbs had the artist's eye, but there were limits to his creative imagination – as is proper for an anatomist – and some of his arrangements of wild animals, such as the huge 'Lion slaying a Buck' and 'Lion seizing a Horse' (Paul Mellon collection), have too much the air of habitat groups in a natural history museum.

After his labours on *The Anatomy of the Horse* were completed, about 1759, Stubbs settled in London and practised as a painter. He started exhibiting with the Society of Artists in 1761 and our knowledge of his painting begins about this time. Three large pictures at Goodwood – which date from about 1760/1 – show the maturity and novelty of his work at this period. The finest is 'The Second Duke and Duchess of Richmond watching Horses exercising' [235],

which is almost an anthology of his various abilities. Horses and dogs and human beings are portrayed with equal sympathy and affection, as well as trees and the broader aspects of English landscape. The lovely group of the horse being groomed at the right has a rival in English painting only in the freshest of Gainsborough's Suffolk landscapes, such as the pictures of 1755 at Woburn, and Stubbs reveals something of the same feeling for musical rhythm in the natural grouping of figures. Yet the composition as a whole tends to fall to pieces and is rather an assembly of fragmentary felicities. Much of Stubbs's finest work was painted between 1762 and the foundation of the Academy in 1769, conversation pieces (with or without horses), some studies of wild animals, and the most splendid of his large horse portraits, the life-size 'Whistlejacket' (receipt dated 1762) lent by Earl Fitzwilliam to Kenwood. Yet because he was considered to belong to that lowly genre of 'sporting painters', Stubbs did not become a founder-member of the Royal Academy. The three painters of real distinction whose work illustrated the exhibition of the Society of Arts, after the defection of the Academicians, in 1769, were Stubbs, Wright of Derby, and Zoffany. Stubbs's intellectual affinities are in fact closer with Wright of Derby than with any other painter. Both had a profound interest in the natural sciences and both, in later life, had professional relations with Wedgwood, one of the first scientific industrialists to seek the co-operation of serious artists in industrial production.

The effect of his exclusion from the Academy was to make Stubbs exhibit at the Society of Arts in 1770 only pictures which were not of a sporting kind. He showed a 'Hercules and Achelous' (a history subject in which it was proper to include a bull), a 'conversation', a 'repose after shooting', and the first of his pictures in enamel, a 'Lion devouring a Horse'. The 'conversation' seems to have been the 'Melbourne and Milbanke Families' (National Gallery, London) [236], in which it must be admitted that there are three horses and a dog;

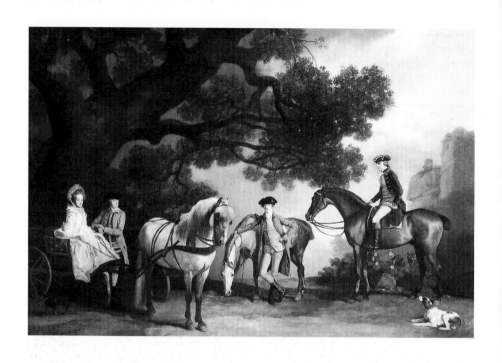

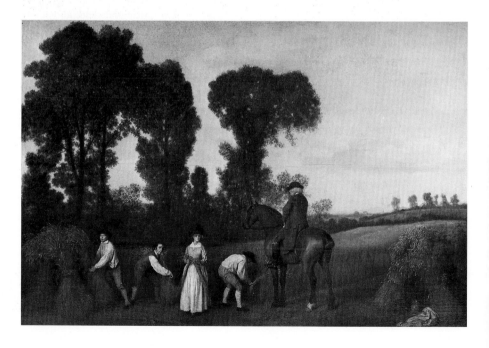

yet the picture counts as one of the most satis-
factory English group portraits of the century.
One of Stubbs's great qualities, which no doubt
militated against his success, was that he had no
eye for fashion at all. He saw human beings of
all degrees at their best when they were affec-
tionately associated with animals, and he shows
us as a result the rural life of the English gentle-
man as no other painter succeeds in showing it,
and the gentle rhythm of his designs, with their
slow curves, makes the ideal formal language
for this revelation.

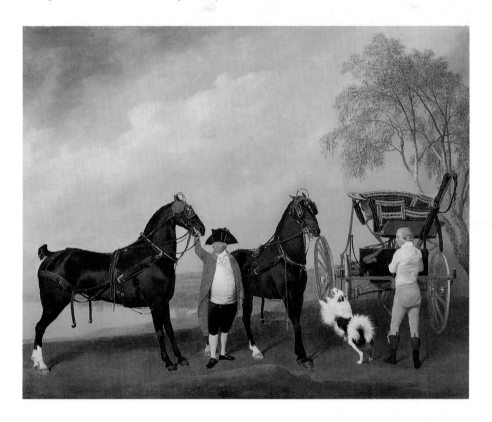

236 (*opposite above*). George Stubbs: The Melbourne and Milbanke Families, 1770. *London, National Gallery*

237 (*opposite below*). George Stubbs: The Reapers, 1783. *National Trust (Viscount Bearsted), Upton House*

238 (*above*). George Stubbs: The Prince of Wales's Phaeton, 1793.
Windsor Castle (by gracious permission of Her Majesty the Queen)

From 1770 onwards he started to experiment in the use of enamel colours on copper, and, by 1778, Wedgwood had managed to produce china plaques of considerable size which were suitable for the same pigments. This technique gives a smooth gloss and polish to some of his later works, even on canvas, which is rather distasteful by modern standards. It was at this time, and at first for these china plaques, that he designed his rustic idylls, but he repeated them, with a greater breadth of feeling and a fuller range of tone in the shadows, on panel or canvas. This can be seen by comparing 'The Reapers' on china at Port Sunlight, with the version on panel of 1783 at Upton House [237]. The former is hardly more than gay and pretty; the latter has something of the mood, mystery, and poetic feeling of early Wordsworth. Stubbs's achievement in this kind of picture is very like that of Cuyp: the simple and veracious study of men and animals in a rural scene, as the faintly melancholy shadows of evening descend, conveys a hint of tears, and this feeling is echoed in a masterly way by Stubbs's use of the formal elements of picture-making.

Throughout his life Stubbs made pictures of any wild animal he had an opportunity of studying. Lions and tigers were his favourite subjects – after horses – but he painted sheep and cattle also and a zebra, a moose, a cheetah, and a monkey as the occasion offered. In the 1790s he enjoyed the patronage of the Prince of Wales, and, in certain pictures of the royal horses and servants – such as 'The Prince of Wales's Phaeton, with the State-Coachman, a Stable Boy, etc.' 1793 [238] – Stubbs contrived to paint a picture which showed his opinion of the relative importance of men and animals. It is a picture more in the Chinese tradition than in that of eighteenth-century Europe, and has, more than most, that quality of strangeness which lifts many of Stubbs's pictures from the category of 'sporting art' into the realm of the poetry of creative observation. For imagination and a sense for the 'grand style' were equally lacking to Stubbs, and for this, in his own day, he was not forgiven. Cuyp also sometimes thought horses superior to men.

Only one other horse painter, Sawrey Gilpin, deserves to be considered as something more than a painter of 'sporting pictures', but two who were sporting painters and nothing more deserve mention as followers, to some extent, of Stubbs. Benjamin Killingbeck, probably a Leeds artist, who exhibited in London from 1769 to 1789 and had begun as a portrait painter, seems to have been considerably influenced by Stubbs when he was working at Wentworth Woodhouse, and, after Stubbs had quarrelled with Lord Rockingham, the latter turned to Killingbeck for portraits of his horses. One, dated 1776, is worthy of a follower of Stubbs, but such later examples as I have noted show a falling off which suggests that Killingbeck would not repay study. John Boultbee (1753–1812)[3] was a more serious painter from a respectable Leicestershire family and first exhibited in London in 1775. He does not seem to have been a direct pupil of Stubbs, but, during the 1780s, the influence of Stubbs is strong on him, the slow curves of his pattern and the rather hazy distances. Such horse pictures as 'Pagan and Monarch' 1784 at Althorp suffice to indicate the prevailing influence Stubbs's art had on the professional horse painters before the emergence of Ben Marshall in the 1790s.

Sawrey Gilpin (1733–1807), like Stubbs, was not specifically trained to be a horse painter. He came of a good family in Cumberland and was a brother of that eminent authority on the Picturesque, the Rev. William Gilpin. In 1749 he came to London and was apprenticed to Samuel Scott, the landscape and marine painter, with whom he remained until 1758. It is said that his market studies attracted the attention of the Duke of Cumberland, who took him under his patronage, and it was in the Duke's stud that he first devoted himself to horse painting. Although lacking altogether Stubbs's detailed knowledge of the horse's anatomy, Gilpin had a good eye for nature and he liked lively movement in horses, whereas Stubbs preferred repose. With his training under Scott, Gilpin also was more experienced than Stubbs in marrying his animals with the landscape and giving the whole picture an air of unity. The

Duke of Cumberland's horses provided him with the material for his first elaborate compositions, and 'King Herod's Dam, with all her Brood, employed according to their Ages' (Society of Artists 1765), now at Scampston Hall, is a remarkable achievement. It contrives to make a lively picture, in an agreeable landscape, out of subject matter which is primarily an equine genealogical tree. Composition, of the academic kind to which Stubbs was almost a stranger, came naturally to Gilpin, and he, even more than Stubbs, must have been irked by the mean position accorded to the sporting painter and by not becoming a founder-member of the Academy. Even before the Academy was founded Gilpin had sought to elevate horse painting by an admixture of history (as Reynolds was doing to portrait painting), and the outcrop of horse-history pictures during just these years was no doubt a bid for proper recognition. Between 1768 and 1772 Gilpin painted three histories of 'Gulliver and the Houyhnhnms'

(Southill, York, and Mellon collection) and in 1769 he showed a sketch for 'The Election of Darius' [239], which was the result of the neighing of his horse. He later painted this picture on a large scale (York Gallery) in which something of Scott and Marlow's style is blent with a figure style which suggests Luca Giordano. But Gilpin had to wait until 1795 before he became A.R.A. (he became R.A. in 1797). By then he had painted dramatic pictures in the Snyders vein like 'The Death of the Fox' (1793), which have the advantage of a naturalistic liveliness over Stubbs's dramatic animal-histories although they look flimsy beside them. Gilpin's pictures are always the work of an artist (which cannot be said of some of the lesser sporting painters of the time) and they are more vivacious than much of Stubbs, but Gilpin was much the lesser man. It was from Gilpin's style, however, that Ben Marshall and James Ward took the first elements of their art, which they were to adapt to suit the landscape style of the next age.

239. Sawrey Gilpin: The Election of Darius, 1769. *York City Art Gallery*

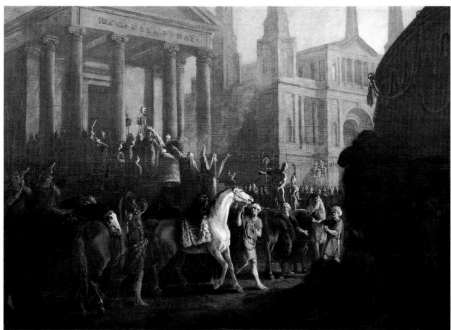

ROMNEY, AND FASHIONABLE PORTRAITURE

George Romney (1734-1802) is accepted by common accord today as next after Reynolds and Gainsborough of the portrait painters before the age of Lawrence. This is a just estimate, and we may fairly place Romney on an isolated and lesser eminence midway between the greater heights of Reynolds and Gainsborough and the lower position of Hoppner and Beechey. Like Gainsborough, Romney was always complaining about the drudgery of face-painting, and we have the evidence of Flaxman (who became his friend only in later life) that 'his heart and soul were engaged in historical and ideal painting', yet there is little to show for this save a mass of drawings for high-flown compositions, mostly in the Fitzwilliam Museum at Cambridge or at Yale, and one or two unsatisfactory pictures for Boydell's Shakespeare Gallery of 1787 onwards. These represent the aspirations of the shadowed side of Romney's life, and we know that he was nervous, introspective, unsociable, and took no part or apparent interest in the larger concerns of the world. Yet, by a curious irony, these very defects of character helped him to become the most successful of fashionable portrait painters. A 'fashionable' portrait painter is not one who, like Reynolds at his best, penetrates into the character of his sitter and forms a personal estimate of his position in the world of politics or society; nor one, like Gainsborough, who could impose his own artistic fantasy upon persons of a very slender personal character: it is one who brings forward all those neutral qualities which are valued by society – health, youth, good looks, an air of breeding, or at least of the tone of the highest ranks of the social scale. No strong likeness is wanted by such sitters, and the artist who succeeds with them must have little curiosity into the secrets of personality. Romney, who seems to have shunned personal contact with most of his

sitters as much as he shunned the risk of criticism by exhibiting his works, had the exact qualities of temperament which were required. Add to this that his prices always remained lower than those of either Reynolds or Gainsborough, that he was very sensitive to good looks in both sexes, and that he had a fine and easily recognizable sense of pattern, and you have the ingredients which made for his success. He was also, like his rivals, a prodigiously hard worker and had the ambition to succeed.

Romney was unlike Reynolds and Gainsborough in two things in particular. There are no overtones, either of character or sensibility, about his portraits, and he achieved his patterns predominantly by line. The flowing curves and easy poses of classical sculpture (of the Roman period) are at the back of all his best designs, and it was characteristic of him that, when passing through Genoa in 1773, he should write that the Genoese women's costumes 'produce the most elegant flowing lines imaginable'. He also had a very good eye for the placing of the figure in the canvas space so as to give it the greatest importance possible, and a number of his experiments in this way approach more closely to the patterns of the society photographer of today than to the paintings of his contemporaries. A portrait such as the 'Samuel Whitbread' 1781 in the Provost's Lodge at Eton has this quality in a high degree, and the truth is that Romney, as a portrait painter, had the dispassionate eye of the camera in expert professional hands, who know that the instrument cannot lie but are not concerned in making it tell the truth.

Romney was the son of a Lancashire cabinet-maker and was apprenticed to a travelling portrait painter named Christopher Steele from 1755 to 1757, when he set up on his own in Kendal. Steele is said to have been a pupil of Vanloo and the two portraits by him that I have

seen are far from contemptible. They are neat and hard and crisply drawn, neither gauche nor provincial, and stylistically related to Highmore. Romney's own earliest portraits, between 1757 and his moving to London in 1762, are not unlike harder and provincial variants on Highmore and they are less accomplished than the work of Christopher Steele.

On first coming to London the young painter, in 1763, won an award from the Society of Arts with a 'Death of Wolfe', which one assumes to have been in classical costume, but he soon settled down to portraiture. His first London period, which lasted until his visit to Italy in 1773, seems to have been devoted to acquiring the linear rhythms of classical drapery, and it is likely that the collection of casts at Richmond House was his principal source for this knowledge. In the ambitious works of this period (the only time when he exhibited his work in public) the figures are of unduly elongated proportions, and 'Sir George and Lady Warren and their Daughter' (Society of Artists 1769) and 'Mrs Yates as "The Tragic Muse"' (Society of Artists 1771) are rather pretentious essays in the Antique with contemporary models. The same characteristics appear more agreeably in the small 'The Artist's Brothers' 1766 [240]. It is significant that, on a brief visit to Paris in 1764, he should have admired Le Sueur above all others. He had not yet seen Raphael, and it is understandable that Le Sueur's use of the Antique should have seemed to him to come nearer to his ideal than anything he had hitherto seen. One of the maturest works of this period is 'Mr and Mrs Lindow' 1772 (Tate Gallery), in which the papery quality of the folds suggests a blend of the classical with the style of Francis Cotes. It was the mantle of Cotes (who had died in 1770) that Romney was to inherit when he returned from Italy in 1775.

Romney's two years in Italy, 1773-5, were passed mainly at Rome, although he spent some months studying Titian at Venice. He copied many figures in the 'Stanze' of Raphael, and it was this direct experience of the Antique and of Raphael which matured him as an artist, gave that sense of poise to his figures, and smoothed

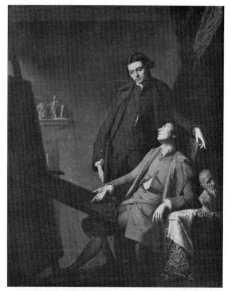

240. George Romney: Peter and James Romney, 1766. *Yale Center for British Art, Paul Mellon Collection*

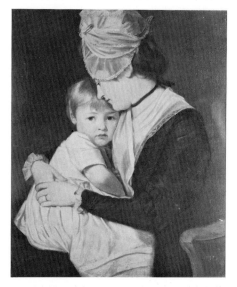

241. George Romney: Mrs Carwardine and her Son, 1775. *Lord Hillingdon, Messing Park, Essex*

out his draperies so that they no longer seem carefully arranged but fall in natural and graceful lines. This transformation from the groping to the mature is apparent in what was almost the first portrait he painted on his return, the lovely 'Mrs Carwardine and her Son' 1775 [241], in Lord Hillingdon's collection. Romney never surpassed, perhaps later never equalled, the best of his works in the years 1775–80, while he was still fresh from his Roman experiences, and this portrait is the most direct expression of his indebtedness to Raphael, freely based as it is on the 'Madonna della Sedia'. In this case he was painting the family of a friend, with a more intimate feeling than was common for him, and we can discern perhaps what might have been Romney's stature had he not been content, or temperamentally compelled, to become a fashionable portrait painter. Serious demands were not often made on his compositional powers, but when they were – as in the 'Children of Earl Gower' of 1776/7 (Art Gallery, Kendal) – he produced a masterpiece.

In 1776 he took a lease of the fine house, with its painting-room, in Cavendish Square that had been Cotes's and he remained there until his final retirement to Kendal, when he sold the lease to Martin Archer Shee, who was to fulfil, in relation to Lawrence, the same sort of position that Romney filled in relation to Reynolds.

Romney's work, from 1776 onwards, is as well documented as that of Reynolds.[1] We have most of his ledgers and his sitter books, and even his accounts with his frame-maker. He maintained an even level of accomplishment in his best work up to the middle of the 1780s, when his nerves and his powers began to flag. To some his powers seem to decline from 1781, when he first came into contact with Emma Hart (later to become Lady Hamilton), who exercised an almost hypnotic fascination upon his imagination, but a study of his dated work does not agree with this hypothesis. Seen in bulk his work is rather monotonous, since Romney's mind did not enlarge, nor did he seek further refinements and perfections in the art of portraiture as both Reynolds and Gains-

borough did in their later years. But his colour is always strong and clear and sound, and the surface of his paint has stood up much better to the action of time than the experiments of Reynolds or Gainsborough's subtleties. He is at his best with people in the bloom of youth and health, with fine clothes and fine looks, young men about to leave Eton and young ladies first flowering upon the world and society. Of the Eton leaving portraits 'Earl Grey' 1784 [242] is as handsome as any, posed in a convention of

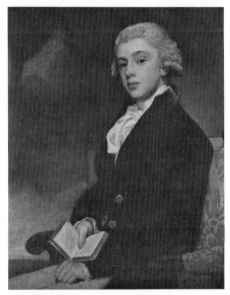

242. George Romney: Earl Grey, 1784.
Eton College, The Provost's Lodgings

which Romney was fond, as if seen both in the studio and against a summer sky. A young woman's portrait of the same date, and with the same arresting quality, is the 'Hon. Charlotte Clive' (Earl of Powis), whom one would take for an ancient divinity who has strayed into society. The awareness of 'society' is always there in Romney, in the look, in the conscious gracefulness of the pose, or in the movement of the arms. A comparison of what can be considered Romney's later masterpiece, 'Sir Christopher and Lady Sykes' 1786 (Sledmere) [243],

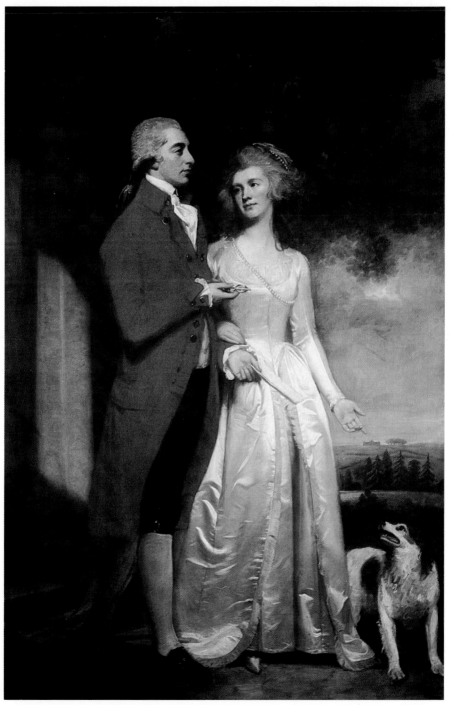

243. George Romney: Sir Christopher and Lady Sykes, 1786. *Sir Richard Sykes, Bt, Sledmere, Yorks*

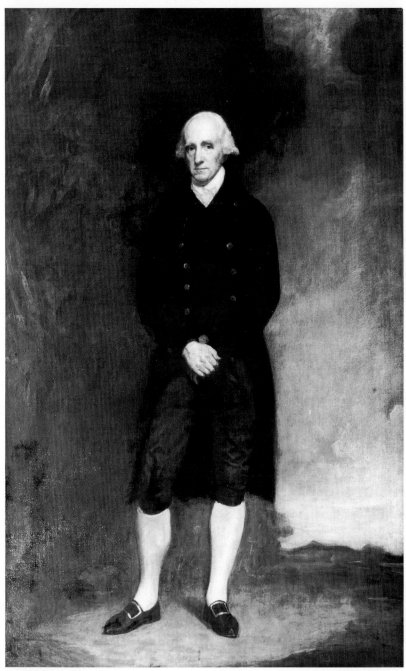

244. George Romney: Warren Hastings, 1795.
London, India Office Library and Records (by permission of H.M. Government in U.K.)

a picture known as 'The Evening Walk', with Gainsborough's 'Morning Walk' [203] is illuminating. The figures are Roman statues in modern dress, but with gestures more momentary and less eternal than ancient statues. They have an air of consequence and of the height of fashion which Gainsborough's beings lack; they could never be taken for anything but the portraits of individuals, while Gainsborough's figures can stand for the image of young love.

In Lady Hamilton Romney found his own equivalent of what Gainsborough had found in his little beggar children, the visible realization of his dreams of an ideal world, and Romney's pictures of her of the 1780s are his equivalent to the fancy pieces Gainsborough was painting during the same years. There must be half a hundred pictures of his 'divine Emma', some made from direct sittings, some from drawings, and some from memory. She is Circe, she is Calypso, she is Alope, or a Bacchante, or à Magdalene, or Contemplation. The character parts which Romney selects for her show the nature of his infatuation. Oddly enough she is hardly ever what one would call 'a lady', and it may well be that the pictures of Lady Hamilton are something in the nature of an escape from the tyranny of for ever painting sitters who had to be made to look like ladies and gentlemen. Whatever the truth, these fancy pictures are not, as Gainsborough's are, one of the glories of British art, and, for the student of Romney, in spite of their past expensiveness, they have rather a clinical than an aesthetic interest.

It is customary to dismiss Romney's last years with something like contempt, and it is true that his fashionable portraits of these years show a great falling off. Yet unhappiness seems to have given him for the first time something of a perception of mature character and the 'Warren Hastings' of 1795 (India Office Library) [244] is a noble and serious portrait. But it was a final flicker and Romney retired to Kendal in 1798 a broken man and an invalid, and died there four years later.

Nearest to Romney in the broad, flat, planes of his modelling and in the linear clarity of his English period was Gilbert Stuart (1755–1828). Born at Narragansett, Rhode Island, Stuart is the last of the American painters that need be considered, for, although many more came to England to become pupils of Benjamin West, the only one of them who settled and made any mark in London for a time was Washington Alston, who belongs wholly to the generation of the Romantics. Unlike West and Copley, Stuart returned to the United States (in 1793) to become the leading portrait painter of his own country.

Although Stuart's American style can hardly be said to belong to the history of British painting, we cannot understand him without taking it into account, for it seems to have developed the moment he returned to America, and this instinctive adaptation to the requirements of patronage suggests a mind of considerable awareness. Stuart's New England style has something in common with Raeburn's Scottish idiom, but his lighting is less theatrical. He prefers a short bust, often cut with deliberate awkwardness, no hands, and a strong concentration on the character and likeness of the face. West had already said, in the early 1780s, that Stuart *nails* the face to the canvass', but his portraits of English and Irish sitters, who had no desire for such a strong likeness, hardly give that impression. During his English period, therefore, we must consider that Stuart showed his genius only in a muted form, calculated to the requirements of his patronage.

Stuart's first contact with European painting was a few months with Cosmo Alexander in Edinburgh, before the latter's death in 1772, but he returned almost immediately to New England and sailed for London in June 1775. He entered West's studio as an assistant in 1777, but was free to do portraits on his own, as he first exhibited at the Academy of that year. In 1782 he set up on his own and is reported by a contemporary as having 'had his full share of the bust business'. Extravagant living caused him to escape from his creditors to Ireland *c*. 1787/8, where he also did good business (and lived very extravagantly) until his return to America in 1792/3. But Stuart's style is not,

even technically, dependent on West. His handling of paint is much more accomplished and his key of colour much gayer. It is difficult to suppose that he did not study Romney and he must certainly also have studied the portraits of Copley. His own portrait of 'Copley' (National Portrait Gallery) [245], of about 1783/4, is characteristic of the best work of his London period, a strongly lit, broadly modelled bust

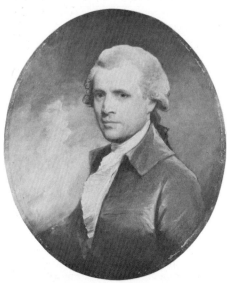

245. Gilbert Stuart: J. S. Copley, c. 1783/4.
London, National Portrait Gallery

against a romantic sky. Ovals of this kind were the 'bust business' in which he specialized and the best surviving group of them is the half-dozen, ranging from 1781 to 1786, at Saltram. With a knowledge of Stuart's New England style we can read backwards into these the strong sense of character and likeness which Stuart has been at pains to under-emphasize. To show that he was not (as his detractors had alleged) incapable of drawing the human form below the waist, Stuart exhibited at the Academy of 1782 the full-length of 'Mr Grant, skating', now at Washington, which was a brilliant success. But most of his rare full-lengths are dull things, for Stuart could not im-

part the feeling of life, which it was natural for him to concentrate in the face, over the rest of the human form. The most ambitious of his English works is 'The Percy Children' of 1787 at Syon House, which is altogether in the style of Copley, but without Copley's liveliness.

The next portraitist in public repute after Romney is John Hoppner (1758-1810), who admittedly had a large name in his own day, but the recent fashion for him is due chiefly to assiduous puffing by the art trade early in this century and to the childlike desire of the very rich in that far-off age of collecting to fill their houses with portraits of beautiful women and lovely children. He had enough personal style usually not to leave any doubt as to whether a portrait is by him rather than by another, and yet he is for ever reminding us of the work of one or other of his greater contemporaries, at first of Reynolds and Romney, and later of Lawrence and Raeburn. He told Danloux that he kept a picture by Gainsborough in his studio as a model, and he bought some half-finished portraits at Romney's sale. He veered backwards and forwards between these rival influences, for – to take examples only from his best pictures – while Lord Dartmouth's 'Lady Charlotte Duncombe' of 1794 is entirely in the vein of Lawrence, the 'Lady Elizabeth Bligh' (Royal Academy 1803; formerly Alvan T. Fuller) might be mistaken for a Reynolds. He is best in half-lengths, or in groups of children, for which he had a certain flair, for his full-length ladies are little more than torrents of white muslin without form or shape.

A pupil at the Royal Academy schools in 1775, Hoppner first exhibited in 1780, and there can be little doubt that his earliest works, from the 1780s, in which he combined something of Reynolds's facture with Romney's feeling for large pattern, are his best. Unexpectedly he is well represented in the National Collections. The 'Princess Mary' (Royal Academy 1785) [246] at Windsor and 'Sir M. W. Ridley' c. 1786 at Blagdon represent about the peak of his achievement, and the former is a really very astute combination of elements taken from Reynolds and Romney. But every one of

246. John Hoppner: Princess Mary, 1785.
Windsor Castle
(by gracious permission of Her Majesty the Queen)

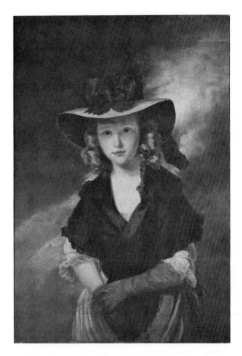

Hoppner's borrowings and combinations is contrived because it was calculated to please the flashy taste of those circles whose centre was the Prince of Wales. He had his reward, for in 1789 he was appointed Portrait Painter to the Prince of Wales, though he did not become A.R.A. until 1793 and R.A. until 1795. Happily death carried him off in time for the Prince, whose taste had matured, not to be too late to give his patronage to Lawrence. Lawrence's portraiture has given to the Regency and to the reign of George IV a *cachet* without which they would have cut a much poorer figure in history. Hoppner himself was attaining something nearer sobriety of style in his last years, as well as a more individual distinction, for his 'Earl Spencer' of 1808 at Althorp almost for the first time does not remind us of any other painter – or at least Hoppner has gone back to the Old Masters for strength rather than to his contemporaries. But the success of the portrait is a *tour de force* in spite of bad drawing.

Hoppner's chief rival – if we omit Lawrence – was Sir William Beechey (1753-1839) who was a better draughtsman and a more conscientious painter. But he is deadly dull. This praise-worthy dullness stood him in good stead, for, while Hoppner suited the flashy taste of the Prince of Wales, Beechey's stolid prose was more agreeable to Queen Charlotte and he was made Portrait Painter to the Queen in 1793. Beechey studied in the Academy schools in 1772 and first exhibited in 1776. He is said to have been a pupil of Zoffany and he began with small-scale full-lengths in Zoffany's manner, but painted as if by a pupil of Reynolds. The few of these which have been traced are pleasing and original. From 1782 to 1787 Beechey was settled at Norwich and painted the Norfolk gentry and his sound, provincial, unfashionable

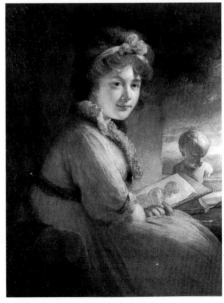

247. Sir William Beechey: Princess Mary, 1797.
Windsor Castle
(by gracious permission of Her Majesty the Queen)

style is well represented by the 'George Maltby' of 1785 in the Hall of Durham Castle. It is much more solid and respectable than his attempts at pleasing London taste after he had settled there in 1787. Half a dozen portraits of the children of the Duke of Buccleuch (at Bowhill) show Beechey in 1789 and have something of the uneasy charm of the newcomer from the country after the first impact of the London fashions. But, by 1791, when he exhibited the 'Dashwood Children' (Toledo, Ohio), Beechey had arrived at his final style, which was modified only by the increasingly ugly fashions of the next fifty years. His roots always go back to the age before Lawrence and his respectable prose was always a counterweight to the more fancy style, first of Hoppner, and later of Lawrence. We may compare with Hoppner's 'Princess Mary' [246] Beechey's portrait of the same sitter (Royal Academy 1797) [247] at Windsor. It is modest and gentle and unassuming and has all those domestic virtues which the royal family (other than the Prince of Wales) appreciated.

Between them Hoppner and Beechey show the two opposite sides of the pre-romantic tradition in its last phase, and Beechey, who answers to Dahl a hundred years earlier, carried on the tradition for persons who preferred the old modes until after Lawrence's death. The other portrait painters of the early nineteenth century, Shee, Owen, Harlow, and Jackson, all belong to Lawrence's following. Often distinguished in half-lengths, their pursuit of an elegance of which Lawrence alone held the knack gives an unfortunate quality to most of their whole-length portraits, which Haydon neatly summed up by calling them the 'tip-toe school'.

One of the lesser rivals of Beechey who deserves not to be omitted – perhaps because his portrait of 'Lord Nelson' and one or two others have become well known from engravings – was Lemuel Francis Abbott (c. 1760–1802). He came to London early in the 1780s, and, from about 1788 until he went mad in the later 1790s, he had a considerable vogue, especially in naval circles, and his bust portraits have distinct individuality. When he essayed the human form below the waist he was less a master. Good work by him can be seen at the National Portrait Gallery and at Greenwich.

ZOFFANY: THEATRE GENRE AND LATER CONVERSATION PIECES

The class of picture which can be called the 'theatrical conversation piece' was rare before the 1760s, when Garrick seems to have become alive to its advertising possibilities. A 'theatrical conversation' is by no means merely a scene from a play: it shows certain well-known actors in parts for which they were famous and its rise to popularity coincides with a change in the social position of actors, just as the conversation piece proper had appeared with the emergence of the prosperous middle classes. Although Richard van Bleeck had painted stage scenes, no actor was identifiable in them, and Hogarth's 'Beggar's Opera' picture, of 1728/9, which can be called the ancestor of the genre, was famous mainly because it combined the drama on the stage with drama in real life, and showed the young Duke in the box who ran away with the heroine. Hayman's Shakespearean scenes are also usually unconcerned with particular actors, and it is probable that it was Pieter van Bleeck (1697-1764), the son of Richard, who first introduced the genre. A large and gloomy picture in the Garrick Club of 'Griffin and Johnson in *The Alchymist*' was engraved by Van Bleeck himself in 1748, with the statement that it was painted in 1738, but a far finer, and rather later, example is 'Mrs Cibber as "Cordelia"' (Paul Mellon Collection, Yale: engraved 1755).[1] This and Hogarth's 'Garrick as "Richard III"' are both large pictures and have little of the stage about them and nothing of the conversation piece. The marriage of the two genres was due either to Zoffany or to Benjamin Wilson.

Benjamin Wilson (1721-88) is an elusive and unsatisfactory figure. A native of Leeds, he is said to have been a pupil of Hudson, and he was at first equally addicted to painting and to scientific experiment. After two years in Dublin he settled in London in 1750 and was in a good way of business as a portrait painter for the next twenty years. To contemporaries his vaguely Rembrandtesque use of chiaroscuro seemed a sign of the new age, and as late as 1759 he seemed to some to be superior to Reynolds. His signed and dated portraits on the scale of life are not numerous but enough exist, ranging in date from about 1752 to 1769, for us to feel sure that he was a thoroughly bad painter. The curious can see examples in the Leeds and Dulwich Galleries. In spite of this the art trade and its satellites have in recent years attached his name to a number of conversation pieces and small-scale portraits of undoubted elegance which are obviously not by Zoffany. I have not found a shred of evidence that any of these are by Wilson and do not believe it. None the less he seems to have been a pioneer in the theatrical conversation piece in the 1750s. In 1754 there was published an engraving after his 'Garrick as "Hamlet"' (a single figure), later came a 'Garrick and Mrs Bellamy in *Romeo and Juliet*' (Paul Mellon Collection, Yale), and in 1761 a conversation of 'Garrick as "King Lear"' was also engraved. It is possible that the execution of the last of these may have been due to Zoffany, who was kept by Benjamin Wilson in his house as a sort of unseen painter's 'devil', but the evidence is conflicting and obscure. What is certain is that Zoffany freed himself, with Garrick's assistance, from some unsatisfactory arrangement of this sort with Wilson about 1761, and Wilson painted no more theatrical conversations. From about 1770 Wilson devoted himself more and more to experiments into the efficiency of lightning conductors, and strays out of the purview of the historian of art.

Whatever the truth about his early connexion with Benjamin Wilson, Johann Zoffany or Zauffelij (1733-1810) was the real creator and master of this genre. A native of Frankfurt, he seems to have spent a long period in his youth copying Old Masters in Rome, and he arrived in England within a year or two of 1760 with a

neat, polished, highly finished German style and a tendency to the lively and minute imitation of natural objects in the vein of the Flemish little masters. It is probable that his introduction to the genre of theatrical conversation pieces came while he was working as drapery painter to Benjamin Wilson, but it is a reasonable hypothesis that the inventor of this genre was Garrick himself, who was a close friend of Wilson. Garrick was the first of the great actor-managers with a real flair for publicity and he saw how pictures of this character, popularized by engravings, would be the best publicity in the world. Certainly our continued awareness today of Garrick as a vital and living personality is largely due to his relations with artists, and not least to Zoffany. By a happy arrangement of Providence, Garrick discovered in the young

man working in Benjamin Wilson's studio an artistic talent of limited capacity which was almost perfectly suited to his purpose. The details of the transaction are obscure, but it is certain that, in August 1762, Zoffany, who had lately exhibited his first theatrical conversation, had escaped from Wilson and was living in Garrick's house. Eight of Zoffany's works were in Garrick's possession at his death, mainly theatrical conversations, but some of them views of his villa and domestic conversation pieces.

The first of these theatre pictures was exhibited at the Society of Artists in 1762 and showed 'Garrick in "The Farmer's Return from London" ' [248], of which at least three versions are known, but the first original, which was Garrick's, belongs to Lord Lambton. Its novelty

248. Johann Zoffany: Garrick in 'The Farmer's Return from London', 1762.
Private collection

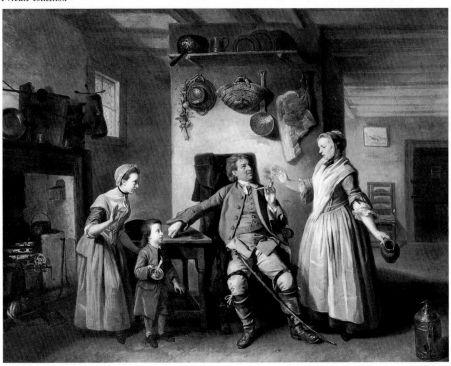

and its immediate success, and the reasons for that success, can be gauged by Horace Walpole's remark in his copy of the 1762 catalogue: 'Good, like the actors, and the whole better than Hogarth's.' Walpole is not referring to Hogarth's theatre pictures (such as *The Beggar's Opera*) but only to an etching by Basire after Hogarth, which served as a frontispiece to *The Farmer's Return* (1761). This illustrates the same moment in the play, and is exaggerated and generalized.

This picture was followed in 1763 by an illustration of Garrick in a tragic role, 'Garrick and Mrs Cibber as Jaffier and Belvidera' (Lord Lambton), and Zoffany continued later with pictures of other actors in other plays. The theatrical series continued until 1770, when the vogue may have become exhausted, for Zoffany did not again exhibit portraits of actors until his decline in the 1790s. The eight or nine theatrical masterpieces of these years – of which the most accessible are two at Birmingham – constitute one of Zoffany's chief claims to fame. They are better composed and more lively than his other pictures, and although this may be in part due to their accurate rendering of skilful production on the stage, it seems unlikely that, for instance, 'Garrick in *The Provoked Wife*', Society of Arts 1765 (Marquess of Normanby), is really an accurate rendering of the scene as it was performed. During the same decade one or two other painters produced occasional examples of this genre nearly as good – there are single examples by Mortimer and Benjamin Vandergucht at the Garrick Club – but this vogue, created by Garrick, did not persist as a lively tradition. Samuel de Wilde (1748-1832) was Zoffany's only close follower in this respect, but he mainly limited himself to single figures of actors, in character parts, of great neatness, and the real theatre conversation piece was not revived until the work of George Clint in the second decade of the nineteenth century.

It was inevitable that Zoffany should turn his hand from the theatrical to the domestic conversation piece, which at last emerged in the 1760s from its middle-class smugness. Domesti-

city was in the air in the new reign of George III and it became fashionable to have groups of one's children painted on a small scale or family groups with all one's children round one. Zoffany may have been introduced to the King by Lord Bute, whose children he painted in two admirable groups, and the beginnings of royal favour date from about 1764. But Zoffany still exhibited at the Society of Arts in 1769, the year of the first Royal Academy, though in 1770 he had become an R.A. under pressure from the King and showed a group of the 'Royal Family', not altogether judiciously attired in Van Dyck costumes, at the Academy.

It is not surprising that George III should have shown an appetite for the work of a painter who was both a German and a limner of domesticity, and Zoffany's most accomplished conversation piece is 'Queen Charlotte and her two Eldest Children' [249] dating from 1764, at Buckingham Palace. It is one of the prettiest and neatest of English eighteenth-century pictures. Though very far removed from anything which can be called 'great art', in British painting before the age of Turner and Constable we should be grateful for small mercies – and this is one of them. It is the best designed of all Zoffany's works and in the minute imitation of nature, a thing which usually pleases royalty, it is unexcelled. We can recognize the clock, which is still at Windsor, the picture over the door, and there is a perfectly recognizable image of a lady-in-waiting seen reflected in a mirror in the ante-room. Although George III's father, Frederick, Prince of Wales, had set the fashion for royal portraits of a certain informality, this is the first picture of the kind to be commissioned by a British king, and Zoffany later did admirable life-size half-lengths of the King and Queen in an informal manner, as if they had been private citizens. This tendency was directly opposed to the formality of Reynolds in doing portraits of important personages, and in Zoffany we have, almost by accident, the leader of a sort of popular reaction, sponsored by royalty, against the high-flown tendency of official art.

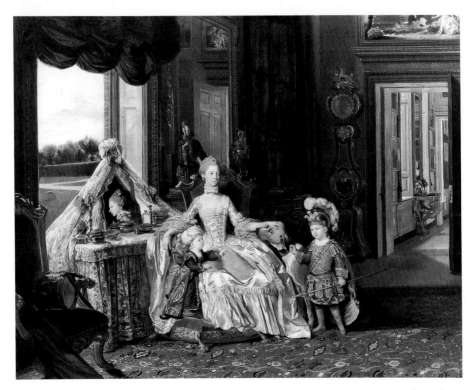

249. Johann Zoffany: Queen Charlotte
and her two Eldest Children, 1764.
London, Buckingham Palace
(by gracious permission of Her Majesty the Queen)

Support will never be lacking for the meticulous imitation in paint of the precise setting of daily life, and the attempt at arriving at a presentation of reality by simple enumeration has been at the bottom of such earnest painting as that of the Pre-Raphaelites. In the domestic conversation piece Zoffany carried it to its extreme in 'Sir Lawrence Dundas and his Grandson', of about 1769 (Marquess of Zetland), in an interior where not only the chairs, the carpet, and the standish are portraits, but all the eleven pictures on the walls and all the seven bronzes on the mantelpiece can be identified. Zoffany became hypnotized by his own skill and produced for the Academy of 1772 'The Life-Class at the Royal Academy' (Windsor) [250], which

is almost a miracle of improvisation, for we have Walpole's evidence that he made no design or plan for the picture but 'clapt in' the figures of the Academicians, one by one, as he got the chance of taking their likeness. It is from this point that we can mark Zoffany's decline. His skill remained the same at first but he became lazy about the intellectual operation involved in composing a picture. From 1772 to 1776 he was at Florence, where he devoted untiring patience to a picture of 'The Tribuna of the Uffizi'[2] (Windsor), with all its pictures and statues, most of the British colony in Florence, and a good deal of bric-a-brac for full measure. This has ceased to be a picture, and is simply a prodigy – and a historically fascinating one – of pictorial imitation. He was back in England (by way of Vienna) by 1779 and carried his bric-a-brac method of designing even into his conversation pieces, as in 'The Sharp Family' (Royal Academy 1781) at Hardwicke Court, Glouces-

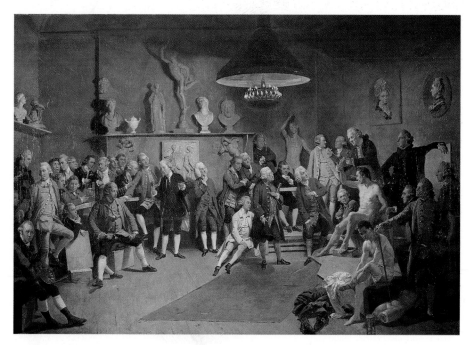

250. Johann Zoffany:
The Life-Class at the Royal Academy, 1772.
Windsor Castle
(by gracious permission of Her Majesty the Queen)

ter. A visit to India (1783-9) increased his prosperity but further undermined his artistic conscience, and the work of his last years adds little to his reputation, although the 'Charles Towneley among his Marbles' (Royal Academy 1790)[3] in the Burnley Art Gallery is a rather better organized experiment in the vein of 'The Tribuna' and showed that his powers of imitation had not flagged. Zoffany also occasionally painted fancy pieces and portraits on the scale of life. The full-length of 'Mrs Oswald' in the National Gallery, of the earlier sixties, is altogether exceptional, but it deserves mention as one of the best pictures of its kind and period by one who does not figure among the great names in British life-scale portraiture.

Zoffany's pupil, Henry Walton (1746-1813), has already been mentioned as one of the best painters of fancy pictures in *le genre sérieux* and he also occasionally tried his hand at the conversation piece, adding to Zoffany's formula just what Zoffany lacked, a sense for tone and a sense of breeding. But his work in this genre is exceedingly rare, as also is that of Hugh Barron (*c.* 1747-91), a pupil of Reynolds who executed a few conversations in Zoffany's style at the end of the 1760s and early 1770s. It is Francis Wheatley whose work in portraiture is most often confused with that of Zoffany.

Francis Wheatley[4] (1747-1801) was an artist of much greater variety than Zoffany and is best remembered today for his latest style, pictures from common life in the country or the rural side of city life, of which the *Cries of London*, engraved in 1795, are the most familiar. The originals of these were shown at the Academy in 1792/3 and some are now at Upton House

(National Trust). These are in a tradition which descends from Mercier and Hayman, through Henry Robert Morland[5] (1716–97), the father of George Morland, and may owe something of their added sweetness to a tincture of Greuze. But Wheatley has a richer personality than these late works would suggest.

He first exhibited at the Society of Arts in 1765 and these early works were almost wholly small-scale portraits or conversations. He may well even have been a pupil of Zoffany, but he looked elsewhere for the qualities which Zoffany lacked, a broadness of touch and a feeling for tone and the quality of English landscape. Indeed his 'Landscape with a Harvest Wagon' 1774 (Nottingham) is a shameless, but not insensitive, crib of Gainsborough's picture in the Barber Institute at Birmingham. From 1779 to 1783/4 Wheatley worked in Dublin and painted the pictures in which his indebtedness to Zoffany is most manifest. 'The Irish House of Commons' 1780 (A. D. F. Gascoigne) is exactly in the spirit of Zoffany's 'Life-School at the Royal Academy' but is more sensitive in touch,

251. Francis Wheatley: Arthur Philip, 1786.
London, National Portrait Gallery

and the 'Family of the Earl of Carlisle riding in Phoenix Park' 1781 (Castle Howard) has married Zoffany's minuteness to something of the broad feeling for landscape of Stubbs. On his return to London Wheatley continued small-scale portraiture until the end of the 1780s, and pictures such as 'Arthur Philip' 1786 (National Portrait Gallery) [251], with its broad touch, clean outline, and clear Romney-like colour, show how superior he had become to Zoffany in everything which goes to make a work of art. It may well be that Wheatley is the correct candidate for the best of the conversation pieces which have been masquerading under Benjamin Wilson's name.

But Wheatley abandoned this vein for the sentimental bourgeois genre which was beginning to be popular, and in his 'Mr Howard offering Relief to Prisoners' 1787 [252] at Sandon (which was exhibited at the Academy of 1788) he made the nearest approach to a Greuze achieved by an English painter. The 'proper' relations between the upper and lower classes are here fully displayed, and, in all his later works of this kind, although the representative of the upper classes is not present, he is there by implication in the spectator. It is not surprising that pictures of this kind should have become popular in the more idealistic period of the industrial revolution, and they have kept their popularity among the collecting classes today. Periodically, in the history of taste, it is discovered that the lower orders are very picturesque. Wheatley also painted a number of pictures for Boydell's Shakespeare Gallery and he contrived to introduce exactly the same social sentiment into 'Polixenes and Camillo in the Shepherd's Cottage' as he had shown in the picture of Mr Howard's benevolence.

In the later 1780s the conversation piece almost vanished from the fashionable scene and the small-scale full-length was limited either to the provinces, as in the work of the young Beechey at Norwich, or to very secondary painters, such as Mather Brown (1761–1831), an American pupil of Benjamin West, whose even leatheriness (enlivened only very occasionally by flashes of insight) barely deserves notice.

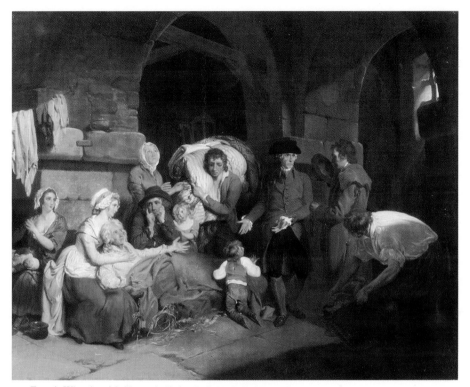

252. Francis Wheatley: Mr Howard offering Relief to Prisoners, 1787.
Earl of Harrowby, Sandon, Staffs

Only in Scotland, in the work of David Allan and the young Nasmyth, did the tradition of conversation painting persist. The fashionable world of London preferred the watercolours of Downman and the miniatures of Cosway. In the pre-Regency and Regency world these two artists took the place of the conversation painters of the earlier years of the reign of George III.

John Downman (*c.* 1750-1824) came to London in 1767 and became a pupil of West, entering the Academy schools on their first formation. His early oil portraits on the scale of life are gauche, but he visited Rome in 1774/5, and was settled for a time in 1777 at Cambridge, where he painted a number of small-scale oil half-lengths on copper of both Town and Gown, which are like neat and elegant large miniatures in the style of West's best portraits.

He travelled round the country for a year or so and soon settled in London, having perfected a method of taking charming likenesses. He would make his studies in coloured chalks and then produce one or more repetitions in lightly tinted watercolours. The earlier are usually ovals and have something French about them, the air of a *bibelot*. He excelled with children and with young and lovely people of fashion, and he achieves a faint fragrance of character exactly suited to his almost evanescent medium. This evaporates in his own oil portraits on the scale of life, and when he attempts small-scale histories in oil, such as 'The Return of Orestes' (Royal Academy 1782), or 'Edward IV and the Duchess of Bedford' (Royal Academy 1797), he only gives the impression of a number of desperately modish persons performing private theatricals.

But he captures the fleeting charm of Regency society as Hoppner, in his clumsier paint, never did. His quality hardly alters throughout his long life, but the dowdier clothes of the years after 1800 suit his medium less. His art is gracious, while that of Cosway is foppish.

Richard Cosway (1742–1821) was a youthful prodigy, who won many prizes for his drawings in the 1750s. Although he had exhibited throughout the 1760s, he studied in the Academy schools at their first opening and was rewarded by becoming A.R.A. in 1770 and R.A. the following year. He set up as a fashionable portraitist on the scale of life and his oil portraits are more numerous and less deplorable than is usually made out. He painted large oils right into the nineteenth century, but his forte was in miniatures, which are invariably exquisite in execution and of tip-top elegance. Cosway was a fop and a 'character' and was for some years intimate with the Prince of Wales, and he made a stir in Regency society such as no miniaturist had made before. No portraits give quite such a convincing image of that artificial world as the miniatures of Cosway and of his more pedestrian rival, George Engleheart (1750–1829), and the miniature again, after a long lapse since the days of the Restoration, deserves to be mentioned by the historian of British painting. It is presumably no accident that this medium should have flourished luxuriantly at two periods which show a certain similarity with one another in the corruption of their manners and the prodigality of their wealth.

LATER LANDSCAPE IN OILS: EARLY WATERCOLOURS

It would be natural to expect that something like a continuous development could be traced in landscape painting in oils to mark the gradation from the classical landscape of Wilson and the rococo landscape of Gainsborough to the consummate presentation of the English scene which flowered in Turner and Constable. But no such gradual transition is to be discerned and the fructifying influences on Turner and Constable were the early watercolour painters and the great masters of the Dutch school. This is not to say that landscape painting in oil was not practised abundantly, and that a few names are not deserving of mention. The chief painters are de Loutherbourg, George Morland, and Ibbetson.[1]

It is probable that, of these, Philip James de Loutherbourg (1740-1812) was the most important and influential painter. He was an Alsatian, son and pupil of a miniature painter, and had studied under various practised hands, more particularly the battle painter Francesco Casanova. In 1767 he became a member of the French Academy and exhibited at the Salon of that year battle-pieces, marines, and landscapes, which earned a good deal of comment from Diderot, who admired their workmanlike qualities, but compared them unfavourably with

253. P. J. de Loutherbourg: A Midsummer Afternoon with a Methodist Preacher, 1777. *Ottawa, National Gallery of Canada*

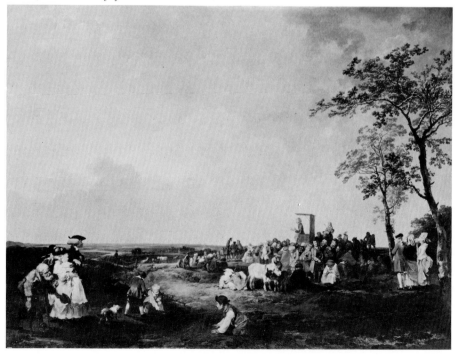

Vernet's works. De Loutherbourg was in fact an extremely capable professional artisan. He could paint anything he liked out of his head, but was too lazy to refer back to nature. All this professional baggage he brought over to London in 1771, with an introduction to Garrick, who induced him in 1773 to become his stage and scenery designer.[2] After Garrick's death he continued to practise this art with aplomb up to 1785. This gives a clue to the style of Loutherbourg's landscapes: they are generally arrangements of scenery. Loutherbourg knew his Wouvermans and his Berchem by heart and his contribution to British landscape painting was this European background. Curiously enough, it is in his earlier work that he took more trouble to adapt his style to the English scene and his 'A Midsummer Afternoon, with a Methodist Preacher' (Royal Academy 1777, at Ottawa) [253] has a good deal of the savour of Rowlandson transferred to oil paint. In the Mellon Collection's 'Storm' (dated 1784) the same characteristics have been added to a dash of Gainsborough and the result is a more vigorous picture of the type which Morland was soon to make popular, only the trees and the landscape have a slightly 'foreign' air. But soon Loutherbourg gave up attempting to represent the English scene and simply painted out of his head landscapes with pastoral figures or soldiers foraging, or even views of the Danube. His religious scenes for Macklin's Bible are equally foreign, and after 1800 his preoccupation with stage scenery and a sort of panoramic moving peepshow, called the *Eidophusikon*, which he had opened in 1781, led him to devote his energies to an enormous 'Battle of Valenciennes', which found its way to Easton Neston. These are works of ingenuity rather than art, and he was also associated with a polygraphic method for reproducing his and other people's pictures which still sometimes deceives the unwary today. But for all this, in his best pictures he anticipated all that was worth anticipating in George Morland.

George Morland (1763-1804) was the son of a painter apparently named Henry Robert Morland,[3] who was an occasional portraitist but is best known for genre pieces in the style of Mercier, which he repeated with too great frequency. The Tate Gallery possesses a 'Ballad Singer' by him and versions of his two most popular designs of 'Laundry Maids'. More important for his son's education was the fact that he was a restorer of Old Masters and presumably a dealer as well, and he employed young George, who was something of an infant prodigy in executive ability, to repair and to fake Old Masters of the Dutch school of landscape. George Morland, who was articled to his father from 1777 to 1784 and seems to have been kept in fairly strict durance, thus acquired by force something of the same cosmopolitan training that de Loutherbourg had received, and was a master of the international landscape style as soon as he set up on his own. Although more abundantly forged in his own lifetime than the works of any other painter, Morland's paintings have long continued to fetch high prices quite independently of changes in fashionable taste. The same unusual phenomenon is found in the works of Teniers and we may not unreasonably consider Morland a sort of English Teniers. The best works of both painters are nicely, and even freshly, executed and they are quite brilliantly lacking in intellectual qualities. As long as there are private collectors of means there will always be some to whom Morland will readily appeal, and once such a person starts collecting Morland, he collects him in bulk. Morland's more recent apologists have sought to explain this by considering him one of the most 'essentially English' of painters, but Morland's only 'essentially English' qualities were his liking for gin and low company, and his style was nearly as international as that of de Loutherbourg. If the best of Morland's landscapes be compared with one of Turner's English views this distinction will become clear. But Morland does come very close to the heart of common things. The piggishness of his pigs and the dampness of his wet woodlands are very complete, but for all that, he did not love trees and shrubs as Constable did, hardly even enough to

have been an inspiration to Constable. A good and typical specimen of his work is 'The Tavern Door' [254].

from the engravings and without Morland's name, to guess that they were not by Wheatley. In 1786 Morland married the sister of the en-

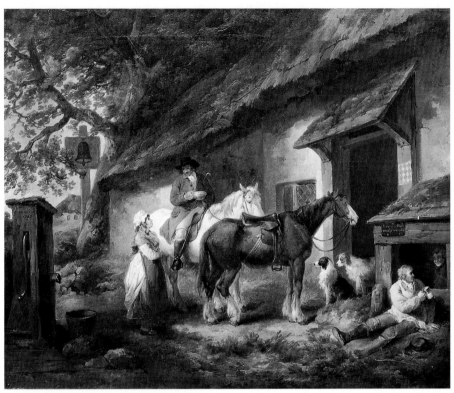

254. George Morland: The Tavern Door, 1792.
Edinburgh, National Gallery of Scotland

Morland's youthful exhibited works were stained drawings, but when he first set up on his own, for a few months in 1785 at Margate and later in the same year at Saint-Omer, it was as a portraitist. But he first came into public notice with works in Wheatley's latest style, fancy pseudo-rustic pictures, a sort of Greuze in muslin. A series of pictures of 'Lavinia' (not from Thomson's *Seasons*, but from *The Adventures of an Hackney Coach*), one of which was shown at the Academy of 1785, represents his first mature style. These were popularized by engravings, and one would be hard put to it,

graver William Ward and his works were largely popularized by engravings of excellent quality from then onwards.

Morland's best work was done between 1788 and 1798 and is wholly consistent in style, though uneven in execution: peasants and animals in and about the farm, the interiors of stables, rustic figures in a landscape, and occasionally such poignant figures of common life as soldiers, sailors, or deserters. It is a characteristic virtue that he is at his best with children and animals, and the more dressed up his people are, the further they are from nature.

The very large 'Inside of a Stable' of 1791 in the Tate Gallery is as fine an example as any, of his best period. It is sufficiently remarkable that a man who chiefly painted in the intervals of dissipation should have been able to bring to completion a picture so large and of such sure design. All Morland's natural talent and effortless ability is to be seen here, but he never improved upon these. Had he given his genius any encouragement he might have been worthy to rank with the masters of the succeeding age. But he spent much of his time evading his creditors and profited by retiring to the resorts of smugglers in Cornwall or the Isle of Wight to paint some coastal landscapes. His pictures become more slipshod with advancing years and it is no longer possible to distinguish altogether between his own inferior work and that of his innumerable copyists. But at his best he has a freshness of touch and a command of tone which lift his works above those of most of his contemporaries.

The third painter who deserves mention is Julius Caesar Ibbetson (1759–1817). The background of his style is equally international, for he came to London in the later 1770s and was employed in copying or forging Dutch landscapes and also the works of English painters, such as Gainsborough or Wilson. Imitations or copies of Gainsborough's Suffolk landscapes of the 1750s are particularly deceptive and this sort of work formed the chief element in Ibbetson's style: the other element was de Loutherbourg, and the small Shakespearean scenes which Ibbetson painted for Boydell's Gallery would pass very well as the work of Loutherbourg. Most of Ibbetson's life after 1800 was spent in his native Yorkshire, where the sweeping landscape and the old topographical tradition had a better effect on his art than all the learning of the studios. His later Yorkshire views are competent and neat and charming, but they are closer in style to the topographers of the 1750s than to the giants of landscape painting who were practising in London at the same time.

Far more important than these painters in oil were one or two watercolour artists, whose direct study of nature and observation of the particular tone of the British scene led up to the work of Girtin and Turner in the 1790s. It is with Turner and Girtin that the historian of our great age of landscape painting must begin.

The climate of the United Kingdom is decidedly moist, and the particular beauties of atmospheric effect with which those who put up with it are sometimes rewarded are the result of this moisture. Watercolour is undoubtedly the medium best adapted to render these transient effects, and we need look no further afield for the reason why watercolour painting is one of the peculiar glories of British art. But this discovery was not made until men began to see beauty in these transient effects of nature, and it is no accident that the first mature period of watercolour painting should have coincided with the appearance of the early poems of Wordsworth and Coleridge. But for it to have developed so rapidly, once the desire for it was felt, demands a long tradition in the use of the medium, and the medium of watercolour had been in use in humble hands, whose names need not find mention in a general history of British painting, throughout the whole of the eighteenth century.

At the beginning of the century there were many skilled topographical draughtsmen who employed watercolour in the service of antiquarian persons. The professional used mainly a greyish or brownish wash, which he enlivened with occasional notes of colour: but amateurs sometimes used a livelier and more varied palette. The aim of these tinted drawings was to render faithfully the lineaments of buildings or ruins, and the picturesque effects of light and tone produced by the vagaries of our climate were a hindrance to this purpose and not taken into account. The great landscape artists of the classical period of British painting were not interested in accurately portraying existing natural beauties, and we can capture the exact tone of contemporary thought in a letter from Gainsborough (undated, but written probably about 1762) to the Earl of Hardwicke, who had asked him to paint a picture of some particular spot: 'Mr Gainsborough presents his humble

respects to Lord Hardwicke, and shall always think it an honour to be employed in anything for his Lordship, but with respect to real views from Nature in this country he has never seen any place that affords a Subject equal to the poorest imitations of Gaspar or Claude. Paul Sandby is the only man of genius, he believes, who has employed his pencil that way.'[4] It is with Paul Sandby, the only watercolour painter of landscapes to be one of the foundation R.A.s, that we may reasonably begin.

Paul Sandby (1730–1809),[5] the younger brother of the architect (and topographical draughtsman) Thomas Sandby, lived right through the rise and blossoming of British watercolour painting. He himself would probably have said that he survived into the time of its decay into a 'wild rumble-tumble (or anything else you please) of penciling', if, as one may suppose, that expression, used by his son in his obituary notice of his father, echoes the old man's exasperated words. He himself was trained in a more austere tradition and he emerges quite literally from the tradition of the topographical draughtsmen. He and his brother came to London from Nottingham to take up appointments in the Drawing Office of the Tower, the ancestor of the present Ordnance Survey Department, and Paul was sent as draughtsman with the Ordnance Survey party which went to survey the Highlands of Scotland after the rebellion of 1745. Up to 1751 he worked on the survey or in Edinburgh and this period in Scotland is the formative period for his art. Kept constantly to the faithful imitation of nature by the meticulous requirements of map-making, he was yet surrounded with some of the most picturesque scenery in the kingdom, and by a landscape which was exceptionally prone to atmospheric variations. He emerged a loving and faithful interpreter of the British scene and he did not neglect figure studies from the daily life of Edinburgh or from the soldiers on the survey party. In 1751 he came to London and he lived the rest of his life mainly in London or with his brother in Windsor Great Park, but made several excursions (after 1770) to Wales. He occasionally practised in oils but nearly all

his work is either in transparent watercolour or in gouache, and many of his most important drawings he reproduced as aquatints, a process which he introduced into England. He was one of the first who drew in watercolour with the brush and did not limit himself to washing or tinting drawings made first with the pencil, and the most splendid series of his works is in the collection at Windsor Castle, where nearly every phase of his art can be studied, not least the series of views of the castle itself. Sandby's works are the first 'real views from Nature' to form the bulk of the achievement of a considerable artist, and they are not, as Samuel Scott's had been, arranged into compositions according to the principles of Canaletto. His aim, in his son's words, was to 'give to his drawings a similar appearance to that seen in a *camera obscura*' and he 'never introduced, or depended at all upon violent contrasts for effect'. A later generation was to discover that violent contrasts could also be an important element in the truthful rendering of the English atmosphere. Sandby's studies of trees in Windsor Great Park also deserve attention at the beginnings of that loving portraiture of individual trees which was to become a passion with Constable. With the after-knowledge of Constable's work Sandby's trees seem still to be rather formal beings, but they are much closer to English nature than those in the classical English landscape painters, and a date which deserves to be recorded in the annals of British painting is 1793, when Sandby painted a room at Drakelowe entirely with forest foliage [255]. This room has now found its way into the Victoria and Albert Museum.

The figures are not the least among the charms of Sandby's watercolours, but they rarely predominate in his art. Exactly the opposite is the case with the other great watercolour master of this phase of painting, Thomas Rowlandson (1756–1827). Although a full generation younger than Sandby, he belongs to the same technical phase of the art as the older man and remained equally uninfluenced by the innovations of his younger contemporaries. His style became fixed about 1780 and he never altered it. He deserves attention for his great

255. Paul Sandby: Painted Room from Drakelowe, 1793. *London, Victoria and Albert Museum*

gifts as an artist, which appear with surprising frequency in the torrent of drawings which flowed from his pen. But he is an isolated figure, since his subject-matter never entered the traditional repertory of British watercolour painting, and that subject-matter was the rollicking life of the times. He is a Morland of greater gifts run to caricature.

Like Morland, Rowlandson benefited by some study in France, where he was trained in figure drawing from 1771 to 1773, and his sense of rhythm and the bounding life of line is in the French rococo tradition and unlike anything English. Like Morland too, he spent his life predominantly in low company, but with much greater profit to his art, for he depicts it with an amoral objectivity which gives it life, and the characters in Morland's pictures, for all that they were studied from his boon companions, appear refined into the creatures of a respectable female novelist when compared with Rowlandson's. But Rowlandson had an over-developed sense of the ridiculous, which, though a comfortable armour for a layman in his passage through life, is a disadvantage for an artist of such natural gifts who is not inspired as well – as Hogarth and Gillray were – by a social conscience and a divine indignation. It is where Rowlandson comes closest to Sandby, as in his 'Skaters on the Serpentine' of 1784,[6] where his rollicking feeling for life is added to great truth of atmospheric tone, that we can see his contribution to the landscape tradition. There are as yet no violent contrasts of effect, but Sandby's placid style has been shaken up and enriched and an advance has been made towards the full interpretation of wind and sky.

Parallel with this purely native tradition there grew up, during the same years, what has been called the 'Southern School' of watercolour painting, practised by artists who drew their subjects from the scenery of Italy or Switzerland. Starting in the same way as the topographical school had started, with gentlemen taking a watercolour painter with them on their tours to depict the splendours of the scenery, a new attitude towards the subject-matter was soon evolved. The grandeur of mountain prospects, solitude, and the moods which the poetic traveller associated with southern landscapes became the painter's object. The great initiators of this school are Alexander Cozens (c. 1717–86), who settled in England in 1746, and his son, John Robert Cozens (1752–97). Both were associated with William Beckford, one of the prime figures of the Romantic period, and their work forms a necessary prelude to the consideration of Turner. It was from the marriage of these two traditions that the great British school of watercolour painting emerged. They are more properly treated in the volume which begins with the Romantic period.

PAINTING IN SCOTLAND IN THE EIGHTEENTH CENTURY

Scottish painting of this period is still a very lightly explored field.[1] Most of the painters of real stature, from the time when Aikman in 1723 had migrated to London, went south, and the most distinguished of them all, Allan Ramsay, although he made periodical visits to Edinburgh (and probably stole the best commissions from the local painters), was based on London and has to be considered in the broader panorama of British painting. The same is true of the history painters, Gavin Hamilton and the Runcimans, whose works, in so far as they were exhibited at all, were shown in London. It was not until the beginning of the 'romantic' period, with Raeburn, that Scottish society reached a condition when it could fully employ a native painter of international quality – and Raeburn belongs with Lawrence to the nineteenth century. There was, however, a steady stream of patronage to artists who never strayed south of the Border between the 1720s and 1780s, and a consistent body of portraiture survives (and a few other paintings), which makes a slight sketch necessary. Outside London, with the possible exception of East Anglia, there is nowhere else in the kingdom where a continuous tradition can be traced to anything like the same extent. A certain number of the painters had Jacobite leanings, which found them ready patrons at home and made them unwilling to stray into the sister kingdom.

The first in date is John Alexander, a great-grandson of George Jamesone, who was probably born in Edinburgh about 1690. He was in London in 1710, copying Scottish historical portraits, and in Rome at least from 1714 to 1719. Back in Scotland in 1720 he painted the unique example of Scottish baroque painting, an enormous canvas of 'The Rape of Proserpine' (1720/1) for the roof of the staircase at Gordon Castle. The big picture has vanished, but the little 'modello' [256] is in the Edinburgh Gallery. Though hard and liny in outline, it is not altogether negligible in design and shows that the baroque spirit had found its way to north of Aberdeen. In Gordon Castle too – the collection was dispersed in 1938 – were thirteen portraits by John Alexander ranging in date from 1736 to 1743. A few of these now belong to the Duke of Hamilton and are as professional as the secondary line in London portraits at the time. Alexander was 'out' in 1745, and may have gone to Rome with his son. But he was back by the 1750s and working at Aberdeen till he disappears from view about 1757. His son, Cosmo Alexander (1724–72), also claimed to be a history painter but nothing but portraits has survived. These exist in relatively large numbers in houses throughout Scotland and are more sophisticated in style than his father's. He too was 'out' in 1745 and retired to Rome, where he is recorded in 1749. Back in Scotland by 1754 he improved his mind and style by travelling and was a member of the painters' guild at The Hague in 1763/4. From his Dutch period dates a group of Hope portraits, one of which, 'Adrian Hope', is in the Edinburgh Gallery and shows marked affinities with the style of such Dutch painters as Troost or F. van der Mijn. After a visit to London in 1765 he toured the eastern seaboard of the United States from 1768 to 1772 and returned to Edinburgh shortly before his death, bringing with him the young Gilbert Stuart, whose first teacher he seems to have been. The family dynasty was carried on by Cosmo Alexander's brother-in-law, Sir George Chalmers (c. 1720–91). His father had been a herald painter and his own portrait work (and engraving) begins in 1738. He was in Minorca in 1755 but back in Scotland by 1760, where he married Isabella Alexander in 1768. He had looked at Reynolds but he had the Alexanders'

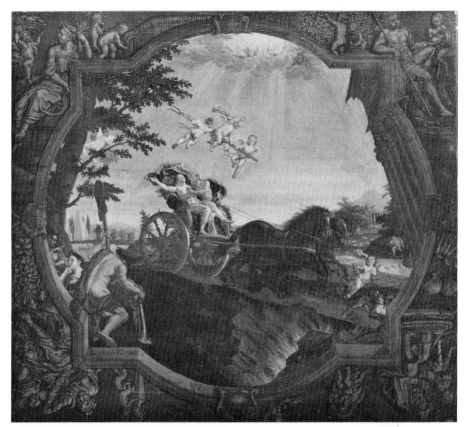

256. John Alexander: Modello for the Rape of Proserpine, 1720. *Edinburgh, National Gallery of Scotland*

wiry outline. In his best work, such as 'William Hay' 1770 at Duns Castle, he is on a level with such a painter as Tilly Kettle. Scottish patronage does not seem to have sufficed for him, as he settled in Hull about 1776/9 and later in London, where he died.

Aberdeen was also the main base and home of the most interesting of the earlier portraitists, William Mosman (c. 1700–71), whose work there can be traced from 1731. There is some evidence that Mosman may have studied in Rome under Imperiali, probably in the 1730s and a little before Ramsay entered Imperiali's studio. Ramsay in 1740 seems to have thought

him the best painter working in Scotland and he was then working in the southern part of the country. His 'Mrs James Stuart' 1740 (Edinburgh) still has a faint Mediterranean flavour about it and Mosman's best work dates from the 1740s. Later it becomes more provincial, and by the middle 1750s he was settled in Aberdeen, where he taught drawing at the two universities.

Mosman may have been driven north by abler practitioners of the London modes who came to Edinburgh. Peter De Nune (of a family from Ross) signed portraits from 1742 to 1751, and, at his best, was very close to Hudson in

style; and from 1751 to 1763 a painter who signs 'R. Harvie' was active in the Border country in a closely related style. But the ablest of the native Edinburgh painters at the middle of the century was William Millar. Millar is first found copying Ramsay portraits in 1751 and he modelled his style upon Ramsay, who, although not his teacher, expressed a high opinion of him. He was active until at least 1775, and his 'Thomas Trotter' 1767 at Edinburgh has a real grasp of Scottish character and an agreeable quality of paint.

In 1760 William Delacour (d. 1767),[2] who is recorded in London in 1747, had Jacobite connexions, and reached Edinburgh in 1757, became the first Master of the Trustees Academy. He painted occasional portraits, but his most interesting works are large wall paintings in a mixed Gaspard Poussin-cum-Pannini style which put the provincial work of the Norie firm in the shade. The ballroom at Yester was decorated in this way by Delacour with large panels dated 1761, and these seem to have served as models for the similar and competent work by Charles Steuart, a Gaelic-speaking Athollman, who painted the Saloon at Blair Atholl from 1766 to 1778.

Painters in Scotland would suddenly become fashionable for a year and then disappear. A certain F. Lindo, probably an Englishman, painted a number of portraits in 1761, and one J. Clark was acquiring a reputation in 1767, when he was enabled (about 1768) to go and study in Naples by the generosity of Sir Ludovic Grant and Sir John Dalrymple. He seems to have flourished moderately as a painter in Naples until his death about 1801.

It was in the 1770s that painters who had been trained in London began to return to Scotland for a livelihood. John Thomas Seton (c. 1735–c. 1806), a pupil of Hayman, who had first exhibited in London in 1761, settled in Edinburgh in 1772 and painted life-size portraits as well as a few conversations, of which one in the Edinburgh Gallery was long understandably mistaken for a Zoffany. These works were certainly up to the level of works in the London exhibitions. From 1776 to 1785 Seton visited India,

where he made a considerable fortune and painted a number of nabobs, from Warren Hastings downwards. He returned once more to Edinburgh, where he was living as late as 1806. The ambitious full-lengths of his last period, such as the 'Lady Catherine Charteris' 1786 at Gosford, which is planned in the Reynolds tradition of twenty years earlier, were the first of this class of picture actually to be painted north of the Border. Another Edinburgh painter with a similar career was George Willison (1741–97), who first exhibited in London (1767), made a fortune in India (1772–81), and settled in Edinburgh (1784/5). The rather little of his work which has been traced is varied and reflects a pliable mind which was open to the influence of Gainsborough as well as to the prevailing style.

Finally there came David Martin (1737–97), who provides the rather tenuous link between Ramsay and Raeburn. Martin had been Ramsay's direct pupil and remained his studio assistant into the 1760s, but when we recognize his first independent work, about 1765, he had

257. David Martin: George Murdoch, 1793. *Glasgow City Art Gallery*

already veered over towards the more forceful patterns of Reynolds, and the rough texture of his paint in later years seems also to have been due to seeking for something of Reynolds's style. In 1784 he settled in Edinburgh and became the fashionable portrait painter for the next decade, his reputation not being eclipsed by the young Raeburn, to whom he is said to have lent one of his portraits to copy. He was always slovenly in execution and his hands are often astonishingly feeble, but his portraits have an individual tang and cannot readily be mistaken for the work of any other painter. He was well suited by sympathy to depict some of the more characteristic kinds of Scottish face, and his masterpiece is 'George Murdoch' [257] 1793 in the Glasgow Gallery. It may be that he was not above taking a hint from Raeburn's sense of pattern and method of lighting the head in his later years, but what we know of Raeburn's chronology (and the knowledge is very imperfect) rather suggests that the influence was the other way about. Martin was appointed Painter to the Prince of Wales, and he seems to have been the first painter since the days of Sir John Medina to have made a good and steady income out of painting portraits in the capital of Scotland.

PORTRAITISTS IN CRAYONS OR PASTEL

The art of portraiture in crayons or pastel or kindred media was in sufficient vogue throughout much of the eighteenth century to demand separate treatment here. Most of the painters involved practised in oil also, but a number of them hardly made a name outside of their work in crayons to demand consideration as oil painters. Writing of the collection at Stourhead in the early years of the nineteenth century, Sir Richard Colt Hoare refers to 'painting in crayons, a style now quite unfashionable', so that we may properly conclude with a chapter on a form of painting which came to a temporary close with the period of which this volume treats.

It has been plausibly suggested that portraiture in crayons was introduced into England from France about the time of the Restoration. At any rate such work first appears in the 1660s among the circle of Lely's immediate associates. Two theatrical portraits by John Greenhill are the earliest which have been traced, 'Betterton as Tamerlane' 1663 at Kingston Lacy and 'Harris as Wolsey' in the President's Lodgings at Magdalen College, Oxford. It may be that something more highly coloured than the ordinary portrait drawing was felt as appropriate for the first portraits of actors in character parts, and the new medium gives them a strikingly modern air. But crayons were not confined to actors' portraits, as the two surviving crayon portraits (one in the Ashmolean Museum, Oxford) by an otherwise unknown associate of Lely, T. Thrumpton, are of more conventional sitters. They date from 1667.

The first artist whom we may reasonably consider to have been a professional specialist in crayon portraits was Edmund Ashfield, who can be certainly traced only from 1670 to 1675. He was copying Lely portraits in oil in 1670 but is stated by Walpole to have been the pupil of Michael Wright, which seems plausible on grounds of style. His crayons are about 11 by 9

in. in size, sometimes rich in colour and of high quality, when in good preservation. The best signed examples are at Ham House. We also learn from Walpole that Ashfield enriched the crayon painter's palette and was the teacher of Edward Lutterell, a hardly more tangible figure.

Lutterell is reputed to have been an Irishman and trained to the Law. What is certain is that he also practised as a mezzotint engraver. He first emerges with any certainty about 1680 and he may have been living as late as 1723. His only crayons of note at present traced date from the 1690s and his work answers to some extent to Kneller's in painting. It is technically of considerable originality, since he devised a means of using crayons on copper by first preparing the ground as if for mezzotint. His clear key is very different from Ashfield's more sombre and sonorous colouring.

For the first quarter of the eighteenth century crayon portraits do not seem to have been in high fashion, although the work of a number of provincial masters is occasionally met with. But it was brought into repute again by three artists after their return from Italy. Arthur Pond (c. 1705-58) came back from Italy in 1727; George Knapton (1698-1778) returned in 1732; and William Hoare (c. 1707-92) in 1737. As a crayon painter, although Pond was the first to become fashionable, Knapton was the best and most important. The first report of the new fashion comes from Mrs Delany, writing to her sister, Anne Granville, on 30 June 1734. 'Lady Dysart', she says, 'has got to crayons, and I design to fall into that way. I hope Mr Pond will help me too, for his colouring in crayons I think *the best* I have seen of any English painter.' Pond's quality in crayons, to judge from a signed example of 1737 at Melbury, is little higher than his quality in oils, but his work found favour and imitators as well. George Vertue disapproved of the vogue for crayon

portraits and a singularly ungrammatical passage in his notes for 1741 gives his views (111, 109/10): 'crayon painting has met with so much encouragement of late years here, that several painters – those that had been in Italy to study, Knapton, Pond, Hoare, for the practice of painting in oil – found at their return that they could not make any extraordinary matter of it, and turned to painting in crayons, and several made great advantages of it. It looked pleasant, and, covered with glass [and in] large gold frames, was much commended for the novelty. And the painters, finding it much easier in execution than oil colours, readily came into it.' I have modified Vertue's punctuation, but retained his meaning. He closes his paragraph with the words: 'the want of ambition in art thus shows its declining state. Small pains and great gains is this darling modish study.' Knapton worked in London, Hoare in Bath. Knapton's tonality is rather brownish and greyish, while Hoare's is gayer, but it was Knapton who became the teacher of Francis Cotes, who brought the crayon portrait on to the same level as the portrait in oils, and who was the first of what Vertue calls the 'crayoneers' to adopt the portrait style of the new age. Independent of these was Catherine Read (1723-78), a Scottish lady who studied in Paris and Rome, worked in London from 1754, and went to India in 1775.

Francis Cotes (1726-70) first appears as an independent crayon artist in 1748. Even in his first years he is much brighter in colour than Knapton and he expresses admiration for the work of Mengs and Rosalba in a way which suggests that he had seen their works and profited by them. Indeed, a visit to Italy is not improbable, but is not documented. Rosalba herself never visited England but Cotes must have been put on his mettle by the appearance of Jean-Étienne Liotard (1702-89), the Swiss painter, who arrived in London in 1753 with an international reputation and a considerable English clientele. Liotard was in London from 1753 to 1755 and was at first a tremendous success, rousing the jealous criticism of the young Reynolds. Horace Walpole remarks that Liotard's likenesses were 'too like to please those

who sat to him' and that he had great business the first year and very little the second. 'Freckles, marks of the small pox, everything found its place, not so much from fidelity, as because he could not conceive the absence of anything that appeared to him.' But for liveliness and vivacity of colour they were something quite new in portraiture in England. The series of portraits at Windsor of the Princess of Wales and her children (1755) is the most modern in appearance of any portraits of the age, and the fact that one can discern which of the children had adenoids is perhaps more interesting to posterity than it was to contemporaries. Certainly such work convinced Cotes that he must abandon altogether the old tonality of Knapton and he brought his crayons to a very high pitch of technical perfection and employed bright colours along the same lines. Although Cotes turned more and more to oils after 1763, he still took pupils in crayons, and Russell was in his studio as late as 1767. Liotard returned to London from 1772 to 1774, but the force of his first impact was spent.

A passing mention may be made of François Xavier Vispré, a native of Besançon, who worked in London (and a little in Dublin) from 1760 to 1789. His rather infrequent but charming crayon portraits brought to England something of the French manner of Perronneau, but seem to have been without influence. Perronneau himself also visited England at least once, and exhibited crayons in London in 1761. A neat painter of small-scale crayon heads, rather out of the main tradition, was Hugh Douglas Hamilton (c. 1739-1808), who is reputed to have acquired the technique at the Dublin school of art. He worked in London from about 1764 to 1778, and the charming little ovals of this period are his best work, anticipating the small watercolour portraits of Downman, who succeeded to his vogue. Hamilton's work is generally subdued in colour and unrelated to the contemporary style of Cotes. From 1778 to 1791 Hamilton worked in Rome, specializing in small-scale full-length crayons which are like miniature portraits by Batoni. But he was persuaded by Flaxman to take to oils and retired to

Dublin, where he prospered as an oil painter, but his work lost its elegance and neat charm.

The tradition of Cotes was maintained by John Russell (1745–1806), who was his pupil up to 1767. Russell bought certain works by Rosalba Carriera which he studied to advantage and cultivated a rather smudgier technique than had prevailed before, 'rubbing in' his crayons, as his contemporary, Bacon, reported. His personality is rather difficult to grasp, as he was a churchman of unusual devoutness, much given to favouring the Methodists in the days of their early enthusiasm. Yet he turned out a steady stream of portraits which seem to make his sitters more modish, or more mannered, than reality. He became A.R.A. as early as 1772, but was not elected R.A. until 1788. In 1785 he was appointed 'Crayon Painter to the Prince of Wales' and his prices in the 1790s were as high as those of Reynolds. From the end of the 1790s his London vogue lessened and most of his commissions came from Yorkshire, where he made extended tours, and where he died. The insipidity about his style must have appealed to his contemporaries, who continued to sit to him, in spite of his preaching at his sitters.

Russell's rival towards the close of his career was Ozias Humphry (1742–1810), who had begun as a miniature painter of some distinction, settling in London in 1763. In 1773 he accompanied Romney to Italy, returning in 1777, and he visited India from 1785 to 1788. An accident in 1772 affected his eyesight and had diverted him from miniatures to oil painting, but he was never better at oil portraits than a third-rate echo of Romney's style. In 1791, however, he became R.A. and switched over to crayons, becoming soon afterwards 'Portrait Painter in crayons to His Majesty', no doubt as a sort of antidote to Russell's corresponding appointment to the Prince of Wales. In his crayons Humphry shows a rather greater probity than Russell and adopted a more linear and less smudgy style.

The youngest of the three chief masters of the crayon, Daniel Gardner[1] (1750–1805), was the most distinguished and at the same time the most original. A native of Kendal, where

Romney had first practised, he became a pupil of Romney and studied at the Royal Academy schools. But from Romney he learned nothing, except that it was not necessary to exhibit at the Academy, and the late style of Reynolds, in its least solid aspect, was Gardner's model. It has even been suggested that Gardner was Reynolds's assistant towards the close of his life. His first practice was in crayons, and in a letter of 12 November 1779 he describes the portrait of Philip Egerton as 'absolutely the first oil picture I ever finished'. Certain early oil portraits of the Pennington family (personal friends of Gardner) which have passed through the auction rooms in recent years suggest that, although technically far from accomplished, he was capable of a vein of tender and romantic sentiment in this medium which is surprising. His masterpiece in oil, the 'Heathcote Hunting Group' belonging to the National Trust and exhibited at Montacute, is based on Reynolds's latest style, but retains, as always with Gardner, something of the effect of having been painted on a rough towel. This roughness of texture he evidently valued, for he carried it over into his pastels. These are technically highly original, for Gardner mixed brandy or spirits of wine with his crayons, which had been scraped to dust with a knife, and drew with this highly loaded preparation. The result is something half-way between crayons and oil painting and achieves a violent and almost harsh brilliance of effect unparalleled in any other medium. To this lush material Gardner added a very flashy style, torturing his white draperies more with the art of the *pâtissier* than of the painter, and organizing his family groups (or even his single figures) in a riot of voluptuous curves. Except for Cosway's miniatures, no paintings give quite such a complete synthesis of the artificial world of pre-Regency and Regency times, and it is understandable that Gardner's art died with him. But in fact the three chief painters in crayons all died in the early years of the nineteenth century and left no successor to carry on their art, which, almost overnight, ceased to be fashionable. Nor has it ever been, to any serious extent, revived.

NOTES

Bold numbers indicate page references.

CHAPTER 1

13. 1. H. G. Wayment, *The Windows of King's College Chapel, Cambridge* (*Corpus Vitrearum Medii Aevi: Great Britain*, supplementary volume 1) (O. U. P. for the British Academy, 1972).

2. A case is generally made out for Henry VIII as a great patron of the arts, compared with his Tudor successors; and he certainly spent prodigious sums on ephemeral art which would redound to his own glory – leaving the exchequer bankrupt. For a case for him see Erna Auerbach, *Tudor Artists* (1954), 4–6, which collects all the very scattered documents about Tudor painters in dictionary form, and has an excellent bibliography of the published and manuscript sources.

3. Roy Strong, *National Portrait Gallery: Tudor and Jacobean Portraits*, 2 vols. (1969), *s. v.* This book reproduces most of the more important portraits of eminent persons of the sixteenth century, whether or not they are in the National Portrait Gallery, and discusses the iconography of the sitters. It is thus a source of reference for most of the pictures mentioned in my first three chapters. It is arranged alphabetically by sitters, and I shall refrain from giving continual references.

4. John Fletcher, *Burl. Mag.*, CXVI (May 1974), 250 ff. This research has revolutionized our knowledge of these pictures, which were not datable on grounds of style. They are mostly journeyman work, and portraits of the same type can be found in France and the Low Countries.

14. 5. See Note 4.

15. 6. See Note 2.

7. Full documentation and bibliography in Erna Auerbach, *Tudor Artists* (1954), 144 ff.

8. A fine portrait of a lady, dated 1536 and apparently signed A.W., has been associated with Wright (Lee Collection, Courtauld Institute, London) – but it was probably not painted in England.

16. 9. A plausible approach to his style, and the fullest information, is in Hugh Paget, *Burl. Mag.*, CI (Nov. 1959), 396 ff., where a somewhat damaged portrait of William Carey (private collection), dated 1526, is published.

10. See Note 4.

18. 11. K. T. Parker, *The Drawings of Hans Holbein . . . at Windsor Castle* (Oxford, 1945). The fullest collec-

tion of good plates of Holbein's oil paintings from his English period is in P. Ganz's 1950 book – but the text is not always accurate and a number of the attributions are highly speculative.

19. 12. Notes on Dufresnoy's *Art of Painting* in *The Works of Sir Joshua Reynolds*, ed. E. Malone (1797), 11, 250. I owe this reference to Dagobert Frey, *Englisches Wesen in Spiegel seiner Kunst* (1942), 245, where there is a valuable discussion of Holbein's change of style.

13. See Note 11.

21. 14. Roy Strong, *Holbein and Henry VIII* (1967), which has a lively account of the propagandist intentions of Henry's art patronage.

15. The only serious study is Roy Strong, *Burl. Mag.*, CV (Jan. 1963), 4 ff.

22. 16. See Note 11.

17. The 'Unknown Lady' lent to the R.A. 1950/1 by H. E. M. Benn is another, and an 'Unknown Man' dated 1546 in the Besançon Museum as 'School of Holbein' also deserves consideration, but may be nearer to Scrots.

23. 18. Erna Auerbach, *Tudor Artists* (1954), 154–5.

19. Roy Strong, *The English Icon* (1969), 65–7. Only the portrait of Sir William Cavendish seems to me convincing.

CHAPTER 2

24. 1. Erna Auerbach, *Burl. Mag.*, XCIII (Feb. 1951), 46 ff.

2. In this and the next chapter it would be possible to give a reference, against the great bulk of the portraits mentioned, to Roy Strong, *The English Icon: Elizabethan and Jacobean Portraiture* (1969), which is a splendid repertory of good illustrations for the period covered. It is also of the greatest use in isolating, under each painter, those works which are more or less securely documented or signed. The attributed pictures are another matter, to which I shall sometimes have to make reference: but it can be taken for granted that most of the portraits mentioned in these two chapters can be found well illustrated in this book, together with the essential information about them.

3. John Fletcher, *Burl. Mag.*, CXVI (May 1974), 255.

25. 4. G. Glück in *Festschrift für Julius Schlosser* (1927), 224 ff.

26. 5. I have given the evidence at length in the catalogue of the R.A. Winter Exhibition 1950/1 under no. 51.

27. 6. The 1590 inventory of Lord Lumley's collection of pictures is best published by Sir Lionel Cust in *Walpole Society*, VI (1917/18), 15 ff. It is the most important artistic document for the later sixteenth century, giving a list of the most important collection of pictures – mainly but not entirely portraits – in England, which was considerably richer than that of the Crown. It preserves the names of a number of painters, who were first identified by its means. It belongs to the Earl of Scarbrough. See also D. Piper, *Burl. Mag.*, XCIX (July 1957), 224–31, and *ibid.* (Sept. 1957), 299–303.

7. A very few unsigned portraits can reasonably be associated with Flicke, but the fourth 'signed' work which appears in the books is impossible to accept, although the attribution can be traced back to an inventory of the 1720s. It is a Clouet school portrait of the 'Duc de Nemours' belonging to the Marquess of Lothian, on to which a cunning hand, probably *c.* 1720, has painted 'G. Fliccus'. Its acceptance has led to some ingenious hypotheses.

28. 8. This may well be by Moro himself. Lord Windsor was a Roman Catholic and lived much abroad.

29. 9. For what is now known about him see L. Burchard in *Mélanges Hulin de Loo* (1931), 33 ff.; and the ninth volume (1972) of the English edition of Friedlaender, 49–50 and 72–4.

10. The original identification was made, on not strictly adequate grounds, by Sir Lionel Cust in *Walpole Society*, II (1913), but, in spite of qualms by Miss Yates, it may be accepted. For the fullest catalogues and illustrations see Roy Strong's catalogue of the Hans Eworth Exhibition, Leicester/National Portrait Gallery, 1958; and *The English Icon* (1969), 83–106.

11. Roy Strong, *op. cit.*, 143–5 denies that this picture is by Eworth (see Note 17, below).

12. In earlier editions of this book I reproduced the version at Dunster Castle (National Trust), which now turns out to be a copy made in 1591, probably because the original had become damaged. For a full discussion and the elucidation of the allegory – which seems to have reference to the Peace of Boulogne (1550) – see Frances A. Yates in *Essays in the History of Art presented to Rudolf Wittkower* (1967), 149–60.

30. 13. The identification as 'Mary' is not generally accepted: however not only is the likeness very close, but the jewel she wears, with the scene of Esther and Ahasuerus, is surely inconceivable in a portrait of any lesser personage.

31. 14. Roy Strong has made this suggestion and it is at least very probable, although no documentation has

been discovered. It may well be, as he suggests, that this prevented Elizabeth from at first employing Eworth.

15. The picture is signed but not dated (except for the 1540 on the frame of the portrait of Lord Dacre, who was executed in 1541). The costume is *c.* 1555–60, and the likely date is 1558, when Lord Dacre's forfeited honours were reconferred on his son.

32. 16. Strong (*op. cit.*) has isolated, more or less convincingly, the work of one or two contemporaries of Eworth. Another painter who used a large miniature scale in the 1560s is the painter of the two Kirkby portraits (nos. 107 and 111 of the R.A. Winter Exhibition 1950/1). It may prove that this scale was popular for country gentry, while the larger scale was more normal for the Court.

17. Strong (*op. cit.*, 143–5), noting that the form of the monogram is somewhat different from the normal HE, does not allow that this is by Eworth. The signature is clumsy and looks as if it had been tinkered with, but I think the picture is by Eworth – and this seems to me supported by the 1570 picture at Copenhagen.

18. The literary references are given by Frances A. Yates in *Journal of the Warburg and Courtauld Institutes*, X (1947), 60 ff.; see also J. A. Van Dorsten, *The Radical Arts* (1970), 54.

CHAPTER 3

33. 1. The best repertory of illustrations (which includes nearly all those portraits whose authorship can be securely documented) is in Roy Strong, *The English Icon: Elizabethan and Jacobean Portraiture* (1969). There are also many thoughtful observations in Eric Mercer, *English Art 1553–1625* (*Oxford History of English Art*, VII) (Oxford, 1959).

2. A list of known names was given by W. G. Constable and C. H. Collins Baker, *English Painting of the Sixteenth and Seventeenth Centuries* (1930), 34–5: but this has been considerably enriched by the full documentation in Erna Auerbach, *Tudor Artists* (1954).

34. 3. Roy Strong, *op. cit.* (1969), 119–34.

4. For the reconstruction of Gower see J. W. Goodison, *Burl. Mag.*, XC (Sept. 1948), 261 ff., followed by my own elucidation of the 'Selfportrait'.

5. Roy Strong, *op. cit.* (1969), 167–84.

35. 6. *Ibid.*, 195–206 and 349. The same type of criterion, by forms of lettering, is used for establishing the Peake and Gheeraerts studios. But it is significant that the Peake letterer disappears after 1599 – which suggests that he may have been a different person from the painter of the portraits on which the inscriptions appear.

7. For Segar see David Piper, *Burl. Mag.*, XCIX (Sep. 1957), 299–303; Roy Strong, *op. cit.*, 215–24.

8. Roy Strong, *Portraits of Queen Elizabeth I* (Oxford, 1963) (with bibliography). All those that I mention are illustrated in this book.

36. 9. *Ibid.*, 68, for some description and elucidation of these allegories.

10. 'The English Historic Portrait: Document and Myth', in *Proceedings of the British Academy*, XXIX (1943).

38. 11. Erna Auerbach, *Nicholas Hilliard* (1961), is a fully documented and fully illustrated account.

12. Published in *Walpole Society*, I (1912).

13. (Sir) John Pope-Hennessy, *A Lecture on Nicholas Hilliard* (1949).

14. *Arte of Limning*, 23–4: I have simplified the spelling.

39. 15. From Vertue's time until 1912 the signature HE was considered to belong to de Heere and not to Eworth. The documents about him (disregarding the attributed portraits) are in Sir Lionel Cust's article in *Archaeologia*, LIV (1894); a fuller and more up-to-date account of his work is in Frances Yates, *The Valois Tapestries* (1959).

16. Roy Strong, *The English Icon* (1969), 151–7.

40. 17. For the date of his arrival see Roy Strong, *Journal of the Warburg and Courtauld Institutes*, XXII (1959), 359–60.

18. Raffaello Borghini, *Il Riposo* (1584), 573 (Book IV, p. 143 of the Siena edition of 1787): 'in Inghilterra fece il ritratto della Regina Elisabetta, e quello di Milord Lostrè (*sic*) suo favoritissimo, ambedue interi, e grandi come il naturale'.

19. P. Boesch in *Zwingliana*, IX (1949), 16 ff.

20. The legend about Lucas Cornelis was started by Vertue (II, 51–2) and canonized by Walpole (ed. Dallaway/Wornum, I, 65) on the strength of the 'itinerary of one Johnston' (*sic*). On purely stylistic grounds it was exploded by Sir Lionel Cust in the introduction to the Exhibition of Early English Portraits at the Burlington Fine Arts Club, 1909, 49–50: but its most recent victim was S. H. Steinberg in *Burl. Mag.*, LXXIV (Jan. 1939), 35–6, and it is enshrined in Thieme-Becker. It can be exploded on securer grounds by consulting Walpole's misnamed source, Thomas Johnson's *Iter Plantarum Investigationis Ergo Susceptum* (1629) (S.T.C. no. 14703).

41. 21. The documentation on Strong is in Mrs R. Lane Poole, *Catalogue of Oxford Portraits*, II, xi ff.

22. Arthur E. Preston, *Christ's Hospital, Abingdon* (1929), 36 ff.

23. The genealogical documentation is in Mrs R. Lane Poole, 'An Outline of the History of the De Critz Family of Painters', in *Walpole Society*, II.

24. Mrs R. Lane Poole, 'Marcus Gheeraerts, Father and Son', in *Walpole Society*, III, publishes the documents; this is followed by an article on the younger Gheeraerts by Sir Lionel Cust, which is rich in illustrations but devoid of critical value. On the elder Gheeraerts, see A. Schoutheet, *De zestiende-eeuwsche schilder en graveur Marcus Gerards* (Bruges, 1941), with valuable documents; and Edward Hodnutt, *Marcus Gheeraerts the Elder* (Utrecht, 1971), which is valuable for Marcus's work as an engraver in England.

42. 25. See Note 6.

26. Logan Pearsall Smith, *The Life and Letters of Sir Henry Wotton*, I, 460: the mosaic is illustrated I, 452.

27. Vertue, V, 75. The letter does not appear among the published Penshurst MSS.

28. Roy Strong, *The English Icon* (1969), 269–304, illustrates the signed and documented pictures and also those which have been associated with Gheeraerts because of the form of the inscriptions. They are a motley lot.

43. 29. For documentation see Erna Auerbach, *Tudor Artists* (1954), 148–9; for full illustration of the attributed works (and the certain ones), see Roy Strong, *The English Icon* (1969), 225–52.

45. 30. The discovery of Larkin is due to James Lees Milne, *Burl. Mag.*, XCIV (Dec. 1952), 352–6, where the two similar portraits at Charlecote are published. For the fanciful extension of his personality see Roy Strong, *The English Icon* (1969), 313–36.

31. This has been unconvincingly ascribed to Gheeraerts, and, by Roy Strong, to Robert Peake.

48. 32. The National Portrait Gallery original has a signature, usually thought unconvincing, of the Spanish painter Pantoja de la Cruz. The Greenwich version may well be Spanish. See Roy Strong, *Tudor and Jacobean Portraits: National Portrait Gallery* (1969), 351–3.

33. See *Burl. Mag.*, XXXI (Sept. 1917), 89, where the article by F. M. Kelly is valuable only for dating the costumes not later than 1570. See also R. van Dorsten, *The Radical Arts* (1970), 53 ff.

34. Edward Croft-Murray, *Decorative Painting in England 1537–1837*, I, *Early Tudor to Sir James Thornhill* (1962), gives a sufficiently full account.

35. F. W. Reader, 'A Classification of Tudor Domestic Wall Painting', in *The Archaeological Journal*, XCVIII (1941), 181 ff.

36. *Archaeologia Scotica*, III (1831), 312–13. For surviving works, see Roy Strong, *The English Icon* (1969), 135–8; see also Erna Auerbach, *Nicholas Hilliard* (1961), 265–71.

37. James Drummond, *The Portraits of John Knox and George Buchanan* (Edinburgh, 1875) (from *Transactions of the Antiquarian Society*, 10 May 1875), 7.

49. 38. Sir James L. Caw, *Scottish Portraits*, I (1902), plate X.

CHAPTER 4

51. 1. For Van Somer's dates see A. Bredius, *Künstler-Inventare*, III, 807 ff., and VII, 210 ff. It has always been assumed by British writers, without evidence, that he came to England about 1606; but cleaning has shown that the 'signature' *G(?) van Somer London* on a picture dated 1611 at Gateshead is not genuine: see J. Steegman in *Burl. Mag.*, XCI (Feb. 1949), 52 ff., where the 'Lord Windsor' of 1620 is published.
53. 2. Historical MSS. Commission (Duke of Rutland MSS.); *Diary of Lady Anne Clifford*, ed. V. Sackville-West (1923), 105 and 107; Mrs C. C. Stopes in *Notes on Pictures in the Royal Collections*, ed. Lionel Cust (1911), 86.
3. W. Noel Sainsbury, *Original Papers relating to Rubens, etc.* (1859), 355, identifying 'Yor highness' as probably James I, but Charles, Prince of Wales, seems certain.
4. A complete catalogue of Mytens' portraits and a reprinting of all the documents are to be found in O. ter Kuile in *Nederlands Kunsthistorisch Jaarboek*, XX (1969), 1–106.
54. 5. MS. Account Book of Sir Henry Hobart from 5 Oct. 1621 to 29 June 1625 (bequeathed by the eleventh Marquess of Lothian to the Norfolk Record Society), under 22 Dec. 1624 – 'To Mr Daniell Mittens the picture drawer by the hands of Sr John Hobart in parte of payment for ye drawing of yr Lorpps picture 005/10/0'.
6. Ter Kuile, *op. cit.*, believes, probably rightly, that this should be read as 1618.
60. 7. A possible candidate is the picture in the Duke of Leeds sale, 20 June 1930, lot 45, as Van Dyck.
8. *Burl. Mag.*, XC (Nov. 1948), 322.
9. Reproduced in *The Studio* (May 1948), 136.
10. *Burl. Mag.*, LXXIII (Sept. 1938), 125, where two other signed portraits are noted.
61. 11. On 29 Apr. 1613 Michael Austin, an English-man, resident in London, apprenticed his son, Nathaniel (otherwise unknown), to Jan Teunissen at Amsterdam to learn painting (*Oud Holland*, LII (1935), 288).
12. Anon. sale, Christies', 28 May 1948, lot 174, as Van Vliet, but clearly signed CJ in monogram and dated 1617.
13. There is a preliminary catalogue by A. J. Finberg in *Walpole Society*, X. Finberg lists about 175 portraits up to 1643, when Johnson left England, and I have notes of about a further sixty, so that Johnson is the first British painter of whose work a considerable portion has been identified. He usually signs his pictures with some form of the initials CJ.
14. Catalogue of the Centraal Museum, Utrecht, 1933.
15. T. Pearson-Gregory sale, 18 June 1937, as 'A

Lady of the de Ligne Family', but it can be identified from R. White's engraving as Susanna Temple, after-wards Lady Thornhurst and Lady Lister.
16. Sir R. L. Hare, Bart, sale, 1 Mar. 1946, lot 63.
62. 17. *Burl. Mag.*, XC (July 1948), 204.
18. J. Fisher, *The History and Antiquities of Masham, etc.* (1865), 171.
19. Prince Frederick Duleep Singh, *Portraits in Norfolk Houses*, II, plate at p. 40 as '?John Osborne'; and A. C. Sewter in *Burl. Mag.*, LXXVI (July 1940), 25, as Cornelius Johnson.
20. Lord William Howard's account books for Naworth Castle in *Surtees Society*, LXVIII (1877), 182 ff.
63. 21. *Lancashire and Cheshire Record Society*, LI, 118, where his name is misprinted as 'South'.
22. C. H. Collins Baker in *The Connoisseur* (Mar. 1948), reprinted in the N.A.C.F. Report for 1947.
64. 23. Basil S. Long, *British Miniaturists* (1929), 123.
24. The sitters are Sir Richard Saltonstall (1595–1650), his second wife, Mary Parken (married 1633), and the children surviving at the birth of either Bernard (b. 1637) or Mary (b. 1639).
25. Mrs R. Lane Poole, *Catalogue of Oxford Portraits*, II (1925), XXV ff., gives the references for many of them; see also catalogue of the Exhibition of Historical Portraits at Cardiff, 1948.
66. 26. Basil S. Long, *British Miniaturists*. There is a long account of him in Walpole's *Anecdotes*.
27. C. H. Collins Baker, *Lely and the Stuart Portrait Painters*, II, 112.
67. 28. Mrs Hilda F. Finberg in *Walpole Society*, IX, 47–8, for de Jongh and other early landscape painters; also Colonel M. H. Grant, *The Old English Landscape Painters*, I and II (n.d.), III (1947), where all that is known about early landscape painters is copiously related. See John Hayes, *Burl. Mag.*, XCVIII (Jan. 1956), 3 ff.
29. For documentation and illustration of Cleyn's work in Denmark see Francis Beckett, *Kristian IV og Malerkunsten* (Copenhagen, 1937), 43 ff. (There exists an offprint in English of this chapter.)
30. *The Archaeological Journal*, CIV (1948), 172. Emmanuel de Critz is usually supposed to be the painter, but Cleyn seems to me more probable.
68. 31. Duncan Thomson, *The Life and Art of George Jamesone* (Oxford, 1975), for the first time throws much light on Scottish painting of this period. There is a full catalogue and documents.
69. 32. National Galleries of Scotland, Bulletin No. 1 (1973).

CHAPTER 5

70. 1. But see O. Millar, *Rubens' Whitehall Ceiling* (1956). For the Banqueting House in general, see Per

Palme, *Triumph of Peace: a study of the Whitehall banqueting house* (Stockholm, 1957).

2. This is sufficiently demonstrated by the astonishing draft of a letter of 1636 from the Earl of Newcastle to Van Dyck among the Welbeck MSS. (R. W. Goulding and C. K. Adams, *Catalogue of the Duke of Portland's Pictures* (1936), 485).

3. The best short general account and collection of illustrations is that by Gustav Glück in the *Klassiker der Kunst* series (1931), which altogether supersedes the earlier volume in the same series by Emil Schaeffer. But Glück was not very familiar with British collections, and several of the most remarkable groups of works by Van Dyck in this country (such as those belonging to the Dukes of Bedford and Northumberland, and Lord Egremont) are hardly represented at all. A much fuller list of his English portraits, made with only a slight attempt at separating originals from copies, is in Sir Lionel Cust's *Anthony Van Dyck* (1900). The beginnings of a serious study of Van Dyck appear in Oliver Millar, *The Tudor, Stuart and Early Georgian Pictures in the Collection of Her Majesty the Queen* (1963), 92 ff. See also Sir Oliver Millar's catalogue of the Charles I Exhibition, Tate Gallery, Winter 1972/3.

71. 4. The 'Continence of Scipio' at Christ Church, Oxford, almost certainly dates from these months (and is unfinished). See John Harris, *Burl. Mag.*, CXV (Aug. 1973), 526 ff.

5. See M. Jaffé, *Burl. Mag.*, CVIII (Mar. 1966), 114 ff.

72. 6. Published in full in W. H. Carpenter, *Pictorial Notices* (of Van Dyck, etc.) (1844), 66 ff.

75. 7. See O. Millar, *Burl. Mag.*, XCVI (Feb. 1954), 36 ff.

77. 8. Lady Burghclere, *Life of Strafford* (21 Jan. 1636), 11, 19.

9. E.g. the 'Earl of Bristol and Earl of Bedford' at Althorp, and the portrait called 'Mytens and his Wife' at Woburn.

10. For all the documents and illustrations on the de Critz family, see Mrs R. Lane Poole in *Walpole Society*, 11.

79. 11. *Notes and Queries*, First Series, I (12 Jan. 1850), 161. He has been confused also with Jerome Neve (*Latine* Nyphus), who painted in a Vandyckian style two large pictures of his own family which are now at Petworth. There is no reason to believe that this Neve worked in England. He seems to have married about 1625 and had eight children with obviously un-English names. A signed portrait by Cornelis de Neve, dated 1647, is said to be at Long Melford.

12. The version of the 'Robert Davies' at Gwysaney and a detail of the signature are reproduced in *Burl. Mag.*, XC (July 1948), 204 and note.

13. All four are published by A. C. Sewter, *Burl.*

Mag., LXXVII (July 1940), 20 ff. I do not agree with the attribution there to the same hand of the portrait of 'Lord Hussey' – a posthumous imaginary portrait, of which another version is at Doddington Hall, Lincs.

14. He appears wrongly in the *D.N.B.* as *Robert* Greenbury. The best and fullest account of him is by Mrs R. Lane Poole in *Catalogue of Oxford Portraits*, 11, XV ff.

80. 15. See (Oliver Millar), *William Dobson Exhibition*, Arts Council, 1951.

16. See William Vaughan, *Endymion Porter and William Dobson*, Tate Gallery, London, 1970.

82. 17. Others are mentioned by earlier writers, but the 'Decollation of St John' from Wilton is only a copy after Stomer. It is now at Liverpool.

18. Published by Oliver Millar in *Burl. Mag.*, XC (Apr. 1948), 97 ff.

19. Reproduced in *Burl. Mag.*, LII (Feb. 1928), 94; and in N. Stopford-Sackville, *Drayton* (1939).

85. 20. The documentary information about the Stone family (mixed up with a good deal of the mythology) is to be found in W. L. Spiers, 'The Note Book and Account Book of Nicholas Stone', *Walpole Society*, VII.

21. The sources for the 'literary tradition' are the addendum to the 1706 edition of R. de Piles, *Art of Painting*, p. 463, and the various references in Vertue (see Vertue Index).

86. 22. Gladys Scott Thomson, *Life in a Noble Household* (1937), 290.

23. What little is known or to be guessed about Bower, and the bibliography for the evidence, is published in the *Burl. Mag.*, XCI (Jan. 1949), 18 ff.

87. 24. Mentioned in the article, signed B. C. K., in Thieme-Becker. The date is now read as 1637.

88. 25. The thorny subject of the portraits of Cromwell is treated at greatest length, but not exhaustively, in *The Portraiture of Oliver Cromwell*, reprinted from *Biometrika*, XXVI, by K. Pearson and G. M. Morant. There is an unconfirmed tradition that the Walker portrait of 'Cromwell' (based in design on Van Dyck's 'Sir Edmund Verney') which descended to Mrs Polhill-Drabble (last in anon. sale, 2 Nov. 1945, lot 78) was a wedding present to Bridget Cromwell and Ireton in 1646: a similar picture at Burghley House is alleged to have been given to Lord Exeter in 1647. But Mr E. S. de Beer has shown, on historical grounds, that a demand for portraits of Cromwell did not arise until about 1649, when he had gone to live at Hampton Court and was developing into a personage, and the date 1649 is found on the two versions of the Walker design with a page at the left (taken from the 'Lord Newport' in Van Dyck's double portrait at Petworth) at the National Portrait Gallery and at Leeds (from Naworth). The third and latest design, with the page at the right, is documented as 1655/6 by Walker's receipt

for £24 published in Pearson and Morant, *op. cit.*, 77. The Florence portrait and the one at Birmingham are Lelys of 1653/4: see *Historical MSS. Commission, 6th Report* (1877) (MSS. of Miss ffarington of Worden), 437b, and E. S. de Beer in *History*, XXIII (1938/9), 132. C. H. Collins Baker introduced a red herring by supposing that the 'Great Duke' mentioned by Walpole was the Duke of Marlborough, when he was the Grand Duke of Tuscany.

26. An apparent exception is the full-length Lely of 'Monk' at Chatsworth. But Monk himself was an exception, and it is my impression that the head in this has been superimposed upon an earlier picture. The full-lengths of Cromwell all seem to be posthumous.

89. 27. Beyond those pictures mentioned in the text a little 'Head of a Girl' at Dulwich alone has a seventeenth-century attribution to Fuller. His name appears occasionally in eighteenth-century MS. catalogues, as at Dunham Massey and Exton Park, but I cannot reconcile the smooth texture of the two portraits from Exton published by A. C. Sewter in *Apollo* (Mar. 1941), 62, with what we know of Fuller.

90. 28. For what is left see K. Downes, *Burl. Mag.*, CII (Oct. 1960), 451 ff.

29. Vertue MSS., I (*Walpole Society*, XVIII, 101–2).

30. Published by C. H. Collins Baker, *The Connoisseur* (July 1917), 127.

31. One of these, of the 'Fifth Lord Conyers', dated 1656, is now in the York Art Gallery.

32. The best treatment of Wouters is G. Glück, *Rubens, Van Dyck und ihr Kreis* (1933), 222 ff.

33. The view of Canterbury belonged to Mr W. D. Caröe and is reproduced as plate XXXVI of the catalogue (1924) of the Exhibition of British Primitive Paintings, 1923. Another picture with an elaborate architectural interior and figures, signed and dated 1658 and formerly in the Erskine of Linlathen and Woodward collections, is only a copy of a Vredeman de Vries at Hampton Court.

CHAPTER 6

92. 1. Joachim von Sandrart, *Academie der Bau-, Bild- und Mahlerey-Künste von 1675*, ed. A. R. Peltzer (1925), 355. For catalogue and illustrations see R. B. Beckett, *Lely* (1951).

2. It has been fashionable in recent years to plump for Soest in Holland and to treat Houbraken's evidence as an invention. But Lely, on his naturalization in 1661/2, called himself of the Dukedom of Cleve, which presumably involves Soest in Westphalia: see *Publications of the Huguenot Society*, XVIII (1911), 82.

3. Houbraken and others say he came over in the train of William of Orange for the marriage in 1643: but the marriage was in 1641. The two portraits of

the Prince and Princess said to have been painted on this occasion have been identified with: (a) the originals of two portraits in the Earl of Crawford's possession, one of which is by or after Hannemann, while the other is ten years later than 1641; (b) pictures conveniently signed 'P. van der Faes' of which a 'Princess Mary' is published in *Burl. Mag.*, LXXXII (Apr. 1943), 100, signed 'Peter van der Faes 1641', and a 'Prince William', signed 'Van der Faes Pinxt. aet. 26', was in a sale at the Anderson Galleries, New York, 21 Jan. 1927, lot 85. I do not believe in either of these. The only other evidence for Lely being in England before 1643 was the date of '1642' said to be on the head of 'James, Duke of York' at Syon House, but this has turned out to read 1647.

96. 4. Lely's subject pictures have been so wholly and undeservedly neglected in the literature that a few more may be noticed here. A favourite subject was 'Susanna and the Elders', of which an early version (before 1650 ?) is at Birmingham, and later versions at Burghley House and in the Neeld sale, 13 July 1945, lot 98, as Victoors; in the reserves of the Louvre is an 'Atalanta and Meleager'; in the Baroda Gallery a 'Judith'; a 'Boys blowing Soap Bubbles' was in Earl Fitzwilliam's sale, 11 June 1948, lot 38; and a curious 'Idyll' was lent to R.A. 1938, no. 46, by the late Sir Edmund Davis. The only post-Restoration 'subject pictures' are those which represent the lighter ladies of the Court as 'Venus' (at Penshurst and formerly at Lowther Castle) or as the 'Magdalen' (at Kingston Lacy). For many illustrations see R. B. Beckett, *Lely* (1951).

5. *Notes and Queries*, First Series, I (12 Jan. 1850), 162. The companion, 'Lady Finch', is reproduced in R. B. Beckett, *Lely* (1951), plate 31.

97. 6. For my reasons for dating this *c.* 1651 see *Burl. Mag.*, LXXXVI (Feb. 1945), 51.

7. No explanation of these busts is available, but they are so disturbing that later owners painted them out in the two portraits of the 'Earl of Essex' and 'Lord Capel of Tewkesbury' after the Cassiobury sale in 1922. The latter has now found a home in the Metropolitan Museum, New York, and the bust has re-emerged to view.

8. *Letters of Dorothy Osborne to Sir William Temple*, ed. G. C. Moore-Smith (1928), 106.

9. For Lely visiting houses near Bury St Edmunds (near to the Mays' house at Boxted) see Roger North's *Lives of the Norths*, 1890 edition, II, 273.

99. 10. *Memoirs of the Count de Grammont*, translated by Peter Quennell (1930), 190. See J. Douglas Stewart in *English Portraits of the Seventeenth and Eighteenth Centuries* (William Andrews Clark Memorial Library, University of California, Los Angeles, 1974), 3–43.

101. 11. C. H. Collins Baker reconstructs Hayls from certain pictures at Woburn, relying on the list in

Vertue (11, 40), where the artists' names are given 'on the authority of some who pass for judges in painting'. The one traceable picture categorically called Hales in that list is 'Colonel John Russell', a picture of about 1645/8, which may well be an early phase of Hayls. The 'Ladies Diana and Anne Russell' of *c.* 1655/6 is hesitantly called 'perhaps not Vandyck but . . . Hales', but this charming and Vandyckian picture is hard to reconcile with the more solid projection of the Uffington portraits of *c.* 1653. At Lacock a 'Sir Gilbert Talbot' is mysteriously labelled 'Hayles 1679' but looks a good deal earlier. There is also a puzzling monogrammist, *JH*, who seems to have worked in Cheshire and Lancashire, 1647-62 (see M. R. Toynbee, *Country Life* (15 Sept. 1950), 840 ff.).
102. 12. Reproduced in the album of the Exhibition of Seventeenth Century Art in Europe, R.A., 1938.

13. For the style and dating of the Persian Vest see E. S. de Beer in *Journal of the Warburg Institute*, 11 (1938), 105 ff.

14. The 'First Lord Baltimore' was painted by Mytens, but the original found its way to Wentworth Woodhouse. The version sold, with the rest of the portraits of the Lords Baltimore, from Windlestone, at Sotheby's, 26 July 1933, may well have been a copy by Soest. This too now belongs to the Enoch Pratt Library, Baltimore.
104. 15. Reproduced in Roger Granville, *The History of the Granville Family* (1895), 406.
105. 16. C. H. Collins Baker wrongly calls them the children of Thomas Coke. They are in fact Thomas Coke (1674-1727) and his brother and sisters: the Cupid in the sky represents Francis, who died an infant in 1680: see J. Talbot Coke, *Coke of Trusley* (1880), 71.

17. Reproduced in *Country Life* (26 Jan. 1929), 122.

18. Reproduced in *The Fishing Gazette* (13 Dec. 1924).

19. Gascars was born in Paris *c.* 1634/5 and died in Rome 1701. He was *agréé* at the French Academy 1671; in London *c.* 1672-7; in Holland 1678/9; received a Member of the French Academy 1680; and set off on further travels in 1681. A life-size portrait of one of the Estes at Modena is dated 1681; he worked for a time at Munich; was at Venice 1686; and finally settled in Rome, where an altarpiece by him survives in Santa Maria dei Miracoli.
106. 20. *Remarks and Collections of Thomas Hearne*, v (Oxford Hist. Society, 1901), 112-13, under date 14 Sept. 1715. Hearne calls him William, but his informant, where he can be checked independently, seems to have known more about Wright than any of Vertue's sources.

21. Register of Apprentices of the City of Edinburgh, 1583-1666, Scottish Record Society (1906), 213.

22. (P. A. Orlandi), *L'Abecedario pittorico*, p. 329 of the Naples edition of 1733. Walpole's misprinting of the date as 1688 has misled some subsequent British writers. M. Missirini, *Memorie per servire alla storia della Romana Accademia di S. Luca* (Rome, 1823), 472.
107. 23. G. J. Hoogewerff, *Bescheiden in Italië*, 11 (The Hague, 1913), 130.

24. See *Journal of the Warburg and Courtauld Institutes*, VI (1943), 217 ff.

25. Corroboration of this is given in a reference for which I am indebted to Mr E. S. de Beer: the *Journal of Constantin Huygens, Jr*, first part (1876), 361-3.

26. If we are to believe Vertue (I, 50; II, 66), a portrait of the 'Duke of Norfolk' was at Norfolk House in 1718 dated 1656, but the 'pictor regius' in the signature makes this date very hard to believe in, and the picture is not to be found at Arundel today, though there are other Wrights there. It is, of course, possible that Charles II in exile may have given Wright cause to call himself 'pictor regius'.

27. The justification of this statement is in the fact that the picture comes from collateral descendants. It was acquired from the Earl of Chichester, and Walpole saw it in the possession of Thomas Pelham of Stanmer, whose wife was a great-granddaughter of Mr Claypole's sister, Frances. Walpole also saw another version at East Horsley in 1764 (*Walpole Society*, XV, 61).
108. 28. The identity of the sitter is extremely obscure. In addition to the one at Wardour (where there were three other examples of Wright), there is a similar picture at Deene Park called 'Hon. Edmund Brudenell', and a third, formerly at Abbotsford, has lately been most improbably christened 'Sir Philip Stapleton'. A bust version, to which no name is attached, also exists in Essex.

29. Reproduced in *Burl. Mag.*, LXXXVIII (Sept. 1946), 226.

30. For clearing up the tangle of the Guildhall Wrights I am deeply indebted to Mr Raymond Smith, Librarian of Guildhall, and Mr P. E. Jones, Deputy Keeper of the Records. Mr Collins Baker, misled by Evelyn's habit of adding later notes to earlier entries in his *Diary*, wrongly divided the series into two and dated some 1662. For the sad decision to preserve only two, see *The Times* (18 Nov. 1949), 6. Reproductions will be found of the 'Earl of Nottingham' (wrongly captioned as his father) in A. I. Dasent, *The Keepers of the House of Commons* (1911), 176; and of 'Sir Timothy Littleton' in F. A. Inderwick and L. Field, *Report on the Inner Temple Pictures of Judge Littleton and Sir Edward Coke* (1896), 8. See J. L. Howgego, *Guildhall Miscellany* (Feb. 1953).
110. 31. There is a story about a Wright who applied in vain for the post of King's Limner in Scotland about 1700. This may well be Wright's nephew (of the

same name), about whom nothing certain is known beyond the fact of his existence. Four feeble Kneller studio pieces of *c.* 1700, formerly at Melville House, Fife, are the only possible traces of him I have come across.

32. For Borsselaer see C. H. Collins Baker in *The Connoisseur* (Sept. 1922), 5 ff., where most of his known works are illustrated: but it should be observed that several of the portraits at Bisham Abbey now labelled 'Bursler' or 'Burslee' are clearly not by him. A 'Portrait of a Widow' at Amsterdam, signed and dated 1664, was bought in London. For the references to the 1670s see *Catholic Record Society*, XXXIV (1934), 157, 212, 221, and 238.

111. 33. Exhibition, Burlington Fine Arts Club, The Works of British-born Artists of the Seventeenth Century, 1938, exhibit 12, lent Mrs E. Durham. Collins Baker's account of Greenhill is confused by an unusual proportion of unacceptable attributions. The date of the Cartwright portraits at Dulwich remains a mystery, which is only the more baffling with the evidence on the Cartwright family provided by Miss E. Boswell in *Modern Language Review*, XXIV (1929), 125 ff.; and G. E. Bentley, *The Jacobean and Caroline Stage* (1941), II, 402 ff.

112. 34. Thomas Weedon, later a Gentleman of the Privy Chamber to Charles II, married at Westminster Abbey, 24 Apr. 1675.

35. For the full text see Rev. Peter Whalley, *The History and Antiquities of Northamptonshire* (1791), II, 583. The evidence for Wissing's arrival from The Hague in 1676 is in J. H. Hessels, *Archives of the London Dutch Church: Register of Attestations, etc.* (1892), 106.

113. 36. Elizabeth Walsh and Richard Jeffree, exhibition catalogue, *The Excellent Mrs Mary Beale* (Geffrye Museum, London, 1975). Another lady painter, Mrs Carlisle, was working as a professional in Covent Garden from 1654.

114. 37. The correct date was published by Elizabeth Walsh in *Burl. Mag.*, XC (July 1948), 209.

38. See Sir Lionel Cust, *Burl. Mag.*, XXVIII (Dec. 1915), 112 ff.

39. *Chirk Castle Accounts (continued), 1666-1753,* compiled by W. M. Myddelton (1931), 158 and 161.

40. C. Haskins, *The Salisbury Corporation Pictures and Plate* (1910), 15.

41. Mrs R. Lane Poole, *Catalogue of Oxford Portraits*, I (1912), xxvii ff.; II (1925), xiii ff.

115. 42. Gennari's own account of his activities remains unpublished in the Biblioteca Comunale dell' Archiginnasio, Bologna, MS. B. 344.

116. 43. There is full information, partly in dictionary form, in E. Croft-Murray, *Decorative Painting in England,* I (1962).

117. 44. Reproduced, as well as the central portion of

the Sheldonian ceiling, in the *Burl. Mag.*, LXXXIV (Jan. 1944), where there is a summary of what is known about Streeter.

45. This subject is exhaustively treated in H. V. S. and M. S. Ogden, *English Taste in Landscape in the Seventeenth Century* (Ann Arbor, 1955).

46. For what is known of Lankrink see *Burl. Mag.*, LXXXVI (Feb. 1945), 29 ff.

47. T. H. Fokker, *Jan Siberechts* (Brussels, 1931).

118. 48. Reproduced in *Country Life* (6 Feb. 1948), 277.

119. 49. The four large ones are reproduced in W. Shaw Sparrow, *British Sporting Artists* (1922), from which the main facts about Barlow and his engravings can be extracted from a disorderly mass of speculation. The same writer first published the date of his burial in *The Connoisseur* (July 1936), 36 ff.

121. 50. *Oud Holland,* L (1933), 179.

51. For the best account of Cooper and the miniaturists of this period, see Whinney and Millar, 89–103. For Cooper, see also Daphne Foskett, *Samuel Cooper* (1974), and the same author's rather unsatisfactory catalogue of the Cooper Exhibition at the National Portrait Gallery, 1974.

122. 52. For further information on British miniaturists see Basil S. Long, *British Miniaturists* (in dictionary form) (1929); R. W. Goulding's Catalogue of the Welbeck Miniatures, published as vol. V of the *Walpole Society*; and *British Miniaturists* by J. Graham Reynolds (1952). See also Daphne Foskett, *A Dictionary of British Miniature Painters,* 2 vols. (1972).

53. Duke of Hamilton sale, 6 Nov. 1919, lot 18, as 'L. S. Gunemans'; it reappeared correctly catalogued in a sale 12 May 1929, lot 141.

123. 54. The 'Lady Marchmont' at Mellerstain inscribed 'Scugal P. 1666' is in a costume of the 1690s and is presumably an error for 1696. One of the two portraits of 'Sir Archibald Primrose' in the Earl of Rosebery's collection appears to be dated 1670, but the attribution to Scougall is only traditional.

55. *The Household Book of Lady Grisell Baillie, 1692-1733,* Publications of the Scottish History Society, New Series, I (1911).

CHAPTER 7

125. 1. For Verrio's Toulouse period see *Biographie toulousaine* (1823), II, 480-1. There is a full account of the Verrio legend and of his known work in E. Croft-Murray, *Decorative Painting in England,* I (1962).

126. 2. Francis Thompson, *A History of Chatsworth* (1949). For Burghley, see *Country Life,* CXIV (1953), 2104-7.

3. *Country Life,* two articles in July 1935. For further

details on Laguerre and all the other painters mentioned in this chapter, see E. Croft-Murray, *op. cit.* (Note 1).

129. 4. See E. Croft-Murray, *Apollo* (Nov. 1959).

130. 5. Reproduced, after cleaning, in *Illustrated London News* (22 Oct. 1949), 637.

131. 6. See Eric Young in *Apollo*, XCVII (May 1973), 492-9.

132. 7. E. Wind, *Journal of the Warburg Institute* (1938), 122 ff.

133. 8. See *Burl. Mag.*, CXV (Nov. 1973), 735.

134. 9. The engraved 'Sir Thomas Reeve' is published by T. Borenius in *Burl. Mag.* (Jan. 1939), 39. See J. Woodward, *Burl. Mag.*, XCIX (Jan. 1957), 21 ff. For drawings for portraits during his English period, see Elaine Claye in *Master Drawings*, XII (1974), 41 ff.

10. There is a summary of what is known of his English work in C. H. Collins Baker and Muriel Baker, *Life of the Duke of Chandos* (1949), 284-5. The Duke of Chandos was surprised at Amigoni wanting to do his pictures on canvas – but he belonged to the old school.

CHAPTER 8

137. 1. Communicated to me by Sir Oliver Millar.

2. C. H. Collins Baker, *Lely*, etc., 11, 43, curiously misunderstands this arrangement.

138. 3. For a discussion of the evidence see Martin Davies' *National Gallery Catalogue of the British School* (1946), s.v. Kneller. 1646 is the more likely. Until Professor J. Douglas Stewart's full account of Kneller appears, reference must be made to his catalogue of the Kneller Exhibition, National Portrait Gallery, London, 1971.

4. Maratta painted visiting Englishmen in Rome, and these portraits, like Batoni's at a later date, may not have been without their influence in England. Important examples are the full-lengths of the 'Earl of Sunderland' and the 'Earl of Roscommon' (both of the early 1660s) at Althorp; 'Sir Thomas Isham' 1677 at Lamport; and the bust of 'Charles Fox' at Melbury and the 'Second Marquess of Tweeddale' at Yester.

5. It is now generally supposed that Kneller's first portrait of Monmouth is the picture of 1678 at Boughton and the Goodwood picture is left unattributed – but I am still inclined to believe it by Kneller.

6. I know of only three portraits from 1678 and one each for the next four years.

139. 7. Both are illustrated in Collins Baker, *Lely*, etc., 11, 76 and 80. In 1684/5 Kneller was sent to Versailles to paint Louis XIV, and had a chance to see what was being done in France.

142. 8. Pearl Finch, *History of Burley-on-the-Hill* (1901), I, 221-2.

143. 9. Among them are: John Jacob Bakker (perhaps the 'I. Baker' of Simon's mezzotint of the 'Sir Stephen Fox' of 1701 at Melbury), who was painting draperies for Kneller in 1697 and whose name appears on feeble copies of royal portraits formerly at Melville House; the old Marcellus Laroon (1653-1701/2), father of the better-known painter of the same name, by whom there is a 'Lord Lovelace' 1689 at Wadham College, Oxford, and 'William Savery' 1690 at Plymouth; two brothers named Edward and Robert Byng whose sketch-books are in the British Museum, of whom Edward seems to have been Kneller's most trusted assistant at the time of his death, while Robert was working on his own, in a style wholly derived from Kneller, as early as 1697 and as late as 1719; finally James Worsdale (c. 1692?-1767), alleged to have been a natural son of Kneller, whose faithful copy, dated 1731, of Kneller's 'Duchess of Buckingham' is at Mulgrave Castle; in 1733 he was painting royal portraits for the Nisi Prius Court at Chester Castle; in 1735 he had settled in Dublin, but returned to England in the 1740s and was made 'Painter to the Board of Ordnance'.

10. An alphabetical list of some of them is: Joseph Brook of Bury St Edmunds (working 1690-1724, probably died before 1728), who had a good business in Suffolk doing originals and copies; Wolfgang William Claret (d. 1706, will published in *Burl. Mag.*, XXXV, 87-8), a miniaturist as well as a painter, in England from at least 1679, who probably came from Brussels; Charles d'Agar or de Garr (born Paris 1699), son of Jacques d'Agar, later Court Painter in Denmark, who had a fashionable practice in London from at least 1705 until he committed suicide in May 1723, and whose works are hard to distinguish from the general run of Kneller imitations when they are not certified by engravings; Simon Dubois (1632-1708), a Dutchman long resident in Rome, who was in England from 1681 and was made a denizen 8 May 1697; William Gandy (buried at Exeter at a ripe age, 14 July 1729), a Devon painter whose work is said to have given hints to the young Reynolds – see Collins Baker, *Lely*, etc., 11, 56 ff.; Garrison, a painter working in the Wigan-Preston area c. 1713, by whom there are signed works at Balcarres; J. Hargrave, working from 1693 to 1707; Frederick Kerseboom, or Casaubon (Solingen 1632-London 1692/3), who had studied in Antwerp and Paris and spent fourteen years in Rome, two of them as pupil of Poussin – there are engravings of Poussinesque history-pieces by him done in London, and signed English portraits exist from 1683; his nephew Johann Kerseboom (d. 1708), known by engravings as the painter of a few English portraits; Samuel King, working 1693/5; James Maubart (d. 1746), who specialized in copies of portraits of poets and groups of children enriched with sprays of

honeysuckle; Garret Morphey, an Irish Catholic (d. Dublin 1715/16), who was working in Yorkshire 1686/8; Henry Peart (d. a little before 1700), who mainly copied Van Dyck and Lely; William de Ryck (1635-97), an Antwerp painter who was working in England in the 1690s; and finally the Dutchman Willem Sonmans of Dordrecht, who came to England in the early 1680s, and is interesting because he normally spent term time at Oxford and worked the rest of the year in London, where he died in 1708. All these painters show slight individualities of style, but all except Morphey and de Ryck were swallowed up by the prevailing Kneller fashion.

11. For the two Clostermans see J. D. Stewart, *Burl. Mag.*, CVI (July 1964), 306 ff.

12. See a note on Hill in R. W. Goulding and C. K. Adams, *Catalogue of the Duke of Portland's Pictures* (1936), 449.

144. 13. *Diary of the 1st Earl of Egmont* (Hist. MSS. Commission, 1920), I, 224-5.

14.. There is an unexpectedly well-informed article on him in the *D.N.B.*

15. Reproduced in Jens Thiis, *En ukjent Norsk Kunstsamling* (Oslo, 1941), 37.

145. 16. Darby Griffiths sale, at Padworth Place, by Winkworth, 26 ff. Sept. 1933, lot 577, illustrated as Wissing.

17. The crucial source for disentangling the Verelst family is the obituary notice of Harry Verelst, Governor of Bengal, in the *Gentleman's Magazine* (1785), 11, 920.

149. 18. For a list of sources for Gouge see C. H. Collins Baker and M. I. Baker, *Life of the Duke of Chandos* (1949), 86 n.

19. Oxford Historical Society, *Collectanea*, 11 (1890), 403 ff.

150. 20. *The Wentworth Papers*, ed. J. J. Cartwright (1883), 213 and 279.

21. Lord Egmont's Diary (see Note 13), III, 275.

CHAPTER 9

152. 1. See *Van de Velde Drawings*, ed. M. S. Robinson (Cambridge, 1958), for the most informed statement on this subject.

153. 2. See Kenneth Sharpe, catalogue of the Samuel Scott Bicentenary Exhibition, Guildhall, London, 1972.

3. In the collection of Mrs Todhunter at Gillingham.

4. *Walpole Society*, XVI, 49.

154. 5. *Ibid.*, XXI, 34.

6. Reproduced in John Steegman, *The Artist and the Country House* (1949), plate 2. See catalogue of exhibition at Sydney Sabin's Feb./Mar. 1973.

155. 7. Sir Osbert Sitwell, *Burl. Mag.*, LXXX (Apr. 1942), 88.

157. 8. Reproduced in J. Steegman, *op. cit.*, plates 22 and 23: one of the views of 'Chiswick Villa' is plate 12, and there is a good selection of topographers' views of country houses.

9. P. C. Manuk sale, 17 Dec. 1948, lot 76.

10. Mrs Finberg in *Walpole Society*, IX and X. More recently in W. G. Constable, *Canaletto*, 2 vols. (1962).

160. 11. There is a factual account of Scott in Mrs Finberg's article, *Burl. Mag.*, LXXXI (Aug. 1942), 201 ff. See also Kenneth Sharpe, *op. cit.* (Note 2).

12. *James Norie*, privately printed (Edinburgh, 1890), for a Wehrschmidt-Norie marriage.

161. 13. F. Saxl in *Journal of the Warburg and Courtauld Institutes*, VI (1943), 214 ff.; and H. S. Rogers in *Oxoniensia*, VIII and IX (1943/4), 154 ff.

162. 14. Ralph Edwards in *Apollo* (Feb. 1936), 79 ff.

15. Colonel M. H. Grant, *The Old English Landscape Painters*, III (1947), 7.

CHAPTER 10

163. 1. J. Northcote, *Supplement to the Memoirs of . . . Sir Joshua Reynolds* (1815), xvii.

164. 2. I have stolen this apt quotation from T. S. R. Boase's article in the *Journal of the Warburg and Courtauld Institutes*, X (1947), 91.

165. 3. See E. K. Waterhouse, 'English Painting and France in the Eighteenth Century', *Journal of the Warburg and Courtauld Institutes*, XV (1952), 122 ff.

4. T. Atkinson, *A Conference between a Painter and an Engraver* (1736), quoted by T. S. R. Boase, *op. cit.*, 88-9.

167. 5. See further E. K. Waterhouse, *Three Decades of British Art 1740-1770* (Philadelphia, 1965).

CHAPTER 11

169. 1. By far the best account of Hogarth's artistic character, which is bound up with his private character, is in A. P. Oppé's introduction to *The Drawings of William Hogarth* (1948). The bulk of Hogarth's paintings is illustrated and catalogued in R. B. Beckett, *Hogarth* (1949), and in the catalogue of the Hogarth Exhibition at the Tate Gallery, 1971. Full biographical and background material is to be found in Ronald Paulson, *Hogarth, His Life, Art and Times*, 2 vols. (Yale, 1971). F. Antal, *Hogarth and his Place in European Art* (1962), is the best critical work; and the engravings have been properly studied in Ronald Paulson, *Hogarth's Graphic Works*, 2 vols. (Yale, 1965).

174. 2. Dr Antal's valuable essay, 'Hogarth and his Borrowings', in *The Art Bulletin*, XXIX (1947), 36 ff., has suggested several of my remarks in this connexion.

CHAPTER 12

181. 1. The fullest account of John Vanderbank is in Hanns Hammelmann, ed. T. S. R. Boase, *Book Illustrators in Eighteenth Century England* (1975), 79–86.

2. No. 2034 at the National Portrait Gallery, which is signed 'V.p./1712' and assigned to Vanderbank, is more probably by John Verelst.

3. For the later popularity of this mode, which was taken up by the drapery painter Van Aken (who was also employed by Vanderbank), see J. Steegmann in *The Connoisseur* (June 1936), 309 ff.

4. See John Ingamells, 'John Vanderbank and Don Quixote', *Preview* (York, July 1968), 763 ff.

182. 5. J. W. Goodison in *Burl. Mag.*, LXXII (Sept. 1938), 125.

6. The main source for Highmore's biography is the obituary notice in the *Gentleman's Magazine* (1780, pt. 1), 176–9.

7. Gravelot tried his hand at painting too, but his one certain 'Conversation Piece' (see *Gazette des Beaux Arts*, Feb. 1932), in which Liotard and Hayman seem to have collaborated, the 'Augustus Hervey saying farewell to his Wife' 1750, at Ickworth, has nothing of the elegance of Highmore or Hogarth. For a full account of Gravelot in England, see Hanns Hammelmann, ed. Boase (*op. cit.*, Note 1), 38–46.

183. 8. *Burl. Mag.*, XCI (May 1949), 128 ff.

184. 9. Our present information about Dandridge, and a preliminary list of his works, is given in C. H. Collins Baker, *Burl. Mag.*, LXXII (Mar. 1938), 132 ff.

10. The attribution and dating are Collins Baker's, *op. cit.*, but the circumstantial evidence is convincing. An additional fact is that Robert Price was born in 1717.

186. 11. Gladys Scott Thomson, *Letters of a Grandmother* (1943), 136.

12. Lady Elizabeth Cust, *Records of the Cust Family*, Second Series (1909), 247, 250, 260, and 261.

13. All twenty-three are reproduced either in (Sir) Lionel Cust, *History of the Society of Dilettanti* (1898), or in Sir Cecil Harcourt Smith, *The Society of Dilettanti* (1932).

CHAPTER 13

188. 1. There is still a good deal of uncertainty about Mercier's earlier years and the nature of his relationship with Watteau, but it seems reasonably certain that he was in London by 1719. For a summary of what is known see John Ingamells and Robert Raines, catalogue of the Mercier Exhibition, York and Kenwood, 1969. A catalogue of Mercier's *œuvre* by Robert Raines is to appear in a volume of the *Walpole Society*.

189. 2. See John Ingamells, *Burl. Mag.*, CXVIII (July

1976), 511 ff., for the elucidation of this picture.

3. It is signed but not dated, but must have been painted between Lord Tyrconnel's being made K.B. in 1725 and the death of William Brownlow in 1726 (see Lady Elizabeth Cust, *Records of the Cust Family*, Second Series (1909), 191–2).

190. 4. Ralph Edwards in *Burl. Mag.*, XC (Nov. 1948), 308 ff.

5. For a list of the Merciers at Upton see Baker's *History of Northamptonshire* (1822/30), I, 226. The most remarkable was a large convivial group mentioned in Dallaway's notes to Walpole (ed. Wornum, II, 319, note 1): this is now in the Beaverbrook Art Gallery, Fredericton, N.B. See *Journal of the Warburg and Courtauld Institutes*, XV (1952).

191. 6. The list is accessibly published in J. T. Smith's *Nollekens and his Times* (1920 edition, ed. W. Whitten), II, 41 note. See also M. J. H. Liversidge in *Apollo*, XCV (Jan. 1972), 38–41.

192. 7. See Robert Raines, *Marcellus Laroon* (1966), with full catalogue.

193. 8. Mrs Finberg in *Walpole Society*, VI, 51 ff.

9. The painters who appear in the group are Dahl, Hysing, Hamilton himself, Wootton, Kent, and Goupy, and there are the engravers George Vertue and Baron, Rysbrack the sculptor, and Gibbs the architect.

10. Sydney H. Pavière, 'The Devis Family of Painters', in *Walpole Society*, XXV, 115 ff. This was expanded in Mr Pavière's monograph on Arthur Devis, 1950.

195. 11. *Journal of the Warburg and Courtauld Institutes*, X (1947), 91.

12. E. Edwards, *Anecdotes of Painters . . .* (1808), 51. See catalogue of Hayman Exhibition at Kenwood, 1960. See also E. Croft-Murray, *Decorative Painting in England, 1557–1837*, II (1970), 218–20.

13. For what is known of the Vauxhall paintings see Professor L. Gowing's study in *Burl. Mag.*, XCV (Jan. 1953), 4 ff.

14. See H. A. Hammelmann, *The Book Collector* (1953), 116 ff., and the same author's posthumous *Book Illustrators in Eighteenth-Century England*, ed. T. S. R. Boase (1975).

197. 15. Now in the Tate Gallery. The only earlier Shakespearian pictures are two of Hogarth's less characteristic paintings of *c.* 1730.

16. A description of Vauxhall in 1760, with a list of the paintings, is conveniently reprinted in Leslie and Taylor's *Life and Times of Sir Joshua Reynolds* (1865), I, 327 ff. Professor Gowing has made a full study of the Vauxhall paintings in *Burl. Mag.*, XCV (Jan. 1953), 4 ff.

198. 17. W. T. Whitley, *Artists and their Friends in England 1700–99*, I, 219.

CHAPTER 14

200. 1. British Art Exhibition, R.A. 1934, Memorial Catalogue no. 75 and plate xxiii.

2. Published in *Journal of the Warburg and Courtauld Institutes*, x (1947), 92 (now Paul Mellon Collection, Yale University).

201. 3. The baby in the picture is William (b. 1740) and the next son (b. 1742) is not included.

202. 4. Quoted from Sir James Caw's essay on Ramsay in *Walpole Society*, xxv, 79.

203. 5. See E. K. Waterhouse, *Arte Lombarda*, III (1958), 101 ff., and Anthony M. Clark, *Burl. Mag.*, CVI (May 1964), 226-33.

6. For a preliminary census of Batoni's portraits of English sitters see John Steegman in *Burl. Mag.*, LXXXVIII (Mar. 1946), 55 ff. See also *Mostra di Pompeo Batoni: Catalogo* by Isa Belli Barsali (Lucca, 1967).

210. 7. A long letter of 1766 to the Duke of Portland explaining Ramsay's position as official portraitist, in spite of Shackleton's right of office, is published in R. W. Goulding and C. K. Adams, *Catalogue of the Duke of Portland's Pictures* (1936), 470-1.

8. See R. W. M. Wright, *Apollo*, XXXI (Feb. 1940), 39-43; Mary Holbrook, *Apollo*, XCVIII (Nov. 1973), 375 ff.

211. 9. See Michael Wynne, *Burl. Mag.*, CXIV (Feb. 1972), 79-85.

10. M. Kirby Talley has completed a catalogue of Bardwell's *œuvre*, and an analysis of the technical procedure laid down in his *The Practise of Perspective and Painting made Easy* (1756) is in the press.

CHAPTER 15

214. 1. The most reliable text is Robert R. Wark, *Sir Joshua Reynolds. Discourses on Art* (Huntington Library, San Marino, 1959; reprinted Yale University Press, 1975).

CHAPTER 16

220. 1. First published by C. H. Collins Baker in *Gainsborough and Reynolds* (Pasadena, 1936) – a small pamphlet in the 'Enjoy your Museum' series.

2. See *Walpole Society*, XLI (1966-8), 165-7. A sensible chronology of the portraits of this period has been worked out by David Mannings, *Burl. Mag.*, CXVII (Apr. 1975), 212 ff.

221. 3. Thomas Patch (1725-82), who lived mainly in Italy, carried on this tradition of caricature groups of travelling Englishmen: see F. J. B. Watson in *Walpole Society*, XXVII (1939/40), 15 ff.

4. For an analysis of Reynolds's sitter book for 1755 see *Walpole Society*, XLI (1968).

222. 5. Quoted from Sir James Caw in *Walpole Society*, XXV, 59.

224. 6. W. T. Whitley, *Artists and their Friends . . .*, 1, 167.

CHAPTER 17

232. 1. Quoted in W. T. Whitley, *Artists and their Friends . . .*, 380.

2. Thomas Wright, in his *Life of Wilson* (1824) (and others since), talked a great deal of nonsense about de Momper and his influence on Wilson. It is likely that Wilson's idea of 'Momper' was formed by two pictures acquired under that name by his early patron, Lord Dartmouth, which seem to be Neapolitan works of the seventeenth century.

233. 3. For Zuccarelli in England, see Michael Levey, *Italian Studies* (1959).

4. T. Wright, *op. cit.*, 72.

234. 5. J. S. Müller published an engraving in 1747 of 'Dover' after Wilson. A small picture belonging to Paul Mellon (in the style of the Foundling Hospital roundels) may well be the original for this, and I am inclined to think that the pictures at Cardiff and in R. A. Butler's possession are post-Italian variants.

6. Brinsley Ford, 'R. Wilson in Rome', *Burl. Mag.*, XCII (May 1951), 157 ff.

7. Published by Brinsley Ford in *Burl. Mag.*, XC (Dec. 1948), 337 ff. Mr Ford's book on Wilson's drawings elucidated further Wilson's manner of approach to his compositions.

235. 8. One of these is now in the Tate and the other in the Paul Mellon collection at Yale.

241. 9. W. G. Constable, *Richard Wilson* (1953).

242. 10. See John Jacobs, *Catalogue of Thomas Jones (1742-1803) Exhibition* (Greater London Council, 1970).

11. See his 'View of a Greek House at Weston' (Society of Artists, 1772), illustrated in *Country Life* (26 Apr. 1946), 760. Both in the Morland sale in 1863 and in Lord Hillingdon's sale in 1939 this passed as a classical scene by Wilson.

12. The best account of Hodges, and especially of his Indian works, is by Isabel Stuebe, *Burl. Mag.*, CXV (October 1973), 659-66. Mrs Stuebe has also completed a thesis on Hodges for New York University.

13. Bernard Smith in *Journal of the Warburg and Courtauld Institutes*, XIII (1950), 73.

CHAPTER 18

244. 1. Lavinia, Countess Spencer, to her husband, 24 May 1787 (Althorp MSS.).

2. Letter to Lord Hardwicke of 21 July 1763 (Whitley, 41).

246. 3. A preliminary check-list of Gainsborough's

portraits is in *Walpole Society*, XXXIII. For a full catalogue see my *Gainsborough* (1958).
248. 4. See Whitley, 298-9. For all Gainsborough's letters see now: Mary Woodall, *The Letters of Thomas Gainsborough* (1963).
249. 5. Both pictures have identical Christie stencils on the back, but the sitters still elude identification.
250. 6. Gladys Scott Thomson in *Burl. Mag.*, XCII (July 1950), 201 f.
7. Last in anon. sale, 13 Mar. 1936, lot 52. It was at one time in Sir Cuthbert Quilter's collection and wrongly called a portrait of 'Philip Thicknesse'.
262. 8. *Thraliana*, ed. K. C. Balderston (1942), 11, 1082 n. The picture *may* be the one now at Bowood, but the identification is far from certain.
9. See my article (with a full catalogue of the 'fancy pictures') in *Burl. Mag.*, LXXXVIII (June 1946), 134 ff.
10. W. Roberts, *Sir William Beechey*, 22.
264. 11. For Dupont see John Hayes in *Burl. Mag.*, CVI (July 1964), 309-16; and *The Connoisseur*, CLXIX (Dec. 1968), 221-7.

CHAPTER 19

265. 1. This is discussed in my *Jayne Lectures* (Philadelphia, 1965).
2. A catalogue raisonné of Cotes's portraits by Edward Johnson has now appeared (1976).
266. 3. A portrait of 'George Gostling' in Lady Roundway sale, Sotheby's, 2 Oct. 1946, lot 122.
267. 4. Now in the Dublin Gallery. First published, with a full commentary, by A. N. L. Munby in *The Connoisseur* (Dec. 1947), 82 ff.
5. Thesis by David Goodreau, UCLA, 1974.
269. 6. See Lady Victoria Manners and G. C. Williamson, *Angelica Kauffmann* (1924); A. Crookshank, *Catalogue of A. K. Exhibition* (Kenwood, 1955); Dorothy Moulton Mayer, *A.K.* (Gerrards Cross), 1972).
270. 7. See John Sunderland, *Burl. Mag.*, CXVI (June 1974), 317 ff., for Pine's anti-monarchical history pictures and his political filiations, which no doubt account for his not becoming an R.A. A thesis on Pine is in hand in the U.S. by Robert Stewart.
8. See James D. Milner, *Walpole Society*, XV (1926/7), 47-103. A great many more portraits have turned up since Milner wrote.

CHAPTER 20

273. 1. Correspondence at Althorp over the purchase from Hamilton of the two large Guercinos and two Salvator Rosas for Spencer House. See my 'The British Contribution to the neo-classical Style in Painting', *British Academy*, XL (1954), 57 ff.
2. David Irwin, *English Neoclassical Art* (London, 1966).

3. Anonymous writer in *The Bee*, XVI, Edinburgh (10 July 1793), 3.
4. There are conflicting accounts of Barry's 'Death of Wolfe'. Edward Edwards says the figures were in the nude, but a contemporary newspaper account mentions a naval officer, a midshipman, and two grenadiers - which seems to imply uniforms. See D. Irwin, *The Art Bulletin* (Dec. 1959), 330 ff.
276. 5. A suggestive list of subjects treated by Gavin Hamilton, West, and Barry, with their dates and the dates of their French imitations, is in J. Locquin, *La Peinture d'histoire en France de 1747 à 1785*, 157, note 9.
6. The first version, painted in 1770, is now at Ottawa. The later repetition at Kensington Palace shows no appreciable variation.
277. 7. C. Mitchell in *Journal of the Warburg and Courtauld Institutes*, VII (1944), 20 ff.
278. 8. Copley's English work has been fully treated by Jules D. Prown, *John Singleton Copley*, 2 vols. (Yale, 1966).
282. 9. For a number of Opie's portraits during his early Cornish period, see J. W. Scobell Armstrong in *The Connoisseur*, XCIV (1934), 245-51.
284. 10. Best known from Pether's mezzotint. The original was in the Heldmann sale at Worton Court, Isleworth, 13 Mar. 1939, lot 297.
11. Last in anon. sale, Sotheby's, 15 May 1946, lot 59. For the criticism see *The Ear Wig* (1781), 10.

CHAPTER 21

285. 1. F. D. Klingender, *Art and the Industrial Revolution* (1947), 46. Klingender's was the first book to give a serious appreciation of Wright's importance, and I have drawn several ideas from it. Benedict Nicolson, *Joseph Wright of Derby*, 2 vols. (Yale University Press, 1968), has now given a very full account.
286. 2. See Benedict Nicolson in *Revue de l'Art*, no. 30 (1975), 35-8.
290. 3. Duchess of Sermoneta, *The Locks of Norbury* (1940), 45.
4. A serious account of Mortimer first appeared in Benedict Nicolson's *Catalogue of the John Hamilton Mortimer Exhibition* (1968). John Sunderland (see *Burl. Mag.*, CXVI (June 1974), 317 ff.) is preparing a full account of him.
5. A 'Death of Orpheus' has been sold from Lord Belper's collection, and two large Roman histories are at Radbourne: reproduced in my *Jayne Lectures* (1965).
291. 6. Reproduced in Sacheverell Sitwell, *Conversation Pieces* (1936), figure 103.
293. 7. Duncan Macmillan has completed a full study and catalogue of Runciman's work.
8. *Diary*, 1, 185, under date 16 Jan. 1797.

9. John Brown (1752–87) unfortunately can hardly be included in a history of painting, since he made only drawings and abandoned any idea of excelling in painting. He studied in Italy from 1771 to about 1781, and perfected a style of portrait drawing which looks backward to Giles Hussey and forward to Ingres. He also was friendly with Fuseli's circle in Rome and did a few fantastic drawings in that style. His most remarkable works are the portrait drawings of the founder-members of the Scottish Society of Antiquaries, now in the Scottish National Portrait Gallery. A brief contemporary account of him is given in *The Bee*, XV, Edinburgh (8 May 1793), 27 ff.

CHAPTER 22

299. 1. Most of the Seymours at Ammerdown are reproduced in *Country Life* (26 Jan. 1929), 126 ff.
2. *Memoir of George Stubbs*, printed for Joseph Mayer (Liverpool, 1879), 11. This is one of the few sources of information about Stubbs's beginnings. Fuller accounts of Stubbs are now available in two books, both published in 1971, by Constance Anne Parker and by Basil Taylor.
304. 3. The few facts known about Boultbee are published by W. Shaw Sparrow in *The Connoisseur* (Mar. 1933), 148 ff.

CHAPTER 23

308. 1. The sitter books and the payments from 1776 onwards are incorporated in the Catalogue volume of Ward and Roberts' *Romney* (1904), but no one has checked how accurately this was done and long use of that book has led me to misgivings. The location of the MSS. is unknown to me, as is the whereabouts of some unpublished Romney sitter material for the earlier 1770s, which belonged to W. Roberts. A sociological study of Romney by G. C. Rump (2 vols., Hildesheim, 1973) is more curious than useful.

CHAPTER 24

315. 1. Reproduced in *Journal of the Warburg and Courtauld Institutes*, X (1947), plate 25A.
318. 2. Oliver Millar, *Zoffany and his Tribuna* (London, 1967). For curious and debatable further matter on this, see Ronald Paulson, *Emblem and Expression* (1975).

319. 3. It was painted, however, in 1782; cf. *Burl. Mag.*, CVI (July 1964), 317 ff.
4. Mary Webster, *Francis Wheatley* (London, 1970).
320. 5. For what is known or surmised about Henry Morland see Martin Davies' National Gallery Catalogue, *The British School*, s.v.

CHAPTER 25

323. 1. The best general account of the development of landscape is now Luke Herrmann, *British Landscape Painting of the Eighteenth Century* (1973).
324. 2. See Rüdiger Joppien, *Die Szenenbilder Philippe Jacques de Loutherbourgs* (Cologne, 1972); and the same author's catalogue of the De Loutherbourg Exhibition at Kenwood, London, 1973.
3. See Note 5 to Chapter 24.
327. 4. Quoted from W. T. Whitley, *Gainsborough*, 358.
5. The earlier literature on Sandby has been substantially corrected in A. P. Oppé, *Sandby Drawings at Windsor Castle* (1947); and by articles by A. P. Oppé in *Burl. Mag.*, LXXXVIII (June 1946), 143 ff., and E. H. Ramsden in *Burl. Mag.*, LXXXIX (Jan. 1947), 15 ff. For Sandby's date of birth see Luke Herrmann, *op. cit.* (Note 1), 37, where there is also the fullest appreciation of Sandby's work.
329. 6. Reproduced in Laurence Binyon, *English Watercolours* (1933), 68. This book forms the best short general introduction to the whole subject. A full account of many minor craftsmen has been published by Iolo Williams (1952).

CHAPTER 26

330. 1. This remains true in spite of David and Francina Irwin's *Scottish Painters at Home and Abroad 1700–1900* (1975), which is more concerned with Scottish painters 'abroad' before the last quarter of the eighteenth century.
332. 2. See D. F. Fraser-Harris, *Scottish Bookman*, I (1936), 12–19; John Fleming, *Country Life* (1962), 1224–6; and Duncan Macmillan's forthcoming book on Alexander Runciman.

CHAPTER 27

336. 1. See catalogue by Helen Kapp of the Daniel Gardner Exhibition at Kenwood, 1972.

BIBLIOGRAPHY

Articles in periodicals are normally mentioned in the notes to the text.

I. BIBLIOGRAPHIES

There is no standard bibliography of British Art. A beginning was made of an annual bibliography by the Courtauld Institute, whose *Bibliography of the History of British Art* covered the literature for 1934 to 1945 and appeared in four volumes (Cambridge 1936 to 1951) but had to be discontinued.

A formidable work is in progress for the eighteenth century and the Romantic period:

Johannes Dobai, *Die Kunstliteratur des Klassizismus und der Romantik in England*, I *(1700–1750)*. Bern, 1974; II, 1976.

Also useful for reference are vols. III and IV (Great Britain) of:

Edward Godfrey Cox, *A Reference Guide to the Literature of Travel* (University of Washington Publications in Language and Literature, vols. 12/13). Seattle, 1949 ff.

The few books which have useful special bibliographies have that fact recorded below.

II. DICTIONARIES

The articles on British painters in Thieme-Becker, *Allgemeines Lexikon der bildenden Künstler*, are usually scrappy but are valuable for their (often excessive) bibliographical references. Certain articles on minor painters include small items, derived from British scholars, which are not published elsewhere. The last edition of Bryan's *Dictionary of Painters and Engravers*, revised by G. C. Williamson in 1903/4 (and often reprinted up to 1925), includes some useful articles on the more flimsy painters of the eighteenth century, in whom Dr Williamson specialized. The *Dictionary of National Biography* has some useful articles on the earlier painters by (Sir) Lionel Cust and is worth consulting for a few well-informed articles on minor painters. For the few painters of note of American origin, or who worked in the United States (Pine, West, and Copley) the *Dictionary of American Biography*, New York, 1928–36, is much superior to any of the others.

Other dictionaries include:

FOSKETT, DAPHNE. *A Dictionary of British Miniature Painters.* 2 vols. London, 1972.
This expensive work does not altogether supersede Basil Long (*see* below).

GRANT, COLONEL MAURICE HAROLD. *A Chronological History of the Old English Landscape Painters (in oil).* I and II, London, 1926; III, Leigh on Sea, 1947.
Much of this has reappeared in a *Dictionary*, 1952. It is a mine of information, but the evidence for the attribution of the pictures illustrated is not often given and is not always reliable.

HALL, MARSHALL. *The Artists of Northumbria.* Newcastle, 1973.
'A Dictionary of Northumberland and Durham painters, draughtsmen and engravers, born 1647–1900.'

HAMMELMANN, HANNS (edited and completed by T. S. R. Boase). *Book Illustrators in Eighteenth Century England.* New Haven and London, 1975.
Mainly a dictionary and including lists of books illustrated.

LONG, BASIL S. *British Miniaturists.* London, 1929.
A source book of great value, with a full bibliography.

REDGRAVE, SAMUEL. *A Dictionary of Artists of the English School.* 2nd and revised edition, London, 1878. A reprint 1970.
Still the most useful quick work of reference.

REES, REV. T. HARDY. *Welsh Painters, Engravers and Sculptors (1527–1911).* Carnarvon, 1912.
An amateurish but diligent publication.

STRICKLAND, WALTER G. *A Dictionary of Irish Artists.* 2 vols. Dublin, 1913. There is an anastatic reprint.
A valuable work of reference, in which the term 'Irish' is most liberally interpreted.

III. GENERAL WORKS

There are many popular compilations, but I only list works which have some value as source material or give evidence of a considerable degree of research.

AUERBACH, ERNA. *Tudor Artists*. London, 1954.
Text and illustrations are largely concerned with the illumination of the Plea Rolls, but there is a valuable summary of documentary material about all known Tudor painters. Further documentary material will be forthcoming in a book by Mary Edmund. Full bibliography.

BAKER, C. H. COLLINS. *Lely and the Stuart Portrait Painters*. 2 vols. London, 1912.
The pioneer work on the seventeenth century and still useful.

BAKER, C. H. COLLINS, and CONSTABLE, W. G. *English Painting of the Sixteenth and Seventeenth Centuries*. Florence and Paris, 1930.
A handsome picture book with a good bibliography.

BAKER, C. H. COLLINS, and JAMES, M. R. *British Painting*. London, 1933.
The best short history of the whole field.

BAKER, C. H. COLLINS, and BAKER, MURIEL I. *The Life and Circumstances of James Brydges, First Duke of Chandos*. Oxford, 1949.

The Boydell Gallery. London, 1874.
A reproduction on a reduced scale of 97 engravings from the original edition of 1805.

BUCKERIDGE, B., in R. DE PILES, *The Art of Painting*. 3rd edition of the English translation. London [written *c.* 1706: published *c.* 1754].
An anastatic reprint exists.

BURKE, JOSEPH. *English Art 1714–1800*. Oxford, 1976.
Volume IX in the Oxford History of English Art.

CAREY, WILLIAM. *Letter to I- A- Esq*. Manchester, 1809.
All Carey's, usually privately printed, pamphlets; tend to contain information of value.

CROFT-MURRAY, EDWARD. *Decorative Painting in England 1537–1837*. Vol. 1: *Early Tudor to Sir James Thornhill*. London, 1962. Vol. 2: *The Eighteenth and Early Nineteenth Centuries*. London, 1970.
Each volume has dictionary-form entries as well as a general introduction, and full bibliographies.

CUNNINGHAM, ALLAN. *The Lives of the Most Eminent British Painters*. Revised edition, with continuations by Mrs Heaton. 3 vols. London, 1879–80.
This is the most convenient edition to consult. The original edition was 1829–33.

CUST, SIR LIONEL, and COLVIN, SIR SIDNEY. *History of the Society of Dilettanti*. London, 1898 (reprinted 1914).
See also under HARCOURT SMITH in IV. Catalogues (below).

DAYES, EDWARD. *The Works of the late Edward Dayes*. London, 1805. There is a modern reprint.
Contains biographical material on eighteenth-century painters.

DORSTEN, J. A. VAN. *The Radical Arts*. Leiden/London, 1970.
The subtitle is 'First Decade of an Elizabethan Renaissance'. The book is only partly concerned with the visual arts.

EDWARDS, EDWARD. *Anecdotes of Painters* . . . 'intended as a continuation to the *Anecdotes of Painting* by the late Horace, Earl of Orford'. London, 1808.
There is a modern reprint.

ENGLEFIELD, W. A. D. *The History of the Painter-Stainers Company of London*. London, 1923.
More documents from this source remain to be published.

FARINGTON, JOSEPH. (ed. James Greig). *The Farington Diary*. 8 vols. London, 1922 ff.
An unsatisfactory and incomplete selection from the MSS. at Windsor. A full text is in hand, edited by Kenneth Garlick and Angus McIntyre.

HARDIE, MARTIN. *Water Colour Painting in Britain*. 3 vols. London, 1967.

HERRMANN, LUKE. *British Landscape Painting of the Eighteenth Century*. London, 1973.
Covers both oils and watercolour.

HERVEY, MARY F. S. *The Life, Correspondence, and Collections of Thomas Howard, Earl of Arundel*. Cambridge, 1921.

[HERVEY, S. H. A.] *The Diary of John Hervey, First Earl of Bristol, with Extracts from his book of Expenses*. Wells, 1894.

HUTCHISON, SIDNEY C. 'The Royal Academy Schools, 1768–1830', in *Walpole Society*, XXXVIII (1960–2), 123–91.
The only source for a good many dates.

IRWIN, D. *English Neoclassical Art*. London, 1966.
With a useful bibliography.

KLINGENDER, FRANCIS D. *Art and the Industrial Revolution*. London, 1947 (reprinted 1968).
A first-rate study from a Marxist point of view.

MANDER, RAYMOND, and MITCHENSON, JOE. *The Artist and the Theatre*. London, 1955.

MANWARING, ELIZABETH WHEELER. *Italian Landscape in Eighteenth-Century England*. New York, 1925.
This has been anastatically reprinted.

MERCER, ERIC. *English Art, 1553–1625*. Oxford, 1962. Vol. VII in the Oxford History of English Art.
Good bibliography.

MERCHANT, W. MOELWYN. *Shakespeare and the Artist*. Oxford, 1959.
There is much more to be done on this subject.

MILNER, EDITH, and BENHAM, EDITH. *Records of the Lumleys of Lumley Castle*. London, 1904.
The first publication of the Lumley Inventory. It is more accurately transcribed in the *Walpole Society*, vol. VI (1918).

NICHOLS, R. H., and WRAY, F. A. *The History of the Foundling Hospital.* London, 1935. See also NICOLSON, B., in IV. Catalogues (below).

NORTH, ROGER. *The Lives of the Norths.* Augustus Jessopp edition. 3 vols. London, 1890.
The matter relating to Lely's estate is found only in the Jessopp edition.

OGDEN, HENRY V. S. and MARGARET S. *English Taste in Landscape in the Seventeenth Century.* Ann Arbor, 1955.
An odd but very useful book, written from the viewpoint of a student of literature.

PAULSON, RONALD. *Emblem and Expression.* London, 1975.
A remarkable example of what can happen to a student of literature obsessed with the study of iconography.

PIPER, DAVID. *The English Face.* London, 1957.

PYCROFT, GEORGE. *Art in Devonshire, with the Biographies of Artists born in that County.* Exeter, 1883.

PYE, JOHN. *Patronage of British Art.* London, 1845.
An essential source book.

REDGRAVE, RICHARD and SAMUEL. *A Century of Painters of the English School.* 2 vols. London, 1866.
Illustrated reprint, without the last chapter, 1949.

SAINSBURY, W. NOEL. *Original Unpublished Papers illustrative of the Life of Sir Peter Paul Rubens &c.* London, 1859.
With documentary material on the patronage of artists by Charles I.

SAXL, FRITZ, and WITTKOWER, RUDOLF. *British Art and the Mediterranean.* Oxford (and Warburg Institute), 1948.

SHAW SPARROW, WALTER. *British Sporting Painters.* London, 1922.
An untidy book, but not superseded.

SHAW SPARROW, WALTER. *A Book of Sporting Painters.* London, 1937.
Has an index-dictionary at the end.

SMITH, JOHN THOMAS. *Nollekens and his Times.* 2nd ed. 1829.
The annotated edition by Wilfred Whitten, London, 1920, is the most convenient for information.

SMITH, JOHN THOMAS. *A Book for a Rainy Day.* London, 1845.
The annotated edition by Wilfred Whitten, 1905, is best.

STEEGMAN, JOHN. *The Artist and the Country House.* London, 1949.

STRONG, ROY. *Portraits of Queen Elizabeth I.* Oxford, 1963.

STRONG, ROY. *The English Icon: Elizabethan and Jacobean Portraiture.* London, 1969.
The largest and best collection of plates for this period. Documented works are separated from the others and all are reproduced. The attributions are less reliable.

THOMPSON, FRANCIS. *A History of Chatsworth.* London, 1949.

TINKER, CHAUNCEY BREWSTER. *Painter and Poet.* Harvard, 1938.

VERTUE, GEORGE. *MS. Notebooks* (in the British Museum) published by *The Walpole Society*: XVIII (Vertue I), 1930; XX (Vertue II), 1932; XXII (Vertue III), 1934; XXIV (Vertue IV), 1936; XXVI (Vertue V), 1938; XXIX (Index to I to V), 1947; XXX (Vertue VI – with separate index), 1955.

WALPOLE, HON. HORACE (Earl of Orford). *Anecdotes of Painting in England.* 4 vols. 1765-71. Another edition (including Dalloway's notes) ed. Ralph N. Wornum. 3 vols. London, 1876. Vol. V, ed. F. W. Hilles and P. D. Daghlan, Yale, 1937.
The Wornum edition is the most convenient for consultation. Vol. V consists of Walpole's own collection of contemporary cuttings for the years 1760 to 1795.

WATERHOUSE, E. K. *Three Decades of British Art 1740-1770* (Jayne Lectures for 1964). Philadelphia, 1965.

WHINNEY, MARGARET, and MILLAR, OLIVER. *English Art 1625-1714.* Oxford, 1958.
Vol. VIII of the Oxford History of English Art.

WHITLEY, WILLIAM T. *Artists and their Friends in England, 1700 to 1799.* 2 vols. London, 1929. Also anastatically reprinted.
This is a major source book, but Whitley gives no references. They can, however, often be unearthed from the Whitley MSS. in the Print Room of the British Museum.

WILLIAMS, IOLO A. *Early English Watercolour.* London, 1952.

WIMSATT, WILLIAM KURTZ. *The Portraits of Alexander Pope.* Yale, 1965.

WOOD, SIR HENRY TRUEMAN. *A History of the Royal Society of Arts.* London, 1913.

WOODWARD, JOHN. *Tudor and Stuart Drawings.* London, 1951.

WOODWARD, JOHN. *British Painting – A Picture History.* London, 1962.

IV. CATALOGUES

A selection only of catalogues which have particular value as works of reference. Catalogues of exhibitions of individual artists are listed in section V below.

ADAMS, C. K. *A Catalogue of the Pictures in the Garrick Club.* London, 1936.

BAKER, C. H. COLLINS. *Catalogue of British Paintings in the Henry E. Huntington Library and Art Gallery.* San Marino, California, 1936.

BORENIUS, TANCRED. *The Harewood Collection of Pictures.* Privately printed, Oxford, 1936.

Catalogue of an Exhibition of Late Elizabethan Art. Burlington Fine Arts Club, London, 1926.

Commemorative Catalogue of the Exhibition of British Art R.A. 1934. Oxford, 1935.

CROOKSHANK, ANNE, and the Knight of GLIN. *Irish Portraits.*
Exhibition Dublin, London, Belfast, 1969/70.

CUST, (SIR) LIONEL. *Exhibition illustrative of Early English Portraiture.* Burlington Fine Arts Club, 1909. Illustrated catalogue.

CUST, (SIR) LIONEL. *Eton College Portraits.* London, 1910.

DAVIES, (SIR) MARTIN. *National Gallery Catalogues: British School.* London, 1946; second edition, 1959.
There is matter in the 1946 edition no longer in the second edition, since certain pictures had been moved to the Tate Gallery, which has never had a proper catalogue.

DEVONSHIRE. *Report and Transactions of the Devonshire Association for the Advancement of Science, Literature and Art,* XIV (1882) to XIX (1887).
Catalogues of pictures in Devonshire collections are published in these reports.

DULEEP SINGH, PRINCE FREDERICK. *Portraits in Norfolk Houses.* 2 vols. Norwich, 1927.

FARRER, REV. EDMUND. *Portraits in Suffolk Houses (West).* London, 1908.
The MS. for Suffolk (East) is in the Ipswich Public Library.

FRY, FREDERICK M. *A Historical Catalogue of the Pictures . . . at Merchant Taylors' Hall.* London, 1907.

GARLICK, KENNETH. A catalogue of the pictures at Althorp is in *Walpole Society,* XLV (1976).

GOODISON, J. W. *Catalogue of Cambridge Portraits,* I, *The University Collection.* Cambridge, 1955.

GOODISON, J. W. *Portraits and other Pictures at King's College, Cambridge.* Cambridge, 1933.

GOULDING, RICHARD W., and ADAMS, C. K. *Catalogue of Pictures belonging to His Grace the Duke of Portland.* Cambridge, 1936.
There is new documentary material among the biographies of artists.

GRAVES, ALGERNON. *The Royal Academy of Arts.* 8 vols. London, 1905/6. Also anastatically reprinted.
A complete dictionary of all work exhibited at the R.A. from 1769 to 1904.

GRAVES, ALGERNON. *The Society of Artists of Great Britain (1760-1791): The Free Society of Artists (1761-1783).* London, 1907. Also anastatically reprinted.

GRAVES, ALGERNON. *A Century of Loan Exhibitions (1813-1912).* 5 vols. London, 1913/15. Also anastatically reprinted.

HAILSTONE, EDWARD. *Portraits of Yorkshire Worthies.* 2 vols. London, 1869.

Illustrated catalogue of part of the Leeds Exhibition, 1868.

HARCOURT SMITH, SIR CECIL. *The Society of Dilettanti, its Regalia and Pictures.* London, 1932.

HAWKESBURY, LORD, and LAWRENCE, REV. HENRY. *East Riding Portraits* in *The Transactions of the East Riding Antiquarian Society,* X to XII. Hull, 1903/4.

INGAMELLS, JOHN. *Catalogue of Portraits at Bishopthorpe Palace.* York, 1972.

KERSLAKE, JOHN. *Catalogue of the Eighteenth Century Portraits in the National Portrait Gallery, London.* London, 1977.

MILLAR, (SIR) OLIVER. *The Tudor, Stuart and Early Georgian Pictures in the Collection of Her Majesty the Queen.* 2 vols. London, 1963.

MILLAR, (SIR) OLIVER. *The Later Georgian Pictures in the Collection of Her Majesty the Queen.* London, 1969.

MILLAR, SIR OLIVER. *The Age of Charles I* (Exhibition Catalogue). The Tate Gallery, London, 1972.

National Portrait Exhibitions, South Kensington, 1866 to 1868.
Illustrated albums of these were published and many of the negatives survive in the Victoria and Albert Museum.

NICOLSON, BENEDICT. *The Treasures of the Foundling Hospital.* Oxford, 1972.

O'DONOGHUE, FREEMAN, and HAKE, (SIR) HENRY M. *Catalogue of Engraved British Portraits . . . in the British Museum.* 6 vols. London, 1908-25.

OXFORD. Illustrated catalogues of Loan Collections of Portraits, 1904-6. 3 vols. Oxford, 1904-6: (1) those who died prior to 1625; (2) those who died between 1625 and 1714; (3) those who died between 1714 and 1837.
The portraits are nearly all from Oxford collections.

PIPER, DAVID. *Catalogue of the Seventeenth Century Portraits in the National Portrait Gallery 1625-1714.* Cambridge, 1963.

POOLE, MRS REGINALD LANE. *Catalogue of Portraits in the Possession of the University, Colleges, City and County of Oxford.* Oxford, 1912 (I) and 1925 (II and III).

Royal Academy, The first hundred years of the. Catalogue of the Exhibition, R.A., 1951/2.

Royal Academy. British Portraits. Catalogue of the Exhibition, R.A., 1956/7.

Royal Academy. Bicentenary Exhibition 1768-1968. Catalogue.

RUBENS, ALFRED. *Anglo-Jewish Portraits.* London, 1935.

SHAW, W. A. *Three Inventories of Pictures in the Collections of Henry VIII, Edward VI.* London, 1937.

SMITH, JOHN CHALONER. *British Mezzotinto Portraits.* 5 vols. and a portfolio of plates. London, 1878-83.

STEEGMAN, JOHN. *A Survey of Portraits in Welsh Houses*. I. *Houses in North Wales*. Cardiff, 1957. II. *Houses in South Wales*. Cardiff, 1962.

STRONG, ROY. *National Portrait Gallery: Tudor and Jacobean Portraits*. 2 vols. London, 1969.

TAYLOR, BASIL. *Painting in England 1700-1850: Collection of Mr and Mrs Paul Mellon*. Richmond, Virginia, 1963.

There is additional material in the Catalogue of the Exhibition of the Mellon Collection at the Royal Academy, London, Winter 1964-5. Much of the collection has now been made over to the British Art Center, New Haven.

VERTUE, GEORGE. *A Catalogue and Description of King Charles the First's Capital Collection of Pictures*. London, 1757.

This has now been superseded by Sir Oliver Millar's publications of Van der Doort's original catalogue (*Walpole Society*, XXXVII, 1958-60) and the Commonwealth Sales (*Walpole Society*, XLIII, 1970/2).

VERTUE, GEORGE. *A Catalogue of the Collection of Pictures &c. belonging to King James the Second &c.* London, 1758.

WATERHOUSE, E. K. *The Collection of Pictures at Helmingham Hall*. Privately printed, 1959.

WATERHOUSE, E. K. *The James A. de Rothschild Collections at Waddesdon Manor* (National Trust). Fribourg, 1967.

V. INDIVIDUAL PAINTERS

ALLAN, DAVID
T. Crouther Gordon. *David Allan*. Alva, 1951.
Basil Skinner. *The Indefatigable Mr Allan*. Exhibition Catalogue, The Scottish Arts Council, 1973.

BARDWELL, THOMAS
A catalogue raisonné of his pictures by M. Kirby Tally is forthcoming in a volume of the Walpole Society.

BARRY, JAMES
Dr Fryer (ed.). *The Works of James Barry, Historical Painter*. 2 vols. London, 1809.
A catalogue of his work is in preparation by William Presley.

BEACH, THOMAS
Elise S. Beach. *Thomas Beach* (with catalogue). London, 1934.

BEALE, MARY
Elizabeth Walsh and Richard Jeffree. *The Excellent Mrs Mary Beale*. Exhibition catalogue and check list. Geffrye Museum, London, 1975-6.

BEECHEY, SIR WILLIAM
W. Roberts. *Sir William Beechey*. London, 1907.
This contains the material for a catalogue.

COOPER, SAMUEL
Daphne Foskett. *Samuel Cooper*. London, 1974. (See also the Catalogue of the Exhibition *Samuel Cooper and his Contemporaries*, National Portrait Gallery, London, 1974.)

COPLEY, JOHN SINGLETON
Letters and Papers of John Singleton Copley and Henry Pelham (*Massachusetts Historical Society Collections*, LXXI (1914)).
J. T. Flexner. *John Singleton Copley*. Boston, 1948.
Jules D. Prown. *John Singleton Copley*. Vol. I (America); vol. II (England). Harvard, 1966.

COSWAY, RICHARD
G. C. Williamson. *Richard Cosway*. London, 1917.

COTES, FRANCIS
Edward Mead Johnson. *Francis Cotes*. London, 1976.
With catalogue.

DAHL, MICHAEL
Wilhelm Nisser. *Michael Dahl and the Contemporary Swedish School of Painting in England*. Uppsala, 1927.
Catalogues and a very rich bibliography.

DANCE, NATHANIEL
David Goodreau has completed a catalogue.

DE LOUTHERBOURG, P. J.
Rüdiger Joppien. Catalogue of the De Loutherbourg Exhibition. Kenwood, 1974.
The same author has published a thesis on De Loutherbourg's stage decorations and prepared the material for an extended catalogue.

DEVIS, ARTHUR etc.
Sydney H. Pavière. *The Devis Family of Painters* (with catalogues). Leigh on Sea, 1950.

DOBSON, WILLIAM
(Sir) Oliver Millar. Catalogue of Dobson Exhibition at the Tate Gallery. London, 1951.

DOWNMAN, JOHN
G. C. Williamson. *John Downman*. London, 1907.

DYCK, SIR ANTHONY VAN
W. Hookham Carpenter. *Pictorial Notices of Sir Anthony van Dyck*. London, 1844.
The fundamental publication of the documents relating to Van Dyck's work for the Crown – see also Sir Oliver Millar's Catalogue of the pictures in the Royal Collection.
Sir Lionel Cust. *Anthony van Dyck*. London, 1900.
This contains the fullest list of Van Dyck's English works but no attempt is made to sort out originals from studio works or copies.
Gustav Glück. *Van Dyck* (Klassiker der Kunst). 2nd edition. Stuttgart/London, 1931.
This illustrates a useful selection of Van Dyck's English work but omits several major collections (Petworth, Syon House, etc.).
See also Sir Oliver Millar's Catalogue of the *Age of*

Charles I Exhibition, 1972, for further illustrations.

EWORTH, HANS
Roy Strong. *Catalogue of the Hans Eworth Exhibition.* Leicester and National Portrait Gallery, 1958.

GAINSBOROUGH, THOMAS
G. W. Fulcher. *Life of Thomas Gainsborough.* London, 1856.
 This has the earliest attempt at a catalogue: there is a later and equally uncritical catalogue in Sir William Armstrong, *Gainsborough,* 2nd ed., 1904.
William T. Whitley. *Thomas Gainsborough.* London, 1915.
 The fullest biography.
Mary Woodall. *The Letters of Thomas Gainsborough.* London, 1963.
Ellis Waterhouse. *Gainsborough.* London, 1958.
 The fullest catalogue and collection of plates.
John Hayes. *The Drawings of Thomas Gainsborough.* 2 vols. London, 1970.
 Full catalogue: and the best chronology of the landscapes.
John Hayes. *Gainsborough: Paintings and Drawings.* London, 1975.
 The best selection of plates covering all Gainsborough's work.

GARDNER, DANIEL
G. C. Williamson. *Daniel Gardner.* London, 1921.
Helen Kapp. *Catalogue of the Daniel Gardner Exhibition.* Kenwood, 1972.

GHEERAERTS, MARCUS
A. Schouteet. *Marcus Gerards.* Brugge [1941].
Edward Hodnett. *Marcus Gheeraerts the Elder.* Utrecht, 1971.

HAYMAN, FRANCIS
[Mary Crake]. *Catalogue of the Exhibition of Paintings, Drawings and Prints by Francis Hayman.* Kenwood, 1960.
 There is also an M.A. Thesis on Hayman's history paintings by Deborah Lambert, 1973 (Courtauld Institute).

HILLIARD, NICHOLAS
Graham Reynolds. *Catalogue of the Nicholas Hilliard Exhibition.* Victoria and Albert Museum, London, 1947.
(Sir) John Pope-Hennessy. *A Lecture on Nicholas Hilliard.* London, 1949.
Erna Auerbach. *Nicholas Hilliard.* London, 1961.

HOGARTH, WILLIAM
R. B. Beckett. *Hogarth.* London, 1949.
 The handiest catalogue and collection of plates.
Joseph Burke. *William Hogarth. The Analysis of Beauty.* Oxford, 1955.
Frederick Antal. *Hogarth and his Place in European Art.* London, 1962.

A. P. Oppe. *The Drawings of Hogarth.* London, 1948.
 The best critical appreciation.
Ronald Paulson. *Hogarth's Graphic Works.* 2 vols. Yale, 1965.
 The first serious catalogue of the engravings.
Ronald Paulson. *Hogarth, his Life, Art and Times.* 2 vols. Yale, 1971.
 An exhaustive biography.
Lawrence Gowing and Ronald Paulson. *Catalogue of the Hogarth Exhibition at the Tate Gallery.* London, 1971-2.

HOLBEIN, HANS
Arthur B. Chamberlain. *Hans Holbein the Younger.* 2 vols. London, 1913.
Paul Ganz. *The Paintings of Hans Holbein.* London, 1950.
 The best collection of plates. Text less reliable.
(Sir) K. T. Parker. *The Drawings of Hans Holbein . . . at Windsor Castle.* Oxford, 1945.
Alfred Schmid. *Hans Holbein der Jüngere.* Basel, 1945 (plates) and 1950 (text).
Roy Strong. *Holbein and Henry VIII.* London, 1967.

HOPPNER, JOHN
William McKay and William Roberts. *John Hoppner.* London, 1909, with a later supplementary volume. Catalogue.

HUMPHRY, OZIAS
G. C. Williamson. *Ozias Humphry.* London, 1918.

IBBETSON, JULIUS CAESAR
Rotha Mary Clay. *Julius Caesar Ibbetson.* London, 1949.

JAMESONE, GEORGE
Duncan Thomson. *The Life and Art of George Jamesone.* Oxford, 1974.

KAUFFMANN, ANGELICA
Lady Victoria Manners and G. C. Williamson. *Angelica Kauffmann.* London, 1924. Anastatically reprinted 1976.
 This publishes Angelica's account book.
A. Crookshank. *Catalogue of the Angelica Kauffmann Exhibition.* Kenwood, London, 1955. See also the *Angelica Kauffmann und ihre Zeitgenossen* Exhibition, Bregenz/Vienna, 1968/9.
Dorothy Moulton Mayer. *Angelica Kauffmann.* Gerrard's Cross, 1972.

KNELLER, SIR GODFREY
J. Douglas Stewart. *Catalogue of the Kneller Exhibition.* London, National Portrait Gallery, 1971.
 A book and catalogue by the same author is in preparation.

LAROON, MARCELLUS
Robert Raines. *Marcellus Laroon.* London, 1966.

LELY, SIR PETER
C. H. Collins Baker. *Lely and the Stuart Portrait Painters.* 2 vols. London, 1912.
R. B. Beckett. *Peter Lely.* London, 1951.

MERCIER, PHILIPPE
John Ingamells and Robert Raines. *Catalogue of the Mercier Exhibition.* York/London, 1969.
A full catalogue will be published by the Walpole Society.

MORLAND, GEORGE
There is little except four early and gossipy books:
William Collins. *Memoirs of a Picture &c.* London, 1805.
F. W. Blagden. *Authentic Memoirs of George Morland.* London, 1806.
J. Hassel. *Memoirs of the Life of George Morland.* London, 1806.
George Dawe. *The Life of George Morland.* London, 1807.
Also:
Ralph Richardson. *George Morland's Pictures: their present possessors.* London, 1897.
G. C. Williamson. *George Morland.* London, 1904.
David Thomas. *Catalogue of the Morland Exhibition.* Tate Gallery, London, 1954.

NORTHCOTE, JAMES
Conversations of James Northcote R.A. with William Hazlitt, ed. Edmund Gosse. London, 1894.
Stephen Gwynne. *Memorials of an Eighteenth Century Painter.* London, 1898. (With list of his pictures.)
Conversations of James Northcote with James Ward, ed. Ernest Fletcher. London, 1901.

OPIE, JOHN
J. Jope Rogers. *Opie and his Works.* London, 1878.
Ada Earland. *John Opie and his Circle.* London, 1911.

PETERS, REV. MATTHEW WILLIAM
Lady Victoria Manners. *Matthew William Peters.* London, 1913.
This has a catalogue.

PINE, ROBERT EDGE
Dr Robert Stewart, the National Portrait Gallery, Washington, has a catalogue in hand.

RAMSAY, ALLAN
Alastair Smart. *The Life and Art of Allan Ramsay.* London, 1952.
A *catalogue raisonné* by the same author has long been in hand.

REYNOLDS, SIR JOSHUA
A. Graves and W. V. Cronin. *A History of the Works of Sir Joshua Reynolds* (125 copies). 4 vols. London, 1899–1901.
The fullest, but often inaccurate, documentation.
Ellis Waterhouse. *Reynolds.* London, 1941.

Has a chronological catalogue and an annotated bibliography and the fullest selection of plates.
Ellis Waterhouse. *Reynolds.* London, 1973.
A more popular book than the last, with many new illustrations.
Derek Hudson. *Sir Joshua Reynolds.* London, 1958.
The best of the many biographies that exist.
Robert R. Wark. *Sir Joshua Reynolds. Discourses on Art.* San Marino, 1959. Reprinted Yale, 1975.
The only edition with a reliable text.

ROMNEY, GEORGE
William Hayley. *Life of George Romney.* London, 1809.
Rev. John Romney. *Memoirs of the Life and Works of George Romney.* London, 1830.
Humphry Ward and William Roberts. *Romney.* 2 vols. London, 1904.
Has a full catalogue and the sitter-books, etc.
Catalogue of the Romney Exhibition. London, Kenwood, 1961.

RUNCIMAN, ALEXANDER
Duncan Macmillan is completing a full catalogue.

SMIBERT, JOHN
Henry Wilder Foote. *John Smibert.* Harvard, 1950.

STUART, GILBERT
Lawrence Park. *Gilbert Stuart.* 4 vols. New York, 1926.
William T. Whitley. *Gilbert Stuart.* Harvard, 1932.

STUBBS, GEORGE
Basil Taylor. *Stubbs.* London, 1971.
Constance Anne Parker. *Mr Stubbs the Horse Painter.* London, 1971.

VAN DYCK *see* DYCK

WEST, BENJAMIN
John Galt. *The Life, Studies and Works of Benjamin West.* 2 parts. London, 1820.
Unreliable.
Grose Evans. *Benjamin West and the Taste of his Times.* Carbondale, 1959.
Useful only for its plates.
Catalogue of the West Exhibition. Philadelphia, 1938.

WHEATLEY, FRANCIS
Mary Webster. *Francis Wheatley.* London, 1970.

WILSON, RICHARD
T. Wright. *Some Account of the Life of Richard Wilson.* London, 1824.
Thomas Hastings. *Etchings from the Works of Richard Wilson with some Memoirs of his Life.* London, 1825.
Brinsley Ford. *Richard Wilson's Drawings.* London, 1951.
W. G. Constable. *Richard Wilson.* London, 1953.
With a very full catalogue.

WRIGHT (of Derby), JOSEPH
Benedict Nicolson. *Joseph Wright of Derby*. 2 vols. London, 1968.

ZOFFANY, JOHANN
Lady Victoria Manners and G. C. Williamson. *Johann Zoffany*. London, 1920.
With a very uncritical catalogue.
Mary Webster. *Catalogue of the Zoffany Exhibition*. London, National Portrait Gallery, 1977.

VI. SCOTTISH PAINTING

BROCKWELL, MAURICE W. *George Jamesone and some Primitive Scottish Painters*. London, 1939.
Extracts from Musgrave's eighteenth-century lists of portraits in Scottish houses.

BRYDALL, ROBERT. *Art in Scotland: its Origin and Progress*. Edinburgh, 1889.

CAW, (SIR) JAMES L. *Scottish Portraits*. 4 portfolios. Edinburgh, 1902.

CAW, (SIR) JAMES L. *Scottish Painting, Past and Present (1620–1908)*. Edinburgh, 1908.

CAW, SIR JAMES L., with others. *Catalogue of the Exhibition of Scottish Art* (with an album of plates). Royal Academy, London, 1939.

CURSITER, STANLEY. *Scottish Art to the Close of the Nineteenth Century*. London, 1949.

IRWIN, DAVID and FRANCINA. *Scottish Painters at home and abroad, 1700–1900*. London, 1975.
With a good bibliography.

THOMSON, DUNCAN. *Painting in Scotland 1570–1650*. Catalogue of an Exhibition at the Scottish National Portrait Gallery, 1975.

ADDITIONAL BIBLIOGRAPHY

The following Additional Bibliography, comprising books, catalogues and some periodical articles which have appeared since the last edition of *Painting in Britain 1530–1790*, is longer than as its predecessor compiled by Ellis Waterhouse in 1978. Although the number of publications concerned with British art began to increase in the 1960s, in the past fifteen years they have been produced at a much greater rate. A major factor in this has been the part played by institutions connected with both the name of Paul Mellon and with Yale University. First, in the 1960s, the Paul Mellon Foundation in London began a scheme for publishing books on British art. When that Foundation was reconstituted in 1971 as the Paul Mellon Centre for Studies in British Art (of which Ellis Waterhouse was, until 1974, the first Director of Studies), a similar publishing scheme was established there, and this scheme remains very much in being at the present day. Books approved by the Centre for publication are published by the London office of Yale University Press, which has made its own creative contribution to the scheme through its editorial, design and marketing skills (hence the frequency with which 'New Haven and London' appears in this Bibliography as the place of publication of a book). The Yale Center for British Art in New Haven, opened in 1977, has also been an active generator of scholarship, producing catalogues of the exhibitions it has organized, some of which have also been published by the Yale Press.

As noted in the Introduction to the present edition of *Painting in Britain*, the recent development of the study of British art in its more radical forms has involved the close integration of the history of art with other kinds of history, including literary history. It would obviously be inappropriate to attempt to list in the following Bibliography the 'non-art historical' books which scholars who adopt this approach are accustomed to use (the Introduction does, however, include references to a few of the relevant authors). In practice, however, the new, radical historians nearly always supply their own bibliographies, which include such books, and the existence of especially useful bibliographies of this type is noted below.

Partly because of the omission of books falling outside the field of art history, the present Bibliography, in contrast to the Introduction, may appear biased towards publications employing a traditional approach. Another, more tangible reason for this bias is that, despite the intervention of new, more broadly based approaches, most recent work on British art has continued to be conceived and written on traditional lines.

A major outlet for such work is the exhibition catalogue, a category of publication which has grown enormously in importance since Waterhouse's time. Exhibition catalogues today are prime repositories of research, and many are very large; some, whether by design or *faute de mieux*, are substitutes for books. With their long introductions or series of introductory essays by several hands and with their formidable critical apparatus, these exhibition catalogues are, of course, a world-wide phenomenon, not one peculiar to the historiography of British art. In the present Bibliography, they are included in sections III ('General Works') and V ('Individual Painters'). By contrast, section IV ('Catalogues') comprises catalogues of permanent collections.

Another new type of publication to have emerged recently – and one which, unlike the exhibition catalogue, is especially characteristic of the new approaches to art history – is the collection of essays by several authors, united in pursuit of a common theme. An additional new subject of research, though not one necessarily new in method, is patronage and collecting. However, given the importance of this topic in the development of British visual culture, much work on it remains to be be done.

No publication mentioned in Waterhouse's Bibliography is repeated in the present one. However, in view of the narrowness of his approach, particularly in relation to artistic theory, I have taken the liberty of including a few works published before 1978. A more difficult question to decide was what to do about articles in periodicals. In common with most volumes in the Pelican History of Art series, *Painting in Britain 1530–1790* did not include such articles in the Bibliography but mentioned them where relevant in the notes to the text. To have attempted to bring Waterhouse's notes up to date in this respect would have been arbitrary and have given a false impression of the state of recent research. Instead I have adopted the no less arbitrary but more even-handed solution of citing in the Bibliography all articles published in *The Walpole Society*, while for the most part omitting the rest. In this respect at least, this Bibliography offers a regrettably incomplete picture of the present state of studies in British painting but, beyond apologizing for it, there seemed nothing else to be done.

For convenience of reference, the material is divided into the same sections as those used by Waterhouse.

M.K.

1. BIBLIOGRAPHIES

Johannes Dobai, *Die Kunstliteratur des Klassizismus und der Romantik in England*, already referred to by Waterhouse, has now been completed: III (1790–1840), Bern, 1977; IV (Index volume), 1984.

Peter Bicknell, *The Picturesque Scenery of the Lake District 1752–1855*, Winchester, 1990, is a bibliographical study, mainly of guidebooks, arranged chronologically, relating to the subject.

The only other sources of bibliographical information, apart from the bibliographies in individual books (including this one), are, first, the *Répertoire International de la Littérature de l'Art* ('RILA', 1975–1990, in English) and its successor, the *Bibliography of the History of Art / Bibliographie d'Histoire de l'Art* ('BHA', 1991–, in English and French). Most publications in the history of art, down to reviews and minor articles, are included in these annotated indexes. They are, however, extremely awkward to use. The second source is the annotated *Index to Periodicals* compiled by the Courtauld Institute from the 1930s to 1983, which is available on microfiche from Mindata. This is handier but of more limited usefulness, because of its earlier date and because it began to be run down in the early 1970s, making it less comprehensive after that period.

2. DICTIONARIES

The most useful general dictionary of British art by far is *The Thames and Hudson Encyclopaedia of British Art*, London, 1985, edited by David Bindman. All other single-volume dictionaries of art are more or less ineffectual although the forthcoming multi-volume *Macmillan Dictionary of Art* will surely contain good articles. The new, revised edition of Thieme-Becker, published by Saur (Munich and Leipzig, 1987–) and entitled *Allgemeines Künstlerlexikon*, of which 7 volumes have been published so far (1993), shows promise of being worth consulting for its bibliographies and its information on minor painters but, for the time being at least, English-speaking readers are more likely to turn to the two dictionaries by Waterhouse mentioned below.

Other dictionaries on more specialized topics include:

ARCHIBALD, E. H. H. *A Dictionary of Sea Painters*, Woodbridge, The Antique Collectors' Club, 1980.
Well illustrated, like all this Club's publications.

INGAMELLS, JOHN and others. *A Dictionary of British Visitors to Italy in the Eighteenth Century, based on the Archive compiled over Thirty Years by Sir Brinsley Ford*.
Currently in preparation at the Paul Mellon Centre for Studies in British Art, this publication will be mainly, but not exclusively, a biographical dictionary of the eighteenth-century Grand Tour.

MITCHELL, SALLY. *The Dictionary of British Equestrian Artists*, Woodbridge, The Antique Collectors' Club, 1985.

ORMOND, RICHARD AND ROGERS, MALCOLM (eds). *Dictionary of British Portraiture*, London, 1979: I. *The Middle Ages to the Early Georgians*, by Adriana Davies; II. *The Later Georgians and Early Victorians*, by Elaine Kilmurray.
A portrait dictionary based on material in the archive of the National Portrait Gallery, arranged by sitters, with very brief notes and without illustrations. Only portraits in British public collections are included.

WATERHOUSE, ELLIS. *Dictionary of British 18th-Century Painters in Oils and Crayons*, Woodbridge, The Antique Collectors Club, 1981.
Mainly useful for information on minor painters.

WATERHOUSE, ELLIS. *Dictionary of 16th and 17th-Century British Painters*, Woodbridge, The Antique Collectors' Club, 1988 (published posthumously).
Worth consulting but quirky and unreliable.

3. GENERAL WORKS

Exhibition catalogues are normally listed here under the name of the author or editor, not the place or places where the exhibition was held.

ALFREY, NICHOLAS and DANIELS, STEPHEN (eds). *Mapping the Landscape: Essays on Art and Cartography*, Nottingham, 1990.

ANDREWS, MALCOLM. *The Search for the Picturesque: Landscape Aesthetics and Tourism in Britain 1760–1800*, Aldershot, 1989.
Traditional in approach but thorough and scholarly, with a good bibliography.

APPLETON, JAY. *The Experience of Landscape*, Chichester-New York-Brisbane-Toronto, 1975.
A visual interpretation of landscape from the point of view of a geographer.

ASHELFORD, JANE. *A Visual History of Costume: The Sixteenth Century*, London, 1983.
A useful introductory survey.

ASHTON, GEOFFREY and MACKINTOSH, IAIN. *Royal Opera House Retrospective, 1732–1982* (exhibition catalogue), Royal Academy, 1982.

ATHERTON, HERBERT M. *Political Prints in the Age of Hogarth*, Oxford, 1974.

BARRELL, JOHN. *The Idea of Landscape and the Sense of Place, 1730–1840*, Cambridge, 1972.

An early example of the author's characteristic approach to landscape painting in terms of the interests, non-visual as well as visual, of people living at the time.

BARRELL, JOHN. *The Dark Side of the Landscape: The Rural Poor in English Painting 1730–1840*, Cambridge, 1980.
Discussed in the Introduction to the present book.

BARRELL, JOHN. *The Political Theory of Painting from Reynolds to Hazlitt: 'The Body of the Public'*, New Haven and London, 1986.
Discussed in the Introduction to the present book.

BARRELL, JOHN (ed.). *Painting and the Politics of Culture*, Oxford, 1992.
A book of essays by several authors united by their conviction that visual culture cannot be understood without considering its political dimensions.

BARRELL, JOHN. *The Birth of Pandora*, London, 1992.
A collection of essays by the author similar in character to those published in *Painting and the Politics of Culture*.

BASKETT, JOHN and SNELGROVE, DUDLEY. *English Drawings and Watercolours, 1550–1850, in the Collection of Mr and Mrs Paul Mellon* (exhibition catalogue), Pierpont Morgan Library, New York, 1972.

BAYLY, C. A. (ed.). *The Raj: India and the British 1600–1947* (exhibition catalogue), National Portrait Gallery, London, 1990–91.

BERMINGHAM, ANN. *Landscape and Ideology: The English Rustic Tradition, 1740–1860*, Berkeley-Los Angeles-London, 1986.
The most ambitious and thoughtful long study to date of the permeation of British landscape painting (especially the painting of Constable) by political and economic concerns.

BICKNELL, PETER. *Beauty, Horror and Immensity: Picturesque Landscape in Britain 1750–1850* (exhibition catalogue), Fitzwilliam Museum, Cambridge, 1981.
The landscape as seen through drawings, watercolours, letters, anecdotes, travel books and books of picturesque theory. Useful bibliography.

BIGNAMINI, ILARIA and POSTLE, MARTIN. *The Artist's Model: Its Role in British Art from Lely to Etty* (exhibition catalogue), Nottingham and Kenwood, 1991.
An exhibition about the practices and products of the life class in academies of art from the late seventeenth to the early nineteenth centuries.

BINDMAN, DAVID and others. *The Shadow of the Guillotine: Britain and the French Revolution* (exhibition catalogue), British Museum, 1989.

BLACK, JEREMY. *The British Abroad: The Grand Tour in the Eighteenth Century*, New York and Stroud (Gloucestershire), 1992.

BROWNELL, MORRIS R. *Alexander Pope and the Arts of Georgian England*, Oxford, 1978.

BRYANT, JULIUS. *Finest Prospects: Three Historic Houses – A Study in London Topography* (exhibition catalogue), Iveagh Bequest, Kenwood, 1986.
Early views of Kenwood, Ranger's House and Marble Hill.

CHANEY, EDWARD and MACK, PETER (eds). *England and the Continental Renaissance: Essays in Honour of J.B. Trapp*, Woodbridge, 1990.
Mainly concerned with literary and philosophical topics but with relevance to the history of art as well.

CLARKE, MICHAEL. *The Tempting Prospect: A Social History of English Watercolours*, London, 1981.
Too brief to get far, but a start.

CROOKSHANK, ANNE and THE KNIGHT OF GLIN. *Painters of Ireland, ca.1660–1920*, London, 1978.
A general survey on traditional lines.

CUMMING, VALERIE. *A Visual History of Costume: The Seventeenth Century*, London, 1984.
A useful introductory survey.

D'OENCH, ELLEN. *The Conversation Piece: Arthur Devis and His Contemporaries* (exhibition catalogue), Yale Center for British Art, 1980.

DANIELS, STEPHEN and COSGROVE, DENIS (eds). *The Iconography of Landscape*, Cambridge, 1988.
The geographer's viewpoint. The contributors include no art historians.

DEUCHAR, STEPHEN. *Noble Exercise – The Sporting Ideal in Eighteenth-Century British Art* (exhibition catalogue), Yale Center for British Art, 1982.
A trial run for the author's *Sporting Art in Eighteenth-Century England*.

DEUCHAR, STEPHEN. *Sporting Art in Eighteenth-Century England: A Social and Political History*, New Haven and London, 1988.
The first and so far the only book on sporting art to break free from the gentrified image associated with previous accounts of the subject.

EDELSTEIN, T. J. *Vauxhall Gardens* (exhibition catalogue), Yale Center for British Art, 1983.

EDMOND, MARY. 'Limners and Picturemakers: New Light on the Lives of Miniaturists and Large-Scale Portrait Painters working in London in the Sixteenth and Seventeenth Centuries', *Walpole Society*, XLVII, 1978–80, pp. 60–242.
Extensive new material culled from archival sources.

EDMOND, MARY. 'Bury St Edmunds: A Seventeenth-Century Art Centre', *Walpole Society*, LIII, 1987, pp. 106–18.

EINBERG, ELIZABETH and JONES, RICA. *Manners and Morals: Hogarth and British Painting 1700–1760*

(exhibition catalogue), Tate Gallery, 1987.
The most comprehensive and scholarly survey yet undertaken of British painting in the first sixty years of the eighteenth century.

FAWCETT, TREVOR. 'Eighteenth-Century Art in Norwich', *Walpole Society*, XLVI, 1976–8, pp. 71–90.

FUSSELL, G. E. *Landscape Painting and the Agricultural Revolution*, London, 1984.
The author treats landscape paintings as records of what actually happened.

GAGE, JOHN (ed.). *Zwei Jahrhunderte Englischer Malerei: Britische Kunst und Europa* (exhibition catalogue), Haus der Kunst, Munich, 1979.

GENT, LUCY. *Picture and Poetry 1560–1620: Relations between Literature and the Visual Arts in the English Renaissance*, Leamington Spa, 1981.
Discussed in the Introduction to the present book.

GENT, LUCY and LLEWELLYN, NIGEL. *Renaissance Bodies: The Human Figure in English Culture, c.1540–1660*, London, 1990.
Discussed in the Introduction to the present book.

GODFREY, RICHARD. *Printmaking in Britain*, Oxford, 1978.
An excellent general introduction.

HARRIS, JOHN. *The Artist and the Country House*, London, 1979.
A useful anthology of painted views of country houses. Well illustrated.

HEDLEY, GILL. *The Picturesque Tour in Northumberland and Durham, c.1720–1830* (exhibition catalogue), Newcastle, 1982.

HIND, CHARLES (ed.). *The Rococo in England: A Symposium*, Victoria & Albert Museum, 1984.

HIPPLE, WALTER J. *The Beautiful, the Sublime and the Picturesque in Eighteenth-Century British Aesthetic Theory*, Carbondale (Illinois), 1957.

HOOK, JUDITH. *The Baroque Age in England*, London, 1976.
The political history and the art remain to some extent in separate compartments, but this was a pioneering book nevertheless.

HUNT, JOHN DIXON (ed.). *Encounters: Essays on Literature and the Visual Arts*, London, 1971.
One of the first books to apply the methods of literary analysis to the visual arts.

HUTCHISON, SIDNEY. *The History of the Royal Academy, 1768–1968*, London, 1968.
Serviceable as far as it goes but a new, more searching account of the history of this institution is badly needed.

INGAMELLS, JOHN. *The English Episcopal Portrait 1559–1835: A Catalogue*, London, 1981.

JOHNSON, E. D. H. *Paintings of the English Social*

Scene from Hogarth to Sickert, London, 1986.
A conventional survey useful mainly for its illustrations.

JACKSON-STOPS, GERVASE (ed.). *The Treasure Houses of Britain: 500 Years of Private Patronage and Art Collecting* (exhibition catalogue), Yale University Press for the National Gallery of Art, Washington, 1985.
The exhibition was one of the most sumptuous ever held, and had a catalogue to match.

LIPKING, LAWRENCE. *The Ordering of the Arts in Eighteenth-Century England*, Princeton, 1970.
A parallel investigation of different kinds of writing about the arts by theorists, critics and historians of painting, music and poetry.

LIPPINCOTT, LOUISE. *Selling Art in Georgian London: The Rise of Arthur Pond*, New Haven and London, 1983.
A study of the art market based on the papers of the engraver, Arthur Pond.

LLEWELLYN, NIGEL. *The Art of Death: Visual Culture in the English Death Ritual, c.1500–c.1800*, London, 1991.

MARTINET, MARIE-MADELEINE. *Art et nature en Grande-Bretagne au XVIIIe siècle*, Paris, 1980.
An anthology of texts dating from the period in English and French; not very original but useful.

MITCHELL, T. C. (ed.). *Captain Cook and the South Pacific*, London, 1979.
Essays filling the British Museum *Yearbook* for 1979.

MOORE, ANDREW W. *Norfolk and the Grand Tour: Eighteenth-Century Travellers Abroad and their Souvenirs* (exhibition catalogue), Norwich Castle Museum, 1985.
Very thorough, with a lot of new material and with an especially useful catalogue introduction.

MOUNT, HARRY. *The Reception of Dutch Genre Painting in England 1695–1829*, unpublished PhD thesis, Cambridge, 1991.

MURDOCH, JOHN. *The Discovery of the Lake District* (exhibition catalogue), Victoria & Albert Museum, 1984.
Not only a study of the conventional side to this topic, i.e. as a central episode in the Picturesque movement, but also an account of the social, political and economic causes and consequences of the conversion of the Lake District into a national open-air shrine.

MURDOCH, JOHN. *The Lake District: A Sort of National Property*, London, 1986.

MURDOCH, JOHN; MURRELL, JIM; NOON, PATRICK J.; STRONG, ROY. *The English Miniature* (exhibition catalogue), Yale University Press, New Haven and London, for the Yale Center for British Art, the Art Gallery of Ontario and the Kimbell Art

Museum, 1981.

MURRELL, JIM. *The Way Howe to Lymne: Tudor Miniatures Observed* (exhibition catalogue), Victoria & Albert Museum, 1983.
Includes important technical information.

NOON, PATRICK J. *English Portrait Drawings and Miniatures* (exhibition catalogue), Yale Center for British Art, 1979.

PARRIS, LESLIE. *Landscape in Britain, c.1750–1850* (exhibition catalogue), Tate Gallery, 1973.
A pioneering exploration of the varied types of landscape painting in the period and of the interests underlying them.

PARRY, GRAHAM. *The Golden Age restor'd: The Culture of the Stuart Court, 1603–42*, Manchester, 1981.

PAULSON, RONALD. *Popular and Polite Art in the Age of Hogarth and Fielding*, Notre Dame, 1979.

PAULSON, RONALD. *Book and Painting: Shakespeare, Milton and the Bible. Literary Texts and the Emergence of English Painting*, Knoxville, 1982.
Studies of Hogarth, Blake, Zoffany and Fuseli.

PAULSON, RONALD. *Breaking and Remaking: Aesthetic Practice in England 1700–1820*, Rutgers, New Brunswick and London, 1989.

PAYNE, CHRISTIANA. *Toil and Plenty: Images of the Agricultural Landscape in England, 1780–1890* (exhibition catalogue), Yale University Press, New Haven and London, for Nottingham University Art Gallery and the Yale Center for British Art, 1993–4.
A careful study in which works of art are considered as more or less idealized reflections of social conditions.

PEARS, IAIN. *The Discovery of Painting: The Growth of Interest in the Arts in England, 1680–1768*, New Haven and London, 1988.
A compact, lively and original account which brings together all aspects of the story of the growth of interest in painting in England for the first time; includes both contemporary and Old Master painting, artistic theory, and the workings of the art market.

PIPER, DAVID. *The Image of the Poet: British Poets and their Portraits*, Oxford, 1982.
A sensitive, conventional iconographical study.

POINTON, MARCIA. *Hanging the Head: Portraiture and Social Formation in Eighteenth-Century England*, New Haven and London, 1993.
Discussed in the Introduction to the present book.

POMEROY, ELIZABETH W. *Reading the Portraits of Queen Elizabeth I*, Hamden, CT, 1989.

PRESSLY, NANCY L. *The Fuseli Circle in Rome: Early Romantic Art of the 1770s* (exhibition catalogue), Yale Center for British Art, 1979.
Since Waterhouse did not include Fuseli in

Painting in Britain, the principal recent books on the artist are not listed here. However, Nancy Pressly's exhibition catalogue provides a convenient 'bridge' into Fuseli territory and also explores 'wider aspects of art in Rome in the 1770s.

PUGH, SIMON (ed). *Reading Landscape: Country – City – Capital*, Manchester, 1990.
A collection of seven essays by distinguished radical art historians who have written on landscape; the book also includes an essay by Raymond Williams.

RIBEIRO, AILEEN. *A Visual History of Costume: The Eighteenth Century*, London, 1983.
A useful introductory survey.

RIBEIRO, AILEEN. *The Dress worn at Masquerades in England, 1730 to 1790, and its Relation to Fancy Dress in Portraiture*, New York and London (Garland), 1984.

Rococo: Art and Design in Hogarth's England, (exhibition catalogue), Victoria & Albert Museum, 1984.
A catalogue containing many sections and by many hands.

ROSENBLUM, ROBERT. *Transformations in Late Eighteenth-Century Art*, Princeton, 1967.
An analysis in terms of the history of ideas.

ROSENTHAL, MICHAEL. *British Landscape Painting*, Oxford, 1982.
A brief, intelligent introduction.

ROUQUET, JEAN ANDRE. *L'Etat des Arts en Angleterre*, Paris, 1755; translated and published in London later the same year as *The Present State of the Arts in England*.
Reprinted photographically with an introduction by Ronald Lightbown, London, 1970.

RUSSELL, RONALD. *Guide to British Topographical Prints*, Newton Abbot and London, 1979.
A useful traditional account, with explanations of the techniques employed.

SHAWE-TAYLOR, DESMOND. *The Georgians: Eighteenth-Century Portraiture and Society*, London, 1990.
A mixture of traditional art history and social history, with well-chosen quotations from the period.

SMITH, BERNARD. *European Vision and the South Pacific*, 2nd ed., New Haven and London, 1985.
Not greatly altered from the first edition of 1960, which was for long the only serious study of its kind, but the book now includes a new preface showing awareness of recent developments in the history of the social sciences.

SMITH, BERNARD and JOPPEIN, RÜDIGER. *The Art of Captain Cook's Voyages*, 3 vols., New Haven and London, 1985–88.
Lavishly illustrated as well as containing a

detailed catalogue of the dozens of paintings and hundreds of drawings by Parkinson, Hodges and Webber, who accompanied Cook on his voyages to the South Seas.

SMITH, BERNARD and WHEELER, ALWYNE. *The Art of the First Fleet*, New Haven and London, 1988.
In approach and content, a continuation of the preceding 3 volumes.

SOLKIN, DAVID. 'The Battle of the Books; or, the Gentleman Provok'd – Different Views on the History of British Art', *The Art Bulletin*, LXVII, 1985, pp. 507–15.
This long and important article reviewing a clutch of recent books on British art sets out starkly, as seen by the author from the perspective of that time, the differences in approach between the new, radical art historians and the traditionalists.

SOLKIN, DAVID. *Painting for Money: The Visual Arts and the Public Sphere in Eighteenth-Century England*, New Haven and London, 1993.
Discussed in the Introduction to the present book. Solkin includes an excellent bibliography.

STAINTON, LINDSAY. *British Artists in Rome 1700–1800* (exhibition catalogue), Iveagh Bequest, Kenwood, 1974.

STAINTON, LINDSAY. 'Hayward's List: British Visitors to Rome 1753–75', *Walpole Society*, XLIX, 1983, pp. 3–36.
With a useful list of short biographies of the visitors listed.

STAINTON, LINDSAY. *British Landscape Watercolours 1600–1860* (exhibition catalogue), British Museum, 1985.
A well chosen, well arranged and well catalogued selection of the finest British landscape watercolours in the Museum.

STAINTON, LINDSAY and WHITE, CHRISTOPHER. *Drawing in England from Hilliard to Hogarth* (exhibition catalogue), British Museum Publications for the British Museum and the Yale Center for British Art, 1987.
A comprehensive, well-researched survey, with a good bibliography.

STOYE, JOHN. *English Travellers Abroad, 1604–1667*, London, 1952.
Still the best general study of English travellers on the Continent in the seventeenth century.

STRONG, ROY. *The Cult of Elizabeth: Elizabethan Portraiture and Pageantry*, London, 1977.

STRONG, ROY. *Britannia Triumphans: Inigo Jones, Rubens and Whitehall Palace*, London, 1980.

STRONG, ROY and MURRELL, JIM. *Artists of the Tudor Court* (exhibition catalogue), Victoria & Albert Museum, 1983.

STRONG, ROY. *The English Renaissance Miniature*, London, 1983.

Unusual in giving prominence to miniaturists (Holbein, Hornebolte, Levina Teerlinc) dating from before Hilliard.

STRONG, ROY. *Gloriana: The Portraits of Queen Elizabeth I*, London, 1987.

SUTHERLAND, GUILLAND (ed.). *British Art 1740–1820: Essays in Honor of Robert R. Wark*, San Marino, California, 1992.

TALLEY, KIRBY. *Portrait Painting in England: Studies in the Technical Literature before 1700*, London, 1981.
Contains the results of useful research into artists' pigments.

TALLEY, KIRBY. '"Small, Usuall, and Vulgar Things": Still-Life Painting in England 1635–1760', *Walpole Society*, XLIX, 1983, pp. 133–223.

THORNTON, PETER and TOMLIN, M. *The Furnishing and Decoration of Ham House*, London, 1980.
The detailed documentation concerning the picture collection and its arrangement at Ham House in the late seventeenth century make this book an important source for the understanding of the use to which paintings were put in the period.

WARNER, MALCOLM. *The Image of London: Views by Travellers and Emigrés 1550–1920* (exhibition catalogue), Barbican Art Gallery, London, 1987.

WATERFIELD, GILES (introduction and ed.) *Collection for a King: Old Master Paintings from the Dulwich Picture Gallery* (exhibition catalogue), Washington, D.C. and Los Angeles, 1985.
In many ways more accurate and more informative than the full catalogue of the Dulwich Picture Gallery, published in 1980.

WAX, CAROL. *The Mezzotint: History and Technique*, London, 1990.
Contains a detailed description of the technique.

WENDORF, RICHARD (ed). *Articulate Images: The Sister Arts from Hogarth to Tennyson*, Minneapolis, 1983.

WENDORF, RICHARD. *The Elements of Life: Biography and Portrait Painting in Stuart and Georgian England*, Oxford, 1990.
An interesting attempt to gain new insight into portraits by comparing them with written biographies and with contemporary theories of character and personality.

WHITE, CHRISTOPHER. *English Landscape 1630–1850: Drawings, Prints and Books from the Paul Mellon Collection*, New Haven, 1977.
Catalogue of an exhibition to mark the opening of the Yale Center for British Art.

WILCOX, SCOTT. *British Watercolours: Drawings of the 18th and 19th Centuries from the Yale Center for British Art*, New Haven, 1985–6.
Catalogue of a travelling exhibition in the USA.

WILTON, ANDREW. *British Watercolours 1750–1850*, Oxford, 1977.
A useful introduction, though conceived as a series of studies of individual artists, not a history.

WILTON, ANDREW and LYLES, ANNE. *The Great Age of British Watercolours, 1750–1880* (exhibition catalogue), Royal Academy, 1993.
A brave attempt to break free from the grip of connoisseurship, which has dominated the study of British watercolours for so long, and to construct a history of the art in terms of its visual development. The colour plates are excellent.

WILTON, ANDREW. *The Swagger Portrait: Grand Manner Portrait Painting in Britain from Van Dyck to Augustus John* (exhibition catalogue), Tate Gallery, 1992.

WIND, EDGAR. *Hume and the Heroic Portrait* (ed. Jaynie Anderson), Oxford, 1986.
The twelve essays in this volume are revised versions of papers written by the author from the 1930s to the 1950s, which were mainly published by him in the *Journal of the Warburg and Courtauld Institutes*. The long title essay, however, only existed as a lecture-script, in German and has not been previously published in English. At the time he was writing, Wind was almost unique in adopting a philosophical approach to aspects of British painting.

4. CATALOGUES OF PERMANENT COLLECTIONS

It is generally agreed that the proliferation of exhibition catalogues in the past twenty years or so has been brought about at the expense of the production of catalogues of permanent collections, and this section of the present Bibliography is the only one that is shorter than Waterhouse's. Many museums and galleries have not replaced their catalogues dating from the 1960s or even earlier. Those new publications that do exist, apart from popular illustrated guides, fall into three categories: (i) complete handlists, usually with only a single line for each item, cheaply produced and without illustrations, on the model of *The Collections of the Tate Gallery* first issued in 1967; (ii) complete concise catalogues, with brief entries and postage stamp-sized illustrations; (iii) detailed catalogues in the proper sense of the term. Only the last two categories are listed below. It is fair to add, however, that newly acquired works of art are usually fully catalogued in the regular reports submitted by museums and galleries to their Trustees, and some institutions - for example, the Fitzwilliam Museum and the Yale Center for British Art – use touring exhibitions of parts of their holdings as a means of cataloguing the latter.

I have been able to find only one new catalogue of a private collection containing substantial numbers of British pictures (see under 'Miller' below), though the recent guides to country houses owned by the National Trust generally contain short and reliable catalogue entries by Alastair Laing of the pictures on view.

ARCHER, MILDRED. *British Drawings in the India Office Library*, 2 vols., London, 1969.
ARCHER, MILDRED. *The India Office Collection of Paintings and Sculpture*, London, 1986.
ASHTON, GEOFFREY. *Catalogue of Paintings at the Theatre Museum, London*, London (for the Victoria & Albert Museum), 1992.
BAYNE-POWELL, ROBERT. *Catalogue of Portrait Miniatures in the Fitzwilliam Museum*, Cambridge, 1985.
BELSEY, HUGH and RIELY, JOHN. *Gainsborough and Rowlandson: Drawings in Birmingham Museums and Art Gallery*, Birmingham, 1990.
BROWN, DAVID BLAYNEY. *Ashmolean Museum, Oxford: Catalogue of the Collection of Drawings, Vol. IV: Early English Drawings*, Oxford, 1982.
CLIFFORD, TIMOTHY; GRIFFITHS, ANTHONY; ROYALTON-KISCH, MARTIN. *Gainsborough and Reynolds in the British Museum*, London, 1978.
Concise Catalogue of Oil Paintings in the National Maritime Museum, Woodbridge, The Antique Collectors' Club, 1988.
CORMACK, MALCOLM. *A Concise Catalogue of Paintings in the Yale Center for British Art*, New Haven, 1985.
Fully illustrated with postage stamp-sized illustrations. In view of the importance of the collection, this is an especially useful catalogue.
CROFT-MURRAY, EDWARD and HULTON, PAUL. *The British Museum: Catalogue of British Drawings, Vol.I: XVI & XVII Centuries*, 2 vols., London, 1960.
DARS, CELESTINE. *Subject Catalogue of Paintings in Public Collections, Vol.II. London: The Tate Gallery, Old Masters Collection*, London, 1990.
Includes all artists born before 1860. Though confusingly called a 'Subject Catalogue', this is in fact a normal concise catalogue, with postage stamped-sized illustrations, of paintings arranged alphabetically by artist. In many cases, it is the only published source of illustrations of paintings in the Tate by artists born before 1860.
EINBERG, ELIZABETH and EGERTON, JUDY. *The Tate Gallery Collections, II: The Age of Hogarth, British Painters born 1675–1709*, London, 1988.
This is an exemplary catalogue.
GOODISON, J. W. *Fitzwilliam Museum, Cambridge, Catalogue of Paintings, Vol.III: British School*, Cambridge, 1977.
A full catalogue, though poorly illustrated.

HERRMANN, LUKE. *Beschreibender Katalog der Handzeichnungen in der Graphischen Sammlung Albertina, Band VII. Die Englische Schule: Zeichnungen und Aquarelle britischer Künstler*, Vienna, 1992.

Since exactly half the 138 British drawings and watercolours included here were acquired by the founder of the Albertina, Herzog Albert von Sachsen-Teschen (1738–1822), this catalogue is interesting for that reason alone.

INGAMELLS, JOHN. *City of York Art Gallery, Catalogue of Paintings, Vol.II: English School 1500–1850*, York, 1963.

A good catalogue, though poorly illustrated.

KERSLAKE, JOHN. *National Portrait Gallery: Early Georgian Portraits 1714–60*, 2 vols., London, 1977.

This is wrongly listed in Waterhouse's Bibliography as *Catalogue of the Eighteenth-Century Portraits* ... In fact, the volumes for the *Later Georgian Portraits 1760–90* are still (in 1993) outstanding.

LAMBOURNE, LIONEL and HAMILTON, JEAN. *British Watercolours in the Victoria & Albert Museum: An Illustrated Summary Catalogue of the National Collection*, London, 1980.

MILLER, JAMES. *The Catalogue of Paintings at Bowood House*, London, 1982.

Not a detailed catalogue but good of its kind.

MURRAY, PETER. *Dulwich Picture Gallery*, London, 1980.

A shorter version of this catalogue, with good illustrations, was also published in 1980.

National Portrait Gallery. The Elizabethan and Jacobean portraits now (in 1993) at Montacute, and the late Stuart and Early Georgian portraits at Beningborough, are listed in the illustrated handbooks to those houses published in 1980 and 1979 respectively. Full catalogue entries are in the complete National Portrait Gallery catalogues.

North Carolina Museum of Art: Catalogue of Paintings, Vol. II: British Paintings to 1900, Raleigh, 1969.

REYNOLDS, GRAHAM (ed.). *Victoria & Albert Museum: Summary Catalogue of British Paintings*, London, 1973.

Unillustrated.

ROHATGI, PAULINE. *Portraits in the India Office Library and Records*, London, 1983.

Summary Catalogue of Paintings in the Ashmolean Museum, Oxford, 1980.

A revised, more up-to-date edition of the catalogue published in 1961.

TREUHERZ, JULIAN and WHITTINGHAM, SELBY. *Manchester City Art Gallery: Concise Catalogue of British Paintings*, Manchester, 1976.

With postage stamp-sized illustrations.

TREUHERZ, JULIAN and FARRINGTON, JANE. *Manchester City Art Gallery: Concise Catalogue of*

British Watercolours and Drawings, Vol. I – Text; Vol. II – Illustrations, Manchester, 1984–6.

VALENTINE, HELEN. *From Reynolds to Lawrence: The First Sixty Years of the Royal Academy of Arts and Its Collections*, London, 1991.

A concise catalogue with small illustrations.

[WARK, ROBERT]. *The Huntington Collections: A Handbook*, San Marino, California, 1986.

A concise catalogue like that of the Yale Center for British Art.

YUNG, K. K. *National Portrait Gallery: Complete Illustrated Catalogue*, London, 1981.

A concise, one-volume catalogue, with postage stamp-sized illustrations.

5. INDIVIDUAL PAINTERS, PATRONS AND CRITICS

ARUNDEL, THOMAS HOWARD, 2ND EARL OF

David Howarth, *Lord Arundel and His Circle*, New Haven and London, 1985.

ASHMOLE, ELIAS

Michael Hunter and Others, *Elias Ashmole 1617–1692* (exhibition catalogue), Ashmolean Museum, Oxford, 1983.

BARDWELL, THOMAS

Kirby Talley, 'Thomas Bardwell of Bungay, Artist and Author, 1704–67', *Walpole Society*, XLVI, 1976–8, pp. 91–63.

Ellen G.Miles, 'A Notebook of Portrait Compositions by Thomas Bardwell', *Walpole Society*, LIII, 1987, pp. 181–92.

BARRY, JAMES

William L.Pressly, *The Life and Art of James Barry*, New Haven and London, 1981.

William L.Pressly, *James Barry: The Artist as Hero* (exhibition catalogue), Tate Gallery, 1983.

These two publications naturally overlap to a considerable extent.

BEARE, GEORGE

Nigel Surry, *George Beare* (exhibition catalogue), Chichester, 1989.

BEAUMONT, SIR GEORGE

Felicity Owen and David Blayney Brown, *Collector of Genius: A Life of Sir George Beaumont*, New Haven and London, 1988.

BURKE, EDMUND

A Philosophical Enquiry into the Origins of our Ideas of the Sublime and Beautiful, London, 1957: ed. J. T. Boulton, London, 1958 (paperback, Notre Dame, 1968).

CARTWRIGHT, WILLIAM

Giles Waterfield, Nicola Kalinsky and Others, *Mr Cartwright's Pictures* (exhibition catalogue), Dulwich Picture Gallery, 1987.

An exhibition and catalogue of the quite large collection of (mostly not very good) Old Master paintings bequeathed to Dulwich by the actor, William Cartwright, in 1686.

CHARLES I

Arthur MacGregor (ed.), *The Late King's Goods*, Oxford, 1990.

Includes an important article by Francis Haskell, 'Charles I's Collection of Pictures'.

CLOSTERMAN, JOHN AND JOHN BAPTIST

Malcolm Rogers, 'John and John Baptist Closterman: A Catalogue of their Works', *Walpole Society*, XLIX, 1983, pp. 224–79.

Distinguishes between the paintings of these two brothers, the first being the more important.

COZENS, ALEXANDER

Jean-Claude Lebensztejn, *L'Art de la Tache: Introduction à la Nouvelle Méthode d'Alexander Cozens*, Editions du Limon, 1990.

Alexander Cozens is one of the few British artists to have attracted the attention of post-structuralist critics.

COZENS, ALEXANDER AND JOHN ROBERT

Andrew Wilton, *The Art of Alexander and John Robert Cozens* (exhibition catalogue), Yale Center for British Art, 1980.

Kim Sloan, *Alexander and John Robert Cozens: The Poetry of Landscape* (exhibition catalogue), Victoria & Albert Museum and Art Gallery of Ontario, 1986.

DANCE, NATHANIEL

David Goodreau, *Nathaniel Dance 1735–1811* (exhibition catalogue), Iveagh Bequest, Kenwood, 1977.

DOBSON, WILLIAM

Malcolm Rogers, *William Dobson 1611–46* (exhibition catalogue), National Portrait Gallery, London, 1983.

Much the fullest study to date.

DYCK, SIR ANTHONY VAN

Roy Strong, *Van Dyck: Charles I on Horseback*, London, 1972.

Christopher Brown, *Van Dyck*, Oxford, 1982.

The most recent general study of the artist.

Oliver Millar, *Van Dyck in England* (exhibition catalogue), National Portrait Gallery, London, 1982–3.

Much the fullest account of Van Dyck's career and work in England; contains material, particularly about the artist's sitters and about his portraits outside the Royal Collection, that is not in Millar's other writings.

Arthur Wheelock, Susan Barnes and Julius Held, *Anthony van Dyck* (exhibition catalogue), National Gallery of Art, Washington, 1990–91.

A superb exhibition but one in which the English period was, if anything, understressed. The catalogue includes a full bibliography.

Christopher Brown, *The Drawings of Anthony Van Dyck* (exhibition catalogue), Pierpont Morgan Library, New Work, 1991.

This exhibition contained a sizeable group of the artist's landscape drawings and watercolours. The catalogue includes a full bibliography.

FREDERICK, PRINCE OF WALES

Kimerly Rorschach, 'Frederick Prince of Wales (1707–51) as Collector and Patron', *Walpole Society*, LV, 1989/90, pp. 1–76.

GAINSBOROUGH, THOMAS

John Hayes, *Gainsborough as Printmaker*, New Haven and London, 1972.

John Hayes, *Thomas Gainsborough* (exhibition catalogue), Tate Gallery, 1980.

This was a major exhibition, especially important for the representation of the artist's landscapes. It was also shown at the Grand Palais, Paris, in 1981, with a catalogue in French.

Jack Lindsay, *Thomas Gainsborough: His Life and Art*, London, 1981.

More about the artist's life and career than his art.

John Hayes, *The Landscape Paintings of Thomas Gainsborough: A Critical Text and Catalogue Raisonné*, 2 vols., London, 1982.

With a full annotated bibliography.

Hugh Belsey, *Gainsborough's Family* (exhibition catalogue), Gainsborough's House, Sudbury, 1988.

Anne French (ed.), *The Earl and Countess Howe by Gainsborough* (exhibition catalogue), Iveagh Bequest, Kenwood, 1988.

Since 1988, the *Annual Reports* of the Gainsborough's House Society, under the editorship of Hugh Belsey, have become important sources for new archival information about Gainsborough and for information on unpublished paintings and drawings by him.

GEORGE III

[Oliver Millar], *George III, Collector and Patron* (exhibition catalogue), The Queen's Gallery, Buckingham Palace, 1974.

Christopher Lloyd, *A King's Purchase: King George III and the Collection of Consul Smith* (exhibition catalogue), The Queen's Gallery, Buckingham Palace, 1993.

GILPIN, THE REV. WILLIAM

C. P. Barbier, *William Gilpin: His Drawings, Teaching, and Theory of the Picturesque*, Oxford, 1963.

This conventional scholarly book includes particulars of all Gilpin's published Picturesque *Tours*.

HAMILTON, HUGH DOUGLAS

Fintan Cullen, 'The Oil Paintings of Hugh Douglas Hamilton', *Walpole Society*, L, 1984, pp. 165–208.

HAYLEY, WILLIAM
Victor Chan, *William Hayley and His Circle* (exhibition catalogue), Edmonton, 1982.

HAYMAN, FRANCIS
Brian Allen, *Francis Hayman*, New Haven and London, 1987.
A carefully researched book and catalogue, which also served as the catalogue of an exhibition at the Iveagh Bequest, Kenwood, and the Yale Center for British Art.

HEARNE, THOMAS
David Morris, *Thomas Hearne 1744–1817: Watercolours and Drawings* (exhibition catalogue), Bolton – Southampton – Bath, 1985–6.
David Morris, *Thomas Hearne and His Landscape*, London, 1989.

HEEMSKERK, EGBERT VAN
Robert Raines, 'Notes on Egbert van Heemskerk and the English Taste for Genre', *Walpole Society*, LIII, 1987, pp. 119–42.

HENRIETTA MARIA, QUEEN
Erica Veevers, *Images of Love and Religion: Queen Henrietta Maria and Court Entertainments*, Cambridge, 1989.

HENRY PRINCE OF WALES
Roy Strong, *Henry, Prince of Wales and England's Lost Renaissance*, London, 1986.

HIGHMORE, JOSEPH
Warren Mild, *Joseph Highmore*, privately printed, 1990.
A long and leisurely chronicle of Highmore's career by a scholar who was not an art historian.

HILLIARD, NICHOLAS
Roy Strong, *Nicholas Hilliard*, London, 1975.
R. K. R. Thornton & T. G. S. Cain (eds), *Nicholas Hilliard: 'The Arte of Limning'*, Carcanet Press for the Mid Northumberland Arts Group, 1981 (paperback, 1992).
A new scholarly edition of this famous manuscript (c.1600), together with *A More Compendious Discourse concerning ye Art of Liming* by Edward Norgate (c.1625).

HOARE, WILLIAM
Evelyn Newby, *William Hoare of Bath R.A., 1707–1792* (exhibition catalogue), Victoria Art Gallery, Bath, 1990.

HOGARTH, WILLIAM
Jack Lindsay, *Hogarth, His Art and His World*, London, 1977.
A popular but incisive short biography.
David Bindman, *Hogarth*, London, 1981.
The best introduction; in the Thames & Hudson 'World of Art' series.
Sean Shesgreen, *Hogarth and the Times-of-the-Day Tradition*, Cornell University Press, 1983.
David Dabydeen, *Hogarth, Walpole and Commercial Britain*, London, 1987.
Ronald Paulson, *Hogarth's Graphic Works*, 3rd, revised edition, London, 1989.
The definitive catalogue of engravings by and after Hogarth.
Ronald Paulson, *Hogarth*, 3 vols. (1. 'The Modern Moral Subject', 1697–1732; 2. 'High Art and Low', 1732–1750; 3. 'Art and Politics', 1750–1764), Rutgers University Press (New Brunswick) and the Lutterworth Press (Cambridge), 1991–3.
A complete re-writing of the author's earlier *Hogarth: His Life, Art, and Times* (1971). The new book must be the most detailed and the most deeply pondered monograph on a British artist ever written.

HOLBEIN, HANS, THE YOUNGER
[Jane Roberts and Susan Foister], *Holbein and the Court of Henry VIII* (exhibition catalogue), Queen's Gallery, Buckingham Palace, 1978–9.
John Rowlands, *The Paintings of Hans Holbein the Younger: Complete Edition*, Oxford, 1985.

HOLLAR, WENCESLAUS
Graham Parry, *Hollar's England*, Salisbury, 1980.
Popular, with large plates.
Richard Pennington, *A Descriptive Catalogue of the Etched Work of Wenceslaus Hollar*, Cambridge, 1982.
Unillustrated.
Anthony Griffiths and Gabriela Kesnerová, *Wenceslaus Hollar: Prints and Drawings* (exhibition catalogue), British Museum, 1983.

JONES, THOMAS
Lawrence Gowing, *The Originality of Thomas Jones*, London (Walter Neurath Lecture), 1985.
Francis Hawcroft, *Travels in Italy, 1776–1783, based on the 'Memoirs' of Thomas Jones* (exhibition catalogue), Whitworth Art Gallery, Manchester, 1988.
Catalogue of an enjoyable documentary/antiquarian exhibition comprising paintings, watercolours and drawings by British artists in Rome and Naples, designed to 'illustrate' the *Memoirs* of Thomas Jones.

KAUFFMAN, ANGELICA
Wendy Wassyng Roworth and Others, *Angelica Kauffman* (exhibition catalogue), Brighton, 1992.

KNELLER, SIR GODFREY
Douglas Stewart, *Sir Godfrey Kneller and the English Baroque Portrait*, Oxford, 1983.
Includes catalogues of the paintings and drawings.

KNIGHT, RICHARD PAYNE
Michael Clarke and Nicholas Penny (eds), *The Arrogant Connoisseur, Richard Payne Knight, 1751–1824* (exhibition catalogue), Whitworth Art Gallery, Manchester, 1982.
Claudia Stumpf (ed.), *Richard Payne Knight: Expedition into Sicily*, London, 1986.
Publishes the original English text of Knight's

account of his visit to Sicily in 1777 with Charles Gore and J. P. Hackert, a text previously known only in a German translation by Goethe.

LAROON, MARCELLUS, THE ELDER

Sean Shesgreen, *The Criers and Hawkers of London: Engravings and Drawings by Marcellus Laroon*, Aldershot, 1990.

A complete reprint of Laroon's *Cryes*, first published 1687, with detailed sociological comments on the plates.

LELY, SIR PETER

Oliver Millar, *Sir Peter Lely* (exhibition catalogue), National Portrait Gallery, London, 1978–79.

The most authoritative account of Lely to date.

MERCIER, PHILIP

John Ingamells and Robert Raines, 'A Catalogue of the Paintings, Drawings and Etchings of Philip Mercier', *Walpole Society*, XLVI, 1976–8, pp. 1–70.

MORTIMER, JOHN HAMILTON

John Sunderland, 'John Hamilton Mortimer, His Life and Works', *Walpole Society*, LII, 1986.

A comprehensive study, with catalogue, good illustrations and full bibliography. Occupies the whole annual volume.

PARS, WILLIAM

Andrew Wilton, *William Pars: Journey through the Alps*, Zürich, 1979.

PLACE, FRANCIS

Richard Tyler, *Francis Place* (exhibition catalogue), York and Iveagh Bequest, Kenwood, 1971.

POCOCK, NICHOLAS

David Cordingly, *Nicholas Pocock*, London, 1986.

POND, ARTHUR

Louise Lippincott, 'Arthur Pond's Journal of Receipts and Expenses, 1734–1750', *Walpole Society*, LIV, 1988, pp. 220–333.

POPE, ALEXANDER

Morris R. Brownell, *Alexander Pope and the Arts of Georgian England*, Oxford, 1978.

RAMSAY, ALLAN

Iain Gordon Brown, 'Allan Ramsay's Rise and Reputation', *Walpole Society*, L, 1984, pp. 209–47.

Alastair Smart, *Allan Ramsay: Painter, Essayist and Man of the Enlightenment*, New Haven and London, 1992.

Replaces Smart's earlier biography of the painter (1952); the new book contains much new information.

Alastair Smart, *Allan Ramsay* (exhibition catalogue), Scottish National Portrait Gallery and National Portrait Gallery, London, 1992.

REYNOLDS, SIR JOSHUA

Nicholas Penny, David Mannings and Others, *Reynolds* (exhibition catalogue), Royal Academy of Arts, London, 1986.

A major exhibition with an important catalogue, including a full bibliography.

Francis Broun, 'Sir Joshua Reynolds' Collection of Paintings', PhD thesis, UMI, Ann Arbor, 1987.

Giovanna Perini, 'Sir Joshua Reynolds and Italian Art and Art Literature', *Journal of the Warburg and Courtauld Institutes*, LI, 1988, pp. 141–68.

Makes new use of Reynolds's Italian sketchbooks in assessing his artistic theory.

Renate Prochno, *Joshua Reynolds*, Weinheim, 1990.
In German.

David Mannings, *Sir Joshua Reynolds: The Self-Portraits* (exhibition catalogue), Sudbury and Plymouth, 1992.

RICHARDSON, JONATHAN

Carol Gibson-Wood, 'Jonathan Richardson, Lord Somers's Collection of Drawings and Early Art-Historical Writing in England', *Journal of the Warburg and Courtauld Institutes*, LII, 1989, pp. 167–87.

RIGAUD, JOHN FRANCIS

William L. Pressly (ed.), '"Facts and Recollections of the XVIIIth Century in a Memoir of John Francis Rigaud Esq., R. A." by (his son) Stephen Francis Dutilh Rigaud', *Walpole Society*, L, 1984, pp. 1–164.

ROMNEY, GEORGE

Patricia Jaffé, *Drawings by George Romney* (exhibition catalogue), Fitzwilliam Museum, 1977.

The most important study to date.

ROWLANDSON, THOMAS

Ronald Paulson, *Rowlandson: A New Interpretation*, London, 1972.

An early example of applying the methods of literary-structuralist analysis to works of visual art, and the most interesting 'reading' of Rowlandson to date.

John Hayes, *The Art of Thomas Rowlandson* (exhibition catalogue), New York – Pittsburgh – Baltimore, 1990.

SANDBY, PAUL AND THOMAS

Luke Herrmann, *Paul and Thomas Sandby* (with a catalogue of their drawings in the Victoria & Albert Museum), London, 1986.

SCOTT, SAMUEL

Richard Kingzett, *A Catalogue of the Works of Samuel Scott*, London, 1982.

SHAFTESBURY, 3RD EARL OF

Sheila O'Connell, 'Lord Shaftesbury in Naples, 1711–1713', *Walpole Society*, LIV, 1988, pp. 149–219.

SMITH BROTHERS, OF CHICHESTER

David Coke (ed.) with Peter Mitchell and others, *The Smith Brothers of Chichester* (exhibition catalogue), Chichester, 1986.

The exhibition brought to light a significant number of paintings by all three brothers – William, George and John – for the first time.

SOLDI, ANDREA
John Ingamells, 'Andrea Soldi – A Check-List of His Work', *Walpole Society*, XLVII, 1978–80, pp. 1–20.

STEELE, CHRISTOPHER
Mary Burkett, 'Christopher Steele', *Walpole Society*, LIII, 1987, pp. 193–225.

STUBBS, GEORGE
Terence Doherty, *The Anatomical Works of George Stubbs*, Boston, Mass., 1975.
Judy Egerton, *George Stubbs 1724–1806* (exhibition catalogue), Tate Gallery and Yale Center for British Art, 1984–85.
An exhibition showing all aspects of Stubbs's activity.
Christopher Lennox-Boyd, Rob Dixon and Tim Clayton, *George Stubbs, The Complete Engraved Works*, London, 1989.
With superb illustrations.

SYMONDS, RICHARD
Mary Beale, *A Study of Richard Symonds, His Italian Notebooks and their Relevance to 17th-Century Painting Techniques*, New York and London (Garland), 1984.
With John Evelyn, Symonds was the most assiduous English Royalist connoisseur to travel on the Continent during and after the Civil War.

THORNHILL, SIR JAMES
Katharine Fremantle (ed.), *Sir James Thornhill's Sketch-book Travel Journal of 1711*, Utrecht, 1975.
A photographic reprint of the MS in the Victoria & Albert Museum, recounting Thornhill's visit to East Anglia and the Low Countries, with an annotated transcript.

TILLEMANS, PETER
Robert Raines, 'Peter Tillemans, Life and Work, with a List of Representative Paintings', *Walpole Society*, XLVII, 1978–80, pp. 21–59.

VAN DE VELDE, WILLEM, THE ELDER AND YOUNGER
M. S. Robinson, *Van de Velde Drawings... in the National Maritime Museum*, 2 vols., Cambridge, 1958 and 1974.
M. S. Robinson (revised by Richard Weber), *The Willem van de Velde Drawings in the Boymans-Van Beuningen Museum, Rotterdam*, 3 vols., Rotterdam, 1979.
David Cordingly and Westby Percival Prescott, *The Art of the Van de Veldes*, London, 1982.
M. S. Robinson, *The Paintings of the Willem van de Veldes*, 2 vols., London, 1990.
Is a *catalogue raisonné*.

VERTUE, GEORGE
Ilaria Bignamini, 'George Vertue, Art Historian, and Art Institutions in London, 1689–1768' *Walpole Society*, LIV, 1988, pp. 1–148.
With bibliography.

WEST, BENJAMIN
Helmut von Erffa and Allen Staley, *The Paintings of Benjamin West*, New Haven and London, 1986.
A massive work, fully illustrated with a *catalogue raisonné* and comprehensive bibliography.

WHITBREAD, SAMUEL
Stephen Deuchar, *Painting, Politics and Porter: Samuel Whitbread II and British Art* (exhibition catalogue), Museum of London, 1984.

WILSON, RICHARD
David Solkin, *Richard Wilson: The Landscape of Reaction* (exhibition catalogue), Tate Gallery – National Museum of Wales – Yale Center for British Art, 1982–3.
Discussed in the Introduction to the present book.

WOOTTON, JOHN
Arline Meyer, *John Wootton* (exhibition catalogue), Iveagh Bequest, Kenwood, 1984.

WRIGHT, JOHN MICHAEL
Sara Stevenson and Duncan Thomson, *John Michael Wright: The King's Painter* (exhibition catalogue), Scottish National Portrait Gallery, 1982.

WRIGHT, JOSEPH, OF DERBY
Judy Egerton, *Wright of Derby* (exhibition catalogue), Tate Gallery – Grand Palais, Paris – Metropolitan Museum, New York, 1990.
A comprehensive exhibition and catalogue, showing the full range of Wright's work.

6. SCOTTISH PAINTING

For individual painters, see the previous section.

APTED, MICHAEL R. AND HANNABUS, SUSAN.
Painters in Scotland 1301–1700: A Biographical Dictionary, Edinburgh, 1978.
Archival information from the Scottish Records Office. Most of the painters listed are no more than names whose works can no longer be traced.

HALSBY, JULIAN AND HARRIS, PAUL. *The Dictionary of Scottish Painters 1600–1960*, Edinburgh and Oxford, 1990.

HOLLOWAY, JAMES AND ERRINGTON, LINDSAY. *The Discovery of Scotland: The Appreciation of Scottish Scenery through Two Centuries of Painting* (exhibition catalogue), National Gallery of Scotland, 1978.

HOLLOWAY, JAMES. *Treasures of Fyvie* (exhibition catalogue), Scottish National Portrait Gallery, 1985.

HOLLOWAY, JAMES. *Patrons and Painters: Art in Scotland 1650–1760* (exhibition catalogue), Scottish National Portrait Gallery, 1989.
An effective presentation of Scottish painting as a product of the initiatives of patrons.

MACMILLAN, DUNCAN. *Painting in Scotland: The Golden Age*, Oxford, 1986.

Though accompanying a fine exhibition and containing brief catalogue entries, this was in reality a book recounting, for the first time, the development of Scottish painting in terms of the history of Scotland.

MACMILLAN, DUNCAN. *Scottish Art 1460–1990*, Edinburgh, 1990.

A general introduction.

INDEX

Titles of pictures and other works of art are printed in *italics*; names of owners, museums, galleries, and other indications of location in CAPITALS. Galleries are indexed under the town in which they are situated: thus, NATIONAL GALLERY will be found under LONDON. Where several references to an artist are given, that in **heavy type** is the principal. References in the notes are indexed only where some matter is dealt with in the note that is not evident from the text; in such cases the page on which the note appears, its chapter, and the number of the note concerned, are given, thus: 343(6)[28].

ARUNDELL, JOHN (Tilson), 145
Arundell, Thomas (Tilson), 145
Ashfield, Edmund, 334
Ashley, Robert (Leigh), 79
Ashmole, Elias (C. de Neve), 79; (Riley), 137
Aston, Sir Thomas (Souch), 63–4 (ill. 46)
ASTOR, LORD, *see* HEVER CASTLE
Atalanta and Meleager (Lely), 342(6)[4]
Atholl, Duke of, 151
AUDLEY END (Dobson), 81; (Eworth), 31; (J. Griffier), 155; (Pine), 270
Austin, Nathaniel, 340(4)[11]
Austrian Succession, War of, 157
Aylesford, Earl of, 137

Baciccia, G. B., 138
BACON, SIR EDMUND (Gainsborough), 246
Bacon, Sir Nathaniel, 65 (ill. 48), 66, 67
BADMINTON, 40
Baillie, Grisel and Rachel (J. Scougall), 123
Baillie, Rachel (J. Scougall), 123
BAKER-CARR, MAJOR (Dobson), 80
Bakker, John Jacob, 345(8)[9]
BALCARRES (Garrison), 345(8)[10]; (Jamesone), 68; (Mytens), 60
Balen, *see* Van Balen
BALTIMORE, ENOCH PRATT LIBRARY (Soest), 102, 103 (ill. 86)
Baltimore, 1st Lord (Mytens), 55, 56 (ill. 39), 102, 343(6)[14]
Baltimore, 2nd Lord, with Child and Page (Soest), 102, 103 (ill. 86)
Banks, Mr (Kneller), 138
'Baptiste', *see* Monnoyer
Barber-Surgeons, Grant of Charter to (Holbein), 21–2
Bardwell, Thomas, 211
BARKBY HALL (I.W.F.), 79
Barker, Charles, 62
Barlow, Francis, 118–21 (ill. 100), 162, 297
BARNSTAPLE TOWN HALL (Hudson?), 201
BARODA GALLERY (Lely), 342(6)[4]
Baron, Bernard, 165
Barret, George, 241–2
BARRINGTON PARK, 35
Barron, Hugh, 231, 319
Barry, James, 216, 271, 272, 273–5 (ill. 214), 283
Bartolozzi, F., 268
BASEL (Holbein), 18
Bate-Dudley, Lady (Gainsborough), 257
BATH, MARQUESS OF (Siberechts), 117
Batoni, Pompeo, 203, 211, 267, 269, 335
BATSFORD PARK, *see* DULVERTON, LORD
Bayard, Death of (West), 215, 277
BAYHAM ABBEY (Dance), 268 (ill. 211)
Beach, Thomas, 230–1

Beale, Mary, 113–14, 251
Beare, G., 186
Beattie, Dr (Reynolds), 271
Beaufort, 3rd Duke of, 155, 157
Beaufort, Lady Margaret, 13
Beck, David, 77
BECKETT, JUDGE (Lely), 96
Beckford, Mrs Francis (Reynolds), 222 (ill. 171)
Beckford, William, 329
Bedford, Anne, Countess of (Lely), 94
Bedford, 4th Duke of, 186
Bedford, 4th Duke of (Knapton), 186
Beechey, Sir William, 231, 232, 262, 313–14 (ill. 247), 320
'Beggar's Opera, The', 166, 170
Beggar's Opera (Hogarth), 169 (ill. 134), 170, 315
Belcam, *see* Van Belcam
Bellin, Edward, 62
Bellucci, Antonio, 131
BELPER, LORD (Mortimer), 349(21)[5]
BELTON (Mercier), 189 (ill. 149); (Riley), 137; (Seeman), 186; (Wissing), 112, 113 (ill. 96)
BELVOIR (Holbein?), 22; (Siberechts), 117; (M. Wright), 108
Benefial, Marco, 283
Bentheim, Castle of (Ruisdael), 240
BENTINCK, COUNT (Lely?), 94
Berchet, Pierre, 127, 128
Berghem, N., 234, 324
Berkeley, Bishop, 185
BERLIN (Holbein), 18, 19
BERMUDA, WATLINGTON COLLECTION (Gainsborough), 254
Bernard, Samuel (Rigaud), 174
Bernini, G. L., 74, 107
Berridge, John, 231
BESANÇON (School of Holbein), 337(1)[17]
Bethesda, Pool of (Hogarth), 173
Betterton as Tamerlane (Greenhill), 334
Bettes, John, 22–3
Betts, John, 90
Billingbear (J. Griffier), 155
BINNS, THE (Paton?), 123
BIRDSALL HOUSE, *see* MIDDLETON, LORD
BIRMINGHAM
 ASTON HILL (Opie), 282; (Soldi), 200
 BARBER INSTITUTE (Gainsborough), 260 (ill. 204), 320
 GALLERY (Gennari), 115; (Gentileschi), 68; (Highmore), 182; (Knapton), 187; (Lely), 97, 342(5)[25], 342(6)[4]; (R. Wilson), 240 (ill. 188); (Zoffany), 317
BISHAM ABBEY ('Bursler'), 344(6)[32]
Bishopp, the Misses (Riley), 137
Bisschopp, Cornelius, 138
BLACKHEATH, *see* LONDON
BLAGDON (Hoppner), 312

Strawberry Girl (Reynolds), 215, 227
Streeter, Robert, 15, **116–17** (ill. 98), 125
Stretes, G., *see* Scrots
Strong, Sampson, 41, 80, 114
Stuart, 'Athenian', 273
Stuart, Gilbert, **311–12** (ill. 245), 330
Stuart, Mrs James (Mosman), 331
Stuart, Lords John and Bernard (Gainsborough), 252
Stubbs, George, 119, 215, 284, 297, **299–304** (ills. 234–8), 305
Styles, Mr, 133
SUDBURY HALL (Laguerre), 126
SUDELEY CASTLE (Corvus), 15; (Fuller), 89
Suffolk, Countess of (anon.), 44 (ill. 31)
Suffolk, Duchess of, and Adrian Stoke (Eworth), 31
Sunderland, (2nd) Earl of (Maratta), 345(8)[4]
Sundon, Lady (Amigoni), 134
Surrey, Henry Howard, Earl of (Scrots), 25 (ill. 10), 26
Susanna and the Elders (Lely), 342(6)[4]
Swift, Jonathan, 149
Swift, Jonathan (Jervas), 150 (ill. 124)
Swinburne (Gainsborough), 257
SWINTON PARK (formerly) (Carleton), 62
Sykes, Sir Christopher and Lady (Romney), 308–11 (ill. 243)
Symonds, Richard, 80, 85, 87, 119
SYON HOUSE (Barry), 273, 274 (ill. 214); (Closterman), 143; (Dance), 267–8 (ill. 210); (Greenbury), 80; (Lely), 93 (ill. 72), 94, 342(6)[3]; (Riley), 137 (ill. 111); (Stuart), 312; (Van Dyck), 74–5 (ill. 53); (Walker), 88

Tahiti (Hodges), 243 (ill. 191)
Tailfier, 91
Talbot, Sir Gilbert (Hayls), 343(6)[11]
Taylor, John, 114–15
Teerlinck, Levina, 15
Telfer, 91
Temple, Susanna (C. Johnson), 61 (ill. 43)
TEMPLE NEWSAM (Knyff), 119–21 (ill. 101); (Mercier), 190; (Wootton), 155
Teniers, David, 163, 324
Ter Borch, 66
Terbrugghen, 66
Thames from above Greenwich (anon.), 67 (ill. 49)
Thames, Mouth of the (Gainsborough), 262
Thames, Regatta on the (R. Griffier), 155 (ill. 128)
Thetis Bringing the Infant Achilles to Chiron (Pellegrini), 129
Thicknesse, Mrs Philip (Gainsborough), 253 (ill. 199), 254
'Thicknesse, Philip' (Gainsborough), 349(18)[7]
THIRLESTANE CASTLE (Reynolds), 222–4 (ill. 172); (Seeman), 186
Thomson, James, 'Seasons', 284
Thornhill, Sir James, 127, 130–1, 131–3 (ill. 107),

142, 147, 164, 168–9
THORPE HALL (Mercier), 190
Thrale, Mrs, on Reynolds, 220; *see also* Piozzi
Thrumpton, T., 334
Tiepolo, G. B., 130
Tillemans, Peter, 191, **193**, 194, 297, **298**
Tilney, Earl, 191
Tilson, Henry, 110, 144, **144–5**, 146
Timon of Athens (Dance), 268
Titian, 18, 25–6, 28, 55, 71, 72, 74, 85, 87, 88, 150, 218, 291, 307
TOLEDO (OHIO) (Beechey), 314
Toms, Peter, 265
Tonson, Jacob (Kneller), 142 (ill. 118)
Torregiano, Pietro, 16
Torriano, Samuel (Ramsay), 203 (ill. 161)
Toto, Anthony, 15, **16**
TOULOUSE MUSEUM (Verrio), 125
Tourarde, Michael, 126
Tower of London (Scott), 159 (ill. 131)
Towneley, Charles, Among his Marbles (Zoffany), 319
Trabute, William, 114
Tradescant, Hester, and Stepson (E. de Critz), 77–8
Tradescant, John, and John Friend (E. de Critz), 78–9 (ill. 57)
Tradescant, John, with Spade (E. de Critz), 78–9 (ill. 56)
Tradescant, John, jnr (E. de Critz), 78
Tromp, Admiral (Kneller), 138
Troost, Cornelis, 330
Trotter, Thomas (Millar), 332
Troy, Jean-François de, 143, 169
TUDOR-CRAIG, SIR ALGERNON (formerly) (Murray), 149
Tufton, Sir John, 40
Turner, J. M. W., 152, 213, 238, 240, 323, 326, 329
Tweeddale, John, 2nd Marquess of (Maratta), 345(8)[4]; (Soest), 102 (ill. 85)
TWISDEN COLLECTION (formerly) (Soest), 102 (ill. 84)
Tyers, Jonathan, 195
TYNINGHAME (Gainsborough), 250; (Jamesone?), 68
Tyrconnel, Viscount, and his Family (Mercier), 189 (ill. 149)
Tyson, Edward (Lilley), 144

UFFINGTON (Hayls), 101
UGBROOKE (Roestraeten), 115
Ugolino (Reynolds), 227
Ulysses and Penelope (at Hardwick), 32
UPTON HOUSE (National Trust) (Hogarth), 173; (Pond), 200; (Stubbs), 302 (ill. 237), 304; (Wheatley), 319–20

Valenciennes, Battle of (Loutherbourg), 324
Van Aken, Joseph, **162**, 167, 188, 201, 204